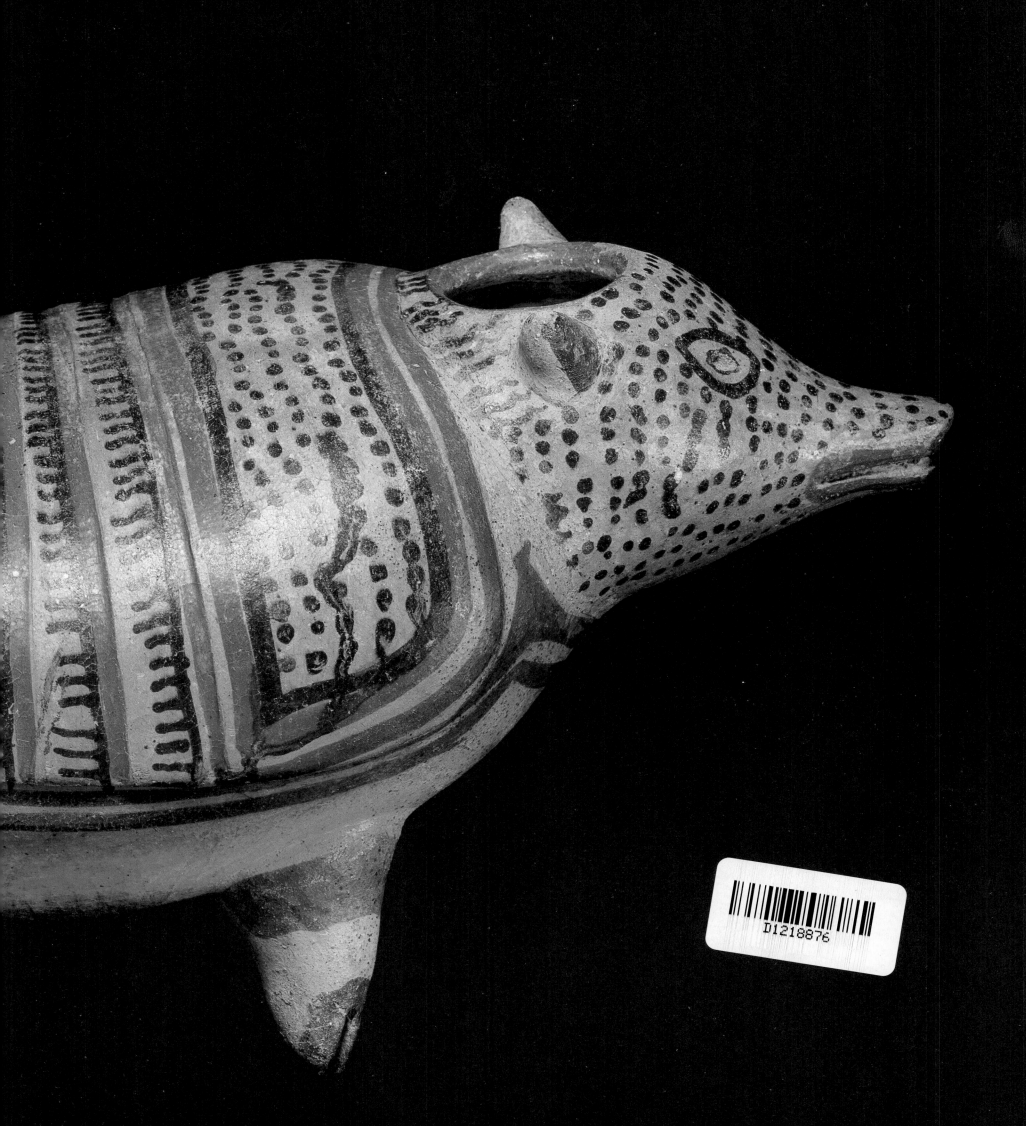

ART
OF
COSTA RICA

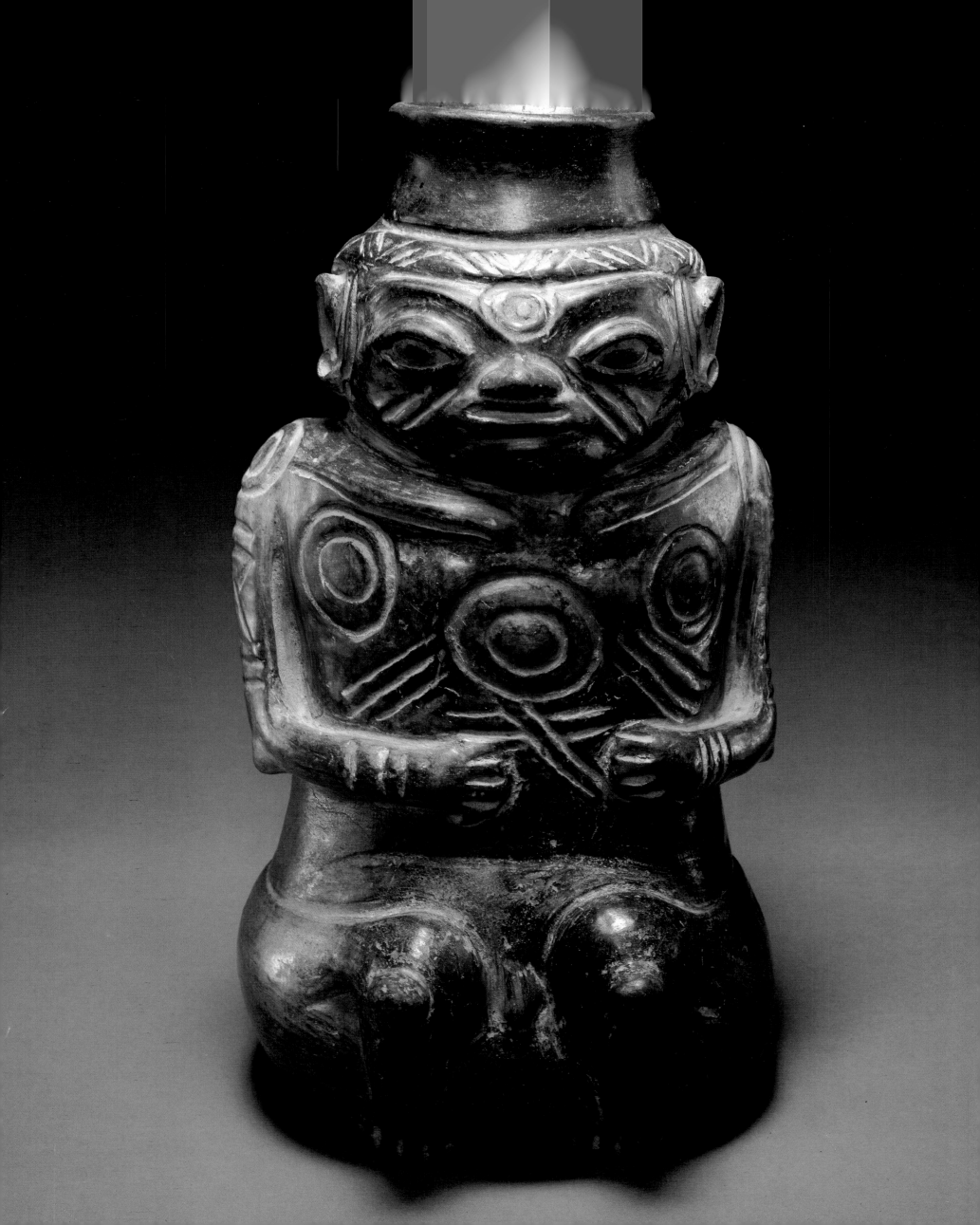

ART OF COSTA RICA

Pre-Columbian Painted and Sculpted Ceramics from the Arthur M. Sackler Collections

Essays by
DORIS STONE
DR. JANE STEVENSON DAY
TOBY and ROBERT STOETZER
Introduction and catalogue by
PAUL CLIFFORD

Edited by
LOIS KATZ
Curator of the Arthur M. Sackler Collections and
Administrator of the Arthur M. Sackler Foundation

THE ARTHUR M. SACKLER FOUNDATION
AND
THE AMS FOUNDATION FOR THE ARTS, SCIENCES AND HUMANITIES
WASHINGTON, D.C.

EXHIBITIONS:

The City Arts Centre, Edinburgh, Scotland
August 3-31, 1985
Duke University Museum of Art, Durham, North Carolina
November 22, 1985–January 31, 1986

COVER: No. 101, *Large Effigy Jar*,
Vallejo Polychrome, Vallejo Variety

END PAPERS: No. 33, *Armadillo Effigy Vessel*,
Mora Polychrome/Mora Variety

FRONTISPIECE: No. 118, *Human Effigy Jar*,
Unknown type

Designed by Victor Trasoff

Assistant to the Editor: Elizabeth Frechette

Photographs by Murray Shear

LIBRARY OF CONGRESS CATALOGUING IN PUBLICATION DATA

Art of Costa Rica:
 Pre-Columbian Painted and Sculpted Ceramics from the
 Arthur M. Sackler Collections
 Exhibition held at the City Art Centre, Edinburgh, Scotland;
 Duke University Museum of Art, Durham, North Carolina
 Bibliography: p. 297
1. Ceramics, Costa Rican—Exhibitions
2. Sackler, Arthur M.—Art Collections—Exhibitions
I. Paul A. Clifford II. Doris Stone, Jane Stevenson Day, Robert and Toby Stoetzer
III. Title IV. Arthur M. Sackler Collection
No. 85-73381
ISBN 0-913-291-01-3

TABLE OF CONTENTS

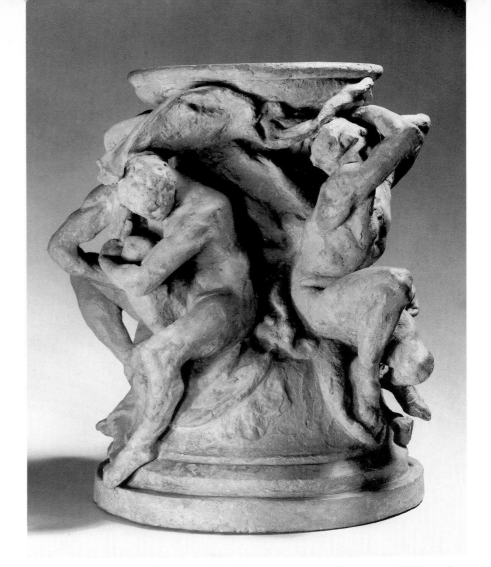

Figure 1. Auguste Rodin, *Vasque des Titans*, terra-cotta, France ca. 1880, and No. 127, *Pot Stand with Atlantean Figures*, earthenware, slipped and burnished, Costa Rica (100 BC-AD 500).

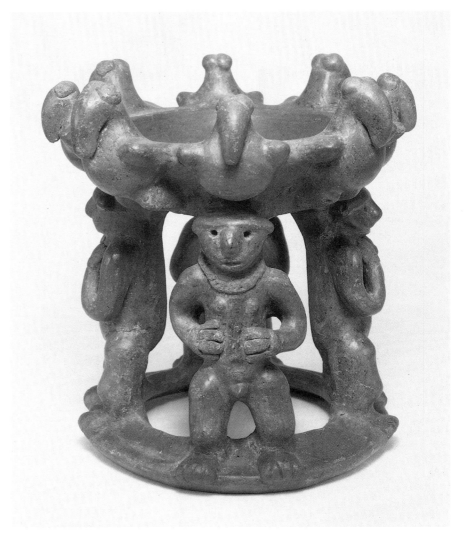

Clay and Civilization

ARTHUR M. SACKLER, M.D.

ONE MUST VIEW the striking and distinctive creative efforts of Costa Rica's early ceramic artists with admiration as one projects their achievements against the backdrop of a culture with no alphabet, with limited technology and no extant monumental architecture. Despite the designation of Costa Rica as the "rich coast" by Spanish explorers who were impressed by the gold adornments of its people, the area would appear to have been poor in terms of the materials, technology and opportunities essential for the development of important stone architecture or a wide range of aesthetic creations in stone and metal.

But the Indians of Pre-Columbian Costa Rica, who inhabited the area "between two continents and two seas," enjoyed the advantages even as they suffered the vicissitudes of living at the juncture between cultures and the transit point for commerce. The Costa Rican isthmus, linking North and South America, was exposed to civilizations more sophisticated than its own, utilizing more advanced technologies manifested in monumental architecture and a wide range of metallurgical skills. It witnessed cultural as well as commercial interchange between the North and South. Though linguistically and culturally related to the peoples of South America, the societies of the lower portion of Central America were also exposed to the geographic "tongue" of Mesoamerican culture ranging down the Pacific coast in later Pre-Columbian times.

Costa Rica and Pre-Columbian America

As in the case of the crossroads of ancient Palestine, where three great faiths were born which today still influence the worlds of philosophy and ethics, the arts and the humanities, Costa Rica was a crossroads of Pre-Columbian cultures and was influenced by neighboring civilizations. This New World cultural intersection however had no continuous impact on world civilization. We are only now exploring archaeologically the ideas, skills and geography of this area and its relationship to neighboring cultures and technologies.

The ceramic art of this crossroads of Pre-Columbian societies demonstrates a dramatic plethora of sculptural expression as well as potters' skills, including a range of color from monochromes and subtle, subdued polychromes to an imaginative contrast of color. The varied and sometimes colorful grotesques call to mind gargoyle counterparts in medieval Europe, even as the modeling of some figurines, although of different inspiration, brings to mind the abstracted forms of modern art. Their sculptural treatment of animal life challenges that of other cultures in range of subject matter and expressiveness and anticipates contemporary innovative adaptation of forms. One must also note with interest the similarity of concept of some Atlantean forms to those used in other societies, as in Rodin's *Vasque des Titans* which has given us so much joy in our collection of European terra-cotta sculptures (Fig. 1).

Early Costa Rican sculpted and painted ceramics, their plastic composition and design and the remarkably high quality of this fine art in small scale, cannot help but challenge an art-oriented, albeit primarily neuroendocrinologically-biased, psychiatrist to find a cause for such dramatic creativity. It is rare that I turn to Freudian psychodynamics whose validity, in the expression of psychoneurotic symptom formation as well as in the interpretation of character and plot in literature, has unfortunately been too often diminished by an overextension of its application to all mental disease. In the instance of Costa Rican ceramics however it seems to me that we have at hand an art of superb sublimation focusing creative forces, condensing and directing aesthetic energies into the development of a distinctive as well as distinguished corpus of potted, painted and sculpted ceramics. In other societies these forces are expressed in literature, architecture, painting and in stone, wood and bronze sculpture.

Clay and the World of Ceramic Arts

Clay undoubtedly provided one of the most significant materials in the annals of human cultural development. While cultural diffusion may be related to some aspects of ceramic manufacture and decoration, the ubiquity of clay and the fundamental similarity of humankind's neurosensory and neuromotor apparatus contributes to the belief in the postulate of independent invention

7

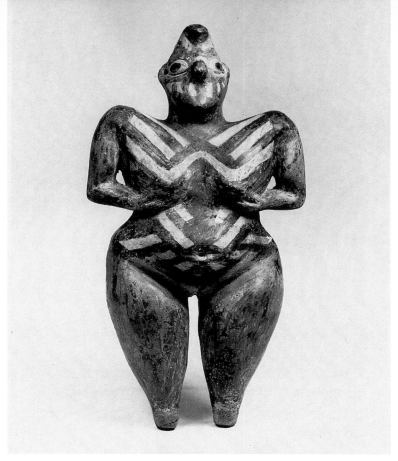

Figure 2. Female Figurine, terra-cotta, Anatolia, ca. 3rd millenium BC.

and development of ceramics in many centers. Perhaps the impression of an erect biped's heel in a clay ground accumulating rainwater provided the earliest impulse for a cup-like utensil, even though present evidence for the shaping of clay vessels does not antedate 8000 BC. But, as we now know, clay was employed in figurines dating to the pre-Magdalenian period (twenty-seven thousand years ago). Baked and painted clay figurines of eight thousand years ago, precursors of the Anatolian goddesses in our collections dated by thermoluminescence to five thousand years ago, demonstrate both a continuity in sculptural traditions and aesthetic sensibilities (Fig. 2). Originally coil-built and shaped by hand, ceramic vessels were so turned out for thousands of years and are still in our own time, as in the blackware by the late Santa Clara Pueblo potter Maria Martinez. They were only joined by wheel-thrown pots about 4000 BC. Although I am convinced of the link between cultures of the western hemisphere and the Asiatic mainland, nevertheless the enigma remains of the failure of New World inhabitants to use the wheel either for potting or other serious purpose.

Evidence of some of the earliest pottery in the New World is from Puerto Hormiga, Colombia, about 3500 BC and from Valdivia, Ecuador, similarly dated, whose forms and decoration led to a postulated Jomon-Valdivian relationship, lately rejected as evidence of early Japanese-New World contact. Ceramic time markers date back possibly as early as 8000 BC in Japan, 7000 BC for the Middle East, 6800 BC for Xien-rendung in China, 6800 BC for pottery fragments found at Spirit Cave in Thailand, 5000 BC for Hassuna in Northern Iraq, 4800 BC for Banpo in Shaanxi prov-

ince, China, 4000 BC for Mehogarh in Baluchistan, and 3600 BC for Ban Chiang, Thailand.

The earliest pottery decoration in all societies appears to be produced by impressions in the pre-fired clay of cords or twisted twine as in neolithic China and ancient Thailand. Incised decor was undoubtedly an early and logical development from cord impressed designs. Painted wares, as in the Yangshao culture of China (Fig. 3), superseded earlier decoration about 5000 to 4000 BC. While one of the earliest and most basic ceramic techniques for building pots was the coiling process, the use of molds for some types of vessels as well as for figurines occurred at a very early date.

Clay and Biologic Evolution

With poetic symmetry and almost dramatic inevitability, clay, the most ubiquitous as well as the most primordial substance, so significant in the development of man's technology, has been proposed as a substrate for the evolution of all forms of life on this globe. That primordial substance which infants and children delightedly squish between their fingers in early exploratory activities is, we now note, no passive, inert medium. Today the advancing edge of science vigorously explores the interface between clay and organic molecules. We confront the possibility of certain clays participating in catalytic and enzyme-like functions.

A. G. Cairns-Smith explains that "all around us, all the time, clay minerals are crystallizing from dilute solutions of silicic acid and hydrated metal ions formed by the weathering of hard rocks. Indeed, the earth's surface has been described as a huge factory that manufactures clay minerals." Energy gathering and storage may be within the potentials of different clays under certain circumstances as well as cyclical "transfers of energy from the environment to the organic molecules."[1] He goes on to note that the process is driven by the geologic cycle energized by radioactive heat from

Figure 3. Burial Urn, clay, painted and burnished, Ban Shan style, Yang Shao culture, China, ca. 5th millenium BC.

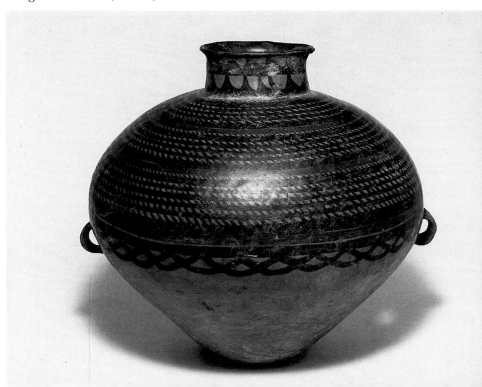

the earth's core as well as a solar cycle which maintains a supply of water through "evaporation from the sea, the formation of clouds, rain, ground waters, streams, rivers and back to the sea." His hypothesis indicates that certain elements of clays could conceivably present a one-dimensional genetic crystal with limited information capability while others may conceivably provide two-dimensional genetic crystals.

In the briefest of condensations, Cairns-Smith's challenging hypothesis proposes that clay provided the scaffolding upon which more complex genetic materials were then structured. These genetic materials, in turn, entered into the classic Darwinian evolutionary process. The presentation of his case for the evolution of life departs from the idea introduced by J. B. S. Haldane* of a "primordial soup of organic molecules existing in the oceans of the prevital earth," or from Harold Urey's views, and from Stanley Miller's experiment. It is a fascinating postulate of the role of clay in the evolution of all species.[2]

Clay and Science Today

The interplay between primordial clay, the genesis of mankind, and the unpredictable and challenging future into which we are being propelled by science and technology and its utilization of clay, is both exquisite and dramatic. More exciting today is the manner in which the accelerating rate of change is altering cultural evolutionary processes by the explosive dynamics of the current scientific and technological revolutions. In these we find it fascinating how the most primordial of substances is being utilized in humankind's escape from gravity, thanks to silicon chip computers and our ceramic thermal shielded space ships, and consequently is linked to the probes of our galaxy and our opening investigations of the outer reaches of the cosmos. Clay is now also extending one of the core functions of civilizations, communication among humankind as we proceed into the age of fiber optics and as photons replace electrons in voice transmission.

Hopefully, these developments will lead to more than mere speed of transmission. Ideally, they will lead to the advance of communications in the service of greater understanding among different societies and greater respect for the individuals who are most vital to them. We can only hope that in the new millennium now virtually upon us that humankind will not enter into a destructive apocalyptic lunacy, but will engage its dynamic creative forces in a glorious constructive era and a flowering in the realms of the arts, sciences and humanities.

*And A.I. Oparin
1. Cairns-Smith, A.C. "The First Organisms," *Scientific American*, 252:8, June 1985, p.97.
2. *Ibid*, p.90.

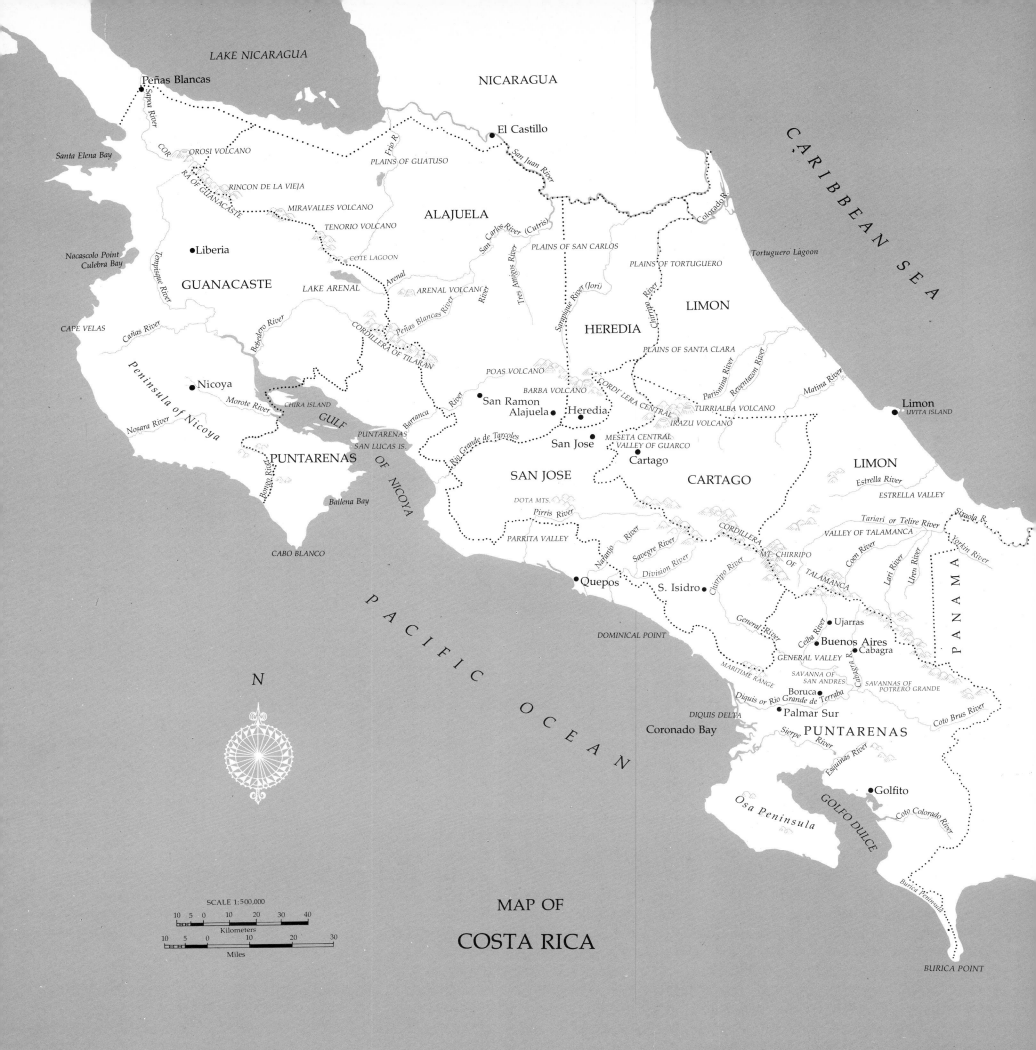

MAP OF

COSTA RICA

SCALE 1:500,000

Kilometers

Miles

Archaeological Work in Costa Rica

by DORIS STONE

THE ARCHAEOLOGY of Costa Rica was practically ignored until the end of the nineteenth century. A little of the Pre-Columbian history was preserved by word of mouth among a relatively few Indian elders at the eastern and western peripheries of the country where it was remote and access was difficult. Lawsuits between Spanish leaders, their rivals, orders of the King, or sparse reports from the clergy and ranking officials of the conquest at times gave insight into the customs of the inhabitants at the advent of the European. Social and artistic developments, new diets, and religions or struggles for power which led to strategic changes in settlement patterns; these, and the whole manner of living throughout the centuries before the white man appeared, are uncovered through the efforts of the archaeologist in his search for man throughout the ages.

The Overall Picture

A small number of investigators have tried to present an overall picture of Costa Rican prehistory either through actual fieldwork, the study of ancient artifacts, a combination of these subjects or simply a synthesis taken all or in part from the investigation of others. The first scholar to study the many aspects of Costa Rican prehistory was the German linguist and art historian Walter Lehmann in the early twentieth century. He journeyed by mule, canoe and on foot primarily to collect linguistic material including legends and songs. He also investigated archaeological collections and even attempted some excavations. Lehmann copied by hand the artifacts, petroglyphs and decorative motifs on the ancient ceramics. Over 1200 of these sketches are in the Ibero-Amerikanischen Bibliothek in Berlin. His studies led him to deduce that throughout the centuries there had been a number of cultural intrusions from the north into much of Costa Rica's territory and also an extension of southern cultural trends from South America. Lehmann further indicated archaeological cultural centers, some of which are valid today.[1]

Herbert Joseph Spinden, a field archaeologist with the Peabody Museum, Harvard University, and The Brooklyn Museum, New York, was also a pioneer in Central America. He was the first to conceive of a Chorotegan culture area and to emphasize the southern roots of the culture in the Nicoya region.[2] This theory is opposed to Lehmann's idea of a dominant thrust of northern traits and a Chiapanecan or Mexican origin of the Chorotega-Mangue, one of the principal groups in the Nicoya region when the Spanish arrived.

Samuel Kirkland Lothrop, connected with the Museum of the American Indian, Heye Foundation, and later with the Peabody Museum, Harvard University, worked throughout Central America. He undertook the tremendous task of classifying the pottery in private collections and the National Museums of Costa Rica and Nicaragua. The results were his two important volumes published in 1926, *The Pottery of Costa Rica and Nicaragua.* Later, his excavations in Diquis produced a chronological ceramic sequence from the delta.[3]

William Duncan Strong from the Smithsonian Institution, Washington, D.C., wrote a synthesis of Central American archaeology in 1948. Although he covered Costa Rica in his survey, he did not work there.

Doris Stone, connected with Peabody Museum, Harvard University, Middle American Research Institute, Tulane University, and the National Musuem of Costa Rica, is the most recent investigator to be concerned with all of Central America. In 1972, her synthesis of this area was published by Peabody Museum, followed in 1977 by a similar book on Costa Rican prehistory only, including pertinent historical and ethnological data. Stone worked in all three archaeological regions of Costa Rica and was the first to report the stone lithic spheres from the Diquis delta.[4]

Stone and Carlos Balser wrote an "Introduction to

the Archaeology of Costa Rica," in 1958, which when it appeared, served as a synthesis to the country's prehistory. The emphasis in the booklet is on pottery types.

Luis Ferrero, a Costa Rican writer, published a synthesis of the archaeology, most of which is a recompilation of other works. Parts of it consist of excerpts from chronicles and colonial documents. There is also an account of the techniques of pottery making, metalworking and stone carving.

The Nicoya Region

The earliest archaeological investigators chose the Nicoya region, probably because of the superlative polychrome ceramics characteristic of this area as well as its climate. The province of Guanacaste has less rain, thereby making travel and excavation more feasible than in the often superwet Atlantic Watershed and Diquis. In the 1880s, J.F. Bransford, a doctor in the United States Navy, and Earl Flint, under the auspices of the Smithsonian Institution, investigated the northern portion of the Nicoya Peninsula. The results of Bransford's work appeared in 1884, while Flint's reports are in the Peabody Museum archives, Harvard University, in letters to the then director, George Putnam. In the same century, a Costa Rican naturalist, Anastacio Alfaro, trained by the Smithsonian, became the first Director of the National Museum and its first archaeologist. He carried out excavations at various locations on the coast of Guanacaste and at the Hacienda Mojica. Among his principal contributions, however, was work at El Guayabo de Turrialba on the Atlantic Watershed.[5]

The twentieth century saw the beginning of scientifically recorded excavations of Pre-Columbian cemeteries in the hands of Carl Vilhem Hartman, a Swedish botanist. He worked in the Central Highlands, at Curridabat, the valley of Cartago, Orosi and on the Linea Vieja, particularly at Las Mercedes, all on the Atlantic Watershed. In the Nicoya region, Hartman excavated various sites including the famous cemetery of Las Huacas near the town of Nicoya. While there he purchased a black fluted flint point which established the presence of paleo-man in the area.[6]

The Costa Rican, Jorge Lines, wrote a number of pamphlets describing archaeological artifacts. In a report of his fieldwork in Guanacaste, moreover, he produced a diagram of his excavation at Filadelfia.[7]

Carlos Balser, one of the foremost authorities on Costa Rican jades and goldwork, has excavated in the Atlantic Watershed and Nicoya regions. His specialty however concerns the techniques in jade and goldworking as well as the documentation applicable to these fields.[8] The first of the newer generations to establish a ceramic sequence in Costa Rica was a French archaeologist from the University of Paris, Claude F. Baudez, who excavated four sites in the Tempisque Valley from 1959-1960. Although his preliminary interest was a pottery sequence, his report also points out the relationship of his finds with sites outside the valley as well as with Nicaragua and Panama.[9]

Almost at the same time as Baudez, Michael D. Coe, sent by the Institute of Andean Research, New York, carried out investigations at several coastal sites and produced a cultural sequence as a result of his work.[10] Furthermore, in combination with Baudez, the Zoned Bichrome Period was established in Costa Rican archaeology for the time span 300 BC-AD 500.[11]

Frederick W. Lange, now at the University of Colorado, is the only one of the new archaeologists who has devoted himself to all aspects of research in the Nicoya region: geography, soil, climate, foodstuffs and cultural history. In short, he is concerned with the total pre-Hispanic cultural adaptation in this area and has excavated many sites.[12]

Laura Laurencich de Minelli, an Italian professor at the University of Bologna, has worked in ethnology, physical anthropology and archaeology. Her excavations have been concentrated in the Diquis region, with the exception of a grotto on the Cerro Barra Honda. Her report of the site is the most complete to date.[13]

Some of the new group of researchers who are working or have worked in the Nicoya region are Richard N. Accola, Suzanne Abel-Vidor, Winifred Creamer, Jane Stevenson Day, Lynette Norr and Jeanne Sweeney. Accola is interested in the classification of ceramics and with Lange is responsible for the finding in Guanacaste of a mold used in casting gold, the first evidence of actual gold working in the province. He has also carried out extensive site surveys on the coast.[14] Creamer's surveys of the islands in the Nicoya Gulf have contributed to our appreciation of trade in the area.[15] Day likewise specializes in ceramics (see her essay) and emphasizes the analytical approach. She has applied stylistic and iconographic analyses with success, using as a medium over three thousand vessels in a collection at the Hacienda Tempisque in Guanacaste, and has shown not only that the interregional trade was responsible for presence of certain vessels but also, by means of neutron activation analysis, that some were local imitations.[16] Sweeney has dedicated herself to ceramic analysis, restudying in part sherds from Michael D. Coe's fieldwork. She has proposed that the Nicoya Peninsula should not be considered as belonging to Mesoamerica, a line of reasoning that to me seems incomprehensible.[17]

Abel-Vidor and Norr do not emphasize pottery, but their contributions form a very essential part in any study of archaeology. Abel-Vidor researches and inter-

prets ethnohistoric sources,[18] while Norr analyzes human bone material to ascertain diet.[19]

The Atlantic Watershed

Toward the middle of this century there was renewed interest in archaeological excavation throughout the Atlantic Watershed. Carlos Humberto Aguilar P., a professor from the National University of Costa Rica, worked at the site of Retes near Cartago. Retes proved to be a cache buried under layers of volcanic sand, and contained stone, clay and wooden artifacts among which were drums, staffs and lapidaries. A radiocarbon date of AD 960 was obtained.[20] Aguilar worked in El Guayabo de Turrialba. Later, he defined the Pavas ceramic phase in the Central Plateau dating approximately from 100 BC-AD 500. Storage pits for maize, seed, etc., are associated with this complex.[21]

Matthew W. Stirling of the Smithsonian Institution and the National Geographic Society worked briefly on the Linea Vieja. Through his excavations and radiocarbon datings, he established that the long-legged tripod decorated with appliquéd figures—formerly called a chocolate pot but recently an "Africa tripod"—nasal snuffers and jade axe-gods are correlated at AD 144.[22]

A pottery sequence in the Reventazon Valley, which can be correlated with that of Baudez and Coe in the Nicoya region, was developed by William J. Kennedy, now a professor at the University of Florida, Boca Raton, but then a graduate student at Tulane.[23] He also classified monochrome wares using surface color and finish, paste color, texture and temper plus the technique of ornamentation for decorated pottery.[24]

Michael J. Snarskis, another North American who came to Costa Rica with the Agency for International Development and later worked at the National Museum but who now is associated with the National University, established three early Atlantic Watershed cultures: La Montaña, 100-300 BC, which indicates a relationship to Venezuela and Colombia particularly through the presence of clay griddles for manioc and a different style of lithic tools; Chaparron in the San Carlos area dating from the same period but with bichrome ceramics, Mesoamerican in character; and El Bosque, 100 BC-AD 500, stressing red on buff ceramics with impressed or appliquéd decoration. This relates El Bosque more to Chaparron than to the La Montaña complex.[25] In the Central Plateau, Snarskis defined the La Selva phase, AD 500-800, with Curridabat Ware characterized by modeling and tripods and gold work replacing jade. Gold, as noted before, is a southern heritage. Negative painted pottery, also a southern trait, appeared from about AD 700-1000.[26] The final sequence identified by Snarskis on the Atlantic Watershed is the La Cabaña

phase, AD 1000-1500. The type site here is Las Mercedes on the Linea Vieja. It combines ceramic styles and elaborate features. The pottery, adorned with appliqué and associated with this phase, is seen as far west as the Aguan River in Honduras, thereby relating La Cabaña to the north coast of Central America.

The last archaeologist associated with the Atlantic Watershed is the Costa Rican, Oscar Fonseca Zamora, whose work at El Guayabo de Turrialba has revealed a community reminiscent of many Tairona sites in the Sierra Nevada of Colombia. El Guayabo has stone causeways, steps, aqueducts, plazas, etc., even to a certain extent the environment one sees at such places as Buritaca 200 in Colombia.

The Diquis Region

It is fitting that a Costa Rican and a naturalist, Pedro Pérez Zeledón, was the first to be associated with this region which until relatively recently remained the least known part of the national territory. Dense forests (difficult to imagine today), heavy rainfall, and a steep, at times impenetrable, approach over rugged and cold mountains aided the isolation. It was a section which lent itself to the needs of fugitives not only from the Central Plateau but also from neighboring Panama. Pérez Zeledón was an early explorer of the General Valley and the Río Grande de Diquís or Térraba. Although his main interest was natural history, he published whatever new archaeological data he encountered on his trips.[27]

Wolfgang Haberland from the Hamburgische Museum für Völkerkunde is responsible for the geographical term "Greater Chiriquí" to cover the highlands and Pacific side of Costa Rica and western Panama, an area of cultural extensions regardless of political borders. In the Diquis region, Haberland defined the oldest phase, Aguas Buenas, 800 BC-AD 600.[28] This is believed to be contemporary with, but distinct from, the Concepción culture of Chiriquí Province in Panama, which is eastern in origin despite the fact that there are Aguas Buenas sites in Chiriquí.[29] Haberland also postulated that agriculture and the ceramic complex of Aguas Buenas might have come from Central Costa Rica and be related to the El Bosque phase.

Maria Eugenia Bozzoli de Willi is the first Costa Rican woman to become an anthropologist. Although primarily interested in ethnology, her reports on the Middle to Late Period Diquis and the Boruca phase in the western part of the General and Parrita Valleys are important.[30] The painstaking excavations of the Italians, Laura Laurencich de Minelli and Luigi Minelli, have provided the most complete information on the Aguas Buenas phase in Costa Rica.[31] Robert Drolet, a Frenchman, made a survey of the Diquis Valley for the

National Museum in 1980-1981. His reports on Aguas Buenas settlements indicate that along the river, including bottom and upland areas, half the sites belong to Aguas Buenas culture and half to the Chiriquí phase, AD 600/800-1500. Aguas Buenas sites are located in the highlands while Chiriquí phase culture is dedicated to the lower valley bottom.[32]

1. Lehmann 1910; 1920.
2. Spinden 1925.
3. Lothrop 1963.
4. Stone 1943.
5. Alfaro 1893, 1896.
6. Hartman 1901, 1907.
7. Lines 1935, 1936.
8. Stone 1953, 1968, 1980; Stone and Balser 1958, 1965.
9. Baudez 1967.
10. Coe 1962.
11. Coe and Baudez 1961.
12. Lange 1971, 1984.
13. de Minelli 1983.
14. Accola 1978a and b; Lange and Accola 1979.
15. Creamer 1980, 1983.
16. Day 1984.
17. Day 1975, 1976.
18. Abel-Vidor 1980, 1981.
19. Norr 1980b, 1981.
20. de Vries 1958 p. 136; also see his bibliography pp. 129-137.
21. Aguilar 1953, 1972, 1974; Snarskis 1984 p. 214.
22. Stirling 1969.
23. Kennedy 1968.
24. Kennedy 1968, 1969, 1975, 1976.
25. Snarskis 1984 pp. 201-209.
26. Willey 1984 pp. 352-353.
27. Zeledón 1901, 1907.
28. Willey 1984 p. 354; Haberland 1959, 1961b.
29. Haberland 1984 pp. 237-238.
30. de Willi 1962, 1966.
31. de Minelli and Minelli 1966, 1973.
32. Drolet 1984 pp. 254-262 as appendix to Haberland's essay.

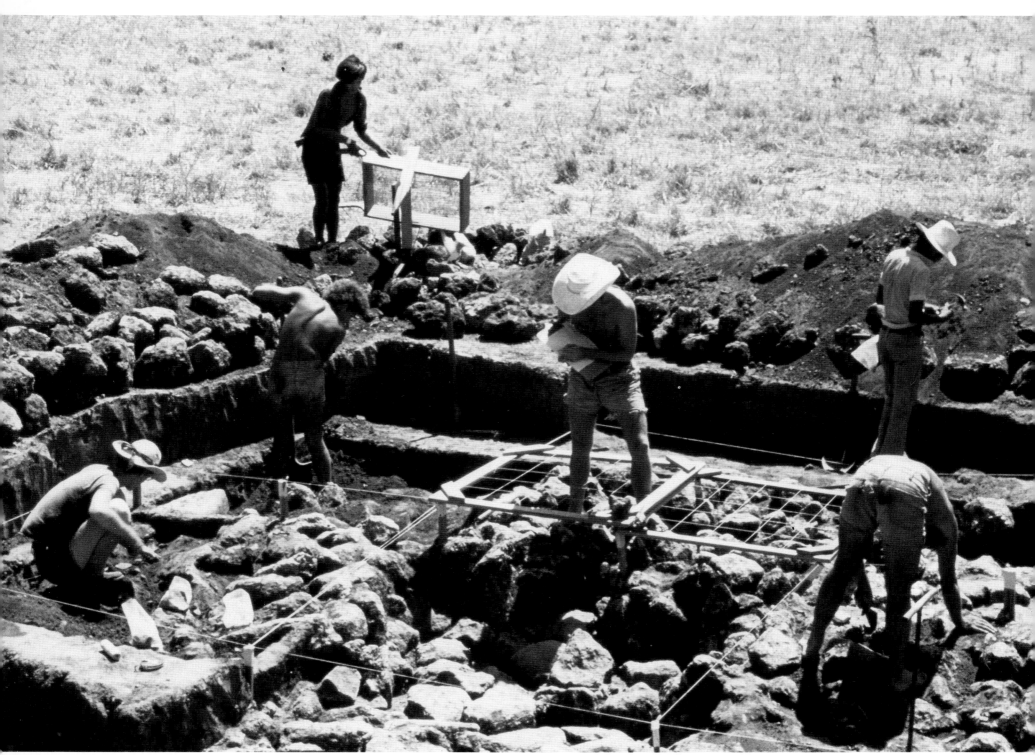

Hacienda Mojica archaeological site.
Guanacaste Province, Greater Nicoya Subarea.

14

Pre-Columbian Trade in Costa Rica

by DORIS STONE

THIS ESSAY deals with trade, a word of multiple meanings. It may refer to hand-to-hand exchange of foodstuffs or any material object of local or foreign origin between individuals of all ranks. It may also apply to the exchange of ideas and systems—religious, social, economic or political—usually between high-ranking authorities and often dependent on organization and long-distance networks. The geographical position of Costa Rica has made it a natural setting for trade, serving as a passageway with ports of call between the northern and southern continents.

One cannot list with certainty the kinds of articles exchanged during this period but from the surviving material it is evident that the early inhabitants were in contact with different cultures associated with foreign areas. Foodstuffs and many other items used in economic exchanges between individuals are perishable. Medicines, narcotics, textiles, feathers, wooden articles and slaves, for instance, must be considered important for barter even if the physical evidence has not survived. Culture contacts and stimulus diffusion of ideas can be noted primarily in luxury and high status goods such as ceramics, cult images and any nonperishable item, for example, of stone or metal. In the period of culture contact with the Spanish, written documentation affords a sharper insight into the economic values of the time whereas during all other periods, one must rely on archaeological evidence. There is no attempt in the following pages to treat all the archaeology of Costa Rica, only a résumé of the differences due to culture changes between time periods. Special emphasis is placed on the obvious foreign elements within these settings.

To date, the earliest evidence of man in Costa Rica is a single black flint fluted point which served either as a lance or arrowhead. It comes from the province of Guanacaste (the Nicoya region). This fluted point is the only sign in Nicoya of paleo-man's journey south through the isthmus although it cannot be placed in time.[1] However, other lithic implements found further

north in the same region may perhaps be dated around 5000 BC.[2]

The continuing story of Costa Rican prehistory begins with Period IV, 1000 BC-AD 500, in Central American chronology, a timetable worked out by an Advanced Seminar held at the School of American Research, Santa Fe, New Mexico. Costa Rica has three archaeological regions: the Nicoya-Guanacaste; the Atlantic Watershed which includes the Central Plateau or Highlands, and the Diquis or the area of the south Pacific which borders Panama.

THE NICOYA-GUANACASTE REGION
Early Period IV: 1000 BC-AD 500

Although it may be that the only egalitarian society in the Nicoya region and the Atlantic Watershed ended just before the first half of Period IV, there is scant knowledge concerning this time span. Clearly, as a result of organized long-distance commerce, Period IV saw the development from simple communities to permanent settlements and trade centers. Trade made available the possession of foreign articles, thereby strengthening the prestige of the more important families, those who logically would have produced leaders or chiefs. There were many chieftains throughout the territory of Costa Rica, and their role dominated all social-political life from at least Period IV and continued to the Spanish Conquest.

Archaeology demonstrates that the people in Guanacaste, who probably lived in extended family groups, settled along the coast, often by estuaries of freshwater streams and in river valleys. Sometimes caves were occupied. Habitations seem to have been similar to the common dwellings made of poles tied with vines and covered by palm leaves, still in use in this section today. The only vestiges that remain are circular adobe-lined hearths and occasional ovens. One such cooking place found in the north at the Vidor site yielded a radiocarbon date of 800 BC.[3] Probably at this

15

time but certainly during the second half of this period, hammocks were used for sleeping, an Amazonian custom in practice when the Spaniards arrived.[4]

There does not seem to have been an organized burial system. Mortuary practices ranged from single, primary, secondary and multiple burials to cremation while any place convenient at the moment was utilized. Cemeteries were usually below plazas.[5] In spite of the manner of interment, the great difference was the prestigious grave furnishings.

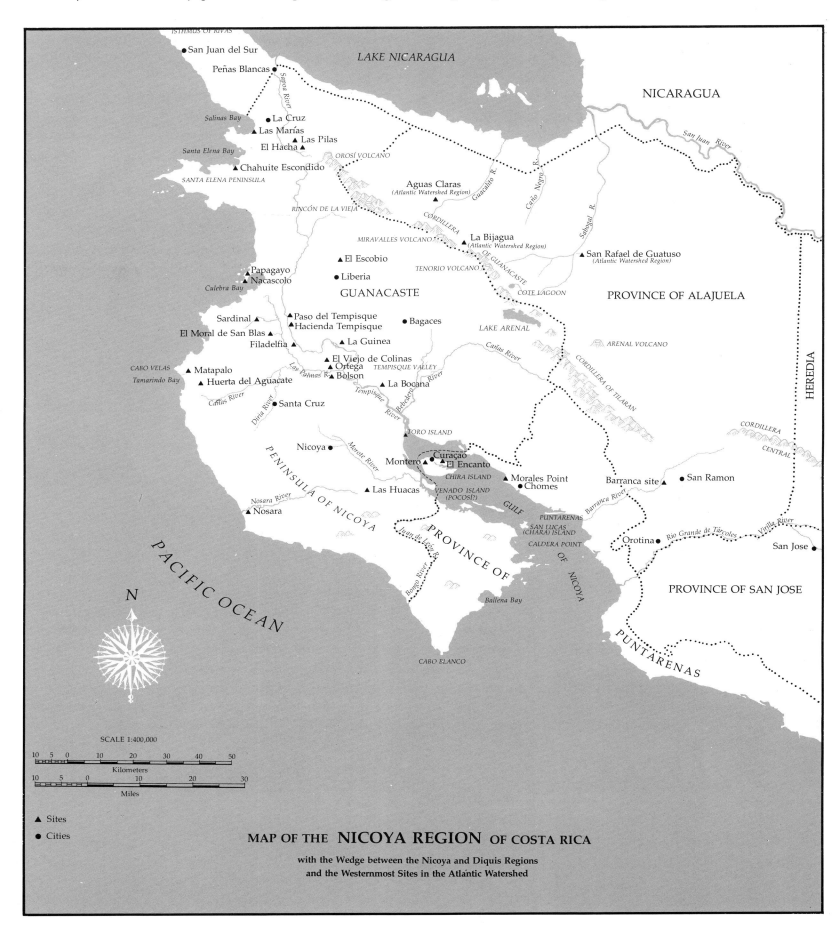

MAP OF THE NICOYA REGION OF COSTA RICA

with the Wedge between the Nicoya and Diquis Regions
and the Westernmost Sites in the Atlantic Watershed

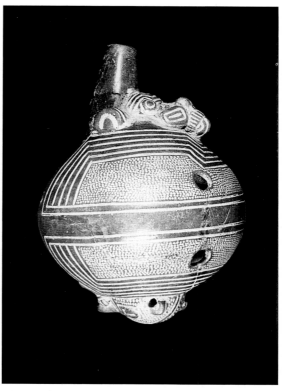

Fig. 1. Red pottery vessel resembling an upside-down mushroom, El Hacha, Nicoya region, Guanacaste. Museo Nacional de Costa Rica.

Fig. 2. Spanish colonial wooden dish with hole for placing drinking gourd, Barba, Central Highlands/Atlantic Watershed Zone.

Fig. 3. Clay ocarina with avian effigy head at one end and animal head at the other. Shell stamped, Marbella style, Las Guacas, Nicoya, Guanacaste. Peabody Museum, Harvard University.

It is probable that the diet was primarily based on tuber agriculture, for example, manioc (*Manihot esculenta*). Tubers can be cultivated around the house and need no special storage facilities as does maize. Northern or Mexican style tripod grinding stones which some authorities believe were not for mealing but for seats, begin to appear around 300 BC and continue to about AD 300. They might imply, however, the existence of limited maize agriculture.[6]

We do not know whether these early inhabitants of the Nicoya region were remnants of tribes which had migrated southward, or northern extensions of groups which had made South America their home after their gigantic trek overland from the Bering Straits. Nevertheless, by the start of Period IV these people were culturally advanced enough to make pottery. At least two wares are identifiable from potsherds. One ceramic type is called Schettel Incised and extends from the Rivas Peninsula in Nicaragua into the Nicoya region. This is a monochrome type with a flared everted rim decorated by multiple broad grooves around the vessel, similar to types found at Chiapa de Corzo, Mexico; La Victoria, Guatemala; Valdivia, Ecuador; and Guyana.[7]

The other type of sherd was found nearly 20 feet (6 meters) below the surface on the coast of Guanacaste.[8] These are pieces from wide round-bottomed vessels with decoration confined to incised lines separating areas of red but occasionally black paint and the natural fired clay which is either buff or brown. It is possible that these sherds come from vessels of the type known as Toya Zoned Incised. Among the forms associated with this pottery is one resembling a mushroom which has led to the suggestion that a mushroom cult, supposedly from Guatemala, extended as far as the Nicoya region (Fig. 1).[9] The decorative motifs, however, are upside down when the "mushroom" is held upright. But if the vessel is turned about, it becomes apparent that the base is deep enough to hold some food while the would-be stalk can serve for drink. These details suggest that artifacts of this type were not intended to represent mushrooms, but might have been placed on the earthen floor or on a potholder with the so-called crown on top taking its position on the bottom to be used as we do a plate and a cup. This was the function of a wooden Spanish colonial circular utensil that had a hole in the center (Fig. 2). The flat part held food and the hole served to maintain the gourd, or *jícara*, which contained the drink. Toya zoned Incised has a close counterpart, Bocana Incised, which, with the multiple brush technique of painting and multiple incised lines, shows a close relationship to other Formative Nuclear American styles and hints of trans-regional culture contacts. Ocarinas with incised line decoration and as bird or animal effigies likewise appear at this time (Fig. 3). The use of

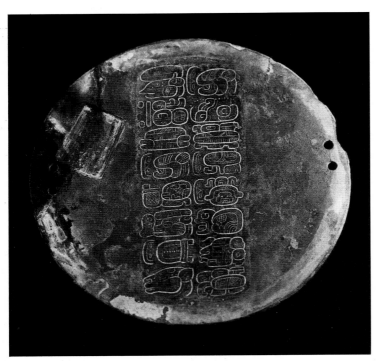

Fig. 4. Slate disc incised with Maya hieroglyphs, Bagaces, Guanacaste. Museo Nacional de Costa Rica.

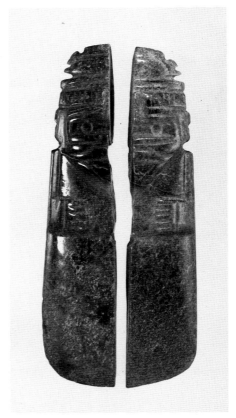

Fig. 5. Split Axe-god pendant, jade, Atlantic Watershed. Ca 100 BC-AD 100. New Orleans Museum of Art.

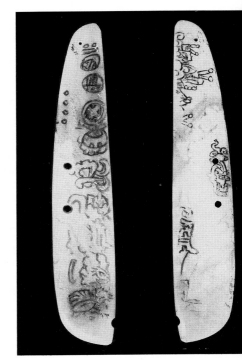

Fig. 6. Reworked jadeite plaque with Maya hieroglyphs, Nosara, Guanacaste. Height 6½″.

incised lines in separate colored areas gave rise to the name Zoned Bichrome (two colors) not only for pottery classification but also for the ceramic phase covering the second half of Period IV, 300 BC-AD 500.

The Second Half of Period IV: 300 BC-AD 500

It is evident from the archaeology of the Nicoya region that the inhabitants, at least during the Zoned Bichrome phase, did not lead a typical nomad's life but were sedentary and used the natural environment around them. Fish and game such as deer, agouti, rabbits, monkeys, birds and, if we may judge from historical documentation, iguanas and frogs supplied protein. It has been emphasized that mollusks were not an important foodstuff during this period although some shells remain to verify at least a minimum consumption.[10] The forest produced fruit-bearing plants, seeds, nuts particularly from palm trees, and acorns from oaks. Roots of varied kinds were gathered, many of which were ground, cracked or pounded on boulders beside streams. Root-crops, for example manioc, probably continued to be the major agricultural product during this period. Maize seems to have had a limited importance. Recent investigations have shown that in certain localities in the interior of the Nicoya region, for example the Mendez site, maize was not used from AD 300-500, the inhabitants relying on other foodstuffs.[11]

Clay figurines and ocarinas, often depicting birds, as well as petroglyphs not only suggest religious rituals and beliefs but also a diffusion of ideas some of which came from the north and others from the south of the isthmus. Evidence of a stratified society composed of a chieftain, ranking but lesser officials (nobles), the populace and slaves is manifested in artistic and luxury items found as tomb furnishings with some graves barren of any material offerings. What interests us here are the objects which show foreign influences, either the direct or indirect results of trade or possibly through the migration of merchants who formed commercial colonies.

Among the foreign luxury items from Guanacaste is the slate back of an iron pyrite mirror found in Bagaces (Fig. 4). It is engraved with early Classic Maya hieroglyphs and has a rectangular space carved out on the surface which suggests the possibility that an attempt was made to rework the object into something more pleasing to the new owner. This idea of converting the meaning of an object or cult image is not new in either Nicoya or the Atlantic Watershed. Jadeite pendants with Maya hieroglyphs have been found reworked, split in

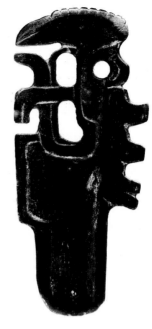

Fig. 7. Two halves of jadeite plaque incised with Maya hieroglyphs, Bagaces, Nicoya region, Guanacaste. Instituto Nacional de Seguros.

Fig. 8. Jadeite plaque with man wearing animal costume. Bagaces, Nicoya region, Guanacaste, C.B. Collection.

Fig. 9. Jadeite Olmec dragon, or monster, spoon; trade piece found in Nicoya region, Guanacaste.

half, or partially erased (Figs. 5-9). Such pieces stress the degree of importance the material alone held for the local inhabitants who apparently placed no value on the article itself.[12]

Three stone artifacts appear with frequency at this time. They are indicative not only of social stratification but likewise of the appeal and power of cult images despite the fact that the conceptions they represent are foreign. Mealing stones or seats, axe-gods, and stone mace heads form the triumvirate. The first item, the tripod grinding stone or seat, has been dated as early as 300 BC.[13] This style, usually with a thin upturned mealing plate and no raised rim, is northern and used in the preparation of maize meal supposedly by the elite. Generally the stones have a protruding animal, bird or reptile head and are carved in bas-relief on the underside of the plate and on the legs which are tubular or slab. The last variety often has openwork which creates an almost lace-like look. The concept that these artifacts might have served as seats is associated with both the north and south. A bench or stool was always used by a person of rank.[14] Many of these elaborately engraved and carved grinding stones have a representation of a plaited mat, a favorite motif of the Maya, who called it *pop*. It was at once a sign of authority and the symbol of

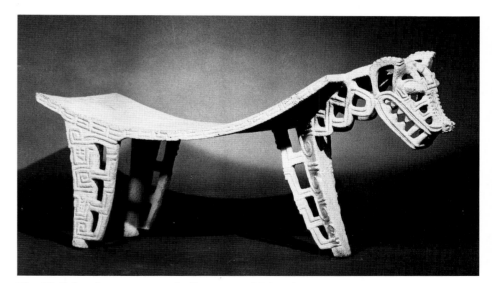

Fig. 10. Solentiname type grinding stone. Volcanic stone, Nicoya region, Guanacaste. Ca AD 300-700. Length 38¾″. New Orleans Museum of Art.

the first month of the year, leading one to suspect that the purpose of the object so characterized was for ceremonial use, such as the ritual mealing of a fermented drink, perhaps chicha, a kind of beer. The most elaborately carved northern style grinding stones seem to have been imports from the Solentiname Archipelago in Lake Nicaragua from whence they reached Costa Rica perhaps by river to Upala although they sometimes appear at Nosara on the seacoast (Fig. 10).

Fig. 11. Types of jade Axe-gods from the Nicoya region, Guanacaste.

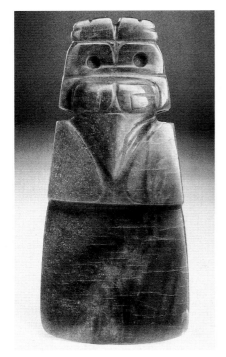

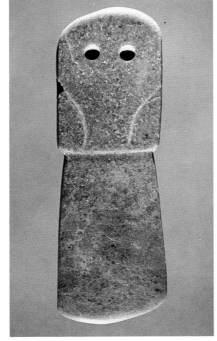

a. Axe-god celt with bird head, Instituto Nacional de Costa Rica.

b. Axe-god celt. Height 3¾″, New Orleans Museum of Art.

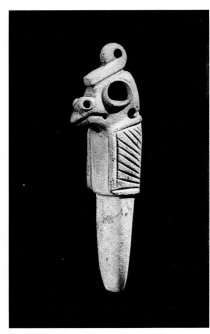

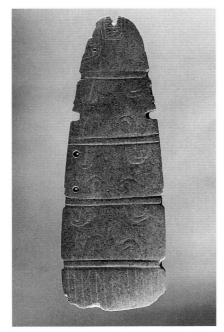

c. Axe-god celt with bird head which once had iron pyrite eyes. New Orleans Museum of Art.

d. Reworked Axe-god in form of a fish. Height 9¾″, New Orleans Museum of Art.

The second artifact, the axe-god, has a long history as a cult image (Figs. 11a-d). Usually made from green stones called jade or jadeite believed to be an import in its raw state from Guatemala, it is usually celt shaped with an anthropomorphic, stylized bird or reptile head such as a crocodile or serpent. As a cult image, it is probably derived from Olmec anthropomorphic celts, in particular the jaguar which was associated with the earth, rain, and thunderbolt.[15] The cult of stone celts,

not only the axe as the thunderbolt but also as the symbol of the rain and fire gods, had a long history in Mexico.[16] The original cult concept of the celt evolved through time to have the stylized head just mentioned as well as a hole for suspension which the Olmec figure lacks. The image might also be associated with the Tuxtla statuette.[17] The axe-god seems to have been highly regarded in upper Central America, in Guanacaste, and in parts of the Atlantic Watershed but it is practically unknown further to the east. A few have been found in the Diquis region, at Sona in Veraguas, Panama, and at least one in Colombia undoubtedly the result of trade.[18]

The third ceremonial object diagnostic of this period and of rank is the stone mace head which occasionally is made of jade (Fig. 12). It is carved with protruding cult images generally zoomorphic but sometimes representing human skulls or faces. Stone mace heads with protruding effigies of the horned owl are known from the Chicama Valley in Peru and also from Olmec territory in caches as well as in Costa Rica.

The second half of Period IV is noted for many types of ceramics, some of them unquestionably foreign, but at least one which might have been made in Costa Rica, Rosales Zoned Engraved ceramics, is indicative of foreign influences and is without visible native roots (Figs. 13, 14). This pottery is sophisticated in concept with aesthetically pleasing decorative motifs at times painted black on a red background or red on buff, but always emphasized by incised or engraved outlines often with a white fill. Designs such as feline-serpent combinations, men with paddle-shaped hands and helmet gear, curvilineal patterns and scroll-like elements recall Olmec art.[19] Clay representations of human beings sometimes portray females with hands under or holding the breasts or on the abdomen. These figures and pottery effigies of the penis point to a fertility cult and recall South America. Boldly painted ocarinas, frequently fashioned to resemble birds, indicate that music formed a part of ritual life. Bottle-shaped, bridged and spout vessels as well as the effigies of human beings and animals together with the vivid coloring suggest influence from the Chorrera phase culture in Guayas province, Ecuador. The greatest number of pieces belonging to the Rosales Zoned Engraved type come from sites along the seacoast and up waterways; for example, Samara and the Tempisque River Valley, implying a relationship to water travel although vessels have been found inland at locations on transcontinental passes and even in the Central Highlands, undoubtedly due to inter-regional trade.[20] Chavez White-on-Red type with predominately linear but also conventionalized zoomorphic designs is another example of South American influence or information flow from Ecuador and Peru.

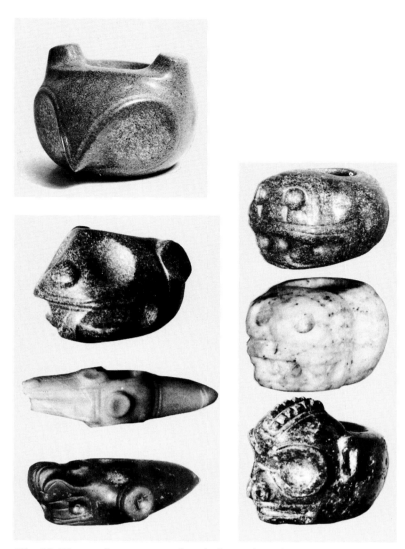

Fig. 12. Types of stone mace heads from the Nicoya region of Guanacaste.

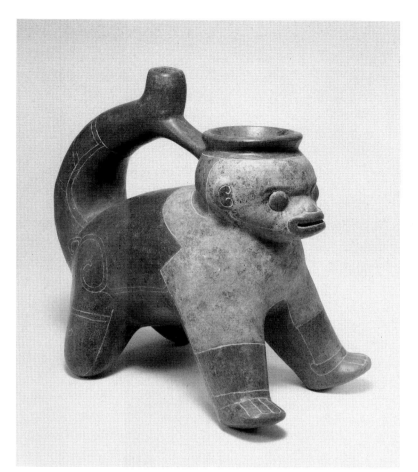

Fig. 13. No. 6, Rosales Zoned Engraved ceramic, Nicoya region, Guanacaste.

Unquestionable evidence of foreign goods, however, is the occurrence near salt flats in northern Guanacaste of three medial-flanged potsherds belonging to the Paso Caballo Waxy Ware Sierra group from the Chicanel period, circa 600 BC-AD 100, at Uaxactun, Guatemala.[21] Salt is well known to have been an important item of trade throughout Mesoamerica.

What seems to have once been an influential trading or cultural center today bears the name of El Hacha, a tiny community at the northernmost tip of the Cordillera of Guanacaste. It lies on a mountain spur by an ancient trail connecting the Bay of Playa Blanca with Lake Nicaragua and is not far from the Camino Real which the Spaniards took over from the Indians and later the Pan-American highway usurped as its own. The original Indian name for the site is lost, its place being taken by the Spanish term *El Hacha*, The Axe. It seems reasonable to suppose that this name was applied because of the number of jadeite axe-gods found there, although stone mace heads and two foreign pottery types are equally associated with this site. These ceramics

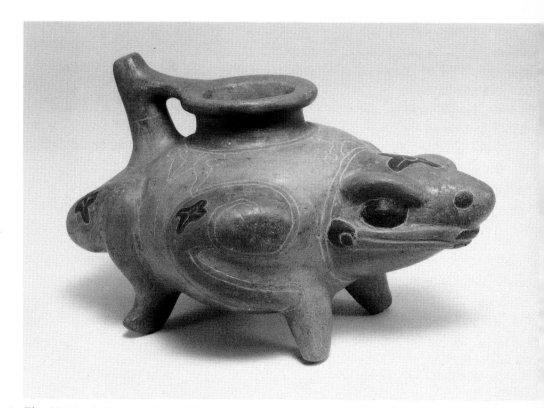

Fig. 14. No. 8, Rosales Zoned Engraved ceramic, Nicoya region, Guanacaste.

21

Fig. 15. Vessel painted with Usulután technique, El Hacha, Nicoya region, Guanacaste.

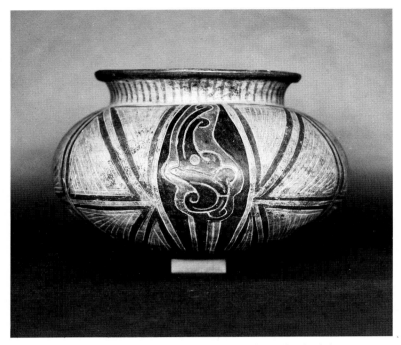

Fig. 16. Palmar Ware (now known as Bocana Incised Bichrome, Bocana Variety) vessel, El Hacha. New Orleans Museum of Art.

are vessels painted with the Usulutan technique and Palmar Ware (Figs. 15, 16). The Usulutan technique of painting on pottery, a resist or negative painting process first noticed in El Salvador, is one of the earliest techniques of decoration known in the area of its greatest distribution, western El Salvador to Guatemala and western Honduras. Occasionally this style appears in Chiapas, Mexico, and to the east at El Cauce, Nicaragua, and El Hacha, Costa Rica. The other ceramic style associated with El Hacha is Palmar Ware (now referred to as Bocana Incised Bichrome type, Bocana or Toya variety), black and black-grayish brown with bold incised lines painted red and sometimes white. Plastic features are also known. The ware is more plentiful in southern Nicaragua and recalls Utatlan Ware from highland Guatemala. Neither pottery seems to have been traded further eastward. The concentration of axe-gods, the Usulutan technique and Palmar Ware at the same site are indicative of movements from the north. This unique grouping of foreign traits might be due to trade alone but the possibility also exists that special artisans were brought to Costa Rica through orders of a chieftain who controlled the region and demanded luxury or high status goods. Certainly the site of El Hacha was in a geographical position within easy reach of all directions. Before Period IV came to a close, trichrome and the first local polychrome pottery appeared although polychrome wares are really diagnostic of Period V.

Early Period V: AD 500-800

Most Period V sites were located on shores of the sea or lakes and reveal not only a preference for or dependence on marine products but also show foreign cultural influences, some of which were undoubtedly waterborne. The chiefdom continued to dominate social organization as it did up to the Spanish conquest. Settlement patterns often with plazas related to dwellings were carried over from Period IV, but the sites were larger and more numerous. Some habitations were constructed of wattle and daub with sandy earthen floors. The remains of fired adobe with cane impressions and postholes are similar to those of dwellings from the same period in central Nicaragua, a pattern probably common to most of Central America. Vestiges of inside hearths and what might be circular pottery kilns are found.[22] Burials, particularly of infants, often in urns placed in refuse but also in tombs constructed with basalt columns and with a stone overlay or a column as markers, appear.[23] This is a custom associated with the southern hemisphere.

Polychrome pottery which was first seen at the close of Period IV increased in importance and quantity. Among the diagnostic ceramics of Period V which were not locally inspired and which, in great part, seem to be dedicated to the Maya and subsequently the Mexican Plumed Serpent and its multiple personalities, is a type

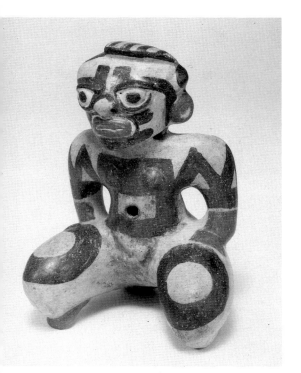

Fig. 17. No. 28, Galo Polychrome, Nicoya region, Guanacaste.

Fig. 18. No. 29, Galo Polychrome vessel, Nicoya region, Guanacaste.

Fig. 19. Ulúa alabaster vessel, Nacascolo, Nicoya region, Guanacaste.

definitely influenced by both these cultures. This is Galo Polychrome with its resinous polished surface and which recalls in form, coloring, painted technique and motifs certain styles of Ulúa Polychrome pottery from the Ulúa-Yojoa region of Honduras and El Salvador (Figs. 17, 18).[24] Most scholars recognize Galo Polychrome as a product of the Nicoya region but influenced by the Honduran prototype.

From the Nicoya region and also associated with coastal sites or large river valleys such as the Tempisque, come alabaster vessels, trade pieces from the Sula-Ulua plain in Honduras (Fig. 19). They reflect the style of the Mexican Totonacs from the state of Veracruz. Conventionalizations of the handles which represent protruding heads of the jaguar, serpent, bat or bird are carved on the body of the vase and the intervening space filled with scrolls. Some show vestiges of a stucco overlay painted in red and green. It is probable that these vessels were the work of a single school, a family, or perhaps traveling artisans but behind it all, commerce and the desire for exotic and luxury goods sparked the appearance of such articles in the Nicoya region and particularly in a port like Nacascolo, where most of these vessels were found.

There are other evidences of trade at Nacascolo and in the area. One such article is Tohil style Plumbate Ware, highly valued in Central America for its iron and aluminum slip which also creates a rare luster. Plumbate

Fig. 20. Double cylinder whistling vessel with head of bird, painted *al fresco*, Nacascolo, Nicoya region, Guanacaste. Height 9¾″, New Orleans Museum of Art.

pottery probably originated on the Pacific coast of Guatemala but was carried by merchants throughout the isthmian region and we feel it is associated with the Nahuat-Pipiles whose homeland was Mexico.

Further evidence that Nacascolo was an important commercial center and possibly the seat of a powerful

23

regional chief is demonstrated by other luxury or ritual artifacts found there. Among these are two stucco covered whistling jars painted *al fresco*, a technique associated with the Maya and the Mexicans (Fig. 20). The whistling jar was first known in the north during the Monte Alban 1 phase in Oaxaca, Mexico, about 790-390 BC.[25] The painted motifs on these vessels are badly deteriorated but on one, remnants of a deer hunt or dance are discernible. *Al fresco* decoration also appears on a slab-footed pot with four Tlaloc (the Mexican rain god) faces, the whole colored in green, blue, red and white (Fig. 21). It is characteristic of the phase Teotihuacan III, AD 300-650, and must have been highly treasured to reach Costa Rica during Period V.[26]

Fine Orange Ware is another ceramic example of long distance trade from northern Central America to the Nicoya region where it has been found with Classic Maya incised jades. Although not plentiful, its presence denotes that it was considered a status or exotic article. Clay funerary masks appeared at this time but, like most objects of foreign inspiration, are rare. The idea might have originated in South America, in Colombia or even Peru, in lieu of the availability of gold for masks. Some clay replicas are representations of copper *tumis* and come from coastal Guanacaste. A *tumis* is a special knife-shaped weapon supposedly designed in Peru for human sacrifice. It was employed as a medium of exchange in Ecuador. Its presence in Guanacaste implies trade and is an example of the flow of information for which interchange can be held responsible.

The art of the metalsmith came from South America and entered Costa Rica through Panama probably around AD 500.[27] Recent excavations have shown that despite the Spanish accounts of gold articles existing in

great quantities, the amount of metal objects is very limited from the Nicoya region which, to date, has not proven itself to be rich in either gold or copper items. The objects we know to be of copper found in Guanacaste are mostly northern in style. Cast copper figures, ear plugs and bells recall the Tarascans and Tula-Toltecs of Mexico and to a great extent Honduras where a cache of over five hundred copper bells was found in a cave near Quimistan.[28] Likewise, there is no Nicoya gold style but the gold objects found there denote foreign inspiration such as Coclé and Veraguas in Panama, or even farther south from Colombia, and serve as examples of cultural influence brought about by trade.[29]

Late Period V: AD 800-1000
and Early Period VI: AD 1000-1200

The years AD 800 to 1200 saw an increase in size and quantity of living sites, particularly near the sea. Shell middens, some used to support dwellings and others as garbage heaps, give evidence of further dependence upon a marine diet although agriculture was not abandoned but was practiced to a greater extent in the interior valleys than on the coast. What did cease was the exchange of ideas and information which made its way by word of mouth. Religious concepts with their corresponding symbols continued to leave their impression on reigning personages and certain other individuals, some of whom filed their teeth in Mexican fashion.[30]

In northern Guanacaste, the result of the persistence of tradition in spite of distance and time is seen in the white background and vividly colored Papagayo Polychrome. Design motifs cover the major images of Tula-Toltec iconography, including human, animal and reptile impersonations with the most spectacular being a bold version of the Feathered Serpent (Fig. 22). A center for Papagayo pottery seems to have been on the Rivas Peninsula, Nicaragua, which adjoins the Nicoya region. From Rivas, Papagayo Polychrome was traded to Guanacaste, the Atlantic Watershed and perhaps even as far north as Tula, Mexico.[31] There is no proof that the Tula-Toltecs actually were present in northwestern Costa Rica. However we seem to find many cultural innovations in Central America, after the fall of Teotihuacan culture in Mexico and the general holocaust that followed. Among such changes, we find that Las Vegas Polychromes from the Comayagua Valley in Honduras appear in El Salvador and seem to serve as the model for Papagayo Polychrome in the Nicoya region. While Papagayo Ware is diagnostic of northern Guanacaste during this time, Mora Polychrome is indicative of the southern portion (see No. 33, etc.). The presence of both pottery styles in the Central Plateau and the coastal Atlantic Watershed reflects their value as status articles

Fig. 21. Al fresco painted Tlaloc vessel, El Panama, Culebra Bay, Nicoya region, Guanacaste. Height 12″.

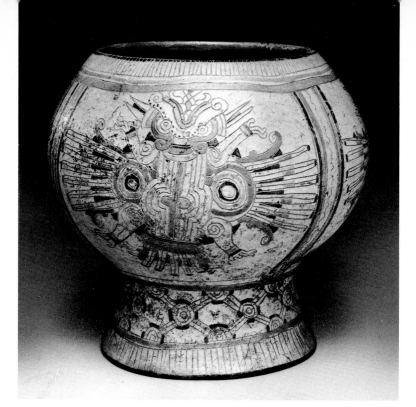

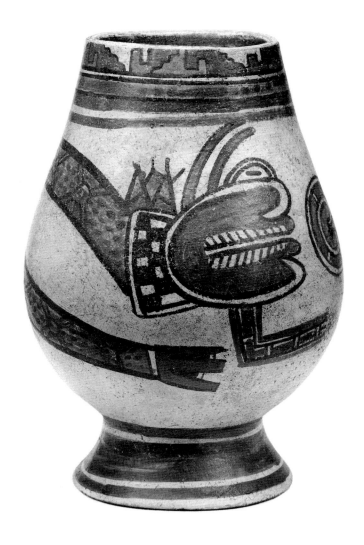

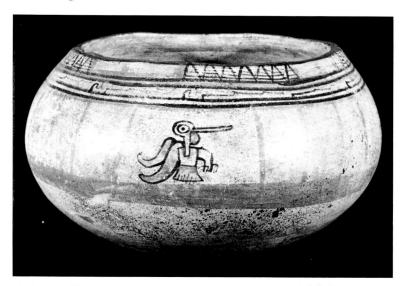

Fig. 23. Vallejo Polychrome vessel with Tlaltecuhtli, the Earth Monster. Nicoya region, Guanacaste. Late Period VI, AD 1200-1550. Height 7¼". Museo Nacional de Costa Rica.

Fig. 22. No. 75, Papagayo Polychrome vessel with a plumed serpent motif, Nicoya Region, Guanacaste.

Fig. 24. Vallejo Polychrome vessel with hummingbird, Filadelfia, Nicoya region, Guanacaste. Museo Nacional de Costa Rica.

and not as ordinary trade items.[31] Mora Polychrome shows a relationship to some Maya vessels through design motifs such as plumed serpent symbols and the *xan* (also given as *kan*) cross as well as shapes. Still another pottery class, Birmania or Highland, likewise had northern iconographic motifs centering around the plumed serpent (see No. 49, etc.). Birmania ceramics appear occasionally on both the Pacific and Atlantic sides of Costa Rica and have been found with Plumbate pottery in El Salvador, a sign of its esteem as a trade item (see No. 58, etc.).[33]

In all probability, external trade between the north and the Nicoya region did not come to a standstill toward the end of early Period V but what had comprised the symbols of an elite social stratum disappeared and definite changes in aesthetic values and/or tastes are apparent. The fall of the southern lowland centers of

the classic Maya and their well-organized "putum" or traders' guild might have been responsible.[34] However, serious volcanic eruptions have been noted on the routes of frequent usage in northern Central America.[35]

The complex of Olmec-Maya jades, together with perhaps locally made but foreign-inspired objects such as ceremonial grinding stones or seats, as well as mace heads, seemed to have ceased and metal objects, principally gold, appeared although the gold was less prevalent in the Nicoya region than elsewhere in Costa Rica.[36]

In Period V, the goldsmith began to replace the jade lapidary with both local and imported types. The art of working gold came from South America and at first, foreign styles, mostly Colombian and Panamanian, were brought into Costa Rica by trade. In spite of Spanish reports to the contrary, very few gold objects have survived in the Nicoya region.

25

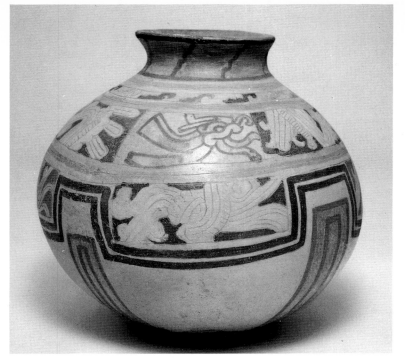

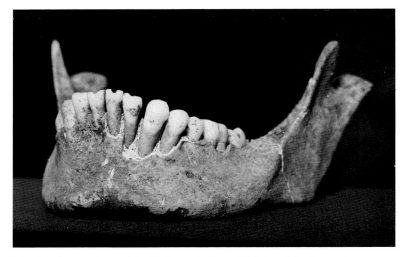

Fig. 25. No. 100, Vallejo Polychrome vessel with serpent, Nicoya region, Guanacaste.

Fig. 26. Lower jaw with filed teeth from El Moral de San Blas, Nicoya region of Guanacaste.

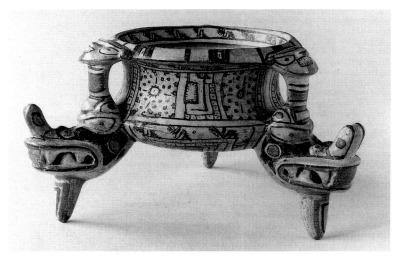

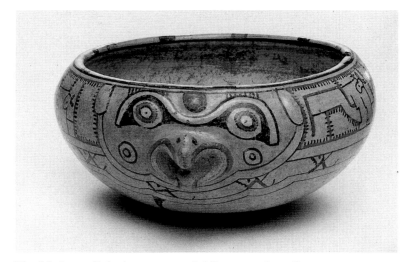

Fig. 27. Luna Polychrome vessel, Nicoya region, Guanacaste, Molinas Collection, Costa Rica.

Fig. 28. Luna Polychrome vessel. Nicoya region, Guanacaste. Diameter 6¾".

Late Period VI: AD 1200-1550

Period VI saw the advent of capital towns, markets and chieftains who controlled a strict feudal social organization among two of the groups in the Nicoya region: the Chorotega-Mangue and the Nicarao.[37] Some of the towns were on the coast while others such as Bagaces favored the inland trade routes. Spanish accounts describe houses with gardens and shade trees, often fruit bearing. There were also ceremonial centers with plazas, prayer structures and the chief's quarters. Mortuary practices show that jade was replaced by gold, although as has been pointed out, metal objects are scarce in Guanacaste.

Obsidian chips, obviously trade pieces and always rare in Costa Rica, are known from the Nicoya region and the Atlantic Watershed, again indicating the north.[38] Northern relationships continued to be manifested in new ceramic types which, if not actually brought south in trade, were obviously foreign in concept. Although the exact cultural sources responsible for two varieties of Vallejo Polychrome, Mombacho (Underslipped Incised) and Vallejo, are not clear, the design motifs and coloring point to Mexico (Figs. 23-25). Vallejo Polychrome has been found with skeletons which had artificially deformed skulls and filed teeth, traits associated with the Mixtec-Puebla region of Mexico (Fig. 26).[39]

Cultural influences were not entirely northern, however. This is noted in the white background pottery known as Luna Polychrome (Figs. 27, 28). Design motifs which include festooned panels suggest vessels from the Amazon, particularly Marajo Island at its mouth. To the contrary, the same ceramic group is decorated with pompons, stepped frets and other Plumed Serpent symbols, along with a silhouette style of painting which recalls the Mixteca Alta and certain pottery types from Cholula and Tlaxcala in Mexico.[40] Luna Polychrome has been found with European glass beads and was much in vogue when the Spanish arrived. It occasionally appears on the Atlantic Watershed as a trade item.

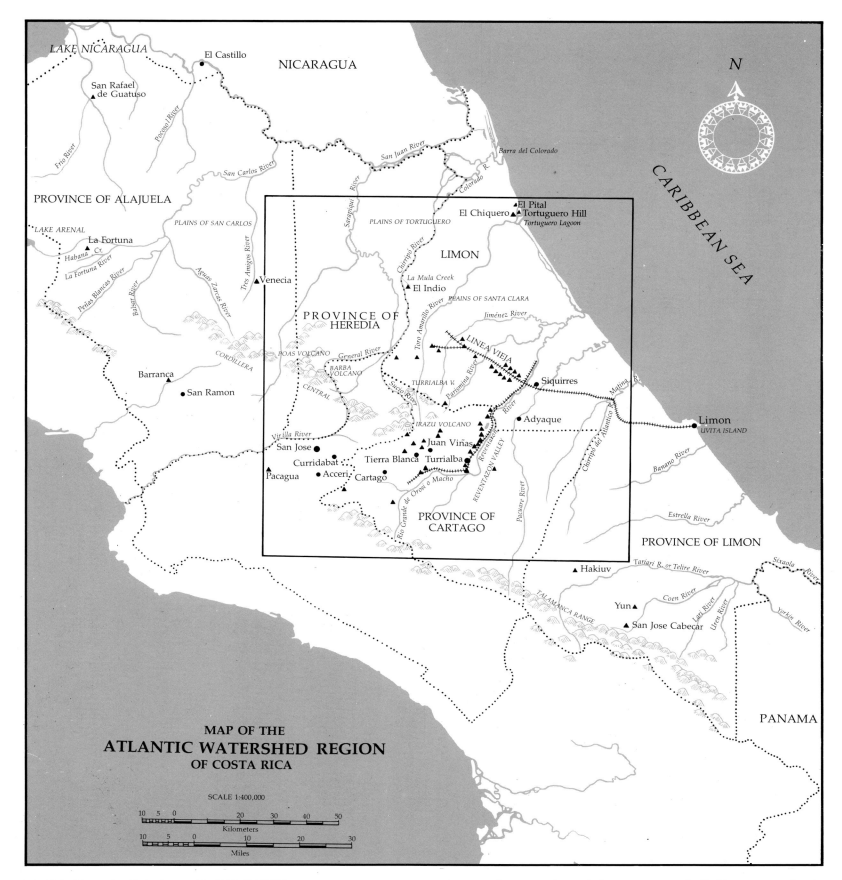

MAP OF THE
ATLANTIC WATERSHED REGION
OF COSTA RICA

SCALE 1:400,000

Kilometers

Miles

THE ATLANTIC WATERSHED

Period IV: 1000 BC-AD 500

The little we know about the archaeology of the Atlantic Watershed bespeaks basically what we have seen during the earliest era in the Nicoya region: undated evidence of paleo-man. In this case, the evidence includes a basal fragment and three projectile points, small simple living sites and two cultural forces at work.[41] One type site is La Montaña in the rainforest of the Turrialba valley with radiocarbon dates ranging from 1500 to 300 BC. La Montaña yielded monochrome pottery with plastic decoration which recalls the ceramics of Barlovento, Colombia. The other small type settlement is Chaparron in the region of San Carlos and the San Juan River. Its affinities as seen through the Zoned Bichrome pottery,

27

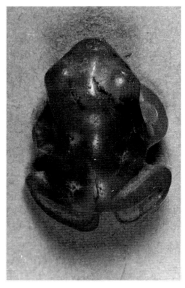

Fig. 29. Jade figurine, Linea Vieja, Atlantic Watershed. Height 2¾". Jaime Solera Collection.

Fig. 30. Jade frog, Linea Vieja, Atlantic Watershed. Length 2".

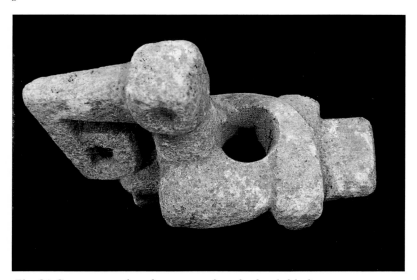

Fig. 31. Stone mace-head representing the beak-bird, Guacimo, Atlantic Watershed. Length 4".

some of which are *tecomate* in shape, point to the Pacific coast and even as far away as Guatemala.[42] Root and tree crops such as alligator pear and palm nuts were probably cultivated aiding a supplementary diet which depended on hunting, fishing and gathering of wild foodstuffs.

From about AD 1-500, however, vestiges of a rank society were noted at the site of El Bosque and the many related locations situated in valleys or on the coastal plain. The name El Bosque is used both for the archaeological site and for a zoned Red-on-Buff ceramic complex which links this and related locations to Chaparron and Mesoamerica.[43] The common house type during the El Bosque complex was rectangular. In the Central Plateau, however, bell-shaped storage pits, some containing maize, beans, unidentified fruit and morning glory seeds (*Ipomoea* sp.) are known.[44]

Jades are among the valued and imported articles even if some were fashioned or reworked *in situ* (Figs. 29, 30). Certain localities seem to have been highly specialized. La Fortuna in the San Carlos plain probably was a center for the distribution of iron pyrite mirrors with slate backs, as most known in Costa Rica have been found there, some engraved with Maya hieroglyphs chosen, it seems, for the calligraphy or decorative effect and not for the meaning; at least one with designs related to Veracruz, Mexico; and some with remains of *al fresco* colors on stucco or without decoration.[45] La Fortuna is also known for tubular jade beads, some as long as 52 centimeters (20.5 inches) and slightly curved to fit horizontally across a human body. These might have been worn to hold up the breasts of women in the manner some gold tubular beads were used in Panama.[46] Similar but shorter beads have come from La Union de Guapiles on the Linea Vieja, which was a long-recognized trading area of Pre-Columbian Costa Rica. This site, also known as Costa Rica Farm, is noted for its jades and grinding stones with incised designs filled in with white paint. The jades include many foreign cult images, for example, curly-tailed animals, a concept associated with Coclé, Panama, winged pendants from South America, and Olmec and Maya motifs frequently reworked into the axe-god or even into the native and South American crested crocodile. Found here and at other sites on the Atlantic Watershed are the familiar stone mace heads (Fig. 31) and tripod grinding stones but with a raised rim decorated in bas-relief representing stylized human heads sometimes so conventionalized that they appear as mere notches on the border. Towards the end of Period V, one sees circular, tetrapod or single pedestal grinding stones bordered with stylized human heads or animal figures probably denoting clan guardians (Figs. 32-34). We feel the circular stones might have served not only for mealing but also as offering tables. In other words, these elaborate lithic examples were essentially ceremonial and used for making an intoxicating drink or drug at the graveside or during any ritual offering homage to the gods. In all probability, they indicate a northern extension of the South American cult of trophy heads. This does not mean what some archaeologists have said, shrunken heads, which implies closed eyes and lips sewn together. Instead they signify the importance of taking a person's head and keeping it as one does a trophy. The heads formed a part of a fertility cult, remnants of which persist in the form of legend.[47]

Tubular nasal snuffers and stone bark beaters belong in this time span. Both items are common to rain

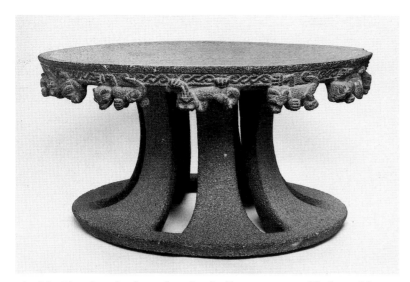

Fig. 32. Circular, single pedestal grinding stone or offering table with border of animals. Guayabo de Turrialba, Atlantic Watershed, ca AD 1000. Height 16″. Museo Nacional de Costa Rica.

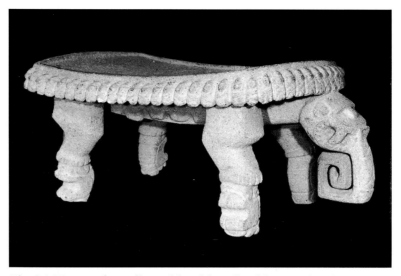

Fig. 34. Tetrapod mealing table with stylized human heads on rim and each paw supported by an open-mouthed head. Volcanic stone. Atlantic Watershed Zone.

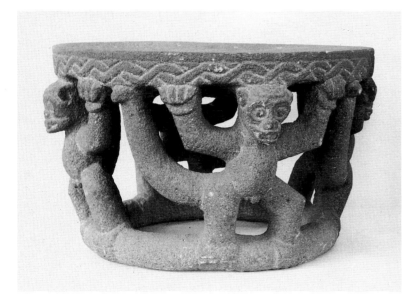

Fig. 33. Stone offering table or seat. Atlantic Watershed. Early Period II, ca. 1000 AD, height 10¾″. Museo Nacional de Costa Rica.

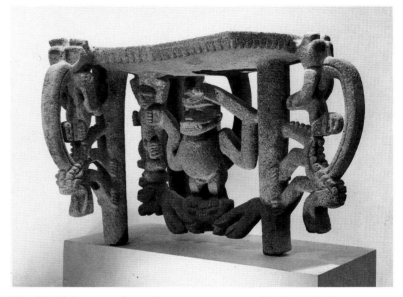

Fig. 35. Flying panel mealing stone or seat with beak-bird as part of adornment on each leg. Atlantic Watershed Zone. Height 24″. New Orleans Museum of Art.

forest populations of South America. The snuffers were also used in the Antilles and probably are indicative of drugs as well as tobacco, whereas the beaters imply the preparation of bark cloth to serve as clothing.

Nearing the end of Period IV and through the first half of Period V, large grinding stones with a "flying panel" connected to all three legs appeared in the Atlantic Watershed particularly along the Linea Vieja and the Reventazon Valley (Fig. 35). These elaborate stones are carved with bold effigies of rain forest animals and always have a striking representation of a water fowl popularly called a "beak-bird" because of its prominent bill (Fig. 36). This type of bird, according to Spanish reports at the time of the conquest in the Greater Antilles, was responsible for the creation of woman and

the procreation of the human race.[48] This concept and the same type of grinding stone is found in Veraguas, Panama, and attest to the extension of Antillean and lowland South American culture traits in Central America due, we feel, to the esoteric value of ideas and luxury goods which were facilitated by trade.[49]

Period V: AD 500-1000

Long-distance trade is not quite so evident during Period V. Nevertheless, the Atlantic Watershed was not isolated. It was a time when southern influence grew stronger. Houses and burials did not adhere to a set style. Rectangular dwellings seem to be replaced in part by circular ones sometimes with a stone foundation, entry ramps and even adjoining causeways, all southern

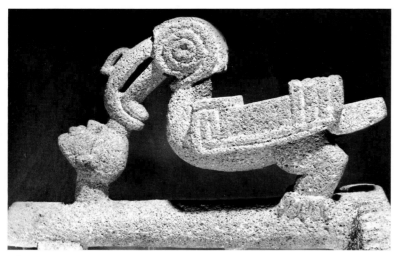

Fig. 36. Beak-bird holding a human head on leg of a flying panel mealing stone. Atlantic Watershed Zone.

Fig. 37. Stone figure of a woman holding her braid, Linea Vieja, Atlantic Watershed Zone.

traits. Towards the end of this period, square houses appear but are not common. Quadrangular-shaped dwellings with burials under the floor and ellipsoidal-shaped houses perhaps used as cooking quarters were built in the Central Plateau where at two sites, Tibas and La Fabrica, the important dead were placed on top of large elaborate grinding stones, thus, emphasizing the ritual nature of these artifacts.[50] Besides such interments, one finds stone-cist tombs, known on the southern continent, while some graves were marked with stone columns, also a southern trait.

Nicoya Wares, including Chocolate Incised and a number of polychromes, some of the latter cracked-laced, indicating how highly they were valued, are evidence that trade continued and with it the interpenetration of ideas. The same interpretation of the continuous interchange, material or information flow, can be given to the appearance of negative-painted wares often with curvilineal designs some of which depict the octopus and recall Panama, Colombia and Peru. Also reminiscent of Panama and South America are White-Line ceramics with its alligator-derived patterns. Stone Cist ceramics with appliquéd bands of zoomorphic and anthropomorphic figures, dots and fillets again point to the south and share their type of adornment with pottery in Ecuador and Atlantic Venezuela.[51]

During Period V, jades show a decided decline in popularity, perhaps due to the poor quality of the available local stone, suggesting that interchange with the north might have been interrupted because of political turmoil in Mexico and much of the Maya area. Metallurgy, on the other hand, begins to boom although never as we see it in the Diquis region. This could be due to a scarcity of raw material on the Atlantic Watershed. The most prominent metal working area was the Linea Vieja but we see none of the larger elaborate pieces found in south Pacific Costa Rica. Instead, the diagnostic types are relatively small beads and figures identifiable with southern religious concepts. Towards the end of Period V and continuing into Period VI, stonework focused on free-standing figures associated with South American fertility cults and portrait-like images.

Period VI: AD 1000-1550

This is the threshold to the historic era and the culture of the Atlantic Watershed shows a stronger affiliation than ever with the south. The circular house form with cobblestone causeways, underground aqueducts for community water and the preference for settlements on hillsides are reminiscent of the Colombian Tairona. A number of sites, particularly on the Linea Vieja, have small plazas or enclosures. This is the time when El Guayabo in Turrialba, Las Mercedes, Anita Grande and Costa Rica Farm, the last three on the Linea Vieja, to name some of the largest places, were at their best. Only El Guayabo near Turrialba, and now a national park, remains today; the others have practically disappeared due to the cultivation of cacao and bananas.

Burials continued to take all forms from primary, secondary, to stone cist tombs, which are found inside and around circular-stone house mounds as well as in cemeteries. Some are rich in grave furnishings while others have no sign of offerings. Certain interments are stone-lined and have a lapidary or gravestone on top, elaborately carved with freestanding animal and human

figures, signs of clan totems. At least at the time of Spanish contact, the important dead were placed over fires to dry them and painted with a resinous gum for preservation, a custom common to Venezuela and Haiti.[52] This gum, called caraña, was a coveted article of trade. Another custom from eastern South America and probably belonging to the trophy-head cult was the use of cups made from human skulls, many of which have come from stone cist graves in the Central Highlands.[53]

As clay figures declined in number, portrait-like stone figures increased, some with a height of 1.8 meters (6 feet). Many statues depict genre subjects such as a woman plaiting her hair (Fig. 37) or holding a parrot, or a prisoner with his hands tied behind his back. However, there are a number of conventionalized males with one or two trophy heads on a rope (Fig. 38), and females holding their breasts, supposedly images connected with a fertility cult. Some of these figures were on or at the base of what were probably circular ceremonial mounds, while other figures possibly served as penates, or household gods.[54]

Elaborate grinding stones tend to disappear, their place being taken by tetrapod jaguar effigies with a raised rim, a type seen in the Diquis region and in Chiriquí, Panama, or by natural undecorated boulders along riverbanks. Boulders by rivers or in cleared fields are often covered with petroglyphs at times resembling some from Venezuela and the south.

The southern inspired negative-painted pottery, usually with a white background and black design, was placed in high status graves, while Mercedes White-Line, Irazu Yellow-Line, and Cot Black-Line ceramics show southern influence. They suggest the Diquis region and Panama ceramic style pointing in the same direction as Turrialba Bichrome, which recalls Tarragó Biscuit Ware from the Diquis area. However, the fondness for imported Nicoya Polychrome persists and remains evident in rank burials. Among these wares are Birmania, Mora and Luna. There was no reciprocal exchange of pottery between Nicoya and the Atlantic Watershed, but among items this last region had to offer in return for the coveted polychrome ceramics were lances of hard black palm wood with fishbones at the tip, bows, arrows, and heavy wooden clubs. Gold and a copper-gold alloy called *guanine* or *tumbago* pendants, beads, bells and fishhooks were also seen among the merchants' wares (Figs. 39-41). Tapirs—the preferred meat of chiefs at feasts—wild pigs and boars, dogs and cacao, colored feathers, seashells and *chaquira* or fine white shell beads akin to the North American wampum and like wampum served as a medium of exchange usually for slaves were also offered by the east coast inhabitants to those from the Nicoya region.

Fig. 38. Stone figure of a man holding a trophy head in one hand and an axe in the other. Linea Vieja, Central Highlands/Atlantic Watershed Zone. Height 24½″, Museo Nacional de Costa Rica.

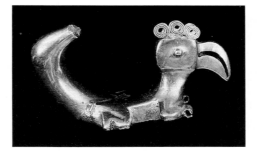

Fig. 39. Coclé style gold bird from Guacimo, Linea Vieja, Central Highlands/Atlantic Watershed Zone.

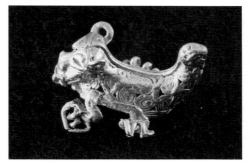

Fig. 40. Gold animal, trade piece from Diquis found on the Linea Vieja, Central Highlands/Atlantic Watershed Zone. New Orleans Museum of Art.

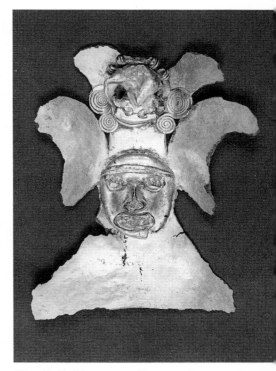

Fig. 41. Gold-copper alloy pendant of a buzzard or eagle with human trophy head. Diquis Zone, 100 AD, New Orleans Museum of Art.

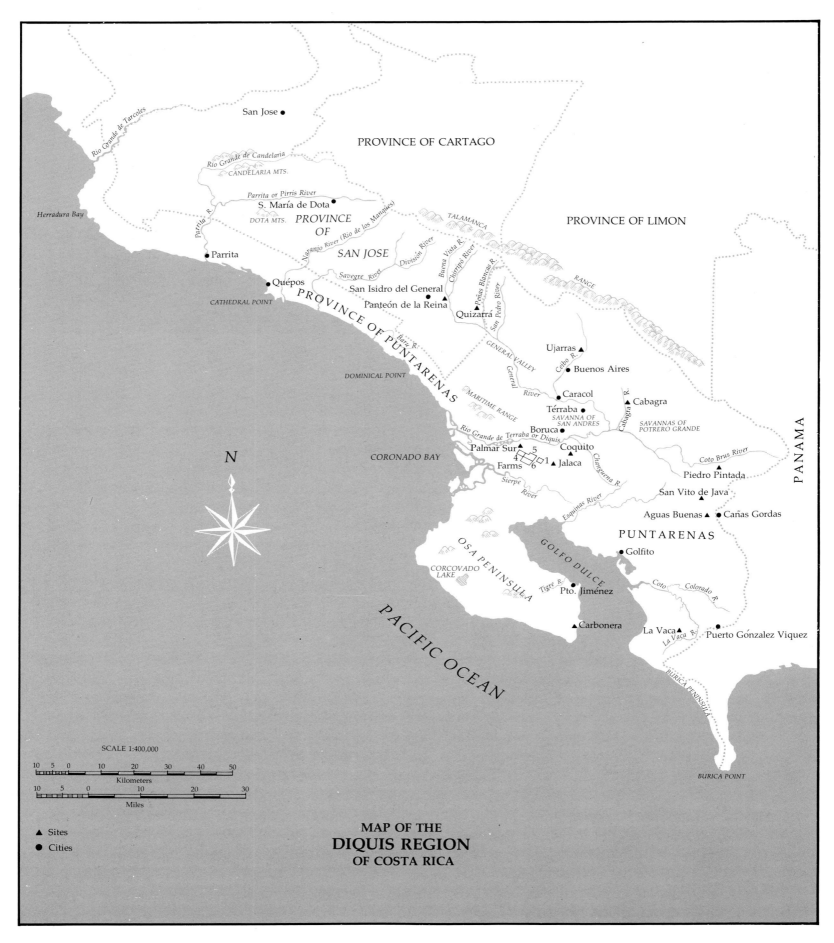

N

PROVINCE OF CARTAGO

San Jose ●

Rio Grande de Tarcoles

Rio Grande de Candelaria
CANDELARIA MTS.

PROVINCE OF LIMON

Parrita or Pirris River
S. María de Dota ●
Herradura Bay
DOTA MTS. PROVINCE
OF
SAN JOSE

TALAMANCA

Parrita ●
Naranjo River (Rio de los Manajtes)
División River
Savegre River
Buena Vista R.
Chirripó River
Peñas Blancas R.
RANGE

Quépos ●
San Isidro del General ●
Panteón de la Reina ●
Quizarra ▲
San Pedro River

PROVINCE OF PUNTARENAS

CATHEDRAL POINT

Buru R.

GENERAL VALLEY
Ujarras ▲
Ceibo R.
Buenos Aires ●

DOMINICAL POINT
General River
MARITIME RANGE
Caracol ●
Térraba ●
SAVANNA OF SAN ANDRES
Cabagra ▲
Labagra R.
SAVANNAS OF POTRERO GRANDE

Boruca ●
Rio Grande de Terraba or Diquis
Palmar Sur ▲
5
Coquito ●
Coto Brus River
4 1
Farms
6 ▲ Jalaca
Piedro Pintada ▲
Changuena R.
CORONADO BAY
Sierpe River
Esquinas River
San Vito de Java ▲

Aguas Buenas ▲ Cañas Gordas ●

PUNTARENAS

PACIFIC OCEAN

OSA PENINSULA
GOLFO DULCE
Golfito ●

CORCOVADO LAKE
Tigre R.
Pto. Jiménez ●
Coto
Colorado R.

Carbonera ▲
La Vaca ▲
La Vaca R.
Puerto Gónzalez Viquez ●

PANAMA

BURICA PENINSULA

BURICA POINT

SCALE 1:400,000

10 5 0 10 20 30 40 50
Kilometers

10 5 0 10 20 30
Miles

▲ Sites
● Cities

MAP OF THE
DIQUIS REGION
OF COSTA RICA

THE DIQUIS REGION:
Period IV: 1000 BC-AD 500

The Pacific southeast of Costa Rica continues to provide evidence of an east-west meeting of cultures already noticed in the other regions examined. North of the Diquis River basin, the largest river in the area, the early settlers responsible for what is known as the Aguas Buenas complex were highland or mountain people, even though there are related sites in the Diquis delta. The culture extended into both the upland and coastal areas of Costa Rica and neighboring Panama, where it probably existed on the Caribbean as well as the Pacific side.[55] Aguas Buenas people are believed to have migrated from the Atlantic Watershed of Costa Rica and are linked to El Bosque culture of that region. In Diquis, they lived in small settlements for the most part on high river terraces or mountain spurs. There were, however, some large ceremonial sites which must have served as seats of government, a place to control the small communities. At present, two such centers are known, Las Bolas in the highlands and El Palmar in the delta. The society was based on rank, common to most of early Costa Rica. Houses, probably associated with the chieftain or for ceremonial use, were on earthen mounds with stone retaining walls. Most of the dwellings have left little or no remains.[56]

The burial pattern is not clear, but sometimes the dead were placed in stone cist tombs under the house floor or around the construction.[57] Shaft and tomb interments, a Colombian and Andean trait but also found in Panama, appear in the Diquis highlands near Canas Gordas on the Costa Rican/Panamanian border (personal excavation). Oval pits were likewise used and large pottery urns served for secondary burials.[58]

Agriculture, which is thought by some to have been brought from central Costa Rica, included maize, beans, root and tree crops. The tubers were easy to raise, did not need storage facilities, particularly important in a region of heavy rainfall, and when gathered, could be boiled, roasted or ground.

The ceramics show the presence of more than one culture or influence in the Diquis region during the Aguas Buenas phase. What is generally accepted as Aguas Buenas pottery is usually plain or incised. At times, however, red paint is applied, leaving zones of natural clay akin to El Bosque ceramics in the Atlantic Watershed. Clay roller stamps are likewise present. Scarified Ware is a Panamanian style associated with the Concepción phase, a contemporary of the Aguas Buenas era. Whether the people responsible for Scarified pottery actually made the ceramics found in Costa Rica or introduced the varied Panamanian customs

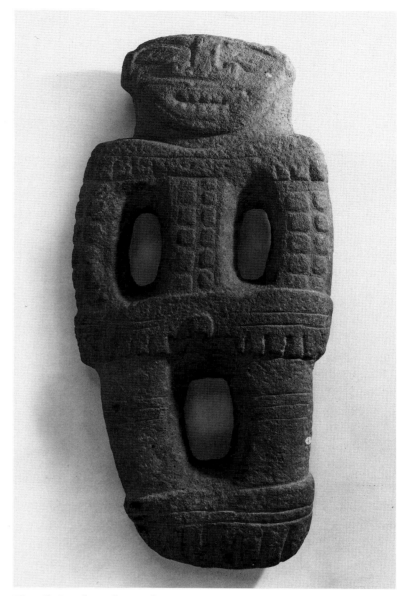

Fig. 42. Peg-base figure from Diquis Zone, red stone, AD 1000-1550. Height 19¼″. New Orleans Museum of Art.

noted, we cannot say. Some archaeologists feel that the chimney-like vessels are imports from Panama and not fashioned on Costa Rican soil.[59]

In the delta area, Parallel-line Incised Ware with its large globular and legless jars decorated by parallel lines and interspersed conical projections—a technique which recalls the Amazon—and Red- and Black-Line Ware similar to pottery from Chiriquí, Panama are other foreign culture intrusions introduced by merchants or travellers if the idea was not brought by information flow. Clay figurines representing human beings and a single sherd of negative painted pottery are also southern links.[60] The Osa Peninsula which extends into the Pacific from the delta region has a third type of ceramic, the relationship of which is not completely understood. Unique among this class is a painted zoned incised human effigy figurine portrayed as presenting an offering. Unquestionably a foreign concept, it has been associated by some with the south.[61]

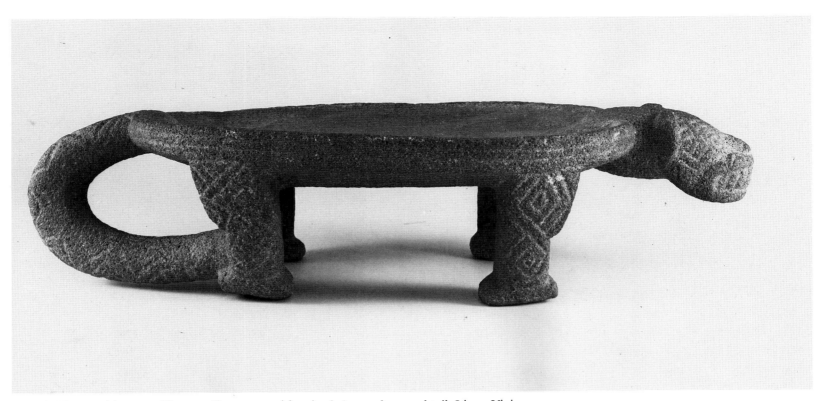

Fig. 43. Tetrapod jaguar effigy mealing stone with raised rim and curved tail, Linea Vieja. Ca. AD 850-1502. Height 6". New Orleans Museum of Art

There is a decided difference in stone sculpture between the highlands and the delta. The highlands show a close affinity to the culture of Barriles, Panama, which lies on the slopes of Barú volcano. In the uplands of Costa Rica, there are small stone effigies of human beings; often only the heads survive. These heads wear a conical cap similar to that seen on the larger statues at Barriles. Barrel-shaped objects, perhaps seats with bas-relief at either end—an artifact which gave its name to the Panamanian site—are common to both cultures.

On the other hand, the delta statues are human, anthropomorphic and zoomorphic figures usually with a peg base which was buried in the ground for support (Fig. 42). Carved in the round or as slab figures, many are reminiscent of San Agustín, Colombia, while some, for example curly-tailed dogs, recall Coclé, Panama.

Pictographs on boulders occur in the highlands, but the massive stone spheres which usually mark cemeteries in the delta are known at only one or two sites in the uplands where the largest known is 2 meters (8.2 feet) in diameter, whereas in the delta some balls are 6.1 meters (20.1 feet).

It has been claimed that the large tetrapod Barriles grinding stones, with effigy-human heads or bodies on the legs and around the raised rim, appear in the Diquis region. I have never seen them. Smaller versions similar to the Barriles stones, however, come from the Atlantic Watershed and may be the result of information flow or actual trade with material objects.

Periods V and VII: AD 500-1550

Aguas Buenas culture probably ceased around AD 500. In Costa Rica, Period V has not yet been assigned an intermediate phase such as that of Burica in Panama. The final Diquis culture phase is now called Chiriquí and shows strong ties to the east, that is Panama and beyond. Habitation sites are usually along lower river terraces near rich alluvial margins ideal for agriculture. Settlements vary in style. Some have circular cobble-stone house foundations often with ramps connected by stone-paved causeways. One also finds large, low, stone-faced platforms of multiple shapes surrounded by high retaining walls and surface pavement. These mounds are frequently marked with basalt columns or slabs beside them, a feature related to burials. The pillars or columns are interspersed with what might be house mounds.[62]

By 1550 in the delta, there was at least one community in the center of a river while the savannas of highland Diquis had forts and villages.[63] Such locations and settlement types are indicative of the life-style of the populace. The social pattern was based on the cult of trophy heads which since Period IV was predominant in the Diquis and Atlantic Watershed, probably reaching

Costa Rica from Panama through information flow. In the 16th century, the religious pressure had become so great that a human being was sacrificed every moon.[64] It is quite natural that this would lead to warfare between unrelated communities. One objects to sacrificing one's own blood kin particularly when nonrelatives are available.

As a rule, cemeteries are on elevated locations, for example hillsides, at times on top of former Aguas Buenas settlements. Although burials differ, all are in cemeteries and include primary but more often shaft and tomb graves suggesting secondary interment.[65] The great discrepancy in grave furnishings, some without a sherd and others with whole vessels including polychrome ware—an article which seems to have been used primarily as funeral offerings, at times with gold artifacts, seashells and carved bone—again emphasizes a social system based on rank.

A diagnostic mealing stone during Period VI is a tetrapod jaguar effigy with a raised rim and a curved tail projecting from the rear of the grinding plate and attached to a hind leg (Fig. 43). A guilloche pattern is usually on the head, rim, limbs and tail. This type of stone is seen on the Atlantic Watershed and in the province of Chiriquí, Panama. Its origin seems to be the Caribbean side of Costa Rica and must have been an important trade item of Period VI.[66] The stone sculpture so indicative of the Diquis region, however, lost its popularity and is not seen in Chiriquí times.

Trade has left an archaeological record in the Diquis region primarily through pottery and gold. Heavy appliquéd tripod vessels from the Osa Peninsula were traded locally. This form seems to have been quite important since the only shape of Lerida Red-on-Orange exported from the Atlantic slope of Panama to Costa Rica is a tripod. Also originating in Panama are some types of Ceiba Red-Brown Ware which might be a variant of Panamanian Handled Ware. This was traded beyond the Diquis region into the central highlands.

Other examples of Chiriquí ceramics are Tall Brown Tripods, Fish Ware and the strikingly elegant, well fired, and very thin San Miguel Biscuit which probably was first manufactured on the Pacific side of the Cordillera (No. 161).[67] A Panamanian polychrome ware traded, or culturally an extension, into the Diquis region where it was one of the most popular pottery classes and still in vogue after the Spanish arrived, is Red and Black Line (or Buenos Aires Polychrome, Nos. 153-160). There is a large variety of vessel shapes, ocarinas, flutes and figurines, which cover genre and zoological subjects. It has been suggested that many pieces were copied in the region from Panamanian originals. Red and Black Line Ware was also traded to Las Mercedes on the Linea

Vieja, the Nicoya region and perhaps as far west as the Ulúa Valley in Honduras.[68] Likewise brought into Costa Rican territory but probably originating farther south than Chiriquí are some negative painted wares: Black-on-Beige, Black-on-White and Red-on-Red, all with motifs resembling versions of the stylized crested crocodile or alligator. White Line Ware from the Atlantic Watershed reached the Diquis region, where it is known as Panteon White-Lined. While from Guanacaste, various classes of pottery were traded eastward to Diquis and Chiriquí. Among these wares were Chocolate Incised and Carrillo Polychrome.

The fame of the Diquis region, however, is gold. The art of working metal came from Peru around the second millennium BC and reached Costa Rica by way of Colombia and Panama at least by AD 500.[69] Gold was either washed from rivers or dug from beneath tree roots on hilltops or in the plain, but always near water. A community owned each gold-bearing stream and in the fort of Coctu, at least one chieftain was a goldsmith. The raw material was traded within and outside the region, as were manufactured articles. Gold artifacts include utilitarian objects like tweezers, needles, awls, etc., as well as ceremonial and luxury items such as fish hooks, cult images, masks for the dead, finger rings, beads and dress ornaments.

Possibly there were traveling artisans who served a local head of state (if a chieftain may be thus termed). There is no doubt, however, that the external artist left the impact of his skill on local disciples. Manufactured articles which reached Costa Rica were not only traded but also frequently copied. A number of styles are present, almost all from Colombian cultures, including Quimbaya, Muisca, Darien and Tairona. Diquis style is characterized by the relatively large size of the cast or cold-hammered pieces, often false filigree and bangles (Fig. 44). There is usually a combination of boldness with simplicity which makes this goldwork unique in Central America.

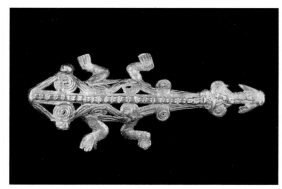

Fig. 44. Gold frog with false filigree. Found in Germania, Linea Vieja, Central Highlands/Atlantic Watershed Zone, but from the Diquis Delta.

EPILOGUE

Archaeology has left a record of foreign culture traits brought to Costa Rica by the trader, whether as articles of exchange, the result of mental stimulation or from the impact of external artisans who performed their skills for a price at a chieftain's command. The record remains despite the centuries involved.

The concept of trade is economic and basically reciprocal. We had a glimpse of foreign items and ideas that reached Costa Rica before the advent of the European. But the question remains, "What did Costa Rica have to offer the merchant?" It is not within the scope of this essay to deal further than we have with ideas. If we do, we find ourselves in the realm of philosophy.

Foodstuffs have always served as articles of exchange. Agricultural products, including cacao (chocolate) were important. Cacao grew wild in Costa Rica, but nowhere else in Central America, and was not cultivated there until shortly before the Spanish conquest.[70] There were also other priority items such as salt and honey (the equivalent in native life to Old World sugar). Spanish accounts speak of the tapir and peccary, two wild mammals native to the New World, as the favorite banquet meat of the elite. The tribes of Talamanca on the Atlantic Watershed even today are noted for the domestication of these beasts who live with their master and follow him like dogs. A tapir in Pre-Columbian times brought the same price as a human slave, 20 *chaquiras*, while the peccary was worth 10.[71] *Chaquira* is a tubular bead made from an oyster shell and used as a medium of exchange.

Strangely enough, obsidian, long an important article of trade in upper Central America, is very seldom seen in Costa Rica, where it does not exist as raw material. Jade and jadeite, however, were coveted over a lengthy span of time, and during a given epoch were essential for fashioning religious images and were brought into the country through long-range commerce. Other priority articles of trade were *caraña*, an aromatic liquid for preserving dead bodies; resin for caulking canoes and carving cult figures; mother-of-pearl shells and pearls from the Gulf of Nicoya. These pearls were so famous that the Spaniards saw Indian divers, who had come all the way from Panama, in the gulf waters. The mother-of-pearl shell was used as a hoe by the Pre-Columbian farmers of the Nicoya region and by mariners in the gulf.[72] It also served as a coating for gold cult images on the Atlantic Watershed during Period VI, perhaps because of the esteem given *chaquira*.

Seashells and manatee bones from the Atlantic were brought to the Pacific in trade. Some Nicoya mounds dating from Period V had *Murex* shells which suggests that the famous purple dye common to this region and Diquis was also in demand.[73]

Fine cotton cloth, plain white or with bright colors, was a highly prized item from Diquis. It is also probable that narcotics had a commercial value. Archaeological artifacts associated with the use of coca and figures with a quid in the cheek are known from Diquis and adjacent Panama. Spanish chroniclers credit the Nicarao, who, by the time of the conquest, had settlements in the Nicoya region, as being cultivators of coca brought from Venezuela.[74]

Slaves were an essential item of exchange at least from Period IV, when the trophy-head cult appeared. As we saw earlier, slaves were needed for sacrifice and not for work. The social organization was such that sufficient vassals were on hand to supply the labor force. This demand for sacrificial victims every moon, however, made war and the taking of captives for slaves a necessity in order to avoid killing one's blood relatives.

The final era of native domination found gold important, replacing the jade of earlier periods. It remained for the trader to supply the extra quantity that the Atlantic Watershed rivers and the hilltops and streams of Diquis could not furnish. After the Spanish arrived, there was an abrupt change. The routes of long-distance commerce stayed open for Spanish travel, the familiar Camino Real or King's Highway, but internal provincial trade suffered. Economic values differed. Handloomed cotton cloth gave way to European clothing. Glass beads with their many colors took the place of the native beads of jade, shell, and gold. Indian graves from conquest times reveal the new values and priorities on the merchants' list. Side by side with pottery vessels are articles from a different world such as knives, scissors, guns, bridles and trappings for the horse.[75] They are silent indications of Costa Rica at the beginning of a new culture era.

1. Swauger and Mayer-Oakes 1952.
2. Stone 1977, p.29.
3. Abel-Vidor 1980; Lange 1984, p.172.
4. Snarskis 1981, p.30.
5. Lange 1984, p.175; p.190.
6. Lange 1984, p.190.
7. See e.g., Lange 1971, p.20.
8. Snarskis 1982, p.21.
9. Snarskis 1982, p.23.
10. Coe and Baudez 1962, p.371.
11. Lange 1984, p.190.
12. See Stone 1972; 1977.
13. Lange 1984, p.190.
14. Lothrop 1926.
15. Covarrubias 1946, p.99. Cf. Druker 1955; pl.36F; Easby 1981, p.138; pl.66.
16. Covarrubias 1966, F.
17. Stone 1972b, p.213.
18. For this last see Perez de Barradas 1954, pl. XX.
19. Stone 1972, pp.93-95.
20. Stone 1983, p.203.
21. Lange and Scheidenheim 1972, p.260.
22. Lange 1984, pp.180-181.
23. Stone 1966, p.31; Snarskis 1981, p.31; Lange 1984, p.178.
24. Stone 1967; p. 1970.
25. Stone 1972, p.65.
26. Stone 1966, Frontispiece; 1977, pp.60-62; Lange 1984, p.178.
27. See Root 1961, p.255 and Bray 1981, p.154.
28. Stone 1966, p.4; 1977, p.67; Lange 1984, p.182 and Blackiston 1910.
29. Balser 1966, pp.391-392.
30. Stone 1977, fig. 92; Lange 1984, p.180.
31. Snarskis 1981, p.35; Lange 1984, p.179.
32. Lange 1984, p.180.
33. Stone 1977, p.71.
34. Sharer 1984, pp.76-77.
35. Sheets 1984, pp.95-106.
36. Sharer 1984, pp.76-77; Lange 1984, pp.176-77; Willey 1984, p.373.
37. Stone 1977, pp.92-94.
38. Lange 1984, p.187.
39. Stone 1982.
40. Stone 1977, p.82; 1982, p.195.
41. Snarskis 1984, p.199.
42. Snarskis 1981, pp.201-06; Willey 1984, p.352.
43. Snarskis 1984, p.209.
44. Snarskis 1984, p.26.
45. Stone and Balser 1965.
46. Balser 1953, p.17; Stone 1977, p.162.
47. Stone 1962, p.48.
48. Martir de Angléria 1944, dec. 1, lib. 9, cap. 5; Balser 1955.
49. Lothrop 1950, p.29.
50. Snarskis 1984, pp.221-222.
51. Lothrop 1926, p.346; Stone 1977, p.212.
52. Fernández de Oviedo 1851:1, pp.203-204.
53. Snarskis 1981, p.65.
54. Stone 1977, pp.178-184.
55. Haberland 1984, pp.240-241.
56. Stone 1977, p.102; p.106.
57. Drolet in Haberland 1984, pp.255-256.
58. Laurencich de Minelli and Minelli 1973, pp.219-220; Snarskis 1981, p.76.
59. Haberland 1984, p.239.
60. Lothrop 1963, pp.72-75; Stone 1977, p.105.
61. Snarskis 1981, p.76.
62. Cf. Snarskis 1981, pp.80-81; Haberland 1984, p.251;
 Drolet in Haberland, p.261.
63. Stone 1977, pp.132-135
64. Fernández 1886, vol. V, p.156.
65. Stone 1977, p.110.
66. Haberland 1984, p.250.
67. Lothrop 1963, p.63 for tall brown tripods, and Haberland 1984, p.248 for
 San Miguel Bisquit.
68. Lothrop 1926, p.262; 1963, pp.85-86; Haberland 1957, pp.261-262;
 Stone 1977, pp.110-111.
69. Bray 1984, pp.126-127.
70. Stone 1984.
71. Fernández 1896, vol. V, p.161.
72. Fernándo de Oviedo 1853, vol. 3, p.110.
73. Coe 1962, p.372.
74. Fernándo de Oviedo 1851, vol. 1, pp.206-207; Colon 1947, p.285, pp.296-
 297. See also Stone and Balser 1958, fig. 9e; Lothrop 1963, pl. 17e.
75. Stone 1958, p.50 fig. 1.

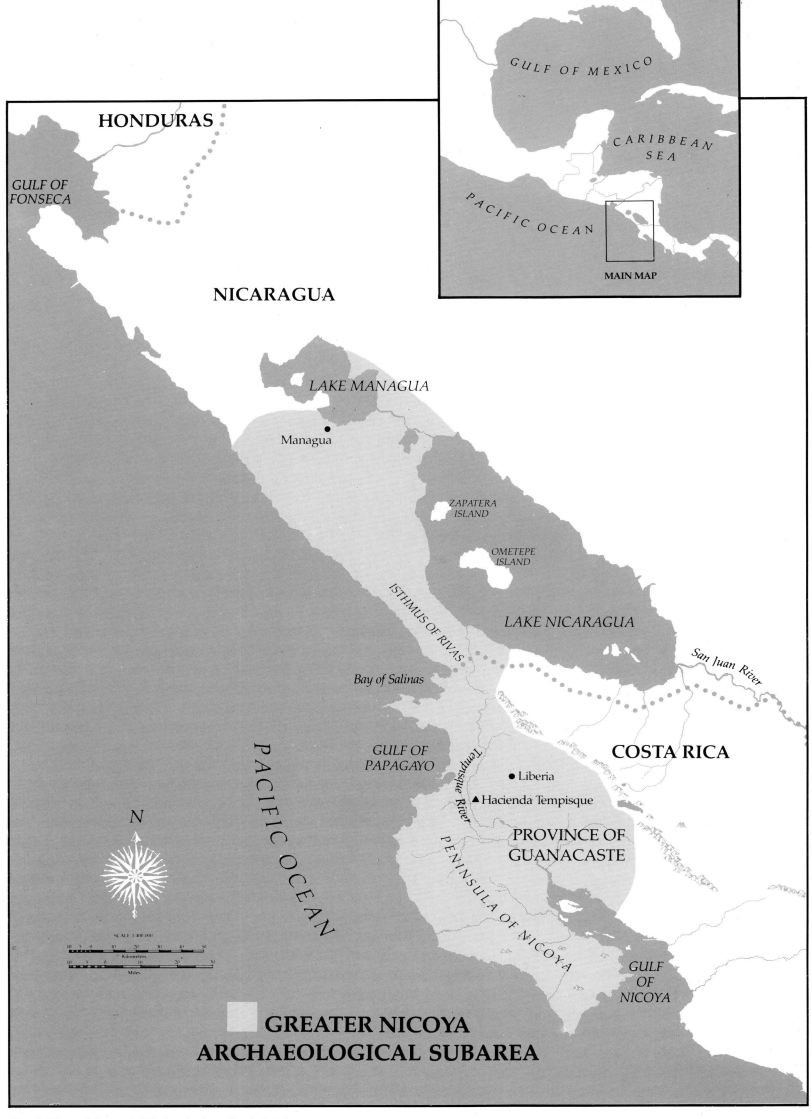

HONDURAS

GULF OF FONSECA

NICARAGUA

LAKE MANAGUA

• Managua

ZAPATERA ISLAND

OMETEPE ISLAND

LAKE NICARAGUA

ISTHMUS OF RIVAS

San Juan River

Bay of Salinas

PACIFIC OCEAN

GULF OF PAPAGAYO

Tempisque River

• Liberia

▲ Hacienda Tempisque

COSTA RICA

PROVINCE OF GUANACASTE

PENINSULA OF NICOYA

GULF OF NICOYA

N

SCALE 1:400,000

Kilometers

Miles

**GREATER NICOYA
ARCHAEOLOGICAL SUBAREA**

Fig. 1. Map of Greater Nicoya Archaeological Subarea.

38

Polychrome Ceramics and Iconography

DR. JANE STEVENSON DAY
Denver Museum of Natural History

OSTA RICA is a country where ceramics are of particular importance to the study of the art and archaeology of early cultures. In this area of Lower Central America there was no monumental architecture, few stone monuments and no known writing system. In addition, only scattered aboriginal groups have survived into modern times to give us a fleeting glimpse of past lifeways. In contrast, there is an abundance of ceramic remains. Archaeologists, farmers and *huaqueros* will all attest that in most parts of the country, particularly along the river drainages, you can't put a spade in the ground without turning up remnants of pottery. Based on stratification evidence from archaeological excavations and the seriation of thousands of pottery sherds, chronological and cultural sequences have been established for most of Costa Rica.

Further information about the past survives to us in the form of embellished funerary pottery from tombs. Whole decorated vessels, buried with the dead, have been recovered in great numbers from what appear to be high status graves. The iconography and artistic design elements from these ceramics have illuminated relationships among ancient areas and peoples and suggested the prehistoric presence of elaborate ritual activities and a rich mythology. This specialized decoration of pots, which are fundamentally utilitarian objects, appears to turn the basic container into a ritual vessel. With the addition of prescribed elements, the secular becomes sacred and as a result we can consider that in prehistoric cultures the decorative additions were as important as the creation of the vessel itself. Because the design elements and iconography used to embellish burial ceramics are sensitive to changes in styles, ideas and rituals, they have proven to be particularly valuable in the study of past lifeways.

Many finely decorated burial vessels were made throughout all the regions of Costa Rica for at least the two thousand years preceding the Spanish conquest in 1522. Most of these were monochrome or bichrome ceramic effigies, jars, bowls and figures. They were embellished by means of incision, appliqué or modeling and then carefully interred with the honored dead. The one major exception to the long continuity of this tradition occurred in northwestern Costa Rica. There, after AD 500, there was a development of elaborately painted polychrome pottery. Fine monochrome incised vessels continued to be made as well, but it was the brightly painted polychrome vessels that were dominant in elite burials during the last one thousand years of the prehistoric period.

This essay is concerned with the polychrome tradition of pottery in northwestern Costa Rica and its relationship to iconography in the region. Northwestern Costa Rica is composed of the Province of Guanacaste and the Nicoya Peninsula. Prehistorically this area was part of what is now known as the Greater Nicoya Subarea, which also included the Rivas and lakes region of southwestern Nicaragua just north of the present-day border (see Map, Fig.1).[1] Political boundaries of today were, of course, meaningless several thousand years ago, and it was the natural boundaries of ocean, mountains and lakes that served to separate groups of earlier peoples or to relate them genetically, artistically and culturally to each other. The Greater Nicoya area was such a cultural entity; it was linked together by common languages, art styles and iconography as well as by ecological, economic and political bonds. This area, between AD 500 and 1522, exhibited an ever increasing resemblance to Mesoamerican artistic and iconographic traditions. This cultural relationship with regions to the north is reflected in the polychrome ceramic sequences of the area. These sequences, as well as the chronological divisions of earlier time periods, were first established for the area on the basis of pottery sherds from stratigraphic excavations.[2] Recently, chronological divisions have been further refined and elaborated on the basis of stylistic and iconographic evaluation of the polychrome pottery itself (see Chronological Chart, Fig. 2).[3]

Central American Periodization	Regional Periodization	Calendar Years	Bay of Salinas Santa Elena Peninsula	Bay of Culebra	Tempisque River Valley	Lower Nicoya Peninsula	Rivas
Period VI	Late Polychrome	1550 / 1500 / 1400	La Cruz A	Ruiz	Bebedero B	?	Alta Gracia
	Late Polychrome	1300 / 1200	La Cruz B	Iguanita	Bebedero A		Las Lajas
	Middle Polychrome	1100 / 1000	Doscientos	Monte del Barco	Palo Blanco B	Tamarindo	La Virgen
Period V		900 / 800		Panama	Palo Blanco A		Apompua
	Early Polychrome	700 / 600	Santa Elena	Culebra	San Bosco	Matapalo	Palos Negros
Period IV	Zoned Bichrome	500 / 400 / 300	Murcielagos	Mata de Uva	Ciruelas	Las Minas	San Roque
		200 / 100 / BC/AD / 100 / 200	Chombo	Orso	Catalina	Monte Fresco	San Jorge / Aviles
	?	300 / 400 / 500 / 600 / 700 / 800 / 900 / 1000		Loma B			

Fig. 2. Chronological chart of Greater Nicoya Subarea.

Background

On the earliest time levels, Costa Rica—and Lower Central America in general—were related to culture traits which probably arrived in the area from northern South America. Language, iconography, subsistence crops and religious practices, such as ritual drunkenness and the taking of trophy heads, have long been seen as having their origin to the south in the ancient tropical or riverine Amazonian tradition.[4] Indeed the actual art of making pottery probably spread north from Colombia and Ecuador, first into Panama and then into Costa Rica. For at least a thousand years, pottery at Costa Rican sites appears to have developed in a manner stylistically and technically similar to ceramics from northern South America. During the years from 500 BC to AD 500 the dominant decoration on pottery took the form of mod-

eling, appliqué, resist paint and various types of incising on monochrome and bichrome vessels. (For examples of these decorative techniques, see Nos. 1, 3, 4, 13, 110, 118 and 139.) After AD 500, there was, however, a great explosion of polychrome painted ceramics in the Nicoya area which replaced the earlier bichrome tradition. At this time we also begin to see a change in the iconography depicted on these painted vessels. It is as if the potters were suddenly presented with new ideas and images as well as new ceramic techniques.

The technique of decorating pottery with polychrome paint-was known both to the north and the south of Costa Rica before it made its appearance in the Nicoya area. To the south, before AD 500, polychrome vessels were being made in coastal Peru, Ecuador, Colombia, Panama and Venezuela.[5] To the north, they

were found on the west coast of Mexico, in southeastern Vera Cruz and in the Maya area.[6] Any of these regions might have been the source of polychrome technology for Greater Nicoya. Interestingly enough, there is no general agreement between scholars about the directional spread of painted pottery. Coe, for example, argues for a gradual spread from Venezuela to Mesoamerica while Reichel-Dolmatoff argues instead for diffusion from north to south.[7] However the spread may have occurred, the closest resemblances to early Greater Nicoya polychrome pottery are found in the Maya and Ecuadorian areas, and these seem most likely to have been the donors.[8] This premise is supported by the two earliest polychrome ceramic types: one, Carrillo Polychrome (Nos. 23, 24 a, b, 25), has been convincingly compared to Guangala Phase Polychromes from Ecuador; the other, Galo Polychrome (No. 26), has strong stylistic ties with peripheral Maya ceramics of the same period.[9]

The Polychrome Tradition

Carrillo Polychrome seems most likely to have been the first polychrome type in Nicoya as it has been found in burial association with Zoned-Bichrome Period ceramics which date before AD 500.[10] This is further supported by the fact that its abstracted, decorative elements continued a long tradition of cayman or alligator imagery, a deity which had great time depth in both Costa Rica and South America (Nos. 21, 107, 110). In contrast, Galo Polychrome initiated the arrival of Mesoamerican iconography in the form of a stylized jaguar with a bifurcated tongue and a rosette-patterned pelt (No. 29).

For a time the more ancient abstract alligator symbol lingered on in Guanacaste, blending with the newer jaguar icon to create a dragon-like image (No. 26), but it was soon replaced in the area by the Maya-related motifs of Galo Polychrome vessels. This does not mean that populations were necessarily replaced as well but certainly indicates the presence of new ideas and new contacts in northwestern Costa Rica by about AD 500. Aesthetically, Galo Polychrome with its highly polished surface and deep rich colors was one of the high points of ceramic art in Greater Nicoya as well as the hallmark of the first polychrome period of the region.

The Tan Slipped Tradition

These first polychrome ceramics were slipped an orange/tan shade and the designs were painted on them in deep blacks, reds and oranges. They began a sequence of fine, tan slipped, hard fired and highly polished polychrome types known as Guanacaste Ware.[11] This ware began in the Early Polychrome Period (AD 500-800), reached its zenith in the Middle Polychrome Period (AD 800-1200), and finally disappeared with the advent of the Late Polychrome Period (AD 1200-1550) amid a growing preference for white slipped pottery (see Polychrome Ceramic List, Fig. 3).

POLYCHROME CERAMIC TYPES

Tan Slipped Tradition: AD 500-1200	White Slipped Tradition: AD 800-1550	
Carillo Polychrome	Papagayo Polychrome	Luna Polychrome
Galo Polychrome	Papagayo Variety	Luna Variety
Assientillo Polychrome	Culebra Variety	Luna/Filadelfia Variety
Altiplano Polychrome	Manta Variety	El Menco Variety
Birmania Polychrome	Serpiente Variety	Madeira Polychrome
Mora Polychrome	Pica Variety	Madeira/Filadelfia Variety
Mora Variety	Fonseca Variety	Pataky Polychrome
Guapote Variety	Mayer Variety	Pataky Variety
Guabal Variety	Mandador Variety	Leyenda Variety
Chircot Variety	Banda Polychrome	Pataky/Filadelfia Variety
Cinta Variety	Bramadero Polychrome	Tempisque Polychrome
Tardio	Bramadero/Filadelfia Variety	Vallejo Polychrome
Gillen Black on Tan	Casares Polychrome	Vallejo Variety
Santa Marta Polychrome	Felino Variety	Mombacho Variety
	Jicote Polychrome	Cara Variety
	Jicote Variety	Cara/Filadelfia Variety
	Mascara Variety	Lazo Variety
	Lunita Variety	Lazo/Filadelfia Variety

Figure 3. Polychrome Ceramic Types of Greater Nicoya: The Tan and White Slipped Traditions

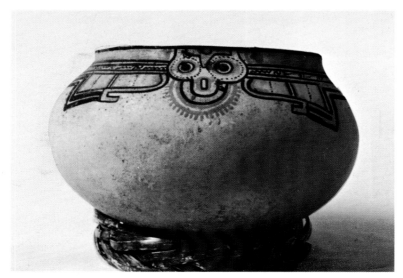

a. Vallejo Polychrome, Cara Variety

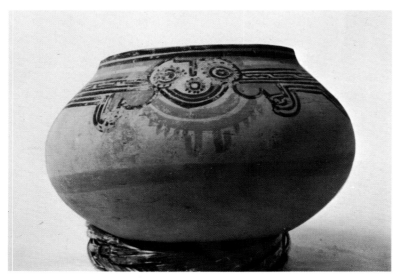

b. Vallejo Polychrome, Cara/Filadelfia Variety

Galo and Carrillo Polychromes died out at the end of the Early Polychrome Period but related tan slipped ceramic types of the Middle Polychrome Period carried on the established tradition. Examples of these Middle Period tan slipped types as seen in the Sackler Collection are: Mora Polychrome in its many varieties (Nos. 34, 36, 39, 44, 46, 51), Birmania Polychrome (Nos. 58, 62), Altiplano Polychrome (Nos. 53, 54), Santa Marta Polychrome (No. 63), and Gillen Black on Tan. The iconography painted on these pottery types continued to reflect the imagery of the Maya peripheral area. The *kan* cross, the royal mat pattern, chevrons, sunbursts, cross-hatching, and a bent figure with elaborate feathered headdress were all iconographical elements shared with the peripheral Maya world. In fact, these design elements continued to appear on tan slipped vessels in the Guanacaste area of Nicoya until around AD 1200,

long after they had faded as a result of the Maya collapse in regions to the north. It is interesting to note that these first early polychromes appeared in the same time period in Greater Nicoya burials as Maya-like jade plaques and mirrors.[12] They reflect a still not well understood cultural relationship between the two areas, a relationship which was probably based on Maya interests in such status items as jade, purple dye, cacao, and the blue-green feathers of the quetzal bird.

Beginning with the introduction of the tan slipped tradition in Greater Nicoya, polychrome ceramics were prepared in a special way to receive the motifs and design elements to be painted upon them. First they were smoothed and then carefully slipped to provide a fine finish or base for the painted theme. After painting and burnishing, the vessels were fired and then covered with a coat of wax or some type of vegetal varnish to maintain the color and finish of the pot. This waxed and glossy finish is still apparent on many of these vessels when they are removed from the ground today and seems to have been a factor in the good preservation of the rich colors and designs.

The White Slipped Tradition

In Greater Nicoya a parallel polychrome tradition of brightly painted white slipped vessels coexisted with the earlier tan slipped ceramics. This white slipped pottery first appeared at around AD 800, considerably after the first occurrence of polychrome types in the region, and continued until the time of the Spanish conquest and beyond. This continuity into the historic period is evidenced by the presence of white slipped Luna Polychromes in graves with Spanish trade goods.[13] Unlike the tan Guanacaste Ware, the white slipped Nicoya Ware polychromes did not depict Maya-like motifs or continue interpretations of older themes such as the alligator. They were associated with new themes and iconography. In addition, from about AD 1200 on, deliberate copies were made of the abundant and aesthetically pleasing white slipped vessels. Figure 4 clearly illustrates the occurrence of this phenomena. The copies were made of tan clay with a salmon slip rather than with the red paste and white slip of the Nicoya Polychrome types. The iconography and designs painted on them were, however, the same and it was clearly the intent of the potter to attempt to reproduce, in local ceramics, the forms and distinctive imagery of the "classic" and more professional appearing white pottery.[14] Results of recent research indicate that the white slipped ceramics, or Nicoya Polychrome Ware, were made in the Rivas and lakes area of Nicaragua and imported into the Guanacaste area of Greater Nicoya.[15] There they are found in elite tombs associated with

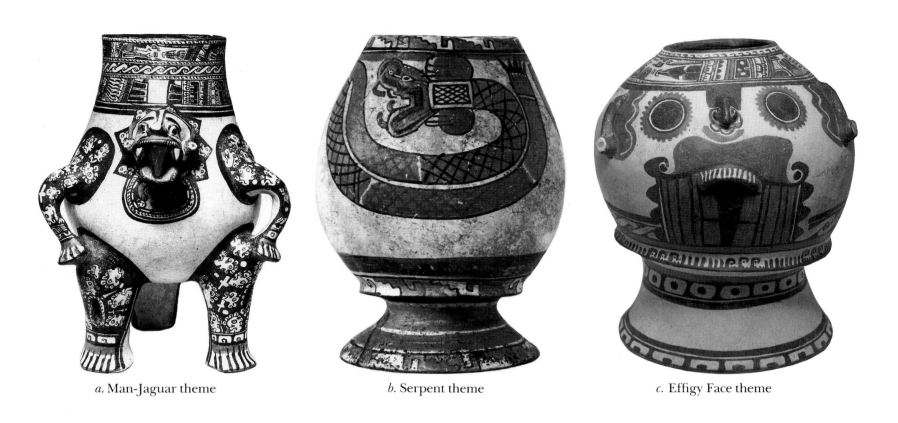

Fig. 5. Major themes of the Middle and late Polychrome Period in Greater Nicoya.

| *a.* Man-Jaguar theme | *b.* Serpent theme | *c.* Effigy Face theme |

salmon slipped copies of themselves, known as Filadelfia Ware, made in clays from the Tempisque River Valley. This interesting association, first established through stylistic analysis, has now been corroborated by neutron activation analysis by Dr. Ronald Bishop of the Smithsonian Institution of Washington, D.C.[16]

In addition to the introduction of new iconography and the creation of ceramic analogues or copies, the third major innovation brought by white slipped pottery was the heavy white base coat itself. This was used as a surface for the brightly painted ritual imagery. It made the themes and their associated elements stand out in a spectacular manner that was distinctive and easy to read. It seems clear that this was truly the purposeful intent of the artist or potter who created the ceramics and that they were meant to serve as vehicles of communication among peoples who shared the same culture (see for example Nos. 67, 79, 84, 87, 88).

Generally in prehistoric New World cultures, women are assumed to have been the makers of pottery. The elaborately decorated polychrome ceramics of Greater Nicoya seem, however, to represent a different tradition. The person who made the pot may not have been the same one who decorated it. The highly stylized and repetitive iconography reflects standardization and specialization beyond household manufacture. It seems probable that a potter may have produced a vessel,

perhaps even slipped and fired it, in preparation for further embellishment by a specialized painter. The painter may have been a priest or scribe or possibly an itinerant artist/priest who carried ritual information to local production centers and painted prepared pottery.[17] Such a possibility is supported by evidence of multiple firings of various types of polychrome vessels in Greater Nicoya as well as by recognition of the hand of more than one artist on a painted pot.

When first viewing these elaborately decorated vessels, it is easy to be misled into thinking that a wide variety of iconography was painted upon them, but closer study and examination reveals that this was not the case. Minor themes came and went over time but only three major themes actually existed in any quantity. These were combined, recombined and repeated over and over on the white slipped vessels in the area for at least 800 years. The three major painted themes that dominate the pottery of the white slipped tradition are a man/jaguar theme, a plumed serpent image, and a round-eyed painted effigy face reminiscent of the popular Tlaloc or rain-god image of Central Mexico (see Fig. 5c). The impression of diversity of iconography is a direct result of wide variance in forms of vessels, interpretation by individual artists, and the long endurance of the themes. This last factor led to abstraction over time of what were once fairly realistic images.

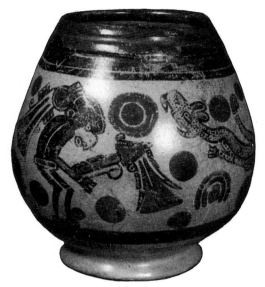

Fig. 6. Man/Jaguar theme: Papagayo Polychrome jar, Culebra Variety (after Lothrop, 1926).

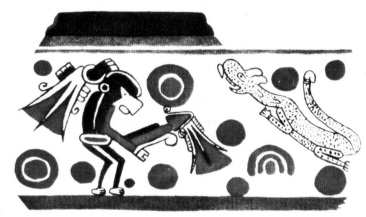

a. Roll out drawing of design on vessel.

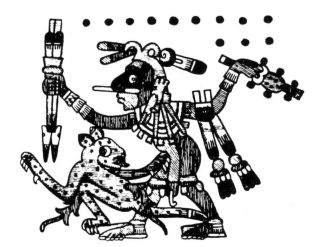

b. Mixcoatl myth in Mexican Codex Fejervary-Mayer.

Minor themes which appear in the area are not necessarily of minor significance but they are usually limited to only one type of polychrome pottery, one vessel form and a brief time interval. In addition, the images they depict tend to be quite realistic and to change little over time. These very limitations, however, are important qualities in the study of Guanacaste ceramics as they are useful spatial, temporal and cultural markers in the area. Minor themes which can be recognized on white slipped ceramics in Greater Nicoya are: a scorpion theme, a realistic crab, a monkey, a winged head and various animal effigy heads which are appliquéd on the front of polychrome vessels (Nos. 73, 76, 88, 89). In addition, a small group of distinctive depictions of Postclassic Mexican deities appear in the region from about AD 1200-1350 on the "classic" white slipped Vallejo Polychrome type, which also uniquely employs the use of blue paint (see Nos. 101, 102, 104).

The white slipped polychrome types, and their salmon slipped Filadelfia Ware copies, which are decorated with these major and minor themes are: Papagayo (Nos. 67, 68, 74, 79, 83), Jicote (Nos. 95, 98), Pataky (Nos. 85, 86, 91), Vallejo (No. 105), Tempisque (No. 99) and Banda, Bramadero, Casares, Granada, Madeira and Luna Polychromes. Most of these polychrome types also have a number of varieties which seem to indicate the presence of several centers of manufacture and local preferences for the style of one artist or potter over another.

There has long been a recognition by scholars of resemblances between the iconography of these white slipped polychromes (including their salmon slipped copies) and some of the religious symbolism of Postclassic Central Mexico.[18] The first appearance of this new iconography is on the Culebra variety of Papagayo Polychrome (Nos. 67, 68, 70, 71). This is the earliest white slipped pottery known and is found in the Isthmus of Rivas and at coastal sites in Guanacaste beginning at about AD 800. The theme on these vessels depicts a masked warrior wearing loincloth and feathered headdress. He stands holding a spear and facing the figure of a leaping jaguar, an animal complete with spotted pelt and ringed tail which identifies him as *Felis onca*, the largest of the American cats.[19]

As first suggested by Lothrop in 1926, this man/jaguar theme seems to be a rendition of the sky deity Mixcoatl who had great significance and time depth in the Central Mexican area. With his magical spear he defended his father, the sun, against his sisters and brothers, the stars. Figure 6 shows a depiction of the Mixcoatl myth as it appears on a Culebra vessel and as it is seen in the Mexican Codex Fejervary-Mayer. A later scholar, Melendez, felt that the painted vessels repre-

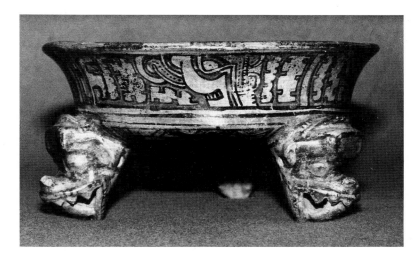

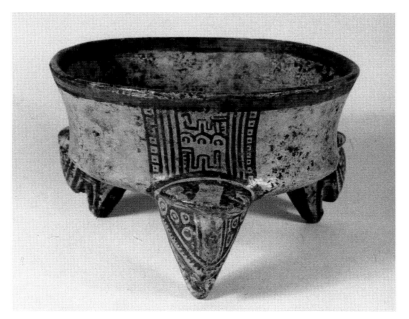

Fig. 7. Madeira Polychrome jar with stylized jaguar motif. Gillen Collection, Hacienda Tempisque, Guanacaste.

Fig. 8. Luna Polychrome tripod bowl with drawing of serpent motif. Gillen Collection, Hacienda Tempisque, Guanacaste.

sented instead Huitzilopochtli, the god considered to be the only purely Aztec deity.[20] This, however, seems unlikely as the Costa Rican vessels were painted with the theme as early as AD 800 and the image of Huitzilopochtli was not known even in the Valley of Mexico until the arrival there of the Aztecs at about AD 1200, almost four hundred years later. For about two hundred years this man/jaguar or jaguar was the only theme painted on the distinctive and new white polychrome pottery. It is as if a group of people arrived in the area carrying with them one major icon or cult symbol, which they continued to use to decorate their mortuary pottery over a long period of time. The cult clearly appears to have had strong connections with Mixcoatl, the ancient Mexican god of the hunt and of war, whom legend continually linked with Venus as the morning star and with a sacred battle against the forces of the night as symbolized by the jaguar.

This is the oldest and longest enduring theme painted on white slipped ceramics in Greater Nicoya. It certainly began by at least AD 800 and continued in one form or another until the time of the Spanish *entradas* in 1522.[21] It moved over time from realism to abstraction and was interpreted in various styles by the hands of different potters, but with careful examination the intent behind the depiction remains clear. Sometimes the complete theme was painted on a pot; at other times only parts of the design, such as the spear or separated

elements of the jaguar, were present. This suggests that the legend was well enough known that only one or two elements were necessary to indicate the whole story. A final standardized and very abstracted version of the theme appears on Madeira Polychrome vessels (Fig. 7). Here we see the entire jaguar myth reduced to a few curvilinear lines, representing the tail, teeth and crouch of the feline. Yet this one stylized icon was probably sufficient for communication purposes among groups sharing the same culture and ideology.

The second major theme to appear on white slipped pottery in the area was the plumed serpent theme (see Fig. 5b). Beginning about AD 1000 it is found on brightly painted Papagayo ovoid vessels in elite burials throughout Greater Nicoya. At first it was depicted in a realistic manner and looked much like the great plumed serpents known from the Toltec culture of Mexico. Soon, however, it too became abstracted as vessel forms and artistic styles changed. Like the standardized "shorthand" Madeira symbol of the jaguar, we can soon recognize the serpent by the use of step/fret bands alone or by an open jaw symbol with a stylized serpent eye (see No. 104). Again, only a part of the whole is needed to represent the entire icon.

The final form of the serpent theme appeared on Luna Ware Polychrome (Fig. 8) at the very end of the prehistoric period in Greater Nicoya. Luna Polychrome vessels form one of the most distinctive pottery types

ever made in the New World. They were completely different in style and appearance from the polychrome ceramics that preceded them in the area. The painting was done with such a fine brush and such delicate lines that from a distance the designs look as if they were incised on the vessels rather than painted. The overall impression is unlike anything else known in Costa Rican artistic traditions and seems to resemble most the painted and incised pottery from the site of Marajo Island in the Amazon Basin.[22] Yet in spite of this new and different technique of decoration, pottery forms and iconography remained the same. The shape of vessels did not change, and the plumed serpent, in its most abstracted form, still appeared on these white slipped vessels. Iconographic elements are often separated from one another but, once recognized, quite clearly represent the open jaw, oval eye, fangs and feathers of the plumed serpent (see Fig. 8). It is interesting to speculate that there was a late migration into the area by peoples from northern South America, or possibly the Caribbean, who brought with them their own style of painting pottery but adopted the iconography and religious symbolism of their new home in Greater Nicoya.

The third theme to appear on the various types and varieties of the white slipped polychromes was an effigy face with round "goggle eyes" reminiscent of the Tlaloc images of Central Mexico (Fig. 5c). Beginning circa AD 1200 the face was painted, or painted and modeled, on opposing sides of round and ovoid jars or on hemispherical bowls of the Pataky, Vallejo, Jicote and Luna Polychrome ceramic types. The facial features were stylized and repetitive and became increasingly standardized over time. Their major feature of artistic and cultural interest for the Greater Nicoya area is that the faces are decorated with depictions of gold jewelry painted in orange. These are in the forms of earspools, mouth and nosemasks, nose rings and necklaces (see Figs. 4 and 5c). The necklaces are most common. They usually have a bifurcated element suspended from them as a pendant. This painting of gold ornaments on ritual ceramics suggests the valued nature of gold itself and perhaps its special association with the deity or creature whose countenance is depicted on the vessels.

It should be noted that well before AD 1200 and the appearance of this theme, the knowledge of metallurgy and the technique of working gold had spread from northern South America into Panama, then Costa Rica and eventually north into Mexico.[23] Gold replaced jade as the most valued material, but sources of the metal were not common in Mexico and its painted depiction on pottery in Greater Nicoya strongly suggests it may have been an important element in contacts between that area and Mesoamerica. The precious metal may have passed in trade, via the Tempisque river valley in Guanacaste, from its sources in northern South America and Panama to Mesoamerican markets to the north. In this vein it is interesting to note that there were two symbols for gold in Postclassic Central Mexico. The one from the Valley of Mexico was a cross in several forms and the other, used in the Mixteca/Puebla area in the southern central highlands, was the out-turned feet of a gold frog.[24] This frog symbol and figures wearing gold necklaces with a round gold disc, a typical Lower Central American ornament, can be seen pictured in the Codex Nutall.[25] Both the cross and the frog symbol are prominent in Guanacaste iconography. The out-turned frog feet form the pendant often seen on the gold necklace of the effigy face theme and the cross symbol appears consistently as a decorative element on Pataky and Jicote Polychrome vessels of the period.

Cultural Contacts

There seems little doubt that there were continuing cultural contacts of various kinds between the Greater Nicoya area and Mesoamerican cultures to the north between about AD 500 and the arrival of the Spanish in 1522. Similarities between the two areas in such things as languages, religious beliefs, the Calendar Round, a periodic market system, games and deity names were all noticed and recorded by the first Spanish chroniclers.[26] At the time of the Spanish conquest, two major linguistic groups were reported by the early chroniclers as present in Greater Nicoya; these were Nahua and Oto-Mangue, both related to language groups in Central Mexico. With a few exceptions, the Mangue speakers or Chorotega were located in Guanacaste, and the Nahua speakers or Nicarao in Rivas. Both groups recognized their ethnic, linguistic and cultural affiliations with each other and with the peoples of Central Mexico. They explained the presence of their many cultural similarities by means of migration legends. The elements that make up these legends are repetitive and consistent and, though they may reflect many changes over the years and various postconquest elements, they must be accepted as seriously reflecting actual migrations that occurred in the history of these two groups.[27]

The legends relate that two distinct ethnic and linguistic groups, the Chorotega (Oto-Mangue speakers) and the Nicarao (Nahua speakers) were forced to leave their homeland in Central Mexico due to cruel treatment by the historic Olmecs. They settled first in separate areas of Soconusco in Chiapas but soon were again driven from their lands by persecution and began a long overland journey south and west. Various pockets of related Pipil language groups in Guatemala and El Salvador remained at the time of the Spanish Conquest to

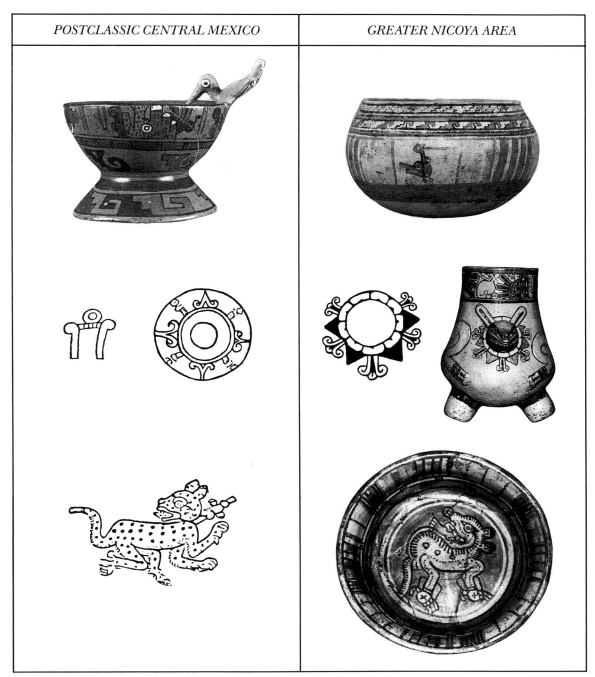

| POSTCLASSIC CENTRAL MEXICO | GREATER NICOYA AREA |

Fig. 9. Ceramic resemblances: Greater Nicoya area and Postclassic Central Mexico. Mexican designs after Ramsey, 1975. Costa Rican vessels from Gillen Collection, Hacienda Tempisque, Guanacaste.

document the path of this migration.[28] The Chorotega group arrived first in Nicaragua but were eventually pushed from Rivas by the arrival of the Nahua speaking Nicarao who had been promised in a prophecy that this fertile lakeshore area, in sight of the twin peaks of Ometepe Island, was to be theirs. The Chorotega were pushed south into Guanacaste by the warlike Nicarao, but in spite of their enmity neither group ever forgot their original ties and the earlier relationship with Mesoamerican cultures.

The ceramic sequence in Greater Nicoya clearly reflects this movement of peoples, but indicates that many migrations, rather than only one, probably took place over a long period of time. That an early migra-tion or contact may have been by sea is suggested by the quite sudden appearance of Central Mexican motifs on polychrome vessels at coastal sites and in the Isthmus of Rivas around AD 800. This occurrence is before there is any evidence of overland movements of Pipil groups in intervening areas and may reflect the fall of the great city of Teotihuacán in the Valley of Mexico.[29] This occurred at about AD 700 and resulted in wide dispersal of populations into other areas of Mesoamerica. Additional contacts by sea are suggested by the presence in Nicoya of pottery and copper artifacts which closely resemble the ceramic and metallurgy traditions of West Coast Mexico during the Aztatlan Horizon, AD 1100-1400.[30] Oceangoing craft capable of such long voyages

are documented by Columbus and by Oviedo, and it seems likely that the movement of peoples, goods and ideas by water had great time depth throughout Pre-Columbian America.[31] The overland route indicated by the Chorotega and Nicarao legends probably reflects later migrations which occurred as the aftermath of the fall of the Toltec Empire at about AD 1200.

There is clear evidence in Greater Nicoya ceramics of at least five points in time between AD 500 and AD 1522 when the polychrome pottery reflected cultural changes in the area; these changes strongly suggest the presence of external contacts. The first is documented on Galo Polychrome when Maya-like motifs replaced the earlier alligator imagery related to northern South America. The second is seen in the arrival of the white slipped ceramic tradition itself and its accompanying man/jaguar theme. Not only was this the first of the Central Mexican themes but it was the only image painted on the white slipped vessels from AD 800-1000. The third occurred at about AD 1000 when there was a proliferation of white slipped polychromes and the addition of two more major themes, first a plumed serpent and then the "goggle-eyed" effigy face. The fourth change is seen with the appearance of Vallejo Polychrome vessels. This pottery type was painted and incised with the three themes just mentioned but, as noted earlier, was also decorated for a short period of time with additional Mesoamerican iconography. Concrete depictions of such Central Mexican deities as Quetzalcoatl, Ehecatl, the Earth Monster and Hummingbirds are clearly recognizable, and there can be little doubt that direct contact between Postclassic Mexico and Greater Nicoya existed at this time.[32] The final major change occurred with Luna Polychrome which first made its appearance in the area at about AD 1350. As previously discussed, this unusual pottery exhibited changes in decorative style rather than in iconography and seems to suggest movements of people or ideas into the Nicoya region from northern South America just before the Spanish Conquest.

Polychromes and Iconography

In discussing Costa Rican Polychrome ceramics such as the ones in this exhibit and others found in museums and collections throughout the world, we must keep in mind that their primary function was as ritual pottery connected with burial practices. Their abundance, relative to other mortuary offerings, indicates that richly decorated vessels were the most important nonperishable items deposited in graves in the Greater Nicoya area from the time of their first appearance at about AD 500 until at least the time of the Spanish *entradas* in 1522.

There were undoubtedly many other forms of art in the area. Due to their unperishable nature, we have clear evidence of ceramics, metallurgy and stone carving, but other media such as textiles, wood and bone leave little trace in tropical regions. We are only aware of them from descriptions in the early Spanish chronicles or from artifacts associated with their manufacture found in archaeological contexts. For example, the presence of spindle whorls suggests textile production, and stone axes and adzes the working of wood. Ceramics, however, are almost indestructible; even if the whole vessel is broken, sherds remain to tell us about the original pot. As a result much of our knowledge and evidence of ancient peoples and past lifeways is based on ceramic studies.

As discussed earlier, the first polychrome ceramic tradition in Greater Nicoya was related iconographically to pottery of the southern Maya periphery. However, by the time it was filtered through provincial Maya areas into Rivas and Guanacaste, much of its direct relationship with Classic Maya imagery was lost. The symbols are recognizable in such forms as a jaguar with a bifurcated tongue, a seated dignitary and the mat pattern, but the meaning behind the symbols no longer had any clear association with specific Maya myths and deities. Such is not the case with the later white slipped ceramics. With the arrival of this tradition in Greater Nicoya we find pottery surfaces specially prepared in a manner that can only be compared to the codices and wall murals of Mesoamerica. Their thick, white base coat must be visualized as being used for purposes of communication in the same way as the pages of a book or the flat planes of a stuccoed wall. This relationship can not be viewed as accidental—the intent of the artist in all cases was to decorate visual surfaces with brightly painted, mutually intelligible iconography.

On the white pottery, in contrast with the earlier tan slipped vessels, we can identify iconography as specifically related to religious imagery and myths of Central Mexico (see Fig. 9). However, unlike the extensive pantheon of Postclassic Mexico, the deities and symbols depicted are limited in number. It is as if only a few specific cults or religious images, perhaps connected with particular groups of people, were carried into the region from the north. The diversity and complexity of the ever blending and changing religious cults of Mexico were not reflected in Greater Nicoya. Nevertheless, we clearly see at least three major deities and their associated symbolic elements which have long continuity in the area. While much of the similar iconography probably reflects the dispersal and migrations to the south of related groups of people after the fall of Teotihuacán and Tula, we must recognize the oversimplification of

such a viewpoint for this Lower Central American area of Costa Rica. Numerous other possibilities for cultural contacts must also have existed. For example the presence of limited Central Mexican icons in Greater Nicoya may be a result of contact with only limited types of groups such as warriors, merchants or guilds who may have introduced into Nicoya only their own cult images. We might also consider that over time other deities were forgotten or became unimportant to people who lived in a different environment far from the source of the ideology. There might also have been a conservative and selective acceptance of new deities by indigenous populations already living in the area, which forced the abandonment of certain religious icons or gods that were unacceptable to them.

Whatever cause or causes underlie the presence of Mesoamerican iconography in Greater Nicoya, it is clear that it did exist and that it was primarily associated with the elaborate tradition of polychrome pottery. No other region of Costa Rica produced a similar ceramic tradition and no other region exhibited the same strong iconographic relationship with Mesoamerica. In the Greater Nicoya area it is inescapable that fine polychrome vessels and ritual imagery were inseparable. Furthermore, it seems clear that polychrome ceramics were used during these last one thousand years of the prehistoric period to depict religious iconography. The brightly painted vessels carried ritual information associated with the rites of passage at the time of death and served as a means of communication among people who shared the same cultural values.

1. Norweb 1964
2. Baudez 1967; Baudez and Coe 1962; Lange 1971; Sweeney 1975; Healy 1980.
3. Day 1984
4. Linnares 1977, Ferrero 1977.
5. See respectively: Willey 1971, Meggers 1966, Bray 1984, Cooke 1976 and Zucchi 1972.
6. See respectively: Bell 1974, Santley, personal communication 1983, Kubler 1975 and Covarrubias 1971.
7. Coe 1984 and Reichel-Dolmatoff 1965.
8. Day 1984.
9. Paulsen 1977, Viel 1978, Hoopes 1980 and Robinson 1978.
10. Ryder 1980.
11. Day 1984.
12. Stone and Balser 1965; Coe and Baudez 1961.
13. Bransford 1887.
14. Day 1982.
15. Day 1983.
16. Bishop 1985.
17. For a discussion of this see Coe 1973.
18. Lothrop 1926, Stone 1975, Nicholson 1982.
19. Leopold 1972.
20. Melendez 1968.
21. Accola 1978.
22. Meggers and Evans 1957.
23. Bray 1984.
24. See Pasztory 1983:85.
25. 1975 Edition: 47,76,7.
26. Oviedo 1945, 1976; Leon-Portilla 1972.
27. See Abel-Vidor 1980.
28. See Fowler 1981.
29. Fowler, op. cit.
30. Ekholm 1942; Day 1984.
31. For a discussion of this see Edwards 1965.
32. Stone 1982.

Overleaf: No. 132. *Tripod Bowl*, La Selva A or Curridabat A Phase (?), Africa Tripod Group.

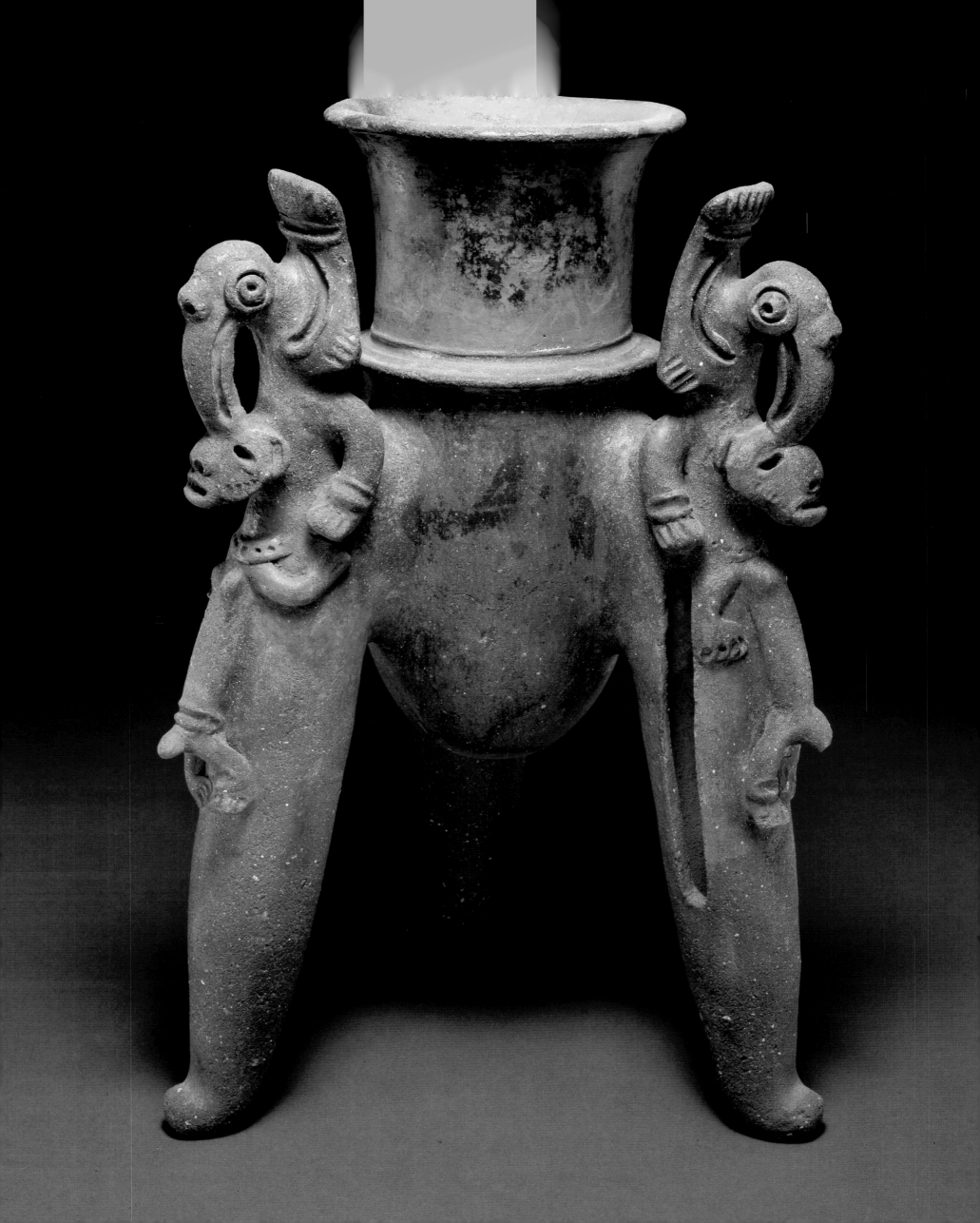

Introduction to the Sackler Collection

by PAUL A. CLIFFORD

POTTERY MAKING is a measure of man's cultural development and of his skills. Nothing produced by man is more durable over time. Sherds persist even when the whole vessel is broken. The ceramic surface becomes a canvas on which man records his myths, religious beliefs, concepts of beauty, and, in some instances, his written language. Shapes reflect his needs, habits or interests in the natural surroundings in which he lives. Often a vessel reflects his concept of animals, birds, and sea life. When he chooses to depict himself, vessels can be our only record of his dress and ornamentation. This catalogue and the exhibition with which it is associated is concerned with the pottery of Costa Rica. It records the imaging of content peculiar to Costa Rican potters before the Spanish arrived in the New World.

Ancient man entered the New World between twenty and fifty thousand years ago.[1] Small groups or families of early hunters, following herds of animals, arrived during the Wisconsin interglacial period when huge glaciers, by absorbing water, lowered the normal level of the sea so that the Bering Strait became a solid land bridge from Asia to Alaska. The earliest worked their way down the east side of the Rocky Mountains, and spreading eastward crossed the North American continent. Some continued through the area of present day Mexico where the earliest remains of men have been found in the central highlands. Texpexpan man from the northeastern shores of Lake Texcoco has been roughly dated to eight thousand BC.

Evidence indicates that ancient man reached the tip of South America about ten thousand BC. Since mountain systems and swamps in lower Mesoamerica inhibited overland travel, he probably worked his way south along the littoral. But because of physical and climatic extremes practically nothing remains to inform us of his early passage through this area. Continued excavation may in time provide more information.

The first Americans lived at a Paleolithic level. They brought little to the New World other than their skills at working stone to produce tools and weapons and knowledge of the use of fire. They dressed in skins and furs and lived in caves or shelters. As hunter-gatherers, they probably moved and lived as family groups. They must

also have believed in a life after death since they felt the need to provide their deceased with gifts of food, raiment, tools and weapons which remain and inform us of their material culture.

The beginning of early man's development of a true civilization is signaled by his reliance on agriculture. Cultural development in the New World begins somewhat later than that of the Old World but the major difference is one of emphasis. In the Old World the domestication of animals was of equal importance to that of agriculture and domesticated animals included, among others, the horse, cow, pig, elephant, and camel. The New World only had the dog, probably brought by man from Asia, the guinea pig and, in the Andes of South America, the cameloid, i.e., the alpaca and the llama. Essentially then, ancient American man was without animals to carry him in hunting over long distances.

The most important Mesoamerican domesticated plant was corn, or maize, which became the staple food of the New World, as wheat was of the Old. Years of tracing its development demonstrates that corn as we know it today derived from the hybridization of two wild grasses. The original area of development was probably Mexico. There may have been a second developmental area in northern South America. George W. Beadle has suggested that the earliest known cultivated corn, which appears in the Tehuacan Valley of Mexico about six thousand to five thousand BC, shows a level of genetic modification which can only be understood in terms of at least one thousand to two thousand years of prior development under primitive cultivation.[2] Standardization of elaborate agricultural practices and genetic modification of key plants were gradual processes which required much prior development to support a formative level of culture. An excavation at the site called La Montaña in Costa Rica finally yielded a carbonized maize cob inside a tripod from a culture phase which supposedly existed during Periods IV/V, AD 400-700.[3] This does not indicate that maize was introduced into Costa Rica at such a late date, but that the nature of the environment did not allow evidence of its use to survive.

Anthropologists generally agree that civilization, in the usual sense of the term, cannot appear until a truly

productive agricultural system has been developed. Fieldwork over the last decade has focused on the origins of agriculture as complex systems. The most complete record of early planting in the New World comes from the coast of Peru where the arid climate preserved evidence of cultivated plants. Now it is also apparent that the important cultivated plants did not originate there but were brought from elsewhere. By twenty-three hundred BC the major domesticated plants in addition to the avocado, chili pepper, squash, and bean, included amaranth, pumpkins, bottle gourds, and a variety of beans. Early man's diet included an increasing number of cultigens and decreasing utilization of wild foodstuffs. By fifteen-hundred BC trade must have been an important factor in the transmittal of certain cultigens from one area to another.

Also by fifteen hundred BC, farming communities were common in most areas. The necessity of remaining in a given area changed early man's lifestyle from that of a nomadic hunter-gatherer to a member of a village community. His subsequent ability to produce more than he needed daily allowed him increased freedom to develop new crops and storage techniques. Concentrating on the development and hybridization of crops he far outstripped Old World man in agricultural skills. In the Andean area some twenty-seven fruits and vegetables were domesticated, grown, and improved.

Since early man in America was without a draft animal to pull a plow, rather than making use of the richly fertile grasslands for agriculture, major agricultural development was restricted to such areas as desert river valleys, high intermontane basins and plateau areas, and jungles and littorals where vegetation was thin enough so that the soil could be turned using hand tools. Throughout man's prehistory in the New World the richly sodden grasslands could support only hunter-gatherers. The most advanced culture groups thrived in those physically difficult areas, which required the work of many people involved as communities, and the development of agriculture led to the evolution of a more sophisticated existence.

CONTRAST BETWEEN NEW AND OLD WORLD CULTURES

Origins of New World culture, so far as Old World contrast and stimuli are concerned, are still a matter of debate and conjecture. Although it is generally felt that New World cultural development is indigenous, occasional transpacific contacts cannot be ruled out. Nevertheless, the influence of such contacts appears to be minimal. Certain puzzles remain to be solved. In general, agricultural products of the New World are unique to its hemisphere and include a long list of fruits, among

them the avocado and vegetables such as white and yellow potatoes. Yet sweet potatoes and gourds are found both in the New World and the Old. Cotton, which exists in both, poses special problems. Old World cotton has thirteen large chromosomes; New World cotton has thirteen small chromosomes. Yet cotton domesticated in early Pre-Columbian times in coastal Peru contains both thirteen large and thirteen small chromosomes.[4]

Other similarities between Old World and New World cultures which remain unexplained include the appearance in the Andean area, during the first millennium BC, of an advanced technological knowledge of metalworking, such as lost wax casting and gilding, which, in the present state of our knowledge, has no antecedents. Pottery decoration in Ecuador was considered similar to that of the Jomon culture in Japan. Bark cloth, found in Peru around two thousand BC, is also known in the Old World. Techniques such as the tie-dye method of producing designs on cloth are found in many areas of the world. So too is the use of weapons and instruments, such as star-shaped mace heads, blow guns, and pan pipes. Pottery house models and headrests occur both in the New World and the Orient.

There is also a similarity between New and Old World art motifs. For instance, the tiger of the Zhou dynasty in China is comparable to the feline motif of Chavin culture in the northern highlands of Peru, both appearing about the first millennium BC.[5] Pertinent to Costa Rica are the tall tripod vessels, such as Numbers 1 and 132. The tripod vessel is found throughout South America and Mesoamerica, assumed to have appeared earliest in Ecuador. The use of similarly shaped vessels in China, at first in clay in the Neolithic period and later in bronze, is an interesting earlier parallel.

MAKING OF PRE-COLUMBIAN POTTERY

One of man's most important inventions, the wheel, was not known in its true use in transportation and pottery making in the New World until the arrival of the Spanish. Another important element in the production of pottery is glaze, a high fired glass-like coating used on ceramics to render them watertight and which also was used for decoration. Although well known in antiquity in the Old World, this important adjunct to the potter's art was not known in, or introduced into, the New World until the arrival of the Spanish.

Since the potter's wheel which had been used throughout the Old World from earliest times was unknown in the New, New World potters employed other methods which, although slower, produced pottery which rivaled that made elsewhere on the wheel. With the coiling process, coils of clay were built up in

spirals to form the vessel shape. The outside and inside of each vessel was then scraped and smoothed to make the coil joints invisible. Using this technique an amazing symmetry could be achieved even on very large vessels. Pastillage and appliqué techniques were similar to coiling: rolls and pieces of clay were pressed onto vessel surfaces as decoration or to enhance the sculptural quality, as illustrated by Number 149, a very large tripod vessel with an appliqué alligator on one side and a large face on the other. Coiling is still used in pottery making in remote areas of the Americas.

In block modeling and slab building the potter began either with a block of clay to which he gave the desired shape by hollowing out and thinning the block or he flattened a slab of clay into a rectangular shape and then bent it into a circle and joined it. To this he added a bottom and the result was a flat-bottomed round-sided vessel. The earliest utility vessels were probably made by this method.

Direct modeling was done by manipulating clay by hand into expressive forms such as figurines or effigy vessels (Nos. 142 a-g and 20). Although Costa Rican pottery is not noted for its great sculptural qualities the results can be striking, as in Number 33, an armadillo, or simply whimsical and Disney-like, as illustrated by Number 126, Santa Clara figurines. While molds were an important adjunct to pottery production in South America and to a lesser degree in Mexico, Guatemala, and Honduras, only a few figurines were made by this method in Costa Rica. This is rather surprising when one considers the outside influences entering Costa Rica both from the north and from across the Isthmus of Panama from South America.

Since glazes were unknown in the New World before the arrival of the Spaniards, decoration and surface finishes had to be achieved by other means. The earliest pottery in South America was monochrome, possibly because of difficulties in obtaining a fired surface light enough to properly take a colored slip. As far as we know Pre-Columbian pottery was fired by placing vessels, separated by potsherds, in bonfires or open pits. Such pottery, made under other than controlled conditions, was a low-fired ware (500-800°C) all the more amazing for the heights of refinement of shape and design achieved. There is some evidence however for what may have been circular pottery kilns in Costa Rica.[6]

Decoration was confined to manipulating the surface finish by burnishing some areas while leaving others matte or by incising, engraving, and appliqué. Early vessels in Costa Rica's Guanacaste-Nicoya zone manifest the latter techniques with the addition of some use of colored slips, as in the Bocana Incised Bichrome, Toya variety vessel (No. 4) and the Rosales Zoned Engraved vessel (No. 5). Incising and appliqué are also illustrated in Guinea Incised ceramics (No. 16). Incising and engraving continued to be an important method of enhancement on such monochromes as Huerta Incised/Engraved or Castillo Incised/Engraved Chocolate Ware ceramics (No. 110). Appliqué is the hallmark of certain wares such as Potosi Appliqué (No. 32) with its bands of bosses simulating alligator scutes. In the Central Highlands/Atlantic Watershed zone most pottery is either monochrome or bichrome. Incising and appliqué are very important decorative techniques as illustrated by the El Bosque phase Red on Buff ceramic group (see No. 120). Modeling also was important in this zone and can be quite spectacular. The pot stand with four Atlantean figures and a ring of sea birds as a pot holder, Number 127, is a striking example of Costa Rican image modeling in the Central Highlands. Tripods in this area usually have long rattle legs either in fully modeled form, as in Number 131, or decorated with complex figures or animals appliquéd on the upper area of the legs, as in Number 132.

Modeling vessels into specific effigy forms was in most instances less than sculptural. There seems to have been little interest in individualization of human or animal effigies. The shape of the vessel itself dictated the final result. For example, large barrel-shaped jars seem to have had a head/neck set directly on the shoulders while three legs were attached to the base, two to the front and one to the back. Other features such as the arms and face were minimally modeled. The potter relied heavily on slip painting to enhance features and ornamentation (see No. 25). A favorite vessel shape in the Guanacaste-Nicoya zone was inspired by the jícara, or pear-shaped gourd. As Samuel K. Lothrop has said, "A clearer picture than it is possible to give would doubtless show that nearly all the forms of the ceramic remains of this region originated in utilitarian objects, such as gourds and other natural receptacles of the country."[7] The adaptation of the jícara shape to that of a jaguar effigy is illustrated in Number 86. A jaguar head is attached to the front of the vessel. The vessel's tripod legs indicate the hind legs and tail of the animal. Its forelegs are placed on the upper body of the vessel. Perhaps the most realistic objects are large ceramic trophy heads from the Atlantic Watershed (Nos. 145-148).

Other methods of surface decoration included combing, shell stamping, rocker stamping, and multi-stripe painting. Engraved lines were often filled with a white or red paste for emphasis or contrast (Nos. 108-118). Designs were also painted on a vessel using clay slip, a watered-down version of the potting clay. By adding minerals or other material to the clay slip a number of colors could be obtained.

The Guanacaste-Nicoya zone is known for its polychrome ceramics that probably resulted from influences which travelled south out of the Mexico/Maya area. Brilliant surface painting, more common in this area of the country, is impressive. The ground color varies from an almost dead white through cream to salmon slip. Black, red and orange paint was applied over it. Other colors used were brown, gray, purple, and a blue-gray somewhat reminiscent of Maya blue. The last appears late in Period VI (see No. 101). The black was used for outline and other colors mainly for filling in the pattern. After firing, the vessel was given a finishing coat composed of wax or vegetal material such as resin or copal. This method is still employed in production of present day Indian pottery in areas from the southwest United States to Peru. While most of this coating disappeared during the time in which a vessel had been buried, traces of it are still discernible on some vessels. Burnishing was accomplished using a smooth pebble or piece of gourd. Modeled detail when added was painted as part of the whole. Such additions consisted of heads, usually in the round, and arms, legs, tails, etc., in low relief.

Resist decoration, a method of pottery design used throughout the Americas, was also used in Costa Rica. An organic material, such as honey or resin, was applied to some areas of the surface of an unfired vessel while leaving other areas unprotected or uncovered. The wax-like material "resisted" the heat of the fire and prevented the dark slip, placed over parts of the design, from penetrating to the vessel surface. The "resist" areas were thus distinguished from others exposed to the heat of the fire. After firing, the wax-like substance was cleaned off and the once-covered surface stands out because it lacks the color of the clay covered with slip or exposed to the heat of the fire (No. 140).

GEOGRAPHY AND CLIMATE

The geography of Costa Rica is closely bound to both that of Nicaragua to the north and Panama to the southeast. Lower Central America narrows until it reaches the Isthmus of Panama where it swings sharply east on its journey to Colombia in South America. The formation of Costa Rica is comparatively recent and near the Pacific coast has been changed by the uplift of a great line of volcanoes. The great Nicaraguan lakes, Managua and Nicaragua, have been formed against the older mountains of the Continental Divide which continue south through Costa Rica. In Costa Rica, the great chain of volcanoes swings eastward coming closer to the Atlantic coast as it nears the border of Panama.

Between the range of volcanoes and the Pacific coast lies the Guanacaste-Nicoya region. The northern part of Guanacaste tilts south toward the Gulf of Nicoya, on the Pacific side of which is the Nicoya Peninsula. A number of islands exist in the gulf. The northern peninsula is composed mainly of rolling hills and valleys while the southern part is mountainous. Along the Nicoya Peninsula's Pacific coast are several bays, the best known of which is the nearly landlocked Culebra Bay. Across the gulf, behind the swampy mainland belt, mountains intersected by long valleys rise abruptly.

Central Costa Rica is a high tableland. Here are the important valleys of San José, Cartago, and Alajuela. The central valleys enjoy a temperate climate and a fertile soil. To the east various streams descend from the edge of the plateau and cut deep valleys before emerging on the broad plains which form the Atlantic coast.

Southern Costa Rica is extremely mountainous with both the Cordilleros and the Continental Divide together turning southward to the Panamanian border. Both coasts of southern Costa Rica have narrow coastal plains. On the Pacific side is the Osa Peninsula, separated from the mainland by Golfo Dulce.

Compressed into Costa Rica's very small space are a variety of climates. The Pacific and Atlantic coastal plains are both subjected to hot tropical temperatures. While the Pacific side has a decidedly dry season, the Atlantic slopes which face the Caribbean receive heavy rainfall much of the year. The high intermontane plateau has generally temperate and pleasant climate.[8]

CLASSIFICATION AND CHRONOLOGY

To a great extent, geography created natural boundaries in Costa Rica which in turn influenced local cultural growth and at the same time directed the flow of external influence in the country. One natural boundary is formed by the chain of volcanoes descending from Nicaragua. The area between this chain and the Pacific also sets apart the archaeological zone which has been labeled Guanacaste-Nicoya. The central highlands and the area east to the Atlantic form a second geographical as well as archaeological zone referred to as Central Highlands/Atlantic Watershed. The southern part of Costa Rica to the Panamanian border is the third geographical area and is called the Diquis archaeological zone. Where this zone extends into Panama it is called Chiriquí.

While each of the three archaeological zones developed autonomously, especially during Costa Rica's formative period, scientific excavations have demonstrated that during later periods there must have been considerable trade. Characteristic vessels from one area are found in graves in another, just as objects of gold and pottery, probably produced in Panama, have been found in graves in the Guanacaste-Nicoya zone.

Iconography must have spread from one archaeo-

logical zone to the other. The alligator/crocodile which was an extremely important cult figure in southern Central America and the northern areas of South America is found in early periods in the Guanacaste-Nicoya zone and later in the Central Highlands/Atlantic Watershed zone. The iconography is so highly stylized that during its spread it must have been independently interpreted in each area to comply with local religious or mythological demands. Both Doris Stone and Jane Day in their essays in this catalogue elaborate further on external influences on iconography and their means of transmission.

In the course of modern archaeological research in Costa Rica, certain identified culture areas have at various times been known by different names, and the chronology proposed for them has undergone, and is still undergoing, repeated revision. All ceramic style phases have a relative chronology within a limited geographic area. The chronology is essentially based on the knowledge that one particular phase preceded or followed another. Absolute dating, where there is no written language, is obviously problematic. Science has come to our aid with tests, such as carbon-14 and, more lately, thermoluminescence analysis of clay samples, which help to support or clarify present information.[9] It is interesting to note that proper excavation and research have pushed backward in time dates which were considered to be quite recent thirty years ago.

Over half of the Costa Rican ceramics in this catalogue have had clay samples taken from them for thermoluminescence analysis which, although unable to provide specific dating, is an absolute dating technique and does provide the confidence that one is dealing with a vessel from antiquity when provenience, through excavation, cannot be verified. Another technique recently applied to Costa Rican ceramics is trace element analysis by means of neutron activation of clay bodies.[10] Trace element analysis is not, however, a dating technique although there is some speculation that the ultimate refinement of this method may lead to such a conclusion. Such trace element analyses already have been done on the Chinese bronze vessels in the Arthur M. Sackler Collections and is programmed for the Sackler Collection of Italian majolica. For the Chinese bronzes, trace element analysis is being utilized to investigate the correspondence between production centers and composition, and changes in alloy composition with time. It will be used to associate the Italian majolica with specific centers of manufacture whose "fingerprints" have already been or are being determined. The trace elements within the clay provide a "fingerprint," so to speak, of the clay in a specific manufacturing locale. Eventually, when the clays of various locales all have

been analyzed, unprovenienced vessels, when similarly analyzed, may also be associated with specific areas. Clay and ceramics from the Guanacaste-Nicoya area of Costa Rica are being characterized by neutron activation analysis. Results of such trace element analyses have already been obtained for Tempisque River Valley ceramics and those from the Isthmus of Rivas in southwestern Nicaragua. Trace element analysis of the Sackler Collection of Costa Rican ceramics, although originally planned, was not possible to effect because reactor time was not available. It might have allowed however a more secure type designation and assignment to production centers.

The style or type designations of the Costa Rican ceramics in this collection have been assigned after consultation with Doris Stone and Dr. Jane Day.[11] The chronology corresponds to the latest consensus for such attributions. Beginning with the monumental work published in 1926 by Samuel K. Lothrop, certain divisions of the polychrome ceramics of the Guanacaste-Nicoya zone were postulated.[12] Other ceramic styles were categorized by type of surface treatment, design and shape, for example monochrome wares or tripod vessels. The three archaeological zones were named after principal "chiefdoms" active in historic times. Culture groups in the Guanacaste-Nicoya zone were labeled *Chorotega*; in the Atlantic Watershed, *Huetar*; and on the Costa Rican-Panamanian border, *Diquis*. While the three archaeological zones remain the same, the old cultural names of *Chorotega* and *Huetar* have been abandoned. We still refer however to the Diquis zone on the Costa Rican-Panamanian border.

Now, as a result of more in-depth research in Costa Rica itself, new interpretations are being arrived at based on evidence from controlled archaeological digs, the study of large collections of previously excavated material, and shared information. Costa Rican prehistory is constantly being pushed back in time. Some gaps have been filled in and there has been a further refinement of pottery identification begun so brilliantly by Lothrop. Since we do not know the names of the ancient people in Costa Rica, culture names are not used when referring to pottery types. Descriptive names for pottery types are used instead, with some incorporating the name of the site where the type was originally found or excavated. For the Guanacaste-Nicoya zone, at least, archaeologists and art historians adhere to a type/variety system. Types and their varieties must be of the same ware. For the Sackler Collection, we have followed the type/variety taxonomy for the Guanacaste-Nicoya zone ceramics. The designations for the Central Highlands/Atlantic Watershed zone follow the phase and group designations used by Michael Snarskis who has concentrated his excavations and research in this area. Only

two types of Diquis zone ceramics are included in this collection and their current designations are followed.

The time-space framework used in this catalogue is based on the periodization established for Central America at the School of American Research Advanced Seminar on Central American Archaeology held in Santa Fe, New Mexico, in April 1980. Organized by Doris Stone of Harvard and Tulane, who served as President of the Board of Directors of the Museo Nacionál de Costa Rica from 1949 to 1967, and Frederick Lange, presently Professor of Anthropology at the University of Colorado, but at that time Professor of Anthropology at Illinois State University, the seminar produced a six-part periodization for all of Central America—Period I (?-8000 BC), Period II (8000-4000 BC), Period III (4000-1000 BC), Period IV (1000 BC-AD 500), Period V (AD 500-1000), and Period VI (AD 1000-1550)—divisions which correspond approximately to cultural thresholds important throughout the New World.[13]

The Arthur M. Sackler Collection includes examples of most of the ceramic styles (types or groups) from the three archaeological zones of Costa Rica. While this catalogue and its associated exhibition is concerned primarily with pottery, a few examples of stonework are included. The peoples of Costa Rica were skilled in the working of stone and metal as well as ceramics. Perishable craft products can only be surmised. Stonework included ceremonial metates (Nos. 183-186), or seats, large and small figures carved as trophy headhunters holding hand axes (No. 187), and trophy heads, nearly life-size, as well as tools and weapons (No. 188). Perhaps best known are the magnificent pendants or axe gods, many carved in jade, although they are not represented in the Sackler Collection. Large stone spheres whose use is still unknown were common in the Diquis zone and one such sphere is in the Sackler Collection at the Museum of the American Indian in New York.

The catalogue and the exhibition do not include any metalwork. It should be noted however that around the sixth century AD metallurgical techniques were introduced into Costa Rica from Colombia and Panama. It seems certain that metallurgy had its beginnings in northern Andean highlands. In Colombia, ancient cultures were noted for their work in gold with lost wax casting. This continued to be the favorite method of gold working in the Isthmus of Panama although some hammered gold ornaments are known.

Although pottery in Costa Rica probably appeared as early as Period III, present knowledge of ceramic sequences begins in Period IV. Society in Costa Rica never reached the high level of culture which appeared in other areas of the New World such as Peru, Mexico, and Guatemala. Most Costa Rican indigenous groups

formed what anthropologists call "chiefdoms" as opposed to "kingdoms." Their "chiefdoms," which may have been made up of several thousand people, were organized around a centralized hereditary hierarchy with a theocratic orientation. Pre-Columbian Costa Rica lacked rigid social stratification as well as institutional means of forceful repression which are the products of civil law in a formal political state.[14] Crafts were important and well developed but monumental architecture, e.g., stone palaces and temples, was lacking, since social and political development was limited.

GUANACASTE-NICOYA ZONE

The western section of Costa Rica which includes the long coastal plain extending into Nicaragua and the Nicoya Peninsula and which forms the Guanacaste-Nicoya archaeological zone is drier than the rest of the country. Nevertheless early settlement occurred in the many small bays along the coasts here because of the rich harvest of sea foods available to early man from both fresh- and saltwater environments. The area has been especially well studied and is noted for its beautiful polychrome ceramics. It is part of what is called the Greater Nicoya Archaeological Subarea which includes southwestern Nicaragua.

Period IV (1000 BC-AD 500)

The earliest object from the Guanacaste-Nicoya zone in the exhibition was considered to be a large tripod of so-called Santiago Appliqué Zoned Bichrome type whose date is given as 800-300 BC (No. 1). Its body is a well burnished black, while the long unburnished legs topped with small birds are left matte. Thermoluminescence analysis of clay samples from this vessel indicates that the samples tested were last fired, at the very earliest, only seven hundred years ago. This late dating calls into question either the attribution itself or the dates assigned to Santiago Appliqué Zoned Bichrome ceramics. Only a few tripods of this type were found in the Guanacaste-Nicoya zone. The distinctive Nicoya shape is a semi-hemispherical bowl with inward curving shoulders surmounted by a chimney-like neck which sometimes assumes the exaggerated shape seen here.[15] Tripod vessels were often soot-covered, and the legs may have been made long so the vessel could be placed over a fire although there is no indication of such use on this vessel.[16] So-called "chocolate" pots from the Central Highlands/Atlantic Watershed zone are tripod vessels believed to have been used to heat over a fire a chocolate drink prepared from the cacao bean.[17]

Another ceramic type dated 500-100 BC, is Bocana Zoned Incised Bichrome, Toya variety. Numbers 2 and 3 are large vessels of the type with incised lines

in association with red slip painted in zones over the upper body. The vessels purportedly came from Zapatero Island in Lake Nicaragua. The large size of such vessels must have presented firing problems for potters using open bonfires rather than kilns. Although TL analysis of Number 2 did not allow age calculation, probably because the sample provided more sandy temper than clay, Number 3 did provide a range for dating the last firing between twelve hundred and seventy and two thousand and ninety years ago, indicating an earliest date of circa 106 BC (see Appendix C).

During the last half of Period IV (300 BC-AD 500), ceramics referred to as Rosales Zoned Engraved were produced in the Guanacaste-Nicoya zone. Charming figures, such as a peccary (No. 5), exhibit a masterly ability to model form. Much of the charm also comes from the carefully incised figural design, a bird in this case, and body features which were filled with black pigment. Number 6 is a modeled monkey with the tail forming a spout connected to the head with a bridge handle. A whistling jar with a bridge handle and spout, it links with nearly identical vessels in the Chorrera culture, Ecuador. Effigy vessels of this style are among the most distinguished sculptured forms in Costa Rica, an example is Number 7.

During the latter part of Period IV (circa AD 200-500), Guinea Incised, another pottery type which developed in the Guanacaste-Nicoya zone, had analogues in the Atlantic Watershed and seems to be part of the southern and eastern Central American tradition of plastic decoration. The exhibition features both whistles and bowls, modeled in human, animal and bird forms, with an orange-brown waxy slip. Number 12 is a figure modeled as a woman with child. Figures such as this and the intricately formed bowls with human figures arrayed as bats (Nos. 15 and 16) are notable for the careful incising of geometric designs and elaborate appliqué which in Number 16 shows the human figure costumed as a bat. Realism of form has given way to symbolic content.

Symbolic content is of major importance in pottery representations. Tola Trichrome vessels of Period IV (circa AD 200-500) very frequently portray humans costumed as animals such as alligators and bats. These may be effigy jars, as Number 20, or rounded tripod vessels with superimposed modeled faces and the conventionalized black and white lines related to the animal costume (Nos. 21, 22). A Carrillo Polychrome bowl, Number 23, oval in shape, simulates the spread wings of the bat which stretch on either side from a modeled figure wearing a bat costume. The wings and the walls of the vessel are painted with alligator motifs. The tradition of cayman or alligator imagery had great time depth in all

Costa Rica and begins early, possibly circa fifteen hundred BC in the Amazon and Andean cultures of South America.

Period V (circa AD 500-1000) marks the beginning of the highly regarded polychrome tradition in this region. What ushered in this new tradition is still uncertain. Changes in pottery production do not necessarily mean an influx of new people but rather the arrival of new ideas which are borrowed. Such new ideas, possibly from the south, seem to have influenced pottery production not only in this region but also in the Central Highlands/Atlantic Watershed. Some characteristics seem to be associated with styles in Ecuador.[18]

Carrillo Polychrome in Period V is a variant of Tola Trichrome and graduates into what is called Galo Polychrome. Number 24a is an interesting example of the type. The large bowl, painted and modeled on one side in the form of a face, rests on legs with appliquéd faces attached to a ring base. Painted around the sides are alligator motifs. Number 25 is another example in the collection which illustrates the type. It is well modeled and highly burnished. The red, black, and orange colors in the designs are brilliant. The Carrillo polychromes are part of the tradition of tan slip, hard-fired, highly polished polychromes which Jane Day calls Guanacaste Ware. Motifs derived from the alligator and bat are still popular during Period V, but on Carrillo polychromes the motifs are abstracted symbols rather than realistically depicted creatures. Earlier bichromes, trichromes, and incised vessels of the Guanacaste-Nicoya zone depicted alligators or deities with alligator masks and attributes. On Carrillo polychromes geometric motifs which symbolize the alligator are constantly repeated.

Galo Polychrome (circa AD 500-800) may well be the finest pottery produced in the Guanacaste-Nicoya zone. The potting and firing was well controlled. Colors are brilliant and the surfaces are burnished mirror bright. Bowls and effigy figures were produced. Number 26 presents an interesting combination of geometric designs engraved in the surface and a painted neck band of alligator motifs. Number 29 closely resembles in style the Ulúa Polychromes of western Honduras. The stylized jaguar on it is similar to the treatment of animal and bird forms in that area.[19] Number 30 demonstrates the Costa Rican potter's ability to blend plastic decoration with the painted design of a monkey. Guilloche (a pattern of interwoven snakes) and mat patterns associated with Mayan iconography also appear as decorative devices.

Incised monochrome, chocolate-slipped ceramics, which appear in Period V (circa AD 500-800), have been called Huerta Incised/Engraved. Bowls and jars are often modeled to represent anthropomorphic figures,

as in Number 110, an alligator effigy with the details of body and hide markings both incised and pecked. The head vessel in Number 111 illustrates an intricate incising on the neck of the vessel. White pigment was sometimes rubbed into the incising. We have assigned such monochrome, incised/engraved ceramics to the Castillo Incised/Engraved type based on comparisons with similarly designated ceramics from other collections and on interpretations of thermoluminescence analysis from clay samples of such vessels in the Sackler Collection.

A very different style of potting during Period V is that of the Potosí Appliqué. Vessels of this type are often in two parts and are assumed to have been incense burners. Most have the lower sections in the form of hemispherical footed bowls which are topped by a fitted dome lid with a short chimney surmounted by a modeled conventionalized alligator, or other creature, as a crest. A diagnostic element of this type is the belt of raised bosses resembling alligator scutes. Often the vessels are left in the natural clay color resulting from the use of a resist technique, or white pigment is painted on the appliqué bands. Number 32 exhibits a combination of natural clay color and burnished red slip. The crest is modeled as an iguana.

With the advent of polychromes in Late Period V and Period VI (circa AD 700-1550) the iconography employed in their decoration becomes very complex. Major themes continue to be man, man and jaguar, alligator, plumed serpent of Mexican influence, and, to a lesser degree, the monkey, crab, and scorpion. The use of the plumed serpent and certain symbols such as the *kan* cross of Mayan inspiration illustrates the strong influences in Guanacaste-Nicoya from both the Mexican and Mayan areas. As the period progresses each motif becomes altered so that over a span of time those which were at first quite realistic become not much more than symbols. Lothrop thoroughly analyzes these motifs and his work has been extensively referred to in the catalogue descriptions.[20] The essay by Dr. Jane Day in this catalogue describes the new research on Late Period Polychrome ceramics in the Guanacaste-Nicoya zone, their types and varieties, time periods and motifs.

CENTRAL HIGHLANDS/ATLANTIC WATERSHED ZONE

The Central Highlands/Atlantic Watershed zone is the largest of the three zones, with differences existing among its various parts both geographically and culturally. There are similarities of style however which seem to make it reasonable to consider the subareas as part of one stylistic zone.

The Atlantic Watershed includes those many small valleys with streams draining from the plateau to the extensive lowland plains. Near the Panamanian border the Talamanca mountain range shoulders towards the Pacific. Cultural influences there seem more closely related to the south. In the Central Highlands two major areas can be identified: one is in the high central plateau with its temperate climate, where the modern capital city of San José is located; to the west is the Pacific drainage with rugged mountains and steep valleys.

One of the early sites excavated by C. Hartman in 1901 was Las Mercedes on the Linea Vieja, the old railroad line running from the highlands to the Caribbean port of Limón. As archaeological investigation continues, the relationship between the Central Highlands and the Atlantic Watershed is becoming clearer. Recent work has led to the naming of certain groups. Other unnamed groups still await a clearer understanding of their relationship to those already named.

Period IV (1000 BC-AD 500)
The earliest ceramics from this zone in the exhibition are from the El Bosque phase Red on Buff group (circa 100 BC-AD 500). Vessels of the type are most often painted in red slip and burnished on their rims, interiors, and bases (see No. 120). The exteriors are left in the natural buff clay fired to a terra-cotta color which is smoothed and decorated with appliquéd figures and heads. Grooving adds texture. In Number 120, the tripods are loops forming snake bodies. Number 122 is an example of a bowl with fanciful alligators appliquéd on the unslipped exterior. Related to El Bosque phase groups are the tripod vessels possibly from the Central Highlands. The acorn-shaped bowl of Number 131 is also slipped and burnished red in the interior, on the mouthrim, and the exterior neck. The hollow tripods are modeled in the form of anthropomorphic figures with rattle pellets incorporated in them. Originally covered with soot on their inner sides, the tripods probably facilitated the heating of the contents of such vessels when they were placed over a fire.

In the Central Highlands, Pavas phase ceramic groups, associated in time with El Bosque phase groups in the Atlantic Watershed, include the elegant Molina Channeled group pot stands (No. 127). The one here is painted in red slip and burnished. A pot stand in the Duke University Museum of Art features a similar circle of birds resting on the back of a deer. The Sackler example has four Atlantean figures, two males and two females, as supports.

Among the charming small Santa Clara figurines from the El Bosque phase are the whistles and rattles modeled as Disney-like figures of birds, animals, and humans. Number 126a represents a rotund dignitary, while Number 126c is in the form of a bird. Often the

whistles take the form of figures on a log or a boat. Possibly they were once painted in fugitive black, white, and yellow, since some still retain their color.

Period V (AD 500-1000)

Popular ceramic groups of the El Bosque phase continued into Period V. Much of the pottery from this period in the Central Highlands/Atlantic Watershed zone was monochrome. Major emphasis was on modeling and appliqué techniques as opposed to polychrome painting popular in the Guanacaste-Nicoya zone.

The Sackler Collection includes examples of one of the major ceramic groups of this period, Africa Tripods. Number 132 is an elegant version of such a tripod with hollow rattle legs appliquéd with anthropomorphic figures and beaked-birds pecking at their heads. The thermoluminescence analysis of the clay sample from this vessel confirms the Period V attribution for the group.

Another Period V group, Zoila Red, is decorated with negative resist painting but sometimes combines the latter with incised designs. Costa Rica probably owes its negative resist decoration to influences from South America. An outstanding example of the Zoila Red group is seen in Number 140, a bowl with hollow rattle, mammiform feet. Thermoluminescence analysis of a clay sample from its base indicates last firing between AD 630 and 980, the La Selva B phase.

There are a number of examples in the Sackler Collection of La Selva phase ceramics. The rather charming piggybank-like animal figurines in Numbers 135 and 139 represent a jaguar and a tapir. The rotund bodies and generalization of features are reminiscent of some Rosales Zoned/Engraved animal forms. The surface finish of Number 135 is finely burnished and includes incised geometrics on the dark red zoning, probably jaguar and alligator related. Number 136, a bizarre blend of a gourd-shaped bowl and a projecting head, seems to have been a popular form, since it appears in many collections. Thermoluminescence analyses of clay samples from Numbers 135 and 136 have given as a calculation of last firing AD 274-894 for the former and AD 505-1055 for the latter. Taking the midpoint of each of these spans, it is possible to say that Numbers 135 and 136 belong in the La Selva A phase (AD 500-800). Number 139 however, apparently belongs to the later La Selva B phase (AD 700-1000) since analysis of its thermoluminescence signal has indicated last firing between AD 754 and 1194 with a midpoint of AD 974.

The lidded bowl, Number 138, illustrates the technique of fastening a lid to the rim of the vessel by passing a thong through lid and body perforations and knotting it to the rim of the vessel. The excess cord formed a carrying handle. Vessels from Peru of the Moche III-IV Period (circa AD 300-500) in the Duke University Art Museum exhibit similar fastening methods.

A number of pottery types in the Central Highlands/Atlantic Watershed zone have been reported on and are exhibited here but have not been named. Among them are red-slipped hollow figurines, Numbers 142 a-g, which might well be part of a village group. Three women and one man, along with three dogs, are represented. Two of the figurines stand with hands on their hips, one woman holds a baby, while another nurses a baby. One figure carries a drum on his back giving the impression that the group may be musicians. Three of the figurines, including the one with the drum on his back, and the three dogs, were purportedly found together in one grave. The largest of the figurines is independent of that group. The modeling is formulaic and tends to be stiff: the figurines are somewhat flattened, they have large heads, broad hips, rubbery, tubular arms, and the eyes are slanted cut slits. Individuality is lacking, yet they have a certain charm, if not the playfulness of the earlier Santa Clara figurines. The principal adornment are hats or headdresses, much like Colima figurines of west Mexico.

During the last part of Period V, large human head effigies and effigy vessels appear. They apparently represent trophy heads, which were important ritually to most Pre-Columbian peoples. Numbers 145 and 146 are realistic examples, and, along with similar stone heads, may have been placed at the feet of a chief seated on his dais. The similarity to head effigy vessels in the Colima area of west Mexico is striking.[21]

Samuel Lothrop recognized three styles of trophy heads.[22] The first type as seen in Numbers 145 and 146 are similar to the stone examples. They are often crowned with conical straw hats. The ceramic walls are thick and the surfaces are covered with dark red slip. The features are modeled with considerable realism. Ears are pierced, probably for earrings. A second group consists of heads with very thick walls made from the typical sandy paste used in other appliquéd ceramics and usually covered with a dull orange wash, similar to Numbers 147 and 148.

Period VI (AD 1000-1550)

In Period VI, very large tripod bowls were found as part of the offerings left in tiny tombs or caches. They were decorated with appliquéd alligators, alligator masks, and alligator-head tripod legs as in Number 149. It is decorated with broad yellow striped geometric designs. Similar vessels are found with designs in broad white lines.

An unnamed type of ceramic includes incense burners shaped like frying pans. The handles are usu-

ally hollow, contain a rattle, and either have a modeled head finial on the handle, as in Number 151, or are fully modeled to represent an animal's head. Incense would have burned on the attached plate.

A style of pottery found in cist burials in the Central Highlands had been given the name Stone Cist Ware because of its discovery in cobbled tombs, either under or around houses, or in cemeteries. This ware is now classified as the La Cabaña-Pavones group. An example in the Sackler Collection is Appendix No. 13. The mouthrim is serrated, and the shoulder of the vessel is decorated with punctate reed circle designs and a conventionalized alligator head centered on either side between the handles. Lothrop claimed that Stone Cist Ware was part of a much larger type of which Costa Rican ceramics were the frontier group to the north. The southern limit of this group reaches south of the equator in Ecuador. Its most common decoration is an appliquéd ribbon of clay punctured with holes or short lines. Hartman considers that the appliquéd dot motif is derived from bumps on the alligator hide.[23]

The Cot Black Line vessel (No. 152) is from another ceramic group of Period VI in the Central Highlands/Atlantic Watershed zone. Here, a hemispherical bowl is supported on three long, conical rattle legs, with circular perforations and vertical slots. Just below the rim, an anthropomorphic head appliqué appears which rests on long arms extending upward from the tips of the legs. Geometric designs are painted as black lines, and were possibly inspired by the markings on alligators.

DIQUIS ARCHAEOLOGICAL ZONE

The Diquis zone, the least known of Costa Rica's archaeological zones, is bordered on the east by the Talamanca Mountain Range and on the west by the Pacific Ocean. It runs south from the town of Parrita to the Panamanian border. Influences are mainly from the south.

Period VI (AD 1000-1550)

While considerable work on the earlier Period III and IV has been done across the border in the Panamanian province of Chiriquí, some of those findings can be compared to Period IV ceramics on the Costa Rican side. The Sackler Collection however does not include any examples from Period IV or V. It does contain examples of two ceramic types from Period VI: Buenos Aires Polychrome and Tarragó Biscuit ceramics.

Buenos Aires Polychrome was once called "Alligator Ware" by earlier authors.[24] The black and red motifs

on a tan slip seem to be associated with the markings on the animal. The figurine in Number 153 is typical of examples from this area. The head of the woman holding a child is almost bird-like in its stylization. Animal figurines such as the feline (No. 156) and the tapir (No. 157) were also frequently produced. Each has a cream slip painted in black and red with alligator-related motifs, the dotted diamond, triangle, and oblong. Whistles too were common, as in Number 159, a double-bird effigy, and in Number 160, a top-like construction.

The second Period VI Diquis ceramic type is Tarragó Biscuit. This is fine, well potted buff-colored ceramic ware with simple, elegant shapes. The Diquis were truly inspired potters with great sensitivity to form. Often bowl and tripod merge into one unit, as illustrated in Number 161. Tiny *adornos* are usually modeled on shoulders, as in Numbers 162 and 169, or necks of vessels, as in Number 164. Number 170 is a tripod vessel. A figure whose bonnet ribbon stretches back to the mouthrim squats on the vessel's shoulder. The tripod legs of bowls often contain rattles, as in Number 167.

The Arthur M. Sackler Collection, one of the few major private collections of Costa Rican ceramics in the United States presents a cross section of many of the major ceramic types in Costa Rica's three archaeological zones. Thermoluminescence analyses of clay samples from a majority of vessels in this collection have added significantly to an expanding knowledge of Costa Rican ceramics. It is hoped that the exhibition and cataloguing of the collection will also contribute to the increasing appreciation of Costa Rican ceramics and their position on the crossroads of cultures in the Americas.

1. Clifford 1983, Introduction.
2. Beadle 1972, pp.2-11, and Lothrop 1975, p.21, citing Beadle.
3. Snarskis 1982, p.108, an 'African' tripod from the La Selva phase cemetery.
4. Clifford 1983, p.8 footnote.
5. von Heine-Geldern 1967, pp.787-791, esp. p.788, fig. 3, the drawing of a Zhou dynasty tiger, after a bronze in the Freer Gallery, Washington, D.C.
6. Lange 1984, pp.180-181, and Stone, this volume.
7. Lothrop 1926, p.109.
8. For a more extensive description of the physical aspects of Costa Rica, its flora and fauna, see Stone 1977.
9. See Appendix B for an explanation of thermoluminescence analysis.
10. Bishop 1982.
11. Day 1984a.
12. Lothrop 1926.
13. Snarskis 1982, p.24.
14. Service 1975, pp.14-16; Snarskis 1982, p.10.
15. Lothrop 1926, pp.342-343, pl. CLXXIX and fig. 232.
16. Snarskis 1981, fig. 125.
17. Stone 1977, p.184.
18. Stone 1977, pp.56-57.
19. Glass 1966, chapt. 8, fig. 6.
20. Lothrop 1926.
21. See also von Winning 1974, pp.55-56.
22. Lothrop 1926, pp.368-371.
23. Hartman 1976.
24. Holmes 1888; MacCurdy 1911; Lothrop 1926.

No. 85. *Jaguar Style Effigy Jar*, Pataky Polychrome, Pataky Variety.

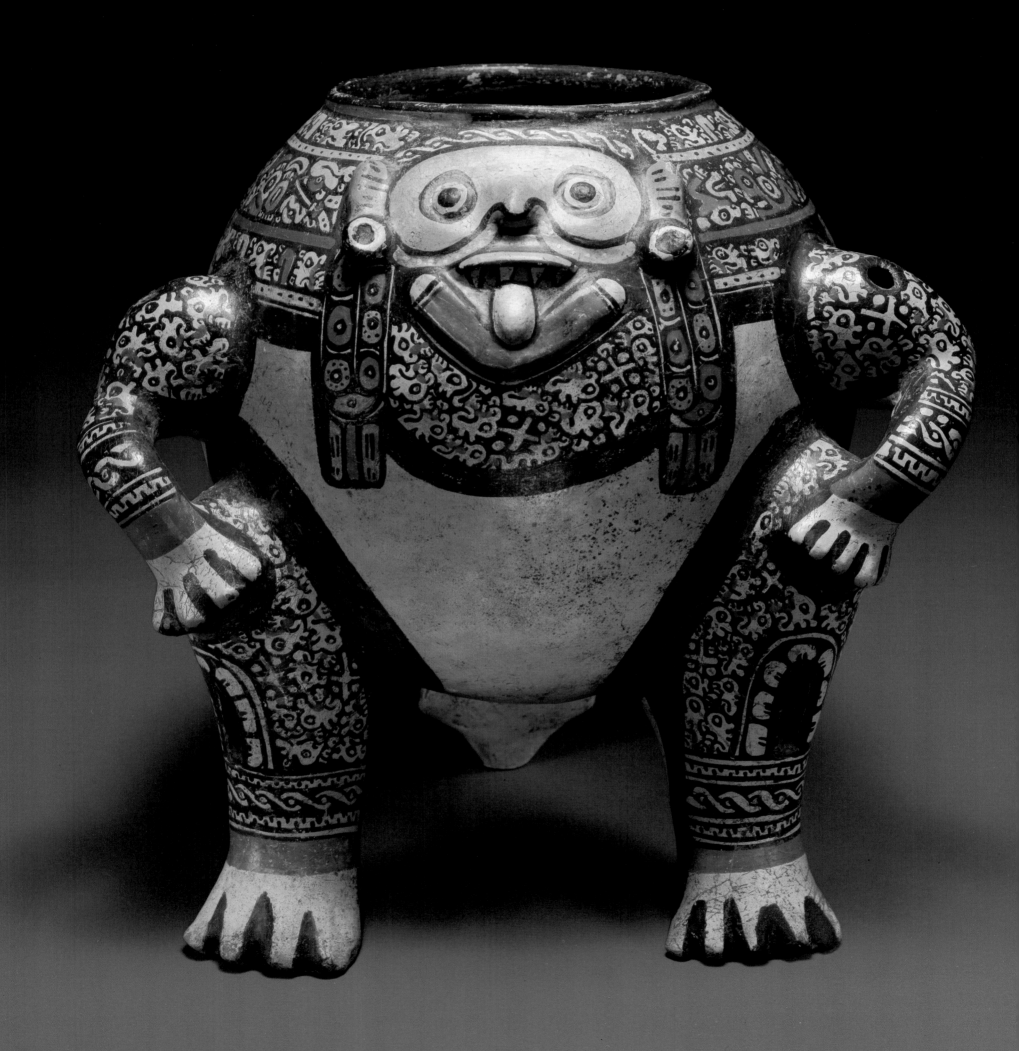

The Catalogue

1. TRIPOD VESSEL

Earthenware, buff body with black slip, burnished, and legs with
white pigment
Guanacaste-Nicoya Zone
Period IV (1000 BC-AD 500)
*Santiago Appliqué Zoned Bichrome (ca. 800-300BC)**
Height 16⅝" (42.2cm) Width 9⅝" (24.4cm) Depth 8¾" (22.2cm)
Condition before conservation: multiple repairs to legs and mouthrim
Accession no. N-930

The rounded body of this large tripod slants inward at the
shoulder from which emerges a long, wide flaring neck with
thickened rim. Long, hollow legs, conical in cross section
with slits and rattles, support the vessel. Where each leg is
joined to the body, a small bird with appliquéd features is
attached. A notched band encircles the shoulder where it
joins the neck. Spaced between each leg is a raised square

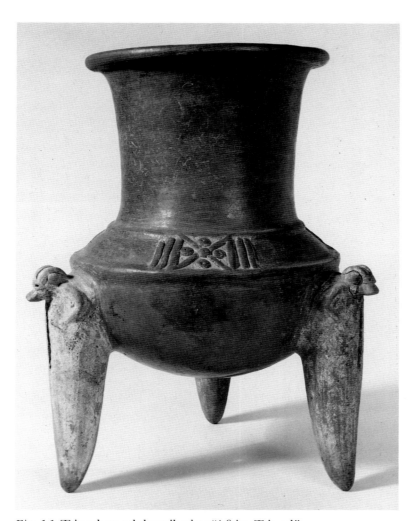

Fig. 1.1. Tripod vessel described as "Africa Tripod,"
Museum of the American Indian, acc. no. 15/8689.

with additional raised diagonal crossbars and a pellet over
the crossing. This geometric decoration is flanked on either
side by a line of raised pellets. The surface of the upper
body is a lustrous burnished black while the legs and birds
are left matte with traces of white pigment.

A few presumed to be early tripods of this type were found
in the Guanacaste-Nicoya Zone, discovered specifically in
the Nicoya Peninsula. The semihemispherical bowl with
shoulder curving in surmounted by a chimney-like neck,
which sometimes assumes the exaggerated shape seen here,
is distinctly a Nicoya shape. This chimney-like neck is seen
again in the Central Highlands/Atlantic Watershed Zone in
the Ticoban and Africa Tripod styles of Period IV-V, circa
AD 400-700 (see Nos. 132-134). Two common leg ornaments
for this type of tripod were representations of the alligator
and the bird. The bird appears here.

In Samuel Lothrop's 1926 publication, this ware was not
named as it is here but was incorporated within the large
group of monochrome or "chocolate" wares which were
produced in the Guanacaste-Nicoya Zone but were found
more commonly in the Central Highlands/Atlantic
Watershed Zone.[1] Lothrop associated the tripod vessel
form in Costa Rica generally with similar vessels in
Ecuador and Peru.

Jane Day believes the Sackler vessel should be attributed as it
is here.[2] Matthew Stirling published a similar vessel in 1964
from a tomb excavated from the LineaVieja, Central High-
lands/Atlantic Watershed Zone which had a carbon-14 date
of AD 144.[3] Nevertheless the TL analysis of the Sackler tri-
pod cautions restraint in dating, with a maximum age of 720
years.[4] Frederick Dockstader published an almost identical
redware vessel with similar shoulder design but slightly
shorter legs, purported to come from the Linea Vieja, Car-
tago, Costa Rica, attributing it to the Central Highlands/
Atlantic Watershed Zone, circa AD 1000-1500 (Fig. 1.1).[5] The
attribution is significantly distinct in time and place from the
one given here. Only an analysis of trace elements in the
clay will determine the actual place of manufacture.

1. Lothrop 1926, vol. II, pp. 342-343, pl. CLXXIX and fig. 232.
2. Jane Day in a personal communication with the author indicated that the
 tripod type seen here was given its present attribution at the Denver Ceramic
 Conference on Greater Nicoya held in Denver, Colorado, 1983. Snarskis 1982,
 p. 24, illustrates a red-slipped tripod with a tall chimney-neck in the Instituto
 Nacional de Seguros (henceforth designated INS) which he dates 800-300 BC;
 on p. 30 is another one in the INS dated 300 BC-AD 300.
3. Stirling 1969, found with jade axes and nasal snuffers.
4. Personal communication from Doreen Stoneham, The Research Laboratory
 for Archaeology and the History of Art, Oxford University.
5. Dockstader 1964, no. 166, Museum of the American Indian, New York, acc.
 no. 15/8689 [height 16½" (42cm), width 10" (25.4cm)].

**OXTL analysis (ref. no. 381L26, 8/1/84) estimates that the sample tested was last*
fired between 380 and 610 years ago (AD 1374-1604). For additional information on this
and all thermoluminescence analysis consult Appendix C.

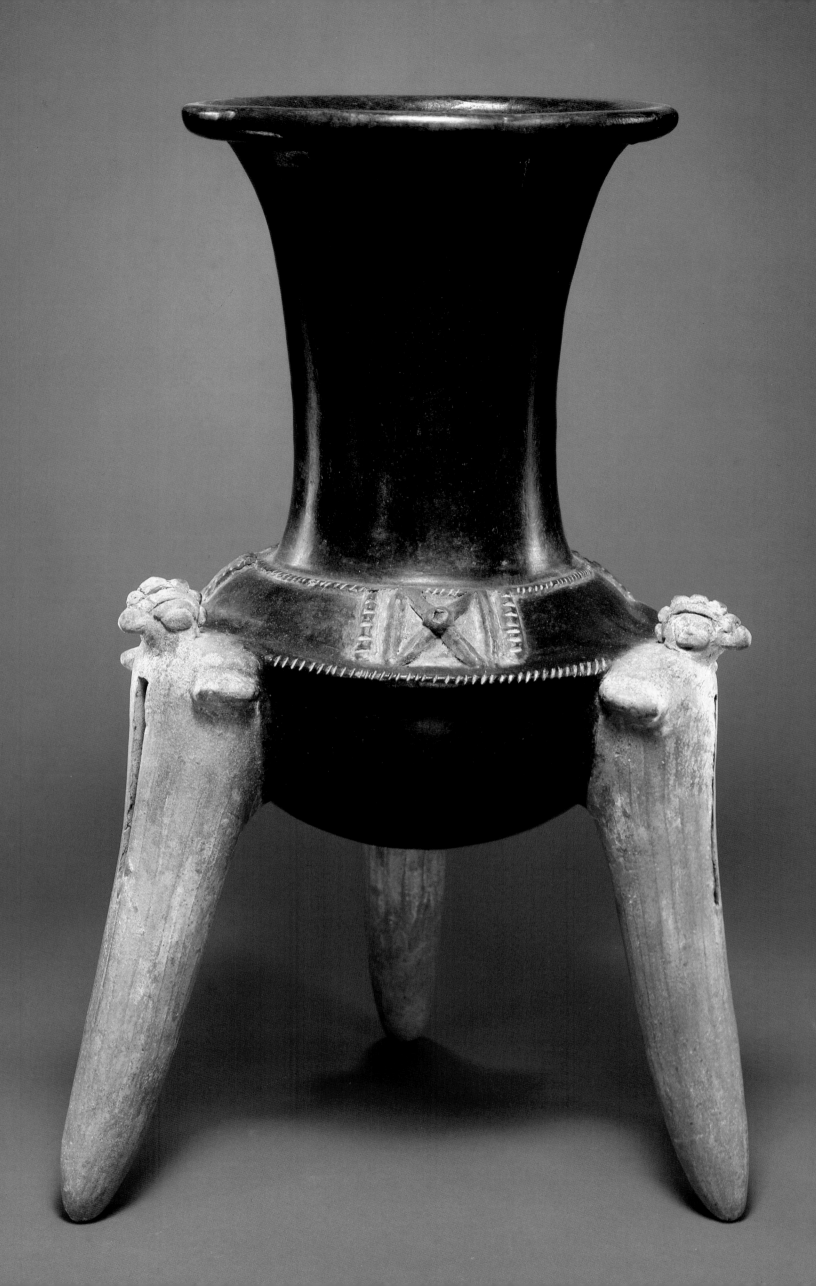

2. BURIAL VESSEL

Earthenware, brownish buff body with red slip, burnished
Guanacaste-Nicoya Zone
Period IV (1000 BC-AD 500)
*Bocana Incised Zoned Bichrome, Toya Variety (500-100 BC)**
Height 17¼" (43.8cm) Diameter 22½" (57.2cm)
Condition before conservation: broken into large fragments
which were reassembled; some fragment edges missing
Accession no. N-1203

This very large bowl emerges from a pointed base and splays to a low shoulder which curves convexly and constricts to a short, narrow neck and slightly splayed mouth-rim. The paste or body clay is composed of a large amount of temper with numerous particles of quartzite (?) clearly distinguished as black specks on the surface. From the neck to the shoulder, the vessel is decorated by sets of four parallel vertical incised or grooved lines and one similar set encircling the neck. But the grooves are not so sharply cut, and the furrows are partially obliterated in some spots by smoothing. The red slip or wash was applied to certain zones of the upper body after the incising was completed, while the remainder of the surface was left natural, i.e., unslipped. Such large vessels produced at this early date must have presented major problems in a firing technique which made use of open bonfires.

Purportedly this vessel is from Zapatero Island in Lake Nicaragua, Department of Rivas, Southern Nicaragua.[1] Its decorative grooving is typical of pottery of the same period in northwestern Costa Rica, indicating Costa Rica's participation in the ceramic tradition of Greater Nicoya and Mesoamerica to the north. Zoned Bichrome is the name given to pottery of this period because decoration usually consists of wide, incised lines, with supposedly round-bottomed grooves, often in parallel bands, separating areas (zones) of red slip on the natural buff or brownish fired clay.

Bocana Incised Bichrome is only one of a number of early zoned ceramics decorated in this manner and has clear affinities with other types such as Rosales Zoned Engraved (or Rosales Zoned Incised) which belongs to a later phase of the Zoned Bichrome Period (see Nos. 5-8).

Bocana Incised Bichrome was traded throughout the Greater Nicoya Archaeological Subarea with, according to Healy, a probable point of origin somewhere in Guanacaste, Costa Rica. Frederick Lange, in reviewing the latest information on the Greater Nicoya Archaeological Subarea, mentions that although Bocana Incised Bichrome is pan-regional during the Zoned Bichrome Period, the Toya variety is most characteristic of the northern sector, and the Bocana Variety is most characteristic of the southern sector.[2] The Sackler vessel, given its reported provenience, is from the northern sector. Michael Snarskis has written that a close similarity exists between Toya variety and Bocana variety and that potsherds of the two varieties may be indistinguishable.[3] He describes the Bocana Variety, however, as having vertical red painted lines on the buff collars of vessels which are otherwise characterized by the same parallel vertical incised lines separating zones of red slip.

The Toya Variety of the zoned incised ceramic type to which the Sackler vessel is attributable was earlier referred to as Palmar Ware, discovered by J. F. Bransford at Palmar in the Department of Rivas, southern Nicaragua, and described by Bransford in 1881 and later by Samuel Lothrop in 1926.[4]

1. Healy 1980A, pp. 91-93. Since Paul Healy has published the most recent cultural historical/ceramic sequence for the Rivas area, or southwestern Nicaragua, his descriptions for individual ceramic types have been consulted in designating Type and Variety of this vessel.
2. Lange 1984, pp. 172-173.
3. Snarskis 1982, p. 16.
4. Bransford 1881, pp. 69-70; Lothrop 1926, pp. 248-249 and pl. CXIV.

**OXTL analysis (ref. no. 381n84, 3/22/85) estimates that the sample tested was too insensitive and a determination of last firing could not be made.*

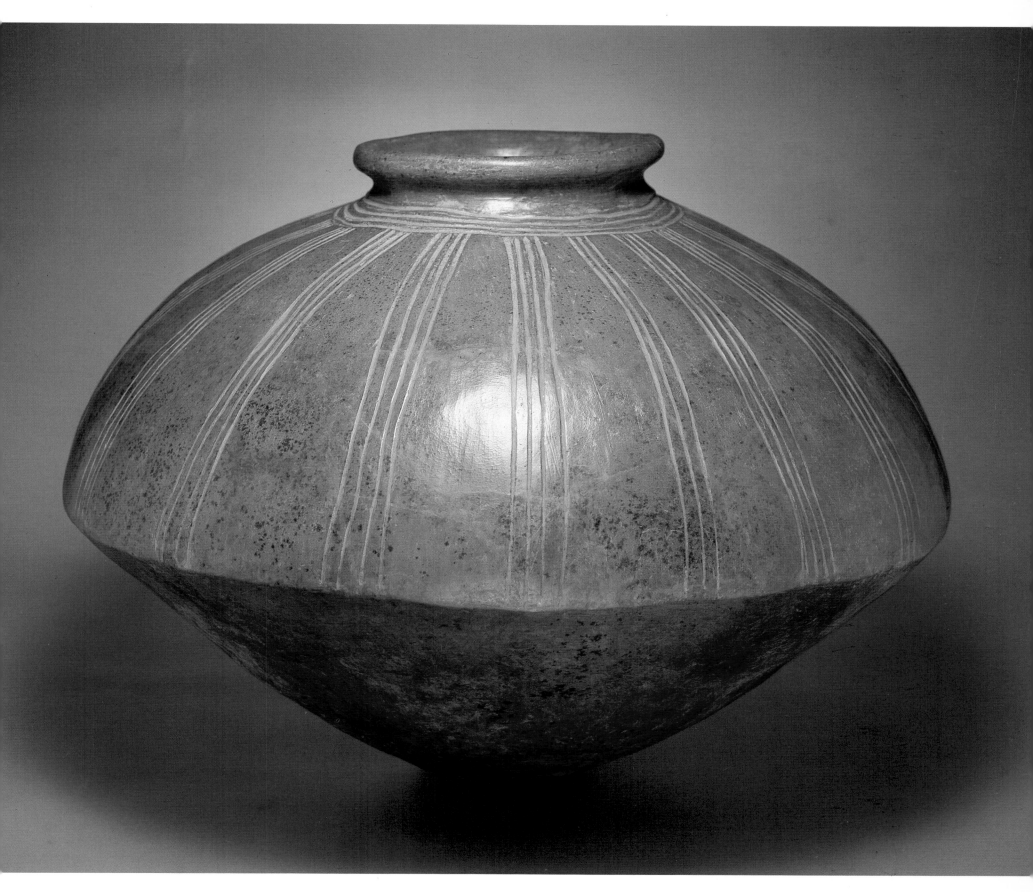

3. BURIAL VESSEL

Earthenware, brownish body with red slip, burnished
Guanacaste-Nicoya Zone (from the Greater Nicoya Archaeological
Subarea)
Period IV (1000 BC-AD 500)
*Bocana Incised Zoned Bichrome, Toya Variety (500-100 BC)**
Height 14" (35.6cm) Diameter 18¾" (47.6cm)
Condition before conservation: base and part of mouthrim
had been broken and repaired with plaster
Accession no. N-1204

This very large bulbous bowl with rounded sides constricting to a wide mouth is decorated around the exterior with two semicircular panels formed by four parallel horizontal incised lines below the mouthrim which turn at right angles at either end to drop vertically toward the base. Within each panel are groups of five parallel incised lines angled slightly in a sawtooth pattern. The area of parallel lines is left in the original brown clay color and burnished. A red slip is painted on the solid surfaces between. The vessel purportedly was excavated from Zapatero Island in Lake Nicaragua, Nicaragua.

As discussed in Number 2, a distinctive class of pottery referred to at an earlier time as Palmar ware, was discovered by J. F. Bransford in 1881 in Palmar, Department of Rivas, southern Nicaragua.[1] The vessel here is, with minor differences, very similar in shape and design to a Palmar vessel published by Lothrop in 1926. The Sackler vessel exhibits only one set of horizontal lines as opposed to the three sets on the vessel which Lothrop illustrated, and which came from Alta Gracia, a small village on the northern end of the island of Ometepe in Lake Nicaragua where several sites were recorded by Bransford.[2]

1. Bransford 1881, fig. 285.
2. Lothrop 1926, pl. CXIVb.

**OXTL analysis (ref. no. 381N83, 4/1/84) estimates that the sample tested was last fired between 1270 and 2090 years ago (106 BC-AD 714).*

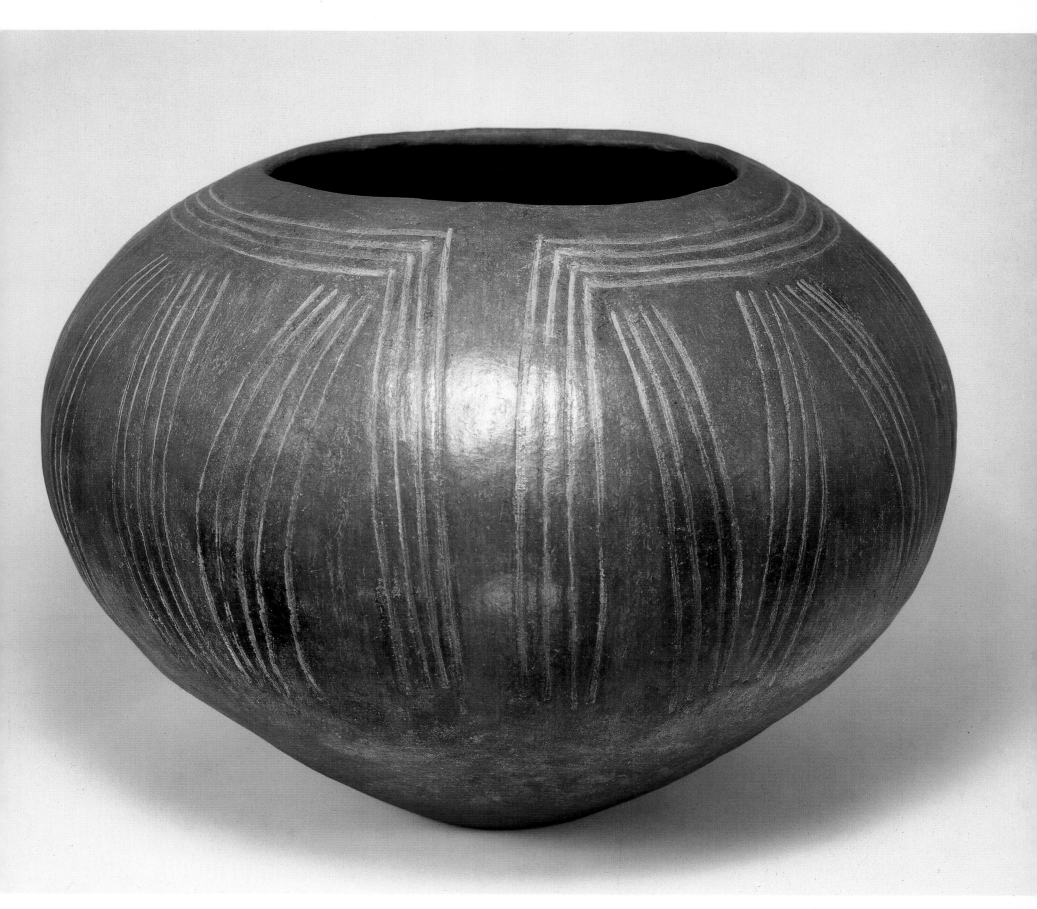

67

4. BOWL with looped handles

Earthenware, light brown body with red slip, burnished
Guanacaste-Nicoya Zone
Period IV (1000 BC-AD 500)
*Bocana Incised Zoned Bichrome , Toya Variety (500-100 BC)**
Height 4⁷⁄₈" (12.4cm) Diameter 6³⁄₈" (16.2cm)
Condition before conservation: intact but some surface pitting
Accession no. N-1138

The rounded bowl, curving in to the mouth, has two large loop handles on opposite sides above the mouthrim. Horizontal incising to form concentric rectangular bands decorates the exterior walls. The incised bands are alternately slipped in red. The two uppermost red ones turn at the ends to run obliquely on either side of the handles. The heavy loop handles are painted in red slip on their exteriors. The shape of the Sackler bowl is unusual among published pieces of Toya zoned incised ceramics, and later in date.

Various authors have labeled this type of ware differently: Toya/Bocana Zoned Incised,[1] Toya Zoned Incised,[2] as having zoned bichrome decoration,[3] and Bocana Incised Ware of the Zoned Bichrome period.[4] All the foregoing designations were applied to examples of jars which, in addition to the incising, are decorated with vertical parallel red lines painted on a buff collar, which Snarskis describes as the Bocana variety and which look like the work of the same potter.[5] Doris Stone published a large round-bottomed bowl of similar type which she described as Rosales Zoned Engraved ceramics, from Zapotillal, Guanacaste Province.[6]

1. Snarskis 1982, p. 25, for a jar in the INS.
2. Snarskis 1981, catalogue no. 2, for a jar in the Alfonso Jiménez-Alvarado Collection, Costa Rica.
3. Baudez 1970, pl. 15, for a jar in the Juan Dada Collection, San José, Costa Rica.
4. Ferrero 1977, Ilus. I-19, for a jar in the Museo Nacional de Costa Rica (henceforth designated MNCR), acc. no. 24.060, and Ilus. I-21, for another jar in the MNCR, acc. no. 23.851.
5. Snarskis 1982, p. 16.
6. Stone 1972, p. 95.

**OXTL analysis (ref. no. 381L84, 9/11/84) estimates that the sample tested was last fired between 790 and 1240 years ago (AD 744-1194).*

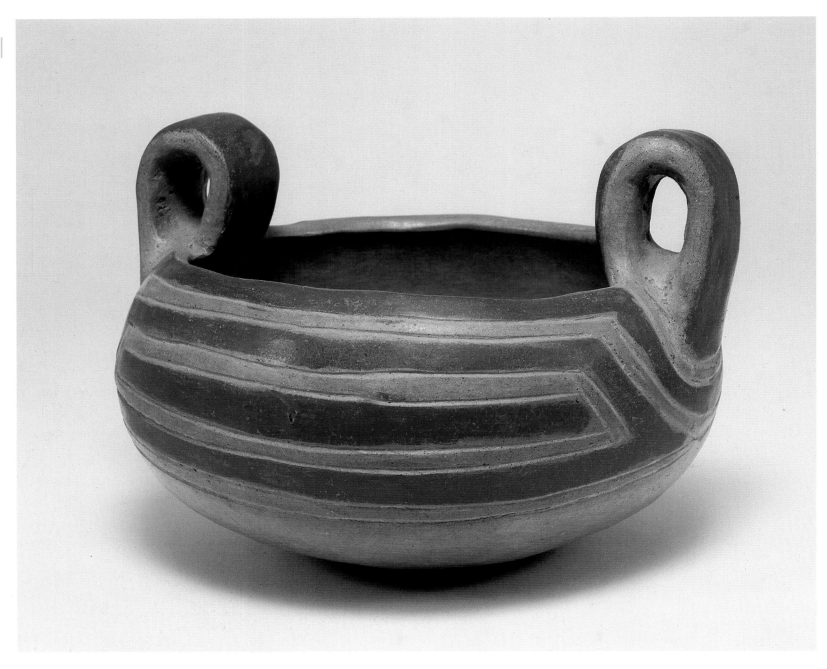

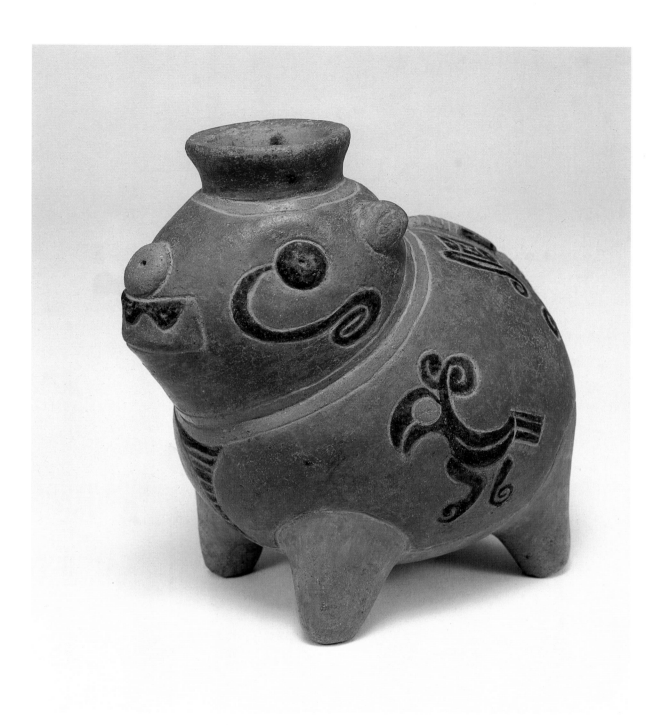

5. PECCARY EFFIGY VESSEL

Earthenware, brownish body under a red slip
Guanacaste-Nicoya Zone
Period IV (1000 BC-AD 500)
*Rosales Zoned Engraved (300 BC-AD 300)**
Height 5⅛" (13cm) Length 3⅝" (9.2cm)
Condition before conservation: fracture rear
right leg and on left side of chest under chin
Accession no. N-1121

This effigy vessel, modeled in the form of a chubby peccary, has a charming sculptural quality and striking decoration with engraved zones filled with black. A flared spout rises from the top of the animal's head. Its facial features include a round button snout, bulging button eyes and a black spectacle-shaped mouth enclosed in a rectangle. Ears project from the back of the oval-shaped head. Two incised lines encircle the base of the spout and a double collar encircles

the peccary's neck. The legs are fitted with an incised line around the juncture with the body. Below the eyes are sunken relief scrolls filled with black. Conventionalized birds rendered in the same manner decorate the sides of the body and additional symbols ornament the back and tail.

Rosales Zoned Engraved effigy vessels are among some of the most distinguished sculptured forms in Costa Rica. They were produced in the Guanacaste-Nicoya Zone purportedly during the last half of Period IV. The TL dating on this vessel and the monkey in Number 6 confirms the attributions given here and the dating of the type itself.

Cf. Snarskis 1981, nos. 9 and 10, for zoomorphic effigy vessels of Rosales Zoned Engraved; also Stone 1977, fig. 43, for a bird effigy vessel from Aguas Claras with the dynamic quality of form peculiar to the Sackler effigy, the delicate lines of design which create grace and a sense of movement as well as similar eye and leg forms.

**OXTL analysis (ref. no. 381L79, 9/11/84) estimates that the sample tested was last fired between 1400 and 2450 years ago (466 BC-AD 584).*

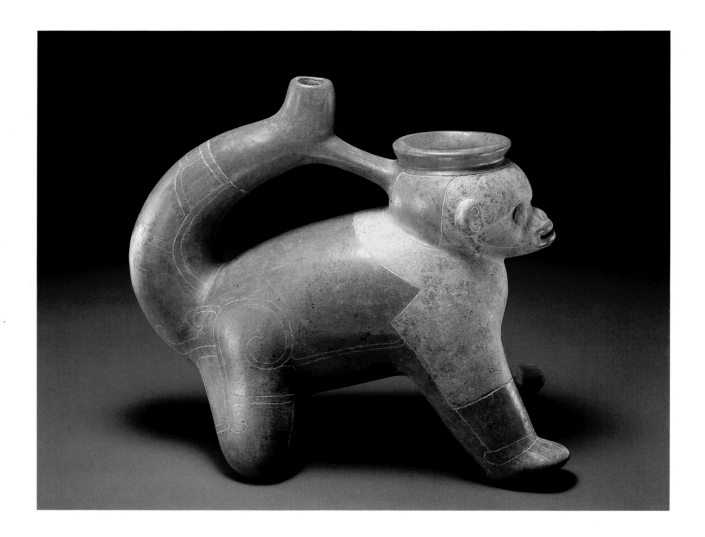

6. MONKEY EFFIGY VESSEL

Earthenware, tan body under red slip with cream paint
Guanacaste-Nicoya Zone
Period IV (1000 BC-AD 500)
*Rosales Zoned Engraved (300 BC-AD 300)**
Height 9¼" (23.5cm) Width 6" (15.2cm) Length 10⅜" (26.4cm)
Condition before restoration: front legs were broken; another break from
neck around chest up through head; breaks on spout and tail
Accession no. N-1109

This effigy vessel is a whistling jar modeled as a standing monkey. The very large tail curls over the back to form a pouring spout and is connected to the back of the monkey's head by a short strap handle. The vessel opening is edged by a flared rim on the top of the head which is realistically modeled. Eyes are round buttons and the mouth an open rectangle. Areas on body, legs and tail are zone-engraved, either to set off the cream paint on the forelegs and head or as decoration. The remainder of the vessel, i.e., the rim, ears and mouth, is slip painted in red. Designs are geometric.

Monkeys were frequent subjects for effigy vessels in Costa Rica and are among the most aesthetically pleasing Pre-Columbian ceramic sculptures. While such whistling vessels are typical of Late Preclassic Mesoamerica, almost exact counterparts are to be found among the Chorrera civilization in Ecuador, dated from 1000 BC to 300 BC.[1] A number of ceramic features were carried from Ecuador to Guatemala and western Mexico during this period, and probably to Costa Rica as well.

1. Lathrap 1975, Chapter VI, fig. 87, kinkajou whistling bottle.
Cf. Stone 1977, fig. 40, for another Rosales Zoned Engraved monkey effigy vessel from Guanacaste, and fig. 41, for similar treatment of an anthropomorphic effigy vessel from Guanacaste; also Snarskis 1981, pl. IV, for a seated monkey effigy vessel in the MNCR, acc. no. 1.5 (26), a trade piece from Guanacaste Nicoya found in a grave, tomb C, Talamanca de Tibas in the Central Highlands.
**OXTL analysis (ref. no. 381M80, 11/30/84) estimates that the sample tested was last fired between 1100 and 1920 years ago (AD 64-794).*

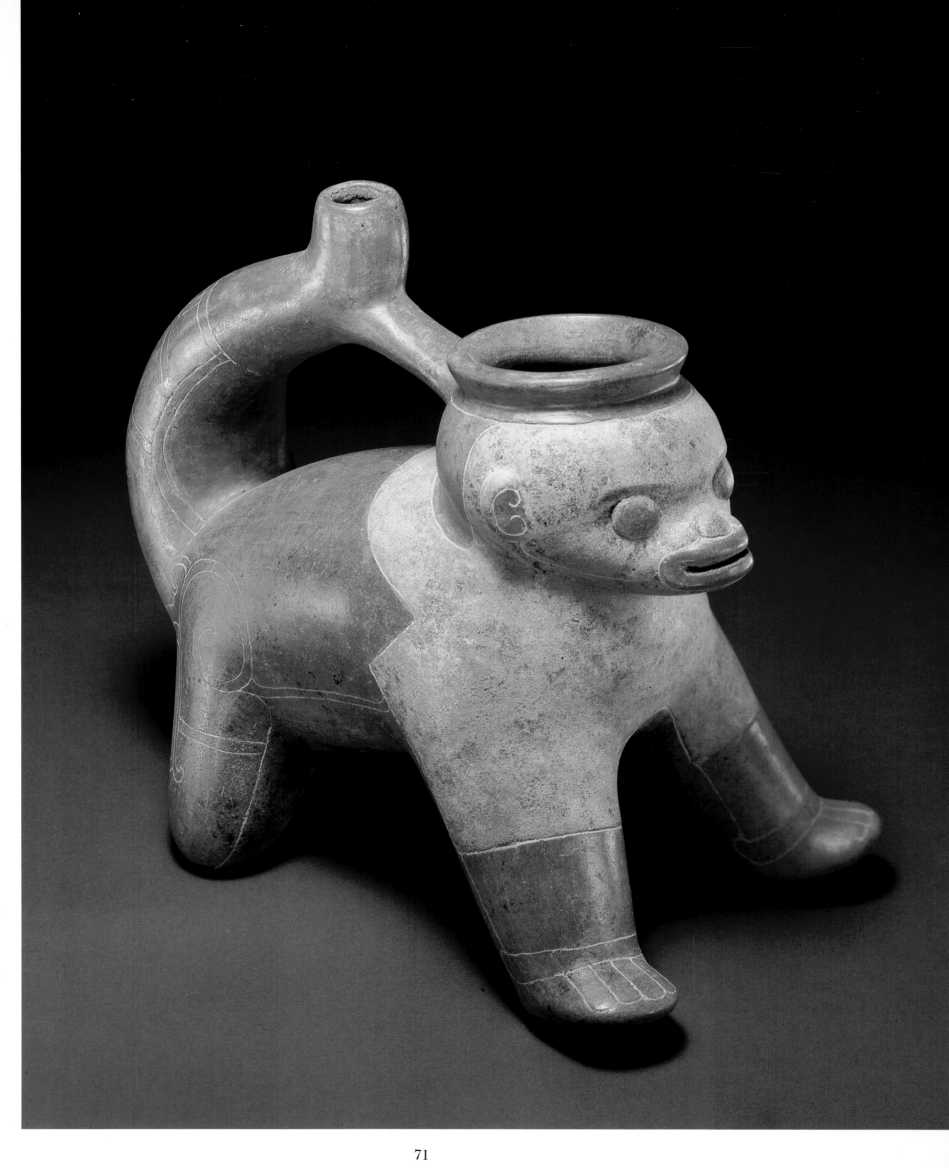

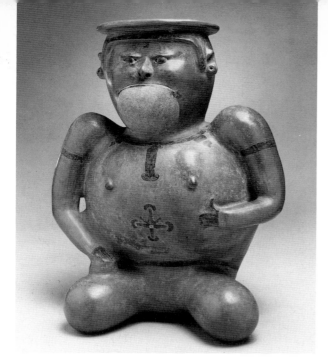

Figure 7.1 Human effigy vessel, Rosales Zoned Engraved, MNCR, acc. no. 9518.

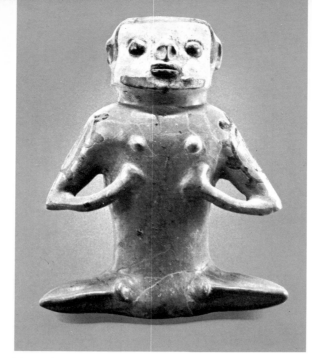

Figure 7.2 Seated human effigy vessel, Rosales Zoned Engraved, from Santa Cruz de Guanacaste, INS, acc. no. 258.

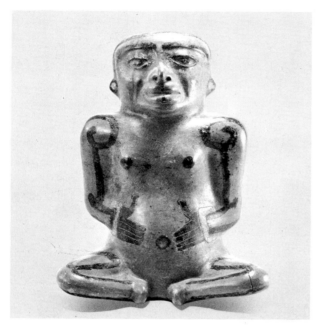

Figure 7.3 Seated human effigy vessel, Rosales Zoned Engraved, from the INS.

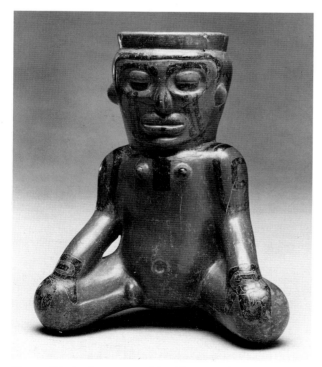

Figure 7.4 Anthropomorphic effigy vessel, Rosales Zoned Engraved, INS, acc. no. 6512.

7. HUMAN EFFIGY VESSEL

Earthenware, tan body under a red slip with remains of black resist paint
Guanacaste-Nicoya Zone
Period IV (1000 BC-AD 500)
*Rosales Zoned Engraved (300 BC-AD 300)**
Height 8½" (21.6cm) Width 6⅞" (17.5cm) Depth 4½" (11.4cm)
Condition before conservation: intact, root marks throughout
Accession no. N-1116

The seated female effigy vessel is modeled with prominent breasts, arms akimbo, and hands resting on her knees. The broad face has deep-set eyes under ridged brows and a small nose over a thick-lipped rectangular mouth. Earspools ornament the ears. A thick band, which also forms the rim of the vessel, circles the head. Incised zoning and the remnants of black paint designs appear on her shoulders, wrists, ankles, buttocks and hatband. Incised and painted zoning around her eyes appear to form conventionalized birds.

The zoning may represent body painting, tattooing or, in some cases on such figures, articles of clothing or jewelry.[1] Although the leg position of the Sackler figure differs, most figures of the type are represented in a seated pose with legs folded under and spread wide in what may be a ceremonial posture or one of sexual receptivity (Figs. 7.1, 7.2, 7.3, 7.4).[2]

1. Snarskis 1981, under no. 12, p. 1980.
2. Other figurines of the type are illustrated in: Snarskis 1981, no. 11, in the Maria Eugenia de Roy Collection; Snarskis 1982, p. 26, in the INS; Parsons 1980, no. 339, p. 220 from the May Collection, but in which zoned areas are no longer apparent; Ferrero 1977, Ilus. III—22, p. 290, for another in the MNCR, acc. no. 9519; and Stone 1972, p. 96, from Zapotillal near Santa Cruz and p. 97, from Samara, Guanacaste Province, present whereabouts not indicated. (Fig. 7.1 is also illustrated in Snarskis 1981, no. 12, Ferrero 1977, Ilus. I-22, and Baudez 1970, pl. 18; Fig. 7.2 is also illustrated in Snarskis 1982, p. 27, and Ferrero 1977, Ilus. III-21, p. 289; Fig. 7.3 is also illustrated in Snarskis 1982, p. 29; Fig. 7.4 is also illustrated in Snarskis 1981, no. 13, pl. 2.)

**OXTL analysis (10/12/84) estimates that the sample tested was too insensitive to draw a conclusion regarding age.*

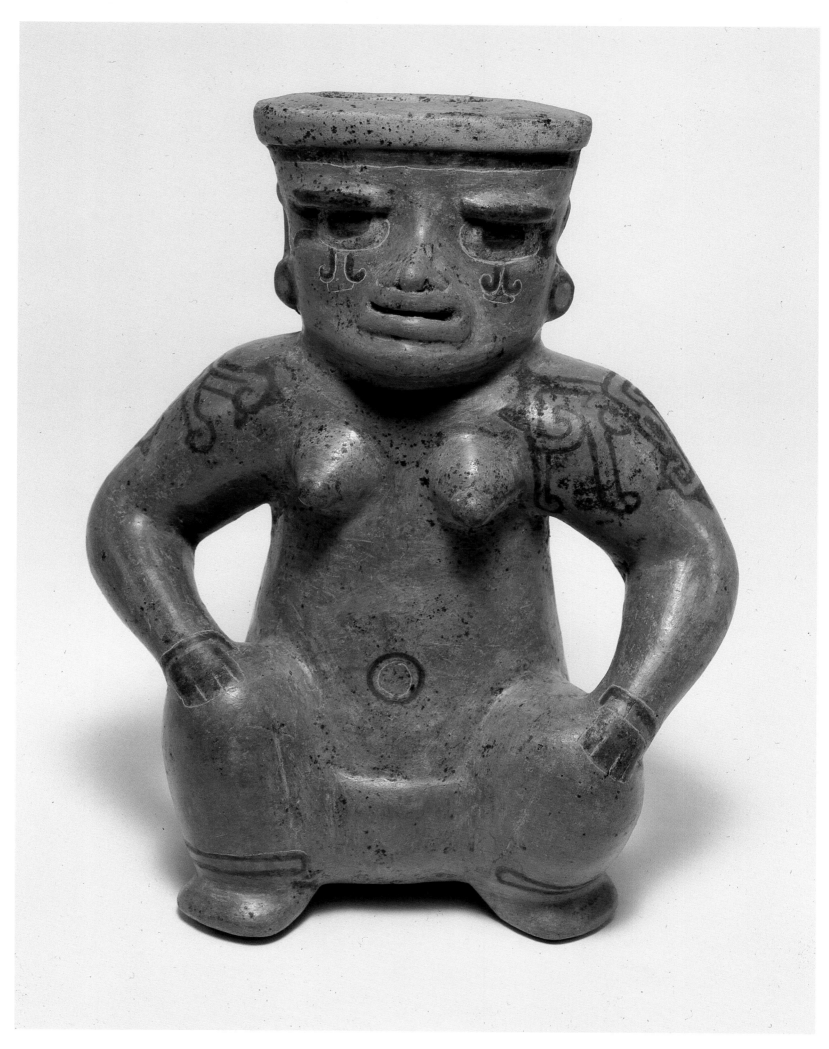

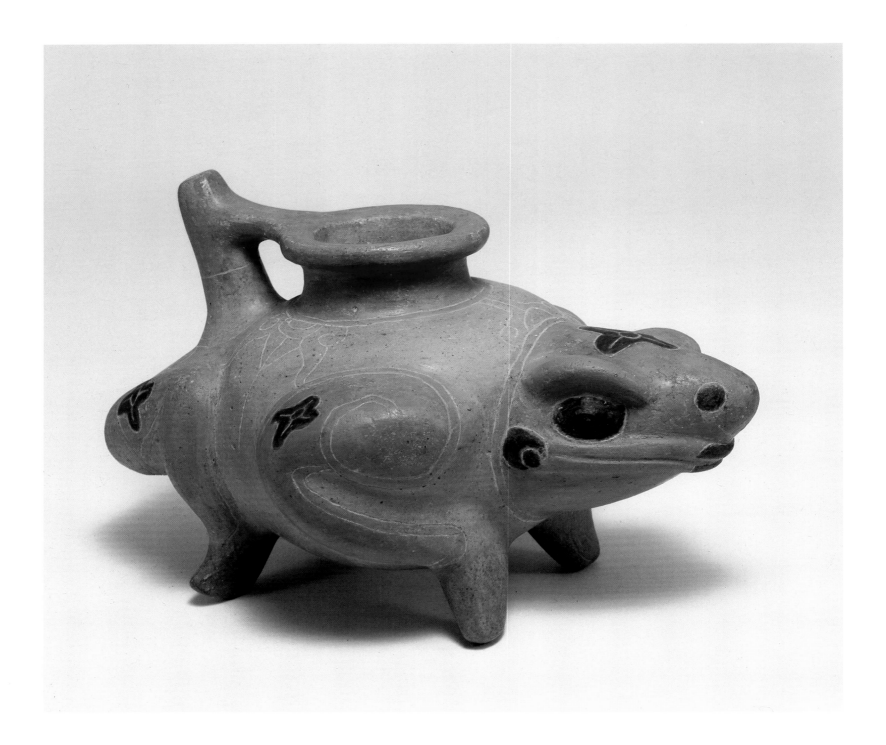

8. IGUANA EFFIGY VESSEL

Earthenware, tan body selectively under a red slip with black paint
Guanacaste-Nicoya Zone
Period IV (1000 BC-AD 500)
*Rosales Zoned Engraved (300 BC-AD 300)**
Height 4¼" (10.8cm) Width 6⅞" (17.7cm) Depth 4⅝" (11.7cm)
Condition before conservation: small hole on right front leg
Accession no. N-1137

This modeled iguana effigy whistling vessel has an opening with a flared, flattened mouthrim emerging from the animal's back. A slanted pouring spout issuing from the iguana's back is joined to the mouthrim by a short handle. The animal's head is realistically rendered with deep-set button eyes, flaring nostrils, and a thick-lipped, wraparound slit mouth. Although both fore and hind legs are fully modeled on the sides, four peg legs support the vessel. Decorative detail is incised or engraved. Some is filled with black paint on the head, legs, around the spouts, and to indicate the eyes and nostrils. Included in the decorations are *kan*(?) crosses on the head and legs. The handle and spout construction is similar to that found on Chorrera pottery of Ecuador.

Cf. Snarskis 1981, pl. 3, for comparable treatment of handle and spout.
**OXTL analysis (ref. no. 381M81, 11/30/84) estimates that the sample tested was last fired between 1160 and 1830 years ago (AD 154-824).*

9. SEATED FEMALE FIGURINE

Earthenware, brownish buff body under a red slip with painted black line
Guanacaste-Nicoya Zone
Period IV (1000 BC-AD 500)
Charco Black on Red (300 BC-AD 300)
Height 3¾" (9.5cm) Width 4" (10.2cm) Depth 3" (7.6cm)
Condition before conservation: unbroken, line eroded, minor surface pitting
Accession no. NN-14

This hunchbacked dwarf or deformed creature with exceedingly large, broad head is seated cross-legged with hands resting on her stomach. Facial and body features are formed by modeling and appliqué. Double black lines frame the forehead. Multiple vertical black lines are painted above and below the eyes, and black lines circle the breasts and navel. Designs on the shoulders are in the form of a grid with longer lines hooked at the ends.

Hunchbacked or deformed figures were objects of fascination in most Pre-Columbian cultures and their depiction may indicate a mythological being or characterize a societal role such as shaman or diviner.

Baudez favored the creation of a separate chronological unit, the Linear Decorated Period, characterizing the mode of ceramic decoration, which he placed between the Zoned Bichrome and Early Polychrome periods.[1] This was defined by the presence in the Tempisque valley of a number of ceramic types with such designations as Cervantes Punctate, Charco Black on Red, Lopez Polychrome (now called Tola Trichrome), Zelaya Trichrome, Nosara Polychrome and Corozal whistles.[2]

1. Baudez 1967, pp. 83-86.
2. Healy 1974, p. 314.
Cf. Snarskis 1982, p. 43, for a stylistically similar female figure of Galo Polychrome (Period V, AD 500-800) with designs on the body representing tattoos or body paint.

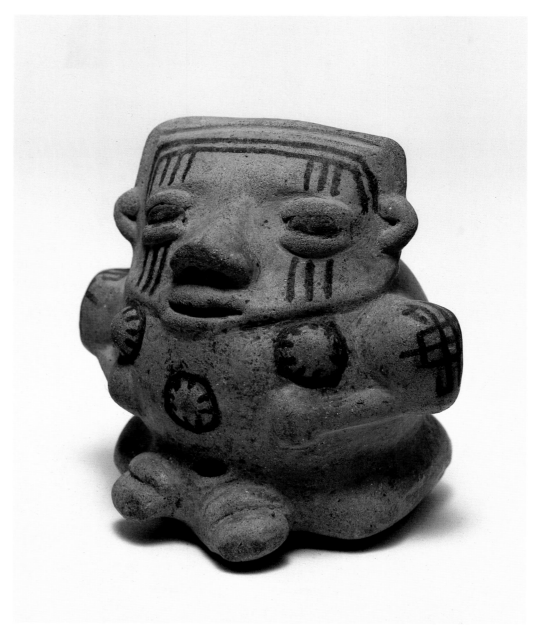

10. BOWL on a ring base

Earthenware, brownish buff body under a red slip, burnished†
Guanacaste-Nicoya Zone
Period IV (?) (1000 BC-AD 500)
*San Lucas Island Ware (300 BC-AD 300)**
Height 9" (22.9cm) Diameter 8⅞" (22.5cm)
Condition before conservation: chips in rim, paint worn in
one area, three cracks in bowl, surface slightly pitted and worn
Accession no. N-1094

The shoulders of this globular bowl curve in to an everted, flattened rim with nodes, regularly spaced, extending from the outer edge. Atlantean appliquéd figures in the form of monkeys in an upside-down position rise from the ring base to support the vessel. Four appliquéd figures on the shoulders alternate between a human/jaguar figure and a toad. A band of incised cross-hatching appears below the mouth and the flattened rim is similarly decorated. What in other instances might be a separate pot stand is here part of the vessel.

An almost identical vessel with relief decoration is published by Doris Stone as being from San Lucas Island in the Gulf of Nicoya.[1] The island of San Lucas, formerly known as Chara, was inhabited by people who, distinct from their neighbors in Costa Rica, at least at the time of the arrival of the Spanish, spoke a different language. Stone speculates that the island of Chara or modern San Lucas, with its ample supply of fresh water and a protected harbor, was a port of call for merchant mariners from northwestern South America, especially around the Gulf of Guayaquil and the Guayas Basin (now Ecuador), who carried on coastal and intercoastal trade between Ecuador and areas of Central America and Mexico from the first millennium BC or earlier. By the time the Spanish arrived they were using large sailing rafts, triangular sails, and centerboards. During their journeys these merchant sailors must have made layovers in whatever good anchorages they came across on the Pacific coast of Central America. Chorrera-phase ceramics from Ecuador seem to have been carried northward and distributed in trade or copied by local potters from the ceramics brought by the merchants. The vessel here and the one published by Stone were inspired by foreign types, but the result of TL analysis of the Sackler vessel argues against the early dating indicated above.

1. Stone 1977, fig. 49, p. 43.
†Clay body has a charcoal center due to insufficient oxidation.
OXTL analysis (ref. no. 381N78, 4/1/85) estimates that the sample tested was last fired between 300 and 610 years ago (AD 1375-1685).

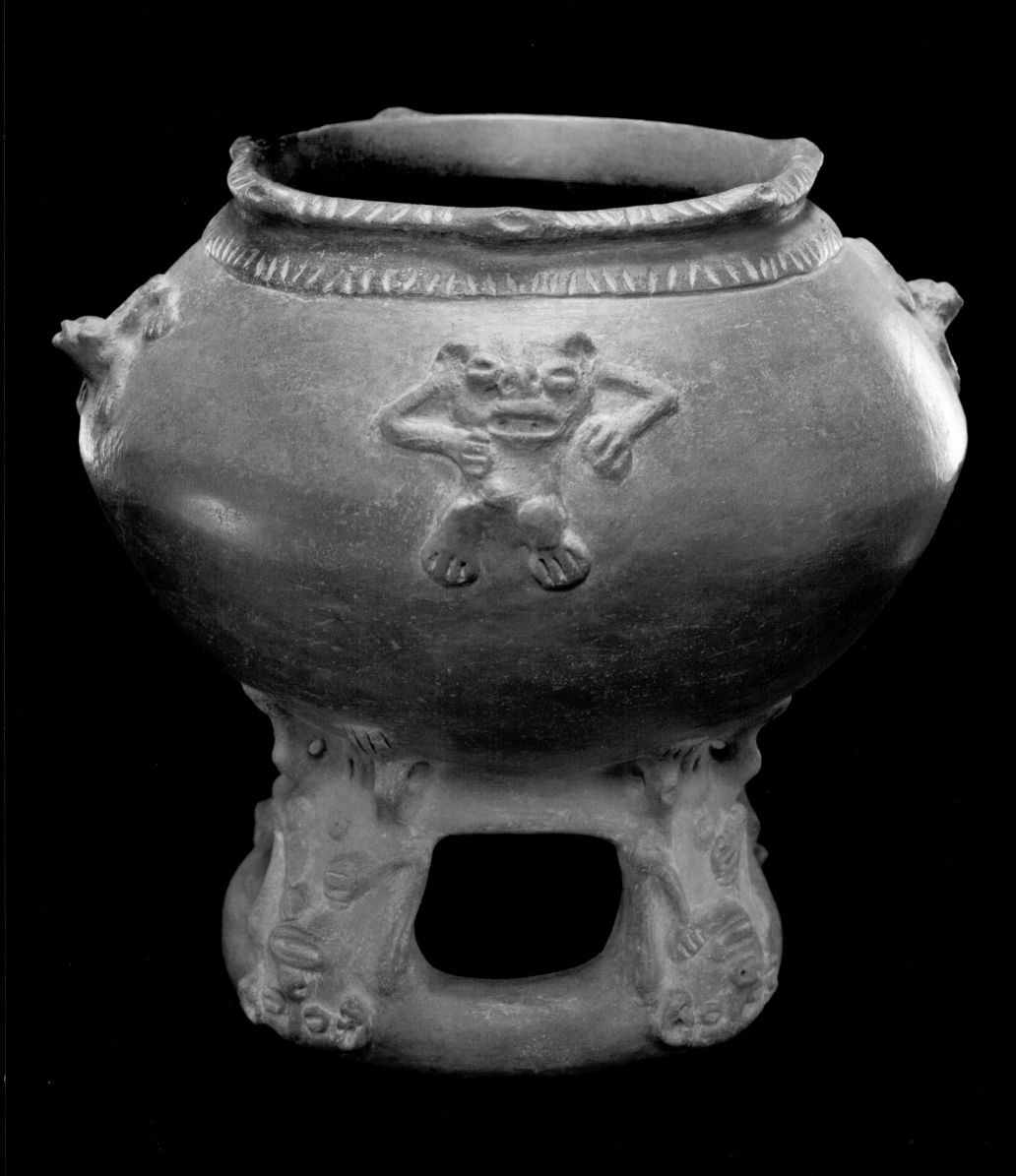

11. FEMALE EFFIGY FIGURE

Earthenware, reddish body under a red slip
Guanacaste-Nicoya Zone
Period IV (1000 BC-AD 500)
*Guinea Incised (AD 200-500)**
Height 8⅛" (20.6cm) Width 6¾" (17.1cm) Depth 5⅝" (14.3cm)
Condition before conservation: minor filling around legs;
small fracture visible on right leg
Accession no. N-1152

This modeled, seated female effigy figure is barrel-bodied with a large head, short looped arms with hands, and short legs. The eyes are appliquéd oval ridges with round pupils, the appliquéd nose is short and looped and the mouth is a large, thick-lipped appliquéd oval with teeth evident. Large earspools ornament the ears. Fingers and toes are indicated by grooving. A rounded cap decorated with geometric incised designs is depicted on the head, and there is a meander design of intertwined lines on the stomach. The back is decorated with a guilloche-filled rectangle and other geometric designs. A conical leg at the rear supports the figure. Firing vent holes were placed behind the ears and were also used for sound.

Guinea Incised (Nos. 11-19) is noted for the geometric designs incised on an orange-brown or red waxy slip. Modeled features, often zoomorphic, are commonly seen on bowls and jars. Its sculptural quality however does not equal the realism of the earlier Rosales Zoned Engraved.

Cf. Stone 1972, fig. 52, for similar figurines from Samara which Stone designates Orange-Brown and Red Wares with engraved geometric motifs associated with the crested alligator as serpent.

**OXTL analysis (ref. no. 381M8, 10/12/84) estimates that the sample tested was last fired between 1050 and 1920 years ago (AD 64-934).*

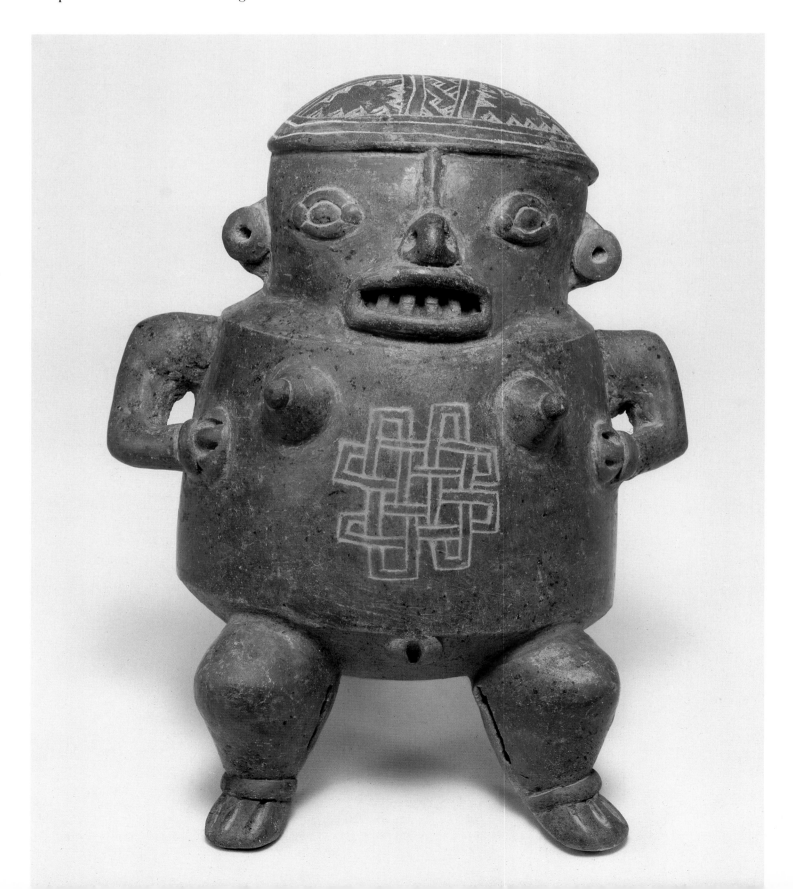

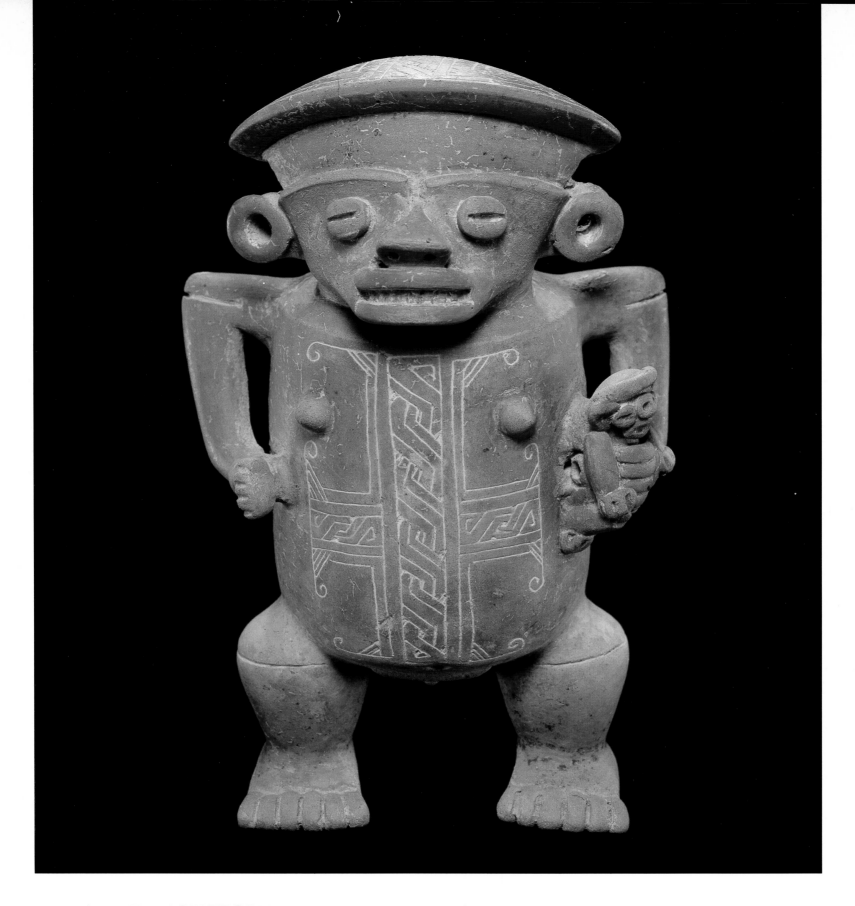

12. FEMALE EFFIGY FIGURE

Earthenware, light reddish body under a waxy orange-brown slip
Guanacaste-Nicoya Zone
Period IV (1000 BC-AD 500)
*Guinea Incised (AD 200-500)**
Height 8 1/8" (20.6cm) Width 5" (12.7cm) Depth 3 1/2" (8.9cm)
Condition before conservation: intact, root marks throughout
Accession no. N-1106

This standing female effigy figure is also barrel-bodied with a large head, squared shoulders, right arm hanging to the side, and short splayed legs with grooved knees. She holds a very small child in her left arm against her side. Coffee-bean-shaped eyes are appliquéd under ridged brows. The nose is broad with flaring nostrils, and the mouth is a large, thick-lipped rectangle with teeth evident. She wears a round, brimmed hat and hourglass-shaped earspools.

The front of her body is decorated with an incised geometric grid. The top of the hat is similarly decorated. There are vent holes above the ears.

Cf. Stone 1972, fig. 52, for a similar figurine that she designated as Red Ware from Samara.

**OXTL analysis (ref. no. 381M12, 10/12/84) estimates that the sample tested was last fired between 1540 and 2730 years ago (746 BC-AD 444).*

13. FEMALE EFFIGY FIGURE

Earthenware, buff body under a waxy orange-brown slip, burnished
Guanacaste-Nicoya Zone
Period IV (1000 BC-AD 500)
*Guinea Incised (AD 200-500)**
Height 8⅛" (20.6cm) Width 6⅝" (16.8cm) Depth 6½" (16.5cm)
Condition before conservation: bottoms of legs rebuilt; root marks
overall; rear legs reconstructed
Accession no. N-1129

The seated female effigy figure has a humpbacked, pigeon-breasted body supporting a large broad head. Facial features include button eyes, a small nose, and a thick-lipped rectangular mouth with protruding bottom lip. The ears contain earspools. The shoulders are pointed and the arms loop to the sides with hands on the waist. An appliquéd clay strip on either side of the chest emphasizes the deformity. Another appliquéd clay strip coils around the hump on the back. The figure sits on a stool, only the back legs of which are modeled. Firing vent holes are located behind the ears and in the back below the hump.

**OXTL analysis (ref. no. 381N75, 4/1/85) estimates that the sample tested was last fired between 1060 and 1830 years ago (AD 155-925).*

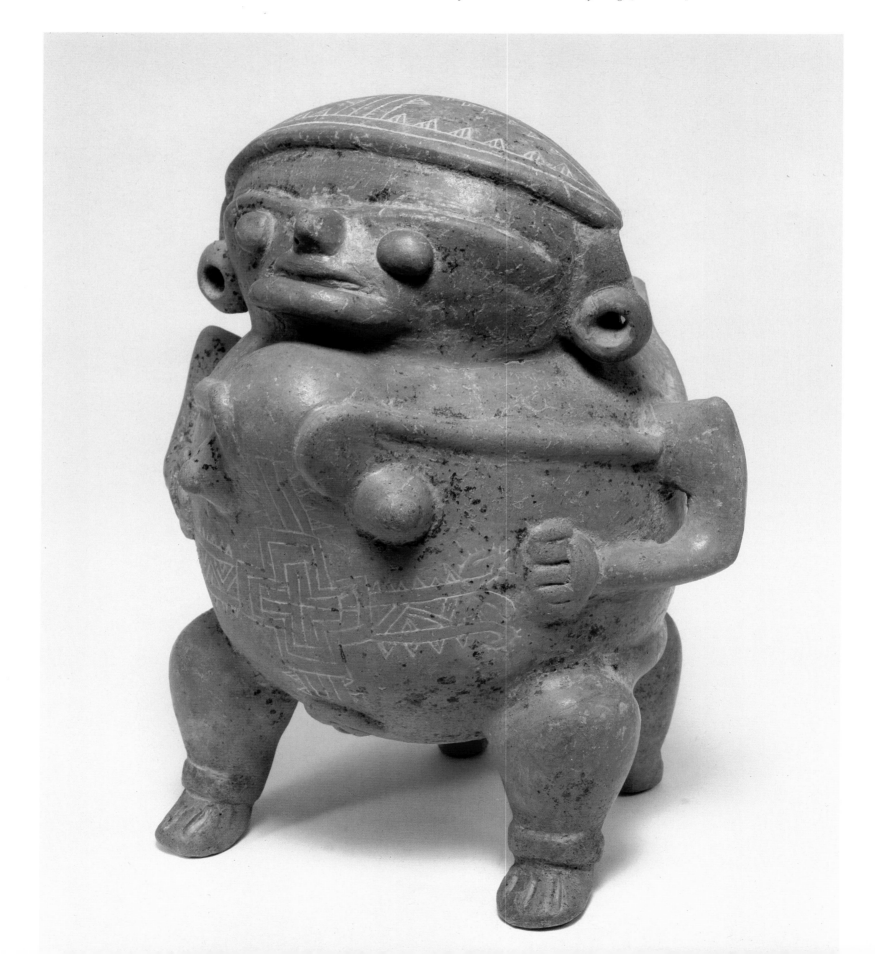

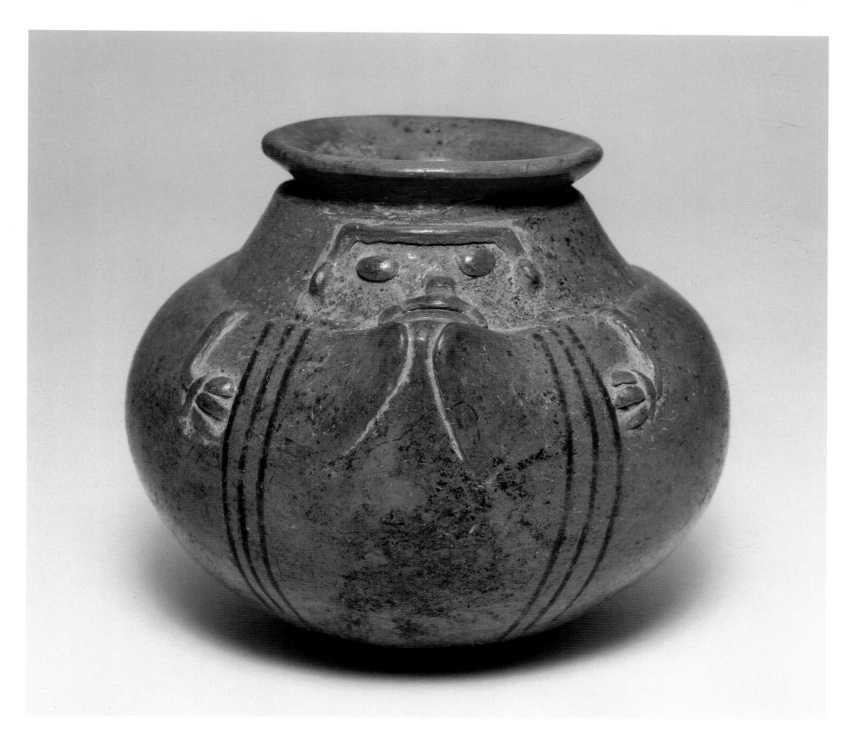

14. ANTHROPOMORPHIC EFFIGY VESSEL

Earthenware, brown clay body under a waxy orange-brown slip
Guanacaste-Nicoya Zone
Period IV (1000 BC-AD 500)
*Guinea Incised (AD 200-500)**
Height 5" (12.7cm) Width 5½" (14cm) Depth 6¼" (15.9cm)
Condition before conservation: intact, root marks through out
Accession no. N-1139

The upper body of this effigy vessel, like the previous effigy whistle, exhibits the same pigeon-breasted deformity in front and back. The otherwise rounded bowl curves in to a slanted collar which restricts to a very short neck under a wide mouth with flaring, rolled rim. A face with button eyes, nose and mouth framed by a rope-like bracket, is appliquéd on the front of the collar. Below the face, appliquéd arms with hands extend on either side of the body.

**OXTL analysis (ref. no. 381M85, 11/20/84) estimates that the sample tested was last fired between 1040 and 1830 years ago (AD 154-944).*

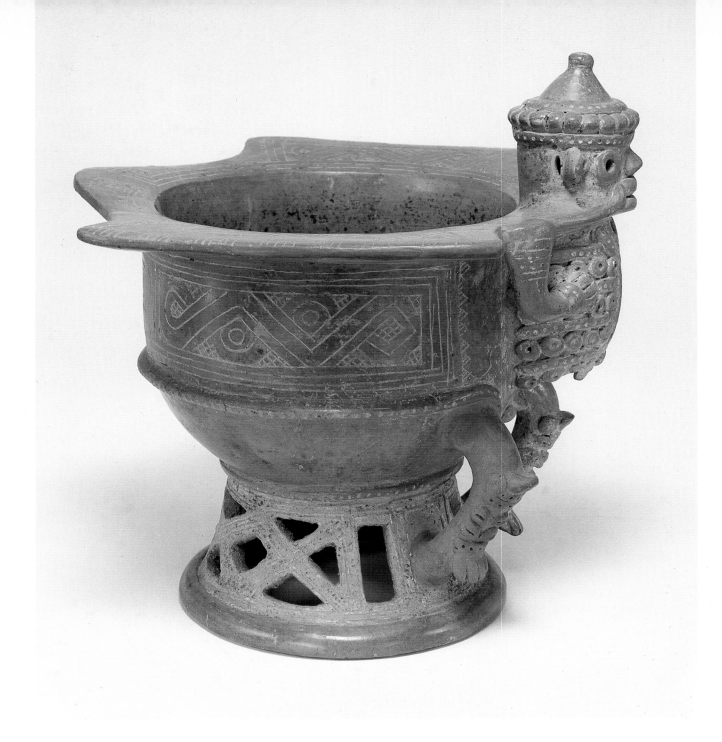

15. BOWL with human figure

Earthenware, light brown body under a waxy orange-brown slip, burnished
Guanacaste-Nicoya Zone
Period IV (1000 BC-AD 500)
*Guinea Incised (AD 200-500)**
Height 8¹/₈" (20.6cm) Width 7³/₄" (19.7cm)
Condition before conservation: part of front right flange on bowl rim
rebuilt; fracture across back rim and into bowl; right leg rebuilt
Accession no. N-1128

The deep bowl rests on a flared, incised and cutout pedestal.
The rim is flattened, flares slightly and forms a wide shelf
on either side. A male figure is attached to one side. The
figure's head is attached above the rim, the body is beneath.
His two arms loop from the shoulders which form part of
the rim, while the legs hang down from the vessel below a
horizontal flange encircling it. His eyes are round bead-like
appliquéd discs, and his mouth is a raised appliquéd rectan-
gle. He wears an ornately decorated conical hat with a top
button and a crown-like brim. He also wears earspools in his
earlobes, a necklace around his neck, bracelets on his arms
and leg ornaments. The body is covered with appliquéd
discs similar to the eyes. The vessel above the flange is com-
pletely covered with very intricate geometric incisings as is
the top of the rim. The flared pedestal has cutouts in rectan-
gular form in front, a diamond pattern at the rear, and is
left unslipped.

Snarskis has pointed out that Guinea Incised ceramics have
analogs in the Atlantic Watershed, and the modeled, appli-
quéd and incised technique seems to be part of the central,
southern and eastern Costa Rican tradition of plastic deco-
ration.[1] The best examples have a highly burnished waxy
brown-orange finish reminiscent of the Usulutan pattern in
Mesoamerica to the north. Both bats and alligators were
important deity figures in the period from AD 300-700.

1. Snarskis 1981, no. 54, for the vessel in the INS, acc. no. 4870 attributed to late
Period IV, which displays the figure arrayed as a bat, complete with mask, in
what might be a flying pose, with the scalloped rim of the vessel representing
wings which shows the figure costumed as an alligator but apparently retain-
ning wings. Its chest cavity is open, possibly, according to Snarskis, implying
ritual sacrifice.

**OXTL analysis (ref. no. 381N82, 4/1/85) estimates that the sample tested was last
fired between 1160 and 2110 years ago (125 BC-AD 825).*

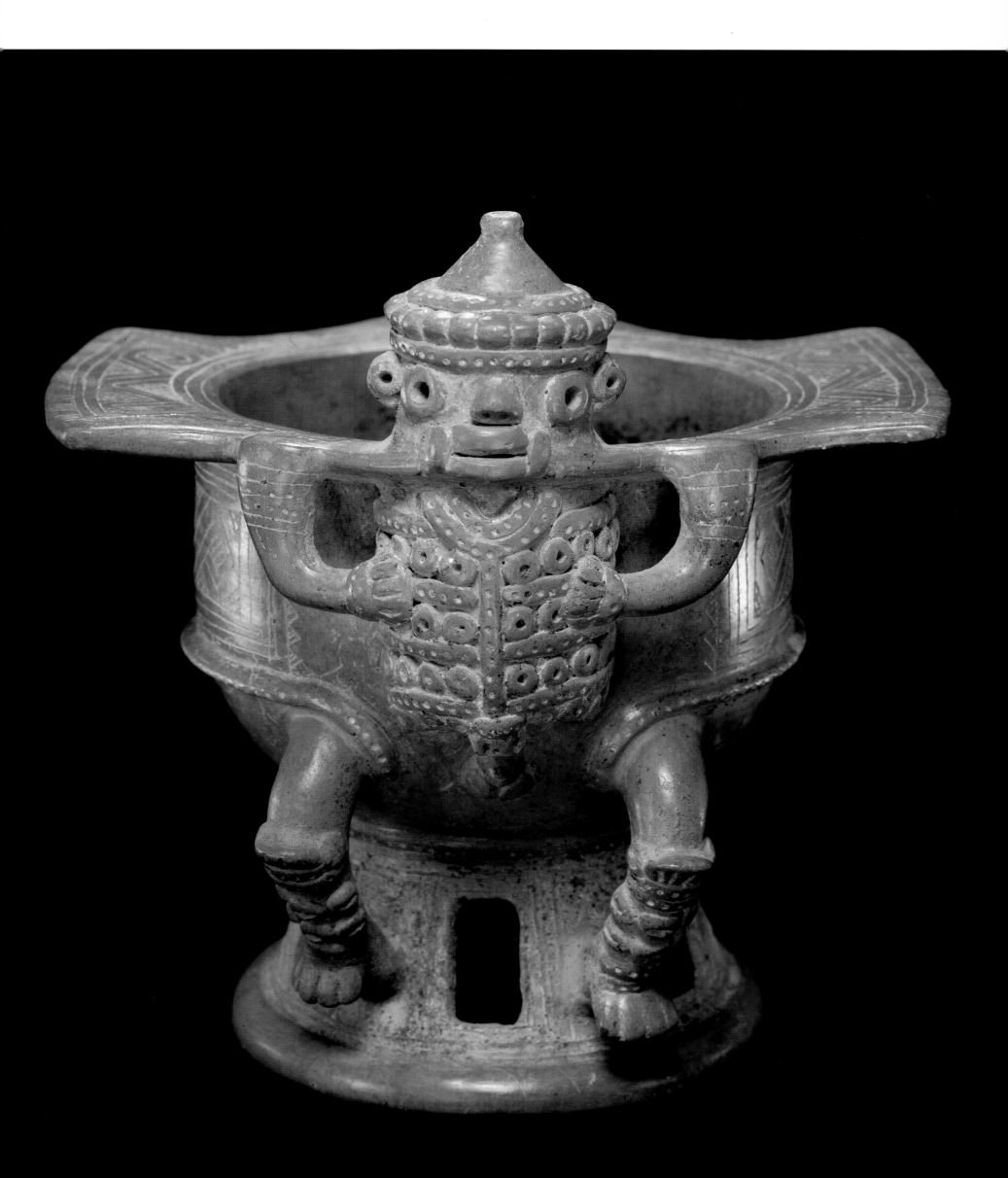

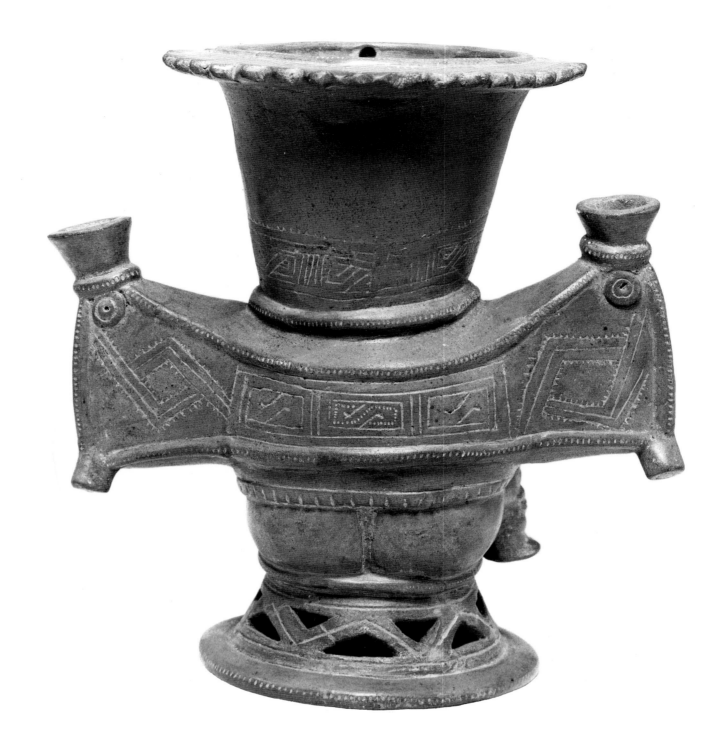

16. BAT EFFIGY VESSEL

Earthenware, light brown body under a waxy orange-brown slip, burnished
Guanacaste-Nicoya Zone
Period IV (1000 BC-AD 500)
*Guinea Incised (AD 200-500)**
Height 8⅛" (20.6cm) Width 8" (20.3cm) Depth 5¼" (13.3cm)
Condition before conservation: vessel had been broken into large
fragments and repaired in a former episode of restoration
Accession no. N-1150

The lower section of this vessel is modeled as a human fig-
ure, with wings outspread to resemble a bat, seated on a
flared cutout pedestal. The broad, hollow wings extend
from either side of the upper body and terminate in vertical
pillars. The figure's head is applied to the front of the body,
and the figure appears to be flying. It wears a hat, earspools
and shoulder and knee ornaments. The vessel's tall upper
body splays to a flattened, flaring rim serrated around the
edge. Intricate geometric incising decorates the figure's gar-
ments and wings as well as the remainder of the vessel.

Cf. Snarskis 1981, pl. 11 and fig. 54, for comparable treatment.
**OXTL analysis (ref. no. 381N79, 4/1/85) estimates that the sample tested was last*
fired between 1800 and 1340 years ago (AD 185-645).

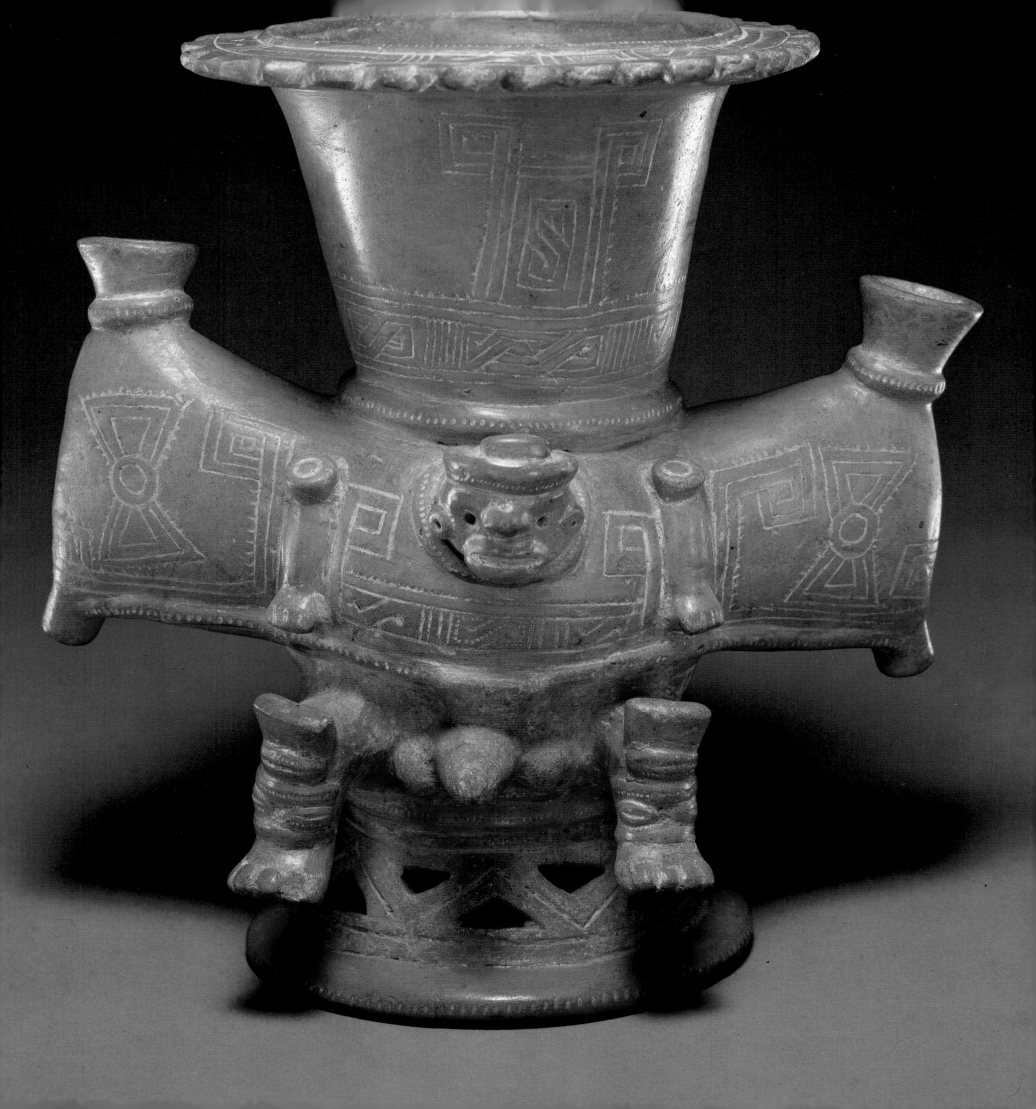

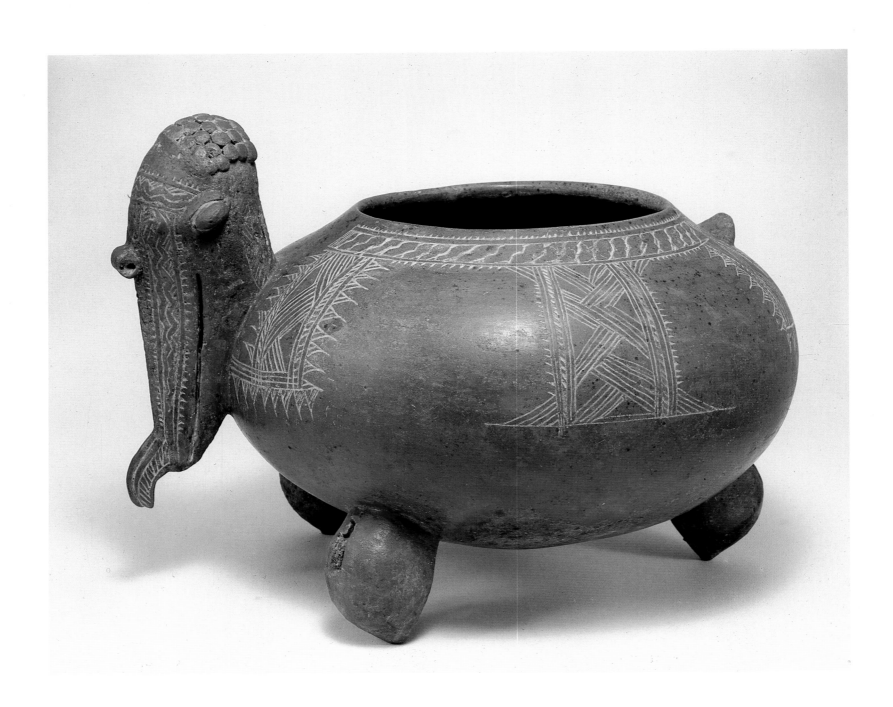

17. BOWL with pelican head

Earthenware, reddish clay under a waxy orange-red slip
Guanacaste-Nicoya Zone
Period IV (1000 BC-AD 500)
*Guinea Incised (AD 200-500)**
Height 8¾" (22.2cm) Width 10¼" (26cm) Depth 12⅛" (30.8cm)
Condition before conservation: some buttons missing from head;
paint worn
Accession no. N-1151

This rounded bowl curves in to a wide mouth and rests on
three gourd-shaped hollow legs. Appliquéd on the front is a
large stylized head of a pelican with button eyes and ears.
A small tail is attached to the opposite side of the bowl. The
pelican's head and beak are incised as is the bowl which has a
border filled with incised oblique wavy lines below the rim
and vertical panels of intricate, lacy geometrics on the side
which may represent wings and feathers.

**OXTL analysis (ref. no. 381N87, 4/1/85) estimates that the sample tested was last
fired between 1750 and 3120 years ago (1135 BC-AD 235).*

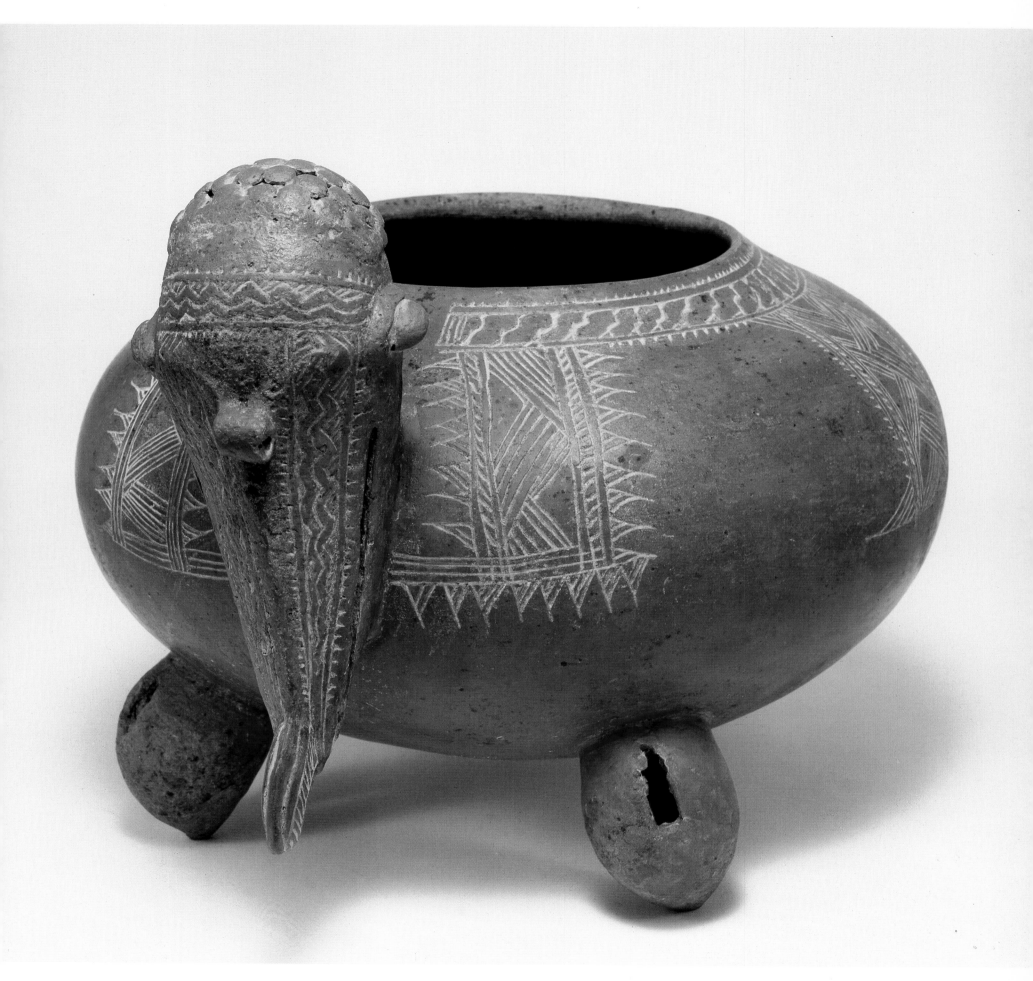

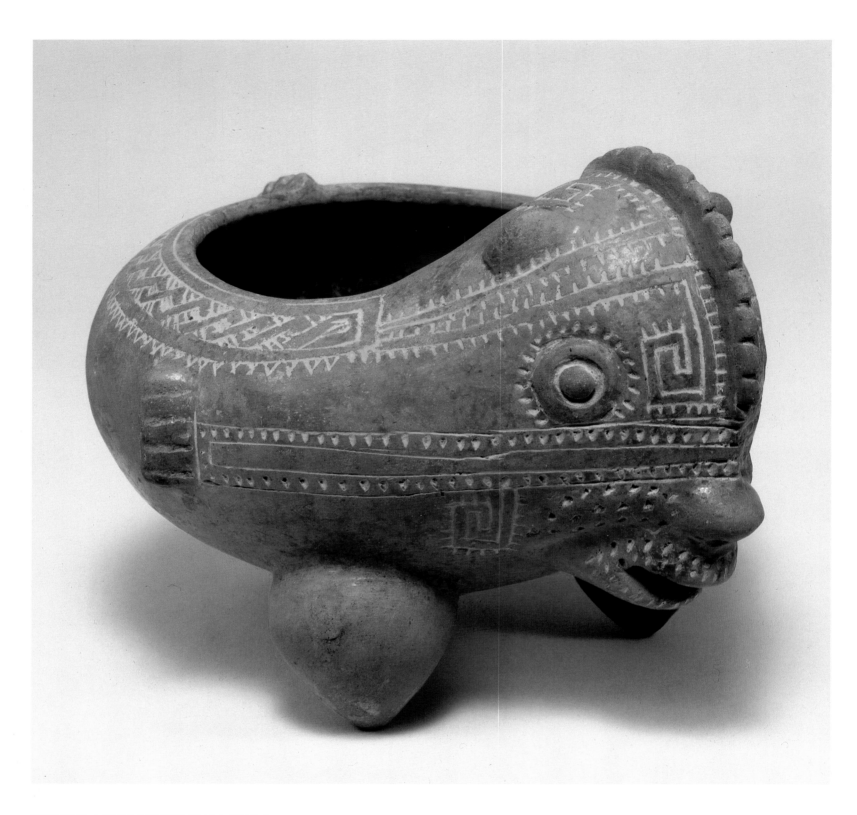

18. PECCARY EFFIGY VESSEL

Earthenware, buff clay under a waxy orange-brown slip
Guanacaste-Nicoya Zone
Period IV (1000 BC-AD 500)
*Guinea Incised (AD 200-500)**
Height 5" (12.7cm) Width 6⅛" (15.6cm) Depth 7½" (19.1cm)
Condition before conservation: minor surface abrasions;
rear leg restored
Accession no. N-1123

A highly stylized peccary is the form for this tripod bowl on hollow, gourd-like legs. The modeled peccary head forms one end of the bowl whose rim curves up to form the back of the head. The peccary has a stylized face with concentric circle eyes, a modeled nose, an open mouth, tab ears and a serrated crest. At the opposite end of the bowl is his tail. Around the rim is a finely incised guilloche border. Additional geometric bands ornament the face, body, and tail.

Cf. Snarskis 1981, no. 56, in the MNCR, acc. no. 23139, described as late Period IV, circa AD 300-500; and Ferrero 1977, pl. xxiv, also in the MNCR, acc. no. 23122, for a bowl in the form of a *sahíno* with incised and pastillage decoration.
**OXTL analysis (ref. no. 381M72, 11/20/84) estimates that the sample tested was last fired between 930 and 1650 years ago (AD 334-1054).*

19. IGUANA EFFIGY VESSEL

Earthenware, buff clay under a waxy orange-brown slip
Guanacaste-Nicoya Zone
Period IV (1000 BC-AD 500)
Guinea Incised (AD 200-500)
Height 5¹⁄₈″ (13 cm) Width 5⁷⁄₈″ (14.9 cm) Depth 8″ (20.3 cm)
Condition before conservation: head and legs broken and repaired
Accession no. N-915

This rounded bowl curves in to the rim and rests on three hollow, gourd-like legs. A stylized iguana head with round button eyes, thick brows, a thick-lipped wraparound mouth, an arched serrated crest on top of the head and a similar element from the top lip to below the mouth is attached to one side. A notched band runs horizontally around the shoulder of the vessel and is interrupted at the back to form a scroll around the tail. A rim band with interlocking hook design encircles the mouth of the vessel. There is additional incising on the head of the iguana.

Cf. Snarskis 1982, p. 33, for a Guinea Incised avian effigy bowl in the INS with decorative mouthrim and notched appliquéd strips on the legs; and Stone 1972, p. 173, for another with extended decorative mouthrim and an articulated bird head.

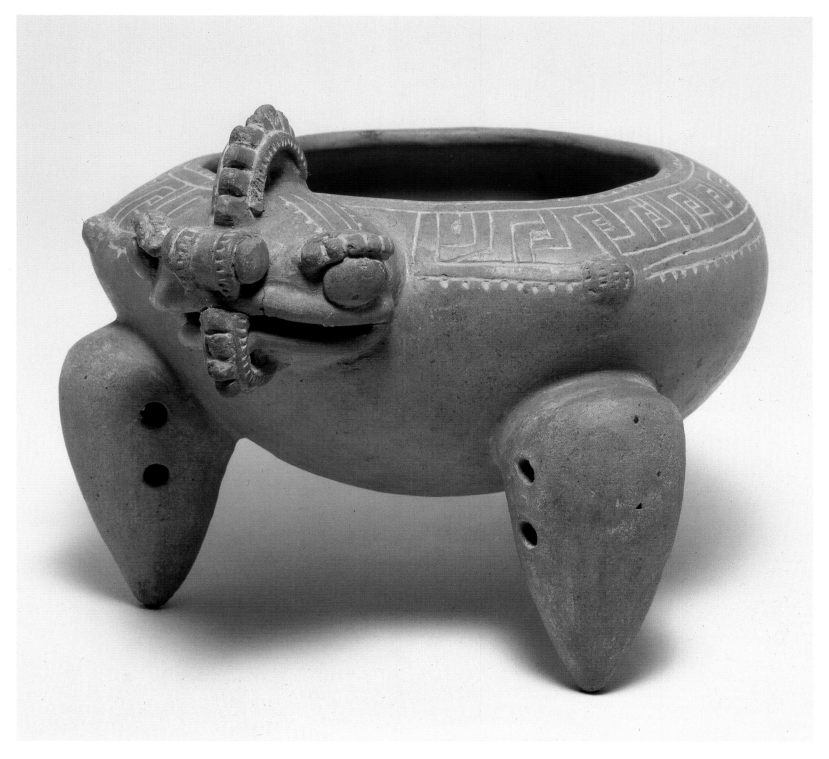

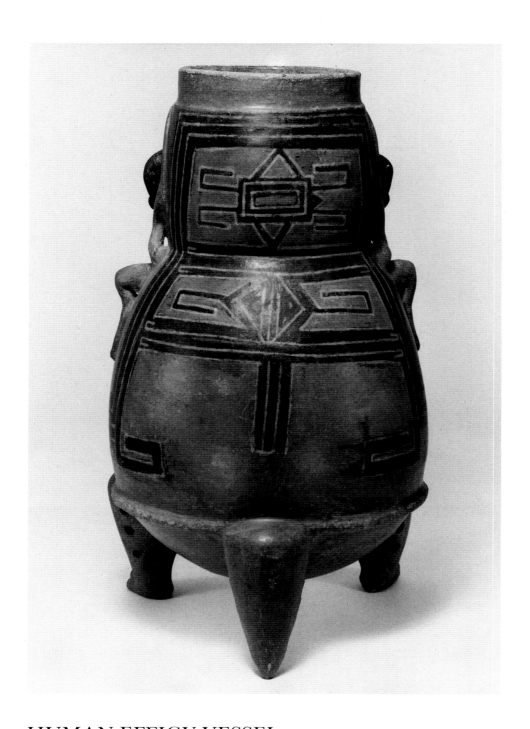

20. HUMAN EFFIGY VESSEL

Earthenware, buff clay body under a red slip, burnished, painted with black bordered with white
Guanacaste-Nicoya Zone
Period IV (1000 BC-AD 500)
*Tola Trichrome (AD 200-500)**
Height 17" (43.2cm) Width 9³⁄₈" (23.8cm) Depth 10⁵⁄₈" (27cm)
Condition before conservation: one leg, hands, tip of nose and tip of chin rebuilt
Accession no. N-1124

This large male effigy vessel has a barrel-shaped body supporting a large head. It rests on three conical, hollow legs with perforations. The figure is decorated with both appliqué and painting. The large eyes are almond-shaped with large pupils. The nose is modeled and the mouth is a ridged rectangle with prominent teeth. The ears hold earspools. Curious tufts protrude from either side of the mouth. A ribbon appliqué encircles the head and drops behind the

ears. Rudimentary arms are appliquéd on either side of the body. Black paint covers the face except for mouth, earspools and tufts. The black continues on the chest as a V-shaped collar. Geometric alligator patterns decorate the body.

Tola Trichrome, as in this vessel and Numbers 21 and 22, combines modeled and appliquéd decoration with a metallic black paint and white painting on a zoned red slip. First named Lopez Trichrome in Costa Rica, Tola Trichrome appeared in the Greater Nicoya area of Nicaragua and Costa Rica and was widely traded. An affinity between it and ceramic styles further north has been suggested, but a relationship with pottery from Santa Maria and Venado Beach, Panama is also suspected.[1]

1. Baudez 1967, pp. 207-208; Baudez and Coe 1962, p. 369; and Stone 1977, p. 55. Cf. Stone 1977, fig. 69, for a similarly formed figure which Stone designates Nicoya Black-line or Nosara Polychrome human effigy figurine from Guanacaste (H. 28.5cm) and which has similar painted designs.
**OXTL analysis (ref. no. 381L81, 9/11/84) estimates that the sample tested was last fired between 1490 and 2480 years ago (496 BC-AD 494).*

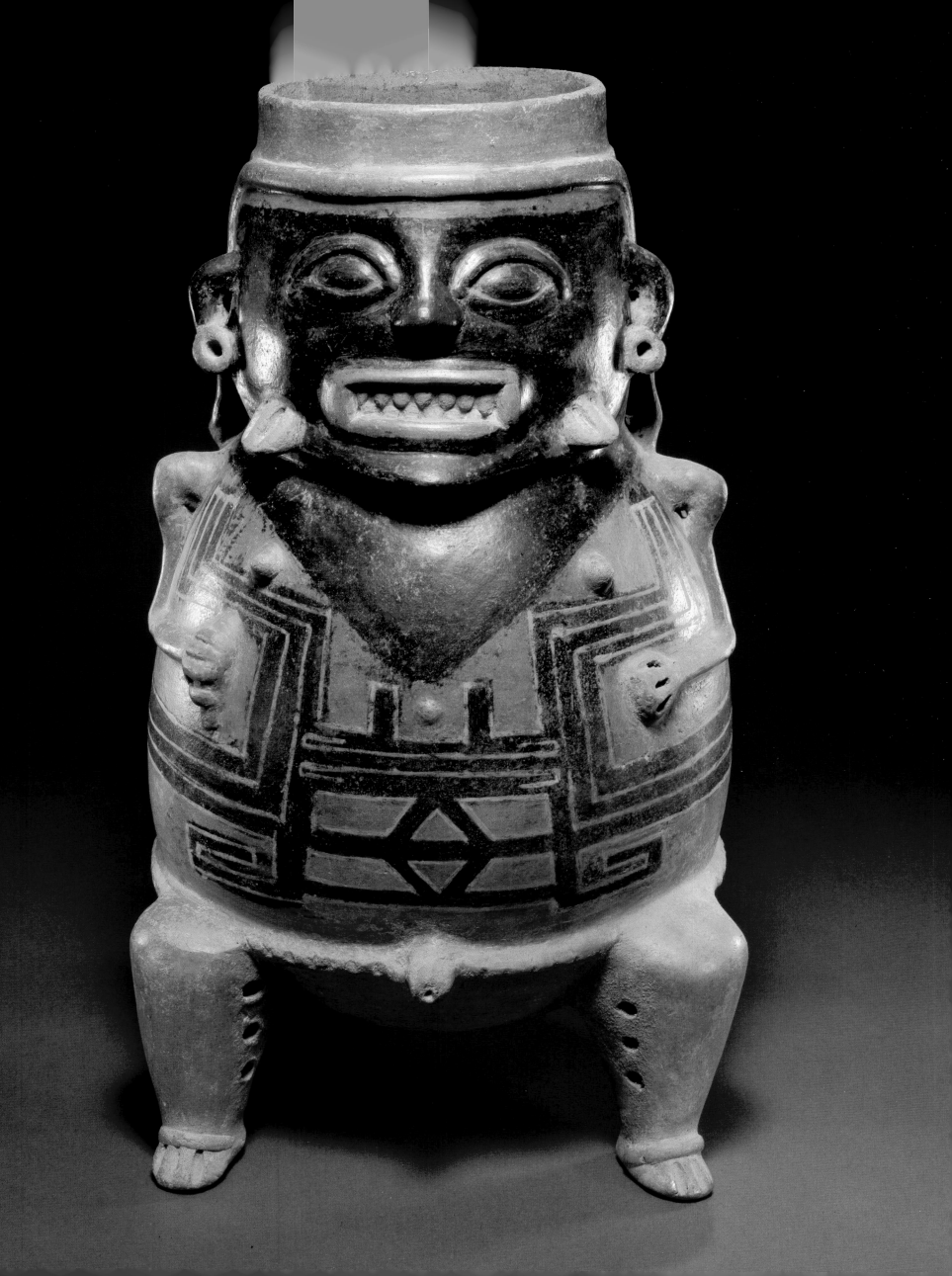

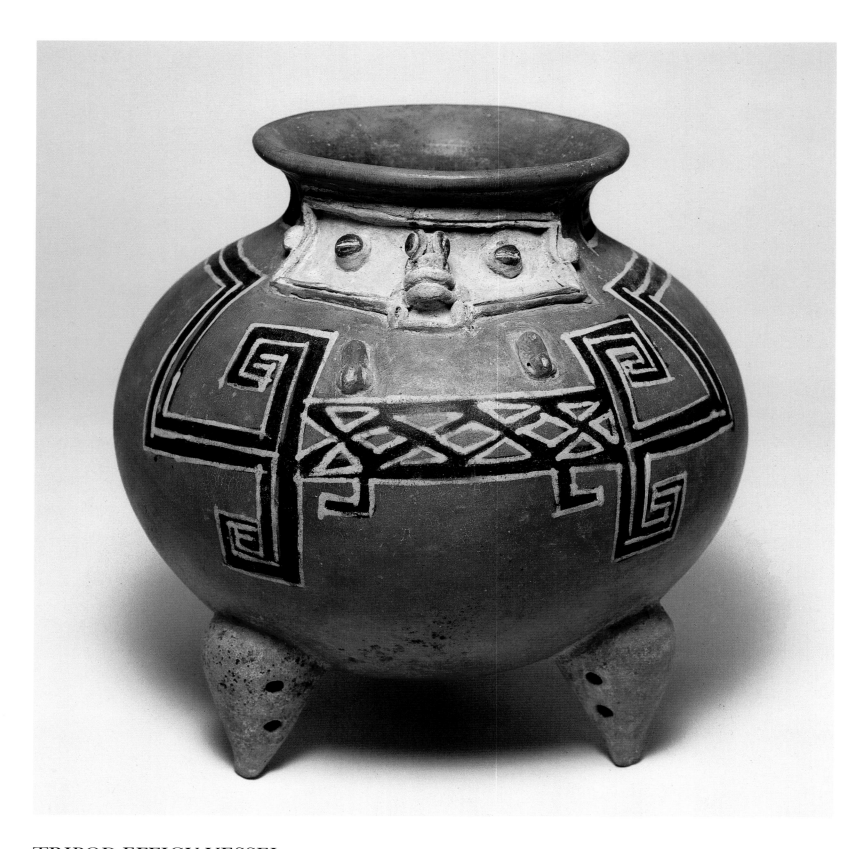

21. TRIPOD EFFIGY VESSEL

Earthenware, buff clay body under a red slip, burnished,
with black and white paint
Guanacaste-Nicoya Zone
Period IV (1000 BC–AD 500)
*Tola Trichrome (AD 200-500)**
Height 10³/₈" (26.4cm) Diameter 10¹/₂" (26.7cm)
Condition before conservation: cracked and repaired; small surface chips
throughout
Accession no. N-888

This large globular vessel has a wide neck with a thickened,
everted rim and rests on three conical, perforated legs.
Appliquéd on the shoulder and neck, is a wide mask. Heavy
black and white lines painted on the vessel fall at right angles
from the vessel's shoulder to create a stylized geometric
alligator design across the waist.

Cf. Snarskis 1981, no. 70, in the Collection Carmen de Gillen, for a Tola Tri-
chrome effigy vessel with a stylized image of a human being costumed as an
alligator which has more modeled detail but whose painted body motifs are
similar to those on the Sackler vessel; also Snarskis 1982, p. 35, for a somewhat
similar Tola Trichrome effigy jar in the INS showing a human costumed as a bat,
but without the tripod legs.

**OXTL analysis (ref. no. 381L25, 8/1/84) estimates that the sample tested was last fired*
between 1450 and 2250 years ago (266 BC–AD 534).

22. EFFIGY JAR with zoomorphic head

*Earthenware, reddish clay body under a red slip, burnished,
with black and white paint*
Guanacaste-Nicoya Zone
Late Period IV (1000 BC-AD 500)
*Tola Trichrome (AD 200-500)**
Height 11⅛" (28.3cm) Width 11" (27.9cm) Depth 10⅞" (27.6cm)
Condition before conservation: broken and repaired
Accession no. N-910

This large globular vessel curves in to a wide neck and expands again to an everted, thickened mouthrim. Appliquéd on the front above the shoulder is a zoomorphic head. A wide, highly stylized band of geometric patterning edged in white stretches around the vessel from the head. Below the head are two geometric legs with their counterparts on the back. The wide band with a diamond design and a narrow, black band with white dots represent alligator motifs. The combination of human and alligator or bat traits probably signifies a transmogrification characteristic of shamanistic practices in many primitive cultures.[1]

1. Snarskis 1981, no. 71, p. 190.
Cf. Snarskis 1982, p. 35, for a Tola Trichrome effigy jar in the INS showing a human costumed as a bat; and Ferrero 1977, Ilus. I-27, for another without legs and with painted designs similar to the Sackler vessel in the MNCR, acc. no. 23.048.

**OXTL analysis (ref. no. 381p 68, 4/3/85) estimates that the sample tested was last fired between 1100 and 1900 years ago (AD 85-885).*

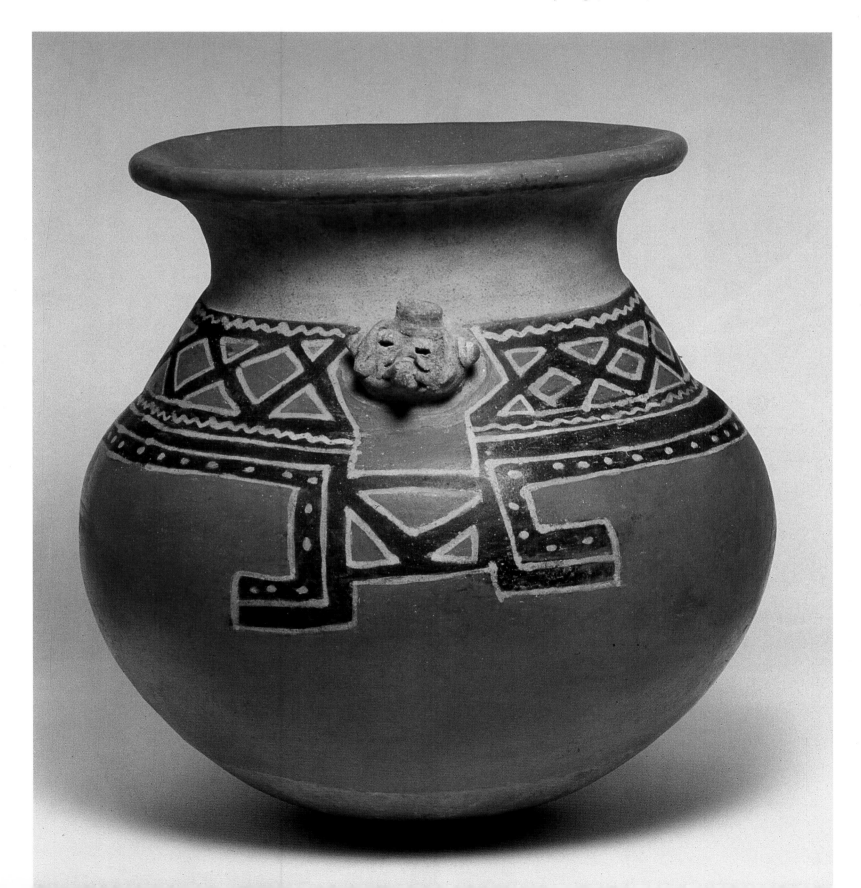

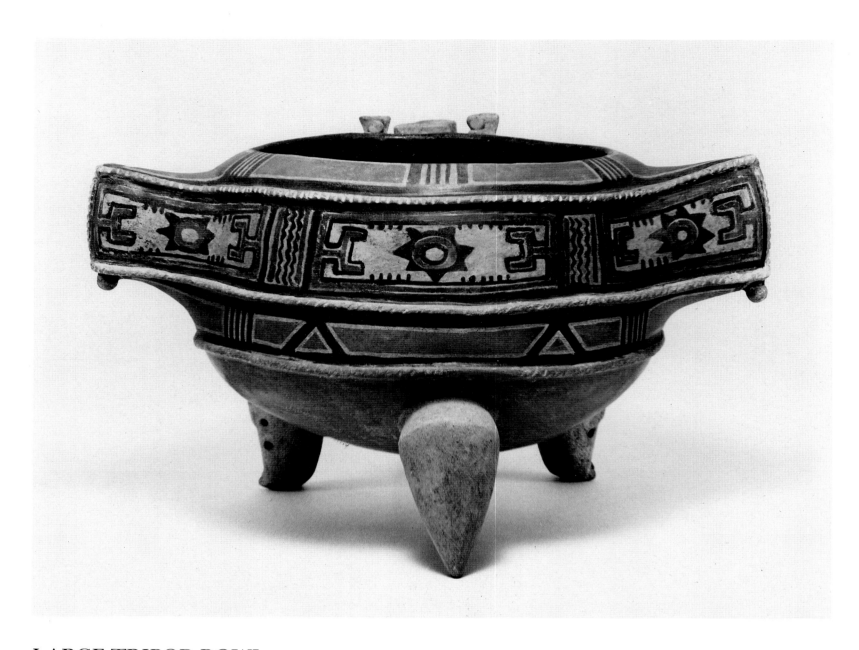

23. LARGE TRIPOD BOWL

Earthenware, red brown body under a red slip, burnished,
with black and cream paint
Guanacaste-Nicoya Zone
Period V (AD 500-1000)
*Carrillo Polychrome (?) (AD 500-800)**
Height 10 ⅜" (26.4cm) Diameter 17" (43.2cm)
Condition before conservation: repaired from large fragments
Accession no. N-1177

The large, deep tripod bowl rises from a curved bottom
with slightly convex sides curving in at the mouthrim. A
raised serrated ridge encircles the vessel where the curved
bottom meets the sidewalls. Appliquéd on the front is an
anthropomorphic head which juts out near the top of an
intricate panel formed with strips and daubs of clay
into a textured grill which is left in the natural buff clay.
Triangular projections extend on either side of the bowl.
Above and below the wing-like extensions are raised ser-
rated borders. The front legs of the vessel are modeled as
decorated human legs, and they together with the anthropo-
morphic head and the wing-like extensions heighten the
impression of a flying man masked and dressed in a bat
costume. Two posts rise from the mouthrim on either side
of the modeled head. The vessel is painted with black and
white geometric designs and alligator related motifs.

Cf. Ferrero 1977, pl. Ib, for a zoned bichromed bat effigy vessel in the Molinas
Collection, Costa Rica; and Ilus. I-46, p. 81, for a vessel in the MNCR with the
representation of an anthropomorphicized bat said to be from Bagaces.
**OXTL analysis (ref. no. 381n 77, 3/22/85) indicates that the sample tested was too*
insensitive and a determination of last firing could not be made.

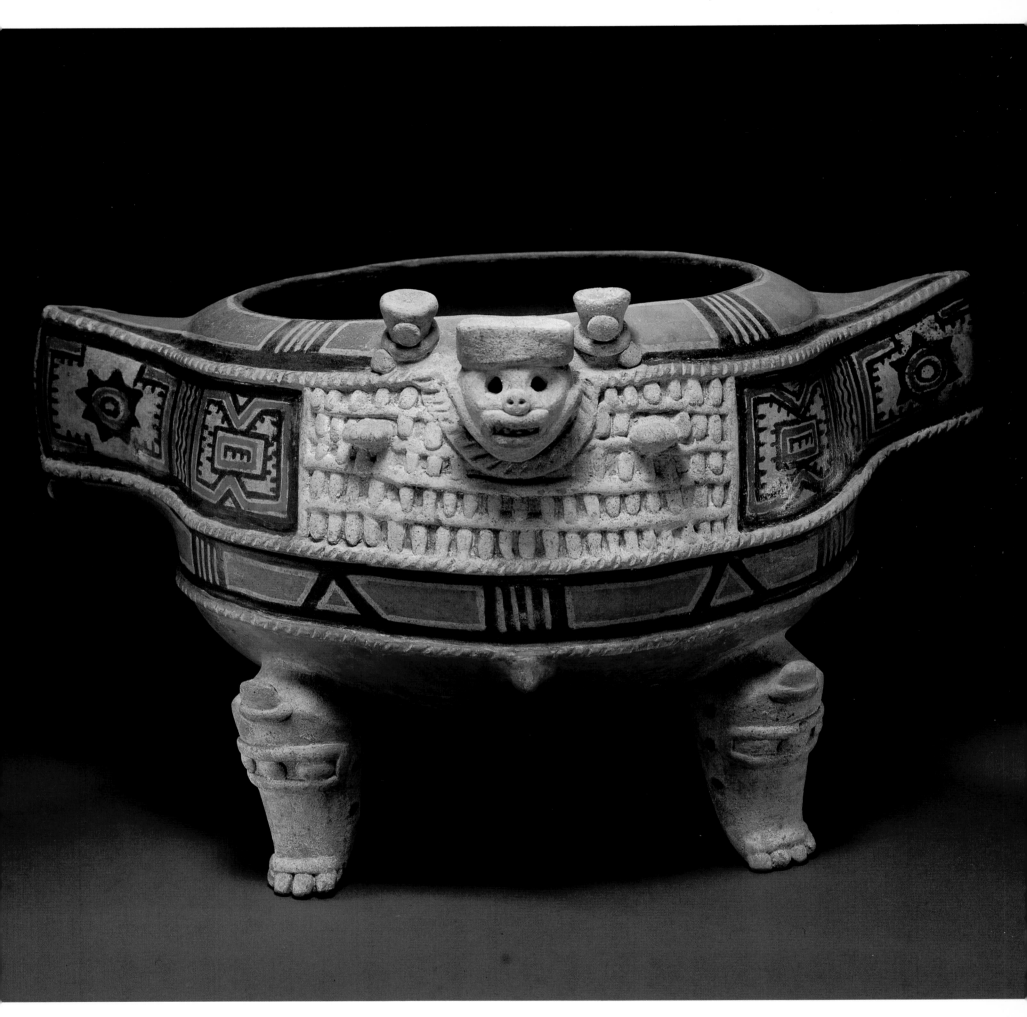

95

24a. RING BASE BOWL with face

*Earthenware, brownish clay body under a creamy-buff slip, burnished,
with black and red paint*
Guanacaste-Nicoya Zone
Period V/VI (AD 500-1550)
*Carrillo Polychrome (?) (AD 500-800)**
Height 10" (25.4cm) Diameter 11½" (29.2cm)
Condition before conservation: cracked and needed cleaning;
Accession no. N-1147

This large, round-bottomed bowl, which curves in slightly to
the thickened mouth rim, rests on four legs with appliquéd
faces attached to a ring base. Appliquéd on one side of the
body is a large face with button eyes under ridged brows, a
small nose and a rectangular mouth with prominent teeth.
The entire face mask is framed by an appliquéd ribbon of
clay. In addition, the upper part of the mask is edged with
an appliquéd serrated border extending down to the ears.
The face is also framed and decorated with heavy black lines

and black geometric bands. Black-bordered rectangles
enclosing red and black alligator motifs are painted on the
rest of the vessel.

Carrillo Polychrome (Nos. 23, 24 a, b, 25) was perhaps the
first polychrome type in Greater Nicoya. It is found in asso-
ciation with Zoned Bichrome ceramics presumed to date
before AD 500 and therefore seems to be the earliest. The
type shares many motifs with Tola Trichrome, particularly
the big geometric patterns that probably symbolize bats and
alligators. Typically, Carrillo Polychrome is painted red,
maroon and black on polished buff, or light brown and
cream slip, and decorated with cayman or alligator imagery
transformed into an abstracted geometric symbol. The Car-
rillo Polychrome attribution on this vessel is based primarily
on such imagery as appears on this vessel although the
result of TL analysis does not indicate the early date associ-
ated with the type.

**OXTL analysis (ref. no. 381L88, 9/11/84) estimates that the sample tested was last
fired between 510 and 830 years ago (AD 1154-1474).*

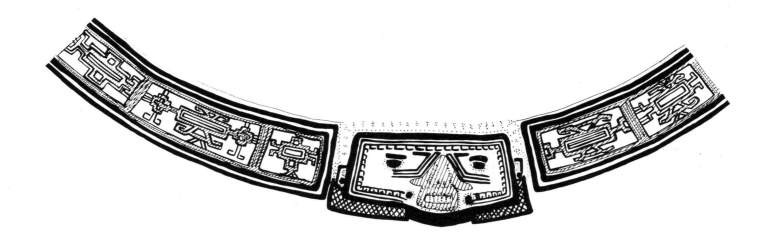

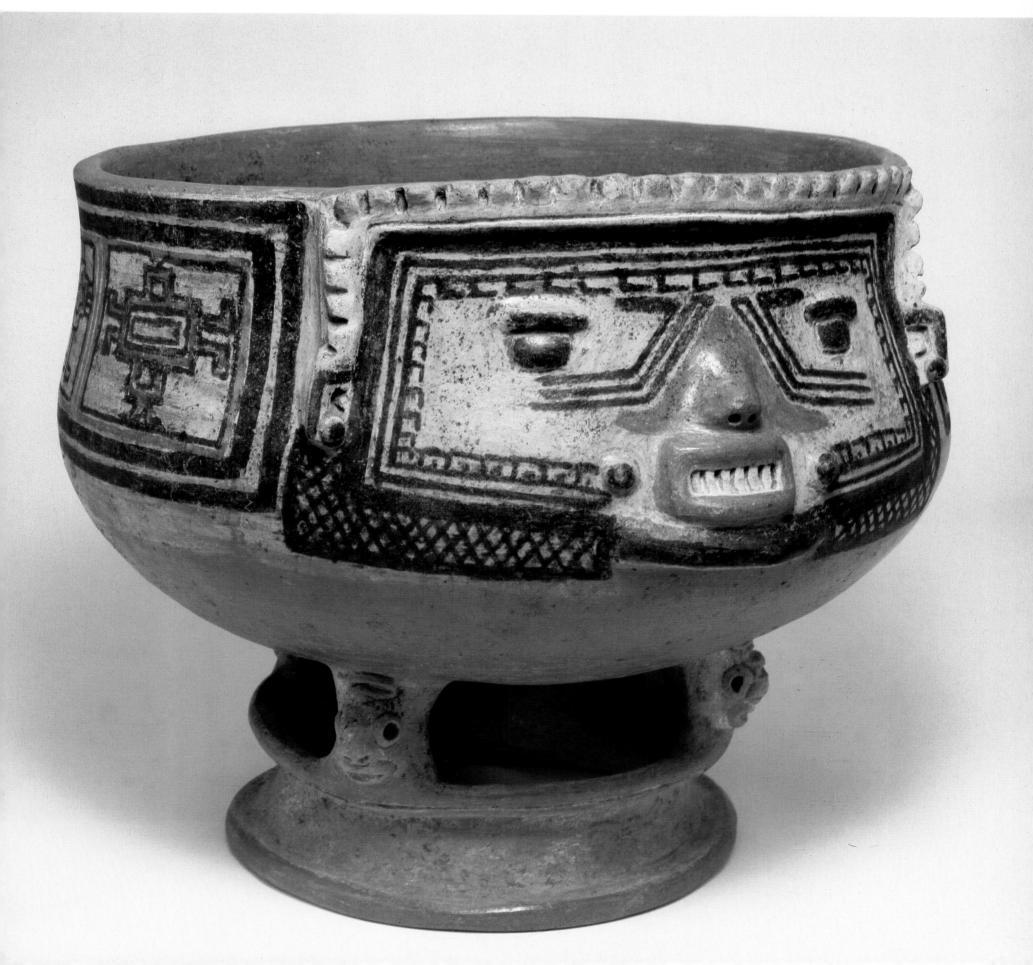

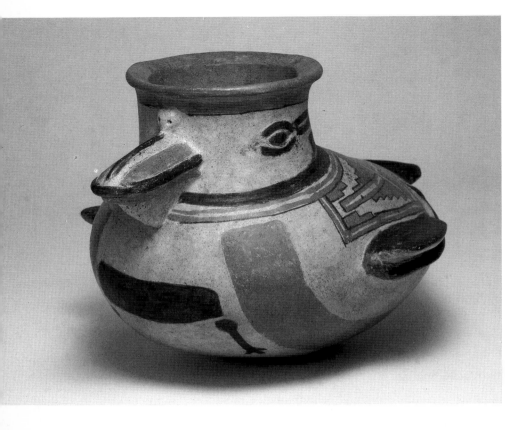

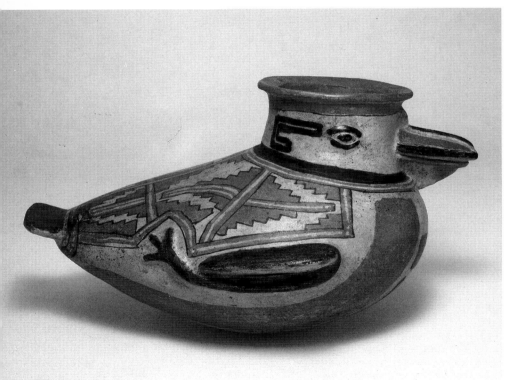

24b. DUCK EFFIGY VESSEL

Earthenware, brownish clay body under an orange-tan slip, burnished,
with black and maroon paint
Guanacaste-Nicoya Zone
Period V/VI (?) (AD 500-1550)
Carrillo Polychrome (?) (AD 500-800)
Height 7¼" (18cm) Width 9" (22.5cm) Length 13¼" (33cm)
Condition before conservation: broken and repaired
Accession no. N-1179

The realism of this duck effigy is achieved even with the generalization of form and its limited detail. Only the essentials of bill, eye, tail and wing are modeled. Body parts are further emphasized with paint. The curve of the duck's underbody is emphasized by the sweeping red band on either side from breast to tail. A geometric design is drawn on the back possibly indicating feathers but rendered as echoing step patterns in maroon against the orange-tan slip and outlined in black. The big geometric pattern may however relate to the alligator motif.

The closest analogies for this vessel are Numbers 24a and 25. The vessel falls among the ceramics of the tan slipped polychrome tradition in the Guanacaste-Nicoya Zone. These tan slipped polychromes, hard fired and highly polished, are known as Guanacaste Ware, a type which began in the Early Polychrome Period (AD 500-800), reached its zenith in the Middle Polychrome Period (AD 800-1200), and finally disappeared with the advent of the Late Polychrome Period (AD 1200-1500).

As this catalogue was going to press, the results of thermoluminescence analysis of the sample tested from this vessel had not yet been determined, consequently it is difficult to attribute a date to the vessel. In Number 24a, the Carrillo attribution with its purported dates of AD 500-800 did not correlate with the estimate of last firing derived from the thermoluminescence analysis of its clay sample, and this vessel is most closely associated with Number 24a. Galo and Carrillo Polychromes died out at the end of the Early Polychrome Period but related tan slipped ceramic types of the Middle Polychrome Period carried on the established tradition. From the results of the TL analysis of Number 24a however it seems the tradition continued to the end of the Late Polychrome Period as well.

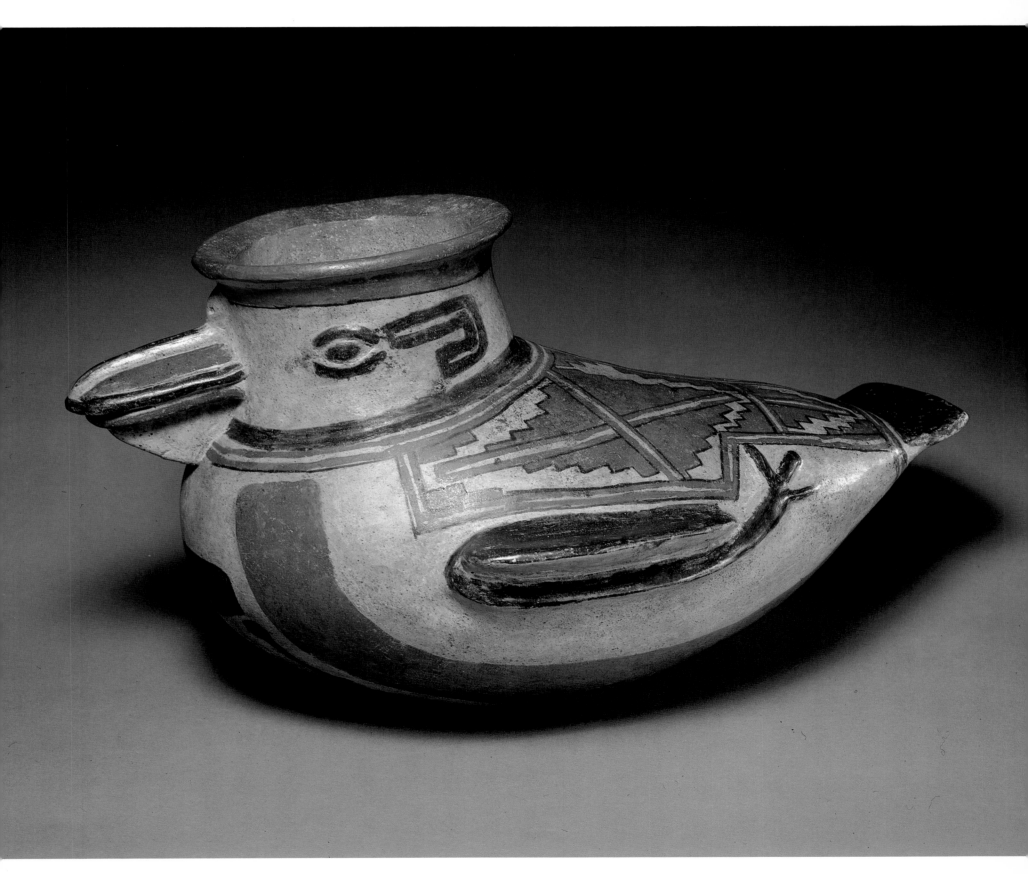

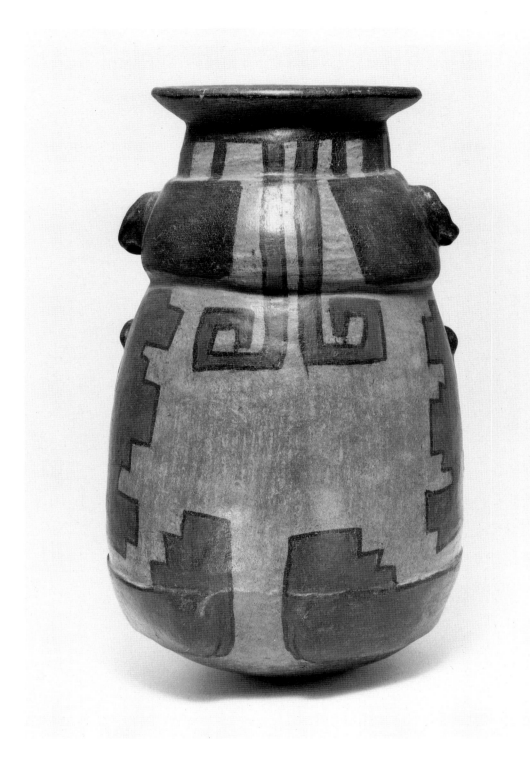

25. EFFIGY JAR

Earthenware, buff clay body under an orange-tan slip, burnished,
with black, red, orange and buff paint

Guanacaste-Nicoya Zone

Period V/VI (AD 500-1500)

*Carrillo Polychrome(?) (AD 500-800)**

Height 13¾" (35cm) Diameter 8" (20.3cm)

Condition before conservation: chips on mouth, chin, and finger
of right hand

Accession no. N-1157

This large effigy vessel is minimally modeled as an anthro-
pomorphic figure. The barrel-shaped body supports a large
wide head, the recessed upper portion of which with its
flared rim forms the figure's hat. Button eyes and raised

brows, the rounded nose with prominent nostrils, the wide-
lipped, rectangular mouth and lobed ears bearing ear orna-
ments are all appliquéd onto the vessel's surface, as are the
modeled breasts and the long arms, with the hands on the
waist. Short legs attached to the lower section of the barrel
body bend at the knees as in a squatting position and form
the vessel's front legs. Modeling or appliquéd detail is
accented by painting outlined in black.

This vessel is unique among published examples of Costa
Rican ceramics. Its form and design illustrate the potter's
creative imagination in imposing content on an ordinary
barrel-shaped ceramic vessel. Its TL analysis puts it into a
closer association with the presumed dating of Carrillo
Polychrome.

**OXTL analysis (ref. no. 381L37 8/1/84) estimates that the sample tested was last fired*
between 830 and 1370 years ago (AD 674-1154).

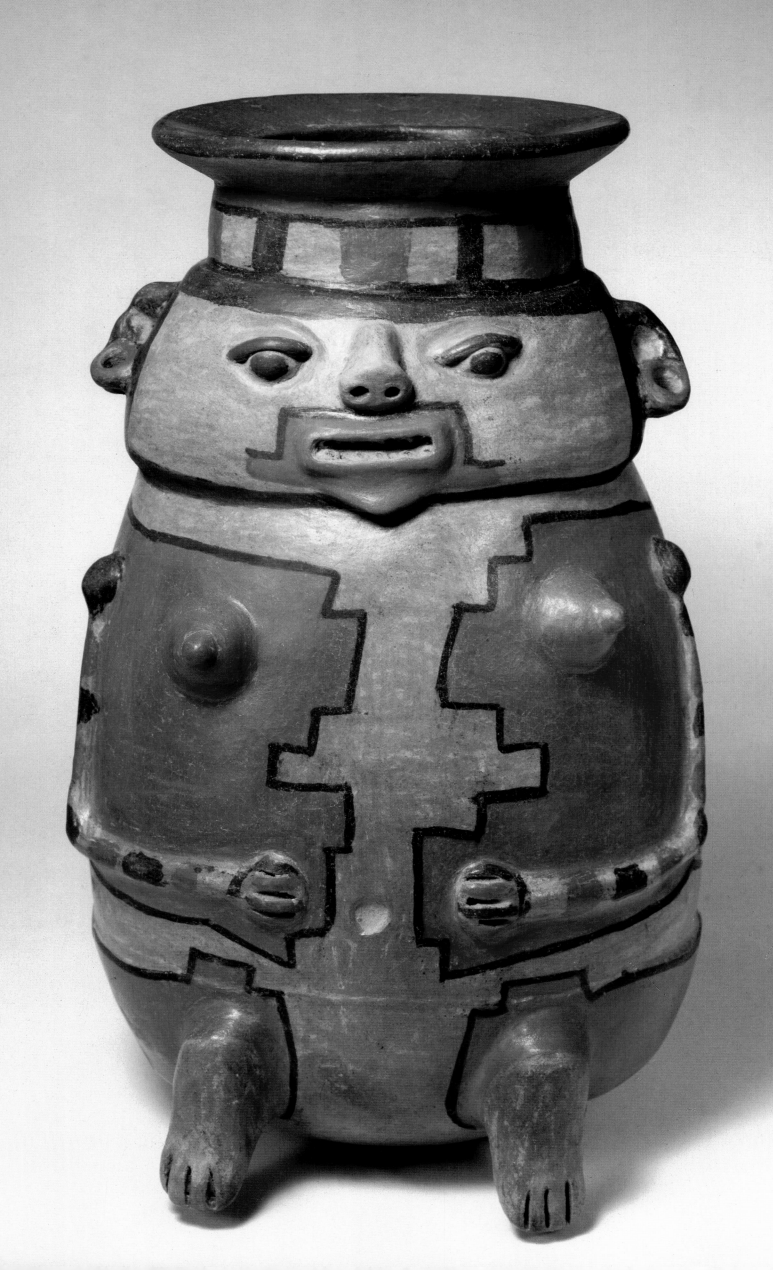

26. JAR with alligator motifs

*Earthenware, brownish clay body under an orange slip, burnished,
with red and black paint*
Guanacaste-Nicoya Zone
Period V (AD 500-1000)
*Galo Polychrome (AD 500-800)**
Height 7³⁄₈" (18.7cm) Diameter 7¹⁄₂" (19.1cm)
Condition before conservation: minor cracks and chips
Accession no. N-911

This large round-bottomed jar curves in from a bulbous
lower body to a slightly tapered neck. Decoration is effected
by both incising (or engraving) and painting. On the orange-
slipped walls of the lower body, grooved parallel diagonal
lines form diamonds and triangles around grooved circles
with carved- or gouged-out centers. The shoulder of the
vessel is decorated with the same circles within horizontal
grooved outlines. A design in red and black, probably of
alligator motifs, is painted on the neck.

Such vessels (Nos. 26-30) are among the best examples of
the potter's art in Costa Rica during Period V. The mirror-
bright burnished surface is unsurpassed by any Pre-Colum-
bian pottery and the colors in the decoration are vivid. Galo
Polychromes also incorporated alligator motifs, depicting
them however in a new, more realistic way, as opposed to the
abstract symbolism on Carrillo Polychromes. They also
introduced into Greater Nicoya a major new iconographic
theme: a jaguar image painted in a comparatively realistic
manner. Galo Polychrome figurines are rendered quite real-
istically and human faces on figurines or vessels are excep-
tionally expressive. In style, Galo is closely related to the
Ulúa polychromes found in Western Honduras and El
Salvador and may have been a product of Mesoamerican
influence.

Cf. Snarskis 1982, p. 45, for a similar modeled and painted vessel in the INS;
Stone 1977, fig. 217, for a jar combining Nicoya polychrome and incising, from
La Fortuna site, San Carlos plains, Atlantic Watershed Zone, apparently a trade
item from the Guanacaste-Nicoya Zone; and Baudez 1970, pl. 52, for a pottery
vase in the Juan Dada Collection, San José, Costa Rica, from Nacascolo,
Guanacaste.

**OXTL analysis (ref. no. 381N81, 4/1/85) estimates that the sample tested was last
fired between 870 and 1450 years ago (AD 535-1115).*

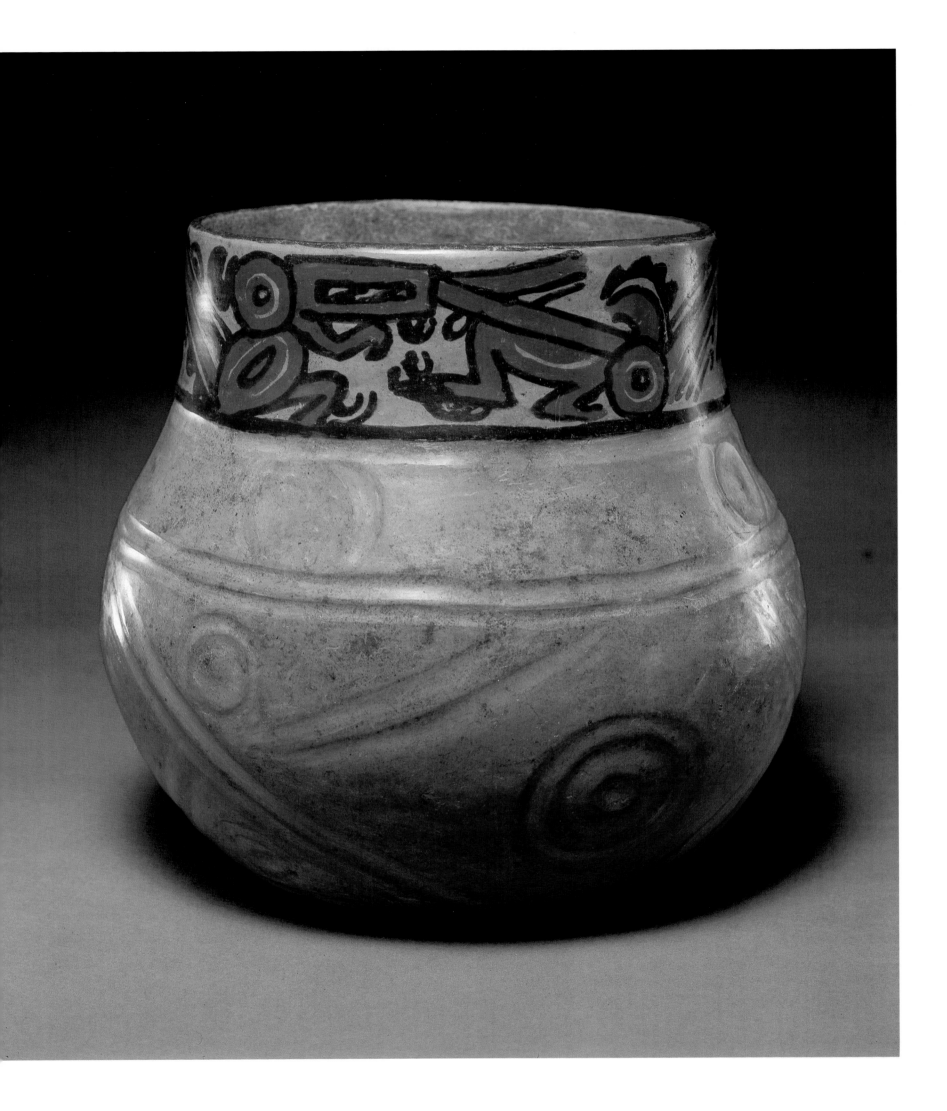

27. BOWL with alligator motif

Earthenware, buff clay body under an orange slip, burnished, with red and black paint
Guanacaste-Nicoya Zone
Period V (AD 500-1000)
*Galo Polychrome (AD 500-800)**
Height 5½" (14cm) Diameter 6⅝" (16.8cm)
Condition before conservation: interior and exterior burnishing worn in spots
Accession no. N-1083

The lower body of the bowl is rounded, curving in to a slightly tapered, fairly tall, wide neck. The shoulder is painted with wide horizontal bands, two of red and two of black. The neck is painted with stylized alligator motifs presenting the head with a large eye, fore- and hind-legs, the turned-back tail with alligator scutes, and the large jaws also with scutes. The lower body of the vessel is decorated with large red circles.

Cf. Snarskis 1982, p. 44, for a similarly decorated Galo jar in the INS; Stone 1977, fig. 70, for a Galo Polychrome vessel from Nacascola with the same neck band design (present location not indicated); also Baudez 1970, pls. 52 and 53, for more realistic renderings of the alligator motif.

**OXTL analysis (ref. no. 381M5, 10/12/84) estimates that the sample tested was last fired between 1120 and 1890 years ago (AD 94-864).*

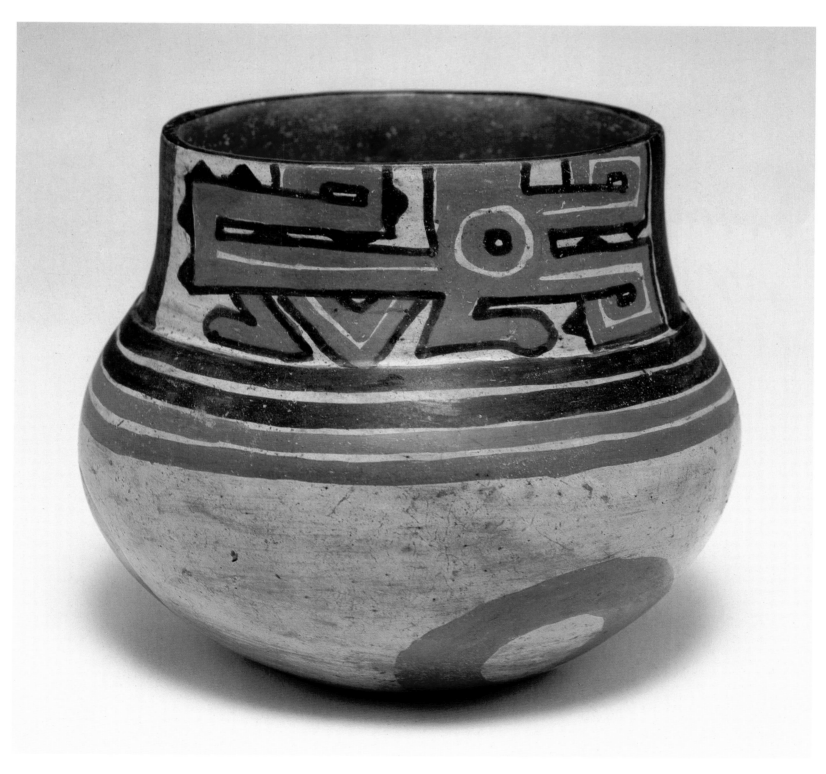

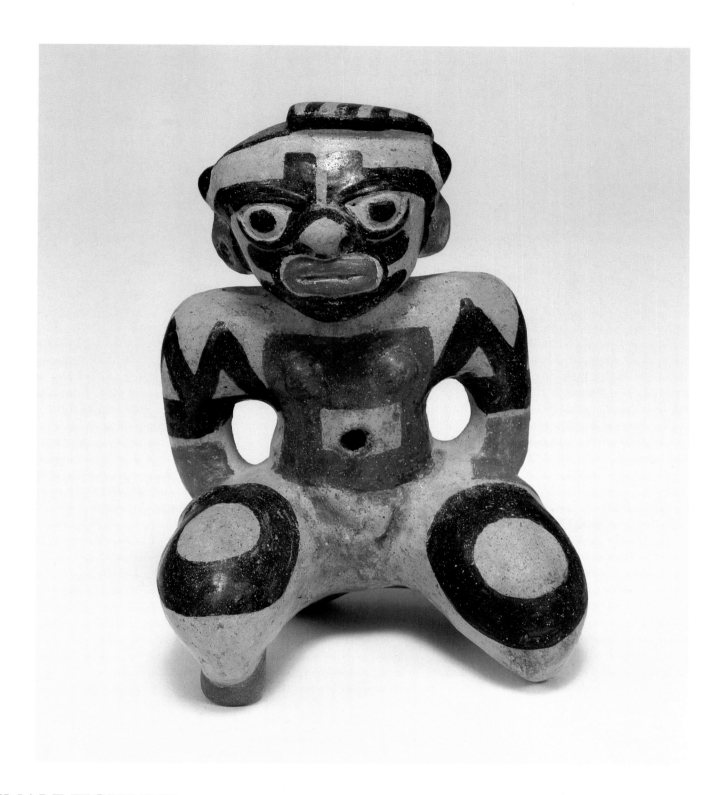

28. SEATED FEMALE FIGURINE

*Earthenware, buff clay body under a cream slip, burnished,
with dark red, orange and black paint*
Guanacaste-Nicoya Zone
Period V (AD 500-1000)
*Galo Polychrome(?) (AD 500-800)**
Height 5¼" (13.3cm) Width 3¾" (9.5cm) Depth 2⅞" (7.3cm)
Condition before conservation: fracture through body repaired
Accession no. N-1143

The seated female is modeled with a slender trunk support-
ing a large head balanced over squared shoulders. Arms
loop to join the large oval legs. Neither hands nor feet are
indicated. Expressive, large, staring eyes, as appliquéd
bosses, are set within ridged lids and under raised appliquéd

brows. The mouth is a thick-lipped wide oval with promi-
nent teeth. Both eyes and mouth are large in proportion to
the small nose. Earspools are set in the earlobes. A cap or
spiral hairdo is on the head. The face is decorated as a black
mask with lips and earspools in red. The body is decorated
with zigzags and geometric designs.

Such figures provide ethnographic detail about clothing and
body painting or tattooing. Some designs may symbolize cos-
tuming as an animal. The black-masked eyes and grimacing
mouth seen here convey a sense of fear, panic, duress or
suffering.[1]

1. Snarskis 1981, p. 84.
**OXTL analysis (ref. no. 381L87, 9/11/84) estimates that the sample tested was last
fired between 780 and 1430 years ago (AD 554-1204).*

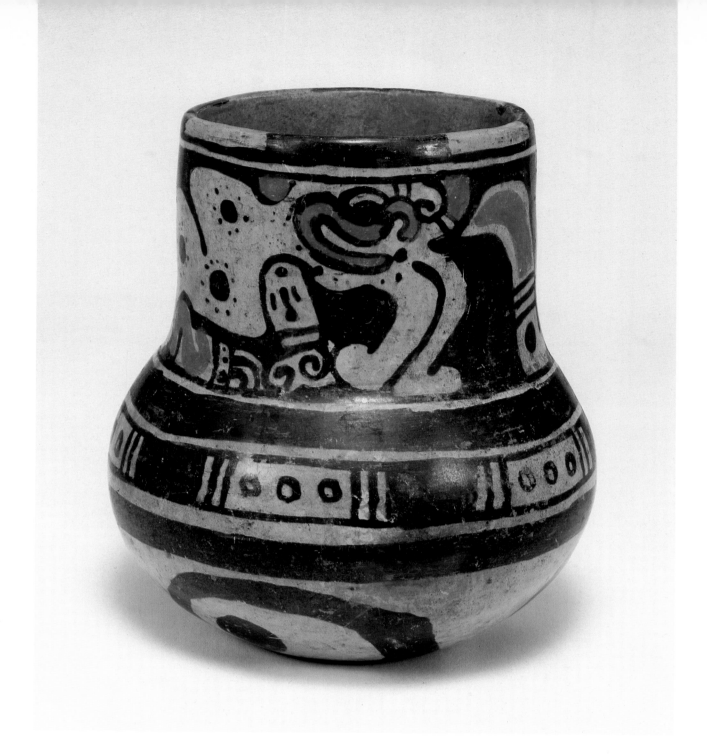

29. JAR with jaguar motif

*Earthenware, buff clay body under an orange slip,
burnished, with red and black paint*
Guanacaste-Nicoya Zone
Period V (AD 500-1000)
*Galo Polychrome (AD 500-800)**
Height 5⅝" (14.3cm) Diameter 5" (12.7cm)
Condition before conservation: broken and repaired
Accession no. N-1164

This highly burnished jar has a bulbous lower body with
sides curving in at the shoulders to a tall, wide neck. It is
painted around the shoulder with triple horizontal bands:
the upper and lower are solid black, and the middle band
has alternating black and orange rectangles containing two
vertical stripes on either end and three small circles
between. The rim is checkered black and orange while the
rounded lower body is painted with black circles. Stylized
jaguars are reserved in the black ground of the neck. Details
such as spots, eyes and mouth are painted in black and red.

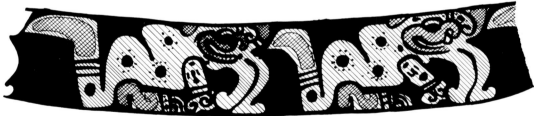

Painted designs employing the jaguar, monkey and serpent
indicate the penetration of northern religious patterns into
the Nicoya Peninsula. Galo Polychrome band motifs also
demonstrate the strong influences from the Maya-related
area of the Ulúa Valley in Honduras and a relationship to
Mesoamerican stylistic traits.[1] The band motifs had cosmo-
graphic significance with celestial symbols in the uppermost
band, followed by terrestrial and underworld symbols below.

1. Snarskis 1981, no. 88, p. 193.
Cf. Snarskis 1981, no. 88, for a round-bottomed jar with jaguar motif in the
MNCR, acc. no. 23967; Snarskis 1982, p. 42, for a round-bottomed jar with
jaguar motif in the INS; Stone 1977, fig. 70, for a cylindrical tripod vessel from
Nacascola with jaguar motif (present location not indicated); Ferrero 1977, Ilus.
I-48, for another cylindrical tripod vessel with jaguar motif in the MNCR,
acc. no. 20048.
*OXTL analysis (ref. no. 381N76, 4/1/85) estimates that the sample tested was last
fired between 890 and 1490 years ago (AD 495-1095).*

30. BOWL with monkeys

*Earthenware, buff clay body under a cream slip,
burnished, with red and black paint*
Guanacaste-Nicoya Zone
Period V (AD 500-1000)
*Galo Polychrome (AD 500-800)**
Height 3¼" (8.3cm) Diameter 3¾" (9.5cm)
Condition before conservation: intact
Accession no. N-1165

The slightly round-bottomed, straight-walled cup or bowl is
decorated with appliqué, engraving (or incising) and paint.
Below the rim is a narrow band painted with stylized alliga-
tor motifs in red with black borders on an orange slip
ground. Two engraved horizontal grooves bordered in black
encircle the bowl just above its midsection. Appliquéd on
either side, and falling between the alligator motifs, are two
monkey heads painted with black eye and nose details and a
red triangular patch on the head. The monkeys' bodies are
painted as stylized profiles with long tails curling up. A black
horizontal basal stripe frames the decoration on the lower
body. The whole is highly burnished and the paint is lus-
trous. The interior is painted red.

Cf. Ferrero 1977, Ilus. I-49, for a Galo polychrome cylindrical tripod vessel in
the MNCR, acc. no. 7606, with modeled animal heads and similar treatment;
also Baudez 1970, pl. 44, for a similarly treated cylindrical tripod vessel with
polychrome decoration and monkey head in relief, in the Walter Soundy Collec-
tion, Santa Tecla, El Salvador, from San Jacinto, Department of San Salvador,
El Salvador, Period III (AD 550-950), indicating the association of such vessels in
Costa Rica with a northern tradition.

**OXTL analysis (ref. no. 381N88, 4/1/85) estimates that the sample tested was last
fired between 880 and 1490 years ago (AD 495-1105).*

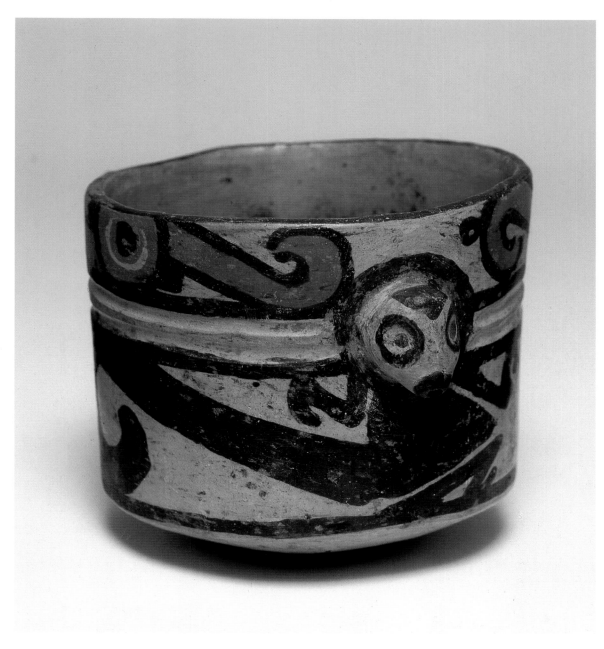

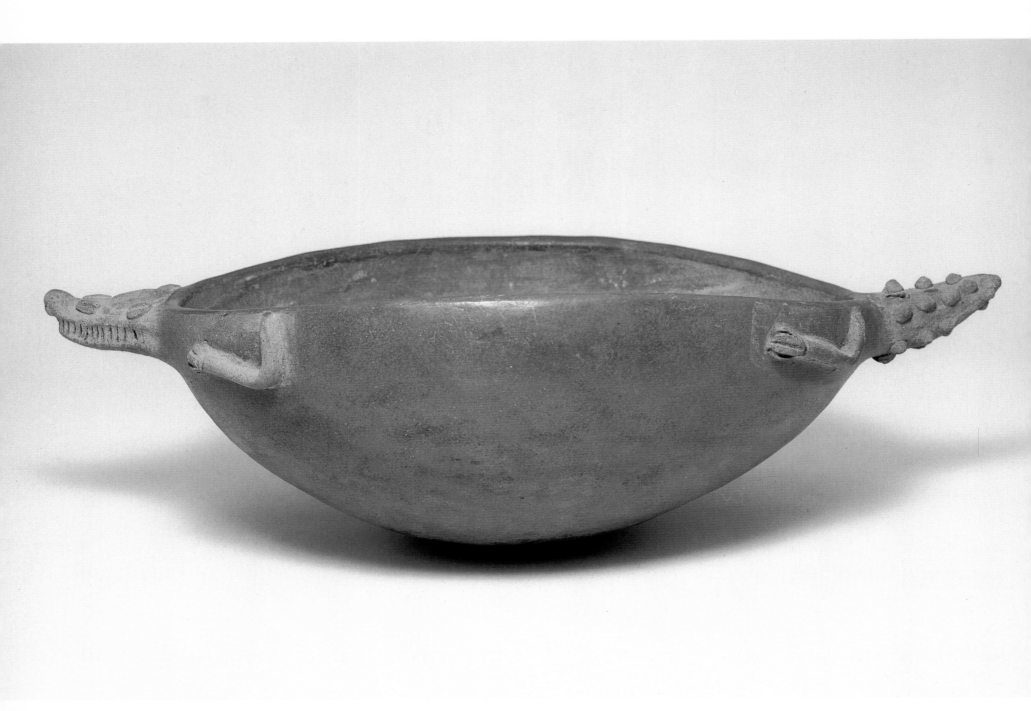

31. BOWL with alligator characteristics

Earthenware, reddish-buff clay body under a red slip, burnished, with traces of white wash
Guanacaste-Nicoya Zone
Period V (AD 500-1000)
*Potosí Appliqué (AD 500-1000)**
Height 5¹/₂" (14cm) Width 17" (43.2cm) Depth 10" (25cm)
Condition before conservation: multiple cracks repaired; appendages broken off and repaired
Accession no. N-883

This uncommonly shaped bowl is an example of Potosí Appliqué. A stylized alligator head with a long snout and prominent teeth is appliquéd on one end of the round-bottomed, oval-shaped bowl with rim curving in slightly. The tail on the opposite end exhibits scutes of the alligator's hide. Coffee bean-shaped eyes and ears are appliquéd on the head. Forelegs are appliquéd on either side of the head, and hind legs appear at the rear. Legs, head and tail are left in the natural clay color with traces of white wash. The remainder of the vessel is slip-painted in red and burnished.

Potosí Appliqué ceramics (Nos. 31 and 32) constituted an important type throughout Period V. Characteristic of this type are the appliquéd bosses imitating alligator scutes. The crocodile or alligator is the predominant motif on its more fantastic *incensarios*. Other zoomorphic effigies, such as the iguana in Number 32 or felines, appear more rarely as modeled decoration.

**OXTL analysis (ref. no. 381p65, 4/3/85) indicated that the sample tested gave a spurious signal and no results were possible.*

32. INCENSE BURNER with lid

Earthenware, buff clay body under a red slip, burnished, with white wash
Guanacaste-Nicoya Zone
Period V (AD 500-1000)
Potosi Appliqué (AD 500-1000)
Height 10⅜″ (26.4cm) Diameter 8⅜″ (21.3cm)
Condition before conservation: cracks in rim and base repaired;
only traces of white wash remained
Accession no. N-884

Bands of multiple appliquéd pellets representing scutes on an alligator's hide decorate this two-part incense burner. The bottom is a wide, shallow bowl resting on a flared ped-estal or annular base. The lid tapers up from the rim to a sharp step-back and then rises to a tapering chimney sur-mounted by a modeled iguana. Burning incense escaped through slits at the top. The foot, alligator-hide bands and the iguana are unslipped and were originally covered with a white wash, some traces of which are still evident. The rest of the vessel, bowl and lid, is slipped red and burnished.

Cf. Snarskis 1982, p. 41, for a two-piece incense burner with fantastic alligator effigy on the lid, in the INS, which is typical of Potosi Appliqué; Snarskis 1981, no. 91, for an *incensario* with a feline surmounting the lid in the Juan and Ligia Dada Collection, San José, Costa Rica; Lothrop 1926, pl. CXVII, and Ferrero 1977, Ilus. I-70, for drawings of typical examples of Potosi Appliqué *incensarios* and pl. XI for one in the MNCR, acc. no. 23069, also illustrated in Snarskis 1981, no. 90; and Dockstader 1973, no. 143, for the lid of an *incensario* with an iguana surmounting the chimney, in the Arthur M. Sackler Collection, Museum of the American Indian, acc. no. 23/6310.

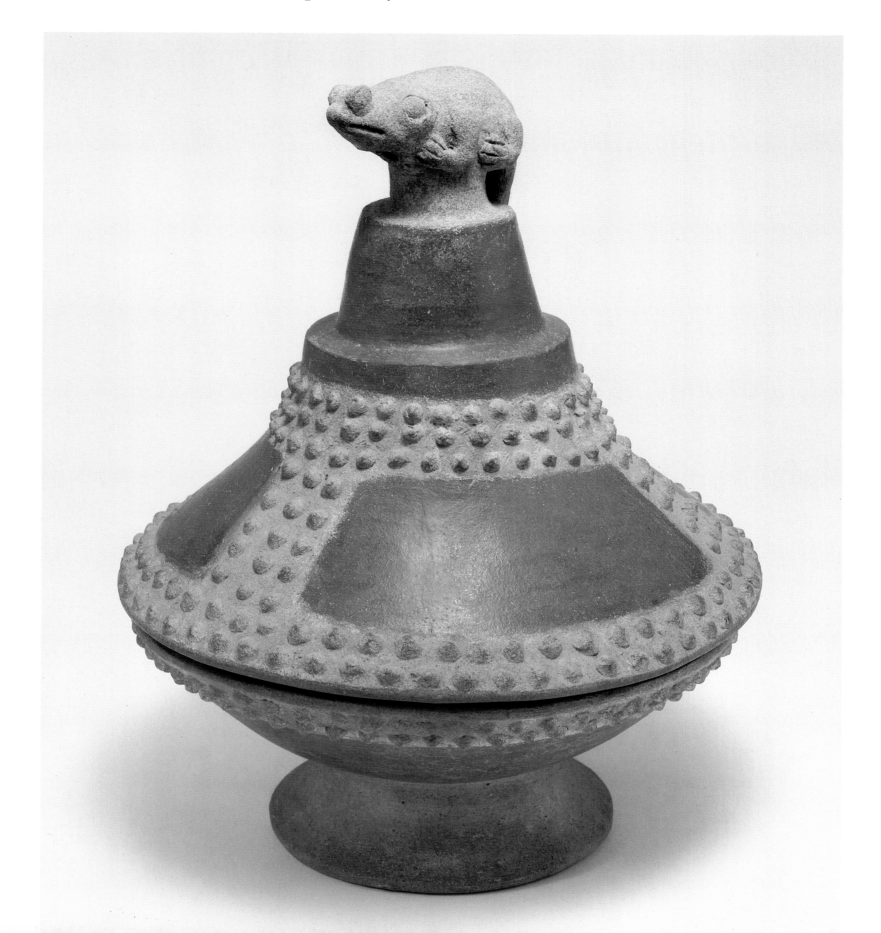

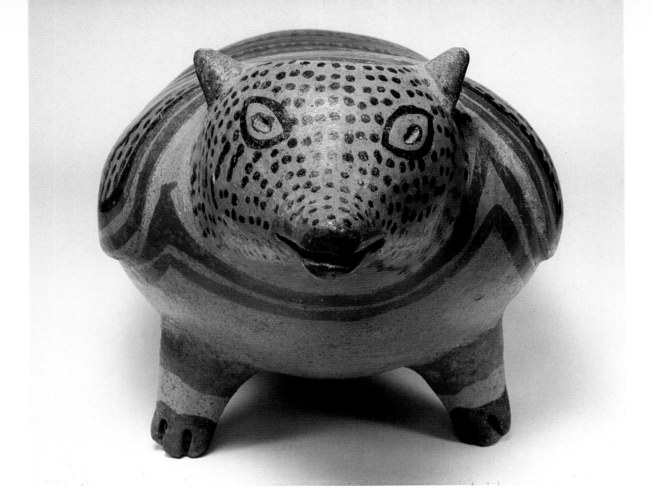

33. ARMADILLO EFFIGY VESSEL

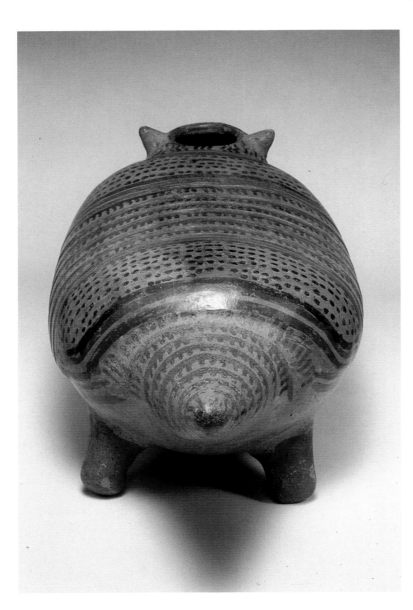

Earthenware, buff clay body under a buff-orange slip, burnished,
with red and black paint
Guanacaste-Nicoya Zone
Period V/VI (AD 500-1550)
*Mora Polychrome/Mora Variety (AD 800-1200)**
Height 7¹/₂" (19.1cm) Width 7³/₄" (19.7cm) Length 18¹/₂" (45.7cm)
Condition before conservation: excellent
Accession no. N-1155

This effigy vessel modeled as an armadillo is an outstanding
example of Pre-Columbian animal sculpture. The elongated
body extends from the pointed snout on one end to the tail
which stretches straight out to a diminished point on the
other. The saddle-like shell of the back contains dots and
bristle-like bars in black bordered with red to represent the
armadillo's armor. The tail is similarly painted while the
head is filled with dots. The bright colors and burnishing are
reminiscent of earlier Galo Polychrome.

Between circa AD 800 to 1200 when Galo Polychrome grad-
ually gave way to Mora Polychrome, the greatest diversity
and production of polychrome ceramics occurred. Its earli-
est varieties incorporate elements common in certain Late
Classic Mayan pottery, such as Copador ceramics (e.g.,
seated figures with headdresses, mat patterns, and the *kan*
cross). These are executed mostly in red, black and maroon
on a buff-orange ground with decoration primarily geomet-
ric but including stylized armadillo, alligator and serpent
motifs. Vessel forms are usually simple hemispherical bowls.
Mora Polychrome seems to have been manufactured in the
southern part of the Greater Nicoya Archaeological Subarea,
but it is often found in Atlantic Watershed/Central High-
lands sites, the result of trade. Numbers 33 to 48 are exam-
ples of Mora Polychrome and its varieties.

**OXTL analysis (ref. no. 381M14, 10/15/84) estimates that the sample tested was last*
fired between 880 and 1490 years ago (AD 494-1104).

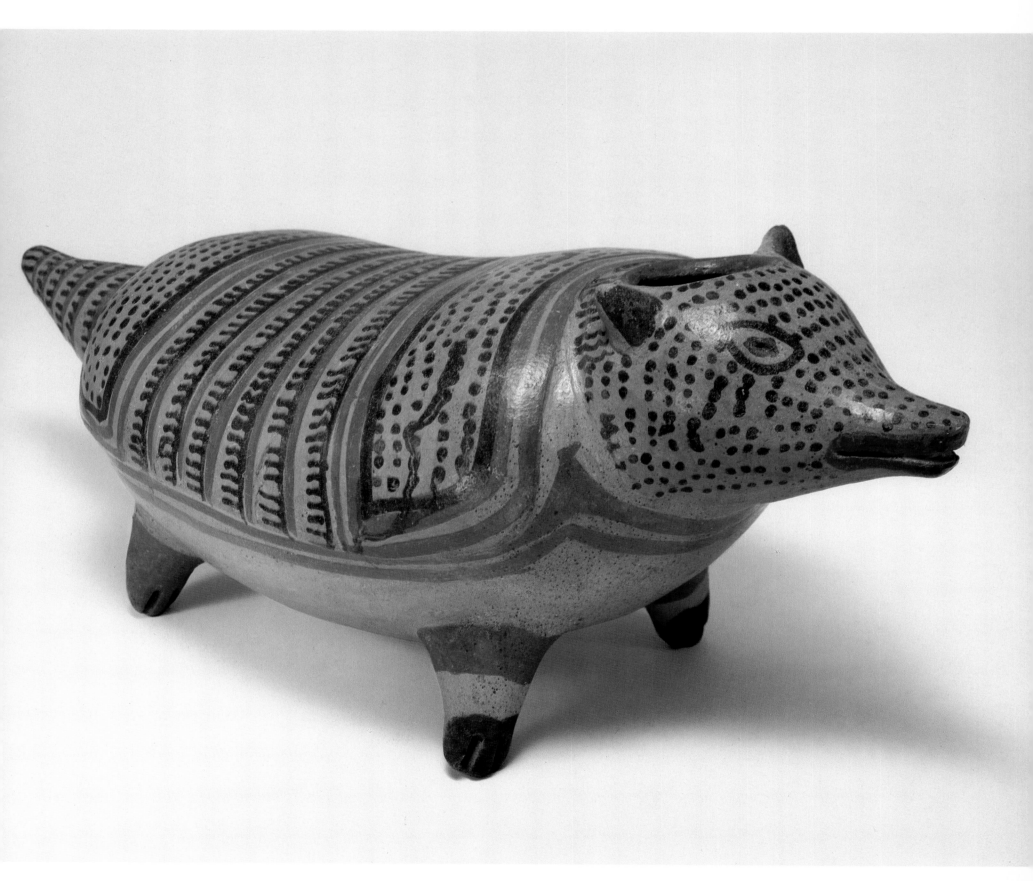

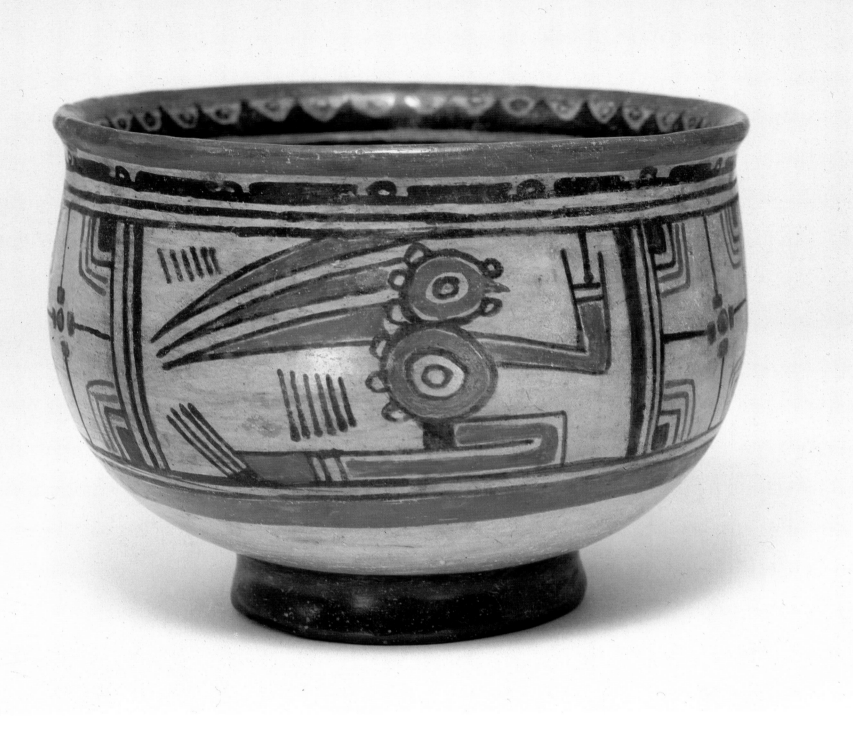

34. BOWL with painted figures

*Earthenware, buff clay body under a buff-orange slip, burnished,
with red and black paint*
Guanacaste-Nicoya Zone
Period V/VI (AD 500-1550)
*Mora Polychrome, Mora Variety (AD 800-1200)**
Height 5¼″ (13.3cm) Diameter 7⅛″ (18.1cm)
Condition before conservation: root marks throughout; base repaired
Accession no. N-1095

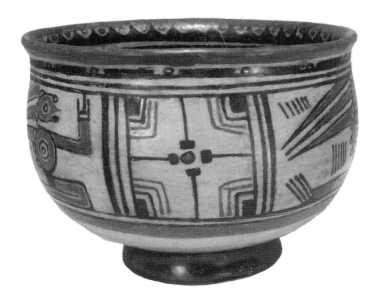

The slightly convex exterior walls of this deep bowl curve in
to the neck, then splay slightly to the thickened rim. They
are painted with alternate panels, one containing a stylized
image of a seated human figure with feathered headdress,
and the other a square with *kan* crosses or geometric devices
reminiscent of the Maya sky bands. Below the red rim is a
narrow band of black-line and circle devices. On the inner
rim is a band of pendant tabs with dot centers which repre-
sent jaguar pelt markings. The stylized human figure here is
very similar to figures on Copador ceramics manifesting
strong influences from Salvadoran and Honduran Mayan
centers, particularly Copán.

1. See Robicsek 1972, pl. 258.
Cf. Snarskis 1982, p. 51, for a bowl with similar stylized human figure with large
headdress in the INS which Snarskis refers to as Mora Polychrome, early vari-
ety; Ferrero 1977, Ilus. I-50, for a vase in the INS, acc. no. 0005, and I-51, for
another bowl in the INS, acc. no. 0003, both with the same seated figure, and
I-52, for drawings of the design on Mora Polychromes; and Stone 1972, p. 173
top right, for a bowl with similar figure in the MNCR, from Meseta Central.
**OXTL analysis (ref. no. 381p85, 5/10/85) estimates that the sample tested was last fired
between 1100 and 1900 years ago (AD 85-885).*

35. BOWL with monkey

Earthenware, buff clay body under a buff-orange slip, burnished,
with red and black paint
Guanacaste-Nicoya Zone
Period V/VI (AD 500-1550)
Mora Polychrome, Mora Variety (AD 800-1200)
Height 3½" (8.9cm) Width 5⅛" (13cm)
Condition before conservation: burnish worn in spots
Accession no. N-1078

This round-bottomed bowl curves in at the neck to a slightly
thickened, everted rim. Painted on one side is a medallion
with a stylized black monkey against the orange ground.
It is framed with multiple red vertical lines. The exterior
decoration is framed by a wide red rim band and triple
horizontal red basal stripes. A two-tiered band containing
connected lozenge shapes filled with black crosshatching
and black circles in the adjacent spaces decorates the
remainder of the exterior. Around the inner rim is the diag-
nostic band of jaguar spots.

Cf. Snarskis 1982, p. 52, for a Mora Polychrome composite silhouette jar with
annular base in the INS which has the same monkey motif and surrounding
bands of crosshatched lozenges and black dots.

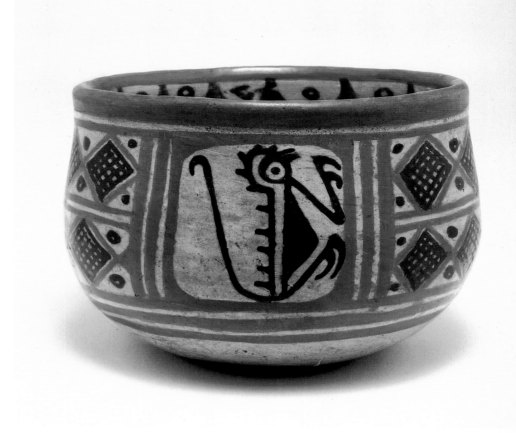

36. BOWL with human head

Earthenware, buff clay body under a cream slip, burnished, with black,
white, purple, maroon, and red paint
Guanacaste-Nicoya Zone
Period V/VI (AD 500-1550)
Mora Polychrome, Mora Variety (AD 800-1200)
Height 2⅞" (7.3cm) Diameter 5½" (14cm)
Condition before conservation: paint chipping around interior rim; crack
extended from bowl rim down wall; small chip on base
Accession no. N-1023

This hemispherical bowl stands on a short foot. It is deco-
rated on one third of the exterior wall with a human face
with minimally modeled eyes, nose, ears and earspools.
Painting emphasizes the details of the face. Double oblique
black lines on a white band run from each earlobe to the tip
of the nose. The upper part of the face is painted purple
and the mouth maroon with white details. The balance of
the exterior is painted with multiple fine-line geometrics in
red and black with occasional circles and *kan* crosses indica-
tive of Mayan influence. On the interior, below the red rim is
the band of jaguar spots in light orange reserved in black.

Cf. Lothrop 1926, fig. 30, for effigy vessels Lothrop designates Birmania Poly-
chrome with such modeled and painted faces (also reproduced in Ferrero 1977,
Ilus. III-27).

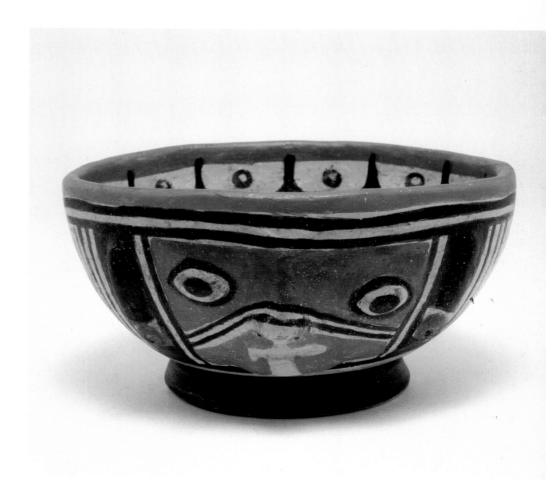

37. FOOTED JAR with monster face

Earthenware, brownish clay body under a buff-orange slip, burnished, with red, black and purple paint
Guanacaste-Nicoya Zone
Period V/VI (AD 500-1550)
Mora Polychrome, Mora Variety (AD 800-1200)
Height 7⅝″ (19.5cm) Width 6⅞″ (17.5 cm)
Condition before conservation: minor crack and rim chips
Accession no. N-1027

The footed jar has a bulbous base which curves in to a tall wide neck flaring slightly to the thickened rim. Red bands encircle the rim and base. Bands of jaguar spots circle the interior and exterior just below the rim. A monster face with button eyes framed by a row of bosses is appliquéd and painted on the neck. A modeled bird circled by a decorated band forms the nose and mouth and a net pattern decorates the cheeks. The remainder of the vessel is painted with the two-headed monster motif.

Cf. Lothrop 1926, pl. CXLVe, for the two-headed monster pattern.

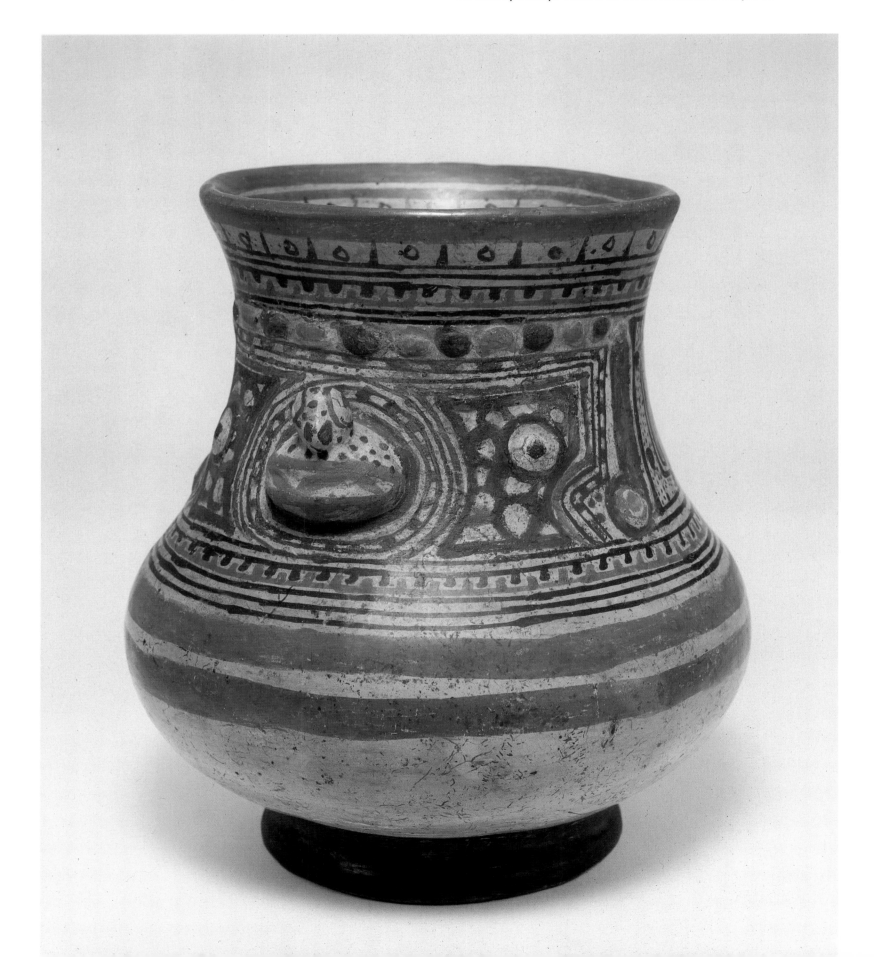

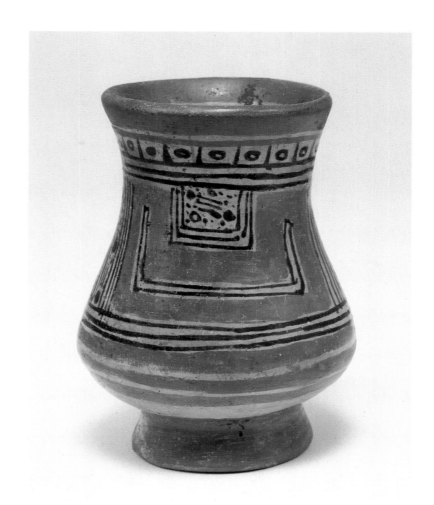

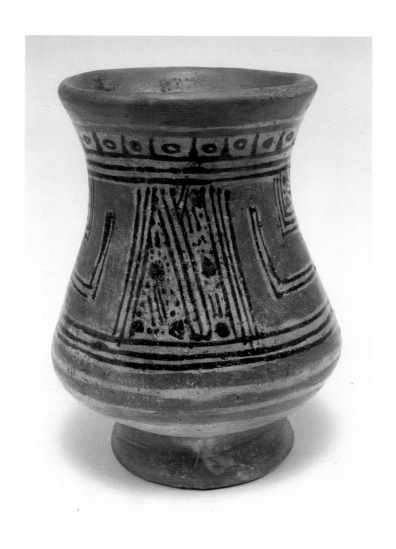

38. FOOTED JAR
with two-headed monster design

Earthenware, buff clay body under a buff-orange slip, burnished, with red, black and brown paint
Guanacaste-Nicoya Zone
Period V/VI (AD 500-1550)
Mora Polychrome, Mora Variety (AD 800-1200)
Height 3⅞" (9.8cm) Diameter 2¾" (7.0cm)
Condition before conservation: chipped on rim and base
Accession no. N-1029

This footed jar curves in from the flared base and tapers to a splayed neck and slightly flared, thickened mouthrim. Below the wide red rim band is another band of jaguar spots. A wide central zone of decoration includes the two-headed monster motif.

Cf. Lothrop 1926, pl. CXLIVe, for the two-headed monster pattern.

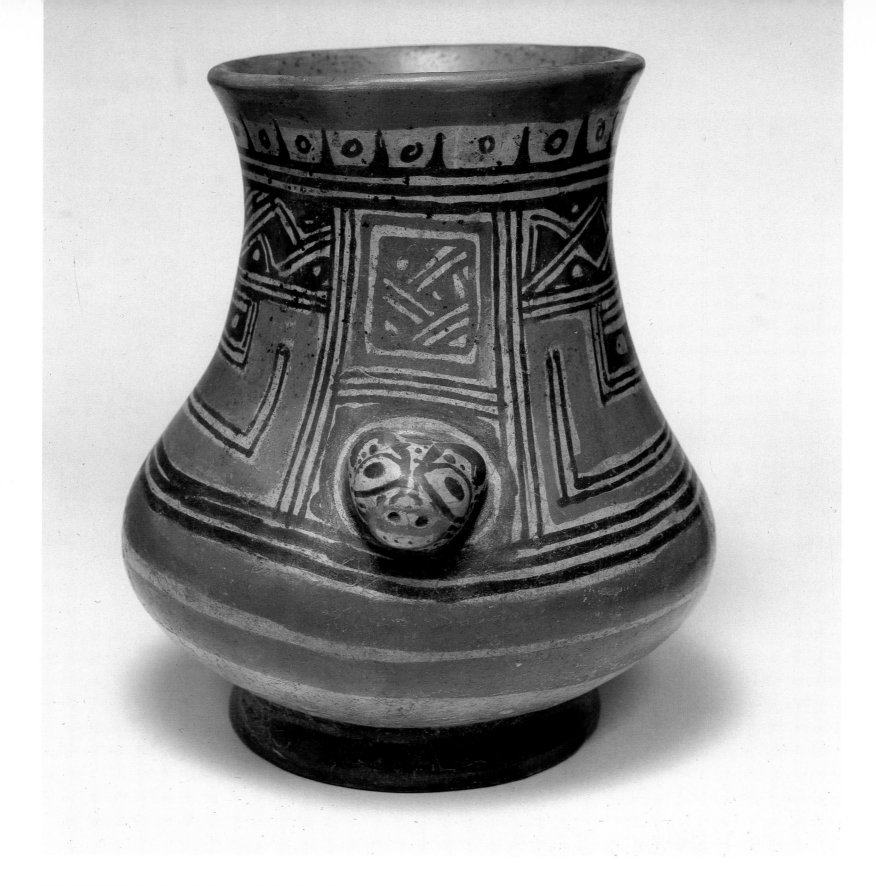

39. FOOTED JAR with modeled animal head appliqué

Earthenware, buff clay body under a buff-orange slip, burnished, with red, orange, black and purple paint
Guanacaste-Nicoya Zone
Period V/VI (AD 500-1550)
*Mora Polychrome, Mora Variety (AD 800-1200)**
Height 7¼" (18.4cm) Width 6⅛" (15.6cm)
Condition before conservation: cracks extending from rim repaired
Accession no. N-1071

This footed jar is similar in shape to Numbers 37 and 38. Attached on the front just above the swell of the lower body is a small jaguar head with facial features minimally modeled and black spots. A wide red band encircles the mouth-rim. Below it is a band of jaguar spots. The remainder of the decoration above the triple black basal stripes is the abstract two-headed monster pattern, a mixture of jaguar and plumed serpent elements. The square over the modeled head and the band of zigzags extending on either side of the head can be associated with the jaguar.

Cf. Lothrop 1926, pls. CXLIVe and CXLV, for other examples of the two-headed monster pattern.
**OXTL analysis (ref. no. 381P79, 4/3/85) estimates that the sample tested was last fired between 870 and 1420 years ago (AD 565-1115).*

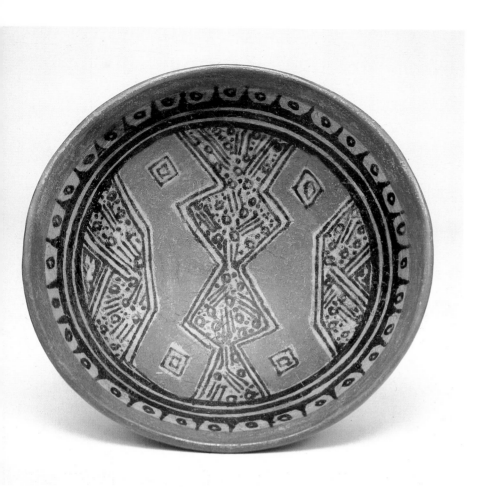

40. FOOTED BOWL
with two-headed monster pattern

Earthenware, light reddish clay body under a pale orange slip, burnished, with red and black paint
Guanacaste-Nicoya Zone
Period V/VI (AD 500-1550)
Mora Polychrome, Mora Variety (AD 800-1200)
Height 2³⁄₈″ (6cm) Diameter 6⁵⁄₈″ (16.8cm)
Condition before conservation: stained in spots; root marks on interior; repaired crack on rim; crack on exterior
Accession no. N-1024

The hemispherical bowl rests on a short foot with a thickened rim. On the exterior and interior below the wide mouthrim is a band of jaguar spots framed by multiple stripes. On the interior below the stripes are double images and patterns of dots and lines possibly representing the jaguar pelt. This is another version of the two-headed monster pattern utilizing elements of both plumed serpent and jaguar motifs.

Cf. Lothrop 1926, pl. CXLIVe, for a similar two-headed monster pattern.

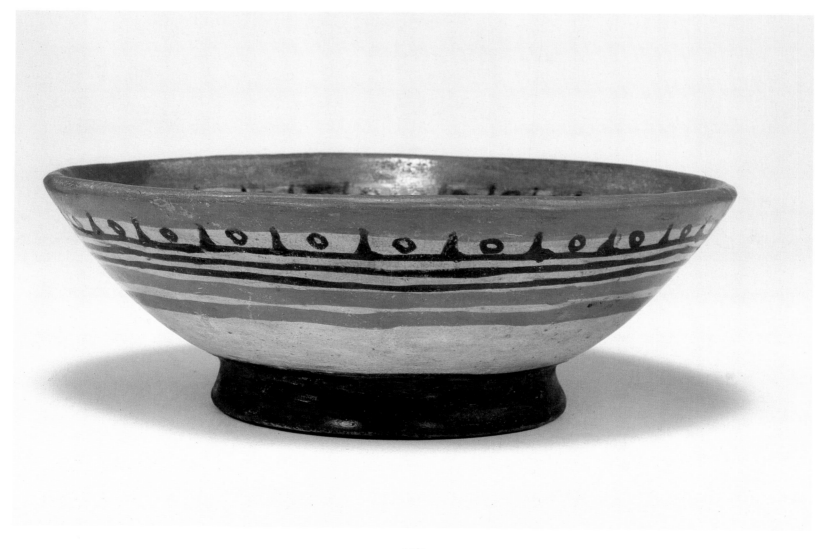

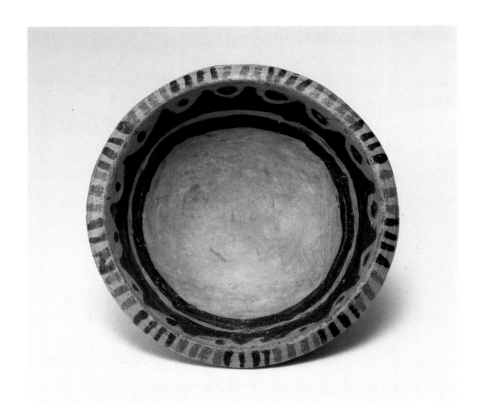

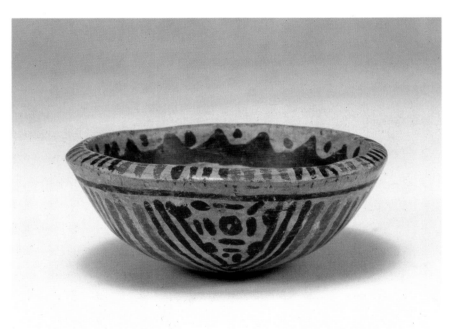

41. BOWL with painted jaguar motifs

*Earthenware, buff clay body under a buff-orange slip, burnished,
with maroon, red and black paint*
Guanacaste-Nicoya Zone
Period V/VI (AD 500-1550)
Mora Polychrome, Mora Variety (AD 800-1200)
Height 1³⁄₈″ (3.5cm) Diameter 3¹⁄₄″ (8.3cm)
Condition before conservation: worn design
Accession no. N-1031

This small round-bottomed bowl has a thickened outwardly
sloping mouthrim. The exterior is decorated with triangular
areas filled with jaguar-hide markings. The spaces between
contain vertical stripes. Just below the mouthrim on the inte-
rior is a band of jaguar spots. The sloping rim is painted
with vertical stripes.

42. BOTTLE with two-headed monster motif

Earthenware, buff clay body under a pale orange slip, burnished, with red and black paint
Guanacaste-Nicoya Zone
Period V/VI (AD 500-1550)
*Mora Polychrome, Chircot Variety (AD 800-1200)**
Height 8¼″ (21 cm) Width 8⅜″ (21.3 cm)
Condition before conservation: rim broken and repaired; root marks on underside; chips on base and rim
Accession no. N-1090

The rounded lower body curves in to a tall, wide neck which splays to an everted mouthrim. Three horizontal black bands encircle the middle of the body. Between them and the neck is a zone with two-headed monster motifs.[1] Above it is a band of meanders, which represents alligator motifs. On the neck, crosshatched squares may represent textile designs. Red slip encircles the mouthrim, and below it on the inner wall of the neck is the typical band of jaguar spots.

The Chircot variety of Mora Polychrome (Nos. 42 and 43) was established as a variety by R.M. Accola and named after the site in the Cartago Valley where Carl Hartman first discovered it under controlled conditions.[2] It is distinguished by the two-headed monster motif, which has stylistic ties to the feathered serpent and jaguar motifs as well as to alligator designs characteristic of Diquis Polychromes (see Nos. 153-160). The two-headed monster motif appears in Altiplano Polychrome but in altered form. The origin of the motif, according to Lothrop, may be Mayan in that it combines the nature of both serpent and jaguar.

1. Lothrop 1926, pl. CXLVIIc, for another example of the two-headed monster Lothrop describes as type A.
2. Accola 1978 and Hartman 1901, p. 65.
OXTL analysis (ref. no. 381 p84, 5/10/85) estimates that the sample tested was last fired between 800 and 1450 years ago (AD 435-1185).

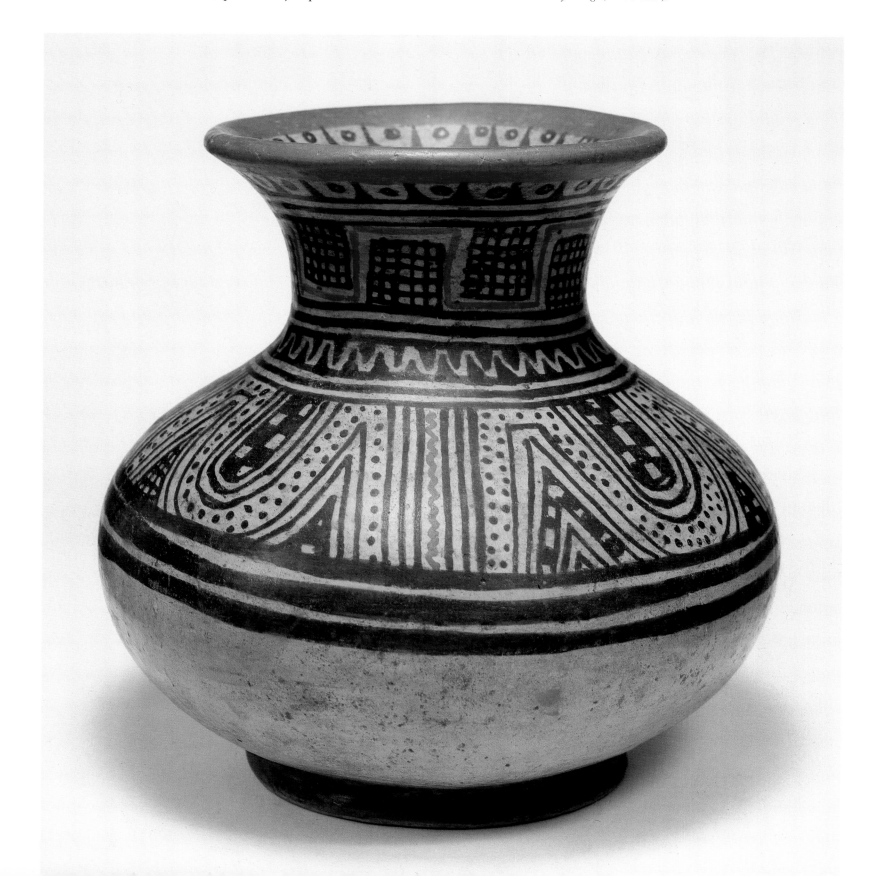

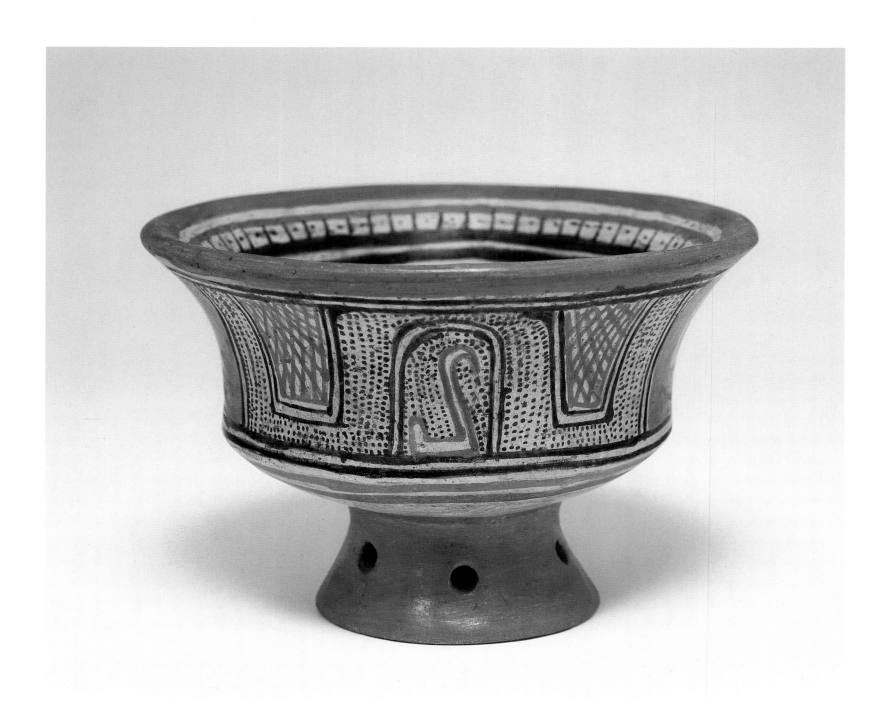

43. PEDESTAL BOWL with two-headed monster motif

Earthenware, buff clay body under a pale orange slip, burnished,
with red and black paint
Guanacaste-Nicoya Zone
Period V/VI (AD 500-1550)
Mora Polychrome, Chircot Variety (AD 800-1200)
Height 4¼" (10.8cm) Width 6" (15.2cm)
Condition before conservation: burnishing worn in spots
Accession no. N-1082

The bowl with walls curving out to a thickened rim rests on a flaring perforated pedestal or annular base containing pellets for use as a rattle. The motif painted on the exterior is that of the two-headed monster.[1] The faces are stylized rectangles with an inner dot-filled area. They are joined by the typical dot-filled loops. The spaces between the loops are crosshatched. Below the two-headed monster pattern, the basal ridge of the bowl is painted with horizontal stripes. The mouthrim is encircled with red slip. A band of jaguar spots decorates the interior below the rim.

1. Lothrop 1926, pl. CXLIV, for other examples of the two-headed monster, which Lothrop describes as Type A.

44. COLLARED BOWL with alligator design

Earthenware, buff clay body under a pale orange slip, burnished,
with red and black paint
Guanacaste-Nicoya Zone
Period V (AD 1000-1550)
Mora Polychrome, Cinta Variety (AD 1100-1350)
Height 5³⁄₈″ (13.7cm) Width 8¹⁄₄″ (21cm)
Condition before conservation: root marks throughout;
some surface and paint chips
Accession no. N-1072

From the bulbous lower body the bowl slopes in to the collar which splays slightly at the thickened, rolled mouthrim. Below the red-slipped rim and at the swell of the lower body is a meander pattern, an undulating ribbon-like design which represents the alligator. Mora Polychrome, Cinta variety, is characterized by such ribbon-like designs painted on the walls of the vessels. Vertical bands of feather(?) designs decorate the sloping shoulder of the bowl.

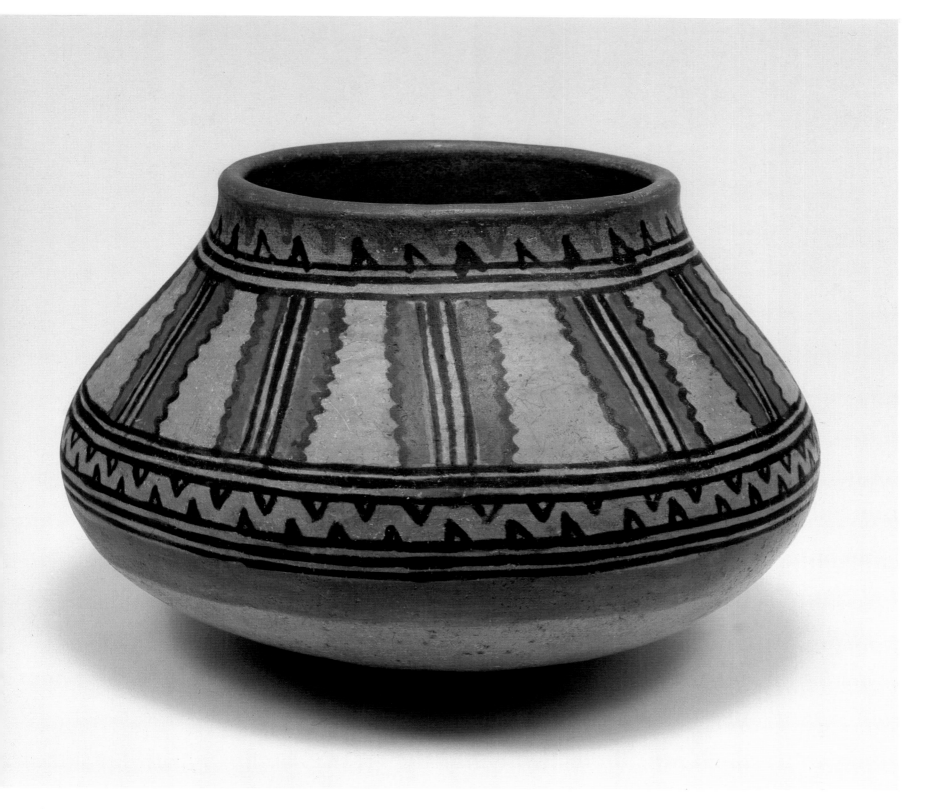

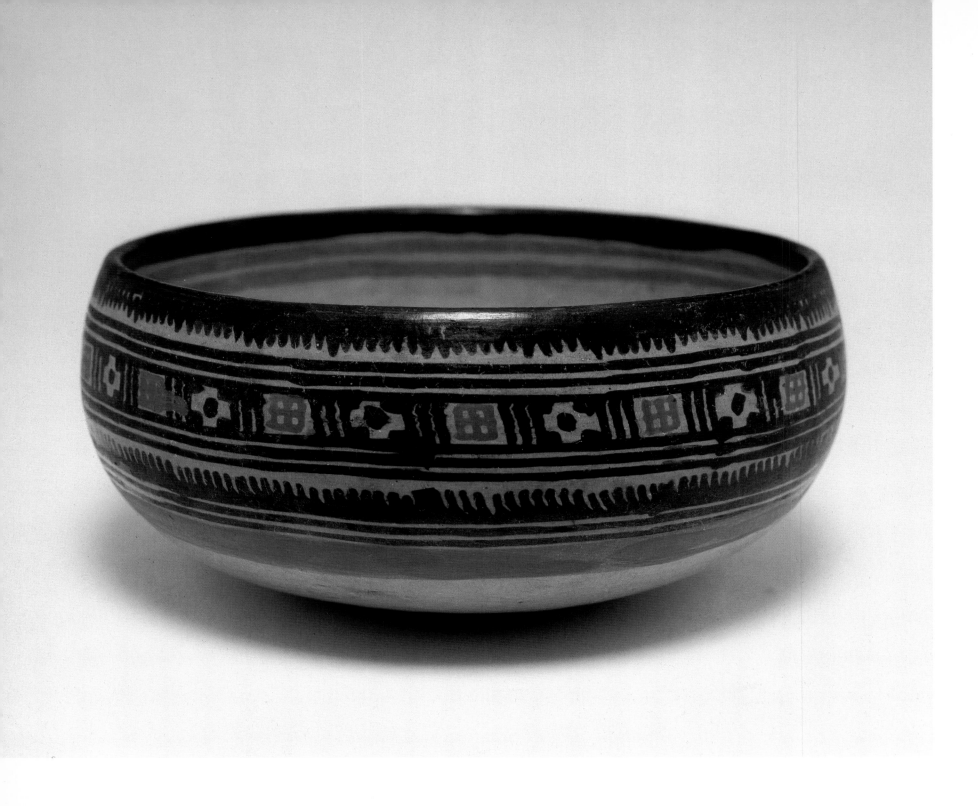

45. BOWL with *kan* crosses

Earthenware, buff clay body under a pale orange slip, burnished,
with black and red paint
Guanacaste-Nicoya Zone
Period VI (AD 1000-1550)
Mora Polychrome, Tardio Variety (AD 1200-1350)
Height 3⅝" (9.3cm) Diameter 7⅞" (20cm)
Condition before conservation: a few tiny surface chips
Accession no. N-923

The hemispherical body of the bowl curves in slightly to a
thickened rim. The black rim band with multiple brush
painting in depending lines is duplicated in reverse below
the major band of decoration. This latter band is framed,
top and bottom, by three black stripes and contains alternat-
ing designs of the Mayan *kan* cross and divided squares. The
colors are vivid and the surface is highly burnished. The
Tardio variety is a late manifestation of Mora Polychrome
which seems to have degenerated in its painting technique
during the first half of Period VI.

Cf. Snarskis 1982, p. 65, for a similarly decorated bowl in the INS.

46. TRIPOD BOWL with human legs

Earthenware, buff clay body under a pale orange slip, burnished,
with red and black paint
Guanacaste-Nicoya Zone
Period V/VI (AD 500-1550)
*Mora Polychrome, Guabal Variety (AD 800-1200)**
Height 4¼" (10.8cm) Diameter 8¾" (22.2cm)
Condition before conservation: crack in rim
Accession no. N-1122

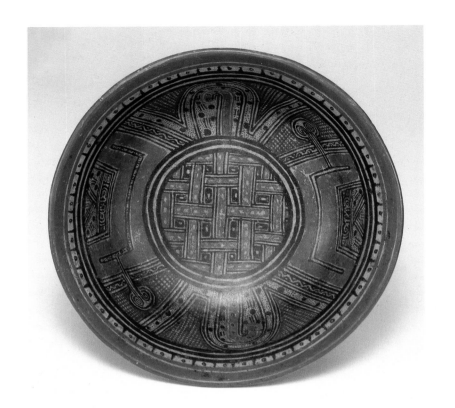

This bowl, with slightly splayed sides and a thickened rim, rests on three legs modeled as standing human figures somewhat similar in style to the Guabal seated female in Number 47. The figures are minimally modeled and painted to emphasize the features and mat-design garments or body painting. A wide red slip band is painted around the bowl's mouthrim. The exterior is covered with a mat pattern of interlocking linear design with red and yellow circles in the spaces between. On the exterior and interior below the mouthrim is a narrow band of jaguar spots. The interior base is also painted as an interlocking mat pattern while the interior walls are decorated with the two-headed monster motif and dot-filled lines. This motif has stylistic affinities with the feathered serpent, jaguar and alligator motifs.

Cf. Lothrop 1926, pl. CLe, for a vessel with similar designs.
**OXTL analysis (ref. no. 381L80, 9/11/84) estimates that the sample tested was last*
fired between 640 and 1080 years ago (AD 904-1334).

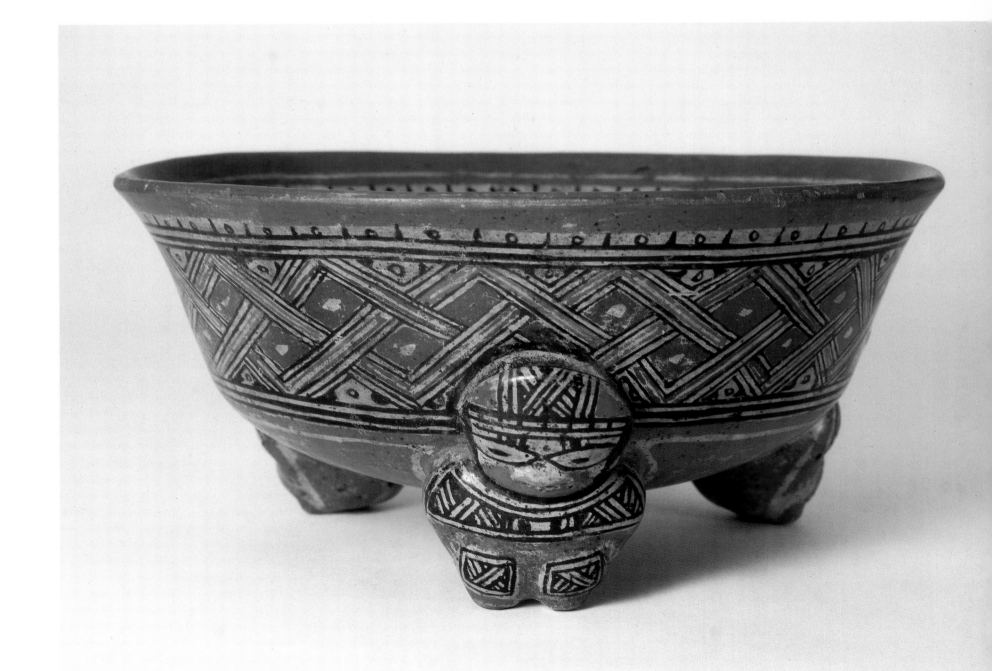

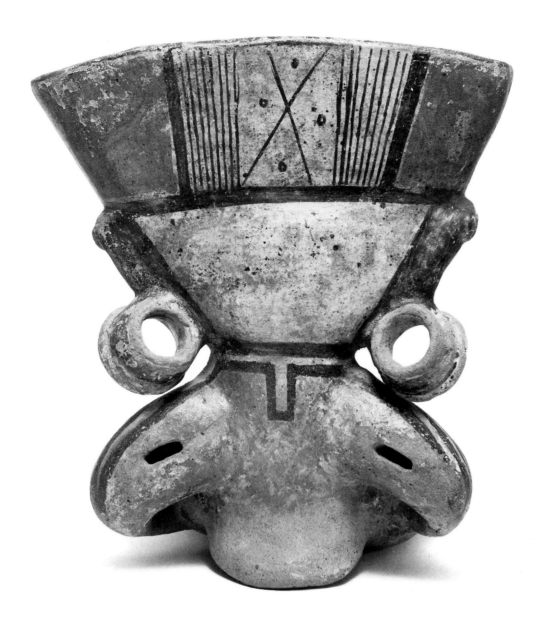

47. SEATED FEMALE FIGURE

Earthenware, buff clay body under a buff-cream slip, burnished,
with black and red paint
Guanacaste-Nicoya Zone
Period V/VI (AD 500-1550)
*Mora Polychrome, Guabal Variety (AD 800-1200)**
Height 11¼" (28.6cm) Width 9½" (24.1cm) Depth 7⅞" (20cm)
Condition before conservation: broken at bottom around both legs and arms
Accession no. N-1111

The broad-legged seated female has a wide, flat head, which may represent cranial deformation, and which is wrapped in a colorful turban. The face is doll-like with slit eyes surrounded by large black-line ovals. She wears huge hollow ear spools. Dress or body painting is indicated by the interlocking mat pattern.

Such female figurines are cast in molds and are of hollow construction. They vary considerably in size and show the figures in different positions, sometimes seated on stools. The Guabal Variety of Mora Polychrome (Nos. 46-48) emphasizes broad-legged, seated human figures, most with intricate painted details representing clothing, tattooing or body painting; an invariably flattened headdress suggests possible cranial deformities, and ear flares or spools are prominent. Such stylized figures, although carrying on the long tradition of seated female figurines, are less realistic than the earlier Galo Polychrome figurines.

Cf. Snarskis 1982, p. 56, for a similar figure in the INS; Stone 1977, fig. 108, for a similar figure described as Guabal Polychrome Ware ? Palo Blanco Phase, (present location not given), and fig. 263, for one excavated from La Union, Guapiles (present location not given); Snarskis 1981, no. 97, pl. 16, for a figure seated on a four-legged stool or bench, reportedly from Nosara, Nicoya Peninsula, now in the Dr. Hermán Paéz U. and Dr. Carlos Robedo Paéz S. Collection; also Ferrero 1977, Ilus. I-86, for another figure seated on a bench, in the Maria Eugenia Jiménez de Roy Collection, San José.

**OXTL analysis (ref. no. 381M10, 10/12/84) estimates that the sample tested was last fired between 840 and 1470 years ago (AD 514-1144).*

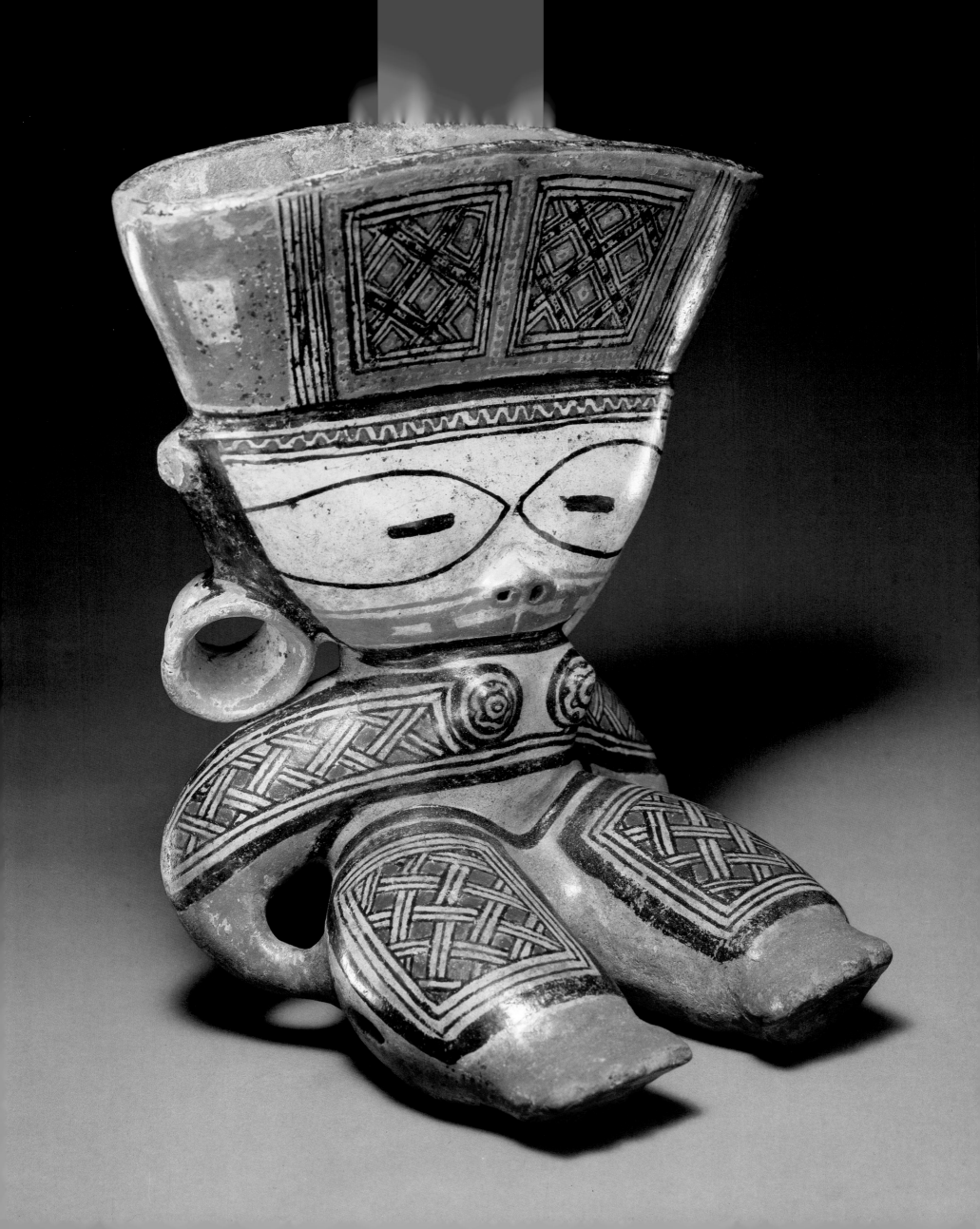

48. TRIPOD BOWL with human-head feet

Earthenware, buff clay body under a pale orange slip, burnished,
with red, maroon, purple and black paint
Guanacaste-Nicoya Zone
Period V/VI (AD 500-1550)
Mora Polychrome, Guabal Variety (AD 800-1200)
Height 3⅝″ (9.2cm) Diameter 5¼″ (13.3cm)
Condition before conservation: cracks on base; chips on interior of rim
Accession no. N-1043

This rounded bowl rests on three hollow feet minimally
modeled as human heads with eyes, hair and ears outlined
in black. A band of red slip encircles the interior mouthrim.
Between the three rim and basal stripes is a running guil-
loche band with black diamonds in the interlocked loops.
Such a band is usually associated with the plumed serpent.

49. ROUNDED BOWL on flared pedestal

Earthenware, buff clay body under a pale orange slip, burnished,
with black, red and orange paint
Guanacaste-Nicoya Zone
Period VI (AD 1000-1550)
Altiplano Polychrome, (AD 1000-1350)
Height 6⅛" (15.6cm) Width 6" (15.2cm)
Condition before conservation: root marks throughout;
rim chip and crack from rim; base broken and repaired
Accession no. N-1062

This globular bowl curves in to a wide mouth and rests on a flared pedestal or annular base. It is decorated with horizontal bands and stripes. The lower band contains interlocked hook/step designs. The upper band contains a stylized pattern related to the plumed serpent feather motif. Around the mouthrim oblique lines may also refer to a serpent motif.

Altiplano or Highland Polychrome (Nos. 49-57) is a ceramic type composed mainly of vessels decorated with four or even five paint colors on the cream slip: brown, orange, red, maroon and black. Black is used extensively to outline zones of color and to add thin, spidery lines of detail. Motifs include alligator and serpent predominantly, and feline or man-jaguars less often. Originally Highland Polychrome was a ceramic group denoted by Lothrop which he believed to have been produced in the highlands. It was subsequently divided into Highland and Birmania, Mora and Chircot.[1] Mora is a Guanacaste type. Highland, Birmania and Chircot may be from a subregion between the mouth of the Tempisque River and the beginning of the Centinelas Mountains.[2]

1. Lothrop 1926, pp. 295-305, pls. CXLII-CLI. Divided and clarified by Baudez 1967 and Accola 1978.
2. Snarskis 1982, p. 63.

Cf. Lothrop 1926, fig. 189, for similar shape; Ferrero 1977, Ilus. I-62, for such a shaped vessel in the MNCR, acc. no. 15003, described as Birmania Polychrome, also Sackler Number 51 for similar shape.

50. BOWL with flaring pedestal

Earthenware, light reddish clay body under an orange slip, burnished, with black, red and maroon paint
Guanacaste-Nicoya Zone
Period VI (AD 1000-1550)
Altiplano Polychrome (AD 1000-1350)
Height 2¾" (7cm) Diameter 4" (10.2cm)
Condition before conservation: root marks; slight crack from rim
Accession no. N-1020

The rounded bowl with thickened mouthrim rests on a flared pedestal. On one side of the exterior is a human face minimally modeled and painted. It is framed in black with wide vertical black bands probably representing hair. The eyes are large, circled in black with pupils as horizontal lines and with oblique black lines underneath which may represent tears. The remainder of the exterior is painted with stylized jaguar motifs.[1]

1. Lothrop 1926, pl. XXXVI, for a description of such designs as jaguar motifs. Cf. Lothrop 1926, fig. 30, for similarly outlined eyes, and pl. CXLV, for a similar face.

51. GLOBULAR URN on a flared foot

Earthenware, light reddish clay body under a pale orange slip, burnished, with red, black and orange paint
Guanacaste-Nicoya Zone
Period VI (AD 1000-1550)
*Altiplano Polychrome (AD 1000-1350)**
Height 7½" (19.1cm) Width 6⅞" (14.7cm)
Condition before conservation: surface worn; cracks at mouthrim; chips on foot
Accession no. N-1070

The globular jar curves in to a wide mouth and rests on a flared pedestal. Painted around the exterior are zoomorphic designs surrounded by groups of short parallel lines. The image, resembles what Lothrop characterizes as an alligator pattern on the ware he describes as Highland Polychrome.[1] A parallel line design appears in the band around the mouthrim. The pedestal is decorated with linear designs.

1. Lothrop 1926, fig. 190, after Hartman 1901.
Cf. Lothrop 1926, vol. II, fig. 189, for a similarly shaped vessel, also Sackler Number 58, for a similar design on a Birmania tripod.
**OXTL analysis (ref. no. 381P78, 4/3/85) estimates that the sample tested was last fired between 720 and 1180 years ago (AD 805-1265).*

52. BOWL on a ring base

Earthenware, light reddish clay body under an orange slip, burnished,
with red, black and purple paint
Guanacaste-Nicoya Zone
Period V/VI (AD 1000-1550)
Altiplano Polychrome (AD 1000-1350)
Height 2³/₄" (7.0cm) Diameter 5³/₄" (14.6cm)
Condition before conservation: root marks throughout;
slightly worn
Accession no. N-1080

The hemispherical footed bowl with thickened mouthrim is
painted with deep toned colors and is highly burnished,
reminiscent of Galo Polychrome. The interior is painted
with stylized plumed serpent motifs around a central circle.

Cf. Lothrop 1926, pl. CXLVIIIa, for similar interior painting style of the
plumed serpent motif designated by Lothrop as Type C.

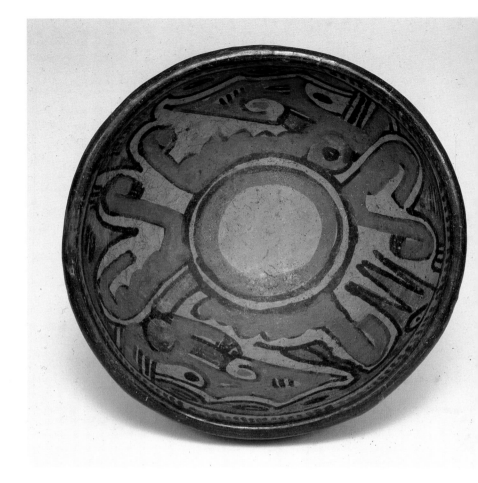

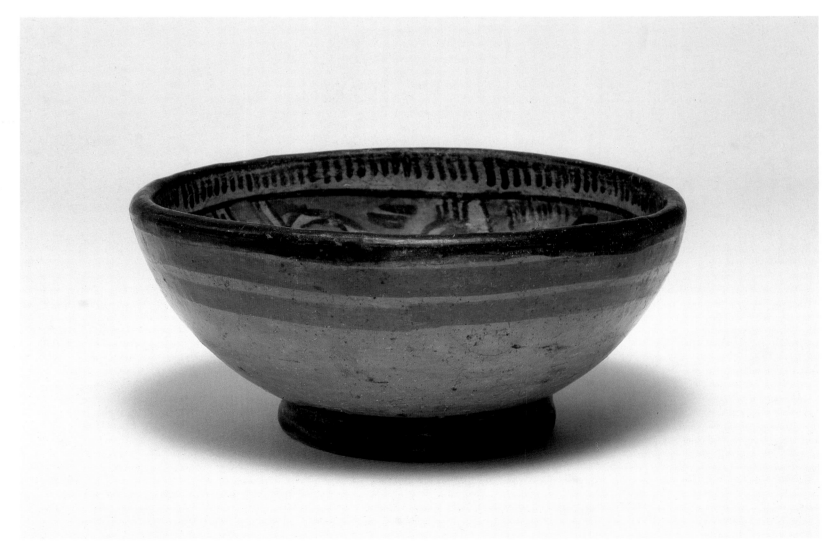

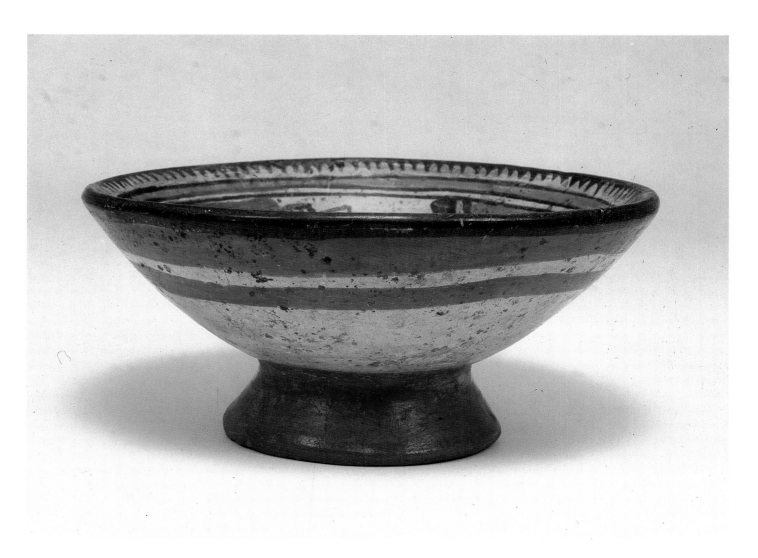

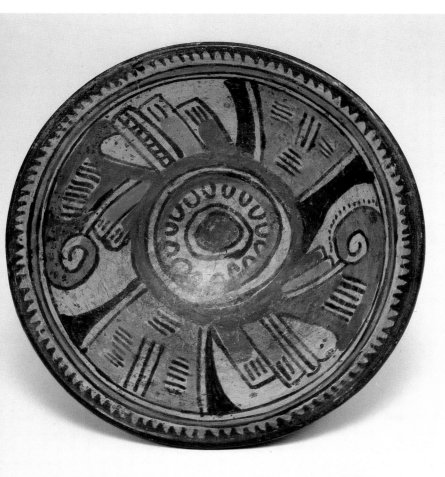

53. BOWL on a flared pedestal

Earthenware, brownish buff clay body under a pale orange slip, burnished, with red, orange, purple and black paint
Guanacaste-Nicoya Zone
Period V/VI (AD 1000-1550)
Altiplano Polychrome (AD 1000-1350)
Height 3⁷⁄₈" (9.8cm) Diameter 6" (15.2cm)
Condition before conservation: interior and exterior surface scratched; root marks
Accession no. N-1068

The funnel-shaped bowl rests on a flared pedestal. The mouthrim is painted black. The interior of the bowl is painted with a stylized two-headed monster motif with the two triangular heads opposite each other joined to a small common body formed by the circular central field. At right angles to the heads are two pairs of arms. Between the head and the arms are looped projections which may be plumes of the plumed serpent.

Cf. Lothrop 1926, pl. CLIb, for an elaborate example of the two-headed monster, Type C, which Lothrop describes as having four pairs of legs treated in a manner which recalls the plumed serpent, Type B, on Highland pottery.

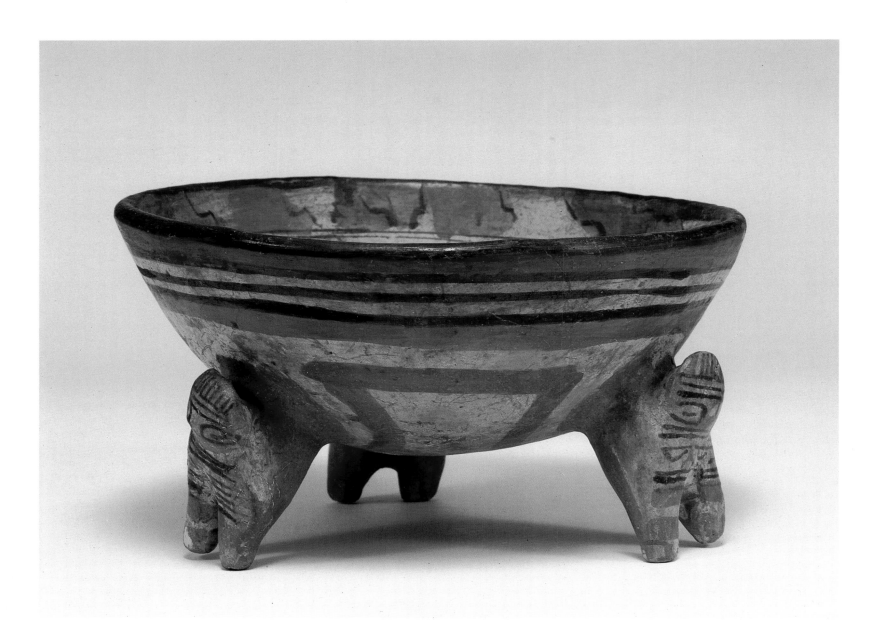

54. BOWL with three caryatid rattle legs

Earthenware, brownish body under a pale orange slip, burnished, with red, black and brown paint
Guanacaste-Nicoya Zone
***Period VI** (AD 1000-1550)*
Altiplano Polychrome (AD 1000-1350)
Height 4" (10.2cm) Diameter 6⁵⁄₈" (16.8cm)
Condition before conservation: design worn; root marks; extensive but slight surface cracking
Accession no. N-1003

The hemispherical bowl rests on three legs which are modeled as busts of bending humans with their extended arms supporting the vessel. The details of the minimally modeled heads are accentuated in red and black. The exterior of the vessel is decorated with red and black encircling lines. The interior of the bowl is decorated with a swirling, stylized two-headed monster motif. This is one of the most typical designs of Altiplano Polychrome. It consists of two opposed faces outlined by broad red bands and connected to each other by loops. The normal field for this pattern is the interior of a bowl although it also occurs as an exterior design.

Cf. Lothrop, 1926, pl. CLd, for a vessel in the two-headed monster motif with the same style of interior painting.

55. BOWL with three caryatid rattle legs

Earthenware, brownish buff clay body under a pale orange slip, burnished, with red, black and brown paint
Guanacaste-Nicoya Zone
Period VI (AD 1000-1550)
Altiplano Polychrome (AD 1000-1350)
Height 3½" (8.9cm) Diameter 5⅞" (14.9cm)
Condition before conservation: design slightly worn and scratched; one leg broken off
Accession no. N-1038

This hemispherical bowl rests on three minimally modeled, animal-head rattle legs, the details of which are enhanced with red and black markings. The exterior is decorated with horizontal red and black bands and stripes. Around the interior rim is a band of step/fret motifs in red and brown slip outlined in black. The interior of the bowl is decorated with what Lothrop describes as a stylized plumed serpent motif which seems to be similar to the two-headed monster pattern in Number 54.

Cf. Lothrop 1926, plate CXLVI, for Highland Polychrome ware with similar interior painting.

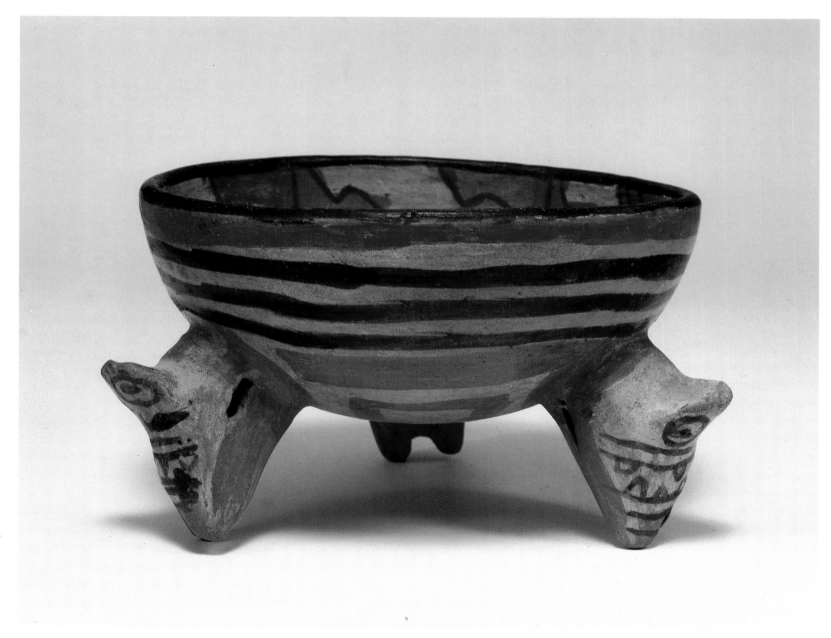

133

56. BIRD EFFIGY BOWL

Earthenware, buff clay body under a pale orange slip, burnished, with red,
orange and black paint
Guanacaste-Nicoya Zone
Period V/VI (AD 1000-1550)
Altiplano Polychrome (AD 1000-1350)
Height 3¹⁄₈″ (7.9cm) Width 4¹⁄₄″ (10.8cm) Depth 5⁵⁄₈″ (14.3cm)
Conditon before conservation: root marks especially on
interior; slight surface chips
Accession no. N-1081

The rounded bowl on three hollow legs incorporates a mod-
eled hollow rattle bird's head appliquéd to one side. It is a
pair with Number 57. Flanges representing wings extend
from either side of the head around the exterior of the bowl
and are striped in black to form feathers. The minimally
modeled head has large eyes, an open beak with beak knob
above it, and is painted to reinforce the modeling. Above
and below the wings are bands of interlocked step motifs.
The legs are painted with black lines, dots and circles on a
white ground with solid red above and below.

Cf. Lothrop 1926, pl. CXLIII, for similar Highland Polychrome animal effigy
bowls.

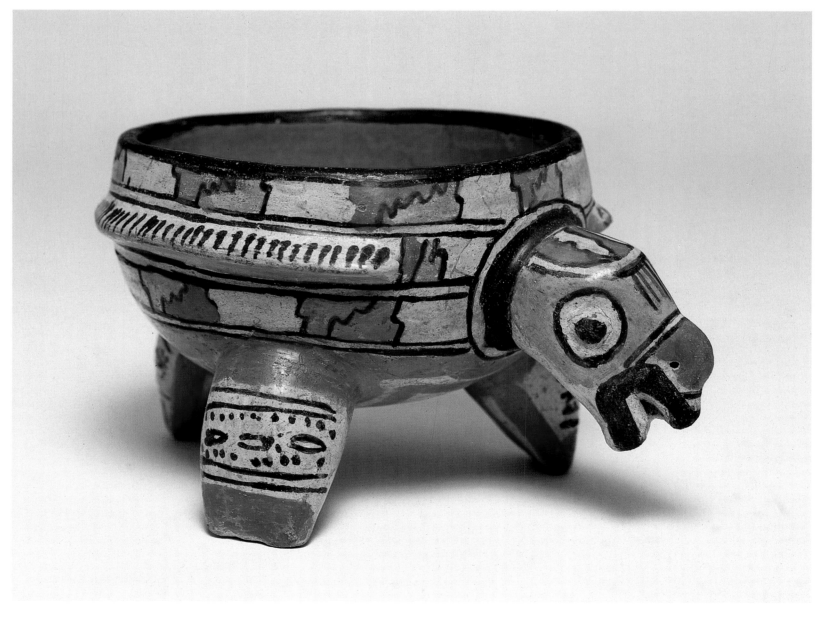

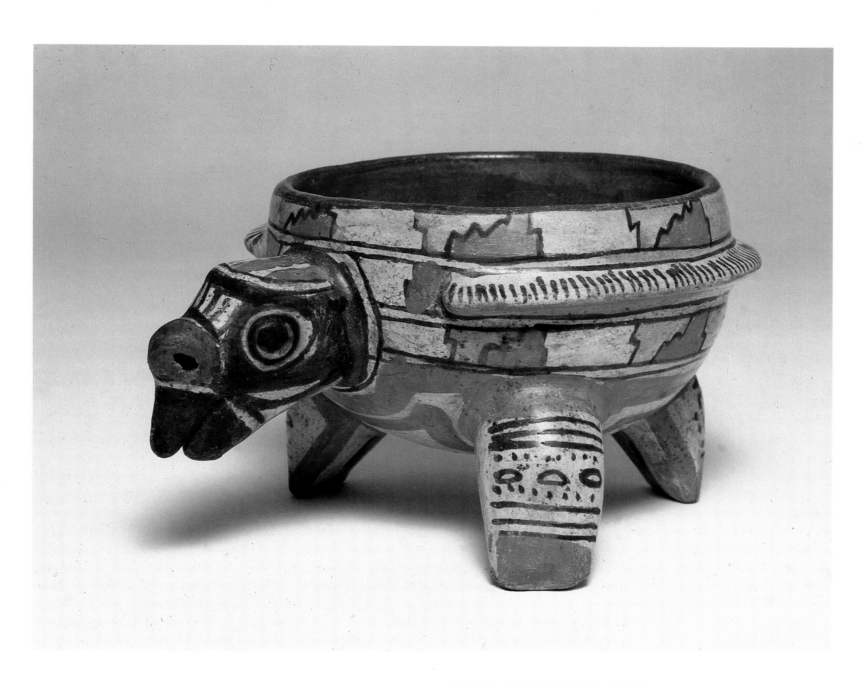

57. BIRD EFFIGY BOWL

Earthenware, buff clay body under a pale orange slip, burnished, with red, orange and black paint
Guanacaste-Nicoya Zone
Period V/VI (AD 1000-1550)
Altiplano Polychrome (AD 1000-1350)
Height 3¼" (8.3 cm) Width 4⅜" (11.1 cm) Depth 5⅞" (15 cm)
Condition before conservation: root marks on underside of bowl; chips around head
Accession no. N-1069

A pair with Number 56, this rounded bowl on three hollow legs also has a modeled, hollow rattle bird's head attached to the side and, except for the difference in head coloring and shape of mouth, is identical.

135

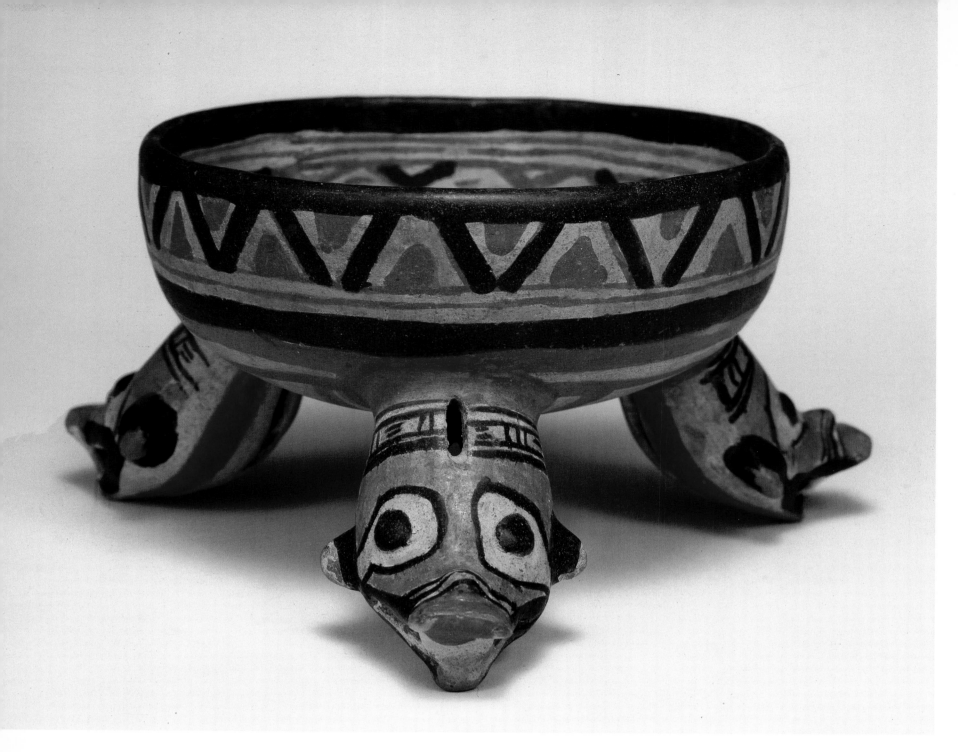

58. TRIPOD BOWL

Earthenware, light reddish clay body under an orange slip, burnished, with red, black and white paint
Guanacaste-Nicoya Zone
Early Period V/VI (AD 500-1200)
Birmania Polychrome (AD 800-1200)
Height 3¾" (9.5cm) Diameter 6¾" (17.1cm)
Condition before conservation: broken and repaired; surface scratches
Accession no. N-1093

The bowl rests on hollow animal-head tripods. The decoration on the interior bottom is similar to that in Number 51, probably a stylized alligator motif. Exterior and interior painted designs refer to the animal's hide. Birmania Polychrome (Nos. 58-62), now separately designated, was part of the ceramic group Lothrop called Highland Polychrome.[1] The vessels of this type may be feline, bird, dragon or sea turtle effigies as tripods and tetrapods, or have annular bases with or without rattles. Ocarinas as birds, turtles and other animals are also known.

1. Lothrop 1926, pp. 295-305, pls. CXLII-CLI.

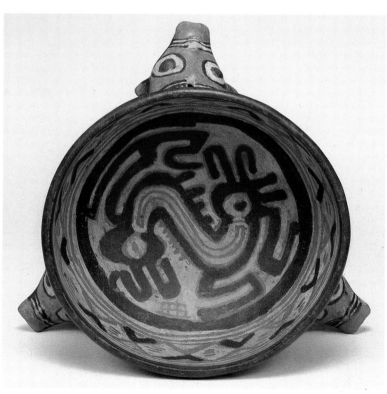

FOUR-NOTE OCARINAS

Earthenware, buff clay body under an orange slip, burnished, with red and black paint
Guanacaste-Nicoya Zone
Period VI (AD 1000-1550)
Birmania Polychrome or Mora Polychrome, Guabal Variety (AD 800-1200)

Numbers 59 to 62 are four-note ocarinas modeled as animals, a human figure and a sea turtle. For the armadillos and the turtle the tail is the mouthpiece. Number 61 has two openings in the back and two in the nostrils. Openings in the neck are for suspension. The turtle's shell is decorated with an interwoven mat pattern (No. 60). Similar ocarinas were known among Guabal Polychromes, and this whistle has the coloring as well as the mat pattern typical of Guabal types.

Cf. Lothrop 1926, fig. 151, for whistles with similar decor.

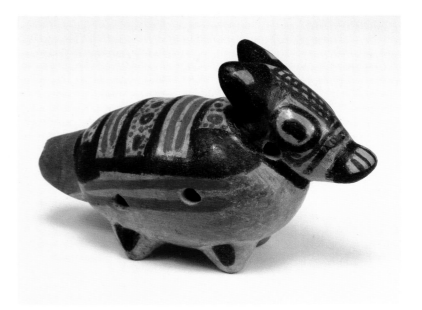

59. ARMADILLO

Height 2³/₈" (6.0cm) Width 1³/₄" (4.4cm) Depth 3¹/₂" (8.9cm)
Condition before conservation: chip on nose, right side of back, left ear and left front foot
Accession no. N-980
Cf. Lothrop 1926, fig. 151, for whistles with similar decor.

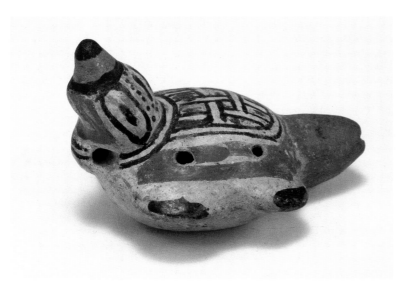

60. TURTLE

Height 2¹/₈" (5.4cm) Width 2³/₈" (6.0cm) Depth 3" (7.6cm)
Condition before conservation: paint worn on back; root marks on belly
Accession no. N-1032
Cf. Lothrop 1926, fig. 151a, for another turtle whistle, a type which Lothrop indicated had a wide distribution.

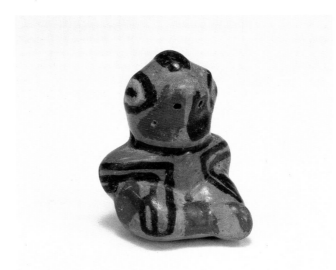

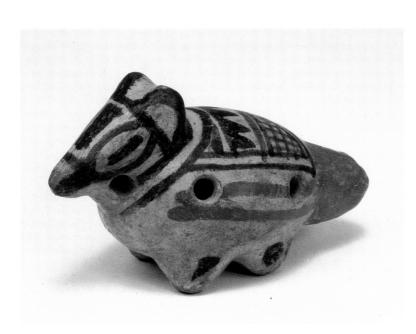

61. HUMAN FIGURE

Height 1¹/₂" (3.8cm) Width 1¹/₄" (3.2cm)
Condition before conservation: painting around right eye worn; root marks
Accession no. N-1035

62. ARMADILLO

Height 2" (5.1cm) Width 1¹/₂" (3.8cm) Depth 3³/₈" (8.6cm)
Condition before conservation: design slightly worn on back and nose
Accession no. N-906

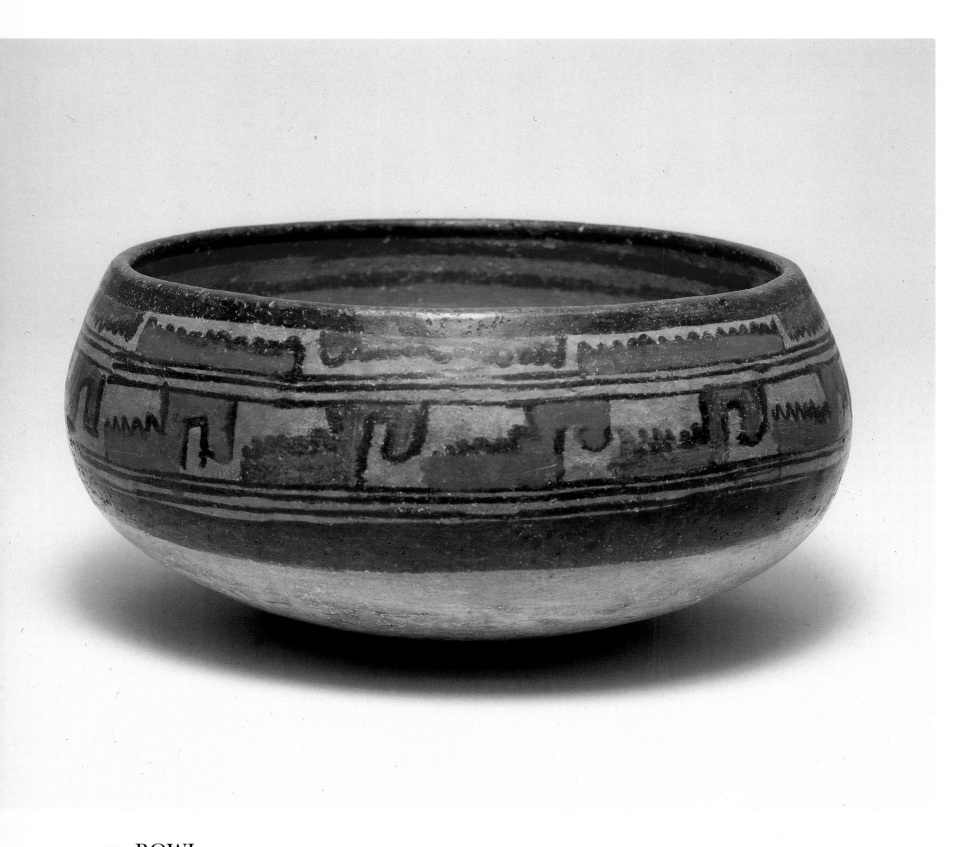

63. BOWL

Earthenware, buff clay body under a pale orange slip, burnished, with red, grey and black paint
Guanacaste-Nicoya Zone
Period VI (AD 1000-1550)
Santa Marta Polychrome (AD 1000-1350)
Height 4¼" (10.8cm) Diameter 8⅝" (21.9cm)
Condition before conservation: paint worn in spots
Accession no. N-1018

The walls of this round-bottomed bowl curve in slightly to a thickened mouthrim. Between the black mouthrim and the wide basal band, the painted design includes an upper band of opposed, jagged-edged rectangles and a lower wider band, edged by multiple black stripes, with large step/hook or step/fret designs in alternating purple and red, edged with black.

By the middle of Period VI, Birmania Polychrome blends into Santa Marta Polychrome with its occasionally vivid red, brown and black paint on a shiny orange slip (Nos. 63 and 64).

64. BOTTLE with jaguar motifs

Earthenware, light reddish clay body under an orange slip, burnished, with black and red paint
Guanacaste-Nicoya Zone
Late Period VI (AD 1200-1550)
*Santa Marta Polychrome (AD 1000-1350)**
Height 7" (17.8cm) Width 9¼" (23.5cm)
Condition before conservation: small section missing from rim; design worn; surface scratches, root marks throughout
Accession no. N-1096

The bulbous lower body of the bottle rises from a rounded bottom, slopes inward at the low shoulder, then rises to a short neck which flares to the everted mouthrim. A heavy black band encircles the mouthrim and is echoed in the black shoulder band. In between, are multiple red stripes bordering a pattern of jaguar-spot motifs alternating with an hourglass shape painted in black.

**OXTL analysis (ref. no. 381p86, 5/10/85) estimates that the sample tested was last fired between 550 and 950 years ago (AD 1035-1435).*

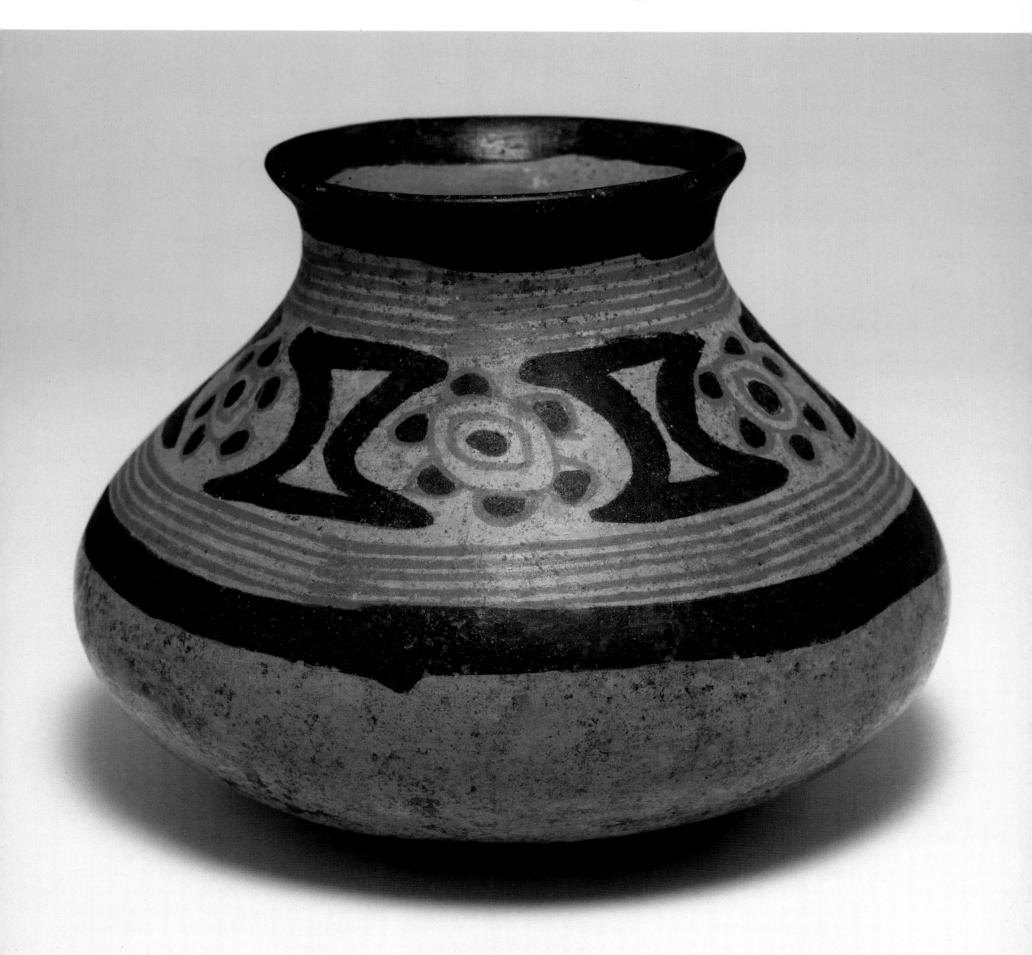

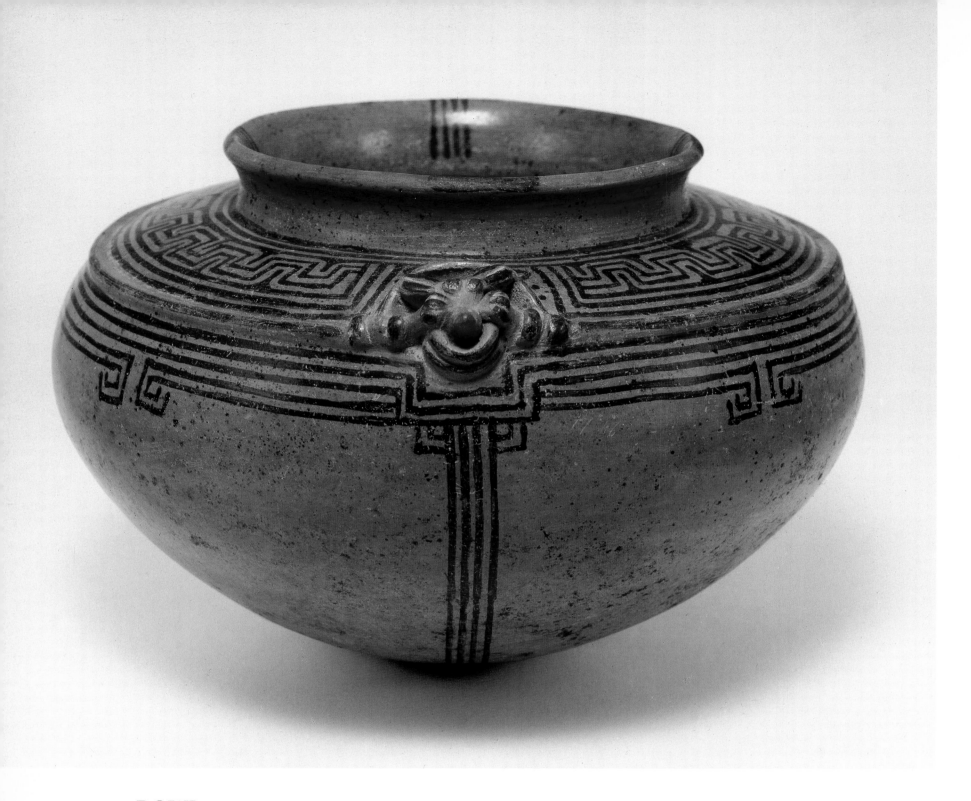

65. BOWL

Earthenware, buff clay body under a buff-brown slip, burnished, with black paint
Guanacaste-Nicoya Area
Period V/VI (AD 500-1550)
*Gillen Black on Red (?) (AD 1000-1550)**
Height 6½" (16.5cm) Width 9⅜" (23.8cm)
Condition before conservation: repair to rear of animal on one side of shoulder and around mouthrim
Accession no. N-1162

This ovoid bowl curves convexly from a narrow, rounded base to a sharp shoulder ridge and constricts in to a horizontally curved shoulder which joins to a short neck that flares to a rolled mouthrim. Appliquéd on the shoulder is a feline head. The vessel is decorated above and below the shoulder ridge with black-line multiple meanders, horizontal stripes and hooks. Multiple brush lines extend vertically from below the feline head over the bottom of the bowl and are also painted on the inside of the mouthrim.

The Gillen Black on Red was newly named by Dr. Jane Day.[1] Characteristically it has black bands encircling a guilloche or mat pattern on vessels, primarily jars, with a red-orange slip. Lothrop had originally subsumed all black-line vessels of the type, along with the earlier Charco Black on Red (see No. 9), under the title Nicoya Black-Line Ware.[2]

1. Day 1984
2. Lothrop 1926, p. 222, pl. XCIX.

**OXTL analysis (ref. no. 381N86, 4/1/85) estimates that the sample tested was last fired between 930 and 1650 years ago (AD 335-1055).*

66. LARGE GLOBULAR BOWL

*Earthenware, brownish buff clay body under a pale orange slip,
burnished, with black paint*
Guanacaste-Nicoya Area
Period V/VI (AD 500-1550)
*Gillen Black on Red(?) (AD 1000-1550)**
Height 8⅛" (20.6cm) Width 11" (27.9cm)
*Condition before conservation: broken into large fragments and repaired;
cracks from rim to underside; root marks throughout*
Accession no. N-885

This large rounded bowl curves in to a short straight neck
which rises to an everted, thickened rim. The pale orange
slip ground is decorated with horizontal and vertical black
stripes and designs, probably representing the markings on
alligator hide. On the shoulder of the vessel is a wide deco-
rated band, framed by thick and thin horizontal and vertical
black lines forming rectangular zones. Alternate zones are
filled either by a wavy horizontal line or by crisscross lines.

Below the shoulder, the surface is quartered by vertical thick
and thin black stripes running under the bottom of the ves-
sel and geometric or stylized animal (alligator) motifs where
the verticals meet the horizontal shoulder band. Similar ver-
tical markings run into the interior neck from the mouth-
rim. Centered between the vertical stripes quartering the
body of the vessel are multiple-line geometric designs with
the lower bar extending out on both sides to a hook, proba-
bly also representing stylized animal (or alligator?) motifs.

It is difficult to associate this vessel with the same type as
Number 65, except that the vertical linear quartering here is
similar to that of Number 65, and both have similar vertical
lines in the interior mouthrim. From the TL analysis, it also
seems possible that this vessel could have been produced
earlier. The designs are not unlike the vocabulary of design
used on Tola Trichromes (see Nos. 20 and 21).
**OXTL analysis (ref. no. 381p66, 4/18/85) estimates that the sample tested was last fired
between 800 and 1500 years ago (AD 485-1185).*

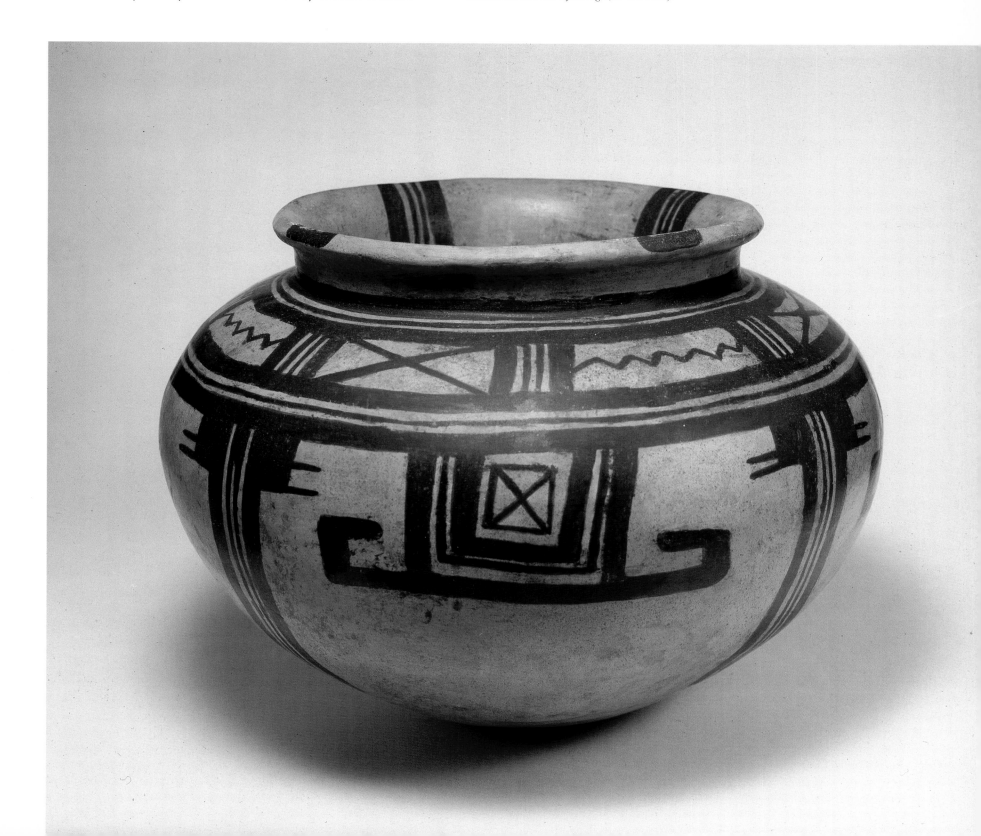

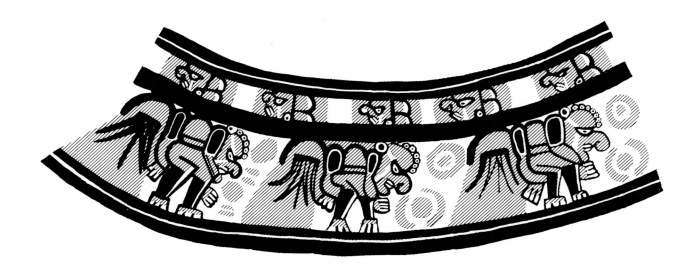

67. FOOTED JAR

Earthenware, reddish clay body under a creamy white slip with red,
orange and black paint
Guanacaste-Nicoya Zone
Period V/VI (AD 700-1100)
*Papagayo Polychrome, Culebra Variety (AD 800-1000)**
Height 7¾" (19.7cm) Width 6½" (16.5cm)
Condition before conservation: design worn in spots;
root marks throughout
Accession no. N-990

This pedestal jar, pear-shaped with an annular base, is a
frequent form in this ceramic type. It stands on a slightly
flared foot with the lower body bulging out as it rises from
the foot and then from a low shoulder tapers to the thick-
ened mouthrim. A horizontal groove on the exterior encir-
cles the neck just below the rim. Above the body swell is a
broad painted band with the hunter as the central theme.
He crouches as he appears to move forward. His features,
with the hooked nose, tend to blend with that of the jaguar
motif as this then becomes more stylized. The red circles
and concentric rings in front of the figure are characteristic
of Culebra ware and may represent the sun. Above is a band
with repeated heads which may either be stylized versions
of the anthropomorphic morning-star god or a stylized
plumed serpent motif, also associated with Venus. The
bands are set off by heavy black stripes while the lower part
of the vessel is zoned red and white.

Papagayo Polychrome was just one of many related white-
slipped wares manufactured in Pacific Central America
during the Middle Polychrome Period, circa AD 800-1200, a
time of great cultural diversity. The broad range of forms of

the Papagayo type included bowls, jars, zoomorphic effigies
and effigy-head tripods. Design motifs vary from simple
bands to complex figural scenes or compositions emphasiz-
ing an aspect of Quetzalcoatl.

Papagayo Polychrome has a white burnished slip over a
brick red paste with designs painted in black, orange and
red. The forms include *jícara* and gourd shapes with tripod
feet or a ring base and composite silhouette bowls with tri-
pod effigy legs. Stylized Mexican deities such as Mixcoatl
(Morning Star), Tezcatlipoca (Jaguar deity and ruler of
darkness), Ehecatl (God of the Wind), Quetzalcoatl (Plumed
Serpent) and serpent symbols are among the common deco-
rative motifs on Papagayo Polychrome with scorpion, crab
and monkey motifs in later varieties. The ware appears
in Costa Rica, Nicaragua, Honduras, Guatemala and El
Salvador, associated with Tohil Plumbate Ware diagnostic
of Mexican Toltec traders.[1] Some Papagayo Polychromes
also resemble Mesoamerican early Postclassic wares like the
Tohil Plumbate and X Fine Orange. Whereas Mora and
Birmania ceramics are found with greater frequency in the
southern half of Greater Nicoya, Papagayo Polychromes
tend to be more northern in manufacture and distribu-
tion, having been made at least as far north as Rivas,
Nicaragua and then traded to Guanacaste-Nicoya.[2]

1. Baudez and Coe 1962, p. 370, and Stone 1977, p. 70.
2. Day and Abel-Vidor 1980.
Cf. Stone 1977, fig. 120, for a jar from Culebra Bay with a similar figural motif
which she describes as Mexican; Baudez 1970, pl 67, for a jar of similar shape
with a spear thrower figure, from Panama, Guanacaste Province, Costa Rica, in
the Collection of Marjorie de Oduber, San José, Costa Rica; and another simi-
larly designed jar in the Thibedaux Collection, Atlanta, Georgia.
*OXTL analysis (ref. no. 381q33, 6/1/85) estimates that the sample tested was last fired
between 500 and 900 years ago (AD 1085-1485).*

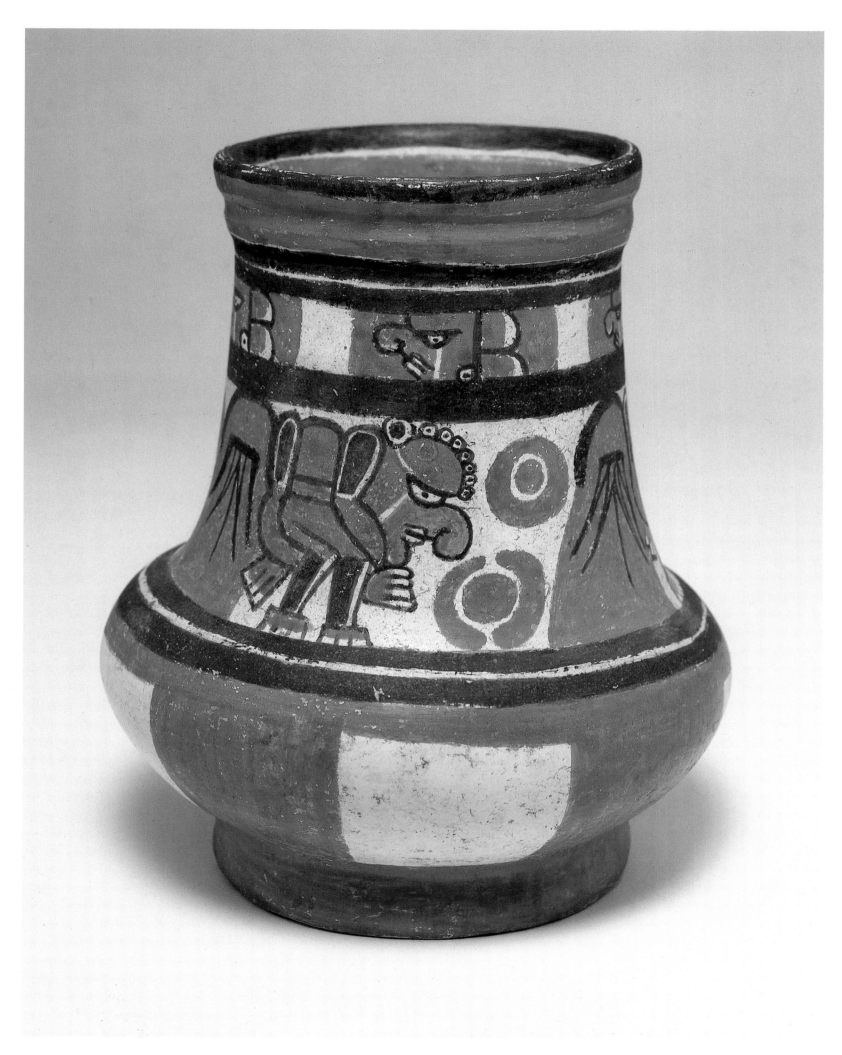

143

68. BOWL with jaguar motif

*Earthenware, reddish white clay body under a creamy white slip
with red and black paint †*
Guanacaste-Nicoya Zone
Period V/VI (AD 700-1100)
*Papagayo Polychrome, Culebra Variety (AD 800-1000)**
Height 2" (5.1cm) Diameter 3⅞" (9.8cm)
Condition before conservation: root marks;
paint chipped on exterior; design worn in spots; burial stains
Accession no. N-988

The walls of this small, footed bowl splay to the everted
mouthrim. A groove encircles the vessel just below the
mouthrim. Painted on the exterior are two black-bordered
panels with spotted jaguars quite realistically rendered and
similar to those primarily shown in man-jaguar themes. The
jaguar has an elongated upper jaw, a large canine tooth, and
jaguar spots. Associated red discs on the paws may represent
sun circles.[1] Lothrop has indicated that these discs are not
characteristic of Nicoya Polychrome as a whole, and are
rarely found except with the jaguar and man-jaguar themes
on Culebra Ware. On the interior sides of the bowl are the
head, arm, hand with weapon, and feathered headdress
of the man in the man-jaguar theme, as well as the red discs
within double red crescents associated with the sun.

1. Lothrop 1926, p. 139.
C.F. Lothrop 1926, pl. XXXIVa, for a similar jaguar figure.
**OXTL analysis (ref. no. 381M4, 7/16/84) estimates that the sample tested was last
fired between 820 and 1370 years ago (AD 614-1164).*
† Refired to remove burial stains. See Appendix C

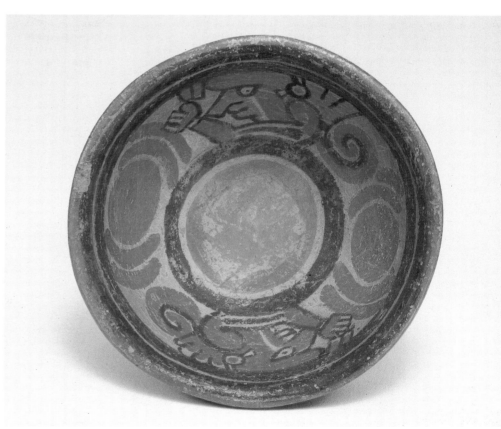

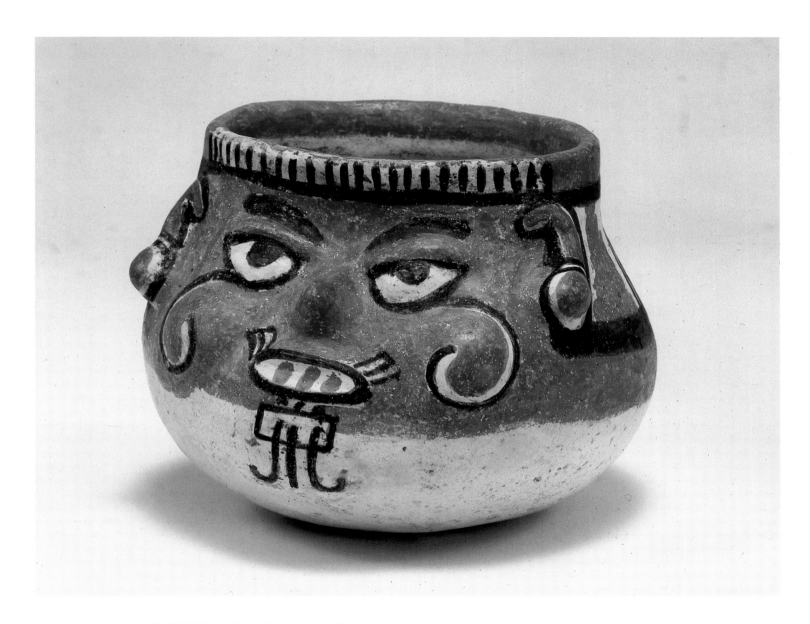

69. BOWL with human face

Earthenware, reddish clay body under a creamy white slip, burnished, with black and red paint
Guanacaste-Nicoya Zone
Period V/VI (AD 700-1100)
Papagayo Polychrome, Culebra Variety (AD 800-1000)
Height 3¼" (8.3cm) Width 4" (10.2cm)
Condition before conservation: design worn in spots throughout; chips on rim and lower body; root marks throughout
Accession no. N-955

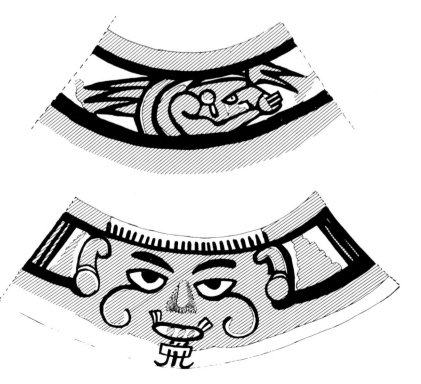

The body of this small round-bottomed bowl bulges out near the base but slopes in to a short neck. On one side is a modeled and painted human face possibly representing this effigy-face theme. The modeling of the eyes, nose, mouth and ear ornaments is minimal. Black lines form the brows, encircle the eyes, outline whisker-like spirals on the cheeks and depict the mouth with whiskers at the upper corners and what may be a pendant below the mouth. Short vertical lines on the rim indicate hair. On the reverse, painted on a cream band, is a stylized figure of a man in profile showing the head, with earspools, a lily foreplume and the nose covered with an arm and hand. The rest of his body has been reduced to plumes. This is nevertheless a reference to the man-jaguar theme.

Cf. Lothrop 1926, pl. XXVIII, for an example of a similar painted profile figure.

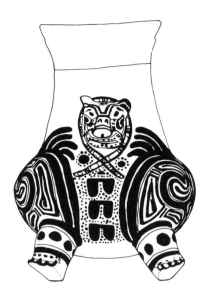

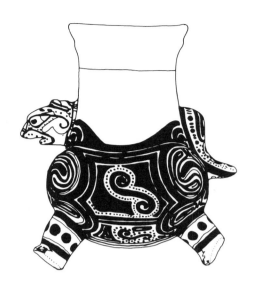

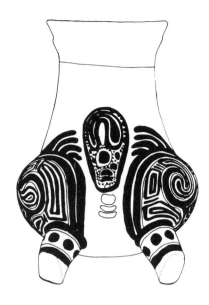

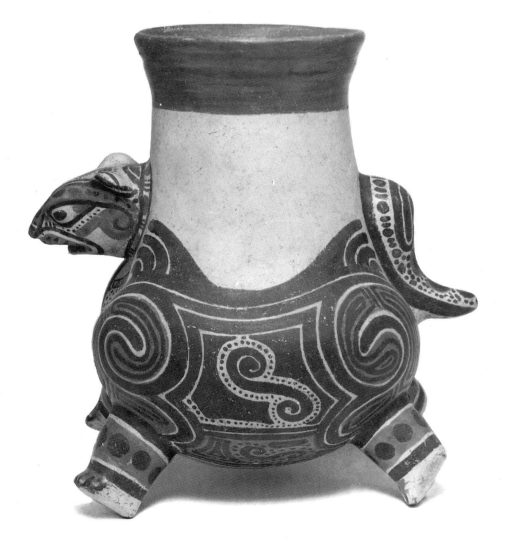

70.

ANIMAL EFFIGY JAR

Earthenware, reddish clay body under a creamy white slip, burnished, with black, red and orange paint
Guanacaste-Nicoya Zone
Period V/VI (AD 700-1100)
Papagayo Polychrome, Culebra Variety (AD 800-1000)
Height 10⅝" (27cm) Width 7½" (19.1cm) Depth 9" (22.9cm)
Condition before conservation: paint chips throughout; root marks; design faded in spots; paint worn in spots on interior rim
Accession no. N-1008

This effigy jar is modeled in the form of a striding jaguar with the rattle head attached to the vessel body as a continuation of the painted figure. A curled tail is applied at the back. The vessel stands on the four modeled feet of the jaguar, rises from a rounded base to four bulging corners indicating the hind quarters and shoulders and then tapers in to a tall neck which splays at the top to a wide mouthrim. The stylized body is decorated with swirls and scrolls, an S-design and lines of dots. Black dots are painted around each leg. The head presents a snarling visage with patternings of black and orange. The vessel neck is grooved near the rim around which a wide red band is painted.

Cf. Ferrero 1977, Ilus. III-43, for similarly shaped turkey effigy vessels but on pedestal feet, from Nacascola, Guanacaste in the Juan Dada collection, Costa Rica, and Ilus. III-44 in the Molinas Collection, Costa Rica from the Bay of Culebra, Guanacaste.

OXTL analysis (ref. no. 381L30, 4/3/84) estimates that the sample tested was last fired between 670 and 1100 years ago (AD 884-1314).

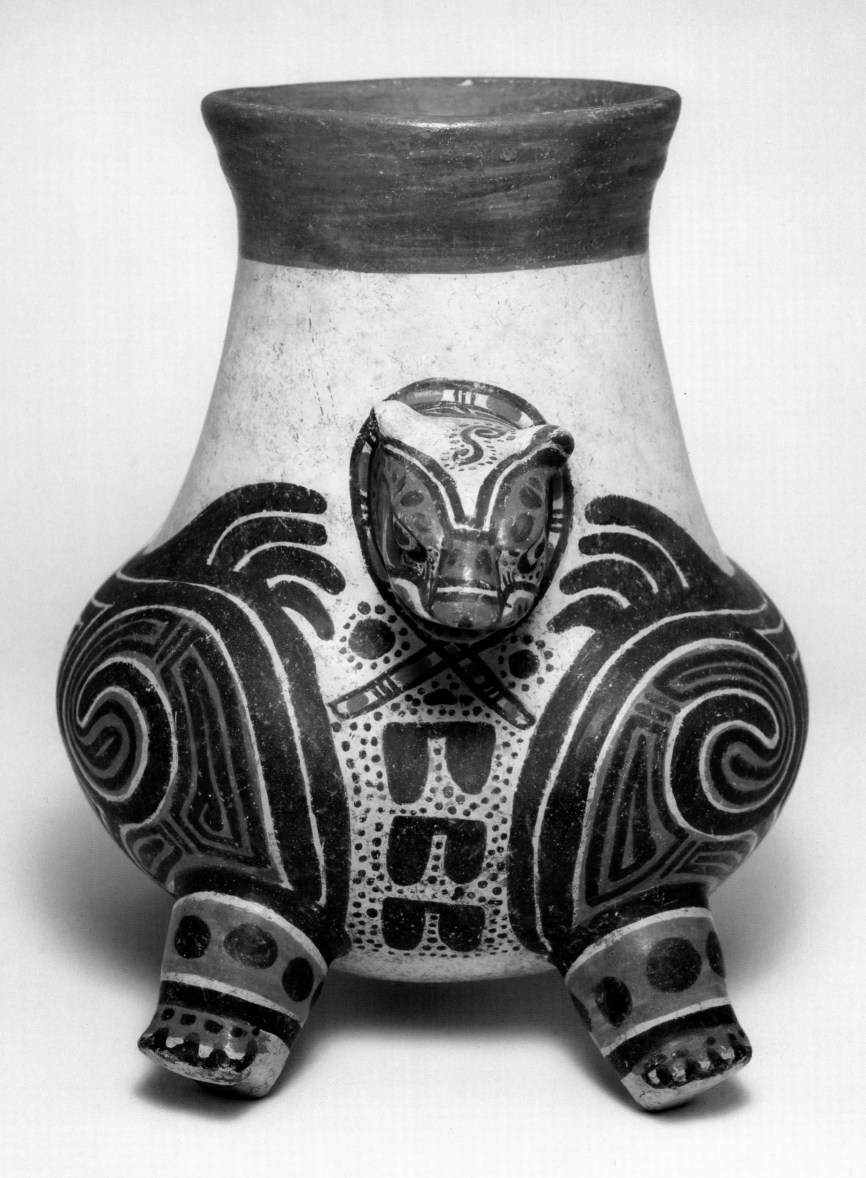

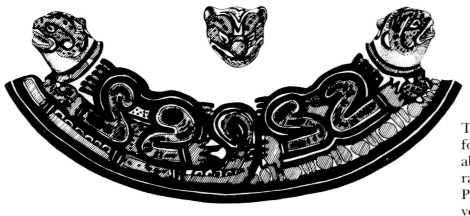

71. JAR with jaguar

*Earthenware, reddish clay body under a white slip, burnished,
with black, red and orange paint*
Guanacaste-Nicoya Zone
Period V/VI (AD 700-1100)
*Papagayo Polychrome, Culebra Variety (AD 800-1000)**
Height 7¼" (18.4cm) Width 6⅛" (15.6cm) Depth 6¾" (17.1cm)
*Condition before conservation: repair on right side near rim;
paint slightly worn; small surface chips on base*
Accession no. N-1026

The jar has a complex silhouette: from a flaring pedestal foot the rounded base curves up to a sharp shoulder ridge; above it the body tapers to a concave neck which rises to a raised and indented collar and a slightly flared mouthrim. Painted in the area from the shoulder to the collar of the vessel is the body of a stylized crouching jaguar whose modeled rattle head and a tail with an open slot are appliquéd on opposite sides of the neck. His collared head is realistically rendered with a snarling open mouth showing fangs. The body painting is heavily outlined in black. The jaguar holds what may be a serpent between its front paws. The shoulder of the vessel is banded with a row of jaguar spots and double black lines. A wide red band encircles the mouthrim. Pendant triangles are painted on the lower body and vertical bars and bands on the pedestal foot.

**OXTL analysis (ref. no. 381q36, 6/1/85) indicates that the sample tested was last fired between 650 and 1100 years ago (AD 885-1335).*

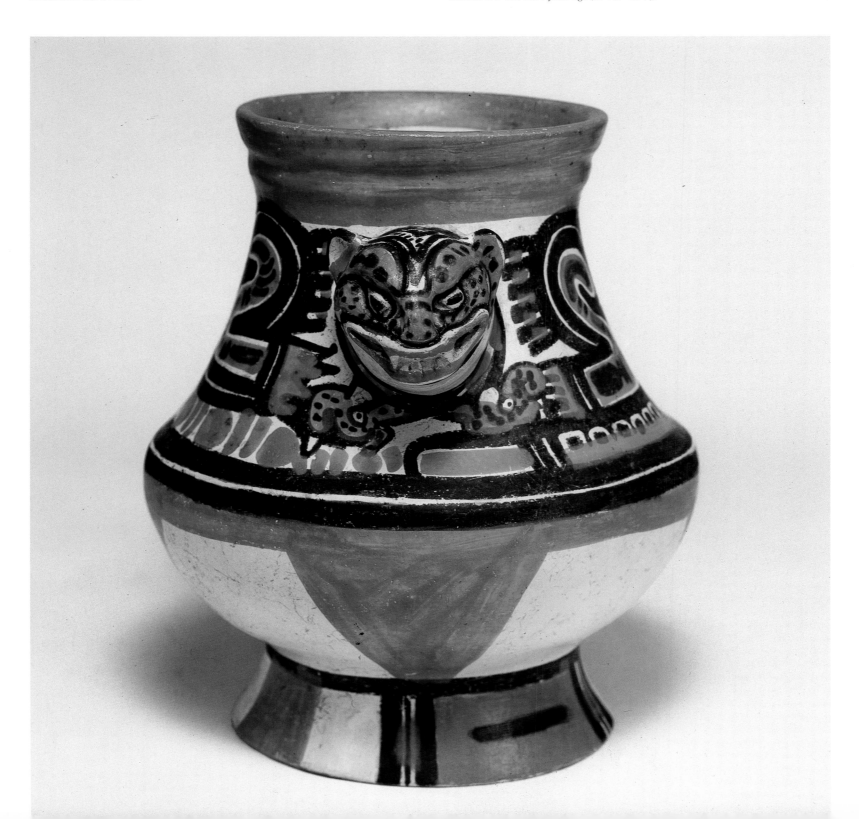

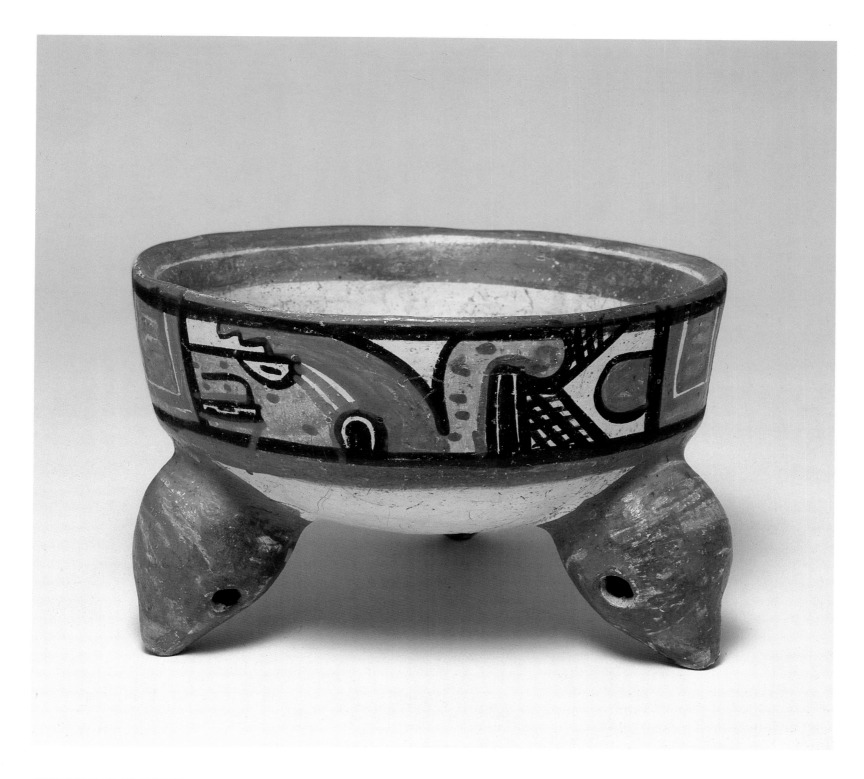

72. TRIPOD BOWL

*Earthenware, reddish clay body under a creamy white slip with orange,
red and black paint*
Guanacaste-Nicoya Zone
Period V/VI (AD 500-1550)
*Papagayo Polychrome, Mandador Variety (?) (AD 800-1000)**
Height 3¾" (7.3cm) Diameter 6¼" (15.9cm)
*Condition before conservation: small surface chips on bowl
above leg and on mouthrim; slight paint chips throughout*
Accession no. N-1040

The round-bottomed bowl rests on three animal-head rattle
legs. Two panels containing stylized plumed serpents or jag-
uars with short snouts are painted on the exterior. The body
arches like the tail of a jaguar but it is flanked by crosshatch-
ings which usually mark the body of the plumed serpent.
Each panel, framed in black, is separated by a square con-
taining striped lines.

Mandador variety was named and briefly described by
Norweb.[1] It was the most widely represented of Papagayo
varieties.

1. Norweb 1964, p. 559.
Cf. Lothrop 1926, plate LVII for a similar motif.
*OXTL analysis (ref. no. 381q38, 6/4/85) indicates that the sample tested was last fired
between 600 and 1000 years ago (AD 985-1385).*

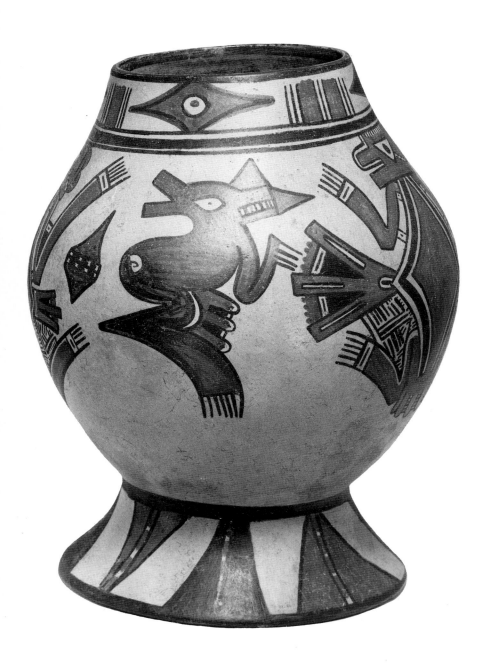

73.

JAR with monkey head

Earthenware, reddish clay body under a creamy-white slip, burnished, with orange, black and purple-brown paint
Guanacaste-Nicoya Zone
Period VI (AD 1000-1550)
*Papagayo Polychrome, Papagayo Variety (AD 1000-1350)**
Height 11" (27.9cm) Width 8⅝" (21.9cm) Depth 9½" (24.1cm)
Condition before conservation: surface scratches throughout; left arm extension from bowl repaired; root marks; cracks at base repaired
Accession no. N-1019

The ovoid jar rests on a flared pedestal foot. A monkey head rattle and two arms are appliquéd to one side of the upper body below the rim band. The arms loop out with one hand resting on top of the head and the other at the mouth. The eyes bulge and the nose is short. An indented ridge encircles the top of the head. Hair and eyelashes are painted as straight vertical lines. The mouth is painted red as are the arms. On either side of the appliquéd head are large stylized monkeys with heads in profile and legs spread. Each faces a geometric object (a version of the *kan* cross?). On the back of the jar, a stylized version of a canine creature is seen. The rim band is painted with stripes and lozenges with circle centers. Triangles are painted on the foot.

A number of Papagayo Polychrome varieties have been named. Papagayo variety, named and briefly described by Norweb, was a Middle to Late Polychrome Period variety, and was a widely traded product of the Middle Polychrome Period.[1]

1.. Norweb 1964, p. 559.
Cf. Lothrop 1926, pl. LXI, for a comparable monkey; also Baudez 1970, pl. 68, for a pottery vase depicting a man on his knees carrying a load; see also Stone 1977, fig. 102, for a human effigy vessel showing the figure holding his head, from Guanacaste Province, Costa Rica (present location not indicated).
*OXTL analysis (ref. no. 381q35, 6/1/85) estimates that the sample tested was last fired between 650 and 1100 years ago (AD 885-1355).

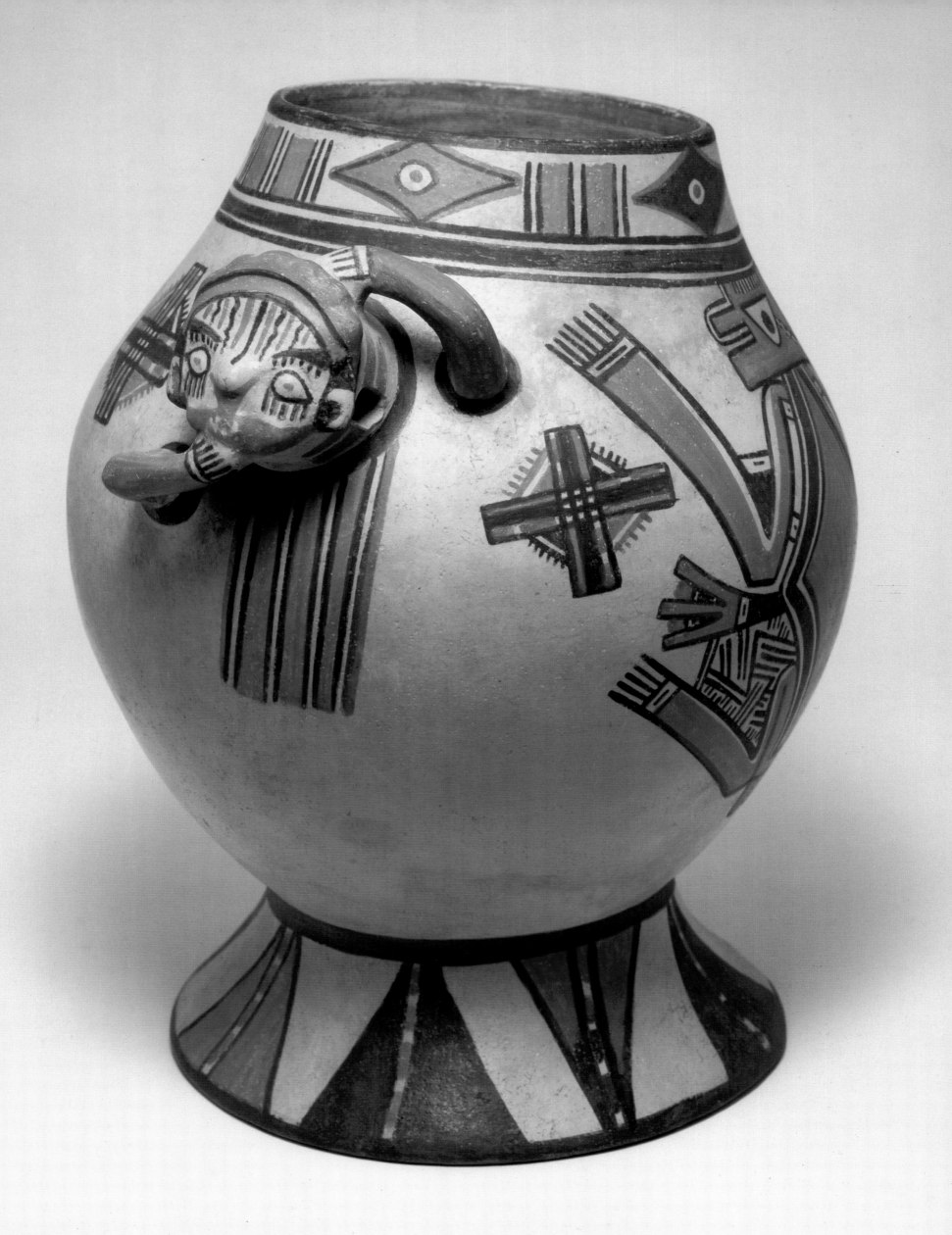

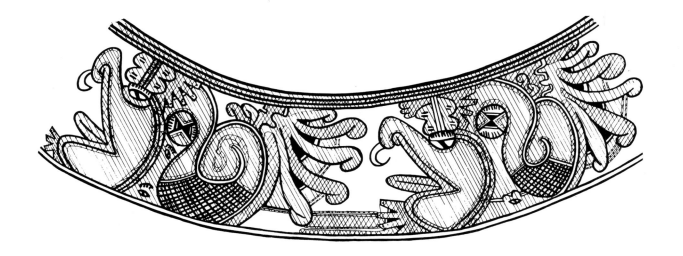

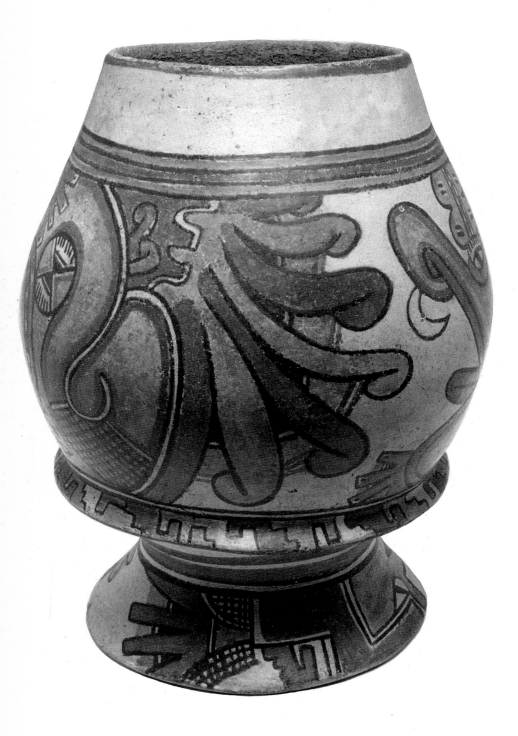

74.

JAR with plumed serpent

Earthenware, reddish clay body under a cream slip, burnished,
with red, orange and black paint
Guanacaste-Nicoya Zone
Period VI (AD 1000-1550)
*Papagayo Polychrome, Serpiente Variety (AD 1000-1350)**
Height 9¾" (24.8cm) Width 7½" (19.1cm)
Condition before conservation: two cracks at rim; design
slightly worn; scratches near rim; chips on basal ridge;
root marks on lower portion; foot broken and repaired
Accession no. N-1057

This jar is similar in shape to Number 75 but it has a basal
flange. Except for a rim stripe and a wide band of cream
below, the remainder of the body is completely covered with
a stylized version of the plumed serpent. Lothrop identifies
this style as Type A. The eye, mouth, tongue and fang are
clearly pictured. On the body crosshatched areas represent
the scales, while the head is crowned by large plumes. The
tail is covered with a rosette of feathers. The basal flange is
decorated with interlocked step/frets. The foot is painted
with another stylized head, perhaps a monkey, with ele-
ments of the plumed serpent or the man-jaguar theme (?).

Cf. Lothrop 1926, pl. L and LV; Stone 1977, fig. 97, for another example of Type
A plumed serpent design from Chira Island, Gulf of Nicoya; Snarskis 1982, p. 53
right, for either another example of a Papagayo vessel with plumed serpent motif
in the INS or the reverse of the same vessel illustrated by Stone 1977, fig. 97; and
Ferrero 1977, Ilus. III-52, for an example in the Molinos Collection, Costa Rica,
which is a more realistic rendering of the plumed serpent motif.

**OXTL analysis (ref. no. 381q39, 6/4/85) estimates that the sample tested was last fired*
between 500 and 900 years ago (AD 1085-1485).

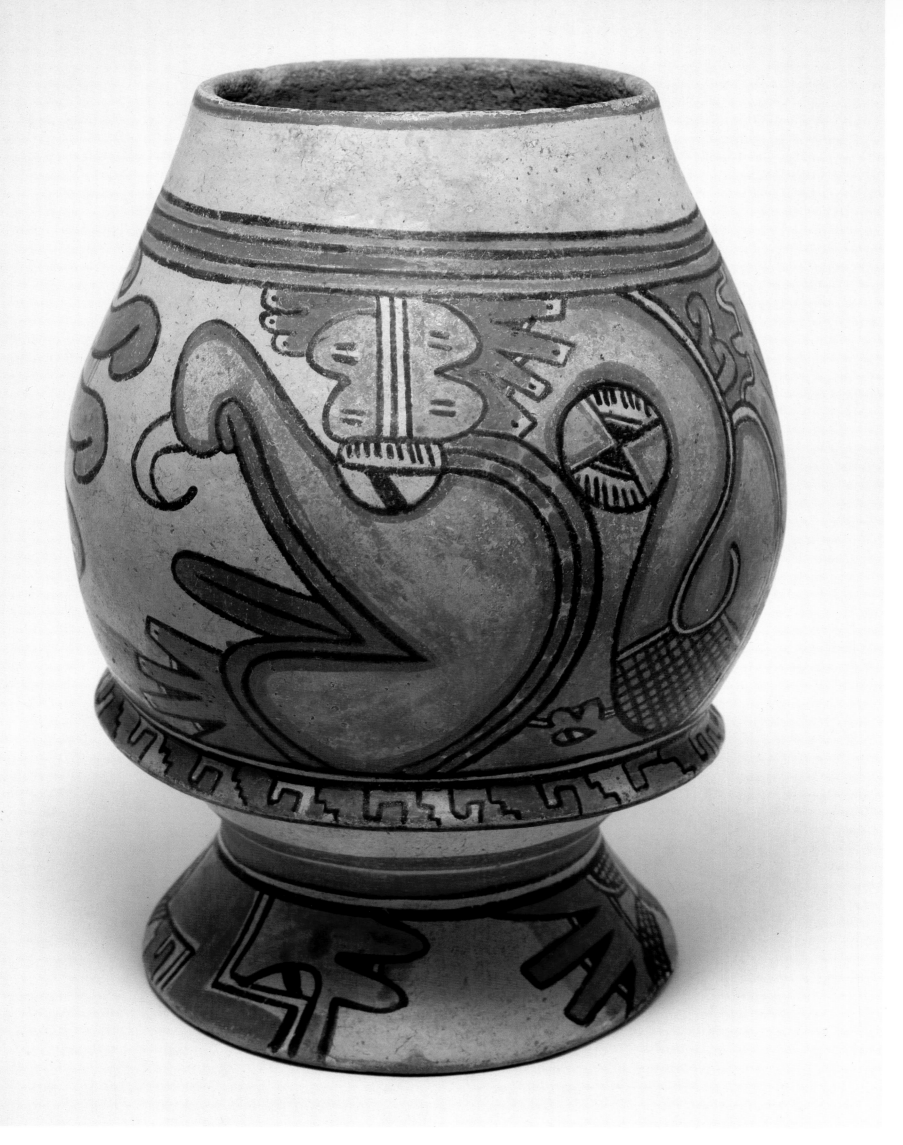

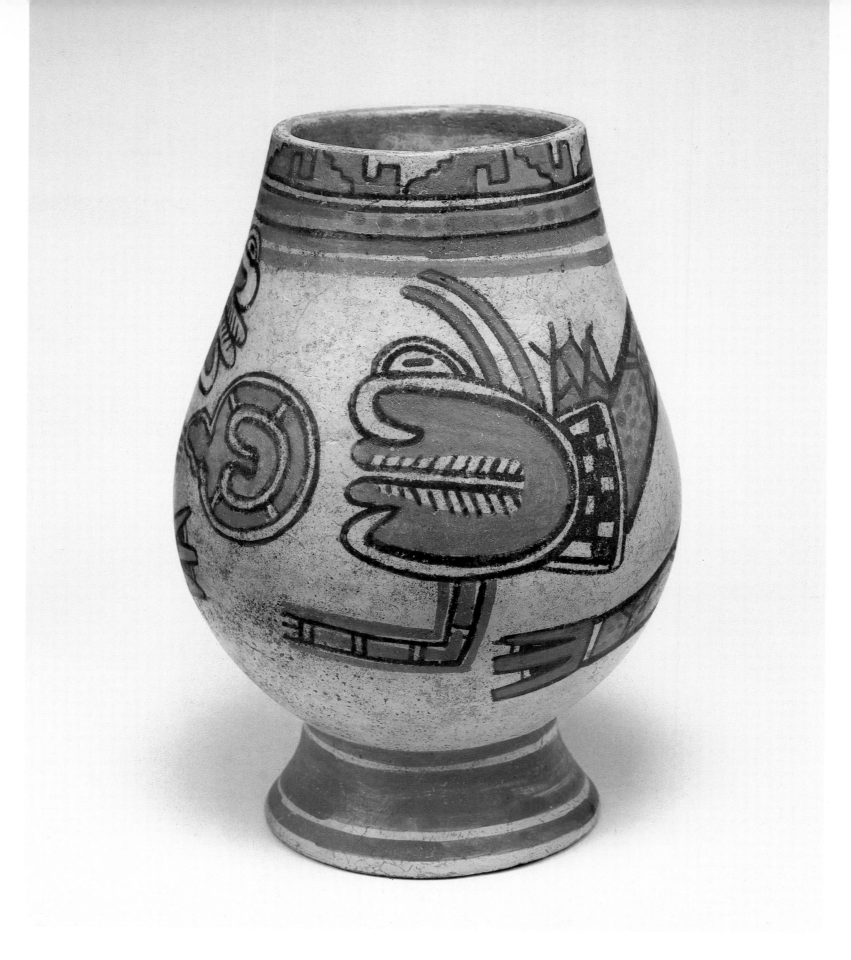

75. JAR with plumed serpent

Earthenware, red-brown clay body under a cream slip, burnished,
with red, orange and black paint
Guanacaste-Nicoya Zone
Period VI (AD 1000-1550)
Papagayo Polychrome, Serpiente Variety (AD 1000-1350)
Height 9¹/₈″ (23.2cm) Width 6¹/₄″ (15.9cm)
Condition before conservation: root marks throughout;
worn design; small chips in rim of base
Accession no. N-1010

This large gourd-shaped jar also rests on a flared pedestal
foot. Below a rim band which contains an interlocked
step/fret pattern the body is covered by a plumed serpent
design. Lothrop subsumes this design under his Type A.[1] An
unidentified symbol appears in front of the plumed serpent.

1. Lothrop 1926, pl. XLVB, for an almost identical vessel.
Cf. References for Number 74 and Ferrero 1977, Ilus. III-51, for an example in
the Collection of the Banco Nacional de Costa Rica, and Ilus. I-98, for another
example of a pair with plumed serpent design on body and step/fret motif on
mouthrim, base ridge and foot, in the Hans Prilas Collection.

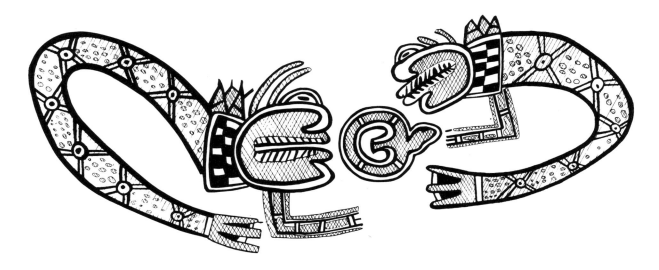

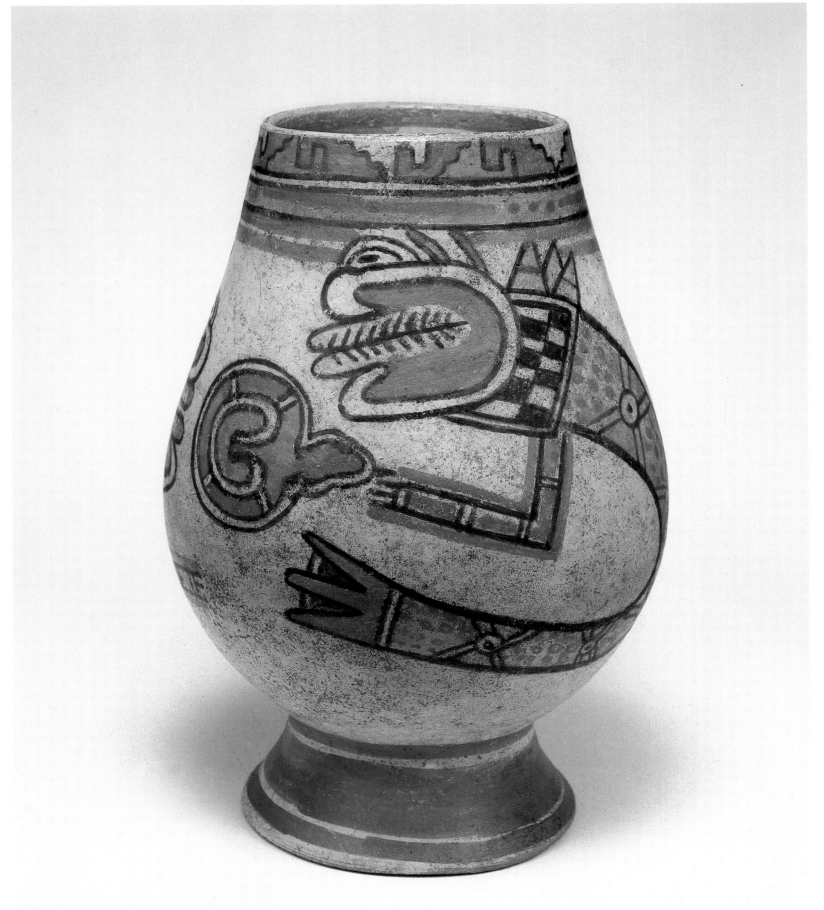

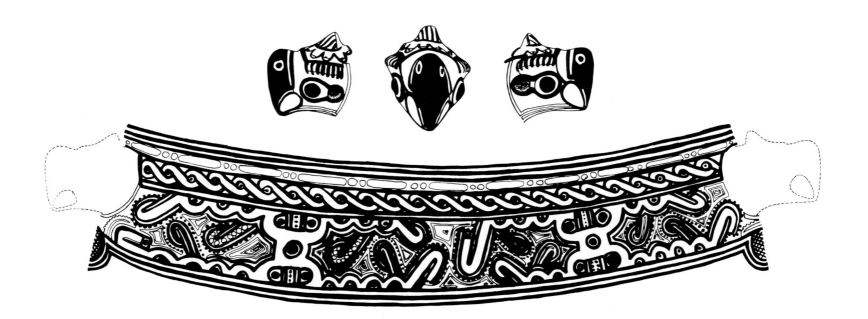

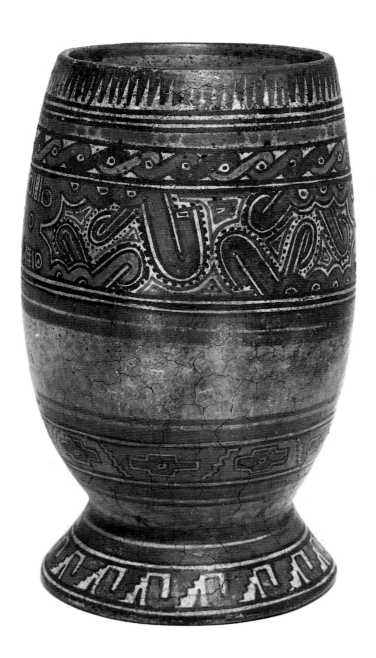

76.

JAR with bird's head

Eathenware, reddish clay body under a cream slip, burnished,
with black, red, orange and pearl-gray paint †
Guanacaste-Nicoya Zone
Period VI (AD 1000-1500)
*Papagayo Polychrome (AD 1000-1350)**
Height 9½" (24.1cm) Width 5½" (14cm) Depth 7³⁄₈" (18.7cm)
Condition before conservation: piece of rim repaired; small chip from horn
of protruding head; burial stains
Accession no. N-1004

This cylindrical jar with flaring foot has a large macaw head rattle appliquéd to it on one side below the mouthrim. The bird's head is realistically modeled and painted with large bulging eyes and a hooked beak. The upper body of the vessel is painted in bands containing stylized plumed serpent elements, including a band of guilloche pattern that represents two intertwined serpents. The lower body band is painted with oblique zigzags outlining a version of the *kan* cross associated by the Maya with the serpent, water and fertility. The foot is painted with the step/fret pattern. The latter design includes the stair, the center and the hook which, together with the plumed serpent motif, is the most typical ornamental form from the Valley of Mexico. The pattern is considered to be the representation of the Serpent of Fire.[1] The ray, represented by the stairs, is an attribute of Tlaloc the rain god who, during the rain of fire, would cause the third destruction of the world.

Cf. Snarskis 1982, p. 53 left, for somewhat similar shape, some motifs and coloring.
1. Westheimer 1970a, p. 157.
**OXTL analysis (ref. no. 381L27, 8/1/84) estimates that the sample tested was last fired between 400 and 630 years ago (AD 1355-1585).*
† Refired to remove burial stains. See Appendix C

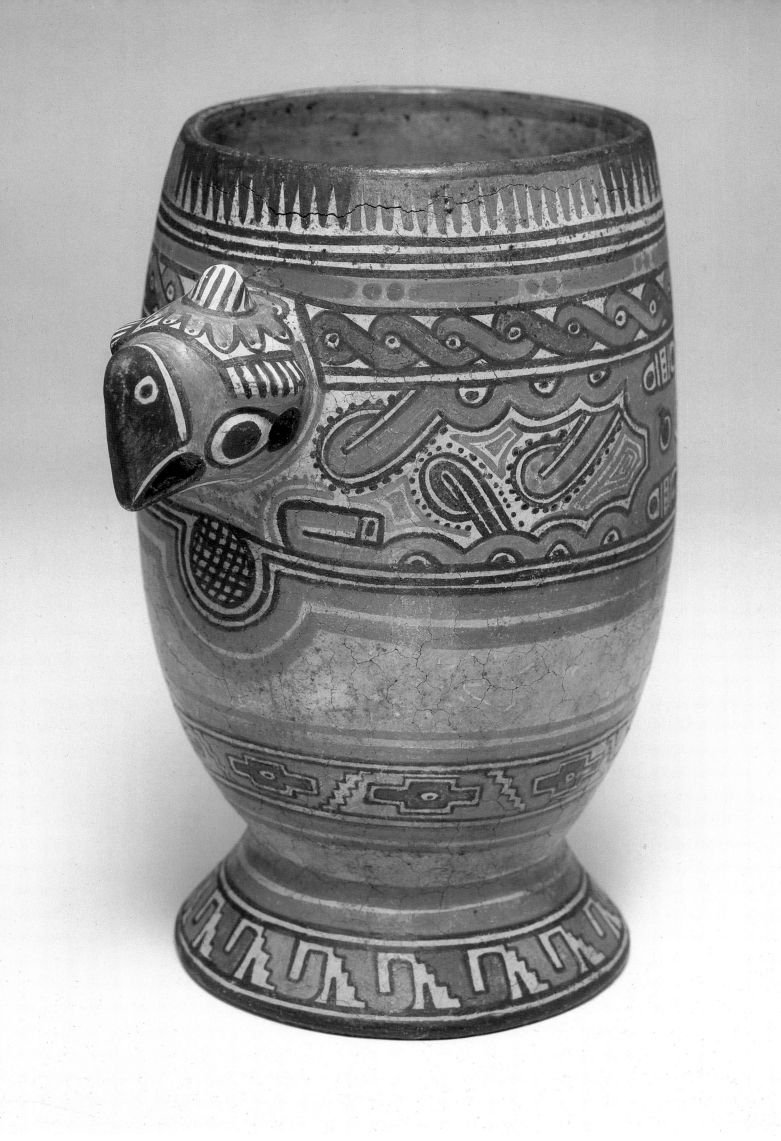

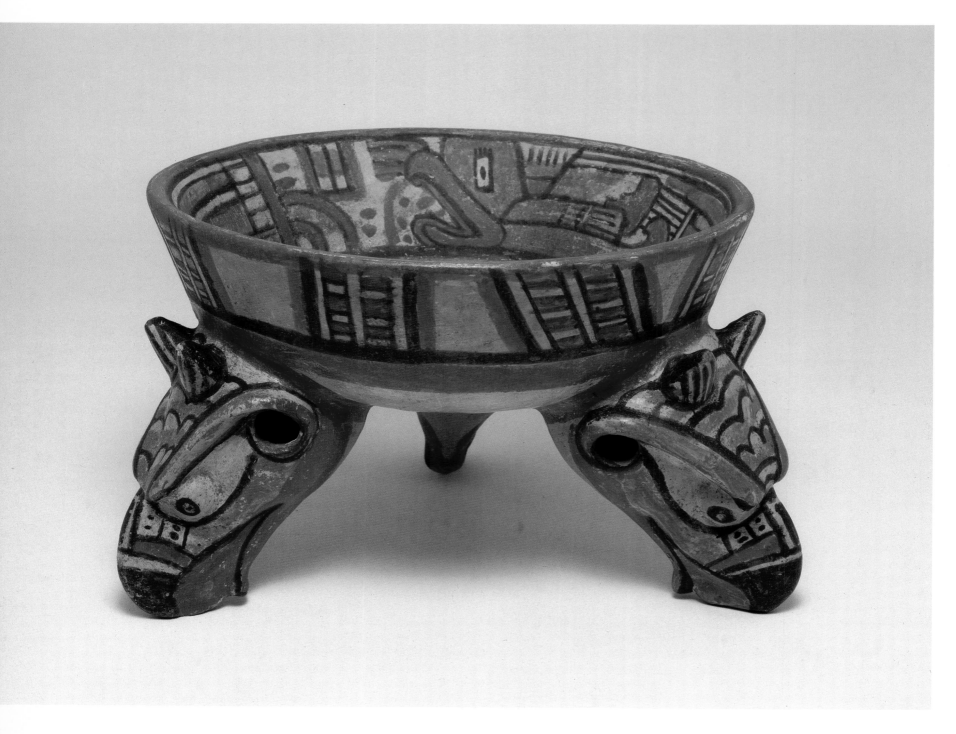

77. BOWL with bird head supports

Earthenware, reddish clay body under a creamy-tan slip, burnished,
with black, red and pearl-gray paint
Guanacaste-Nicoya Zone
Period VI (AD 1000-1550)
Papagayo Polychrome, Papagayo Variety (?), (AD 1000-1350)
Height 4⅝" (11.7cm) Width 7" (17.8cm)
Condition before conservation: chips on rim; design worn in spots;
root marks throughout
Accession no. N-1079

The deep bowl with slightly flaring sides is supported by three well-modeled hollow rattle eagle-head legs. The heads are eared, with open beaks, bulging eyes and a rapacious look. Zones of wing-like designs are painted on the exterior while the interior is painted with a band of two plumed creatures with bloody mouths, perhaps a plumed serpent design, alternating with two very stylized squared heads similar to those which appear in the man/jaguar theme.

A diagnostic feature of the Papagayo variety of Papagayo Polychrome is white over black resulting in a pearl-gray color which appears on this piece on the heads of the bird supports and the stylized wings on the exterior of the bowl.

Cf. Ferrero 1977, Ilus. III-60, for an *escudilla* tripod with bird-head supports, in the collection of the Banco Nacional de Costa Rica, acc. no. 37, which is similar to the Sackler vessel with a wing pattern on the exterior wall above the bird heads, and which Ferrero has placed in the Middle Polychrome Period.

78. BOWL with molded tripods

*Earthenware, reddish clay body under a cream slip, burnished,
with red-orange and black paint*
Guanacaste-Nicoya Zone
Period VI (AD 1000-1550)
Papagayo Polychrome, Papagayo Variety (?) (AD 1000-1350)
Height 3" (7.6cm) Width 5" (12.7cm)
*Condition before conservation: design worn; root marks on
bottom of bowl; chips on one leg*
Accession no. N-1039

The body of this bowl has a composite shape, with
concave sides rising from the ridge which terminates
the round bottom and splaying to the mouthrim. It
rests on three conical legs modeled and painted as
human heads. The faces are typically indicated by
small raised portions representing the eyes, nose and
ears, which are then emphasized with paint. Eye-
lashes and hair are stylized as hooks. The exterior
side panels contain a meander pattern. Lothrop has
pointed out that jaguar-head legs sometimes resem-
ble a human head.

Cf. Ferrero 1977, Ilus. I-92, for a similar bowl with human head
tripods, in the MNCR, acc. no. 12900.

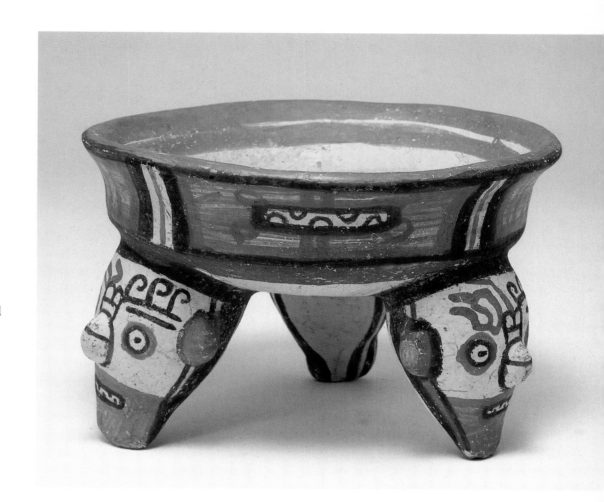

79. TRIPOD BOWL with plumed serpent motifs

*Earthenware, reddish clay body under a cream slip, burnished,
with red and black paint*
Guanacaste-Nicoya Zone
Period V/VI (AD 700-1100)
Papagayo Polychrome, Papagayo Variety (?) (AD 1000-1350)
Height 2⅞" (7.3cm) Width 5¼" (13.3cm)
*Condition before conservation: crack on mouthrim; two cracks
from one air vent hole; former restoration of mouthrim*
Accession no. N-1041

The round-bottomed bowl rests on three hollow,
conical rattle legs. Two panels with solid zones of
color between them are painted on the exterior.
Each panel includes a stylized version of the plumed
serpent. In one, the head has quite human charac-
teristics. Double bands decorate the inside walls at
the mouthrim.

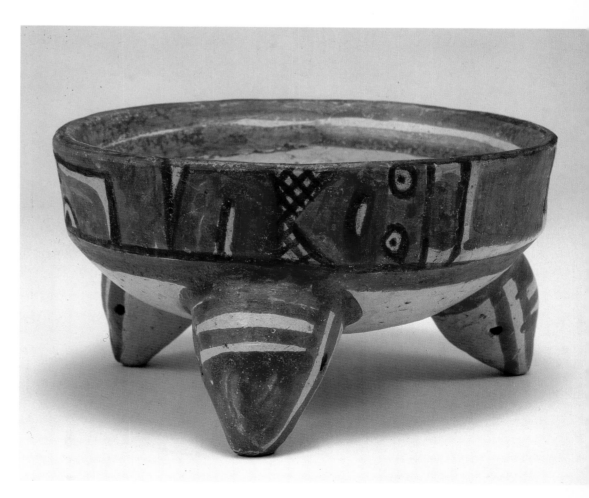

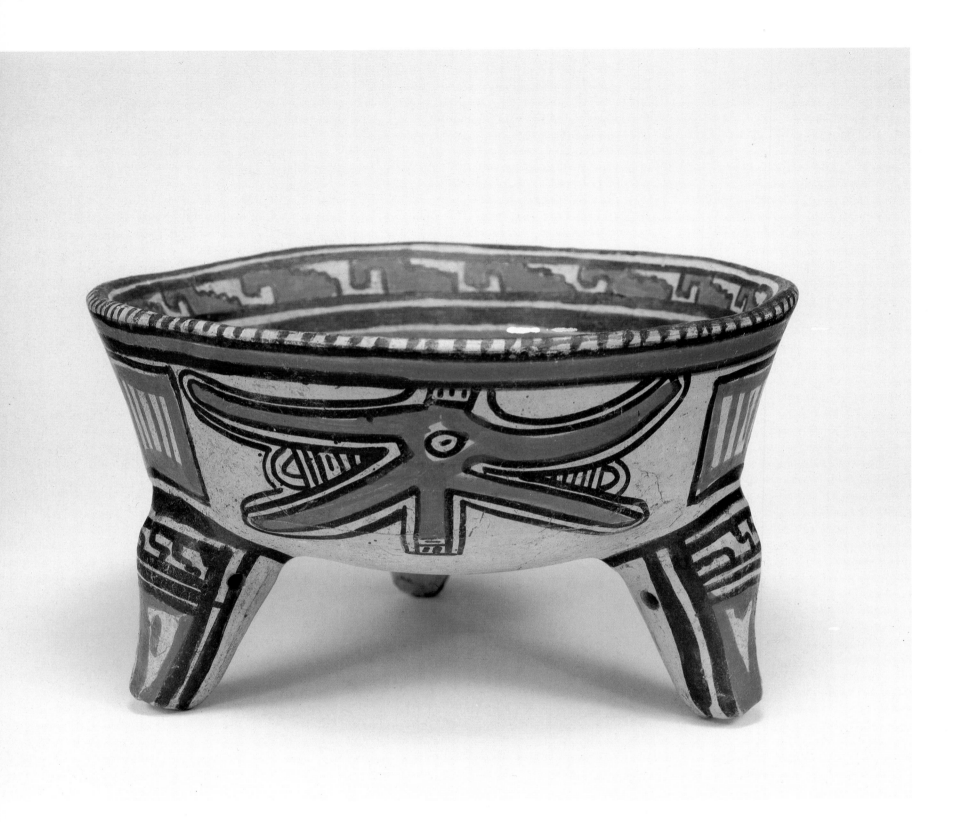

80. TRIPOD BOWL with plumed serpent motifs

Earthenware, buff clay body under a cream slip, burnished,
with red and black paint
Guanacaste-Nicoya Zone
Period V/VI (AD 700-1100)
Papagayo Polychrome, Papagayo Variety (?) (AD 1000-1350)
Height 4¼″ (10.8cm) Width 7⅜″ (18.7cm)
Condition before conservation: broken and repaired; root marks;
design faded in spots
Accession no. N-1067

This rounded bowl with thickened mouthrim rests on three
stylized bird's head, hollow, rattle legs. The exterior is
painted with motifs derived from the plumed serpent which
Lothrop classifies as Type H.[1] Here, the stylized double-ser-
pent heads share a common eye. Lined rectangles separate
each serpent design. The interior mouthrim contains a band
of step/fret design.

1. Lothrop 1926, pl. LIX.
Cf. Stone 1977, fig. 94, for a similar but less stylized serpent-head panel.

81. TRIPOD BOWL

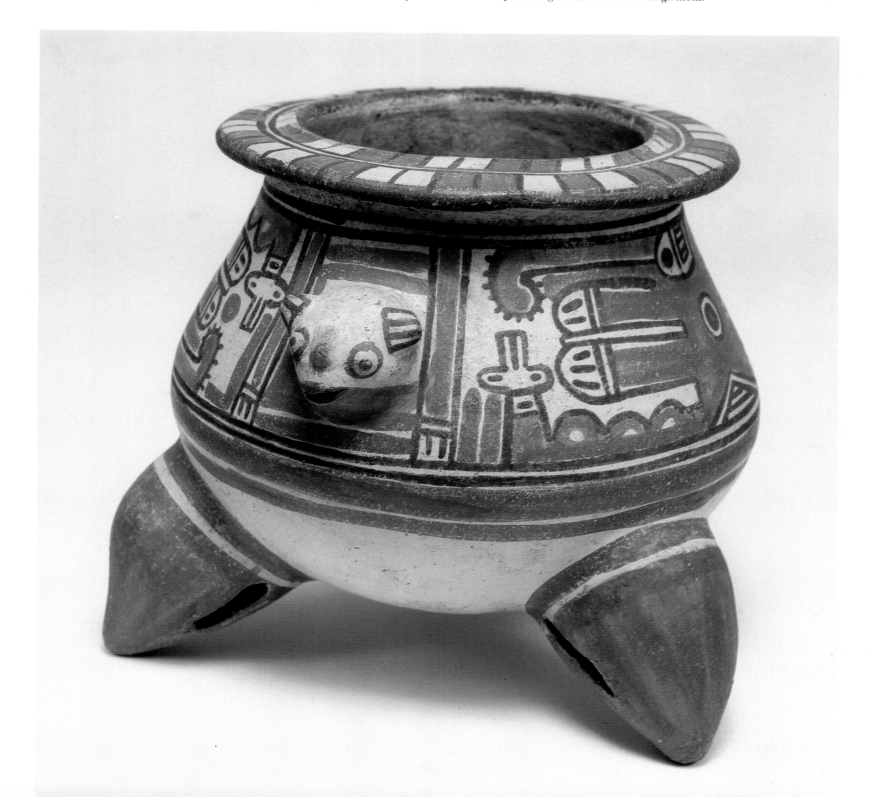

*Earthenware, reddish body under a creamy slip, burnished,
with red and black paint*
Guanacaste-Nicoya Zone
Period VI (AD 1000-1550)
Papagayo Polychrome, Papagayo or Serpiente Variety (AD 1000-1350)
Height 5¾" (14.6cm) Depth 7" (17.8cm)
*Condition before conservation; slight chips on legs, body and mouthrim;
paint worn in spots*
Accession no. N-890

This pear-shaped tripod bowl has a sharply everted rim and
hollow rattle legs. A hollow animal-head rattle is appliquéd
on one side. The exterior is painted with a wide band of
abstract plumed serpent motifs with the stylized head,
plumes, body markings and arms. This design, classified by
Lothrop as the plumed serpent motif, Type I, illustrates the
progressive degeneration of the motif. The rim is painted
with a double row of slanted panels, offsetting each other
and resembling plumes.

1. Lothrop 1926, fig. 56a, for a similar design motif.

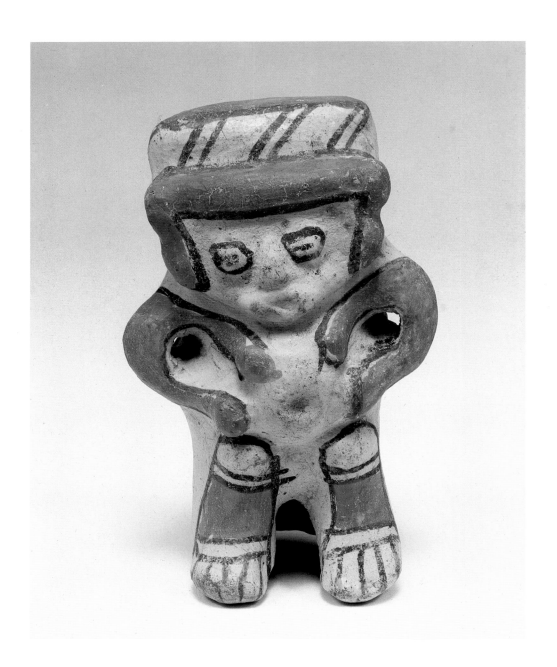

82. FIGURINE

Earthenware, reddish clay body under a creamy-white slip, burnished,
with orange and black paint
Guanacaste-Nicoya Zone
Period V/VI (AD 700-1100)
Papagayo Polychrome, Papagayo Variety (AD 700-1100)
Height 4³/4" (12.1 cm) Width 2⁷/8" (7.3 cm) Depth 2¹/4" (5.7 cm)
Condition before conservation: chips on arms and left ear;
root marks throughout; design worn in spots; repair to headdress
Accession no. N-1030

The brightly painted mold-made, standing figure has
looped arms forming suspension holes, its hands on its hips.
Modeling is minimal. Emphasis is on the large head and face
with modeled eyes, nose, mouth, ears, and the heavy hat-
band. Painting further defines the form, circling the eyes,
indicating knees, toes and striped headband. On the

reverse, a seat-like design is painted in orange on the lower
body. A firing vent hole pierces the middle of the back.

A large number of hollow, mold-made figurines were
recovered from Middle to Late Polychrome contexts. Nearly
all of these were of the Papagayo Polychrome type. They
often have a scowling countenance and are usually shown
wearing a cap. Two varieties occur: those with oval-shaped
openings which run the length of the headdress worn by the
figure and those without openings.

Cf. Ferrero 1977, Ilus. I-112 in the MNCR, acc. no. 23568, for a similar figure
from Nicoya which Ferrero describes as having crossed eyes and cranial defor-
mation and a basket-weave decoration on the headdress which is associated with
the serpent; and Stone 1972, p. 173 top left, for a figure from Alta Gracia,
Ometepe Island, Lake Nicaragua, Nicaragua (present location not indicated),
which has serpent heads emerging from each shoulder toward the breast and
the basket-weave pattern headdress; and Dockstader 1964, no. 148, for a similar
type of figure, elaborately costumed and with distinct facial painting, purport-
edly collected on the shores of Lake Nicaragua circa 1920, now in the Museum
of the American Indian, New York, acc. no. 15/9362, and no. 158, a seated
polychrome figurine from Filadelphia, Guanacaste Province, Costa Rica, also in
the Museum of the American Indian, acc. no. 19/1416, and more closely related
to the Sackler figure here.

83. TRIPOD PLATE

*Earthenware, pinkish red body under a white slip, burnished,
with red, orange, and black paint*
Guanacaste-Nicoya Zone
Period VI (AD 1000-1550)
*Papagayo Polychrome, Mayer Variety (AD 1000-1350)**
Height 4¼" (10.8cm) Width 10⅜" (26.4cm)
*Condition before conservation: broken into many large
fragments and reglued*
Accession no. N-1113

This shaped plate with beveled rim rests on three hollow,
tubular legs. The interior is painted with a complex series of
motifs centered around a stylized human seen in full face
with feathered headdress on one end and a jaguar head on
the other. The human head with headdress alternates with a
stylized jaguar in profile on the rim band. The beveled edge
of the plate and a narrow linear band around the center are
decorated with step/fret designs. The entire design may be a
version of the man/jaguar theme.

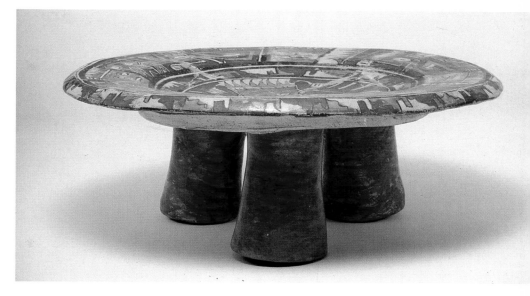

Cf. Lothrop 1926, pl. XXXb, for a similar painted plate with a human head and
multiple designs.
**OXTL analysis (ref. no. 381L77, 7/10/84) estimates that the sample tested was last
fired between 620 and 1020 years ago (AD 964-1364).*

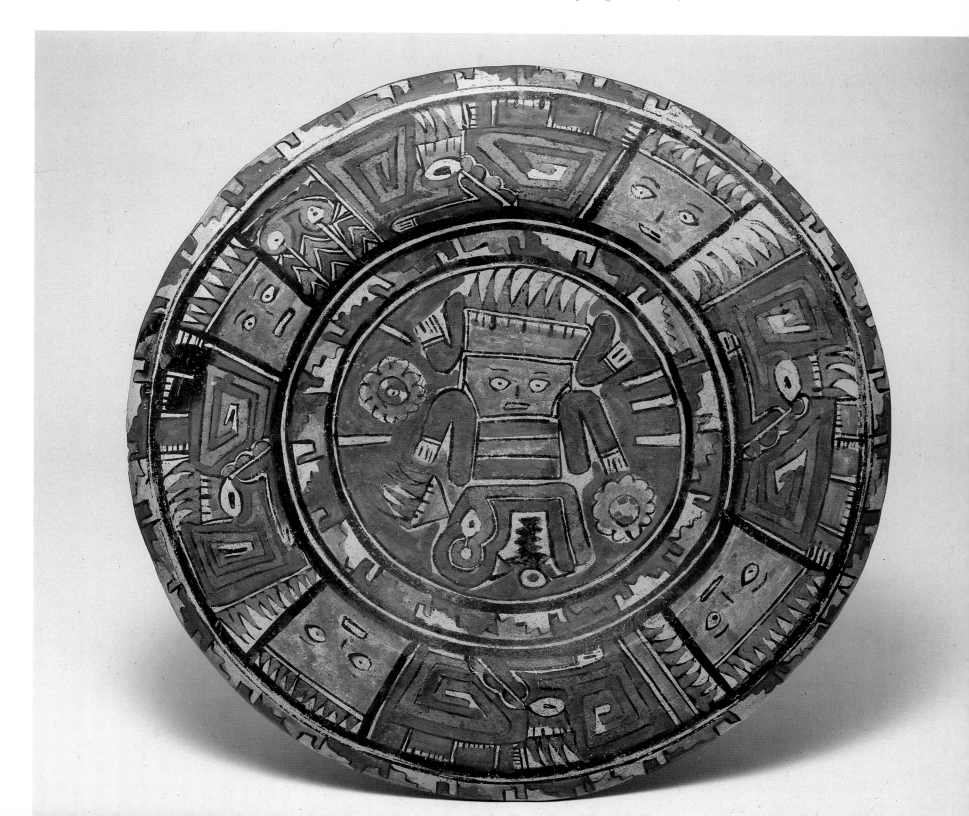

84. "TLALOC" EFFIGY JAR

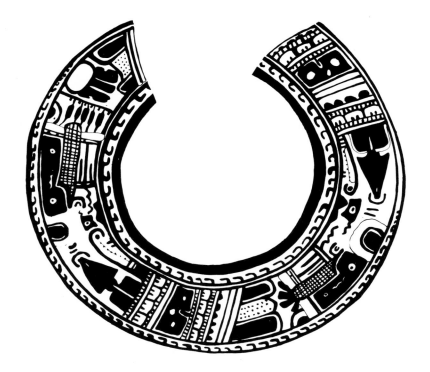

Earthenware, reddish clay body under a creamy-white slip, burnished, with brown-black and orange-red paint
Guanacaste-Nicoya Zone
Period VI (AD 1000-1550)
*Pataky Polychrome (AD 1100-1500)**
Height 13½" (34.3cm) Width 11¼" (28.6cm) Depth 11¾" (29.8cm)
*Condition before conservation: broken and repaired from
a number of large fragments*
Accession no. N-1141

The large ovoid jar rests on a flared foot and curves in to a wide mouth. A vertical flange depends just above the joining of the foot and body. The vessel is painted to represent the head of the Mexican rain god, Tlaloc. Ears with earspools, a small nose and protruding upper teeth are appliquéd on the round vessel. The large double-ringed round eyes are diagnostic of the effigy face theme. The mouth is very large with a heavy red upper lip and black waves and curlicues around the sides representing a mouth mask. The pedestal foot is ringed with a painted decoration of white rectangles and dots bordered by black lines similar to those on Mora Polychrome vessels representing jaguar spots. A similar band encircles the top of the pedestal foot just below the round upper body. A band at the mouthrim contains the stylized man-jaguar motif. The interior of the vessel is washed with the creamy white slip.

Papagayo Polychrome grades into the black and red on white pottery called Pataky Polychrome after circa AD 1150-1250. Thought to have been elite-associated ware, it may have been manufactured as funerary furnishings. The best known vessels of this type are modeled jaguar effigies (see Numbers 85, 86, and 87) and are decorated with intricate, lacy black on white panels which include stylized "silhouette jaguar" motifs, i.e., jaguars silhouetted in black against the white ground giving the effect of negative painting or reserve decoration. Also frequently seen in collar bands are stylized man-jaguar motifs.

Pataky Polychromes present the man-jaguar theme in panels and decorative bands on all forms of vessels with all the same elements first associated with the earlier realistic picturing except the orange circles. These elements—squared human head with downturned nose, feathered headdress, speech scroll, hafted spear, darts, silhouetted jaguar, spotted jaguar limbs, claws, panels of feathers, hatchures and long bones—are presented in their simplest elemental form and standardized from vessel to vessel. The theme probably represents the Mexican deity Mixcoatl disguised as Venus, the morning star, attacking the jaguar of the night. In Mexico, Mixcoatl had great antiquity as the god of war and the hunt and was further connected with Venus as the morning star and with a legendary fight against the forces of the night.[1] By Period VI, dominant zoomorphic figures in apparent mythological symbolic contexts were no longer the alligator and the bat but the jaguar and the plumed serpent.

1. See the description of the mythology in Dr. Day's essay.
Cf. Snarskis 1982, pp. 69 and 70, for similar vessels in the INS; also Doris Stone 1977, fig. 95; Ferrero 1977, Ilus. I-61, from a private collection and Ilus. III-54 from the Molinos Collection, Costa Rica, (No. 103); and Day 1984 Fig. B. 34, from the Gillen Collection, Hacienda Tempisque, Costa Rica.
**OXTL analysis (ref. no. 381N85, 4/1/85) estimates that the sample tested was last fired between 530 and 880 years ago (AD 1105-1455).*

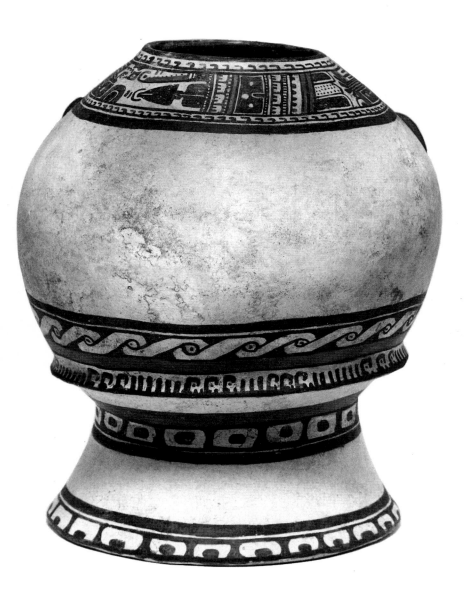

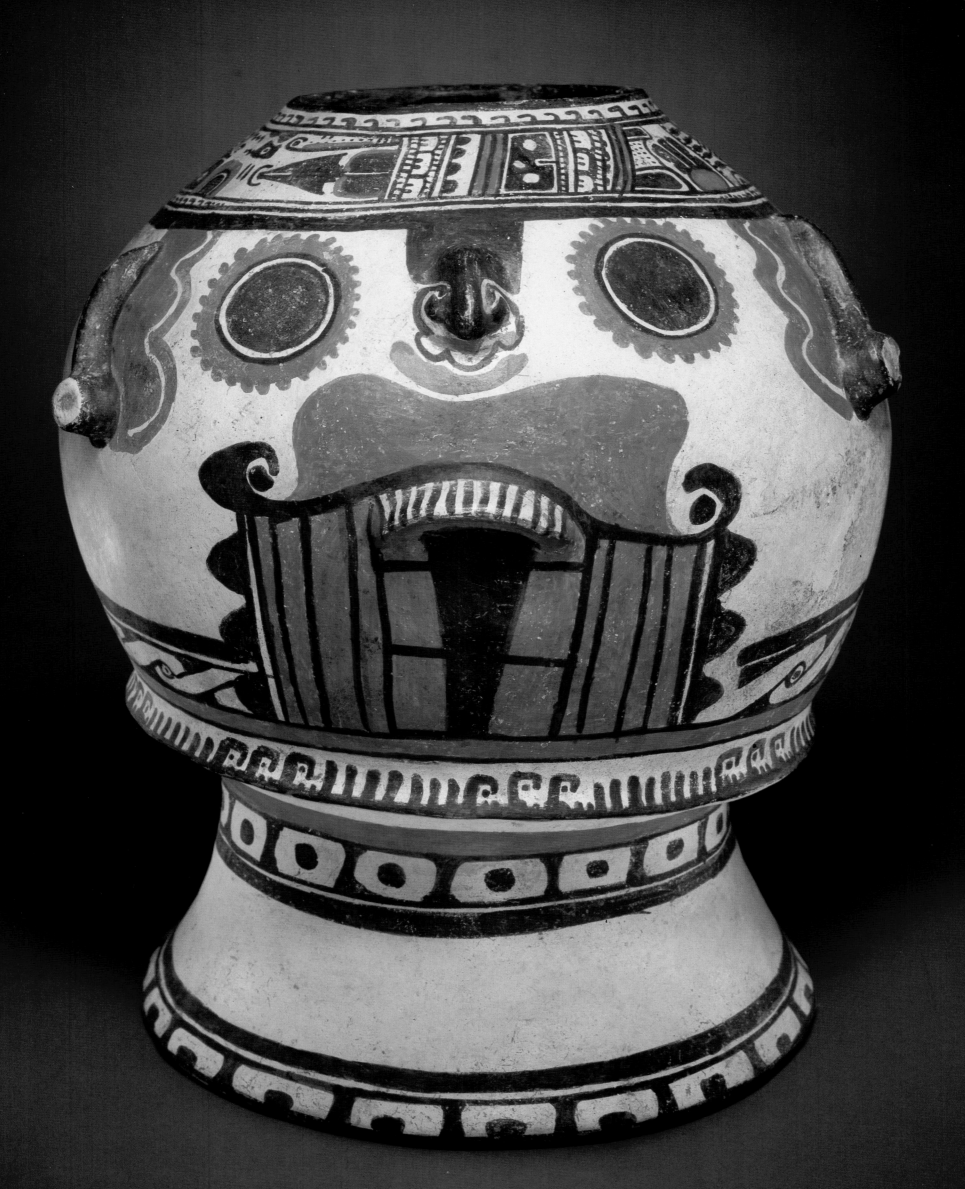

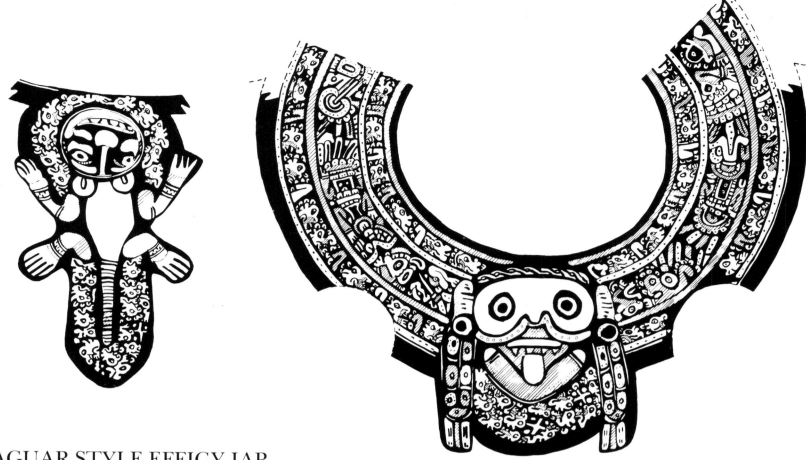

85. JAGUAR STYLE EFFIGY JAR

Earthenware, reddish clay body under a creamy-white slip, burnished,
with black and orange-red paint
Guanacaste-Nicoya Zone
Late Period VI (AD 1200-1550)
*Pataky Polychrome, Pataky Variety, (AD 1200-1350)**
Height 11⅜" (28.9cm) Width 11" (27.9cm) Depth 10¼" (26cm)
Condition before conservation: chips on feet; design worn in spots
Accession no. N-1201

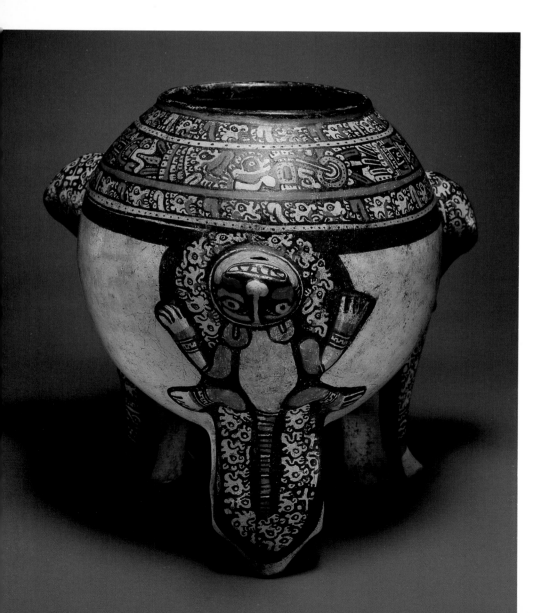

This large ovoid jar curves in to a wide mouth. It has two hollow rattle legs modeled as a jaguar's hind paws and a curved, slit support at the rear. Two shallow rattle forelegs loop down from the side with paws resting on the hind legs. An animal face, with a half-mask imitating contemporary gold masks, is modeled and painted on the shoulder of the vessel. Its upper fangs are prominent and the tongue is extended. Ear ornaments with large tabs also meant to imitate gold and decorated with jade symbols hang down below the mask and over a wide collar filled with stylized silhouette-jaguar motifs and *kan* crosses. Similar motifs are intricately painted in bands around the upper portion of the vessel and on all four legs. Dr. Day writes about the use of orange, which is also present throughout to depict gold jewelry especially on effigy face urns. The interior of the vessel is washed with the creamy white slip.

The realistic modeling of the masked face combines with a human pose of paws on legs. Usually the head is that of a jaguar, as in Numbers 86 and 87, but here it is possibly a masked jaguar with the mask being very owl-like, but definately bird-like. The jaguar, in fact, has very diverse significance. In Greater Nicoya, the jaguar may have signified the Mexican god Tezcatlipoca or his animal totem. In this aspect, among Mexicans, the jaguar was believed to devour the sun during a solar eclipse. The spots on his hide led to a comparison with the stars in the sky and, accordingly, a parallel between the sky and the earth in which the jaguar was the demon of the earth.[1] The smaller silhouette-jaguars have been thought to depict the stars revealed by approaching darkness.[2] The jaguar may also combine with traits taken from man, bird and serpent. The masked figure here is probably an expression of such a combination.

Published: Ferrero 1977, Ilus. I-66.
1. Ferrero 1977, p. 406.
2. Snarskis 1981, no. 108, a personal communication from Luis Ferrero.
**OXTL analysis (ref. no. 381M77, 11/20/84) estimates that the sample tested was last fired between 370 and 600 years ago (AD 1384-1614).*

166

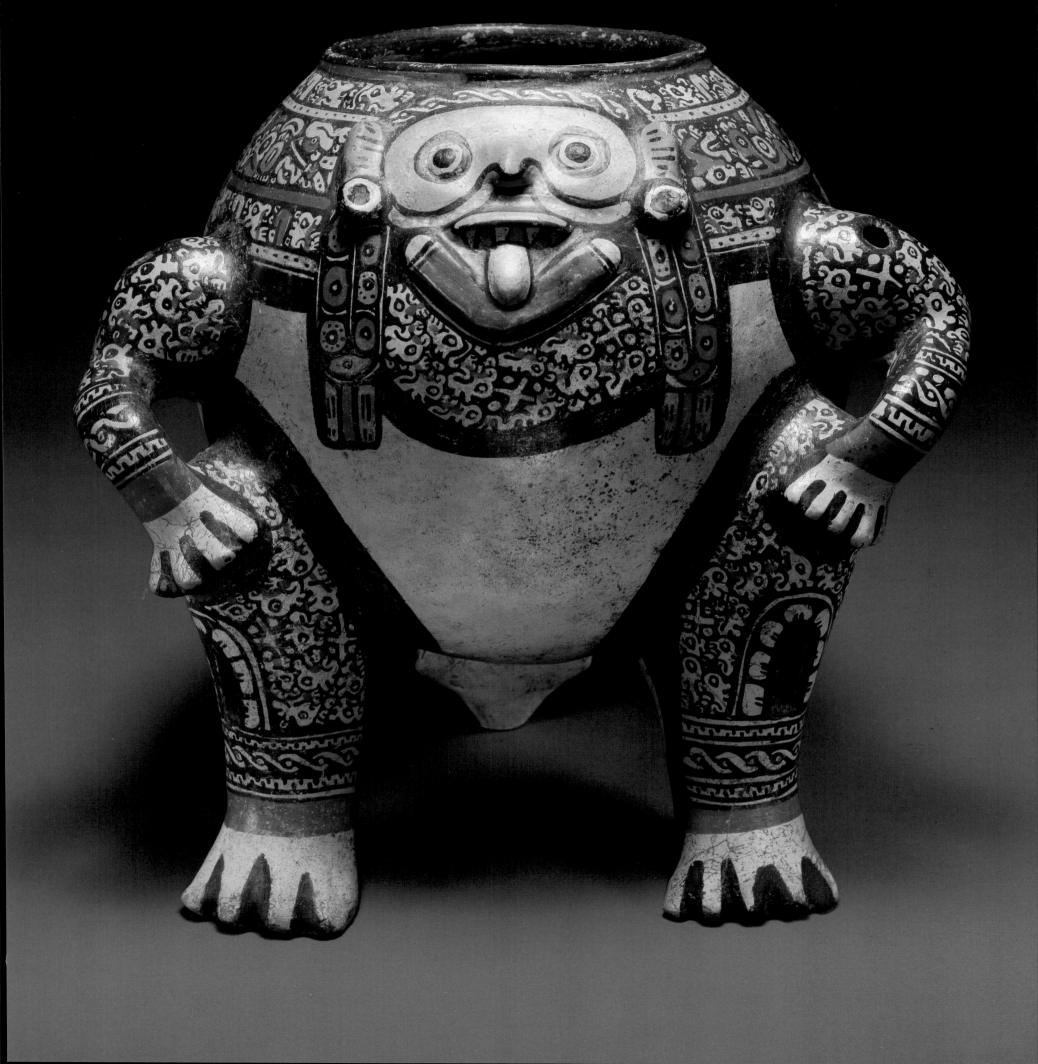

86. JAGUAR EFFIGY JAR

Earthenware, reddish clay body under a creamy-white slip, burnished,
with orange and black paint
Guanacaste-Nicoya Zone
Late Period VI (AD 1200-1550)
*Pataky Polychrome (AD 1000-1550)**
Height 13¹⁄₂" (34.3cm) Width 10³⁄₄" (273cm) Depth 10¹⁄₄" (26cm)
Condition before conservation: design slightly worn; root marks
throughout; three cracks from rim repaired; rear leg broken and repaired;
nose and left ear slightly chipped; chips around interior surface rim
Accession no. N-1011

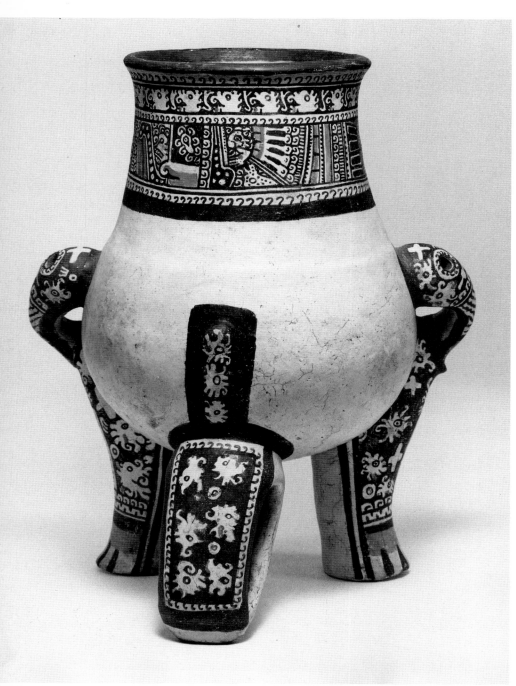

The large pear-shaped jar stands on hollow rattle tripod legs, two of which are modeled to represent a jaguar's hind legs. A third leg in the form of a tail is at the rear. Two short hollow forelegs loop out from the sides of the body with paws resting on the hind legs. An expressive hollow rattle jaguar's head is attached on the upper portion of the vessel spaced between the two hind legs. The open mouth exposing white fangs is surrounded by a serrated collar with a bib and it, the legs and tail are painted with lacy representations of stylized jaguar heads silhouetted in black on a white ground. The wide panel around the neck of the jar is composed of various stylized elements including, just below the mouthrim, the diagnostic jaguar frieze silhouetted in black against a white slip, giving the impression of negative painting, as does the band below it consisting of various stylized and repetitive elements of the man/jaguar theme including feathered darts, speech scrolls, feathered headdress, spear elements, ears and claws of the jaguar and long bones. The interior is painted with a wash of the creamy white slip. Such jaguar effigy jars with their standardized motifs are classic examples of late Nicoya Polychromes.

Cf. Snarskis 1982, p. 66, for a similar feline effigy vessel in the INS, acc. no. 4036 (also illustrated in Snarskis 1981, no. 107); Snarskis 1981, no. 108 for another in the INS, acc. no. 4039, but with red designs on the legs; Lothrop 1926; pl. XLIII for another, and Fig. 45 for jaguar motifs; Ferrero 1977, Ilus. I-60 for one in the MNCR, acc. no. 14510, and Ilus. I-63, for another in the MNCR in the Gallery of Archaeology; and Dockstader 1964, no. 153, for one purportedly from El General, Pentarenas, Costa Rica, in the Museum of the American Indian, acc. no. 19/5896; and Day 1984, Fig. B, 30, for the illustration of one among a number of others in the Gillen Collection, Hacienda Tempisque, Costa Rica.

**OXTL analysis (ref. no. 381P72, 4/3/85) estimates that the sample tested was last fired between 360 and 590 years ago (AD 1395-1625).*

See Number 92 for references to other examples of this form and its designs.

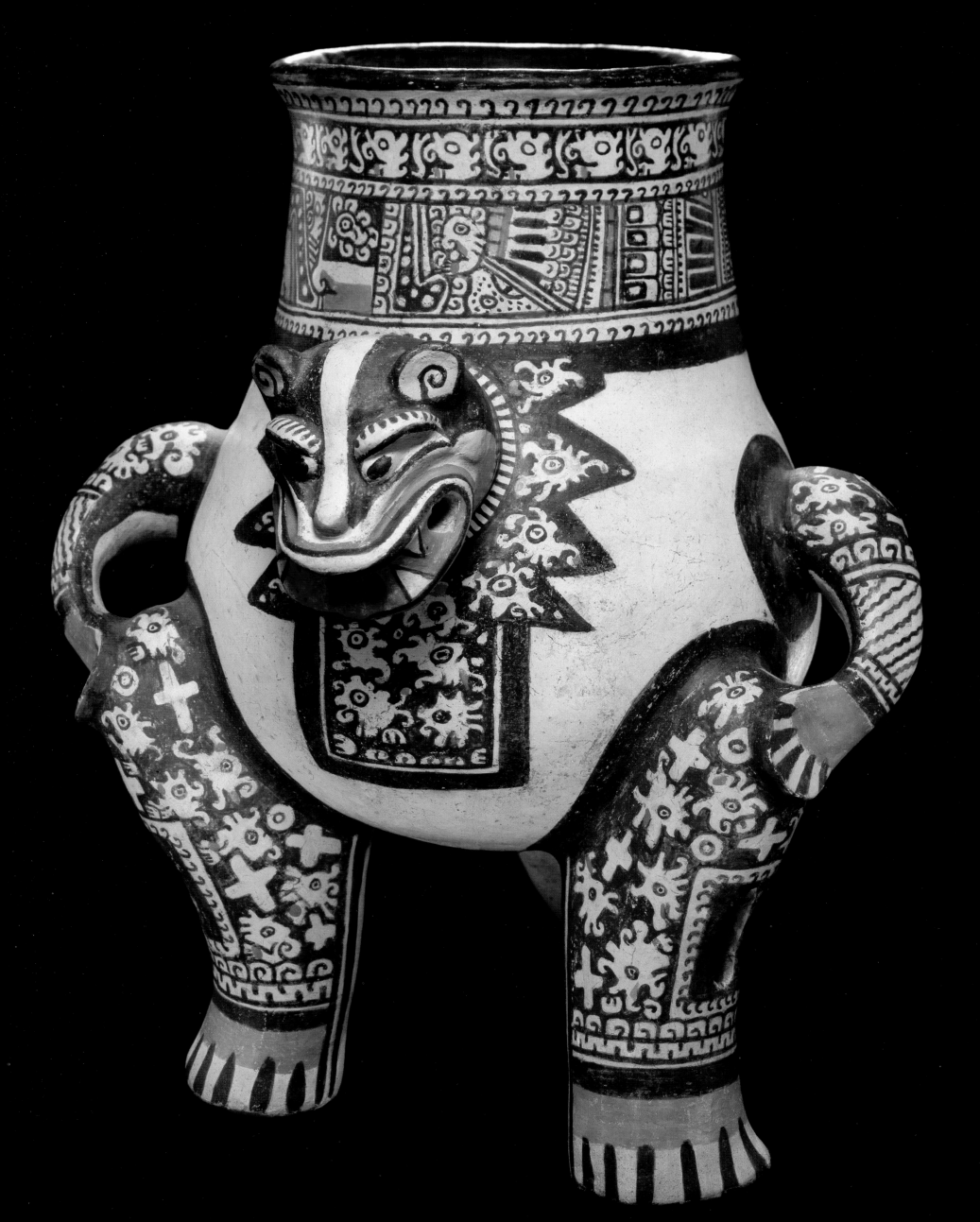

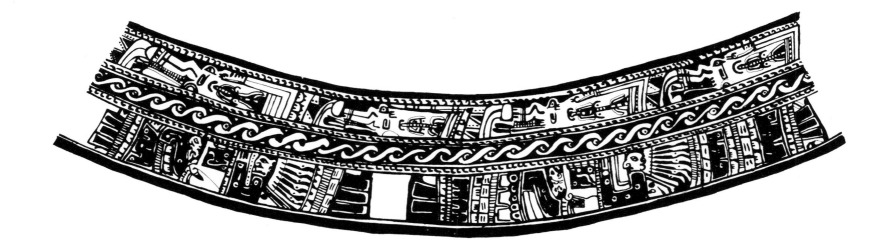

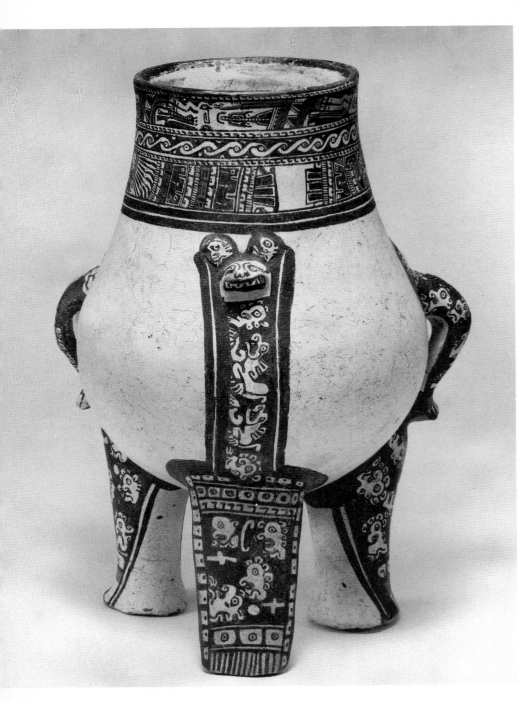

87.

JAGUAR EFFIGY JAR

*Earthenware, reddish clay body under a creamy-white slip, burnished,
with orange-red and black paint*
Guanacaste-Nicoya Zone
Late Period VI (AD 1200-1550)
*Pataky Polychrome (AD 1000-1550)**
Height 14⁷⁄₈" (37.8cm) Width 10⁵⁄₈" (27cm) Depth 11³⁄₈" (28.9cm)
*Condition before conservation; section of rim repaired; exterior design
slightly worn in spots; root marks throughout; paint chips on bowl near
jaguar head and on back leg; cracks on back leg*
Accession no. N-1098

This vessel repeats the basic shape of the jar in Number 86
with certain modifications in the disposition of the animal's
legs and head. The legs here are placed lower on the body
than in Number 86, while the head is directed outward
rather than turned down slightly, and the snarling mouth is
opened wider with the fanged teeth large and emphatic.
While the head represents that of a jaguar, it also has some
human characteristics expressed through the eyes and with
the earspools. The decorative area of the rounded bib and
star-shaped collar encircling the jaguar head also differ in
shape from that in Number 86, and the painting on it and
around the legs is differently disposed. Different also is the
panel of banded decoration encircling the neck of the vessel
with three bands here including one of guilloche pattern
separating the two bands of standardized elements of the
man-jaguar theme including darts, feathered headdresses,
speech scrolls, spotted jaguar limbs, claws, etc. The interior
of the vessel is painted with a swirled wash of the creamy-
white slip.

Cf. Number 86 for references to other examples of this form and its design.
**OXTL analysis (ref. no. 381p88, 5/10/85) estimates that the sample tested was last fired
between 350 and 600 years ago (AD 1385-1635).*

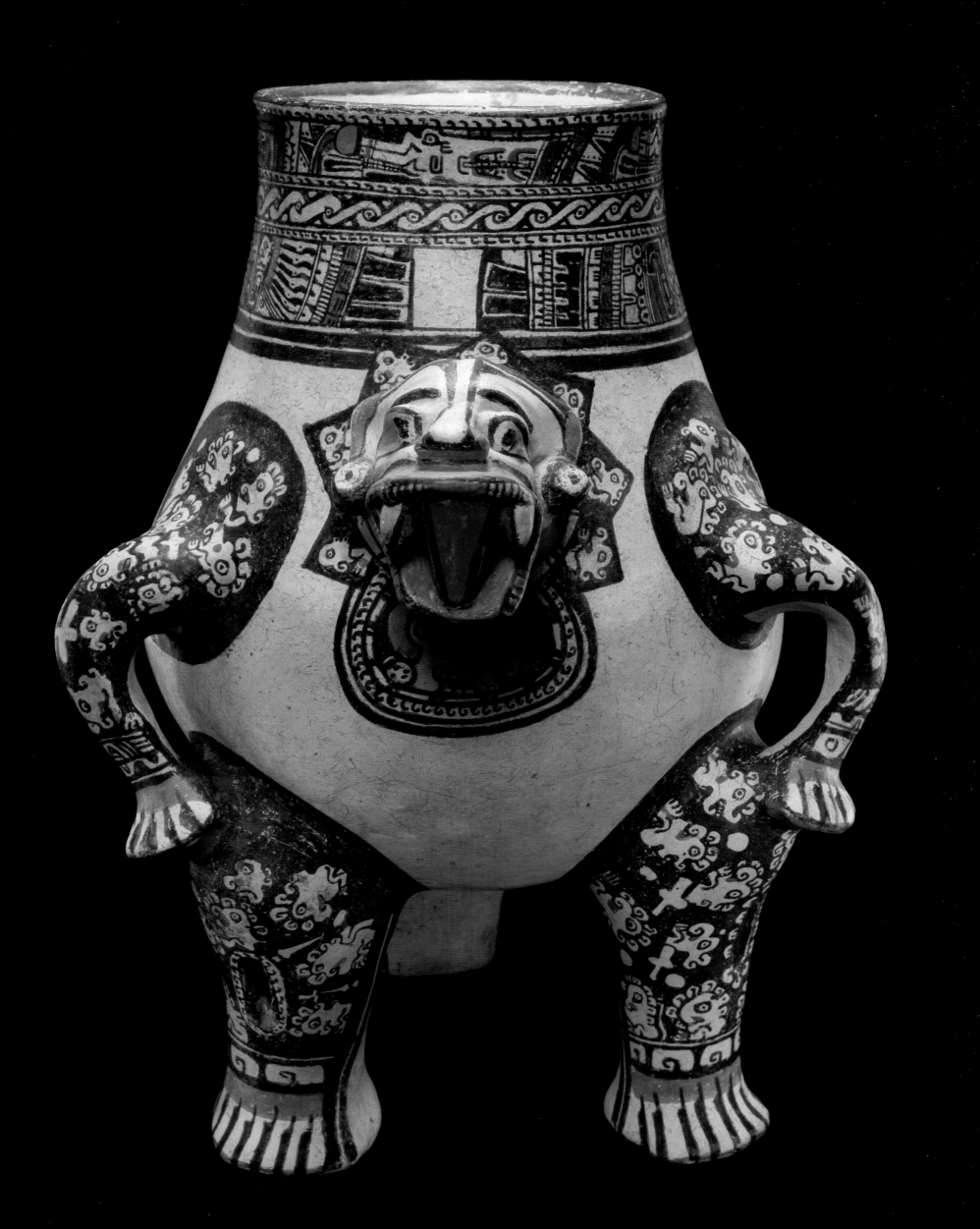

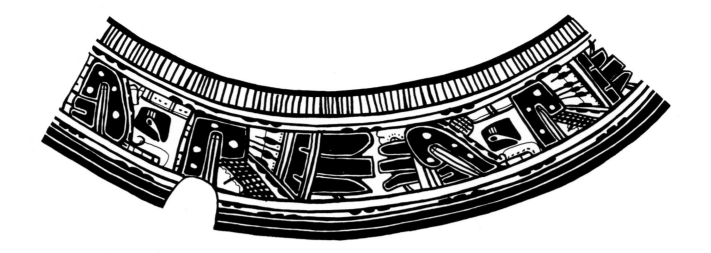

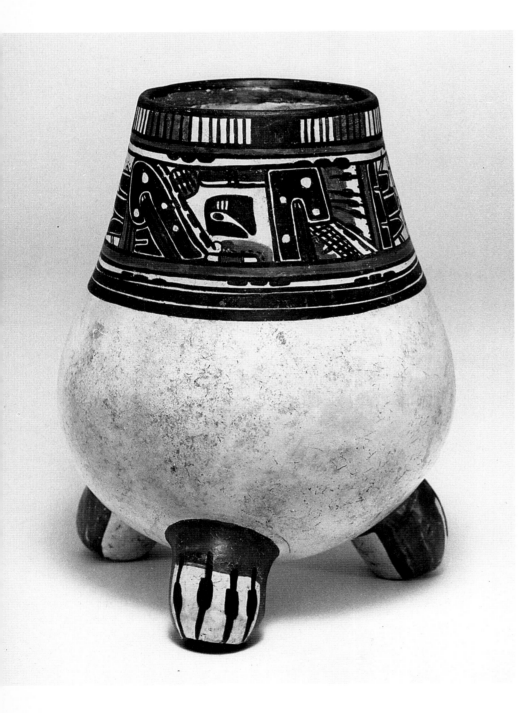

88.

BIRD EFFIGY JAR

Earthenware, reddish body under a creamy-white slip, burnished,
with red and black paint
Guanacaste-Nicoya Zone
Period VI (AD 1000-1550)
*Pataky Polychrome (AD 1000-1550)**
Height 9⅝" (24.4cm) Width 7¼" (18.4cm) Depth 8¾" (22.2cm)
Condition before conservation: repaired cracks on rim, leg and neck of
protruding head; surface chips on back; root marks
Accession no. N-1006

The body of this pear-shaped effigy tripod is utilized to represent that of a turkey buzzard with painted wings and breast feathers. The applied rattle head is centered between the front two of the attached rattle tripods. The third, a tail-like support, is at the rear. The head and feet seem to belong to an animal, probably the jaguar, rather than to a bird as the painted feathers on the body indicate. Encircling the upper portion of the jar is a delicately painted, wide band containing stylized man/jaguar elements such as the squared head with downturned nose, the speech scroll, feathered headdress, hatchures, etc. The interior is painted with a swirled wash of the creamy white slip.

Jaguar heads are the most common applied heads seen on such jars but other heads appear as well, such as the turkey, bird, rabbit, monkey and serpent. Also common, in association with animal attributes, are human or deity heads, possibly indicating shamans.

**OXTL analysis (ref. no. 381L28, 8/1/84) estimates that the sample tested was last*
fired between 650 and 1070 years ago (AD 914-1334).

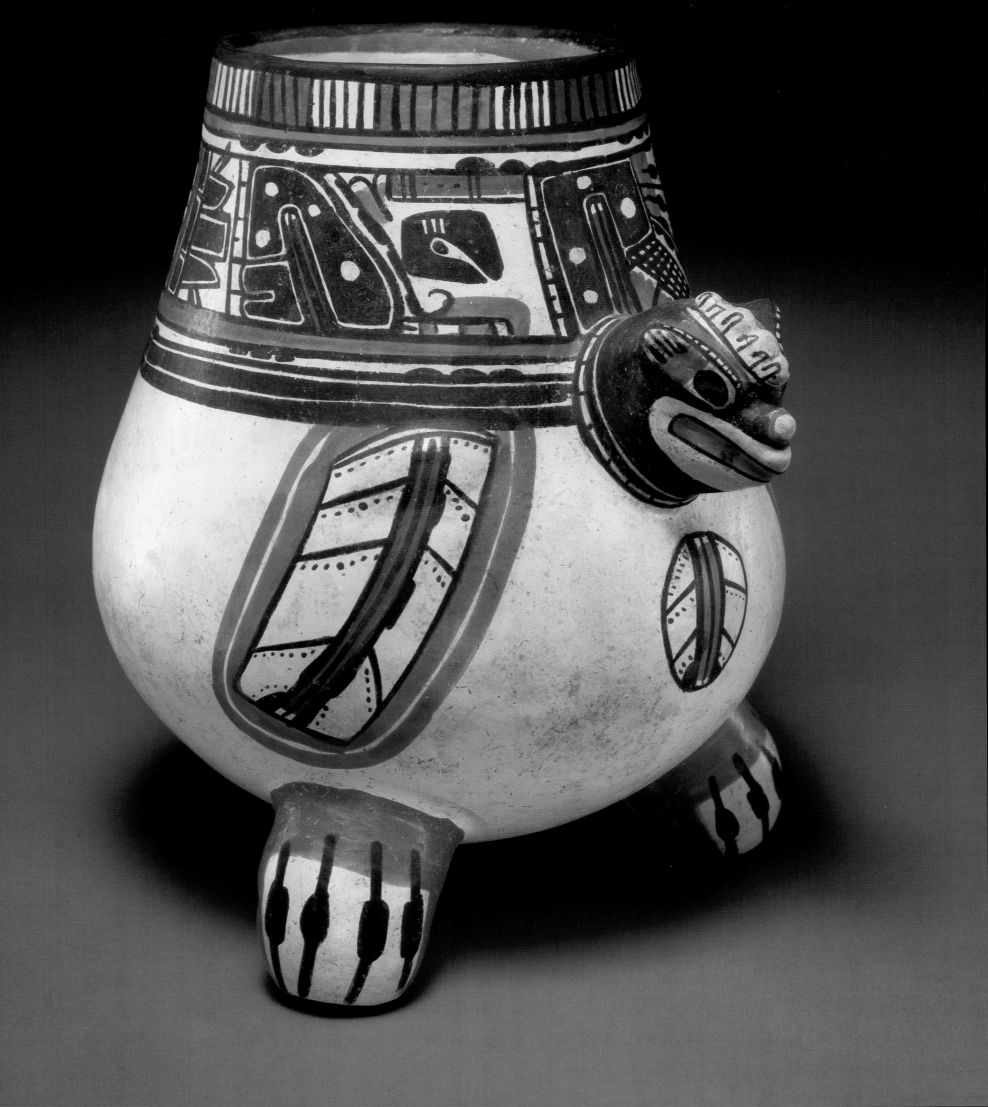

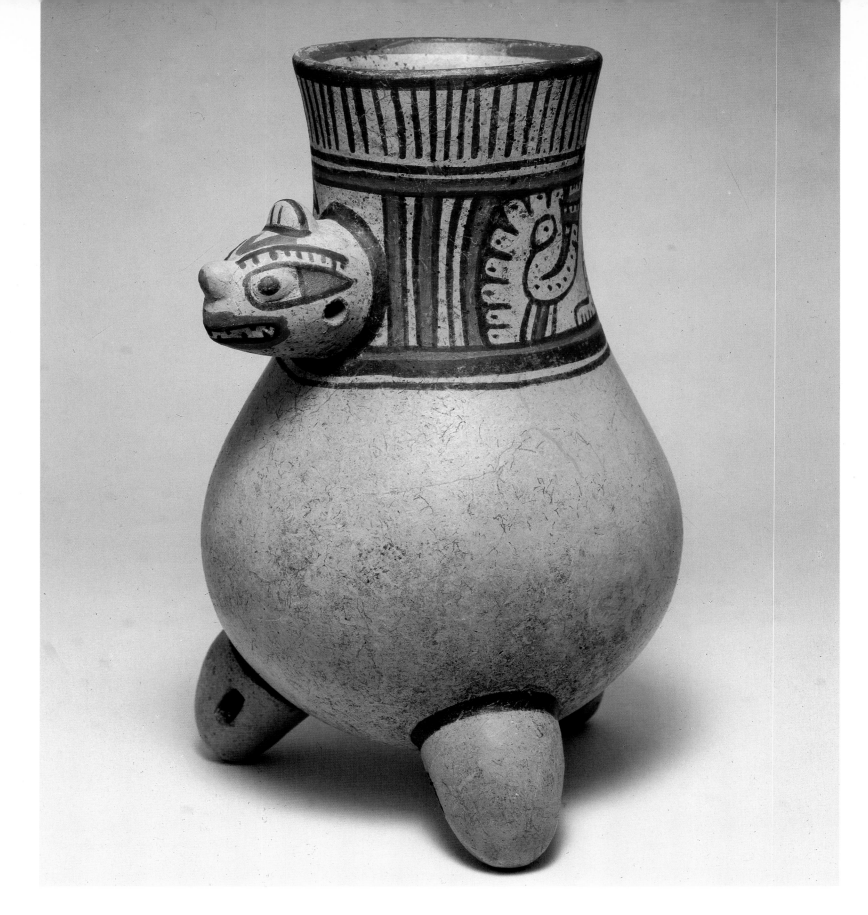

89. JAGUAR EFFIGY JAR

*Earthenware, reddish body under a buff-cream slip, burnished,
with red-orange and black paint*
Guanacaste-Nicoya Zone
Late Period VI (AD 1200-1550)
*Pataky Polychrome, Pataky Variety (?) (AD 1200-1350)**
Height 10½" (26.8cm) Width 7⅛" (18.1cm) Depth 6⅝" (16.8cm)
*Condition before conservation: root marks throughout; small hole in left
rear; surface scratches*
Accession no. N-1009

On the neck of this pear-shaped, hollow rattle tripod jar is a
hollow rattle jaguar head. A band of crouching jaguars with
heads turned back over their shoulders, alternating with
multiple vertical stripes, is painted on the neck.

The difference in slip color between this vessel and other
Pataky Polychromes seems to indicate a different variety of
white-slipped ceramics but its reddish clay body argues
against its inclusion among vessels with a buff or tan clay
body termed Filadelfia Ware from Filadelfia, Guanacaste.[1]

1. Day 1984, p. 59 and pp. 314-315.
Cf. Day 1984, fig. B-38, for a Pataky Polychrome, Filadelfia variety jar with
applied jaguar head and hollow rattle legs similar to the Sackler vessel.
**OXTL analysis (ref. no. 381Q34, 8/1/84) estimates that the sample tested was last
fired between 450 and 760 years ago (AD 1224-1534).*

90. FOOTED JAR with jaguar motifs

Earthenware, reddish clay body under a white slip, burnished,
with red-orange and black paint
Guanacaste-Nicoya Zone
Period VI (AD 1000-1550)
*Pataky Polychrome, Pataky Variety (AD 1200-1350)**
Height 9⅛" (23.2cm) Width 7⅛" (18.1cm)
Condition before conservation: slightly worn design; surface chips
around bowl; chips on rim and at base
Accession no. N-1092

The pear-shaped body rests on a flared pedestal foot and
tapers to a wide neck. A dependent, slightly flaring flange
covers the joining of the body and foot. From the shoulder
to the rim, the jar is painted with multiple horizontal bands
containing various design elements, the principal being a
row of stylized jaguars silhouetted in black against the white
ground. The other bands contain symbolic elements which
may be jaguar related. The flange is painted with jaguar
spots and the foot with vertical stripes probably represent-
ing feathers. The interior is rinsed with white slip.

Cf. Lothrop 1926, pl. XLI and fig. 45, for similar treatment and jaguar motifs.
**OXTL analysis (ref. no. 381Q40, 6/17/85) estimates that the sample tested was last*
fired between 620 and 970 years ago (AD 1015-1365).

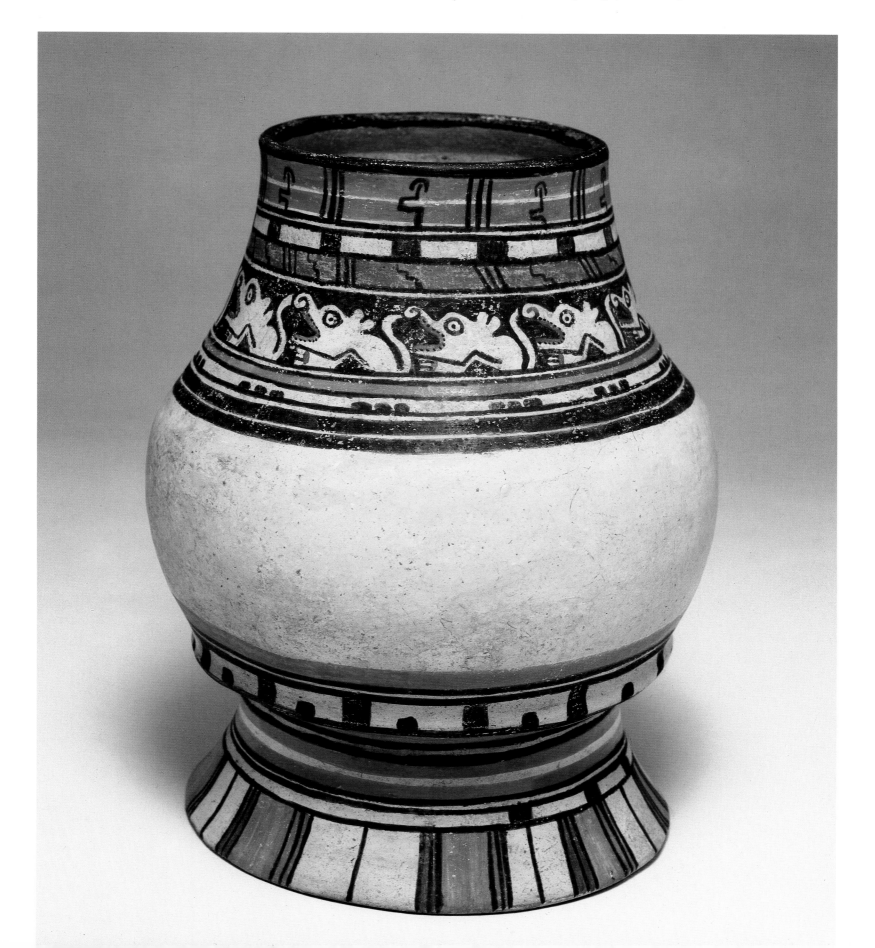

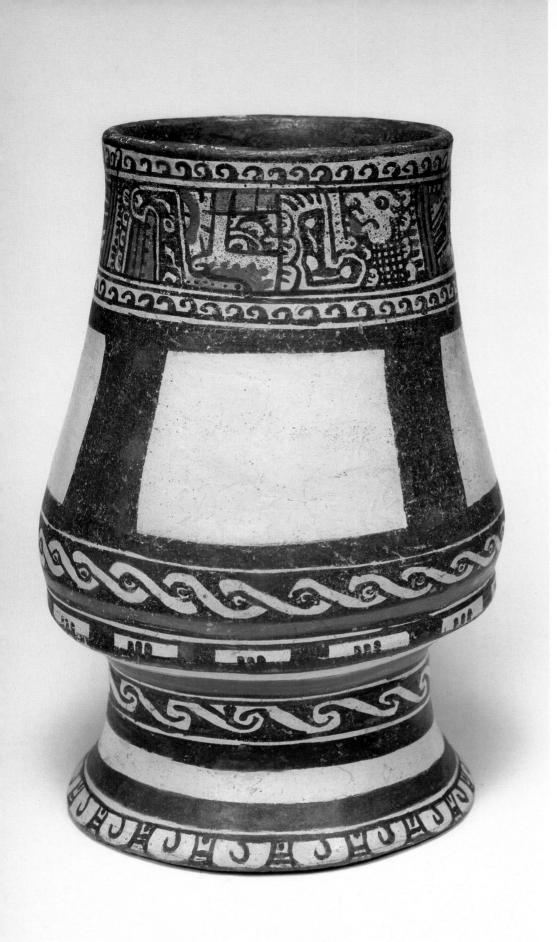

91.

PEDESTAL FOOTED JAR

*Earthenware, reddish clay body under a creamy-white slip, burnished,
with red-orange and black paint*
Guanacaste-Nicoya Zone
Period VI (AD 1000-1550)
*Pataky Polychrome (AD 1000-1550)**
Height 8⅛" (20.6cm) Diameter 5½" (14cm)
*Condition before conservation: chips on outside and inside of
mouthrim and on interior base; minute paint chips throughout*
Accession no. N-887

The pear-shaped body rests on a wide, flared pedestal foot.
It tapers from a bulbous base above a dependent vertical
flange before splaying to the wide mouth. Below the mouth-
rim, a wide band, bordered on top and bottom by a row of
hook designs, is filled with an intricately painted man/jaguar
motif including a feathered headdress, a speech scroll, a
silhouette-jaguar, spotted jaguar limbs, hatchures etc. The
lower body is encircled with a band of guilloche pattern.
Encircling the center of the pedestal foot is a band of *Ilhuitl*
design while the base of the foot is decorated with what may
be an inverted Down Ball symbol.[1] Top and bottom bands on
the body are tied together by a grid of heavy black vertical
stripes. The interior is painted with a swirling wash of
creamy-white slip.

1. Day 1984, fig. 4.16, pp. 107-110, for Late Polychrome Period design elements.
**OXTL analysis (ref. no. 381q32, 6/1/85) estimates that the sample tested was last fired
between 700 and 1200 years ago (AD 785-1285).*

92. FOOTED JAR with jaguar motifs

Earthenware, reddish clay body under a creamy white slip, burnished,
with red-orange and black paint
Guanacaste-Nicoya Zone
Period VI (AD 1100-1550)
*Pataky Polychrome (AD 1000-1550)**
Height 11³/₈" (28.9cm) Diameter 7" (17.8cm)
Condition before conservation: design slightly faded;
root marks throughout; surface scratches
Accession no. N-1028

This jar is similar in shape to Number 91. On it as well, a
wide band below the mouthrim, bordered on top and bot-
tom with a row of hooks, is filled with intricately painted
elements of the man/jaguar motif which includes a squared
face with downturned nose, jaguar claw, speech scroll, hatch-
ures, jaguar head, and long bones. The lower body is
painted with a band of hooks below which is another band
described by Dr. Day as "script step/fret."[1] The vertical flange
and the base of the foot are painted with jaguar spots. Top
and bottom bands are tied together by a grid of heavy black
stripes. The interior is rinsed with white slip.

1. Day 1984, fig. 4.16, no. 6, p. 107.
Cf. Snarskis 1982, p. 67, for a vessel in the INS which is of this shape but has
bands of stylized designs encircling the entire surface; and Day 1984, Fig. B.31,
for a similarly shaped Pataky Polychrome jar in the Gillen Collection, Hacienda
Tempisque, Costa Rica, but with the encircling bands of decoration containing
more realistically rendered jaguars and other design elements.
**OXTL analysis (ref. no. 381q37, 6/1/85) estimates that the sample tested was last fired*
between 430 and 710 years ago (AD 1275-1555).

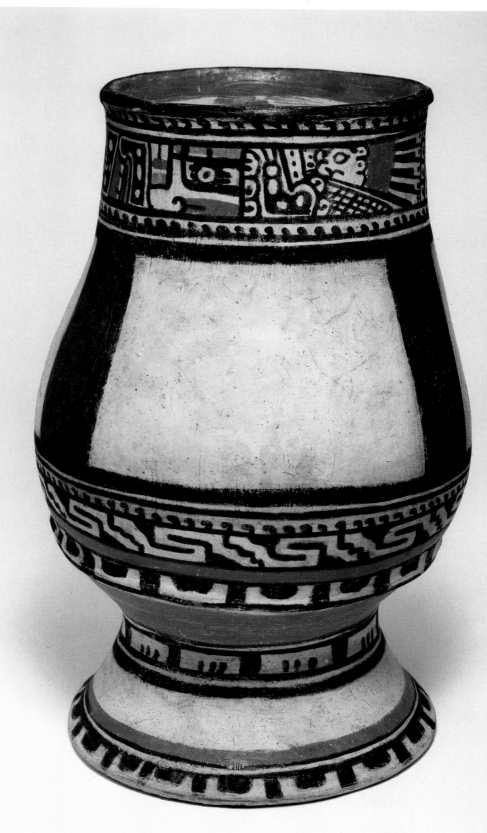

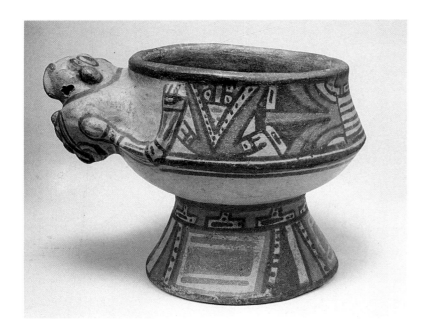

93. PEDESTAL FOOTED BOWL
with appliquéd monkey rattle

*Earthenware, reddish clay body under a buff or tan slip, burnished,
with black, red, orange and purple-brown paint*
Guanacaste-Nicoya Zone
Late Period VI (AD 1200-1550)
Jicote Polychrome, Jicote Variety (?) (AD 1200-1550)
Height 5" (12.7cm) Width 5¼" (13.3cm) Depth 6¾" (17.1cm)
*Condition before conservation: body cracked and repaired; chips on interior
mouthrim and on base of foot; root marks throughout*
Accession no. N-1025

The round-bottomed bowl stands on a wide, flared pedestal
foot. The walls rise from a ridge at the bowl's greatest diam-
eter, then taper just below the splayed mouthrim. Appliquéd
on the exterior is a hollow rattle, hunchbacked monkey with
ridged backbone and short curling tail. The abstract pattern
painted on the exterior is described by Lothrop as a monkey
motif, Type C, which he believes to be a variant of his Type
E, plumed serpent motif.[1]

Jicote Polychrome, the cream or yellow-slipped pottery
manufactured in the vicinity of the lower Tempisque River,
was one of the new decorated ceramic types of the Late
Polychrome Period.[2] It was the major Filadelfia Ware, i.e.,
the major ceramic ware made in Filadelfia, Guanacaste, and
was not as brilliant in coloring as Papagayo, Pataky, or other
white-slipped polychromes also produced in Period V/VI
in the northern part of the Greater Nicoya Archaeological
Subarea. The type was expanded to include three varieties:
Jicote, Mascara, and Luna.[3] Dr. Day has described the body
clay of Jicote Polychrome as tan. The body clay on the Sack-
ler vessel however is different, as are the design elements
which, on Jicote Polychrome, consist of twisted guilloche
patterns, rows of large red step/frets outlined in black,
and separated elements of a jaguar motif which, although
abstract, suggest the animal's characteristics.

1. Lothrop 1926, p. 153.
2. Named by Baudez 1967.
3. Day 1984, pp. 61-62 and 289-291.

Cf. Lothrop 1926, pl. LVb, for similar design.

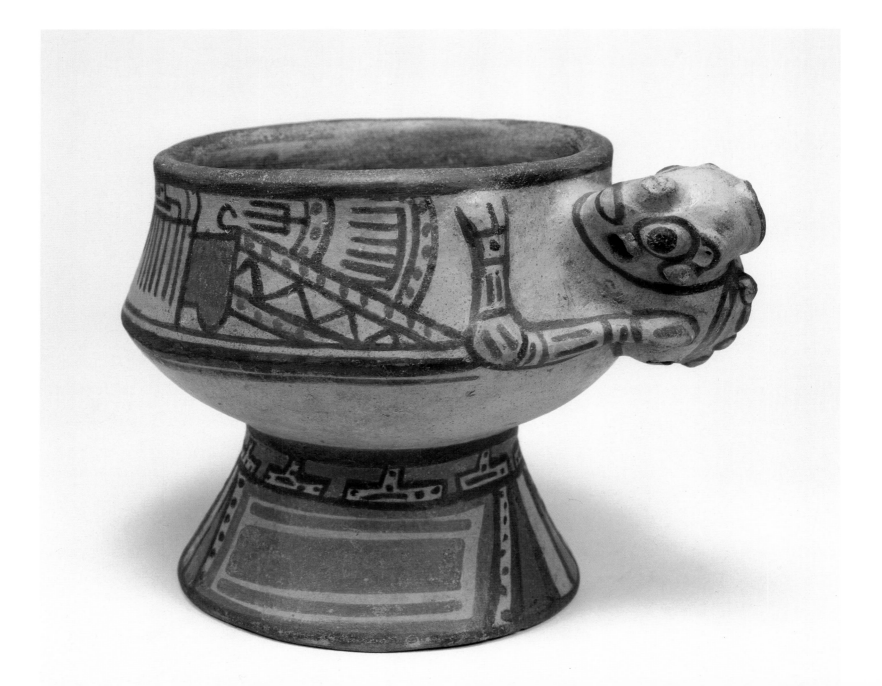

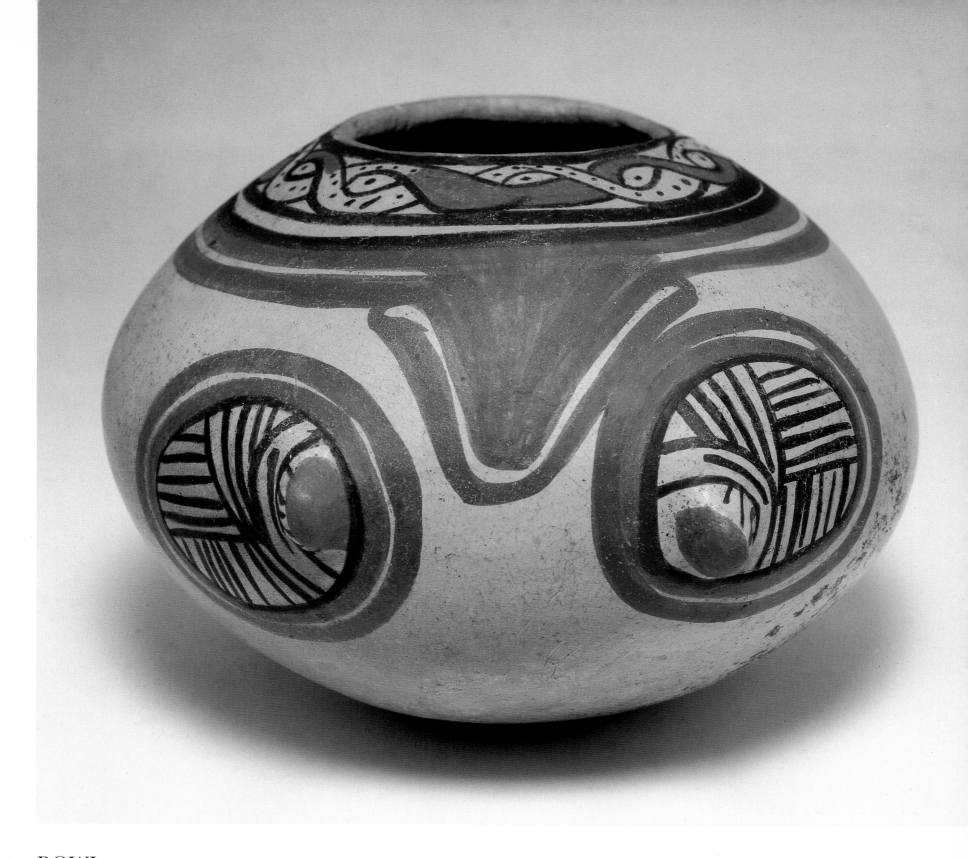

94. BOWL

Earthenware, reddish clay body under a cream slip, burnished, with red-orange and black paint†
Guanacaste-Nicoya Zone
Late Period VI (AD 1200-1550)
*Jicote Polychrome, Jicote Variety (?) (AD 1200-1500)**
Height 6⅝" (16.8cm) Width 8½" (21.6cm) Depth 8⅞" (22.5cm)
Condition before conservation: root marks throughout; repair to rim; "fire-clouding" or staining due to misfiring on front of bowl; surface crack on right side
Accession no. N-1013

The slightly flattened spherical bowl with wide mouth and rolled mouthrim balances on its curved underside without the aid of a footring or rim. The curved surface is interrupted only by the two raised nodules of the eyes (?) in the vessel's decoration. A guilloche band outlined in black encircles the mouthrim. Its interwoven snakes are alternately solid red or filled with black dots. Each loop has a centered black dot. Below the guilloche band are two broad red lines, the lower of which has depending from it a large painted red nose or upper jaw of the serpent in triangular form giving the appearance of a bird's beak. At either side of the red triangle are the modeled and red-painted circular serpent eyes (?). A mat (?) or stylized serpent pattern fills the large circles around the raised nodules.

**OXTL analysis (ref. no. 381L31, 8/1/84) estimates that the sample tested was last fired between 470 and 760 years ago (AD 1224-1514).*

† Refired to remove "fire-clouding." See Appendix C.

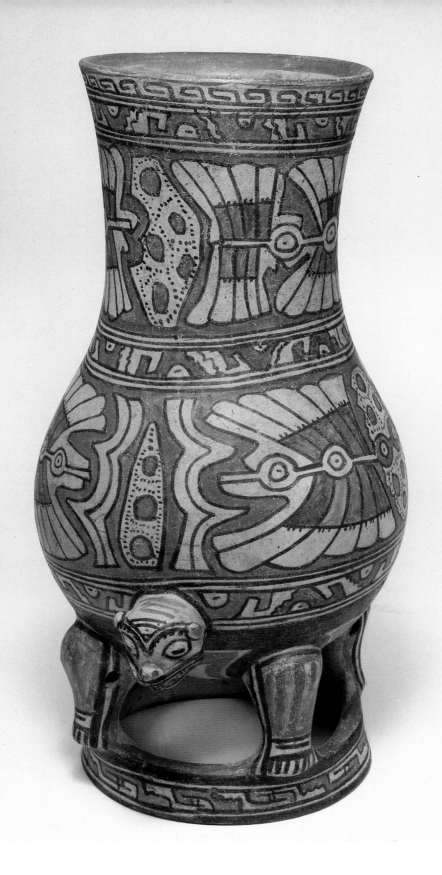

95. TALL JAR on a ring base

*Earthenware, reddish clay body under a salmon slip, burnished,
with black, red and purple paint, waxed*
Guanacaste-Nicoya Zone
Late Period VI (AD 1200-1550)
*Jicote Polychrome, Lunita Variety (AD 1350-1550)**
Height 17⅝" (44.8cm) Width 8¾" (22.2cm) Depth 11¼" (28.6cm)
*Condition before conservation: vegetable staining from root marks;
one head broken and repaired*
Accession no. N-1127

The lower body of this large pear-shaped jar is modeled and
painted to represent two jaguars in apposition whose joint
four legs rest on the ring base providing supports which are
Atlantean in concept. The modeled jaguar heads are

attached at opposite sides of the vessel within an encircling
painted band of step/hook motifs. The large decorative
panel above the jaguar heads, rising to the middle of the
vessel, is filled with a feathered design on either side of large
pointed ovals with large round, red-spectacled eyes whose
shapes continue into the outstretched wing-like feathers.
Perhaps this design is a Lunita variety of the winged-head
design found on Luna Polychrome or possibly an abstrac-
tion of a winged or feathered serpent motif. It also has the
appearance of a bat with outstretched wings. Within the
oval, in addition to the eye circles, dots and spots are
painted. The other large panel above also includes stylized
feathers. In between the two main panels is a narrow band
of step/hook motifs. The interior is painted with a swirling
wash of slip.

Ceramics of the Jicote Polychrome Lunita variety were
established as a variety by Jane Day during her work on the
Gillen Collection ceramics at Hacienda Tempisque, Guana-
caste Province.[1] The sphere of production was in the
Tempisque River drainage, in Guanacaste Province. These
ceramics are salmon slipped inside and out and burnished.
Most also appear to have been waxed. The designs on these
vessels are painted in a large scale, exaggerated manner as
seen here and seem principally intended to fill space on the
variety's large jars. Most of the elements of design on these
elaborately embellished vessels seem to be a blending of vari-
ous themes and design elements borrowed from other
ceramic types of the period. The abstract designs painted on
these ceramics are derived from but do not copy Luna Poly-
chrome vessels (AD 1350-1550), the last major ceramic type
of the Late Polychrome Period, which have been found in
association with Spanish trade goods. Luna Polychrome,
established as a type by Bransford in 1881 at Luna
Hacienda, Ometepe Island, Lake Nicaragua, had as its
sphere the Greater Nicoya Archaeological Subarea includ-
ing Ometepe Island, Hacienda Tempisque, Guanacaste,
Filadelfia, Guanacaste, the Bay of Culebra and the Bay of
Salinas. This ware, not represented in the Sackler Collection,
was covered with a heavy pearly cream to white slip which
formed a thick smooth surface over the clay body. Decora-
tion was painted in fine lines so that from a distance the
design appears to be incised and filled with color, possibly a
copy of a technique used on ceramics from Marajó Island in
the mouth of the Amazon, Brazil. The overall impression is
of a lacy abstraction of elements usually completely filling
the decorated areas of a vessel.

1. Day 1984, pp. 294-5.
Cf. Lothrop 1926 fig. 98a, for a similar type vessel, which he called Luna Poly-
chrome, (also illustrated in Ferrero 1977, Ilus. I-90 but incorrectly labelled I-91
in the illustration), from Filadelfia, Guanacaste, with a design around the neck
similar to the stylized feathers on the Sackler vessel; Ferrero 1977, Ilus. III-39,
for a vessel in the Molinos Collection, Costa Rica, no. 82, of different design but
similarly shaped rising from the back of an alligator, and without a ring base;
Dockstader 1964, no. 156, for another vessel of similar shape supported by a
crocodile standing on a ring base, but taller and more slender than the Sackler
vessel and with panels of stylized feathers covering the surface, from Filadelfia,
Guanacaste, now in the Museum of the American Indian, New York, acc. no. 19/
4981, which in the nature of the drawing seems to be if not by the same hand as
that on the Sackler vessel then from the same workshop; Day 1984, B, 15, for a
Lunita Variety Atlantean supported vessel in the Gillen Collection, Hacienda
Tempisque, Costa Rica; and Cordy-Collins 1979, no. 183a, from the L.K. Land
Collection, for a large jar whose design includes the feather pattern which is
described as "fins of fishes" surrounding a swimming turtle and as wings
attached to double-headed ducks in flight.
**OXTL analysis (ref. no. 381L83, 6/24/84) estimates that the sample tested was last
fired between 330 and 540 years ago (AD 1444-1654).*

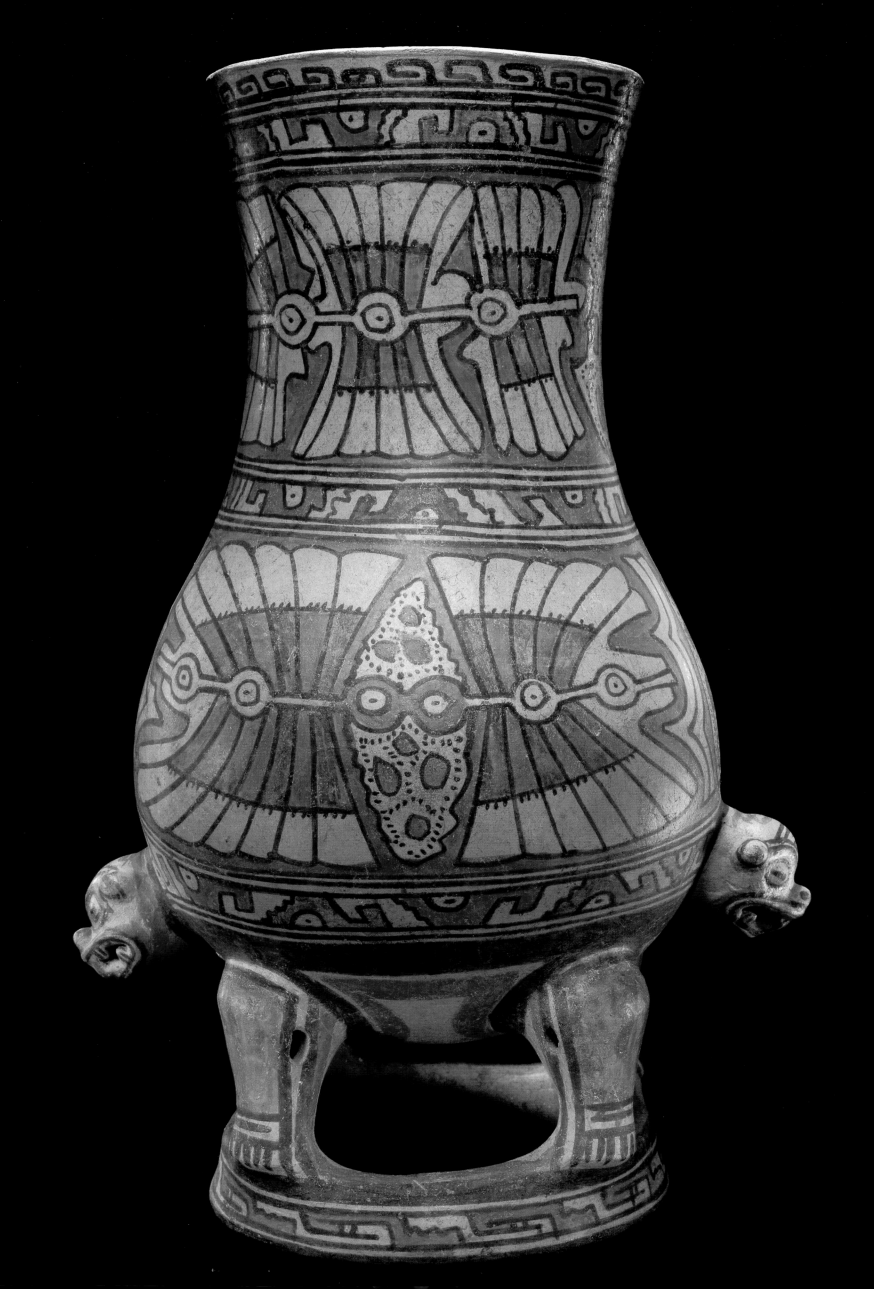

96. BOWL with effigy face theme

*Earthenware, buff clay body under a salmon or tan slip, burnished,
with red and brown paint†*
Guanacaste-Nicoya zone
Late Period VI (AD 1200-1550)
*Jicote Polychrome, Lunita Variety (AD 1350-1550)**
Height 5⅛" (13.0cm) Width 7⅝" (19.4cm)
*Condition before conservation: root marks; rim slightly chipped;
"fire-clouding" due to reduction atmosphere during firing.*
Accession no. N-1056

The globular bowl curves in to a short neck and wide mouth
with slightly everted rim. On the shoulder are stylized faces
with double sets of buttons appliquéd for eyes and ears.
Three loops suggest the lower part of each face. A red band
with right angle projections encircles each face and depends
from the mouths. This decoration continues around the ves-
sel forming panels of abstract jaguar motifs similar to those
seen in Number 97.

The face in this design, an expression of the effigy face
theme which first appeared on Pataky Polychrome vessels,
bears a definite relationship to the "goggle eyed" Tlaloc face
of Central Mexico with large, double-ringed, round eyes
(see No. 84). The eye characteristic predominates as the
effigy face theme becomes the major image on other poly-
chromes until its final appearance on Luna Polychromes is
echoed on Jicote, Lunita variety vessels. These faces are
decorated with earspools, mouth and nosemasks, nose rings
and necklaces painted orange to represent gold jewelry.

Cf. Day 1984, Fig. 4.12e, for a Jicote Polychrome, Lunita variety bowl in the
Gillen Collection, Hacienda Tempisque, Costa Rica, with an effigy face theme
slightly less abstract than that on the Sackler vessel; also Lothrop 1926,
pl. XXVIII, for a drawing of the theme, which Lothrop describes as a
"human-face motive," from a vessel he characterizes as a Filadelfia Ware.
**OXTL analysis (ref. no. 381L34, 4/3/84) estimates that the sample tested was last
fired between 390 and 630 years ago (AD 1354-1594). †See Appendix C.*

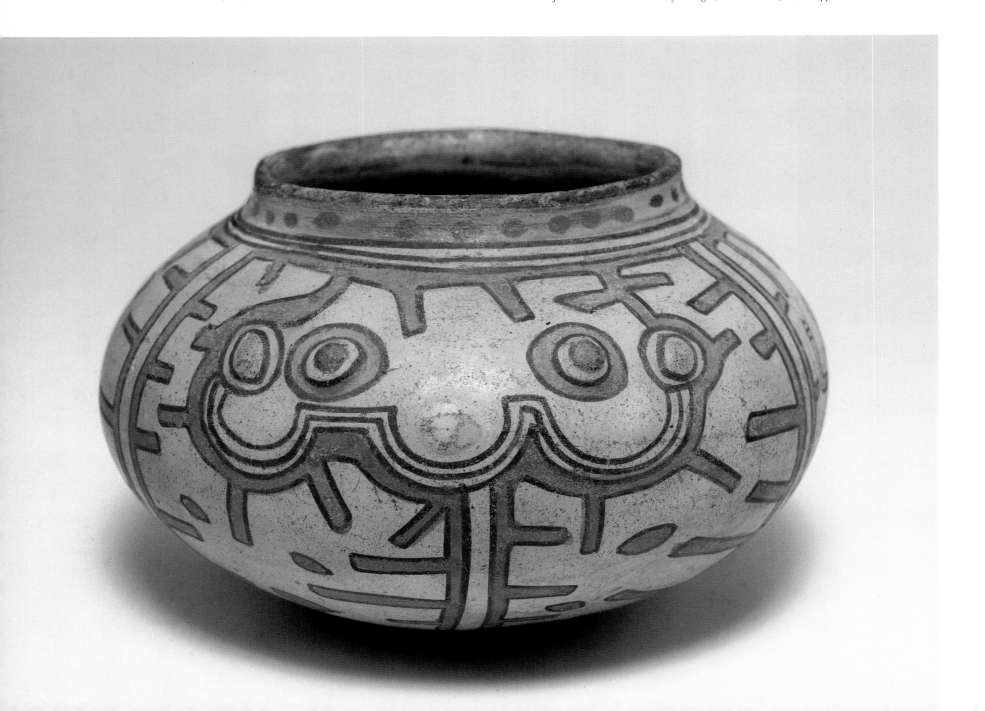

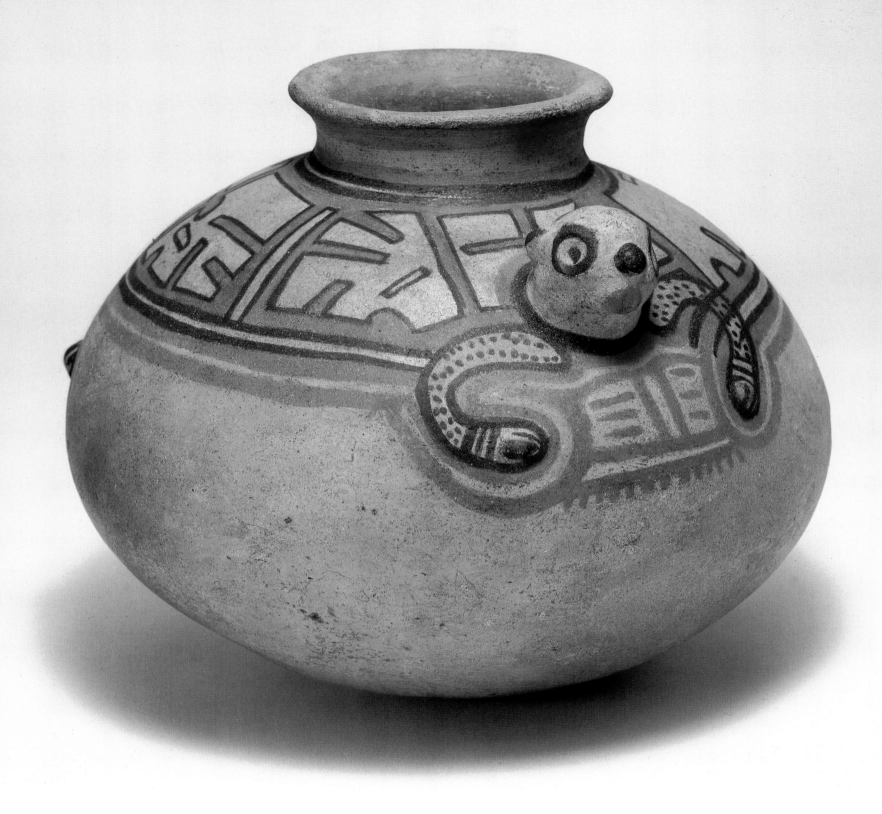

97. JAR with modeled jaguar head

Earthenware, buff clay body under a salmon or tannish slip, burnished, with red and black paint

Guanacaste-Nicoya Zone

Late Period VI (AD 1200-1550)

Jicote Polychrome, Lunita Variety (AD 1350-1550)

Height 8½" (21.6cm) Width 10¼" (26cm)

Condition before conservation: repaired break from above jaguar's head to underside; chip on mouthrim; design slightly worn; staining from reduction atmosphere during firing

Accession no. N-1073

The globular jar narrows at the top to a short neck which flares to an everted mouthrim. Attached to the shoulder is a small minimally modeled jaguar head. The jaguar theme is continued with the painting of two front legs below the head. The wide shoulder band depicts an abstract jaguar body and jaguar markings with angular fragmented zones, a design which represents the jaguar body in one of its most abstract forms, derived from the extremely standardized shorthand symbol for the crouching jaguar seen on Madéira Polychrome vessels. Two small protuberances at the rear indicate hind legs.

Cf. Snarskis 1982, p.77, for a Jicote Polychrome tripod globular jar, in the INS, with feline motifs in its shoulder design similar to that on the Sackler vessel; also Snarskis 1981, no. 103, for a Jicote Polychrome, Mascara variety, in the INS, acc. no. 4045, and no. 104, for a Jicote Polychrome, Lunita variety, also in the INS, acc. no. 99.

98. BOWL with serpent pattern

Earthenware, buff or tan body under a salmon slip, burnished,
with red and black paint
Guanacaste-Nicoya Zone
Late Period Period VI (AD 1000-1550)
Jicote Polychrome, Jicote Variety (?) (AD 1200-1550)
Height 2⅝″ (6.7cm) Diameter 4¾″ (12.1cm)
Condition before conservation: surface chip on rear of bowl;
cracks from rim; root marks on exterior
Accession no. N-1016

The bowl curves in slightly from the rounded lower body to
a thickened mouthrim. The stylized plumed serpent motif
which decorates the exterior walls falls into Lothrop's Type E.
The relationship to the plumed serpent is present although
the nature of each part is difficult to determine. Its central

pattern may represent the eyes of the serpent but more
obvious in relation to Lothrop's Type E plumed serpent are
the encircling arms with claws. Lothrop's illustration of
this type is a simple balanced geometric pattern in which arms
at each end and a triangle containing an eye at the center
can be identified.[1] The Sackler vessel shows the same design
applied to a different field.[2] The abbreviation or distillation
of significant parts ending in almost total abstraction and
symbolic representation can be seen in the stylized plumed
serpent motif in Numbers 104 and 105.[3]

1. Lothrop 1926, pl. LIIIb.
2. *Ibid*, Figure 50b, illustrating the outer surface of a jar cover which the
 Sackler vessel may be as well.
3. See also Snarskis 1982, p. 76, (right-hand vessel of top left illustration) for
 similar design in a Las Marias Polychrome in the INS.
Cf. Lothrop 1926, fig. 50b, for a vessel lid with comparable design.

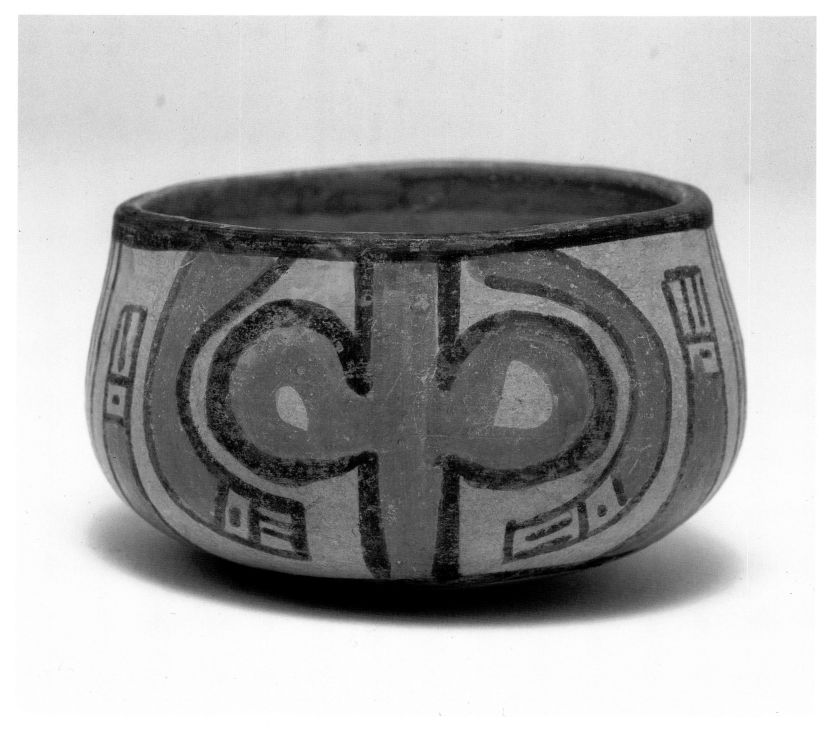

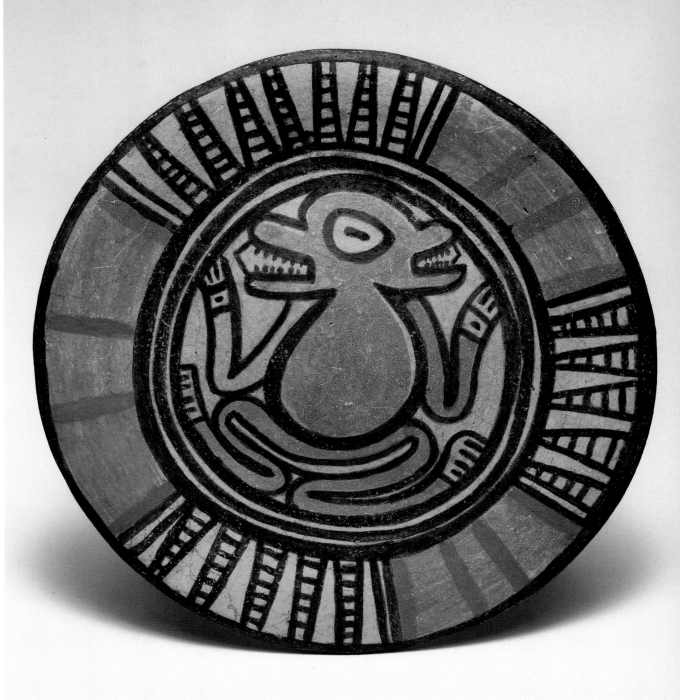

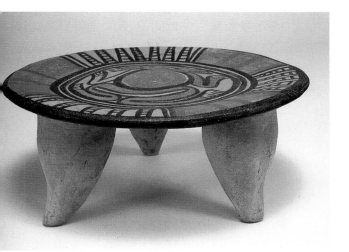

99. TRIPOD PLATE with plumed serpent design

Earthenware, tan clay body under a salmon
slip, burnished, with black and red paint
Guanacaste-Nicoya Zone
Late Period VI (AD 1200-1550)
Tempisque Polychrome, Filadelfia Ware
(AD 1200-1350)
Height 3" (7.6cm) Diameter 6¾" (17.1cm)
Condition before conservation: slight cracks
on legs and rim; one leg broken off
and repaired; root marks on underside
Accession no. N-1089

The plate rests on three rattle, animal-head legs with out-turned tips. An unidentified zoomorphic creature, with two heads in profile sharing one eye and with toothy jaws, is painted in its center. Four arm-like appendages with claws extend from the loop body, but the upper two have three finger-like extremities while the lower two have five. This zoomorphic creature corresponds in its curvilinear form to what Lothrop describes as a plumed serpent, Type B.[1] Another curvilinear form similar to it is Lothrop's monkey pattern, Type A, but his lacks the two-headed aspect. It also resembles the monkeys painted on Number 73 but with the head of the canine seen in association with them. Around the central design on the raised rim is a radiating pattern of three sets of striped triangles, two with five triangles, one with seven, alternating with three sets of lines.

According to Dr. Day, in addition to Jicote Polychrome, the salmon slip on a tan clay body is distinctive and diagnostic of Jicote variety, Filadelfia Ware, and Tempisque Polychrome.[2] In her discussion of design elements associated with ceramic types and varieties of the Late Polychrome Period, Dr. Day indicates that the striped triangle design element seen on

the outer rim of the plate here appears only on Jicote Polychrome, Jicote and Mascara varieties.[3] But she does not associate the plate form with Jicote Polychromes.[4] Such a flat tripod plate however is found among Tempisque Polychrome, Filadelfia Ware, which Dr. Day established as a type during her work on the Gillen Collection ceramics at Hacienda Tempisque, Guanacaste. She suggests it was probably the first Filadelfia Polychrome type, whose appearance initiated the Late Polychrome tradition of imitating other popular ceramics.[5]

1. Lothrop 1926, pl. XLVII.
2. Day 1984, pp. 61-62 and 289-291.
3. *Ibid.*, fig. 4.17.
4. *Ibid.*, fig. 4.5.
5. *Ibid.*, pp. 320-321; Dr. Day had further noted that all the Tempisque Polychrome plates only had red and black chevron patterns covering their entire open surface (*Ibid.*, fig. B.42). She has since indicated in a personal communication to the author that other designs such as the figure here and the striped triangles have been found on Tempisque plates.
Cf. Snarskis 1982, p. 76, upper right, for a similar tripod dish in the INS, which he described as Jicote Polychrome with a lizard design in the center, similar in its sensuous linear movement to the design on the Sackler plate and, like it, encircled by a rimband of alternating stripes and triangles which, following Day's assessment should be designated Tempisque Polychrome; and Lothrop 1926, pl. XLVII, for a plate of similar form and design which he called Nicoya Polychrome Ware, describing its design, as a plumed serpent motif, Type B, which may be Tempisque Polychrome or the kind of original which it imitated.

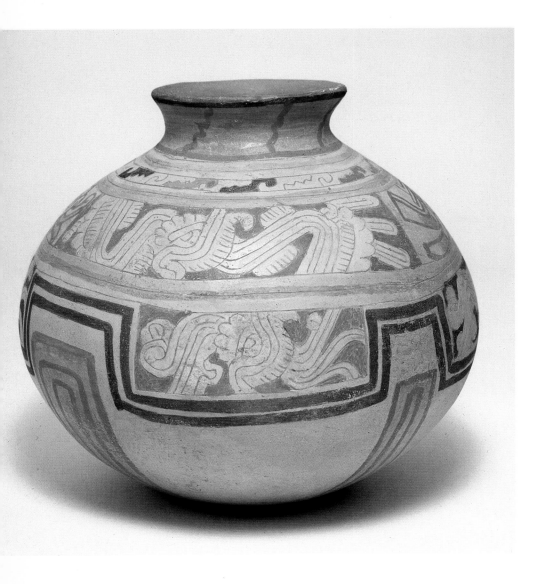

100. JAR

Earthenware, orange-brown clay body under a creamy-white slip, burnished,
painted in black, grey-blue and red
Guanacaste-Nicoya Zone
Late Period VI (AD 1200-1550)
*Vallejo Polychrome, Vallejo Variety (AD 1200-1350)**
Height 8" (20.2 cm) Diameter 8⅝" (21.8 cm)
Condition before conservation: broken into several pieces and repaired;
missing fragment restored; a "kill" hole in one side apparently made
at the time of interment; "fire-clouding" on a large section of one side†
Accession no. N-1205

From a flat base, this globular Nicoya polychrome bottle
rounds to a narrow neck which rises to an everted mouth-
rim. The designs are both painted and incised, with the
incising executed after the slip was applied to the vessel. The
top band consists of step/frets which terminate in a curling
hook. The wider shoulder band is decorated with alternately
incised and painted feathered serpents: the incised serpents
are set within black or red horizontal panels while the
painted serpents are outlined in red. The band below also
includes four horizontal panels of incised plumed serpents
on a red or black ground. Alternating between them are
four vertical panels rising from a red line encircling the flat
base. These are painted a light red-orange wash, outlined in
red, with smaller red outlined panels within them. Separat-
ing the bands of decoration are encircling lines of blue-grey

paint. The designs may represent a cosmographical concept,
i.e. a celestial symbol uppermost, followed by terrestrial and
underworld symbols below.

Vallejo Polychrome was one type of the new white slipped
polychromes produced in the Late Polychrome Period (circa
AD 1200-1550). It was decorated with symbols and deities
such as the hummingbird (No. 102), the serpent, and the
earth monster, Tlaltecuhtli, (No. 101), connected with Central
Mexican cultures, although as yet no one can fully explain
the mechanism behind the occurrence of the Central Mexi-
can pantheon in Greater Nicoya. With the appearance of
this type, a florescence of newly depicted serpent imagery
emerged. In the early part of the Late Polychrome Period
all varieties were decorated with the dominant feathered
serpent theme. In the latter part of the period this motif
ultimately became a standardized symbol on Lazo variety
vessels, Numbers 104 and 105.

Vallejo Polychrome, Vallejo variety vessels include painted
and incised designs, the latter incised through or under-
neath the slip. The incising emphasizes the designs which
recall pictures and symbols associated with the codices of the
Mixteca Alta in Mexico. The vessels themselves are also simi-
lar to vessels from the Mixteca Alta and from Guatemala
and Nicaragua. Mexican deities appearing during a
restricted period of time occur in an identifiable manner
only on Vallejo Polychrome, Vallejo and Mombacho vari-
eties.[1] Dr. Day has noted that the distinction between the
Vallejo variety and the Mombacho variety, a small group
whose designs are incised on the fired clay before the slip is
applied, is the blue paint which does not appear on Momba-
cho vessels.[2]

In the Mexican pantheon, four gods or "four children" are
specified as gods of nature and associated with the four
directions. Grouped in pairs, one pair, the red and black
Tezcatlipoca, represented the morning and evening stars;
the other, Huitzilopochtli and Quetzalcoatl, represented the
sun and the moon. Appearing under numerous and differ-
ent aspects, apparently resulting from the fusion of various
originally distinct forms, Quetzalcoatl was one of the most
important dieties of Mesoamerica. As the celestial spirit, he
represented the celestial ocean during the night, the terres-
trial oceans which encircle the earth, and the subterranean
waters. Tezcatlipoca is generally a companion and competi-
tor of Quetzalcoatl and appears in two forms whose con-
trasting colors, red and black, were frequently repeated in
Mexican mythology to symbolize the contrast between the
diurnal and nocturnal sky, or between the sky and the neth-
erworld. The colors on the polychromes decorated with
Mexican deities probably emphasize the cosmological signifi-
cance of the designs.

1. Mombacho variety was established as a variety of Vallejo Polychrome by Dr.
Day during her work on the Gillen Collection ceramics at Hacienda Tempisque,
Guanacaste (Day 1984, pp. 322-326); but before Day's classification Mombacho
Polychrome Incised is referred to by Lothrop 1926, pp. 191-193, and Norweb
1964, p. 560; and Stone 1977, p. 72, refers to Underslipped Incised Ware or
Mombacho Polychromed Incised as a Middle Polychrome Period ware, and on
p. 81, as extending into the Late Polychrome Period, La Cruz A phase.
2. See also Healy 1980, pp. 146-152; although Snarskis 1982, p. 72, refers to
Mombacho ceramics as frequently displaying a blue-grey paint. The blue on the
Sackler vessel is being analyzed at the Conservation Laboratory, the Fogg Art
Museum, Harvard University.
*OXTL analysis (ref. no. 381p99, 6/1/85) indicates that the sample tested was last fired
between 550 and 900 years ago (AD 1085-1435). †See Appendix C.*

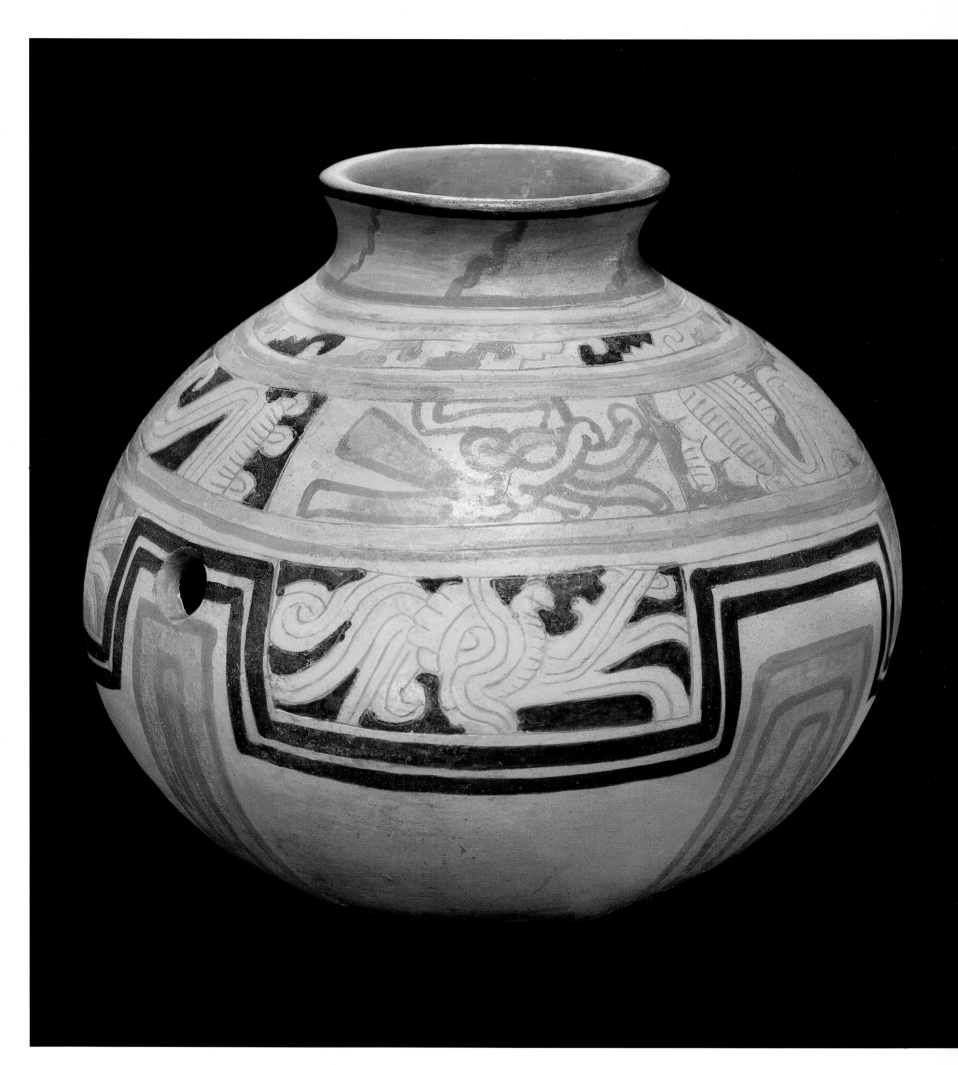

187

101. LARGE EFFIGY JAR

Earthenware, reddish clay body under cream slip, burnished,
with black, red and blue-gray paint.
Guanacaste-Nicoya Zone
Late Period VI (AD 1200-1550)
Vallejo Polychrome, Vallejo Variety, Nicoya Polychrome Ware
*(AD 1200-1350)**
Height 10³/₄" (27.3cm) Width 8³/₈" (21.3cm) Depth 10¹/₂" (26.7cm)
Condition before conservation: crack around front mask; one tooth restored
Accession no. N-1125

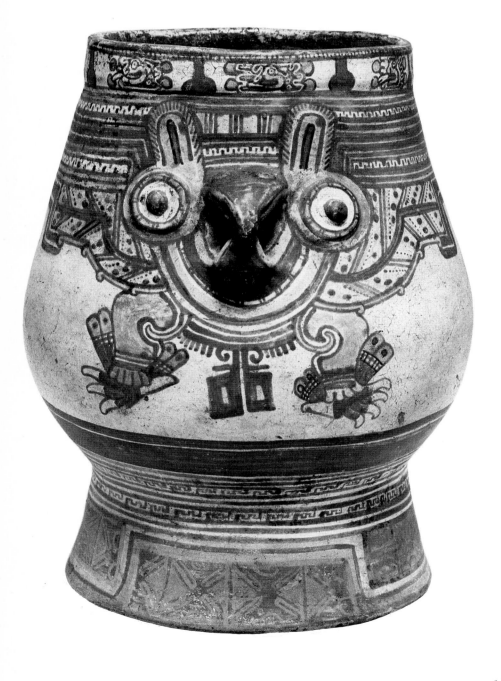

The large pear-shaped jar stands on a tall slightly flaring pedestal foot. From its bulging lower body it tapers slightly to the neck then splays imperceptibly to the wide mouth. Modeled in high relief, on one side below the rim, is a large head of Tlaltecuhtli, the Mexican earth monster with gaping mouth and fangs. Its toad-like body with arms whose claws hold shield-like arrays of feathers is painted on either side of the modeled head. On the opposite side of the vessel is a modeled owl's head (?) with open beak and large round appliquéd eyes. Painted above it on the vessel body is a feather crest and tufted ears; below it is a bifurcated pendant necklace. Painted below the mouthrim is a paneled band with human or jaguar heads. Various geometric bands, undoubtedly of symbolic content, are painted below it, around the base and on the lower portion of the flared foot.

Tlaltecuhtli is a Mexican God represented as a fantastic animal in the form of a toad with open jaws and claws on his feet. He is known as the Earth Monster. The Mexicans associated the earth with an insatiable monster, since it is the place in which the bodies of the dead are interred and also, they believed, where the stars were hidden during the day. As the sun set in the west so the gods descended to the west and slipping below the horizon went to the world of the dead. In Aztec art, the counterpart of Tlaltecuhtli is the Earth Mother and life-giver Tlazolteotl, one of a number of supernaturals who shared an earth-fertility complex. The Earth Mother is the source of life while the Earth Monster is the taker of life. The earth thus personified the source from which all life came and to which all life returned. Tlaltecuhtli often appears as decoration on Vallejo Polychrome, but usually incised and painted onto the vessel body.[1] The representation here in relief is more unusual and arresting. So is the depiction of the owl(?) on the reverse side which seems to indicate a transformation of one into the other and probably relates to the Mesoamerican concept of the struggle between night and day or the transformation from night to day.

1. See two such decorated vessels in Snarskis 1981, no. 111, in the INS, acc. no. 3999, and no. 112, in the MNCR, acc. no. 15001 (also illustrated in Ferrero 1977, Ilus. I-94 and pl. XIVa).
Cf. Snarskis 1982, p. 83, for a small Luna Polychrome bowl in the INS with modeled head with beak as seen on one side of the Sackler vessel which he describes as a feline motif; and Stone 1977, fig. 129, for another Luna vessel with the same beaked head (the species is undesignated).
**OXTL analysis (ref. no. 381L82, 9/11/84) estimates that the sample tested was last fired between 500 and 810 years ago (AD 1174-1484).*

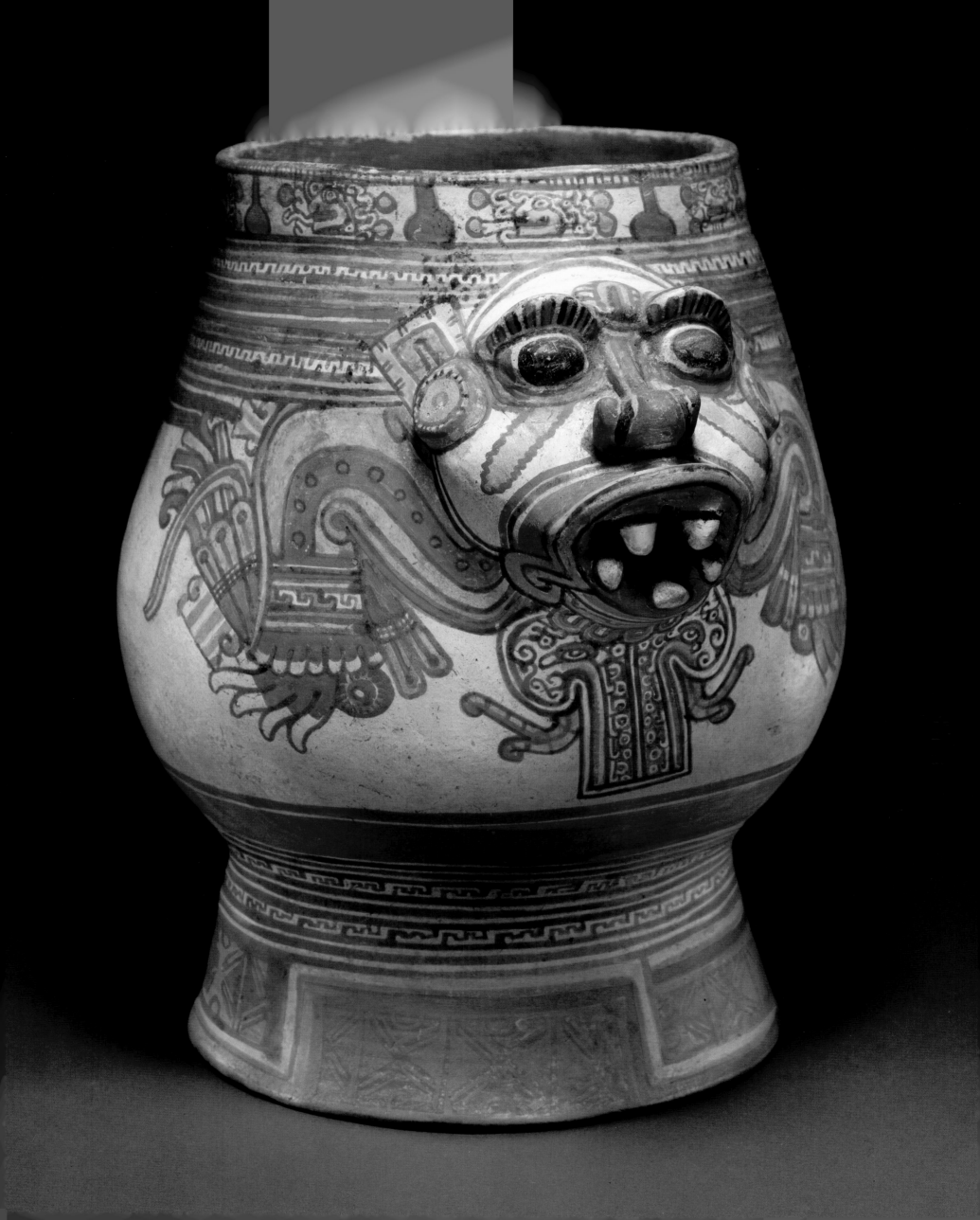

102. BOWL with painted hummingbird

Earthenware, red-brown clay body under a cream slip, burnished, with orange, pearl-gray and black paint
Guanacaste-Nicoya Zone
Late Period VI (AD 1200-1550)
Vallejo Polychrome, Vallejo Variety, Nicoya Polychrome Ware (AD 1200-1550)
Height 5⅛" (13cm) Diameter 8⅝" (21.9cm)
Condition before conservation: rim chips; surface scratches
Accession no. N-920

The hemispherical bowl with slightly everted rim is one of the major shapes of Vallejo Polychrome in all its varieties. It is seen here and in Number 103. The exterior is divided into panels by vertical bands and vertical step/fret patterns. These depend from horizontal shoulder bands, above which are vertical lines bordered by a horizontal "T" form. The main design on the body is a stylized hummingbird.

The hummingbird is associated with the central Mexican Aztec deity Huitzilopochtli. This diety is involved in the so-called "Sacred War," a highly complicated conception that involves various myths, and is variously interpreted, as related to: the creation of the world and of man during five suns or epochs alternating between the dominance of Tezcatlipoca, Quetzalcoatl, Tlaloc, and Chalchiutlicue; eternal preoccupation and fear among Pre-Columbian people that the nocturnal tiger would devour the eagle and cause the end of the world; the constant, bloody struggle in the sky between day and night; and the war between the stars and the moon, and the process by which the gods became stars. Huitzilopochtli participated in the struggle with Tlaloc, the spirit of earthly things, who opposed the sun or Huitzilopochtli and his associates who dominated the sky. Huitzilopochtli was thus involved in the struggle between day and night or life and death. In northeastern Costa Rica the "Sacred War" is essentially the struggle between Huitzilopochtli and Mixcoatl, the former warding off death as he defends himself against the attacks of Tezcatlipoca transformed into a jaguar.[1]

1. Melendez 1959; also Day 1984, p. 104.

Cf. Day 1984, figs. 4.14e and B46, in the Gillen Collection, Hacienda Tempisque, Guanacaste, both exhibiting different depictions of the hummingbird; and Ferrero 1977, Ilus. I-99, in the MNCR, acc. no. 22818.

OXTL analyses (381p69, 4/3/85) estimates that the sample tested was last fired between 450 and 800 years ago (AD 1185-1535).

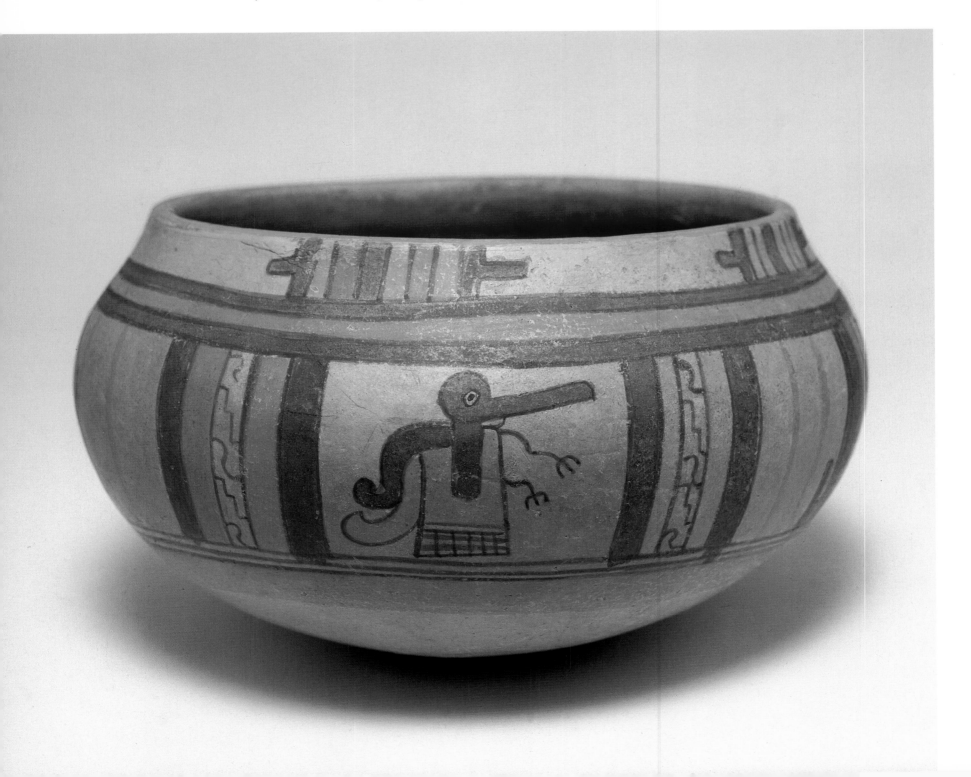

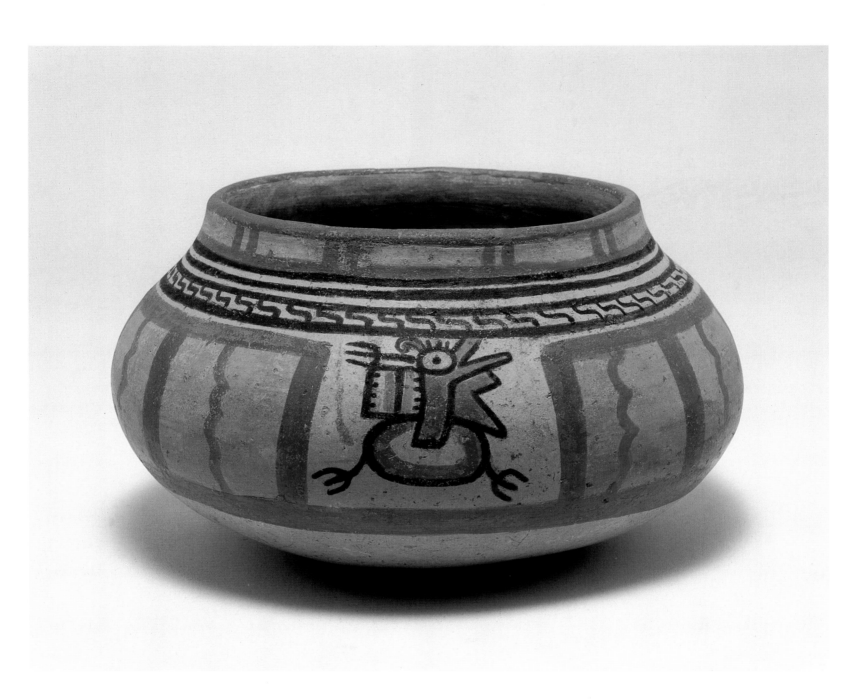

103. BOWL with painted bird

Earthenware, red-brown clay body under a cream slip, burnished,
with red and orange paint
Guanacaste-Nicoya Zone
Late Period VI (AD 1200-1550)
Vallejo Polychrome, Vallejo Variety, Nicoya Polychrome Ware
(AD 1200-1350)
Height 3⁷/₈" (8.6cm) Width 6⁵/₈" (16.8cm)
Condition before conservation: slight surface and paint chips throughout;
design somewhat faded
Accession no. N-1053

This hemispherical bowl with slightly everted rim is painted
with perhaps another version of the bird in Number 102.
Here the exterior is divided into panels by thick horizontal
and vertical red lines. Opposite sides of the bowl are deco-
rated with the stylized bird. The side panels are filled with
an orange wash and vertical zigzag red lines. Below the
mouthrim are stripes forming panels, and below it on the
shoulder is a simplified step/fret band.

Cf. Ferrero 1977, Ilus. I-99, for a similar design on a bowl.

104. BOWL with serpent motif

Earthenware, reddish clay body under white slip, burnished,
with red, black and pearl-gray paint
Guanacaste-Nicoya Zone
Late Period VI (AD 1200-1550)
Vallejo Polychrome/Lazo Variety, Nicoya Polychrome Ware
(AD 1200-1550)
Height 5¼" (13.3cm) Diameter 8⅞" (22.5cm)
Condition before conservation: paint chips on rim; root marks on rim
Accession no. N-1017

The hemispherical bowl here is somewhat distinct from the two in Numbers 102 and 103, but even with its different proportions it is the diagnostic Late Polychrome period shape with a bulging body restricting slightly to the wide mouth. On the body are painted two halfmoon medallions, an abstract stylization of the plumed serpent motif discussed in Number 100 and which Lothrop has designated Type H.[1]

This unique half-circle motif is filled with ray-like elements that surround and radiate from what Lothrop called a serpent mandible but which Dr. Day prefers to see as a serpent eye/jaw motif in the upper half of the lazo.[2] The eye is the central element. Turning the bowl sideways allows a profile view of the serpent's open mouth with bifurcated tongue. The surrounding linear design may represent the plumes of the head or the serpent's body.

The Lazo variety of Vallejo Polychrome was established as a variety by Dr. Day during her work on the Gillen Collection ceramics, Hacienda Tempisque, Guanacaste.[3] The Vallejo Polychrome lazo design element is similar to a motif found on vessels in west Mexico, reflecting the probable influence from that area on Costa Rica through migration and trade.

1. Lothrop 1926, fig. 54.
2. Day 1984, p. 150.
3. *Ibid*, pp. 330-331.
Cf. Day 1984, figs. 5.6 top and middle right, and B51, for examples from the Gillen Collection, Hacienda Tempisque, Guanacaste.

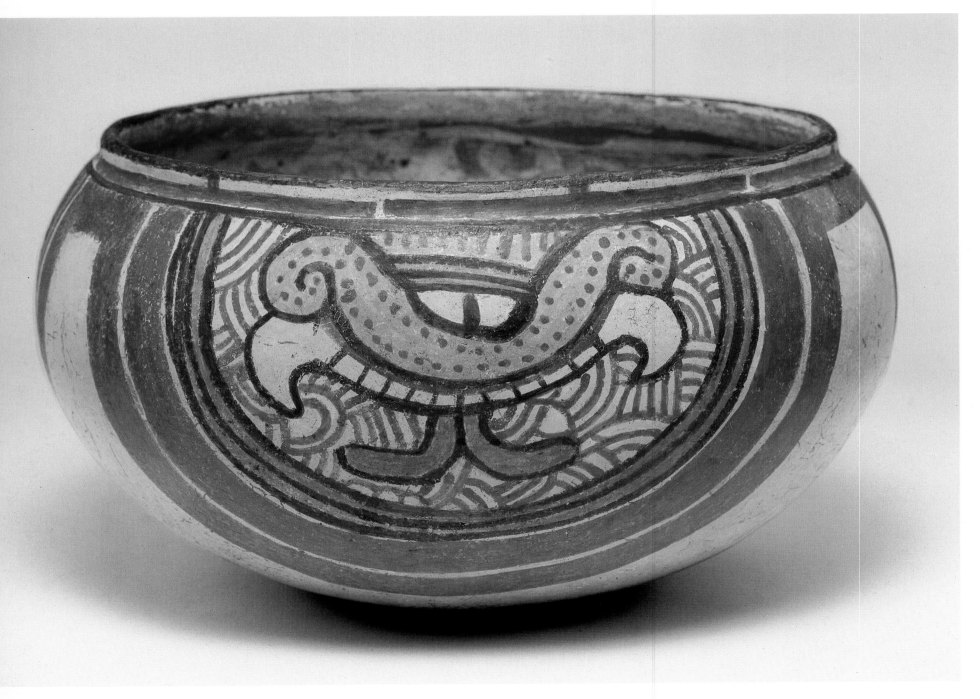

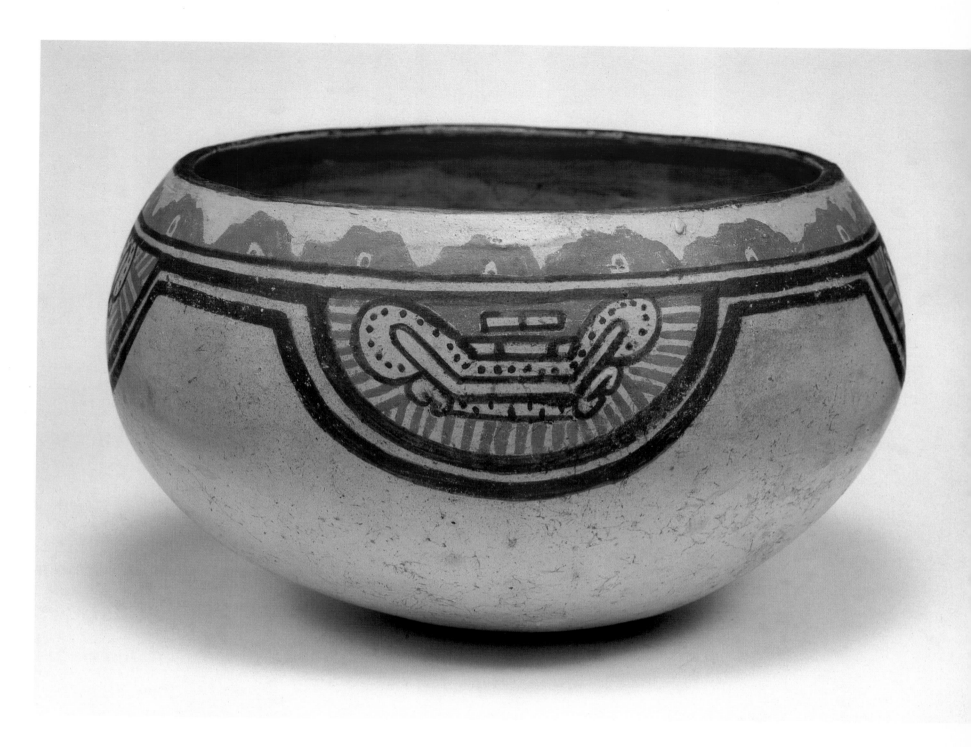

105. BOWL with serpent motif

*Earthenware, tan clay body under salmon slip, burnished,
with red and black paint*
Guanacaste-Nicoya Zone, Tempisque Valley
Period VI (AD 1000-1550)
*Vallejo Polychrome, Lazo/Filadelfia Variety, Filadelfia Ware
(AD 1200-1550)*
Height 5⅛" (13cm) Width 8⅝" (21.9cm)
Condition before conservation: root marks; crack from rim
Accession no. N-1076

The shape of this bowl is again distinct from the one in
Number 104 and those in Numbers 102 and 103 by not
having the diagnostic rim shape. It is the Filadelfia Ware
copy of the Vallejo Polychrome, Lazo variety bowl in Num-
ber 104; i.e., it is the local pottery of the Late Polychrome
Period produced in the Tempisque River drainage that cop-
ied the Vallejo Polychrome, Lazo variety. The difference
between it and the latter is the salmon slip over the tan paste
and the lack of pearl-gray paint. The elements of the design
are the same: two halfmoon medallions are decorated with a
very abstract stylization of the plumed serpent motif, exhib-
iting an eye as the central element, open jaws and surround-
ing rays probably indicating the plumes of the head. The
lazo is outlined in black. A rim band is decorated with red
scallop-like elements. The main design is even more
abstracted than the plumed serpent in Number 104,
but the elements are essentially the same.
Cf. Day 1984, fig. B52.

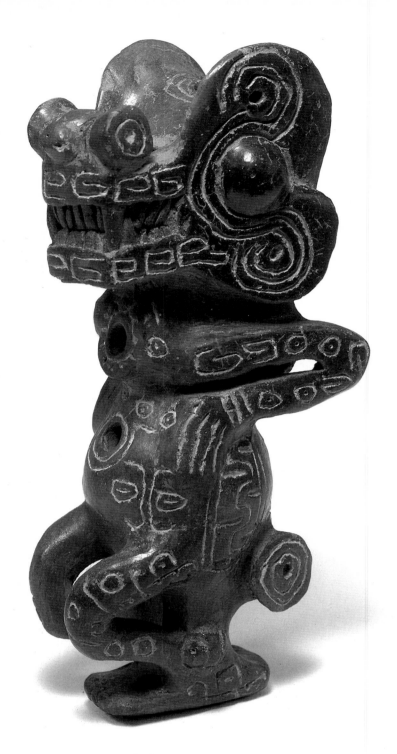

106. OCARINA with alligator-masked figure

*Earthenware, brownish clay body under a chocolate slip, burnished,
with white pigment rubbed into incising*
Guanacaste-Nicoya Zone (?)
Late Period VI (AD 1200-1550)
*Castillo Incised/Engraved (AD 1200-1550)**
Height 9⅛" (23.2cm) Width 3" (7.6cm) Depth 4" (10.2cm)
*Condition before conservation: open fractures on left arm;
repair to bottom of foot*
Accession no. N-1112

This unusual figure wearing an alligator mask is a musical
instrument. The figure is shown sitting on a stool or log of
circular form. His arms are raised with hands on hips. The
hind legs arch out and back as he rests on the stool. The
large squared alligator head mask has button eyes on either
side, head bumps, squared jaws with mouth showing teeth,
and round large nostrils. Engraved designs of squares, dot-
ted circles, scrolls and squiggly lines indicate the markings
on the hide. Finger holes to control the air are cut into the
hollow stomach and chest.

Such figures as vessels also appear before and through
Period VI in central and eastern Costa Rican settings where
modeled and appliquéd decoration was more common, but
such dark-brown and black-slipped vessels of modeled
zoomorphic form and white-filled engraved lines appear in
the Guanacaste-Nicoya zone as well (see No. 110). They
probably represent standing human figures with zoo-
morphic masks and other animal features such as cloaks or
skins, as the ocarina here seems to do. The interpretation of
the roles of these animals in the prevailing mythology is
insufficiently understood because of incomplete icono-
graphic knowledge. Just as the jaguar had a starring role in
the religious and mythological concepts expressed through
the designs on polychrome ceramics in Greater Nicoya the
alligator or crocodile prevailed in design schemes at an ear-
lier period and may represent the expression of continued
beliefs of an alternate cult in the same area in this later
period. Although zoomorphic vessels are not uncommon,
musical instruments with this elaborate form are.

**OXTL analysis (ref. no. 381M84, 11/30/84) estimates that the sample tested was last
fired between 490 and 780 years ago (AD 1204-1494).*

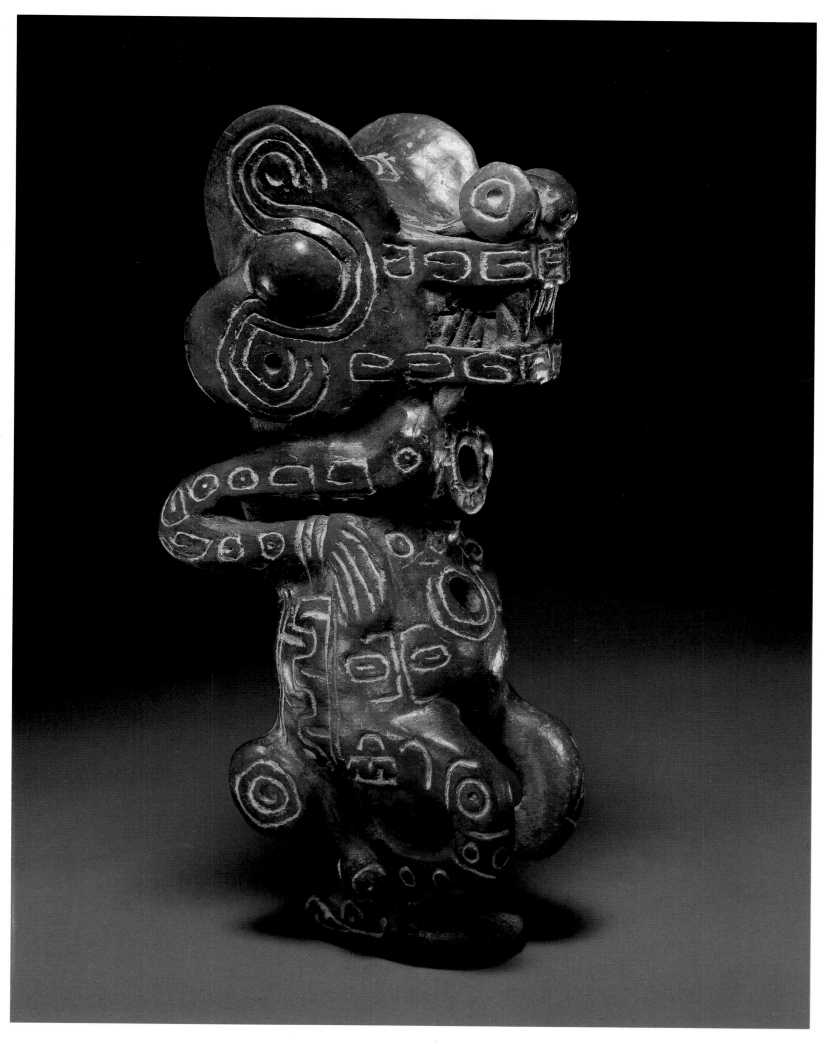

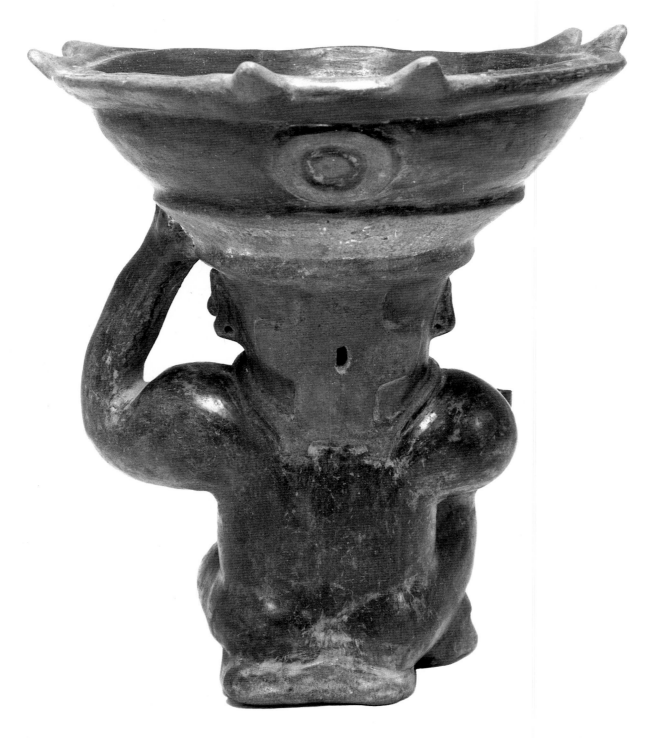

107. BOWL with anthropomorphic figure

Earthenware, brownish clay body under a black slip, burnished
Guanacaste-Nicoya Zone(?)
Period V(?) (AD 500-1000)
*Unnamed Type (300 BC-AD 750)**
Height 9″ (22.9cm) Width 7⅜″ (18.7cm) Depth 7½″ (19.1cm)
Condition before conservation: front left quadrant of rim restored;
fractures in dish; right hand missing; left arm and leg broken and repaired
Accession no. N-1154

This modeled kneeling figure wears an alligator mask and
holds a composite silhouette bowl on his head. The mask is
comprised of an openwork snout, long, open jaws with
prominent teeth, broad nostrils, double ringed, circular eyes
and alligator spikes. The concentric eyes may be that of the

wearer; his ears with earspools show on either side of the
mask. The figure appears to have a plate on top of his head
in which rests the large bowl with flared and crenellated rim.
He wears a necklace with a pendant attached.

The figure is reminiscent of a modeled alligator masked
effigy (No. 144) from the Atlantic Watershed/Central High-
lands. Brown or black slipped ceramics have not received
the attention given to Polychrome types and a type designa-
tion is difficult to assign in the case of the figural vessel here
which may derive from the Guanacaste-Nicoya Zone and be
as early as Period IV.

Cf. Ferrero 1977, Ilus. I-69, p. 92, for a human head surmounted by a similar
type bowl, monochrome ceramic, from Bagaces, Guanacaste, in the MNCR
acc. no. 23051.
**OXTL analysis (ref. no. 381M79, 11/20/84) estimates that the sample tested was last*
fired between 1250 and 2260 years ago (276 BC-AD 734).

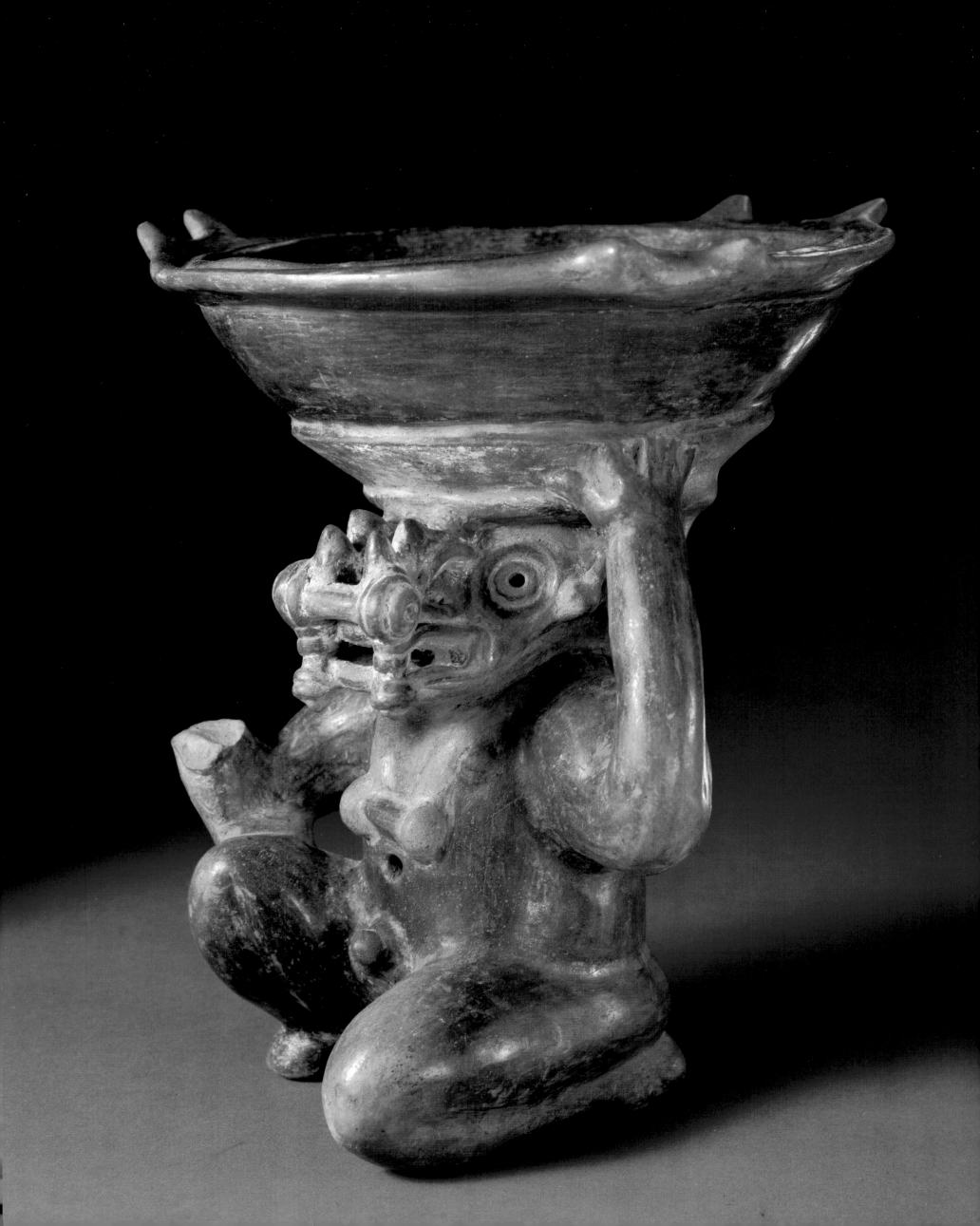

108. LARGE TRIPOD JAR

Earthenware, brownish clay body, under a chocolate slip, burnished
Guanacaste-Nicoya Zone
Period V/VI (?) (AD 500-1550)
*Castillo Incised/Engraved (?) (AD 1200-1550)**
Height 11¾" (29.8cm) Diameter 8⅞" (22.5cm)
Condition before conservation: root marks throughout; surface chips
throughout bowl; section of rim restored; one leg restored
Accession no. N-1012

This elegantly simple pear-shaped jar with bulbous lower
body, long curving neck and wide slightly splaying mouth,
rests on three conical hollow rattle feet. An appliquéd rib-
bon of clay encircles the body at the shoulder but is broken
on each side to allow for an incised design: on one side a
crosshatched square and on the other two concentric circles.
Each design has white pigment rubbed into it.

This vessel, along with Numbers 106 to 118, is an example of
ceramic decoration other than polychrome painting which
continued in Period VI in the Guanacaste-Nicoya zone. Cas-
tillo Incised/Engraved was a pan-regional type and the most
common brown- or black-slipped, incised/engraved pottery
produced during this period. The term Castillo Incised/
Engraved incorporates Chocolate and Black Wares found in
most of Guanacaste. These were the last of a tradition of
fine incised and engraved ceramics which had their begin-
nings in the earliest ceramics in the Greater Nicoya area.
Decorated primarily with geometric forms Castillo Incised/
Engraved ceramics, as evidenced by this vessel and Number
109, are striking examples of the simple yet elegant ceramic
forms manufactured at the same time as the elaborately
decorated polychromes.

**OXTL analysis (ref. no. 381p73, 4/18/85) estimates that the sample tested was last fired*
between 900 and 1450 years ago (AD 525-1085).

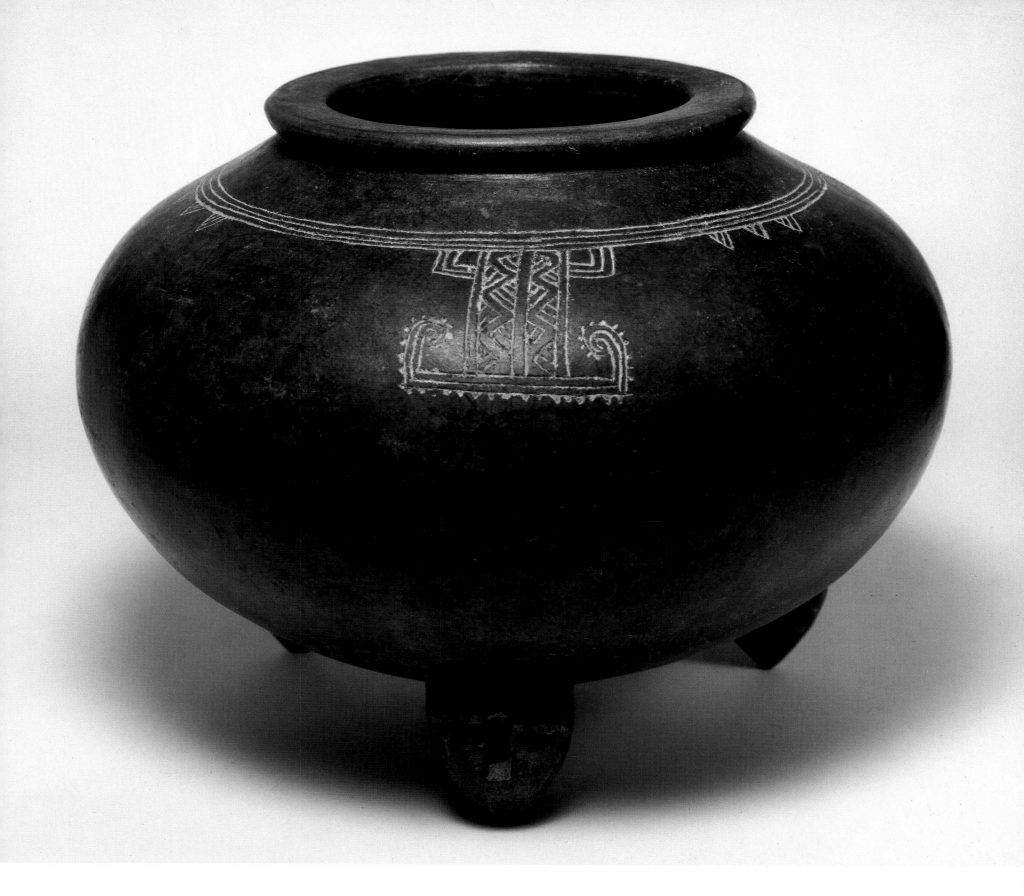

109. TRIPOD BOWL incised

Earthenware, brownish clay body under a black slip, burnished, with white pigment rubbed into the incised designs
Guanacaste-Nicoya Zone
Late Period VI (AD 1200-1550)
*Castillo Incised/Engraved (AD 1200-1550)**
Height 7¼″ (18.4cm) Width 9½″ (24.1cm)
Condition before conservation: surface chips on rim; two legs repaired; tip of one leg broken
Accession no. N-886

The globular bowl, resting on three hollow conical rattle feet, curves in from the bulging body to an everted and thickened mouthrim. Incised or engraved parallel lines encircle the shoulder. Depending from them on opposite sides of the neck are stylized, headless alligator bodies, the double bands of zigzags indicating the scutes of the hide.

Castillo Incised/Engraved ceramics are characterized by designs executed after the firing with a razor-sharp implement, consequently the term engraved to describe the decorating method. Designs, varying greatly in size, are generally rendered in panels, with the major motif continually repeated, although a number of diverse motifs exist.

**OXTL analysis (ref. no. 381P67, 4/3/85) estimates that the sample tested was last fired between 290 and 680 years ago (AD 1305-1695).*

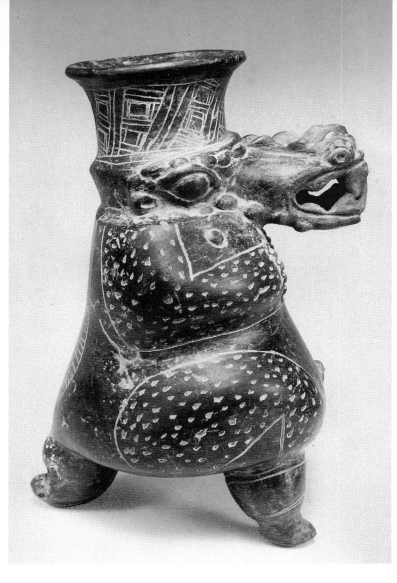

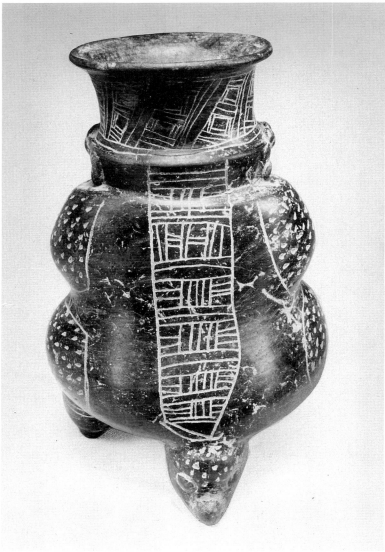

110.

ZOOMORPHIC EFFIGY VESSEL

Earthenware, brownish clay body under a black slip, burnished,
with white pigment rubbed into incising
Guanacaste-Nicoya Zone
Period V (AD 500-1000)
*Huerta Incised/Engraved (AD 500-800)**
Height 8" (20.3cm) Width 5⅛" (13cm)
Condition before conservation: crack on base; broken and repaired;
fangs restored
Accession no. N-1117

This modeled tripod jar seems to represent a seated human figure with an alligator or crocodile mask and animal skin attire. The large body bulges to indicate forearms which are folded across the chest and hindquarters which terminate in shaped legs. The third leg at the rear, in the form of an animal head, is the effigy's tail. Forearms and legs are elaborated with pecking to simulate the scutes or knobbly hide of the alligator. The incised and pecked details are filled with a white wash. The head-mask is naturalistically modeled with a large snout, open jaws, and bumps around the large eyes and along the snout to the raised nostrils. The crocodile or alligator heads were probably modeled after actual masks which incorporated a mythologized alligator or crocodile image. Above the alligator mask is the vessel neck with flared rim incised with stylized alligator markings (?).

Lothrop describes three wares (Chocolate, Black and Orange-Brown) which look identical to Huerta or Castillo Incised/Engraved.[1] He also notes a number of other decorative motifs and vessel forms, with modeled alligators, felines, monkeys, turtles, armadillos and humans from southwest Nicaragua, northwest and highland Costa Rica.

1. Lothrop 1926, pp. 227-244.
Cf. Snarskis 1981, no. 101, zoomorphic effigy vessel with feline mask reportedly from Nosara, Nicoya Peninsula, now in the INS, acc. no. 300, and no. 102, pl. 18, zoomorphic effigy vessel with crocodile mask and feline headdress and supports, also from the Guanacaste-Nicoya Zone and now in the INS, acc. no. 4037, which Snarskis dates to Early Period VI, AD 1000-1350, (no. 102 also illustrated in Stone 1977, fig. 107, and described as "Chocolate Ware" or Castillo Engraved).
*OXTL analysis (ref. no. 381M74, 11/20/84) estimates that the sample tested was last fired between 1070 and 1860 years ago (AD 124-914).

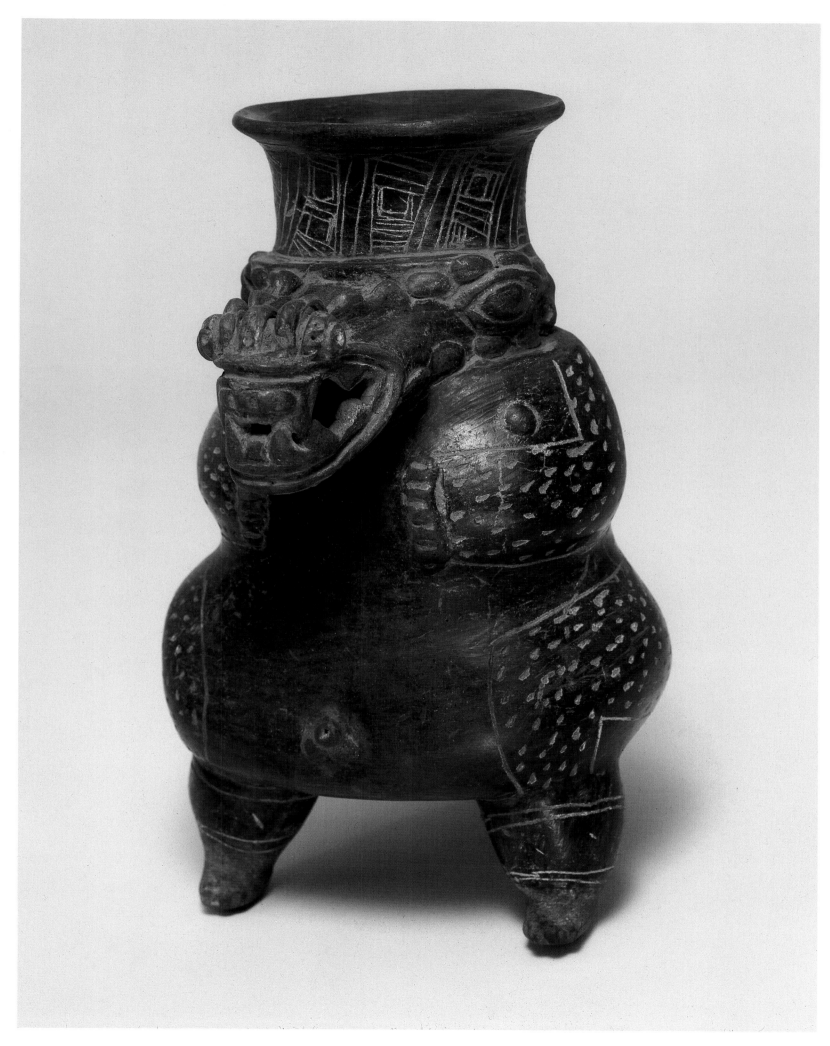

111. HUMAN HEAD BOWL

Earthenware, brown clay body under a black slip, burnished
Guanacaste-Nicoya Zone
Period V (AD 500-1000)
*Huerta Incised/Engraved (AD 500-800)**
Height 6½" (16.5cm) Diameter 5⅞" (14.9cm) Depth 6" (15.2cm)
Condition before conservation: crack on neck and footrim under chin
Accession no. N-1156

The bowl, resting on a pedestal or annular base, is modeled as a human head. The crown of the head rises to the bowl's tall wide neck with everted mouthrim. The bowl's neck becomes the head's hat. Below the high arched brows which join the bridge of the nose are button eyes with appliquéd ridged lids. The mouth is a large oval with teeth modeled and carefully incised. Appliquéd ears are stylized lugs with pierced lobes. The neck is incised with rectangles containing an interlocked mat design. There is incising in bands over the eyes and etched wrinkles from the nose around the corners of the mouth.

This vessel is reminiscent of a black, monochrome, Vicús Moche or Early Moche, trophy or portrait head ceramic cup in the Arthur M. Sackler Collection of Peruvian ceramics, from the Piura Valley on the northwest coast of Peru.[1] Although the Costa Rican head bowl differs in having incised designs, the inspiration to produce a portrait-like image must have been the same. TL analysis of a clay sample from the Vicús Moche cup indicated that it was last fired between fourteen hundred and twenty-two hundred years ago (circa 218 BC-AD 582). The Costa Rican head bowl follows within a similar time frame.

1. Clifford et. al. 1982, No. 27 (N-205).
Cf. Snarskis 1982, p. 50, for a Huerta Incised/Engraved human head effigy jar in the INS; Ferrero 1977, pl. VI left, for another Huerta Incised/Engraved head effigy jar in the INS.

**OXTL analysis (ref. no. 381M76, 11/20/84) estimates that the sample tested was last fired between 1060 and 1920 years ago (AD 64-924).*

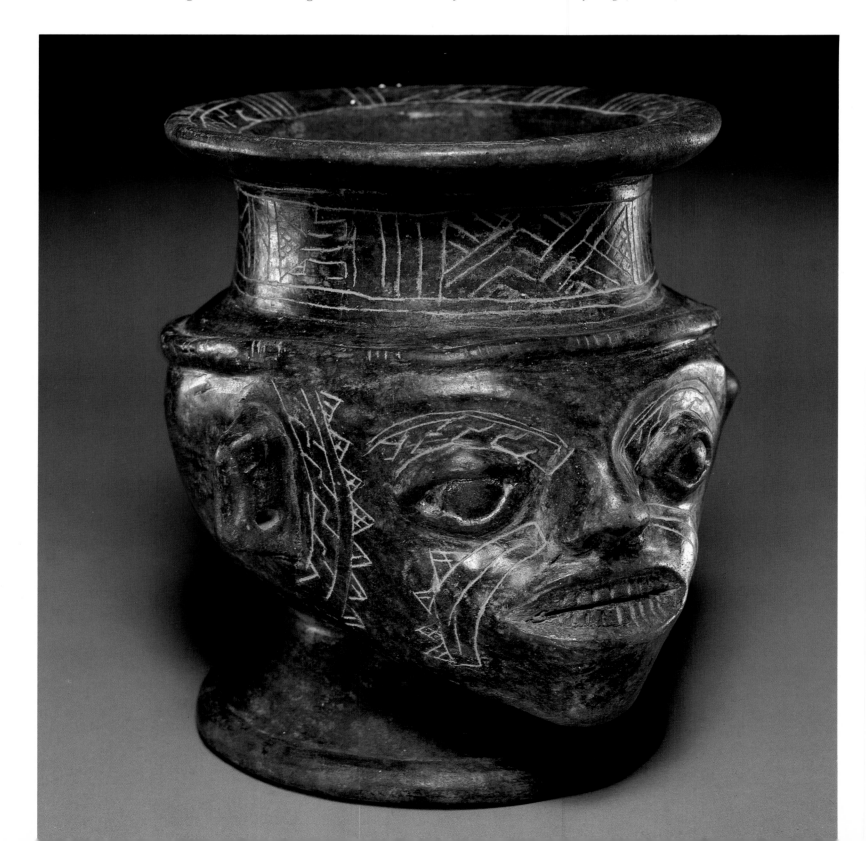

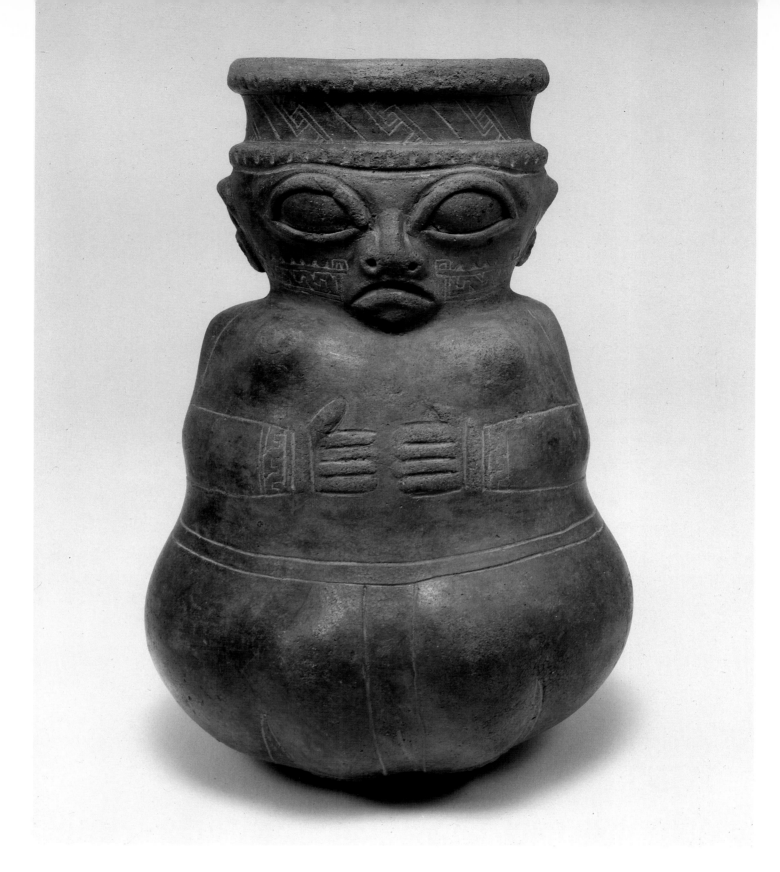

112. ANTHROPOMORPHIC JAR

Earthenware, brown clay body under a blackish brown slip, burnished
Guanacaste-Nicoya Zone
Late Period VI (AD 1200-1550)
*Castillo Incised/Engraved (AD 1200-1550)**
Height 7³⁄₈" (18.7cm) Diameter 5" (12.7cm) Depth 4⁷⁄₈" (12.4cm)
Condition before conservation: crumbly surface
Accession no. N-1145

This jar has minimal body modeling but a well-defined anthropomorphic or zoomorphic head. On the figure's forehead is a notched band. The vessel's short, wide neck with thickened notched rim band serves as the figure's headdress. The face has large almond-shaped eyes with ridged lids, nose with prominent nostrils and a downturned slit mouth; the ears are flattened against the head and the lobes contain hollow spooled ear ornaments. The arms and hands held against the body are outlined by incising and two incised lines encircle the body forming a belt. Bulging below the belt and above the arms suggests knees and breasts.

Cf. Baudez 1970, p. 95, for a jar in the form of a bird of blackish-brown ware with incised decoration from Nacascolo, Guanacaste, Period V, now in the Juan Dada Collection, San José, Costa Rica, to whose general form and style the Sackler jar is similar.

**OXTL analysis (ref. no. 381M75, 11/20/84) estimates that the sample tested was last fired between 420 and 730 years ago (AD 1254-1564).*

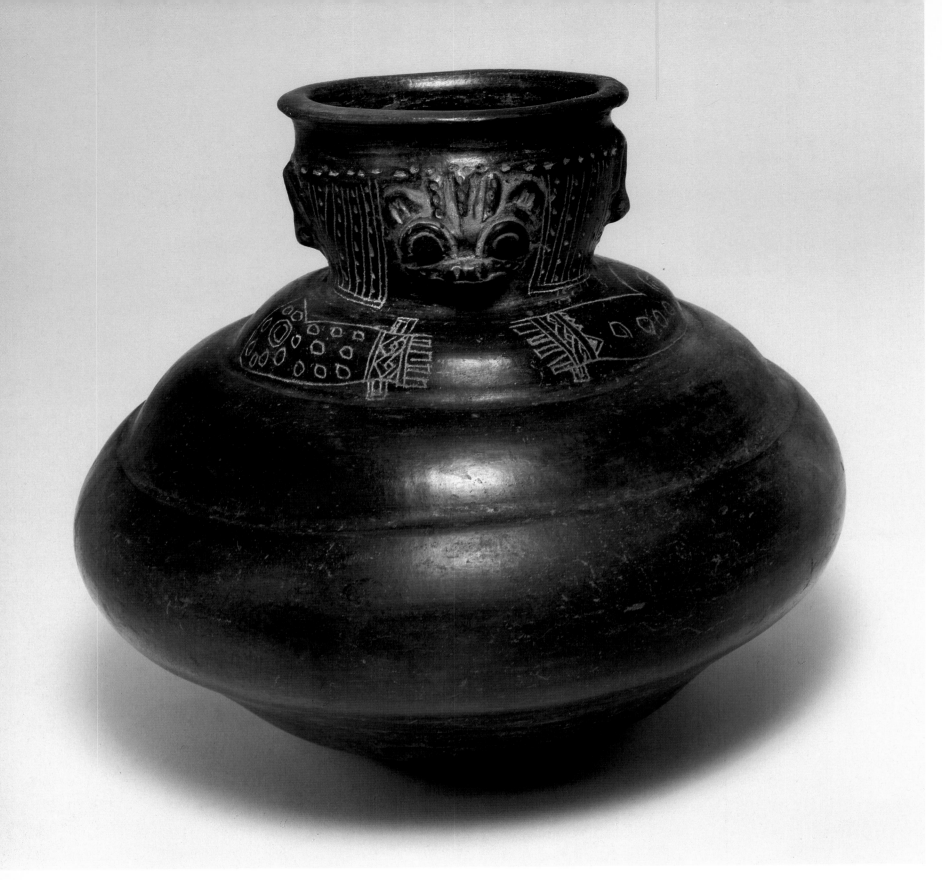

113. JAR with animal

*Earthenware, brown clay under a black slip, burnished,
with white pigment rubbed into incising*
Guanacaste-Nicoya Zone
Period V (AD 500-1000)
*Huerta Incised/Engraved (AD 500-800)**
Height 6⅞" (17.5 cm) Diameter 8" (20.3 cm)
*Condition before conservation: top half broken off, repaired, filled and
repainted; pressure crack from bottom halfway up right side*
Accession no. N-1126

A jar of complex shape, this vessel rises from the rounded
bottom in curved registers to an expanded band around the
middle. It then restricts in stages to the neck and head which
curves up to a flared rim. The head is formed as a human
head would be with ear lugs and earspools and with stylized
hair on the reverse. Instead of a human face however there
is a small three-dimensional animal face with an incised pelt
pattern on either side. Incised on the upper portion of the
jar are two human arms with cat spots and claws. The whole
is slip painted in black. The animal mask suggests represen-
tation of a deity or totemic symbol.

Cf. Baudez 1970, pl. 94, for a blackish-brown ware jar with incised decoration
and a small jaguar on the neck, from Nacascolo, Guanacaste Province, now in
the Juan Dada Collection, San José, Costa Rica, whose shape differs from the
Sackler jar although the handling of the animal head, incising and burnishing
are extremely similar, but which Baudez dates to AD 1200-1525; and Snarskis
1982, p. 57, for a composite silhouette jar which Snarskis describes as type
unknown, circa AD 700-1100, whose shape is somewhat similar but lacks the
incised and appliquéd designs of the Sackler vessel.
**OXTL analysis (ref. no. 381p93, 5/10/85) estimates that the sample tested was last fired
between 800 and 1400 years ago (AD 585-1185).*

114. TRIPOD JAR

Earthenware, brown clay under a black slip, burnished with white pigment rubbed into incising
Guanacaste-Nicoya Zone
Late Period V (AD 500-1000)
*Huerta Incised/Engraved (AD 500-800)**
Height 7" (17.8cm) Diameter 5⅞" (14.9cm)
Condition before conservation: fracture at top rim to right of animal face; cracks on bottom
Accession no. N-1118

The tripod jar rests on hollow, animal-head feet. Above a slightly rounded bottom is a sharp basal ridge. The walls slope in from the base and then taper to a splayed, thickened, grooved rim. Modeled on one side and with engraved and pecked details is a cat-like animal shown full face: the muzzle, eyes, ears, forelegs and hind legs and tail are in relief. The body is reduced to a pattern of gouges indicating the animal's fur. Incising outlines the legs. The long tail extends out to one side and is decorated with incising and pecking. Two incised bands encircle the vessel: one near the top, the other near the basal ridge. The bottom band contains an interlocking serpent(?) design; the upper band, with key-fret and notched design, relates to the alligator. Here too, the animal design suggests the representation of a deity or totemic symbol.

Cf. Snarskis 1982, p. 76, for a similar tripod jar in the INS, with modeled motif but not slip-painted which Snarskis describes as Castillo Incised/Engraved Ware; Lothrop 1926, pl. CIV.

OXTL analysis (ref. no. 381L78, 9/11/84) estimates that the sample tested was last fired between 990 and 1760 years ago (AD 224-994).

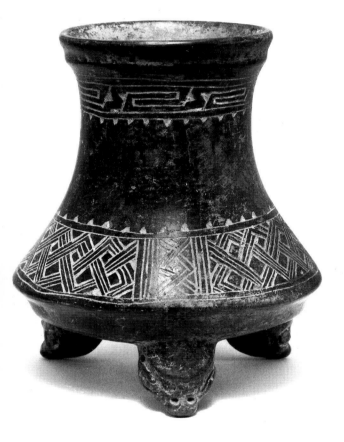

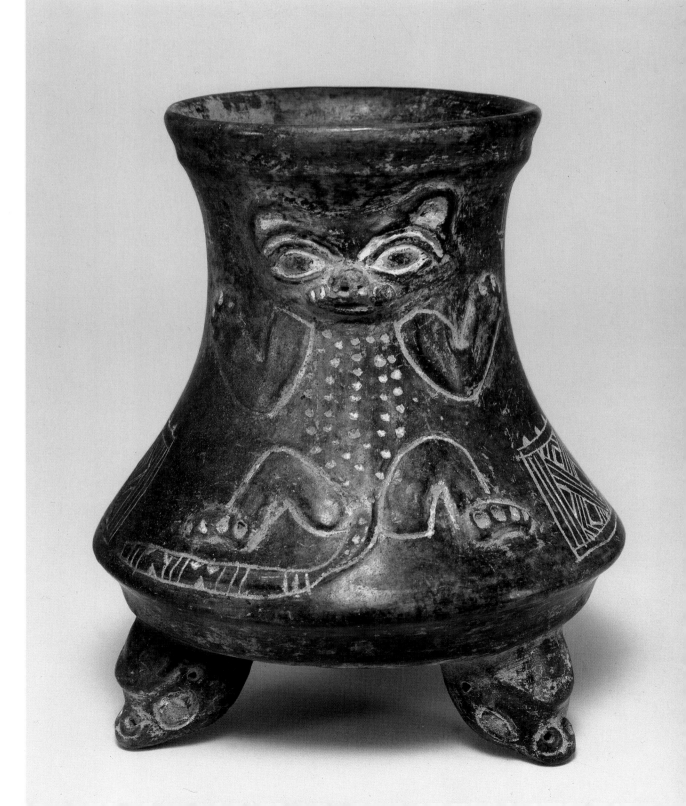

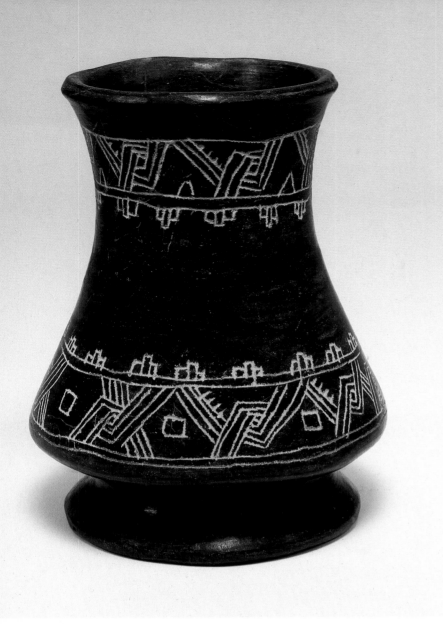

115. JAR with incised designs

Earthenware, brownish clay under a black slip, burnished,
with white pigment rubbed into incised designs
Guanacaste-Nicoya Zone
Period V (AD 500-1000)
*Huerta Incised/Engraved (AD 500-800)**
Height 4⁷⁄₈″ (12.4cm) Diameter 3⁵⁄₈″ (9.2cm)
Condition before conservation: crack extending from rim;
surface scratches; root marks
Accession no. N-1100

The body, similar in shape to Number 114, is supported by a
flared pedestal shape foot. Decoration of the neck and basal
bands is similar; it consists of sets of parallel interlocking
lines with notched marks on the exterior of alternating sets
and interspersed with squares between the interlocking
lines. Rising from the top encircling line of the basal band
and depending from the bottom encircling line of the neck
band are stepped pyramid designs.

Cf. Lothrop 1926, pl. CIV b,c, and f, for examples of similar designs on
"Chocolate Ware" vessels from the Nicoya Peninsula.
**OXTL analysis (ref. no. 318p89, 5/13/85) estimates that the sample tested was last fired*
between 800 and 1550 years ago (AD 435-1185).

116. TRIPOD BOWL

Earthenware, brownish clay body under a chocolate slip, burnished,
with white pigment rubbed into incisions
Guanacaste-Nicoya Zone
Period VI (AD 1000-1550)
Castillo Incised/Engraved (AD 1200-1550)
Height 2¹⁄₂″ (6.4cm) Diameter 5³⁄₄″ (14.6cm)
Condition before conservation: intact
Accession no. N-1058

The miniature round bowl curves in from its convex sides to
the wide mouth and rests on three hollow, conical rattle feet.
A wide decorative band, bordered top and bottom by hori-
zontal parallel lines, is engraved below the rim with a checker-
board pattern of alternately crosshatched squares, vertical
lines and a vertical zigzag design formed by lined triangles.

Cf. Lothrop 1926, pl. CII, for similar designs.

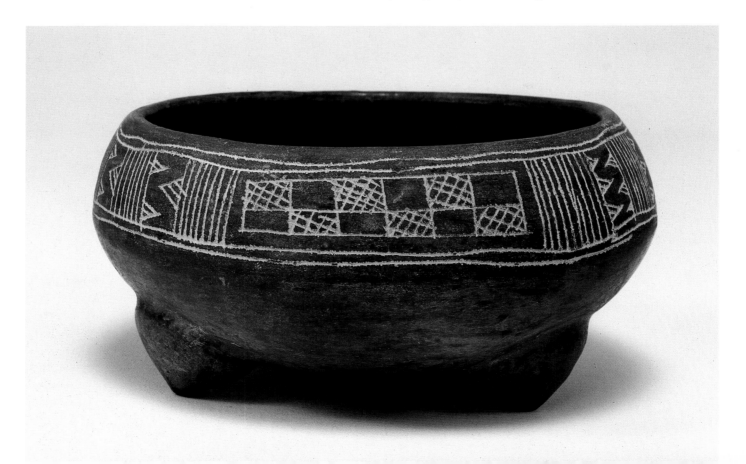

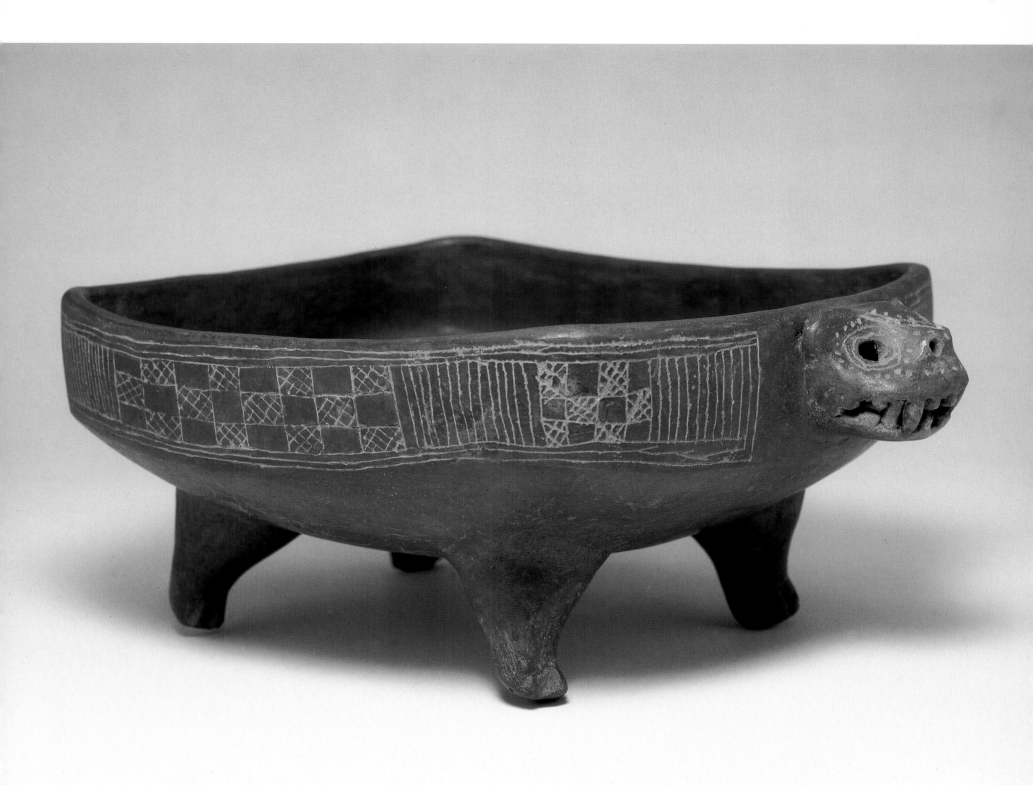

117. FOOTED BOWL as jaguar effigy

*Earthenware, reddish clay body under a chocolate slip, burnished,
with white pigment rubbed into incisions*
Guanacaste-Nicoya Zone
Late Period VI (AD 1200-1550)
*Castillo Incised/Engraved (AD 1200-1550)**
Condition before conservation: broken into four fragments and restored
Accession no. N-1065

The oblong bowl with a slightly rounded bottom and
straight sides is supported by four modeled jaguar legs.
Attached to one of the narrow ends is a minimally modeled
jaguar head with open fanged mouth, round open eyes, ears
and prominent nostrils. The sides of the bowl are engraved
with panels of checkerboard pattern of crosshatched and
solid squares alternating with panels of vertical lines per-
haps presenting a stylized version of a jaguar's pelt. On the
rear of the bowl is a modeled curled tail. The shape of the
vessel is similar to that of stone metates of the same period.[1]

1. See also a stone metate of similar shape, in The Brooklyn Museum, acc. no.
11.403, from the Linea Vieja, and illustrated in Ferrero 1977, Ilus. I-128.
*OXTL analysis (ref. no. 381p77, 4/3/85) indicated that the sample tested did not allow a
conclusion regarding age.

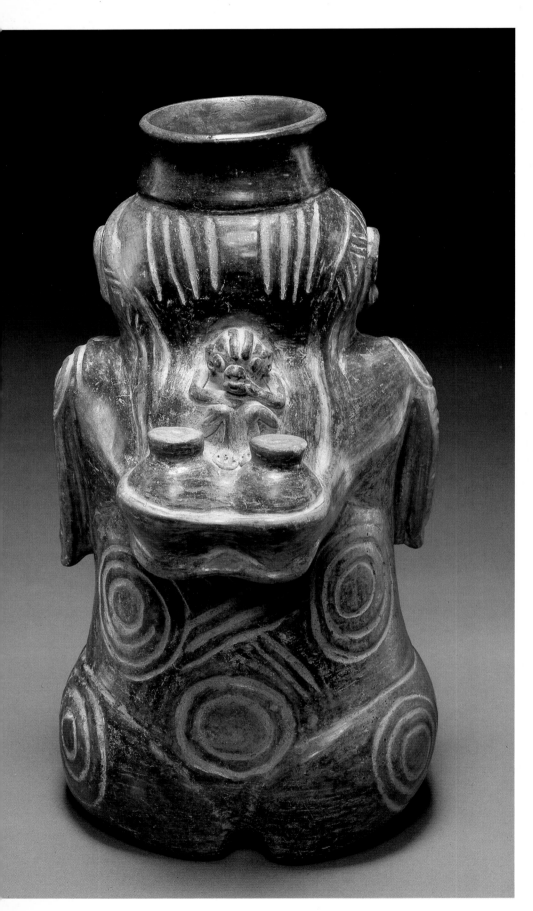

118.
HUMAN EFFIGY JAR

Earthenware, buff clay body under monochrome black slip, burnished,
with pigment rubbed into incisions
Guanacaste-Nicoya Zone
Period V (AD 500-1000)
*Unknown type (AD 474-1134)**
Height 11⅛″ (28.3cm) Width 5¾″ (14.6cm) Depth 6½″ (16.5cm)
Condition before conservation: small repair on feet
Accession no. N-1149

The lustrous, modeled jar is in the form of a seated male
with his hands on his stomach. His frowning face has heavy-
lidded eyes, arching brows which meet above the bridge of
the nose, a pinched mouth, and ears flattened against the
head. Above the brows is a narrow zone of cursive engrav-
ing to suggest a tumpline. The burnished spout forms a cap.
Double lines run obliquely below the eyes. The body is deco-
rated with three concentric circle areas, and diagonal
slashes. There are additional zones of concentric circles on
the buttocks and back with more oblique lines. The tump-
line holds a carrier on the back which contains a baby and
two bottles. The incised designs appear to have been cut
under the slip.

TL analysis on the figure here places it squarely in the Late
Polychrome Period which applies for both Castillo Incised/
Engraved and Murillo Incised and appliquéd ceramics. The
figure here, however, is unlikely to be of the Castillo Incised/
Engraved type since the incising on it seems to have been
done before the slip was applied. Murillo Incised and Appli-
qué was the major decorated monochrome of the Late Poly-
chrome Period. Evidence from excavations indicates that it
was widely distributed in Guanacaste Province and the
Nicoya Peninsula and was apparently a popular ceramic of
the period possibly produced and distributed in many cen-
ters. Established as a type by Claude Baudez, it was further
refined by Frederick Lange from his excavations around the
Bay of Salinas. Although the black surface color is most
common, Murillo Incised and Appliqué may be tan, red or
black. Vessels are incised under the slip and then burnished,
fired and waxed to give a highly polished exterior. There is
no evidence in the literature, however, for effigy vessels of
the kind seen here.

Cf. Snarskis 1981, no. 83 (in color on the front cover, also illustrated in Ferrero
1977, Ilus. I-109), for a Galo Polychrome anthropomorphic effigy vessel (AD 500
and 800) depicting a male with cream-colored disks on his shoulders, knees, and
abdomen, not unlike the circular forms on the Sackler figure, which Snarskis
hypothesized might symbolize body painting.

**OXTL analysis (ref. no. 381L89, 7/10/84) estimates that the sample tested was last
fired between 850 and 1510 years ago (AD 474-1134).*

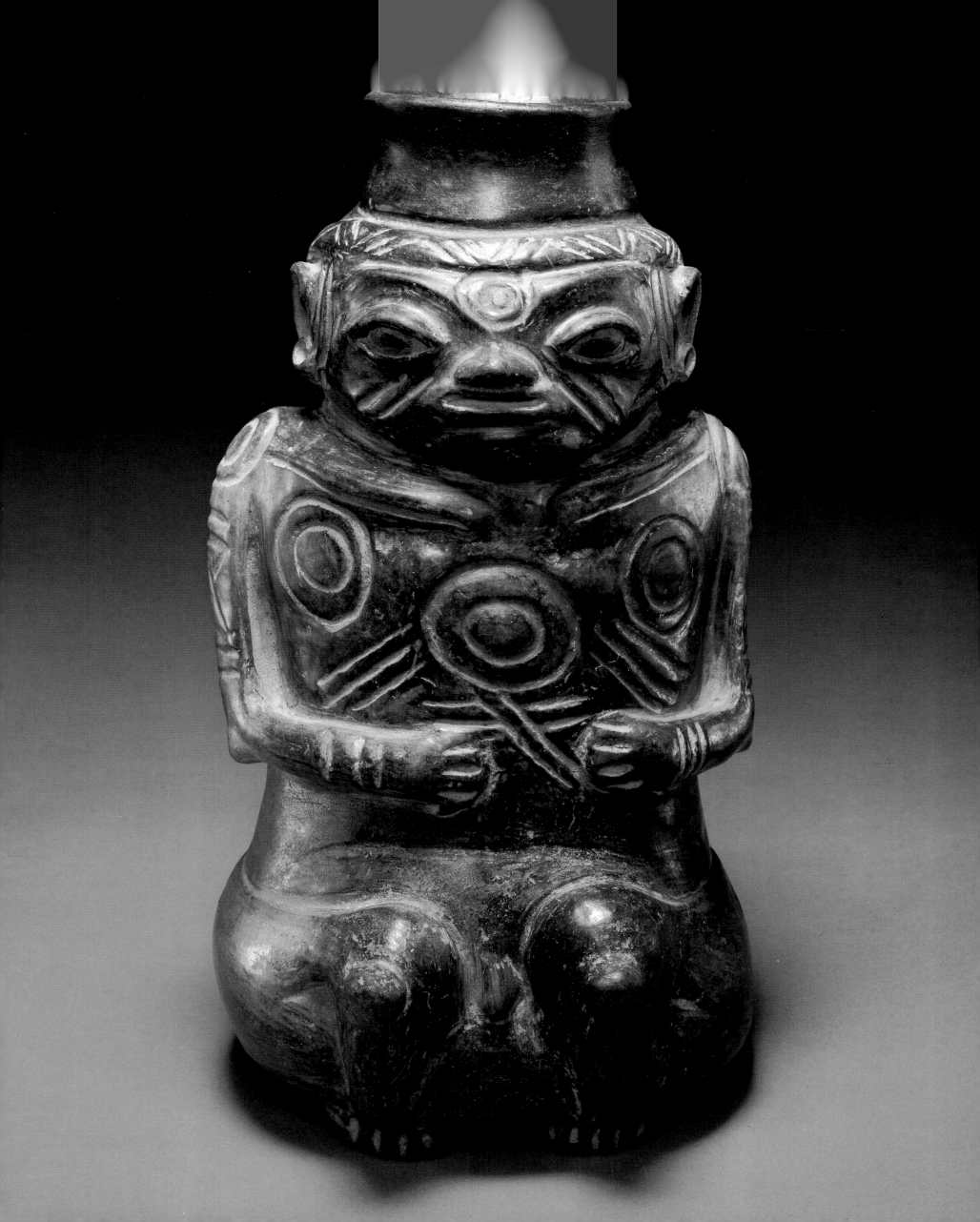

119. SHOE-SHAPED VESSEL

Earthenware, coarse brownish tan clay body under a red slip on the mouthrim only, burnished
Guanacaste-Nicoya Zone
Period VI (AD 1000-1550)
*Sacasa Striated, Sacasa Variety, Zapatero Ware (ca. AD 1200-1550)**
Height 16³/₄″ (42.5cm) Width 17¹/₈″ (43.5cm) Depth 21⁷/₈″ (55.6cm)
Condition before conservation: rim broken off but intact; appliquéd eyes reglued; "fire-clouding" in spots on body; traces of red slip on mouthrim
Accession no. N-1202

This large shoe-shaped urn with red mouthrim was used for burial but was probably also produced for domestic use. It is composed of coarse, friable clay mixed with sand which makes up fifty percent or more of the composition. Comb markings or striations and appliquéd and notched fillets decorate the surface. Two long ribbons of clay and minimal appliqué suggest a face on one end. Below the face are three coffee-bean shaped appliqués. The design is Klee-esque in its simplicity and abstraction, depicting in abbreviated form and with broad strokes the essence of a feline mask. Stria-

tions however are the dominant decoration. Apparently they were made with a brush-type, hard-bristled implement dragged across the pliable, unslipped surface before firing. Here the striations run mostly horizontally around the vessel, although vertically oblique lines can be seen as well. Their randomness supports the idea that the striations were quickly fashioned to cover the surface without much concern for craft and that such lack of workmanship indicates a common household use for the vessel.[1]

Lothrop states that the shoe-shaped form derives from a bird effigy.[2] Snarskis argues the probable culinary function of such shaped vessels, since their proportions and size correspond well to small ellipsoid hearths of burnt adobe excavated in several Guanacaste sites.[3]

The Sackler vessel was purportedly excavated from Zapatero Island, Lake Nicaragua, Nicaragua. Bransford described and illustrated a number of such brushed, shoe-shaped urns of the nearly one hundred excavated on Ometepe Island in Lake Nicaragua at the end of the nineteenth century.[4] Most were the brushed Sacasa vessels like the one here. The term Zapatero Ware however was applied to them by Lothrop since they had also been excavated on Zapatero Island. But in 1964, A.H. Norweb designated the group to which the ware belongs "Sacasa," after the hacienda on which it was first discovered, which included within it Zapatero Island.[5]

When Bransford found these vessels in burial settings they were capped by Luna Polychrome bowls indicating that the two types were contemporary. Many were found without their rims, suggesting to some that these had been removed to accommodate the interment of the deceased. Their late chronological position was reinforced by the fact that glass beads, obviously a European trade item, were found in many of them.

Paul Healy has described the Sacasa group of wares, which originate in the Middle Polychrome Period and include other vessel forms in addition to the shoe-shaped urns, as an important Middle and Late Polychrome time marker in Nicaragua, continuing until the Spanish conquest.[6] It appears to have been a multipurpose ware, used in burials and for common household functions, and was the most common and important utilitarian ware in the Rivas area of Nicaragua until the conquest.

1. Healy 1980, p. 216.
2. Lothrop 1926, p. 254
3. Snarskis 1984.
4. Bransford 1881, figs. 1-10, 114, and pl. I-4, 11, 15.
5. Norweb 1964, p. 559.
6. *Ibid.*
Cf. Lothrop 1926, pl. CXXd, for another shoe-shaped urn with hexagon-shaped rim from Ometepe Island, Lake Nicaragua, also others in pl. CXXa, b, and e, with appliquéd face forms.
**OXTL analysis (ref. no. 381N73, 4/1/85) estimates that the sample tested was last fired between 530 and 870 years ago (AD 1115-1455).*

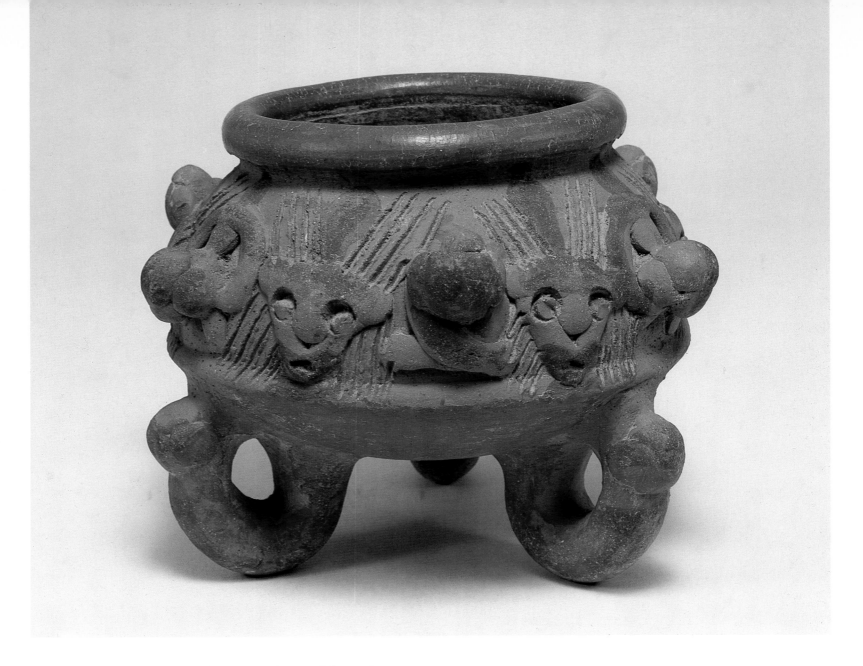

120. TRIPOD BOWL with appliquéd heads

Earthenware, buff clay body selectively under red paint
Atlantic Watershed/Central Highlands Zone
Period IV (1000 BC-AD 500)
El Bosque Phase, Red on Buff Group (100 BC-AD 500)
Height 5" (12.7cm) Width 6¼" (15.9cm)
Condition before conservation: intact
Accession no. N-1175

From the basal ridge around the edge of the rounded bottom of this bowl, the walls slope in to a short neck under a rolled mouthrim. Three looped legs support the body. The exterior is decorated with appliquéd anthropomorphic or monkey heads and adjacent headless bodies. Zones of oblique incised lines surround the heads. Red was applied to the interior, the rolled mouthrim, and the round bottom with attached loop-legs. Around the upper body the natural clay is left exposed.

The El Bosque culture complex dominates the period of approximately 100 BC to AD 500 in the central Atlantic Watershed of Costa Rica. The El Bosque culture succeeds, but apparently not immediately, two earlier phases of the Atlantic Watershed culture circa 1000 to 500 BC: La Montaña, whose pottery is in a monochrome plastic tradition; and Chaparron, north of La Montaña, whose pottery features zoned bichrome decoration. Twelve of the numerous and large sites of the complex have been excavated in part, and all are located on fertile coastal plains or valley floors.

El Bosque ceramics demonstrate greater variety than in the earlier complexes. The El Bosque Red on Buff group, which shows some continuity from Chaparron, has the widest range of forms including globular jars and composite silhouette bowls with various tripod supports, legless carinated bowls and large plates. Their decoration may be impressed or incised into the surface, appliquéd, or painted to become bichrome decor as seen on the vessel here. Other varieties of El Bosque ceramics are El Bosque Red, El Bosque Orange-Purple, and Ticoban Tripod.

In several El Bosque culture sites large numbers of metates and other stone tools, as well as carbonized samples of maize, beans and palm nuts were found, indicating that agriculture was firmly established by this time. There is also indication of a large population increase in eastern and central Costa Rica during the early part of this period, and a trend toward social stratification is apparent from the evidence of symbols of rank such as chiefs' houses and elaborate corridor tombs as elite graves with such "high status" artifacts like elaborately sculpted ceremonial metates (or seats?), ceremonial mace heads, carved jade or similar stone, elaborate tripod ceramic vessels, figurines, flutes and rattles.

Cf. Snarskis 1982, p. 90, for an El Bosque Red on Buff bowl on loop-legs with similar bichrome and plastic decoration in the INS; Stone 1977, fig. 180, for another looped-leg red on buff bowl with bird beak and human head motifs from a Costa Rican farm (present location not given); and Ferrero 1977, Ilus. I-142, for another similarly decorated looped-leg bowl purportedly from Linea Vieja, now in the MNCR (accession number not given).

**OXTL analysis (ref. no. 381p97 6/1/85) estimates that the sample tested was last fired between 1050 and 1700 years ago (AD 285-935).*

121. BOWL with appliquéd monkeys

Earthenware, buff clay body selectively under red paint
Atlantic Watershed/Linea Vieja (Central Highlands Zone)
Period IV (1000 BC-AD 500)
El Bosque Phase, Red on Buff Group (100 BC-AD 500)
Height 3¾" (9.5cm) Width 5" (12.7cm)
Condition before conservation: slip slightly worn around
rim and underside of bowl; rim had been broken and repaired;
chip underside of rim; root marks
Accession no. N-913

From a rounded base under the sharp basal ridge which forms the vessel's low shoulder the upper body of the bowl slopes in a concave curve as it rises gracefully and splays out slightly just below the thick, widely everted, rolled mouthrim which extends out over the vessel's sides. The mouthrim, interior of the bowl and the exterior of the base, are slipped red and burnished. The unslipped and unburnished exterior walls are left in the natural buff-colored clay to contrast sharply with the accents of burnished red slip, decorated with appliquéd stylized monkeys with long straight tails and a row of appliqué buttons just above the basal ridge.

Technically very well made, this bichrome vessel, and Numbers 120, 122 and 123, are typical of shapes and designs found among El Bosque Red on Buff ceramics. Such ceramic vessels with their thick appliqué may be baroque or exquisitely elegant and simple.

Cf. Snarskis 1982, p. 91, for a similarly shaped vessel in the INS but with appliquéd alligators as well as monkeys, and Ferrero 1977, pl. XVII, for a bowl of more squat proportion but with similar abbreviated monkey forms, in the MNCR, acc. no. 21.287.

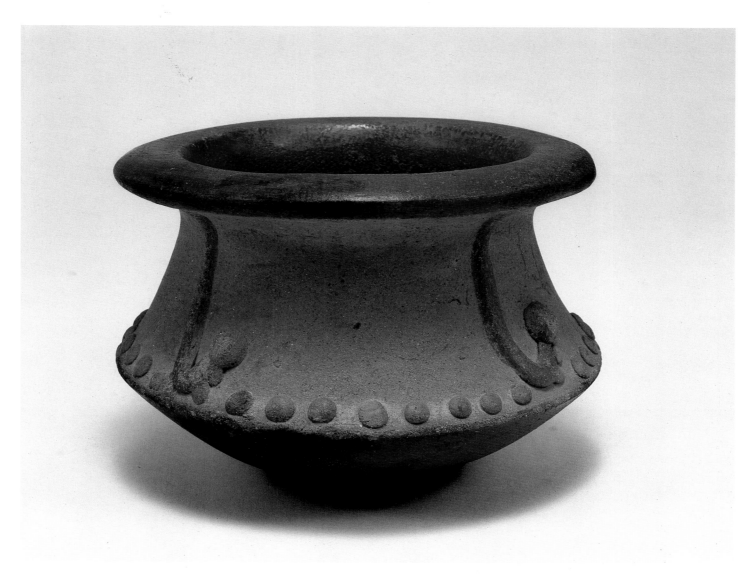

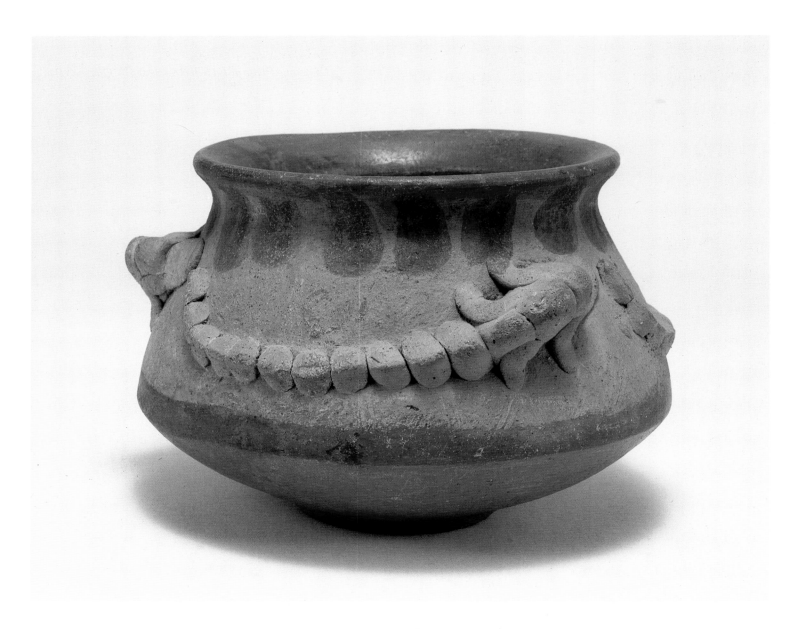

122. BOWL with appliquéd alligator

Earthenware, buff clay body selectively under a red slip, burnished
Atlantic Watershed/Central Highlands Zone
*Period IV (100 BC-AD 500)**
El Bosque Phase, Red on Buff Group (100 BC-AD 500)
Height 4" (10.2cm) Diameter 5¹/₂" (14cm)
Condition before conservation: had been broken and repaired;
root marks on base
Accession no. N-162

Similar in shape to Number 121, this bowl is of squatter proportion with somewhat fuller sides. The bottom is rounded and the upper body slopes in from the basal ridge to a thickened everted mouthrim. The interior, mouthrim, multiple "finger" marks depending from the neck, underbody and a band encircling the basal ridge are painted in red slip and burnished. Appliquéd alligators, snout to tail, gracefully loop around the walls on the unslipped and unburnished upper body.

**OXTL analysis (ref. no. 381P62, 4/3/85) estimates that the sample tested was last fired between 1100 and 1650 years ago (AD 335-885).*

123. BASKET BOWL with appliquéd birds

Earthenware, buff clay body selectively under a red slip, burnished
Atlantic Watershed/Central Highlands Zone
Period IV (100 BC-AD 500)
*El Bosque Phase, Red on Buff Group (100 BC-AD 500)**
Height 11" (27.9cm) Diameter 9¼" (23.5cm)
Condition before conservation: handle broken and repaired; surface chips;
section of rim broken and repaired; slip worn in spots
Accession no. N-1066

A large tubular handle arches from the everted mouthrim of this globular bowl. The rim, handle and lower body of the vessel are slipped in red. The shoulder of the vessel is left in the natural clay, elegantly decorated with encircling designs of four continuous rows of reed circle stamping, a row of small appliquéd birds and multiple "finger" painted vertical red lines depending from the neck. At the base of the loop handles are small, curled-up appliquéd monkeys.

Cf. Stone 1977, fig. 178, for another basket bowl; also Lothrop 1926, pl. CLXXV; and Snarskis 1982, p. 94, for a cup in the INS with tubular handle on the side rather than extending from the mouthrim of the bowl.

**OXTL analysis (ref. no. 7/16/84, 10/12/84) indicated that the sample tested was too insensitive to enable calculation of the time of last firing.*

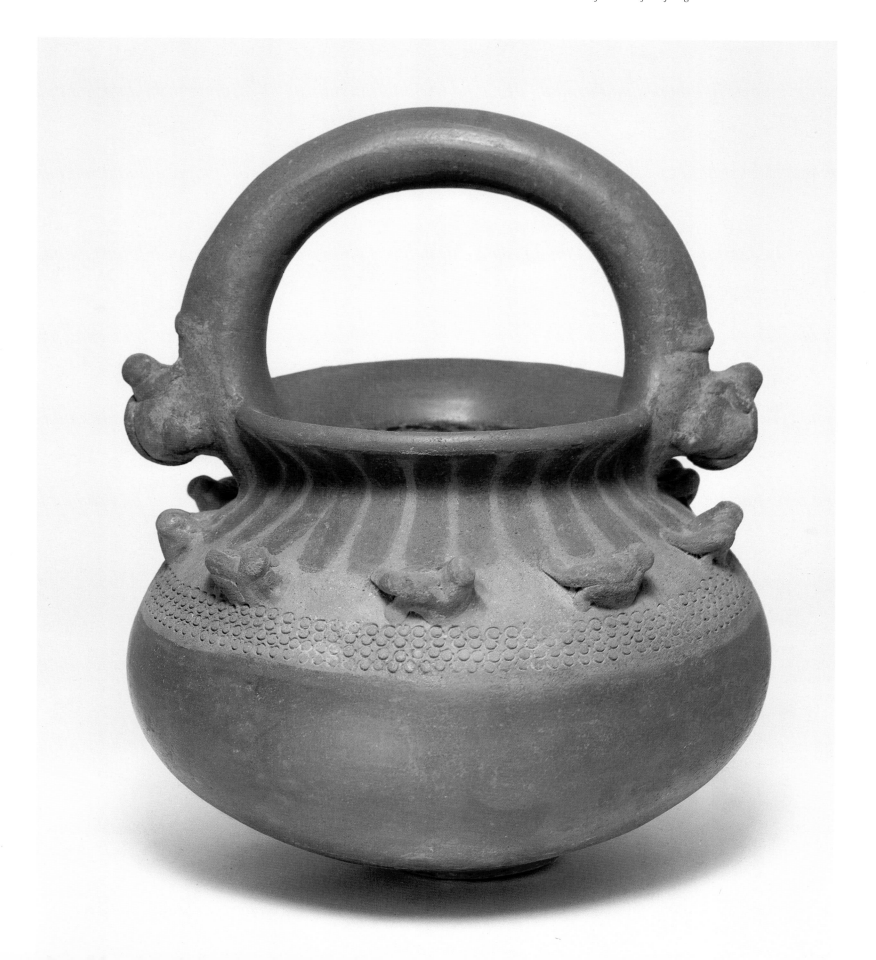

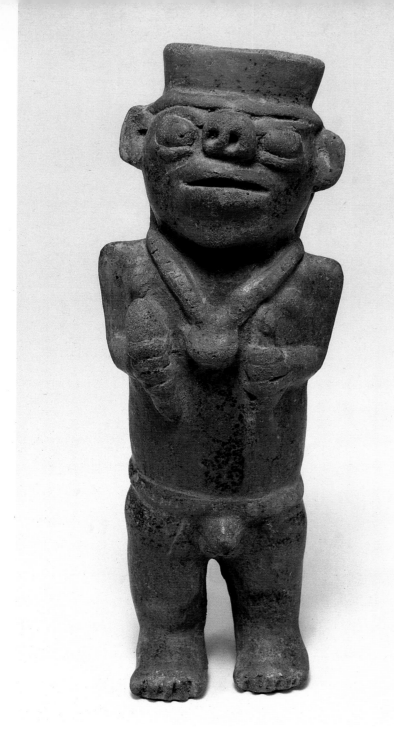

124.

MALE FIGURINE rattle

Earthenware, buff clay body under a red slip, burnished
Atlantic Watershed/Central Highlands Zone
Period IV (100 BC-AD 500)
*El Bosque Phase, Red Monochrome Group (100 BC-AD 500)**
Height 7" (17.8cm) Width 2½" (6.4cm) Depth 1¾" (4.4cm)
Condition before conservation: intact
Accession no. N-1120

This standing male figurine functions as a rattle. He has a large head with facial features both appliquéd and modeled. His large lidded eyes, broad nose with large flaring nostrils, very wide grimacing mouth and large ears combine to portray a rather unhandsome face. He wears a cap, belt and a necklace with a large center bead. His hands, held against his chest, hold what appear to be rattles or implements of a coca chewing ritual or for other type of drug use.

Small ceramic figurines, rattles, whistles, ocarinas, stamps, pipes and nasal snuffers were found almost exclusively in high status El Bosque phase complex burials suggesting a ceremonial or shamanistic context for their use.

**OXTL analysis (ref. no. 381p92, 5/10/85) estimates that the sample tested was last fired between 1500 and 2100 years ago (200 BC-AD 485).*

125.

MINIATURE BOWL
with animal rattle base

Earthenware, buff clay body under a red slip, burnished
Atlantic Watershed/Central Highlands Zone
Period IV (100 BC-AD 500)
El Bosque Phase, Red Monochrome Group (100 BC-AD 500)
Height 2⅞" (7.3cm) Width 3½" (8.9cm)
Condition before conservation: chips on interior mouthrim;
surface eroded in spots; root marks throughout
Accession no. N-1002

The hemispherical bowl rests on a modeled supine feline base. The animal supports the bowl with its front paws and tail. Its body is perforated so that pellets inside it function as a rattle.

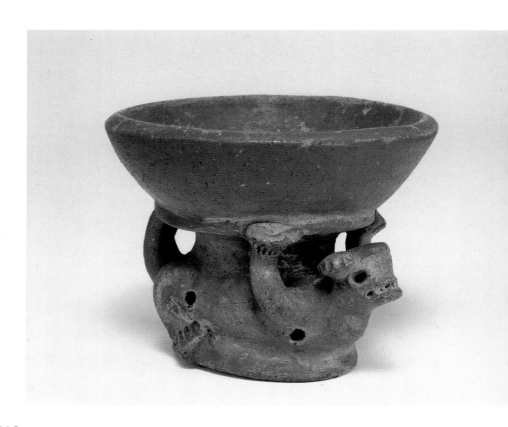

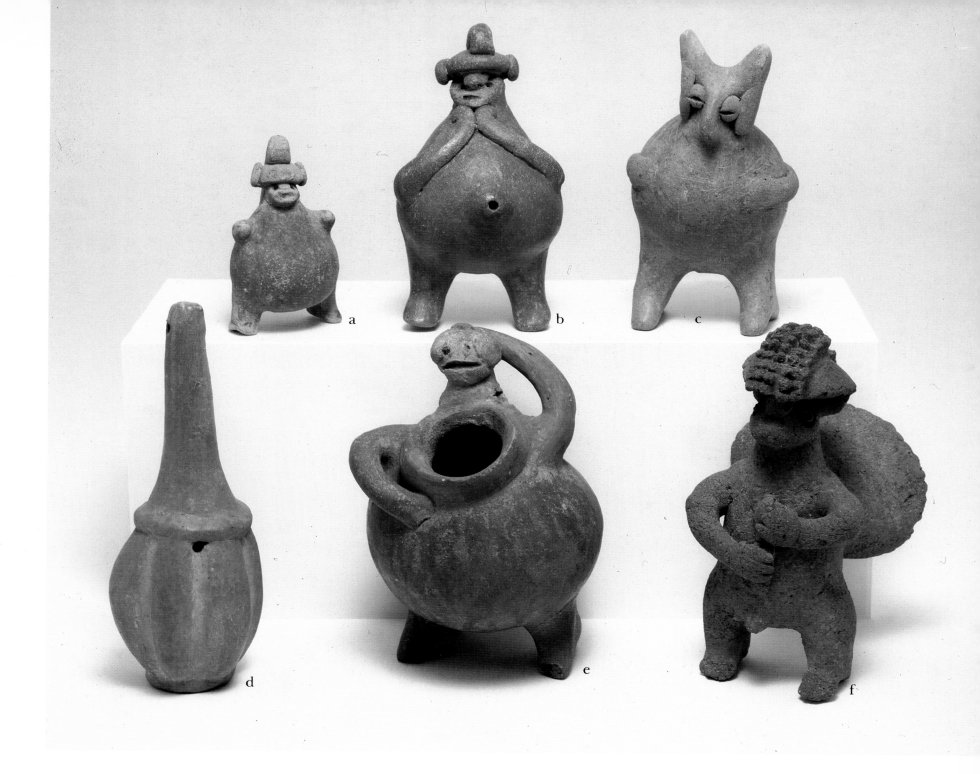

126a-f. RATTLES, WHISTLE and JAR

Earthenware, buff clay some under red slip, some burnished
Atlantic Watershed/Central Highlands Zone (100 BC-AD 1550)
*Period IV Group (100 BC-AD 500)**
*El Bosque Phase, Santa Clara Group (100 BC-AD 500)**

(a) Height 2³⁄₄″ (7cm) Width 1³⁄₄″ (4.4cm)
(b) Height 4¹⁄₄″ (10.8cm) Width 2¹⁄₄″ (5.7cm)
(c) Height 4¹⁄₄″ (10.8cm) Width 2³⁄₈″ (6.0cm)
(d) Height 5¹⁄₄″ (13.3cm) Width 1³⁄₄″ (4.5cm)
(e) Height 4³⁄₄″ (12cm) Width 3³⁄₈″ (8.5cm)
(f) Height 4³⁄₄″ (12cm) Width 2³⁄₄″ (7cm)

Condition before conservation: (a) surface worn on tail, head and face;
missing right front toe; small chip right side of mouth; (b) broken into many
fragments; pellets for rattle lost; (c) root marks and small surface chips
throughout; (d) broken into many fragments; (e) intact; (f) broken into
several fragments; piece missing from chest

Accession nos. N-994(a), N-982(b), N-1047(c), N-921(d), N-1206(e),
N-900(f)

**OXTL analysis (ref. no. 381r45, 7/22/85) estimates that the sample tested (N-1206)*
was last fired between 800 and 1500 years ago (AD 485-1185).

Left to right, top: (*a*) small figurine rattle wearing head covering, with pompons and drooping plume; (*b*) pregnant-female rattle with long braid down back; (*c*) effigy owl whistle perforated for blowing at end of tail feathers with opening for sound under tail. Bottom: (*d*) gourd-shaped rattle; (*e*) anthropomorphic pregnant-female effigy jar; (*f*) anthropomorphic turkey rattle.

Hollow figurines, known as the Santa Clara Group, are found in El Bosque phase high status tombs or caches and were probably shamanistic paraphernalia or for some ritual use in life, for burial, or both. Often they double as rattles, ocarinas and whistles of various shapes. Usually tubular or globular, they are mostly zoomorphic or anthropomorphic forms with the latter almost always adorned with costumes and complex headdresses. The small rotund anthropomorphic figures, in a variety of poses and often conveying a humorous aspect, give insight into domestic and ceremonial behavior during the El Bosque phase.

Cf. Snarskis 1982, p. 98, for other anthropomorphic and zoomorphic Santa Clara figurines in the INS; also Lothrop 1926, pl. CXC, and Stone 1972, pp. 182-183; and Ferrero 1977, pl. XXI, for a similar gourd-shaped flute in a private collection .

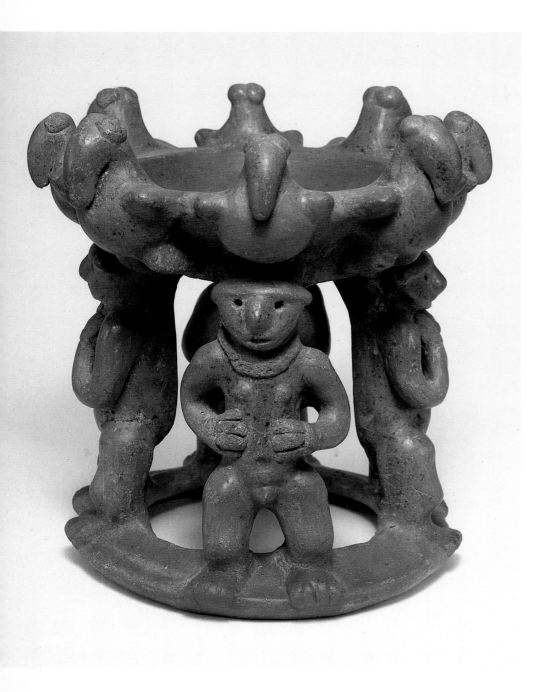

akimbo with hands resting on hips while the females' arms are folded against their bodies with hands seemingly covering their breasts and resting at the top of their chests. The avian effigies supported by the male and female figures present a vertical order of birds and humans which undoubtedly had significance in the mythology of the period.

The birds and human figures on the Atlantic Watershed/Central Highlands pot stands, or other vessel forms, may combine iconographic elements associated with maize in the Olmec cultural tradition, as do, apparently, most motifs on contemporary Costa Rican stonework.[1] Snarskis suggests that intensive maize agriculture and a reverence for carved jade amulets were integral components in a mythic complex of a politico-religious world view propagated in the northern half of Costa Rica by an elite oriented trade network directly or indirectly including "classic" gulf coast Olmec sites or the heirs to that Mexican cultural tradition. Such a tradition links with the Olmec Bird Monster which, although having primary solar and celestial associations, also had an association with maize agricultural fertility and the trance produced by psychotropic substances.

The Pavas phase was defined for the Central Plateau at Hacienda El Molino in Cartago. Its ceramics are similar to El Bosque phase ceramics but with greater emphasis on orange slip and channeled (gadrooned) decoration. The term "channeled" is used to describe the vertical or horizontal fluting which often appears as a decorative device on ceramics in the Central Highlands, particularly on pot stands with pedestal supports instead of the Atlantean figures on a ring base here. Molina channeled vessels are usually of larger size than El Bosque complex ceramics and, as seen here, are more graceful.

Bottle shaped pits were discovered at Pavas, the type site of this complex located west of San José in the Central Highlands. They were apparently used for storage. Similar pits found at other Pavas phase sites, with ten to twenty centimeters of carbonized plant remains carpeting their floors and containing thousands of maize kernels, give evidence of the adoption of full scale maize agriculture whose cultural dynamics stimulated faster population growth and necessitated the creation of new communities on rapidly inhabited fertile alluvial soils. This resulted in the increased size and ubiquitousness of El Bosque and Pavas phase sites.[2]

1. Snarskis 1984, p. 216.
2. *Ibid.*
Cf. Snarskis 1981, pl. 125, for a similar pot stand, in the MNCR, acc. no. 23125, but with sixteen birds instead of the eight on the Sackler stand, and pl. 26, in the INS, acc. no. 3248 for one with a solid pedestal type with channeled decoration, (also published in Snarskis 1982, p. 95).
OXTL analysis (ref. no. 381P91, 5/10/85) estimates that the sample tested was last fired between 1300 and 2100 years ago (115 BC-AD 685).

127. POT STAND with Atlantean figures

Earthenware, tan clay body under a red or red-orange slip, burnished
Atlantic Watershed/Central Highlands Zone
Period IV (100 BC-AD 500)
Pavas Phase, Molina Channeled Group (100 BC-AD 500)
Height 9" (22.9cm) Diameter 8¼" (21 cm)
Condition before conservation: ring of birds was broken and repaired; one bird beak, one figure's head and one figure's feet were rebuilt
Accession no. N-1110

This circular construction was probably made as a pot stand to hold round-bottomed vessels. Its ring base supports four alternating male and female Atlantean figures who in turn support a circle of modeled birds facing out whose wings and bodies form the stand proper. The four Atlantean figures stand with legs spread. The two males have arms

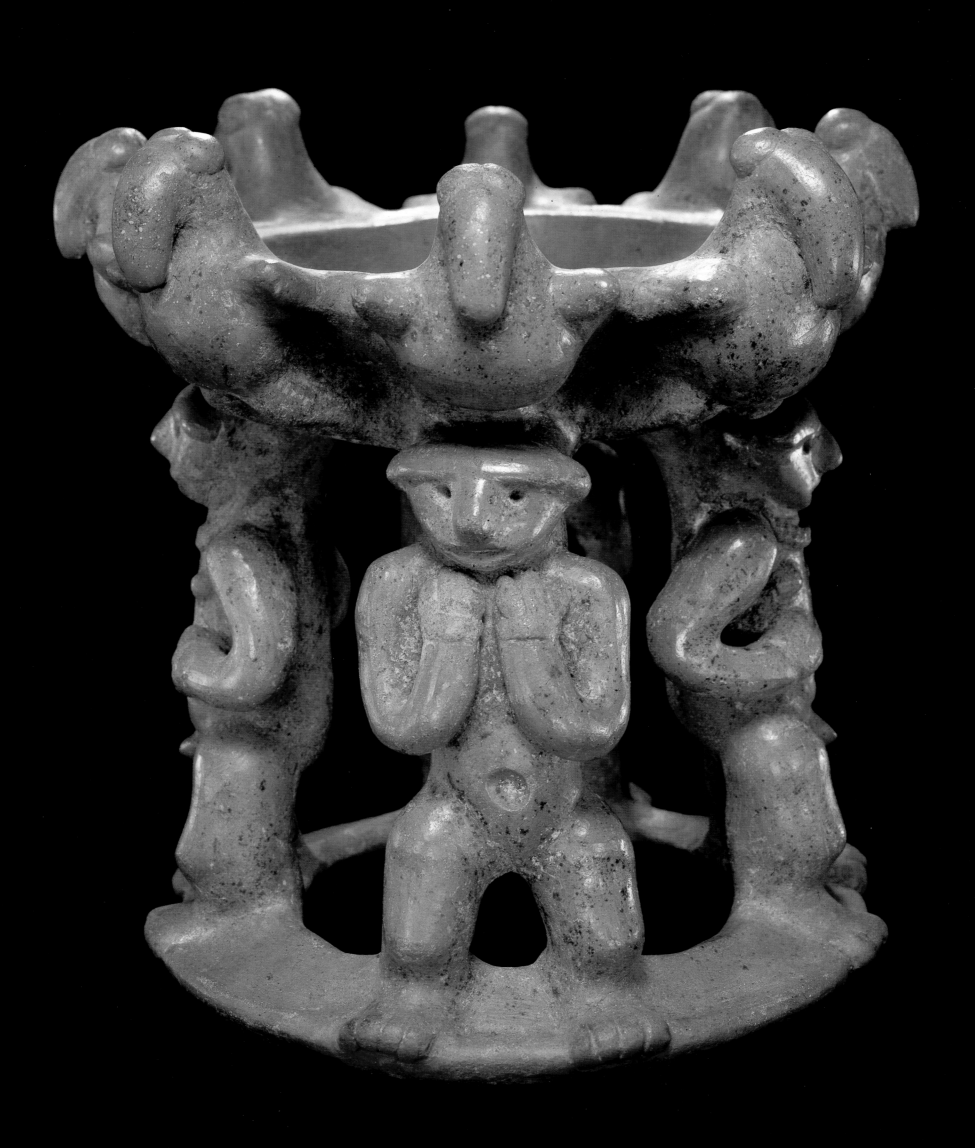

128. TRIPOD BOWL with zoomorphic legs

Earthenware, tan clay body selectively under a red slip, burnished
Atlantic Watershed/Central Highlands Zone
Period IV/V (AD 400-700)
El Bosque Phase or La Selva A Phase (?), Guácimo Red on Buff
Group (AD 400-700)
Height 5½" (14 cm) Width 6⅝" (14.3 cm)
Condition before conservation: bowl and rim broken and repaired;
surface worn
Accession no. N-1087

This large cup-shaped bowl with broad everted and slightly rolled mouthrim rests on three thick hollow rattle legs modeled on the front as male zoomorphic creatures. The head of each is thrust forward and each face has deep-set button eyes and an animal muzzle with a wide toothy mouth. A fringed cap of hair overhangs the forehead. Arms and legs are rudimentary, amphibian-like. The bodies of these creatures end just above the rounded flat bottom of each tripod which also has a grooved line above the base. Interior and mouthrim are slipped red as are the tripods. The undersides and legs are soot covered, probably indicating their use or placement over a fire.

The Ticoban Tripod group of the El Bosque phase included large, cup-like vessels with variously shaped long tripod legs, mostly solid with zoomorphic *adornos* at the shoulders.

These were gradually replaced by the Africa Tripod group vessels with gracefully curved legs.(Nos. 132-134)

In Numbers 128 to 131, a variety of modeled attachments decorate or form the tripod supports. All are unlike those on typical El Bosque phase pottery but the bowls continue a basic cup shape with everted lip found in the El Bosque phase repertoire of forms, particularly among the Ticoban Tripod group. The manner of placing the zoomorphs on the tripods here however is reminiscent of that on a vessel with modeled zoomorphs resembling manatees in the Museo Nacionál de Costa Rica which Snarskis suggests is of northern Atlantic-lowland style from the subregion San Carlos, east of Guanacaste.[1] But the ceramic paste or body in Numbers 128 to 131 is sandy and friable indicating another ceramic complex, possibly the El Bosque or La Selva phase Guácimo Red on Buff group which includes many of the same modes of form and decoration as El Bosque Red on Buff but whose paste is sandier.[2] Guácimo Red on Buff ceramics began in Period IV and reached their greatest popularity in Period V. Whether they differ from other El Bosque ceramics in space or time is not yet clear. The La Selva phase has been divided into two parts: La Selva A (circa AD 500-700) and La Selva B (circa AD 700-1000).

1. Snarskis 1981, no. 124; Stone 1977, fig. 181, illustrates the same vessel which she indicates comes from a site on the Linea Vieja.
2. Snarskis 1982, p. 104.

129.　TRIPOD BOWL with zoomorphic legs

Earthenware, tan clay body selectively under traces of red slip
Atlantic Watershed/Central Highlands Zone
Period IV/V (AD 400-700)
El Bosque Phase or La Selva A Phase (?), Guácimo Red on Buff
Group (AD 400-700)
Height 6" (15.2 cm) Width 7¼" (18.4 cm)
Condition before conservation: broken and repaired; surface scratches
Accession no. N-1088

The rounded cup-shaped bowl constricts to a short wide neck which in turn splays to a broad everted mouthrim. It is supported on the backs of three standing male zoomorphic creatures with cat-like heads, large ears, reed form punctate eyes and bulging bellies, whose bodies are attached to the rounded sidewalls of the bowl rather than being extensions from its underside. The legs of the supporting figures are separated but the feet are tightly together with an object held between the ankles. The figures' arms are folded on their breasts. Each figure is somewhat different: one wears a flattened cap with streamers and has a long tongue terminating in a serpent's head hanging down over his chest; another wears a serrated headdress and his tongue curls out of his mouth; the third has a rounded cap and appears to be sporting a beard. Unfortunately the significance of the figures in the mytho-religious system of the Atlantic Watershed/Central Highlands Zone is not known. Firing slits are cut into the sides of each figure. Traces of the red slip appear on the interior lip and lower legs. The underside and legs are soot covered.

130. TRIPOD BOWL with human head effigies

Earthenware, tan clay body selectively under a red slip, burnished
Atlantic Watershed/Central Highlands Zone
Period IV/V (AD 400-700)
La Selva A Phase (?), Guácimo Red on Buff Group (AD 400-700)
Height 4¼" (10.8 cm) Width 6" (15.2 cm) Depth 5⅝" (14.3 cm)
Condition before conservation: body of bowl and one leg broken
and repaired; cracks on rim
Accession no. N-1099

The bowed legs attached to the rounded sides of this broad cup-shaped bowl are decorated with hollow rattle, modeled heads appliquéd at the top of each. The lower part of the bowl is globular, its rounded sides rise to a curved shoulder which constricts to form the nearly straight short neck below the everted mouthrim. The legs on this vessel appear more integrated with the body, not simply attached as supports for the bowl. Surmounting the human heads and in the act of pecking at their foreheads is a stylized bird with a long beak. Thick halfmoon decorations are appliquéd around the neck of the bowl. Its interior and rim were painted in red slip and burnished. Stripes of red are also on the faces of the applied heads, on the surmounting bird heads, their beaks and wings and on the lower part of the tripods. The underside and legs are darkened with soot.

The beak-bird god is ubiquitous in Atlantic Watershed art. His importance reflects a Pre-Columbian procreation myth, reportedly from the Greater Antilles at the time of the Conquest and associated with Arawak peoples, (see No. 132).

131. TRIPOD BOWL with anthropomorphic legs

Earthenware, tan clay body selectively under a red slip
Atlantic Watershed/Central Highlands Zone
Period IV/V (AD 400-700)
El Bosque Phase or La Selva A Phase (?), Guácimo Red on Buff
Group (AD 400-700)
Height 7" (17.8 cm) Width 6⅝" (16.8 cm)
Condition before conservation: rim broken and repaired: two tripod
figures broken and repaired; arm of one figure restored
Accession no. N-1091

Three massive, hollow rattle legs, each modeled in the form of an anthropomorphic male creature, support the round bottomed cup-shaped bowl. Its tall neck is stepped back slightly from a small curved shoulder and splays out as it rises to form the gently curving everted mouthrim. Each tripod creature's head is animal-like with big ears, its facial features indicated by a broad nose with large nostrils, reed circle eyes and a wide slit mouth. Ornaments or earspools decorate the ears and crouching felines(?) or turtles(?) surmount each head, possibly as headdresses. Each has its arms raised to its chest, its right hand holding an object. Its legs are articulated and set apart; the feet are joined together to hold a ball between the ankles. Around their large bellies they wear thick belts or yokes(?). Firing slits are on the sides of each figures' body. On the neck of the bowl coffee bean appliqués and punctate reed circles in between and above each tripod figure give the impression of faces.

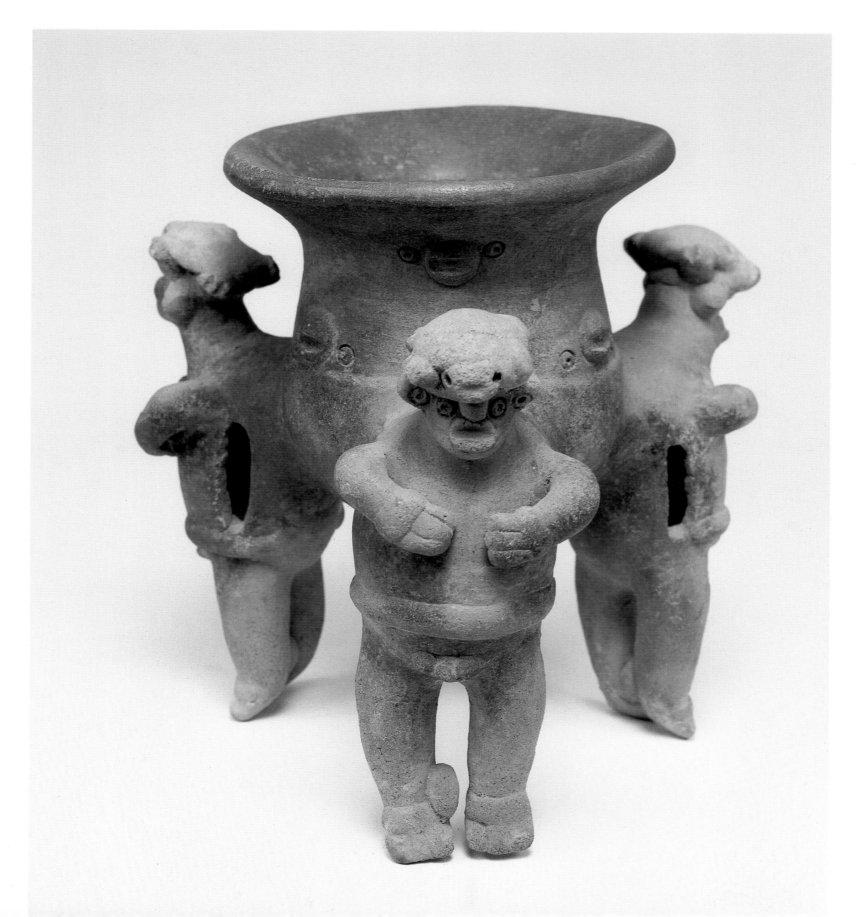

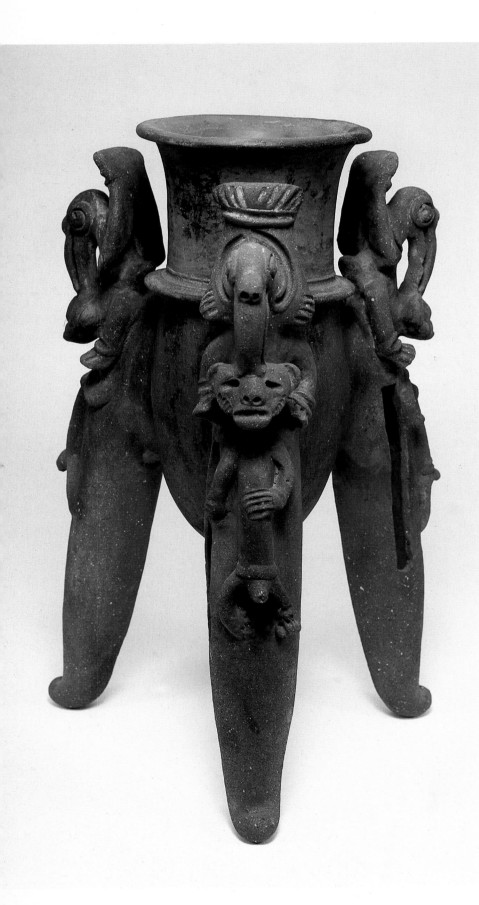

132. TRIPOD BOWL with appliqués on legs

Earthenware, brown clay body under a red slip
Atlantic Watershed/Central Highlands Zone
Period V (AD 500-1000)
La Selva A- or Curridabat A Phase(?), Africa Tripod Group
*(AD 400-700)**
Height 13⅛" (33.3 cm) Width 6⅞" (17.5 cm)
Condition before conservation: legs broken and repaired
Accession no. N-1176

The so-called "chocolate pot" with the *jícara* (pear-shaped gourd) body on long, straight or outcurved hollow tripods decorated with appliquéd animals, birds, reptiles, or human effigies appears near the end of Period IV and continues into Period V. Vessels of this type are either unpainted or slip painted in brown or red-brown. This vessel has the typical long, tapering hollow tripods containing ball rattles which were enclosed in the legs before the vessel was fired. Such vessels are referred to locally as *floreros* because of their pear-shaped bowls which look like flower vases. The bowl here is typical with its long lower body rising from the rounded bottom to an encircling flange above which the long neck splays slightly to the everted mouthrim. The modeled decoration applied to the tripod legs includes beak-bird gods perched on the shoulders of the legs pecking with long curved beaks at the foreheads of male creatures whose cat-like heads are thrust out and down. Below each figure's body is another body, serpent, crocodile, jaguar, or monkey, whose configuration is difficult to identify.

Such vessels have been found in corridor tombs within cemetery sites and may represent a funerary vessel connected with ceremonies associated with the interment of the dead. The beak-bird god, ubiquitous in the art of the Atlantic Watershed and even seen in Guanacaste as a jade ornament, is associated with a fertility cult. The procreation myth reported from the Greater Antilles at the time of the conquest and associated with the Arawak people indicates its importance. According to Arawak belief the beak-bird god made an opening between the groins of sexless creatures and thus created females.[1] Sometimes, as seen here and in Number 130, it pecks the head of a human being, in combination with a serpent, crocodile, jaguar or monkey effigy, also associated with fertility. "In historic times at least, Talamancan tribes in Costa Rica conceived of a single, principal deity, which they called Sibö. Sibö, associated with a long-beaked bird, apparently a kite or buzzard-like carrion-eater, brought the seeds from which all people sprouted and later selected the clans upon which rights to produce shamans, etc., were bestowed. Sibö charged his sons with the duties of distributing different kinds of jobs or work to all clans and of teaching agriculture, song and dance."[2]

1. Stone 1977, p. 192.
2. Ferrero 1981, p. 103.

Cf. Ferrero 1977, figs. V-26, for a tripod vase with stylized reptiles on the supports excavated from site 18-LM-Turrialba in the Reventazon Valley; also Lothrop 1926, vol. II, fig. 127.

**OXTL analysis (ref. no. 381P98, 5/10/85) estimates that the sample tested was last fired between 870 and 1320 years ago (AD 665-1115).*

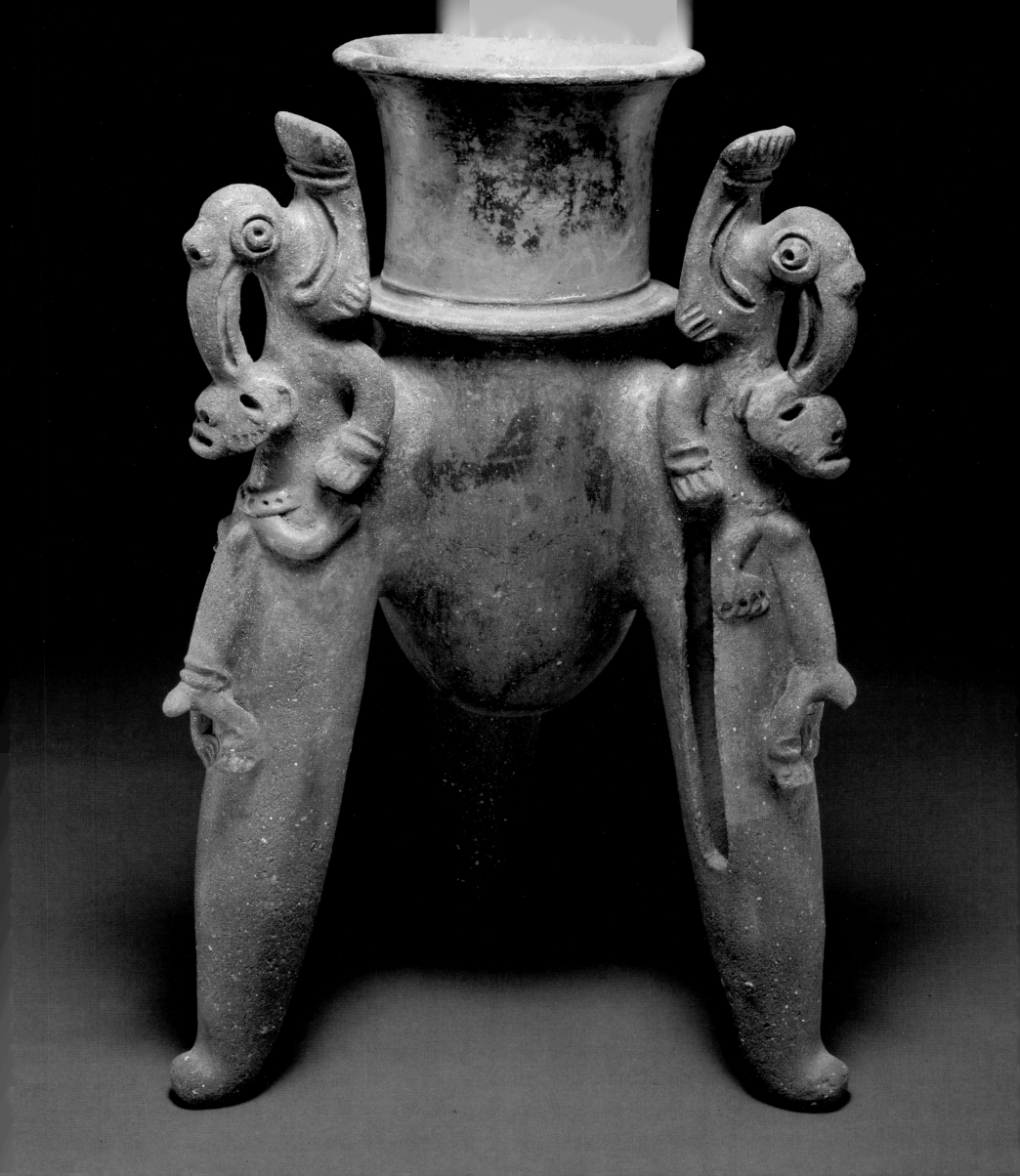

133. TRIPOD BOWL with appliquéd birds

Earthenware, reddish-brown clay body under a brown-black slip, burnished
Atlantic Watershed/Central Highlands Zone
Period V (AD 500-1000)
*La Selva A Phase, Africa Tripod Group (AD 400-700)**
Height 7¾" (19.7 cm) Width 5¾" (14.6 cm) Diameter of bowl 5½" (14 cm)
Condition before conservation: legs broken and repaired;
surface of bowl worn in spots
Accession no. N-976

The form of this vessel differs from that of Number 132. Its
rounded lower body curves in to a sloping shoulder from
which rises the tall outwardly splaying neck. Its tripods also
have a more pronounced outward curve. A plaited appli-
quéd band encircles the base of the neck. Appliquéd at the
top of each leg is a small bird disposed so that its body tilts
up and it appears to be looking up to the top of the vessel.
Its eyes are appliqué circles and the flattened stylized wings
have serrated edges.

Cf. Snarskis 1981, pl. 34, for an Africa Tripod with legs bearing men in alligator
array with an alligator's elongated snout and crested head, in the INS, acc. no.
2513; Snarskis 1982, p. 105, for an Africa Tripod with costumed human effigies
on the tripod shoulders, also in the INS (no acc. no. given); Stone 1977, fig. 253,
for another with articulated bird heads on the tripods, from the Linea Vieja;
Ferrero 1977, fig. V-24, 25, 27, and 28, for similar tripods excavated at site 18-
LM-Turrialba in the Reventazon Valley, as well as pl. XXIII, for a tripod with
appliquéd flying birds with human heads held in their claws, from Guápiles,
Linea Vieja, now in the MNCR; and Lothrop 1926, pl. CLXXVII.

**OXTL analysis (ref. no. 381P70, 4/3/85) estimates that the sample tested was last
fired between 820 and 1390 years ago (AD 595-1165).*

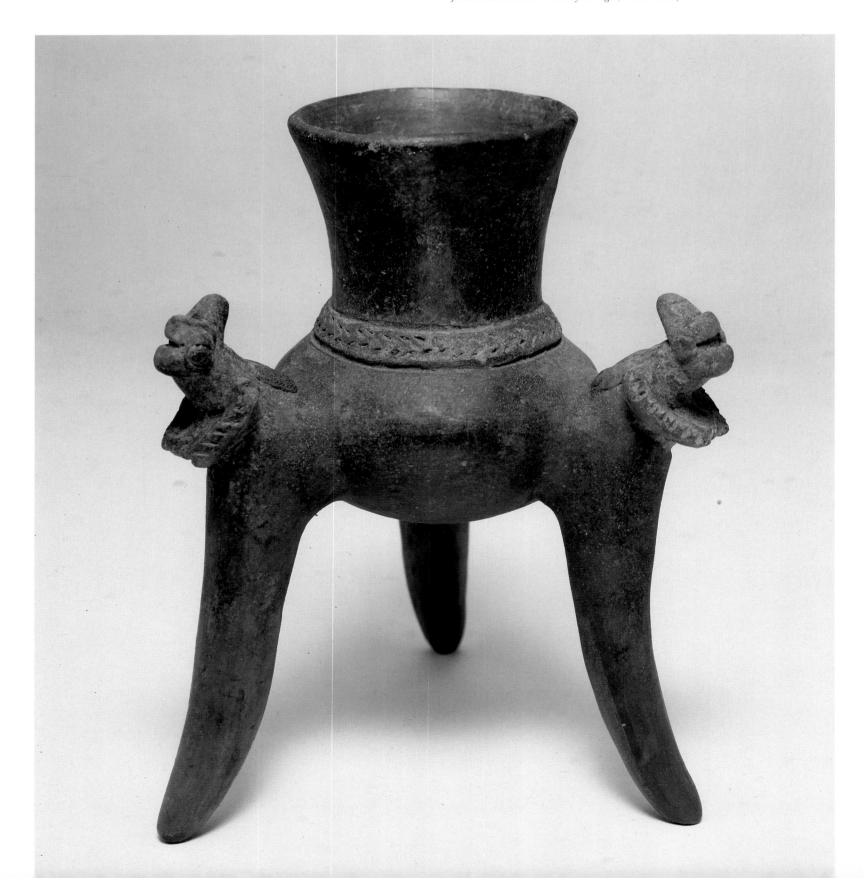

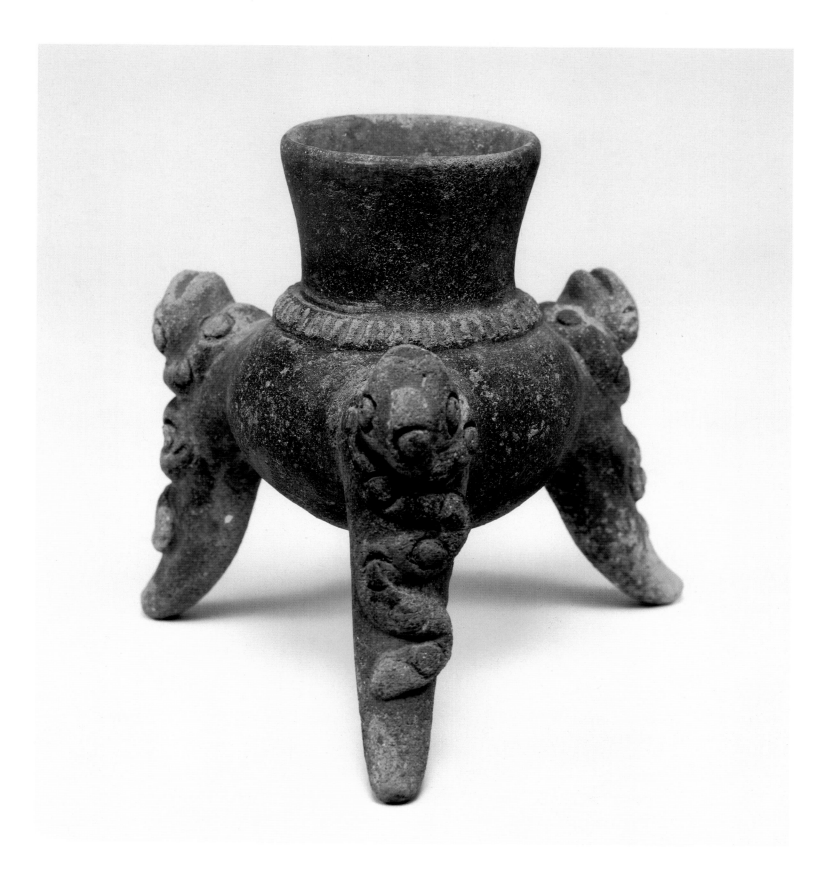

134. TRIPOD BOWL with serpent appliqué

Earthenware, light brown clay body under a brown slip, burnished
Atlantic Watershed/Central Highlands Zone
Period V (AD 500-1000)
La Selva A or Curridabat A Phase, Africa Tripod Group (AD 400-700)
Height 4⅝" (11.7 cm) Width 5⅛" (13 cm)
Condition before conservation: bowl and legs broken and repaired;
surface worn
Accession no. N-1075

The globular lower body of this vessel constricts to a sloping shoulder before the neck splays as it rises to the slightly flared mouth. A striated appliqué band encircles the base of the neck where it joins the rounded lower bowl. Appliquéd at the top of the tapering legs is the head of a serpent with reed circle eyes whose body, stamped with reed circles, undulates up each leg.

Cf. Ferrero 1977, fig. V-28, for a vase with serpents on the tripod supports, excavated from site 18-LM-Turrialba in the Revéntazon Valley.

227

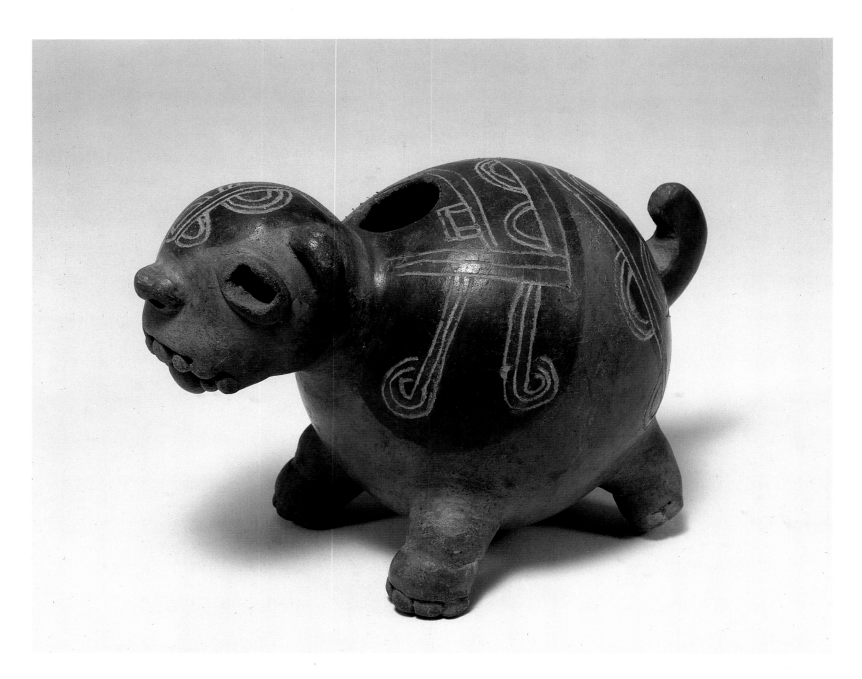

135. ANIMAL EFFIGY

Earthenware, buff-brown clay body under an orange slip, burnished, with maroon-red paint
Atlantic Watershed/Central Highlands Zone
Period IV/V (1000 BC-AD 1000)
*La Selva A or B Phase, La Selva Polished Orange-Purple Group (AD 500-1000)**
Height 4" (10.2cm) Width 3¾" (9.5cm) Depth 5⅞" (14.9cm)
Condition before conservation: head and two legs broken off and repaired
Accession no. N-1158

The animal probably represents a jaguar. Its rotund body is paired with an attached round head and stands on four short stubby legs. A short tail curls up behind. Its lidded eyes are open slits, the nose is broad with nostrils indicated, and its wide open mouth displays peg-like teeth and a protruding tongue. A small back opening and round openings piercing the neck were probably vent holes during firing. The buff-orange burnished body is zoned with maroon-red on the back and head and decorated with linear and scroll designs associated with stylized jaguar motifs incised through the slip. The color contrast was possibly achieved by a resist technique using a waxy resin, over the area not to be covered with the slip, which burned away in the firing.

Numbers 135 to 139 have been assigned to the La Selva Polished Orange-Purple ceramic group based on comparisons with similar ceramics which Michael Snarskis designates as of this group.[1] The La Selva phase corresponds roughly to Period V. Its ceramic complexes overlap El Bosque's in time but the decorative modes of the La Selva lead directly into later ceramic complexes.

**OXTL analysis (ref. no. 381L90, 7/10/84) estimates that the sample tested was last fired between 1090 and 1710 years ago (AD 274-894).*

136. TRIPOD JAR

*Earthenware, buff-brown clay under an orange slip, burnished,
with maroon-red paint*
Atlantic Watershed/Central Highlands Zone
Period V (AD 500-1000)
*La Selva B Phase, La Selva Polished Orange-Purple
Group (AD 700-1000)**
Height 6½" (16.5cm) Width 4⅝" (11.7cm) Depth 5¼" (13.3cm)
*Condition before conservation: slight surface scratches;
root marks on underside; rim slightly worn*
Accession no. N-1077

This gourd-shaped jar rests on three hollow mammiform
rattle legs. Jutting from the rim is a zoomorphic head with
raised round eyes, a crested snout and a small mouth with
teeth. The maroon-red zoned area is incised with alligator-
related motifs. The mammiform supports, the vegetal body
and animal head combine to produce an extraordinarily
graceful ceramic form. Two other examples published by
Ferrero are so similar as to lead one to conclude that they
were all produced by the same craftsman.[1]

1. Ferrero 1977, pl. XXII, effigy with mammiform supports, negative resist
and incised decoration, in a private collection, and Ilus. II-3, for another very
similar effigy vessel with similar incised design, also in a private collection.

**OXTL analysis (ref. no. 381P80, 4/3/85) estimates that the sample tested was last
fired between 930 and 1480 years ago (AD 505-1055).*

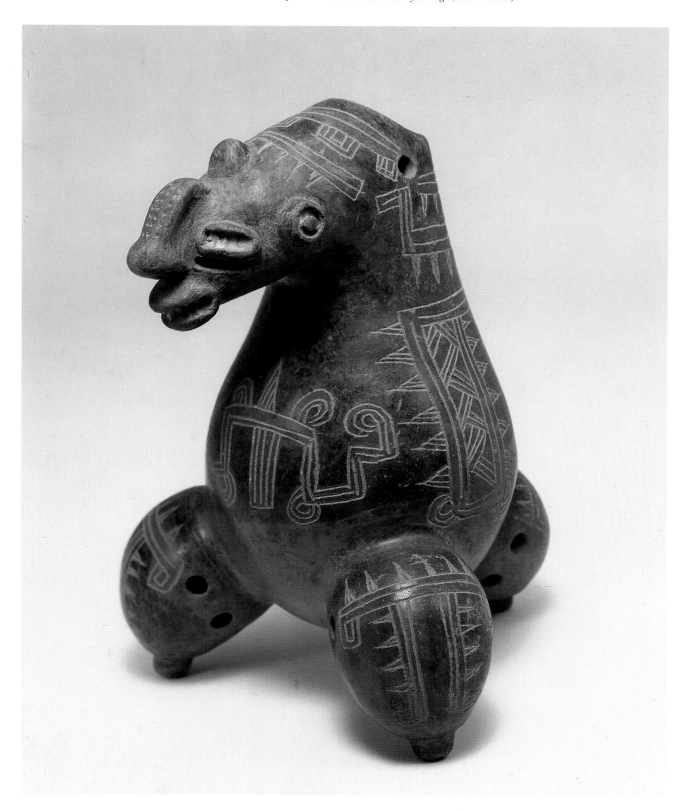

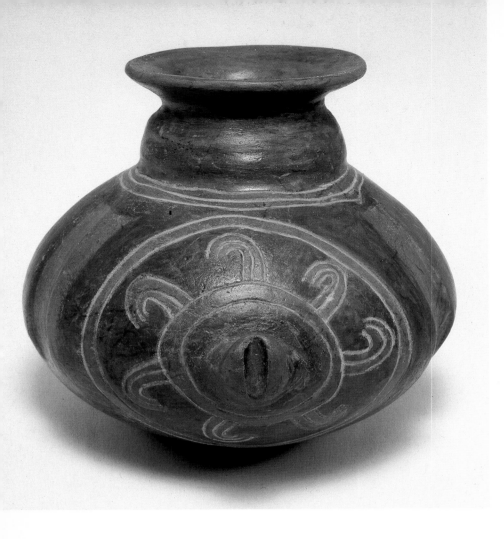

137. SMALL JAR

*Earthenware, buff clay under an orange slip burnished,
with maroon-red paint*
Atlantic Watershed/Central Highlands Zone
Period V (AD 500-1000)
*La Selva Phase, La Selva Polished Orange-Purple Group (AD 500-800)**
Height 3⁷⁄₈" (9.8cm) Width 4⁷⁄₈" (12.4cm) Depth 4¼" (10.8cm)
Condition before conservation: chips on rim; small surface chips
Accession no. N-1021

A round bulging neck constricted just below the flaring
mouthrim surmounts the elliptical body of the jar. Its sur-
face, zoned in maroon-red, is decorated with incising: three
lines encircle the neck; and two sets of double lines with
radiating hooks or arms extending from one to the other
circle the bosses on each end and enclose the maroon-red
zone. Lothrop refers to an analysis of this pattern as derived
from the octopus with the bosses possibly representing the
suction tip of an octopus arm.[1]

1. Lothrop 1926, p. 321.
Cf. Snarskis 1982, p. 106, for another small jar with similar decoration in the INS.
*OXTL analysis (ref. no. 381P74, 4/3/85) estimates that the sample tested was last
fired between 840 and 1310 years ago (AD 675-1445).*

138. BOWL with bird finial lid

*Earthenware, buff clay body under an orange slip, burnished
with maroon-red paint*
Atlantic Watershed/Central Highlands Zone
Period V (AD 500-1000)
La Selva B Phase, La Selva Polished Orange-Purple Group (AD 700-1000)
Height 4⅛" (10.5cm) Width 3" (7.6cm)
Condition before conservation: chip near rim of bowl; lid broken
Accession no. N-1051

The rounded bowl which curves in to a large mouth is fitted
with a domed lid which terminates in a stylized bird finial.
Both the bowl rim and lid are pierced for string or thong
attachment which served both to keep lid and vessel
together and as a carrying strap. The modeled bird's head
exhibits prominent round eyes, sharp beak and a feather
crest. The wings, tail and feet are minimally modeled and
eyes, wings, beak and crest are touched with black. Alligator
motifs are incised on the bowl.

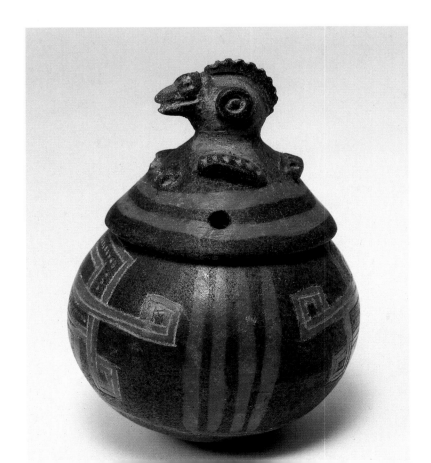

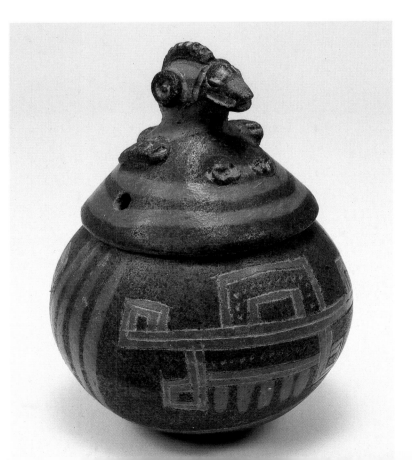

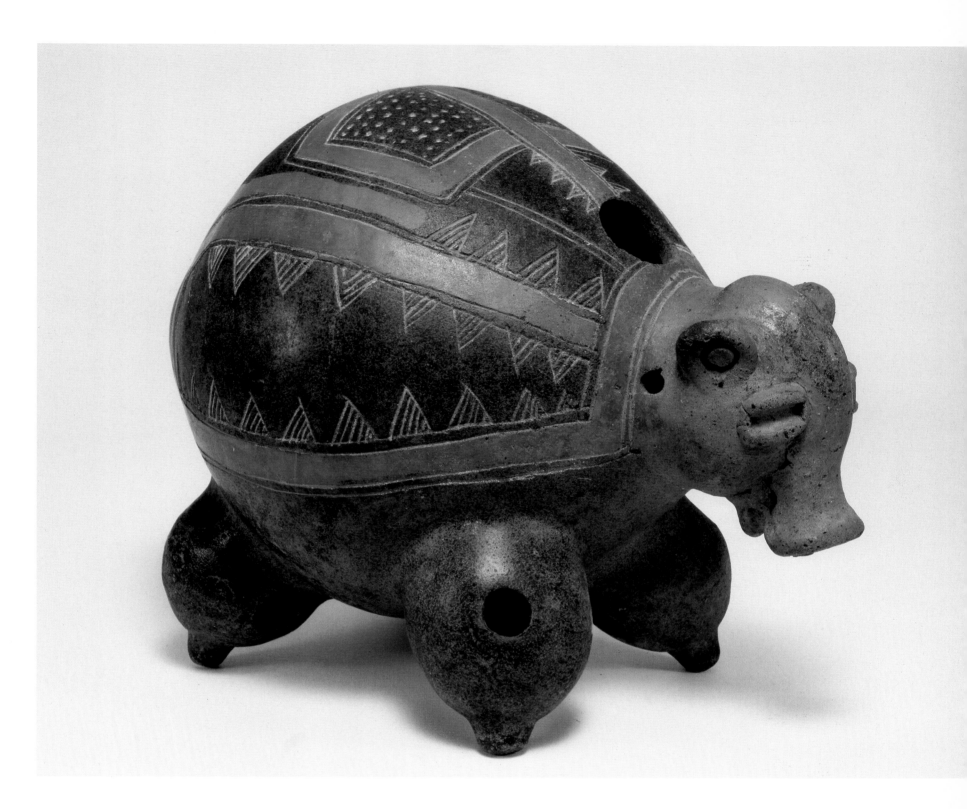

139. TAPIR EFFIGY

*Earthenware, buff-brown clay body under an orange slip, burnished,
with deep red-brown paint*
Atlantic Watershed/Central Highlands Zone
Period V (AD 500-1000)
*La Selva B Phase, La Selva Polished Orange-Purple Group (?)
(AD 700-1000)**
Height 6¼" (15.9cm) Width 6" (15.2cm) Depth 9" (22.9cm)
*Condition before conservation: right front leg repaired;
pressure crack at midsection*
Accession no. N-1148

The elliptical body supported by four hollow mammiform
legs is drawn out into a stubby tail at one end. Its head has a
pig-like snout, ridged slit eyes and projecting ears with reed
circle openings. A small opening in the back near the head
and round openings through the neck probably served as
air vents during firing. The surface is zoned with buff-
orange slip and dark red-brown and incised with lines form-
ing bands edged with incised triangles filled with oblique
lines usually associated with the alligator motif and seen on
Castillo Engraved/Incised ceramics (see Nos. 108-117). A rec-
tangular patch on the back is pecked with dots.

**OXTL analysis (ref. no. 381M13, 7/16/84) estimates that the sample tested was last
fired between 790 and 1230 years ago (AD 754-1194).*

231

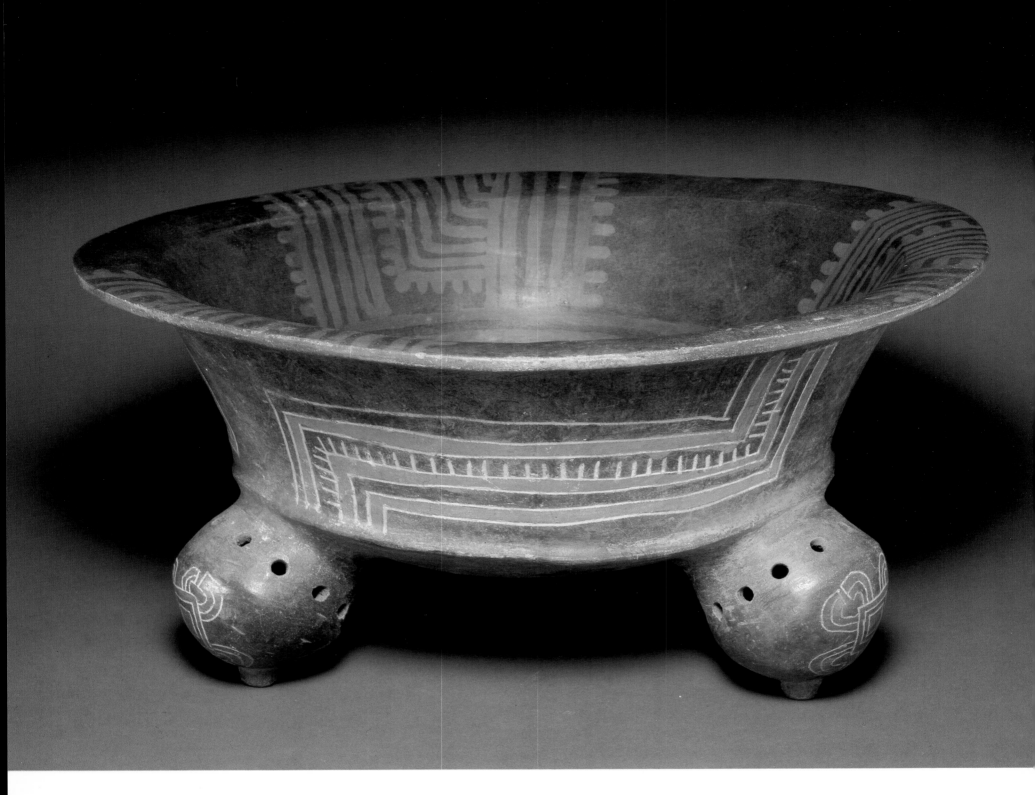

140. LARGE TRIPOD BOWL
with incised and painted designs

Earthenware, light reddish clay body under an orange slip, burnished,
with red and black resist paint
Atlantic Watershed/Central Highlands Zone
Period V (AD 500-1000)
*La Selva B Phase or later, Zoila Red Engraved (AD 700-1000)**
Height 6³⁄₄" (17.1cm) Diameter 14" (35.6cm)
Condition before conservation: broken and repaired;
piece missing from rim; cracks in base and around legs
Accession no. N-1036

An outstanding example of the potter's skill, this large bowl
is a typical *escudilla* shape which appears as an early ceramic
form in Costa Rica and continues into the late period.
Supported by hollow rattle, mammiform tripod legs, the
bowl emerges from a rounded dish-shaped base from whose
ridged edge the splayed sides rise to the everted mouthrim.

It is decorated with negative painting or resist as well as
engraving or incising and the designs in both techniques
depict a stylized zoomorph. During this period, resist or
negative painting became more popular possibly due to
influence from the Pacific coasts of Peru, Ecuador and
Columbia where the technique had been in use for a long
period of time. It appears throughout Costa Rica in late
Period IV but becomes more popular in the Atlantic
Watershed/Central Highlands and Diquis Zones in Periods
V and VI.

One of the characteristic ceramic groups of the La Selva A
Phase or the first few centuries of Period V was Zoila (Bon-
illa) Red which continued into the La Selva B Phase in the
second half of Period V. The Zoila Red and La Selva Brown
ceramic groups of the Atlantic Watershed are analogues of
red-slipped Gutierrez Incised/Engraved and the earliest
brown-slipped incised types of Guanacaste-Nicoya.

**OXTL analysis (ref. no. 381L33, 4/3/84) estimates that the sample tested was last*
fired between 630 and 980 years ago (AD 1005-1355).

232

141. ANIMAL EFFIGY BOWL

*Earthenware, light brown clay body under red slip, burnished,
with black negative resist painting*
Atlantic Watershed/Central Highlands Zone
Period V (AD 500-1000)
*La Selva B Phase, Zoila Red Group (AD 500-1000)**
Height 3³/₄" (9.5cm) Diameter 8³/₈" (21.3cm)
*Condition before conservation: horns of animal broken
and repaired; surface design worn; root marks on interior*
Accession no. N-1103

The body of a standing animal, probably jaguar, forms the
bowl of this vessel; its feet provide the supports. The
upward turned head of the animal shows a heavily appli-
quéd face with its mouth wide open, prominent fangs and
tongue extended. On the interior of the bowl, decoration
consists of jaguar spots and stripes effected in a black resist
technique.

Cf. Snarskis 1982, p. 104 right, for other examples of the Zoila Red group
engraved variety, but with the same resist designs as in this bowl.

**OXTL analysis (ref. no. 381p90, 5/10/85) estimates that the sample tested was last fired
between 650 and 1100 years ago (AD 885-1335).*

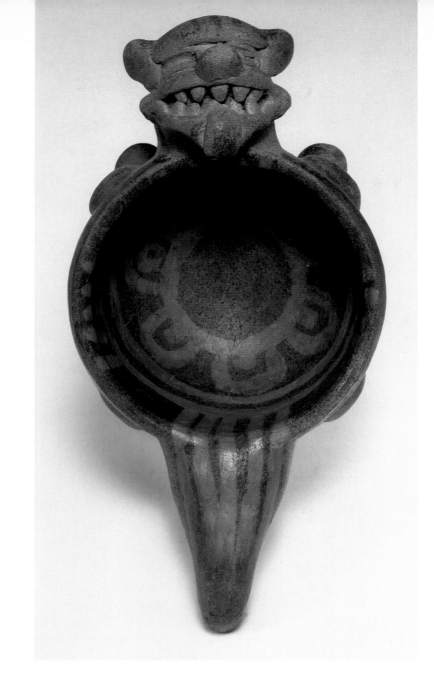

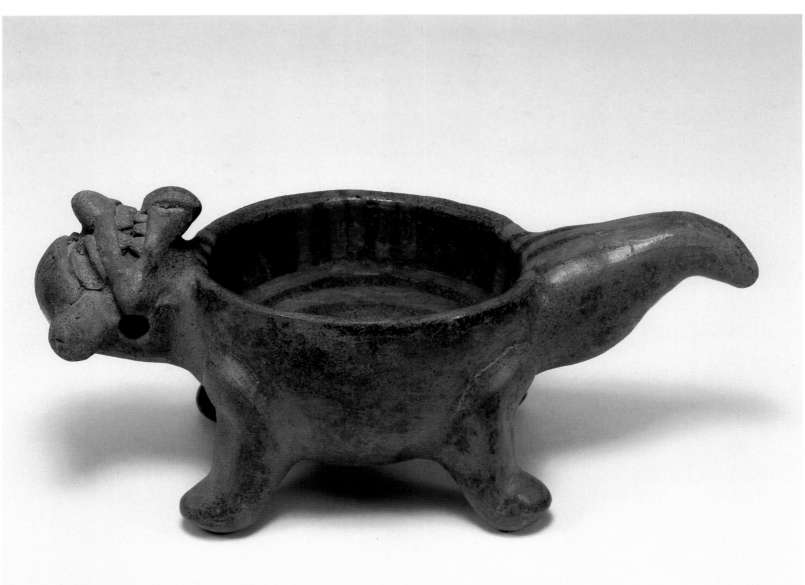

142a-g. FIGURINES—human and animal

Earthenware, reddish clay body under a red slip, burnished
Atlantic Watershed/Central Highlands Zone
Period V (AD 500-1000)
La Selva A or B or Curridibat A or B Phase, Unnamed Type
(AD 500-1000)
(a) Height 7" (17.6cm) Width 4" (10cm)
(b) Height 5⅞" (14.9cm) Width 2⅞" (7.3cm)
(c) Height 5⅞" (14.9cm) Width 3⅜" (8.6cm)
(d) Height 5½" (14cm) Width 2⅝" (6.7cm)
(e) Height 1¹/₁₆" (2.7cm) Width 1" (2.5cm)
(f) Height 1½" (3.8cm) Width 1⅜" (3.5cm)
(g) Height 1¼" (3.2cm) Width 1¼" (3.2cm)
Condition before conservation: intact
Accession nos. N-983 (a), N-1130 (b), N-1131 (c), N-1132 (d),
N-1133 (e), N-1134 (f), N-1135 (g)

Various authors have referred to such hollow figures, mostly female with elongated heads and full hips. Doris Stone associates them with Guapiles on the Linea Vieja and suggests they may have been an item of trade as several similar effigies were found in a grave near San Ramón in the Pacific watershed as well as in Guanacaste. Stone assigns them to circa AD 400-850.[1] Ferrero assigns the same type of figurines to the Late Period but Snarskis has also assigned a seated figure with child from this group to Period IV-V, or AD 400-700.[2] Baudez published a figure of this type which he claims derives from Aguas Zarcas in the San Carlos plains of northeastern Costa Rica.[3]

The figures seem to be part of a widely distributed pottery figurine tradition. Almost invariably they are nude figures of women whose function is difficult to determine. Unlike the solid figurines of earlier periods, these are of hollow construction. The earlier figurines appear in Kaminaljuyu, Guatemala, from the Las Charcas phase, attributed to the beginning of the first millennium BC, in the Guatemalan Peten at the site of Uaxactun, during the Mamom phase (900-550 BC), or in the Sula Plain in northwestern Honduras during the Playa de los Muertos phase, also of the first millennium BC. The most widely distributed are the Playa de Los Muertos unpainted, highly polished, solid figurines, seemingly genre figures modeled by hand and with individual characteristics whose physical similarity suggests a homogeneous racial group, as do the figures here. Whether or not these figurines have a direct relationship with the earlier types further north is impossible to know, but they obviously continue a long tradition.

1. Stone 1977, fig. 182, for a drawing of two of these figures which she says come from Guapiles.
2. Snarskis 1982, p. 109, for a female figure with child seated on a circular seat, in the INS; Ferrero 1977, Ilus. I-113, for four figures in a private collection.
3. Baudez 1970, fig. 145, from Aguas Zarcas, San Carlos plain, Costa Rica, now in the Collection of Evelyn de Goicoechea, San José, Costa Rica.

142a. OXTL analysis (ref. no. 381R4, 7/8/85) estimates that the sample tested was last fired between 850 and 1350 years ago (AD 635-1135). 142c. (ref. no. 381 p 94, 6/17/85) estimates that sample tested was last fired between 580 and 950 years ago (AD 1035-1405).

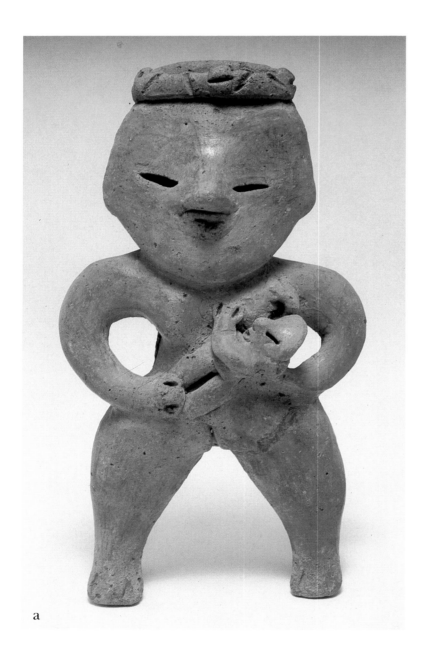

a

a. The hollow standing woman has an elongated head, full hips and holds a baby at her breast. Her straw hat (?) or headdress has punctate decoration. Evidence of black resist decoration remains on the body, indicating textile patterns or tattooing.

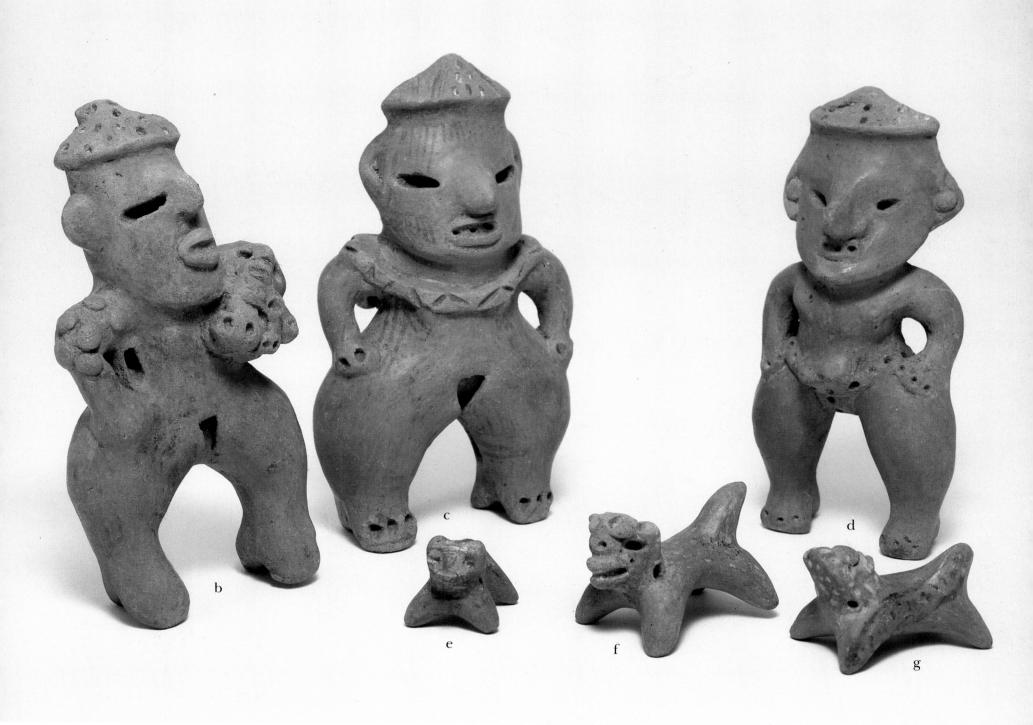

b. This hollow standing woman with elongated head and full hips, holding a baby on her shoulder, is actually a rattle. She wears a straw hat(?) or stylized hairdo or headdress with punctate decoration. Evidence of black resist decoration is also on the surface of her body.

c. This hollow standing woman with large elongated head, looped arms and hands resting on her full hips, is also a rattle. She wears a pointed straw hat(?) or hairdo decorated with ribbons and punctate marks. An applied and incised rope or breast strap represents a tumpline fastened over her shoulder to attach and carry a drum on her back. Black resist decoration is evident on her face and body.

d. The hollow standing man also has his hands on his broad hips and he wears a pointed and ribbed straw hat(?) with punctate

marks. His breechclout is similarly decorated. His eyes are deeply set and he wears ear ornaments.

e. The smallest solidly modeled dog has its tail coiled over its back joining the back of its head. A hole for suspension is drilled through its neck.

f. Another small solidly modeled dog, but with an anthropomorphic face, is slipped red but has a greyish head with purple pigment. A small hole for suspension is also drilled through its neck.

g. The third solidly modeled dog has its head turned back and is wearing an anthropomorphic mask. Its body is slipped red and burnished but its head is grey with white spots. It too has a small hole drilled through the neck. Black resist lines can still be seen on the red slip.

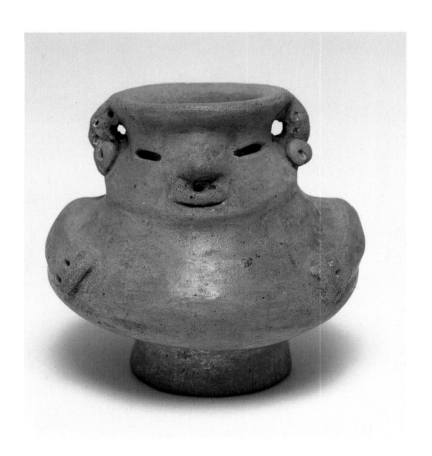

143. SMALL ANTHROPOMORPHIC JAR

Earthenware, reddish clay under a light red slip, burnished
Atlantic Watershed/Central Highlands Zone
Period V/VI (AD 500-1550)
La Selva A or B Phase or later, Unnamed Type (AD 500-1000)
Height 2⁷⁄₈" (7.3cm) Diameter 2⁷⁄₈" (7.3cm)
Condition before conservation: intact
Accession no. N-1136

The jar rests on a narrow slab base from which the walls of
the vessel rise to become the body of a small person whose
head is modeled on the jar's neck. The treatment of the face
with its slit eyes and modeled nose and mouth, as well as the
punctate markings in fingers and hair and the button ear
plugs, demonstrates its association with the small figures in
Number 142 a-g.

Purportedly this small jar was found together with Number
144 and was thought to serve as a lid for that vessel but there
is no evidence of similar function among other Costa Rican
ceramics. When placed over the mouth of the alligator-
masked jar, however, this vessel forms a perfect stopper, and
its body clay and slip color are identical (see Fig. 1).

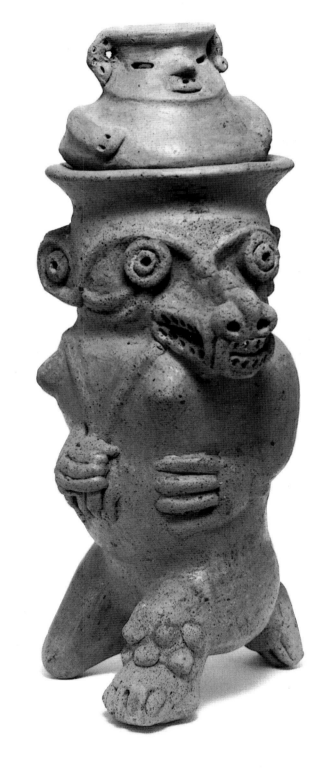

Fig. 1. Number 144 with Number 143 as lid.

144. HUMAN EFFIGY JAR
with alligator mask

Earthenware, reddish clay body under a light red slip, burnished
Atlantic Watershed/Central Highlands Zone
Period V/VI (AD 500-1550)
*La Selva Phase, Unnamed Type (circa AD 800-1300)**
Height 8¹⁄₈″ (20.6cm) Width 4¹⁄₄″ (10.8cm) Depth 4⁵⁄₈″ (11.7cm)
Condition before conservation: intact
Accession no. N-1119

The jar is modeled as a pregnant(?) female figure with
prominent breasts, kneeling on one knee, and wearing an
alligator mask with appliquéd circles of clay for the round
projecting eyes and a long snout with modeled nostrils and
fangs. Ears or earplugs(?) are also appliquéd circles of clay.
Applied clay bosses indicate alligator hide scutes on the fig-
ure's feet. A pendant on a cord is appliquéd around the
neck and held in the right hand which with the left hand is
held against the swollen belly. An appliquéd cord runs from
the bumps on the nose around the eyes to encircle the ears
or earplugs. The facial mask and feet are unslipped.

Although the provenience of this vessel is not known, an
anthropomorphic effigy vessel from a La Selva phase ceme-
tery at the La Montaña site near Turrialba (site 18-LM, Tur-
rialba) has the same distinctive eyes with double circles of
applied clay and sharp-edged eyebrow ridges, as well as an
unslipped surface.[1] It was excavated by archaeologists from
the Museo Nacional de Costa Rica with another smaller por-
trait vessel less embellished. The Sackler alligator jar may be
a product of the same potter or style.

Other grave goods excavated from the long corridor tombs
at the La Montaña cemetery included a beaded necklace
with a large jade pendant placed to hang centrally on the
chest. The figure here is wearing such a beaded necklace
with a central pendant. Various ceramic types such as Rox-
ana Shiny Maroon on Orange, Zoila Red, La Selva Brown,
Africa Tripod and La Selva Sandy Appliquéd were also
unearthed from the tombs in this cemetery. The presence
of all these types together confirms the perception of the
contemporaneity of various ceramic types.

1. Snarskis 1981, no. 191 and pl. 33 (also illustrated in Ferrero 1977, fig. V-29 and
 cover illustration).

**OXTL analysis (ref. no. 381M88, 9/4/84) estimates that the sample tested was last
fired between 680 and 1060 years ago (AD 924-1304).*

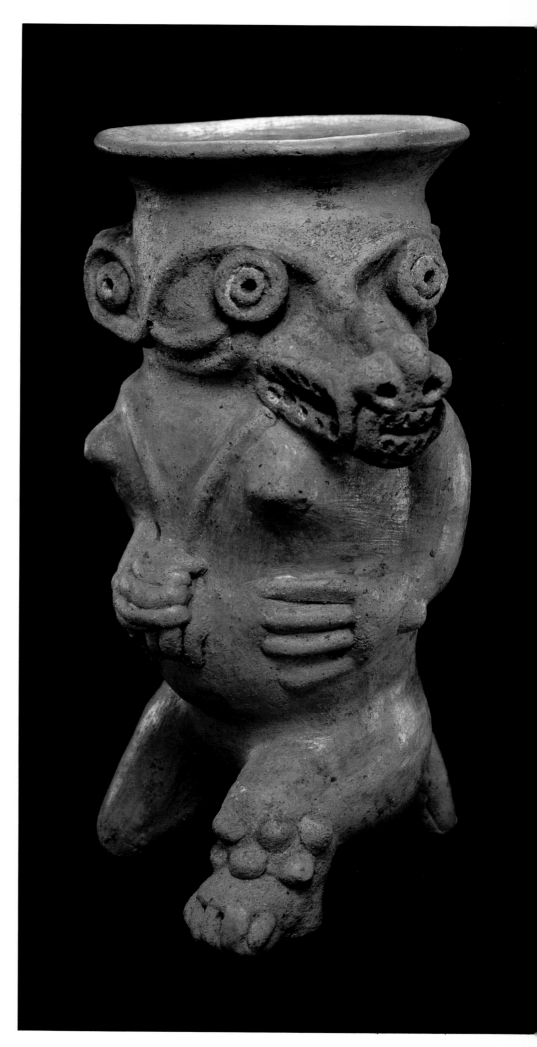

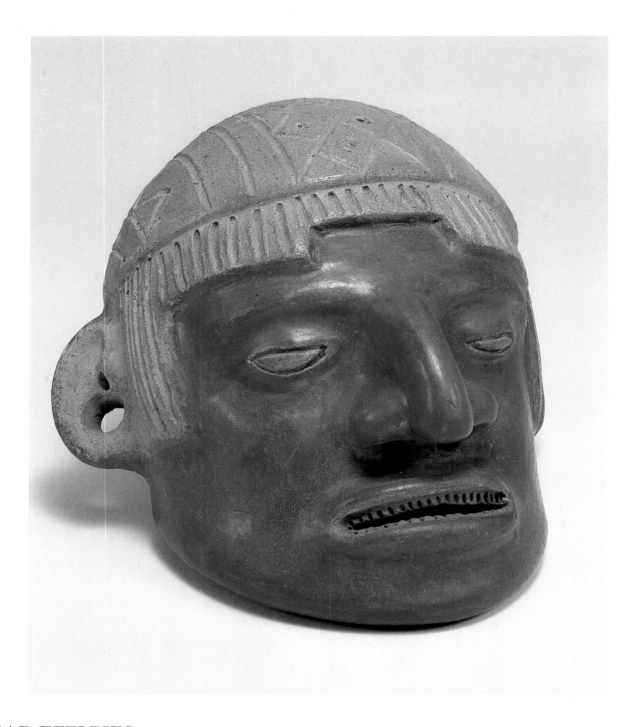

145, 146. HUMAN HEAD EFFIGIES

Earthenware, dark brown clay body under a red slip, burnished, with tan paint
Atlantic Watershed/Central Highlands Zone
Period VI (AD 1000-1550)
*Unnamed Type (AD 1000-1550)**
Both vessels: Height 5¼" (13.3cm) Width 6½" (16.5cm)
Condition before conservation: (145) back of head broken and repaired; (146) tip of nose and lower lip broken and repaired
Accession nos. N-1104 and N-1105

Modeled quite realistically, these effigies represent human heads. In both the eyes are incised under heavy brows, the noses are large and hooked, the mouths are open with rows of teeth showing, and the ears are large loops with lobe perforations for earspools. The hair is rendered as incised striations forming bangs and side burns around the face and fitted under hats decorated with incised dotted lozenges and line designs. The faces are covered with dark red slip and

burnished, while the hair, hat and ears are slipped and painted tan. Similar heads were carved in stone.

Various ceramic types can be distinguished by their style of modeling, their headdresses and their facial characteristics. Many are modeled with considerable realism, as are these two, and likewise are covered with dark red slip. The modeling here can be compared to Peruvian portrait head vessels of the Moche culture although the latter express realism through the harmony of painting and modeling. In the plastic ceramic art of the Atlantic Watershed such heads are outstanding. In style they are related to carved stone heads, except those in stone achieve a size up to fifty centimeters. The majority of the latter have been localized to one area: the site of Las Mercedes and its environs.

Taking of trophy heads in war and sacrificial beheading of captives was of considerable ritual importance in Costa Rica,

238

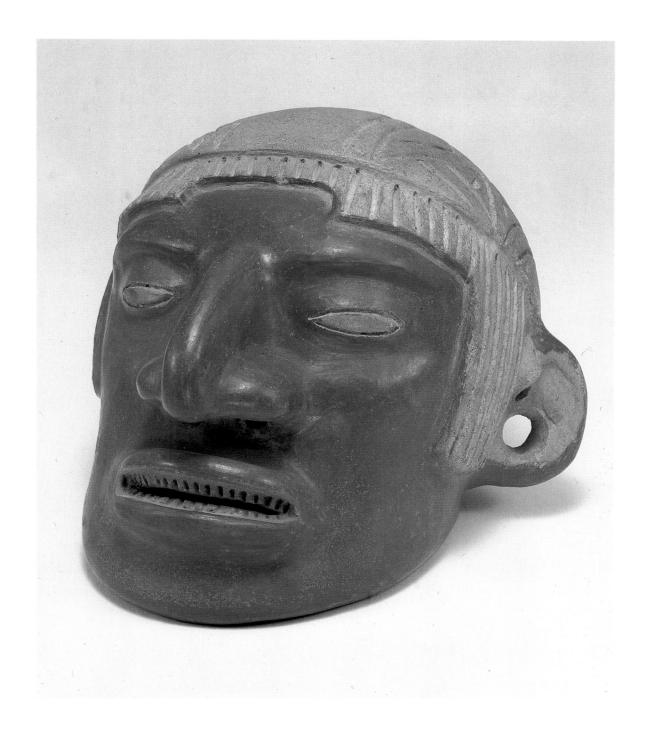

practiced from the early Christian era until the arrival of the Spanish, who noted that at every moon a human being had to be sacrificed. Since families or clans looked for nonrelatives to serve as victims continual warfare took place. When the Spanish arrived the trophy-head cult was still practiced by tribes of South American descent who inhabited parts of the lower isthmus of Central America. It was probably originally brought north from lower Central America by itinerant merchants, themselves warriors. As one aspect of the fertility cult that dominated art and life in the Atlantic Watershed/Central Highlands Zone, it manifested itself not only in the actual taking of heads but in their representation in stone and clay. Such objects embodied religious beliefs associated with procreation and fertility that demanded war and decapitation. Ceremonial warfare was constant and the high cost of defeat was underscored by the decapitated heads often borne by triumphant warriors as trophies.

Cf. Stone 1977, fig. 282, for examples of human head effigies in clay and stone, among them one in particular (also illustrated in Ferrero 1977, Ilus. III-125 in a private collection and identified as a monochrome ceramic although, as illustrated in Stone, the hair and cap are a lighter color) which is obviously by the same hand or from the same mold as the two in the Sackler Collection, except for the designs incised on the cap; Snarskis 1981, no. 188 (Height 8.8 cm, Width 7.3 cm), for one in the Alfonso Jiminéz-Alvarado Collection (also illustrated in Ferrero 1977, Ilus. III-126) which is a representation, perhaps to scale, of a shrunken trophy head which could also be mounted on a pole, and no. 189 (Height 4.8 cm, Width 5.5 cm), of similar type, in the MNCR, acc. no. 24198, the two considered to be of unusual style, almost Colombian, with facial scarification or painting indicated, mouths stretched in unnatural expressions, and ears depicted with double undulating incised lines, also no. 190 (Height 9.0 cm, Width 10.7 cm), which represents a trophy head with eyes sewn shut, all three being of smaller size than the Sackler heads, and attributed to Period V; see also Lothrop 1926, pl. CLXXXVIII and fig. 261, and pl. CLXXXIX, for other examples of stone and pottery heads.

OXTL analysis of Number 145 (N-1104: ref. no. 381L75, 7/24/84) estimates that the sample tested was last fired between 550 and 860 years ago (AD 1124-1434); and the OXTL analysis of Number 146 (N-1105: ref. no. 381L76, 6/24/84) estimates that the sample tested was last fired between 510 and 780 years ago (AD 1204-1474).

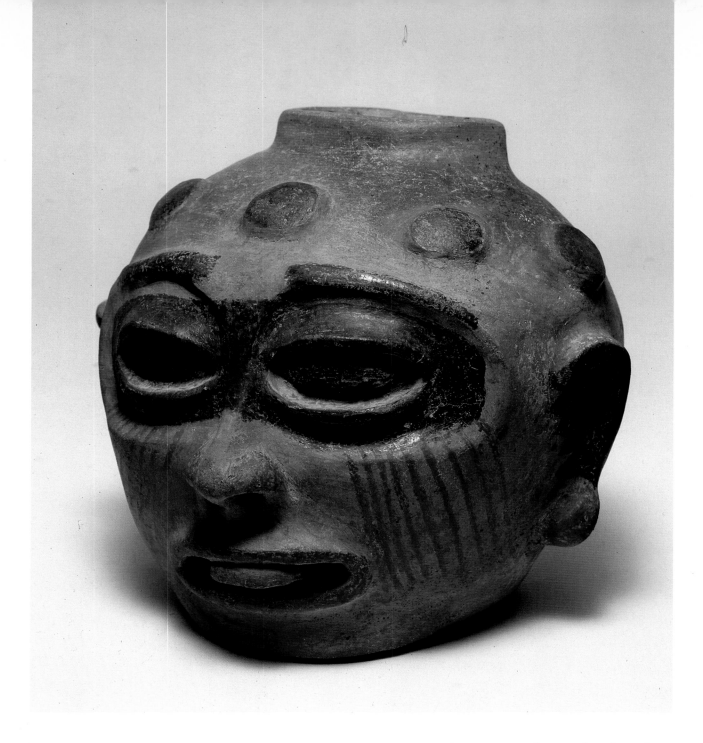

147, 148.

HUMAN HEAD EFFIGY VESSELS

*Earthenware, reddish clay body under a pale orange slip,
with some black paint*

Atlantic Watershed/Central Highlands Zone

Period V/VI (AD 500-1500)

*Unnamed Type (AD 314-1154)**

*Number 147 (N-1161): Height 6" (15.2 cm) Width 6¾" (17.1 cm)
Depth 6⅝" (16.8 cm)*

*Number 148 (N-1160): Height 5⅞" (14.9 cm) Width 6⅛" (15.6 cm)
Depth 5⅞" (14.9 cm)*

*Condition before conservation: some flaking of paint; chips around
mouthrims and bases*

Accession nos. N-1161 and N-1160

These two effigy vessels also represent human heads and
are modeled quite realistically but they obviously manifest
different styles and facial types from those in Numbers 145
and 146. In Number 147 high straight brows surmount the
ridged lids of the oval-shaped hollowed eyes. Brows and
eyes are circled with black paint. Fine black lines extend
down from the eyes to the cheeks. The close-set ears have
the remains of black paint on them. Bosses painted black
encircle the top of the head and black speckling appears
around the back. A tongue protrudes between lips and teeth
suggesting death by strangulation.

In Number 148, with the raised arched brows surmounting
lidded round bulging eyes, the look on the face is one of
surprise. The nose is pug and the mouth pursed. Here too,
a row of bosses encircles the head. Remnants of black paint
appear around the top of the head and over the bosses.

It is obvious, by comparison with the human head effigies in
Numbers 145 and 146 that a different potter made these
two heads. They do not seem to be from molds and there is
greater individuality in their expressions.

**OXTL analyses of Number 147 (N-1161: ref. no. 381M78, 11/20/84) and Number
148 (N-1160: ref. no. 381M73, 11/20/84) indicate that the samples tested were
last fired between 830 and 1670 years ago (AD 314-1154) and between 880 and 1600
years ago (AD 384-1104), respectively.*

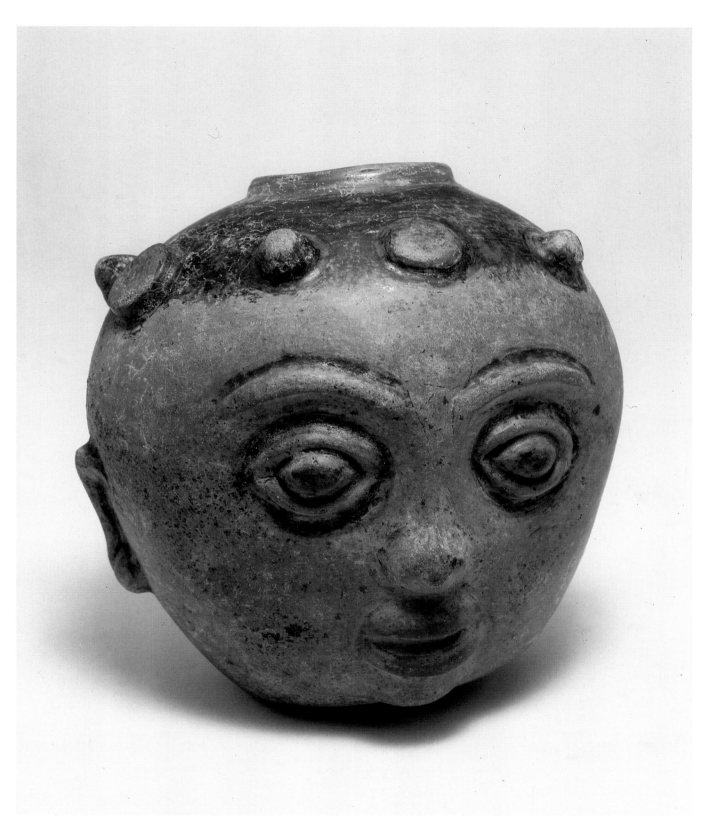

149. LARGE TRIPOD BOWL

Earthenware, brown clay body under a red slip, burnished, with light orange paint and remains of white wash on legs
Atlantic Watershed/Central Highlands Zone
Period VI (AD 1000-1550)
*Reportedly from Linea Vieja, Unnamed Type**
Height 11⅛" (28.3 cm) Width 11" (27.9 cm)
Condition before conservation: two legs broken and repaired; cracks in bowl; root marks; surface scratches; rim chips; resist designs almost completely worn away
Accession no. N-1007

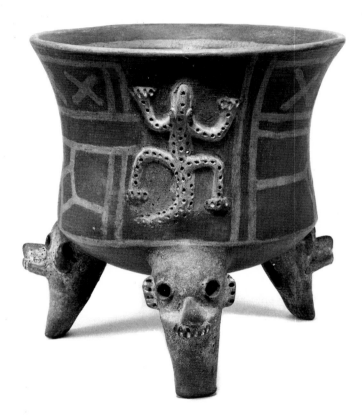

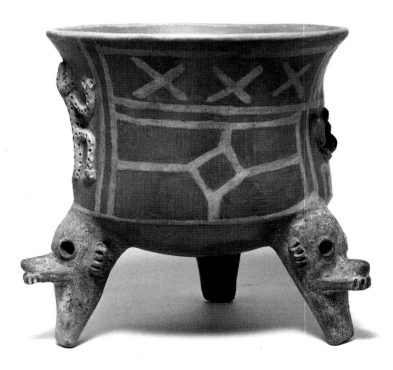

This very large bowl with modified cylindrical shape rests on three hollow zoomorphic-head legs. Appliquéd on one side is a large mask, ferocious in aspect, and probably representing an alligator. The arched brows, snout and mouth have punctate ridges. On the opposite side is an entire alligator also with punctate markings along the appliquéd ribbons which form its body. Interior and exterior are slipped dark red with linear designs in yellow-orange. Such large vessels were reported at the Las Mercedes site in the Atlantic lowlands. While often decorated with a white line, they are also reported with broad yellow lines and red lines. According to Snarskis, such vessels were also found at the site of La Cabaña, Guácimo. They were grave goods in high-status burials in all places where they were discovered.

During Period VI, pottery, with few exceptions, was generally of poor quality compared with that of earlier periods and there appears to have been less of it, ceramic production possibly having declined as a craft in relation to other activities. Settlements in eastern Costa Rica during this time appear to have become small ceremonial centers with rudimentary architectural features such as earth-filled cobble-faced, mostly circular mounds and cobble-paved causeways. Only a handful however have been even partially excavated. Las Mercedes was the first. It was found when Minor Keith put the Linea Vieja (Old Line) railroad through the middle of it (the old railroad line runs from Cairo to Guapiles, with a branch to the Santa Clara River, on the Caribbean side of Costa Rica). Parts of it were excavated in 1896, but it has been destroyed since by cacao and banana cultivation and pothunters.[1] The largest, most complex site known so far for this period is Guayabo de Turrialba, located to the north of the modern town of Turrialba.[2] Similar sites include Costa Rica Farm, Anita Grande, Majera and La Cabaña. La Cabaña, near Guácimo, a smaller site than Guayabo de Turrialba or Las Mercedes, was excavated in 1976-77 by a team from the Museo Nacional de Costa Rica. Noted at these sites were ceremonial precincts marked by a ridged quadrangular plaza adjoining the highest house mounds.

The vessel form here is diagnostic for Period VI and such tripods appear in several ceramic types and sizes. Urns like this, usually painted with white bands, and having modeled appliquéd human-trophy heads on the sides (see No. 150) and zoomorphic head supports, were found in small tombs surrounding the main plaza at the La Cabaña site.[3] One of similar type, but closer in shape to Number 150, was found in a large stone-cist tomb capped with flagstones at La Zoila, Turrialba, in which there were four other ceramic vessels of different types.[4]

1. Hartman 1901.
2. Snarskis 1981, p. 104.
3. Snarskis 1978, pp. 248-249, figs. 181-182; Snarskis 1981, no. 208, in the Molinos Collection, Costa Rica, and reportedly from Linea Vieja; Ferrero 1977, fig. V-34, from Tomb 9, site 20-CB Guácimo (height 23 cm, width 24 cm).
4. Snarskis 1981, no. 209, pl. 45, in the MNCR, acc. no. 5-T21 (I)-(5).

Cf. Arqueológia de Costa Rica No. 3, Instituto Costa Ricense de Turismo, cover illustration, for a three-legged vessel with alligator decoration in the Conozca Collection, Costa Rica, from the Linea Vieja; and Lothrop 1926, pp. 451-467, and pl. CLXXIII, for similar vessels from San Isidro de Guadaloupe, and Las Mercedes.

**OXTL analysis, 7/9/84, indicated that the material tested was too insensitive to allow conclusions regarding dating.*

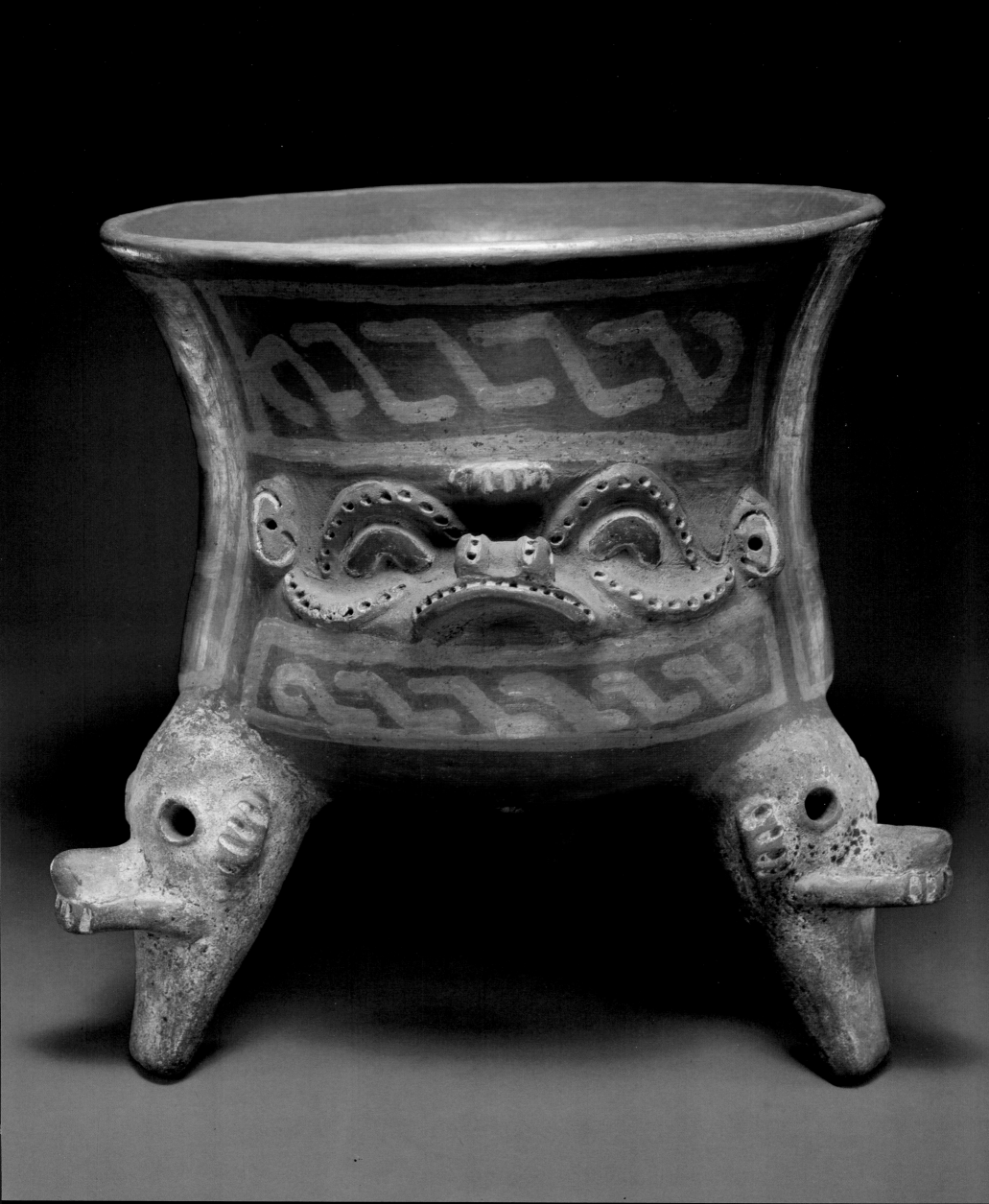

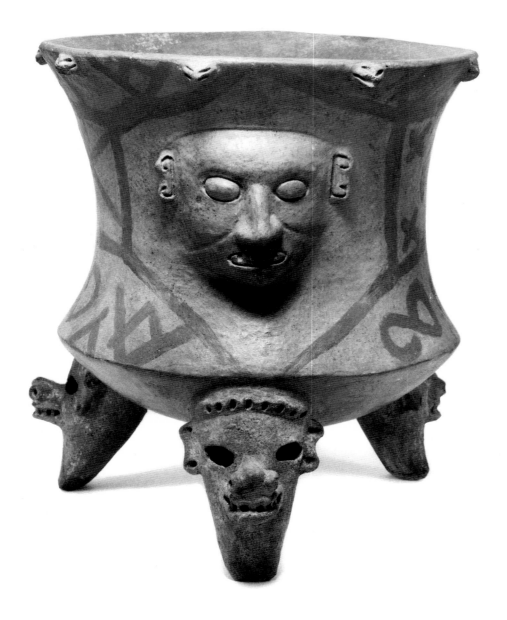

150. LARGE TRIPOD BOWL

Earthenware, brown clay body under an orange slip, burnished,
with red paint
Atlantic Watershed/Central Highlands Zone
Period VI (AD 1000-1550)
*Reportedly from the Linea Vieja, Unnamed Type**
Height 14¼" (36.2cm) Diameter (at mouth) 13⅛" (33.3cm)
Condition before conservation: three cracks running down from rim,
surface chips and checking
Accession no. N-1102

This very large bowl with modified cylindrical shape also
rests on three hollow zoomorphic effigy head supports, the
latter probably felines, but possibly coyotes or alligators.[1] On
opposite sides are appliquéd large human-trophy head
masks. Bulging eyes are appliquéd onto deep hollows. The
nose is very large and the oval mouth reveals prominent
teeth. Its stylized ears are also seen in some ceramic trophy
heads.[2] Small reptilian-head lugs are appliquéd around the
rim. Broad-lined designs are painted on the walls between
and around the masks. These large vessels were reported at
Las Mercedes, excavated as early as 1896 by Carl Hartman.[3]
Their precise function is not known, but they seem to have
been connected with the trophy-head cult and were found
in high-status burials.[4]

1. Snarskis 1981, nos. 208, 209 and pl. 45.
2. *Ibid.* nos. 188 and 189.
3. Hartman 1901; also Lothrop 1926, pl. CLXXIII for examples from San Isidro
 de Guadalupe and Las Mercedes.
4. See Ferrerro 1977, Ilus. I-133, I-134, and Fig. V-37, for other examples
 of the type.

**OXTL analysis, 7/9/84, indicated that the material tested was too insensitive to allow*
conclusions regarding dating.

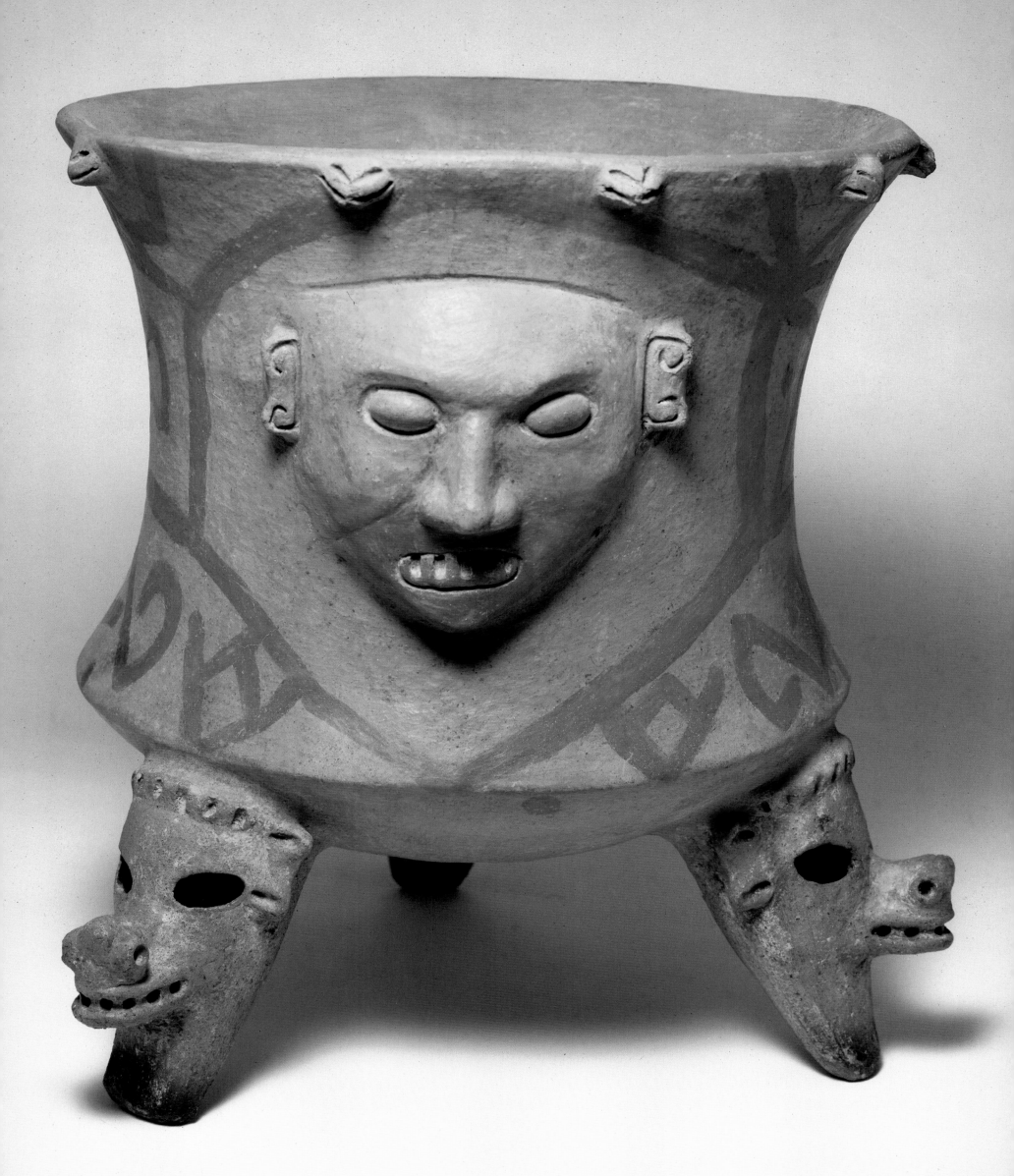

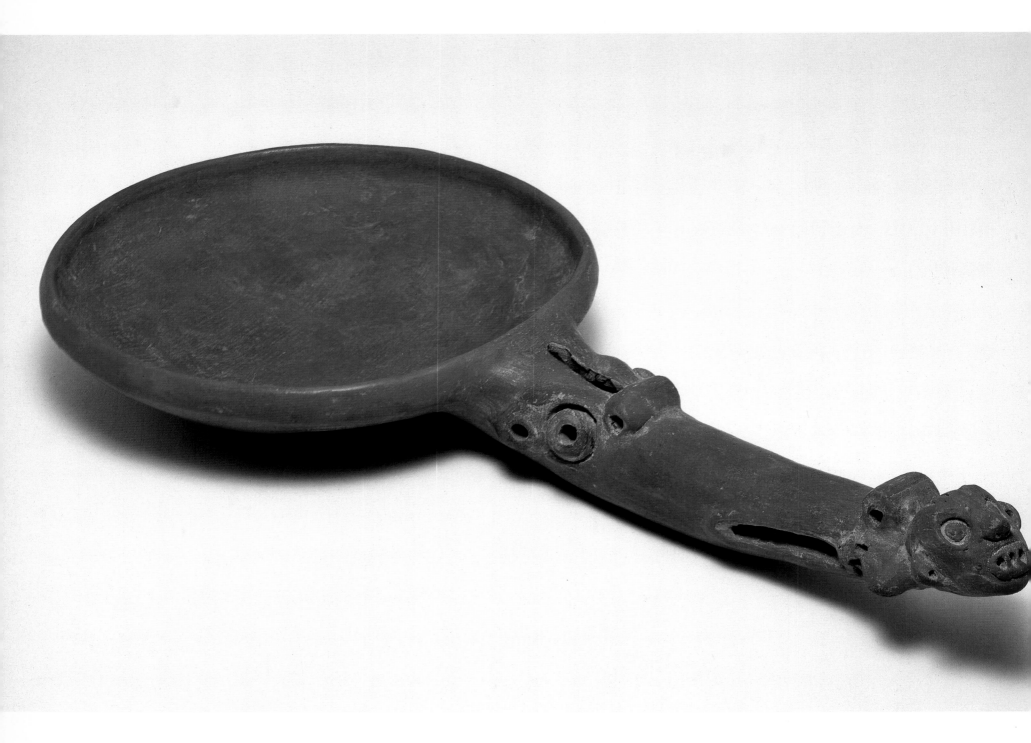

151. "FRYING-PAN" CENSER

Earthenware, reddish clay body under a red slip, burnished
Atlantic Watershed/Central Highlands Zone
Period VI (AD 1000-1550)
Unnamed Type (AD 1000-1550)
Height 2" (5.1 cm) Width 7⅛" (18.1 cm) Length 13½" (34.3 cm)
Condition before conservation: broken into many fragments and repaired
Accession no. N-1101

These so-called "frying-pan" forms were apparently used as censers for burning incense, probably on ceremonial occasions. Their form is diagnostic for Period VI. The extended handle here is in the form of an alligator swallowing a human figure.

Cf. Hartman 1901, pl. 16 (fig. 11), for a censer found on grave-pit 18 at Hacienda Las Mesas, Santiago, Cartago Province; Ferrero 1977, Fig. V-38, for a censer with a human figure from Site 5-Z Turrialba, tomb 7; and Snarskis 1981, fig. 25, p. 69, for another.

152. TRIPOD BOWL with animal effigy

Earthenware, reddish clay body under a red-orange slip, burnished, with black paint
Atlantic Watershed/Central Highlands Zone
Period VI (AD 1000-1550)
Cot Black Line Group (AD 1000-1550)
Height 4³/₈" (11.1 cm) Diameter k7³/₄" (19.7 cm)
Condition before conservation: broken into a number of pieces and repaired; surface worn
Accession no. N-971

The hemispherical bowl rests on three conical rattle legs decorated with incised triangles filled with perforations, some extending through the legs. Appliquéd below the rim is a modeled anthropomorphic head which rests on the hands of long thin arms extending from the tips of two of the vessel's legs. The bowl is decorated inside and out with geometric designs in faint black lines on the red slip. The designs are probably alligator inspired.

Irazu Yellow Line ceramics of similar shape exhibit designs in thick, yellow paint on two-tone orange and brick-red slip. Cot Black Line ceramics have similar motifs in black and red paint on orange-brown (red-orange ?) slip. Probably the potters who made Irazu Yellow Line vessels also produced those decorated with black lines. Their geometric designs recall those of Chiriqui Polychrome, a late Diquis Zone ceramic type.

The tripod here is of a standard shape, so similar to others that the form probably was made in a mold with the painted decoration only serving to distinguish them.

Cf. Snarskis 1982, p. 115, for an effigy dish, jaguar or monkey, in the INS, of the Irazu Yellow Line group which is almost identical in shape to the Sackler vessel, the difference being its yellow lines and the Sackler vessel's incised design; Snarskis 1981, fig. 28 for another similar vessel of the Irazu Yellow Line group; also Hartman 1901, pl. 72 (6), and Lothrop 1926, pl. CLIXe, for others.

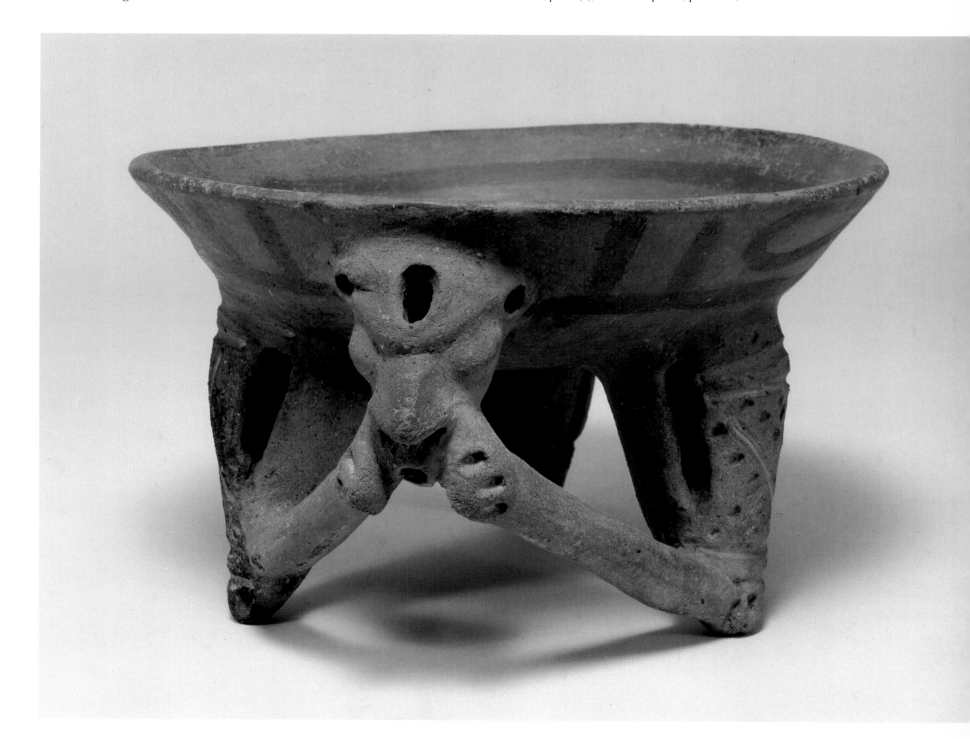

153. SMALL FIGURINE—mother and child

Earthenware, reddish clay under a cream slip, with red and black paint
Diquis Zone
Period VI (AD 1000-1550)
Chiriquí Phase, Buenos Aires Polychrome (AD 1000-1550)
Height 6" (15.2cm) Width 4" (10.2cm) Depth 2½" (6.4cm)
Condition before conservation: both legs repaired
Accession no. N-894 A

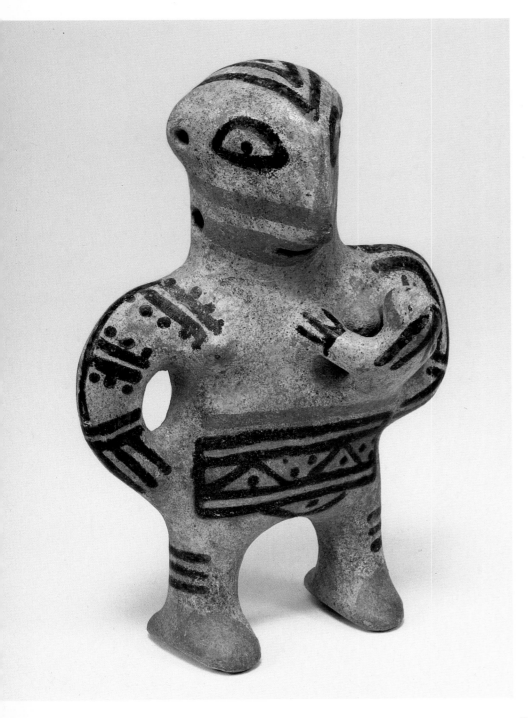

The highly stylized, standing female figurine holds a child against her left side. The modeling of the form is a minimal slab-like body, with looped extensions for arms and hands at hips, which rests on short squat legs, with arched feet providing balancing supports. A broad thick neck rises from the straight line of the shoulder, and the large triangular head surmounting it appears almost bird-like with the nose modeled straight down from the forehead to a beak-like point. The mouth is a sharp line around either side of the nose. The ears have perforations which once may have held ear ornaments. Facial as well as body features and the long hair down the back, are painted in simple red and black stripes. Decoration on the body (tatooing?) depicts alligator patterning. The neck is pierced for suspension.

The Sackler Collection includes only two ceramic types from the Diquis Zone from Period VI: Buenos Aires Polychrome and San Miguel (or Tarragó) Biscuit Ware. During the last six or seven hundred years before the arrival of the Spanish however, there were numerous pottery types produced in the Diquis Zone. Among them was the type referred to by early authors as "Alligator Ware."[1] It is now generally called Buenos Aires Polychrome and Urabá Polychrome. The term "Alligator Ware" applied because the stylized painted motifs appear to refer to that animal. Buenos Aires Polychromes seen in Numbers 153 through 160 are painted in black and red on a cream slip.

"Alligator Ware" or the Buenos Aires Polychrome Group with its black and red line decoration on a cream slip is one of the widest spread classes of pottery showing affinities with Panama. The painted motifs consist of combinations of lines with triangles, dots, V's, X's, diamonds and zigzags, purportedly symbolic of the alligator. The group comprises human figurines which often appear to represent genre scenes, as well as animals, reptiles, fish and birds, along with whistles and ocarinas, in such forms and others, and varying vessel shapes. The highly stylized figurines were apparently widely traded since they have turned up in Las Mercedes in the Atlantic Watershed and in the Nicoya Peninsula.

A few of the figurines are hollow, but most are solid. Often they portray seated females, legs crossed in front, or more frequently, spread wide in an acute angle—horizontally—giving them firm support. Their arms descend and loop out to the sides with hands on hips; or they carry a small child raised to their shoulder or breast. Characteristically the heads are triangularly shaped and the broad faces have features formed by button eyes and appliquéd nodules. Necks are pierced with holes for suspension. Other examples of this type are the whistles in the following: the double-bird, Number 159; the monkey, Number 160; and the top-shaped whistle, Number 161.

1. Holmes 1888; MacCurdy 1911; Lothrop 1926.
Cf. Snarskis 1981, no. 243, from the Alfonso Jiminez-Alvarado Collection, for a seated figure with child, perhaps by the same potter who did the Sackler figurine; Stone 1977, fig. 144, for a seated woman with child on her back peering over her shoulder and holding a bowl between her legs; Stone 1972, p. 199, for a number of figurines excavated at Palmar now in the Peabody Museum, Harvard University; Holmes 1883; MacCurdy 1911; Lothrop 1926; Ferrero 1977, Ilus. III-116, for a line drawing of a seated female nursing an infant (after Holmes 1888, fig. 227, and Lothrop 1926, fig. 268 and pl. CXXIX), and others of the type in Illus. III-118 and pl. XXXIIIb; also Baudez 1970, pl. 124, for a figurine in the MNCR from Congo, Osa Peninsula.

154. SEATED FIGURINE

*Earthenware, reddish clay body under a cream slip,
with red and black paint*
Diquis Zone
Period VI (AD 1000-1550)
Chiriquí Phase, Buenos Aires Polychrome (AD 1000-1550)
Height 4" (10.2cm) Width 4¼" (10.8cm) Depth 2" (5.1cm)
Condition before conservation: both legs repaired
Accession no. N-894 B

Here the seated figure (male or female) has its legs spread
wide. The arms loop around and down so that the hands
rest on the knees. Like other figures from this group, it is
highly stylized with an almost bird-shaped head. Painting is
used to highlight facial and body details. A black and red
cap and what appears to be a black tunic with red borders
cover the head and body. The figure's neck is pierced
through for suspension.

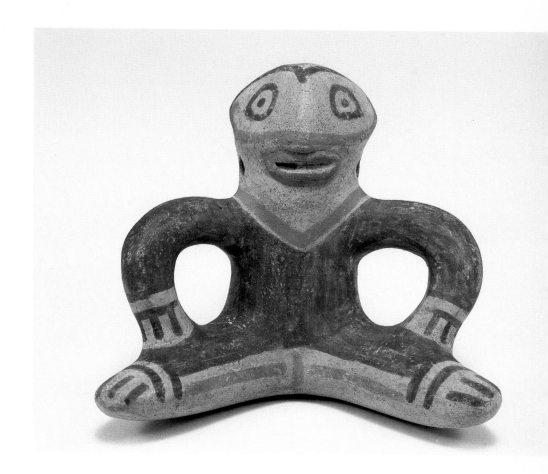

155. MONKEY OCARINA

*Earthenware, reddish clay body under a tannish-cream slip,
with black and red paint*
Diquis Zone
Period VI (AD 1000-1550)
Chiriquí Phase, Buenos Aires Polychrome (AD 1000-1550)
Height 4" (10.2cm) Width 3⅜" (8.6cm) Depth 2¾" (7.0cm)
*Condition before conservation: right arm broken and repaired;
crack around neck filled*
Accession no. N-899

A standing monkey, modeled with one arm raised to the top
of its head and the other curving down the side, forms this
ocarina. A long tail curls up the back. The head and one
side, including the tail, are painted black. The remainder of
the body is slipped tannish-cream with black markings out-
lining toes and indicating fur. The ocarina's mouthpiece is
provided by a hole in the chest surrounded by a red scor-
pion design. Finger holes are on the back. The arched tail or
looped arms provided suspension loops.

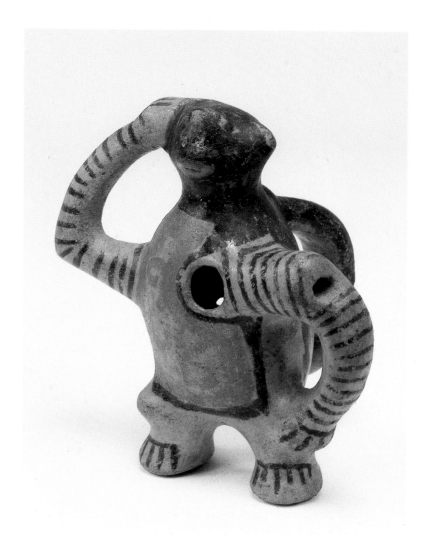

156.

FELINE EFFIGY

Earthenware, reddish body under a cream slip, burnished,
with red and black paint
Diquis Zone
Period VI (AD 1000-1550)
*Chiriquí Phase, Buenos Aires Polychrome (AD 1000-1550)**
Height 9¼" (23.5cm) Length16⅝" (42.2cm)
Condition before conservation: intact
Accession no. N-1163

During Period VI a considerable quantity of Buenos Aires
Polychrome human and animal figurines appeared, among
them feline effigies. The jaguar here is particularly appeal-
ing with its charmingly realistic yet generalized feline shape
and amusingly benign ferocity. Its ridged head and wide
mouth are comparable to similarly sharp features on the
figurines in Numbers 153 and 154.

Cf. Stone 1972, p. 199, for a group of Buenos Aires Polychrome figurines, now
at the Peabody Museum, Harvard University, from Palmar in the Diquis region,
which includes a small feline effigy.

**OXTL analysis (ref. no. 381M15, 7/16/84) estimates that the sample tested was last
fired between 420 and 680 years ago (AD 1304-1564).*

251

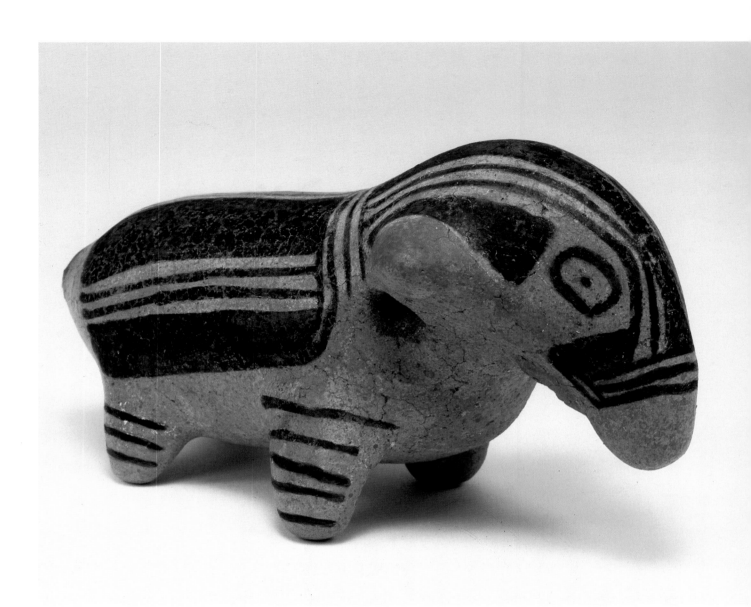

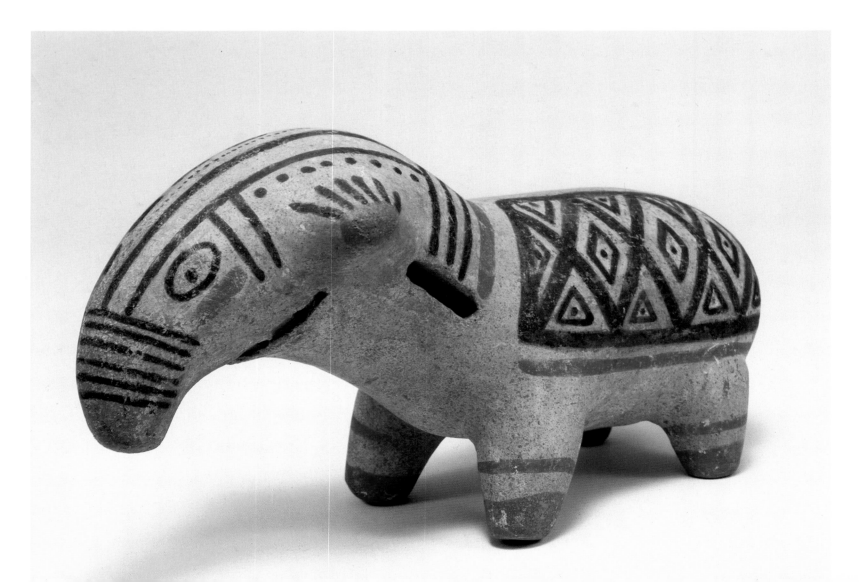

157, 158. TAPIR EFFIGY RATTLES

Earthenware, reddish body under a cream slip, with black and red paint
Diquis Zone
Period VI (AD 1000-1550)
Chiriquí Phase, Buenos Aires Polychrome (AD 1000-1550)
No. 157 Height 3¾" (9.5cm) Width 2⅜" (6.0cm) Length 7¼" (18.4cm)
No. 158 Height 2½" (6.4cm) Width 2" (5.2cm) Length 4⅞" (12.3cm)
Condition before conservation: surface pitted and worn
Accession nos. N-897 and N-898

These two tapir effigy rattles are minimally modeled to express the essential form of the animal. Number 157 has a long, almost pointed snout with open slit mouth and stubby ears. Number 158 has an oversized neck, a longer snout which curves down, an open slit mouth, stubby ears, and a long slit in the neck. Each has its neck pierced for suspension. The two are distinguished from each other by their slightly differing shapes which do not seem to have been made in molds, and by their decoration: Number 157 is painted black in zones on the slip, leaving cream striped markings on the head and back, with black horizontal stripes on the legs; Number 157 has the usual alligator designs of dotted triangles on the back, with black and red facial markings. Typical of Diquis Zone Period VI figurines, these small animal rattles, although stylized and composed of generalized forms, manifest a realism which expresses the essence of the animal depicted.

The tapir was of great use in Pre-Columbian Costa Rica. It provided a major source of protein in the diet, and its hide was used to make shields carried in battle.

159. DOUBLE-BIRD OCARINA

Earthenware, reddish clay body under a cream slip,
with red and black paint
Diquis Zone
Period VI (AD 1000-1550)
Chiriquí Phase, Buenos Aires Polychrome Group (AD 1000-1550)
Height 1⅛" (2.9cm) Width 1⅝" (4.1cm) Depth 1⅛" (2.9cm)
Condition before conservation: design slightly worn; paint chipping
Accession no. N-1034

Two modeled birds joined together form this whistle. Modeling is minimal and details are painted in. Wings and tail feathers are indicated by black lines. Each tail forms a separate mouthpiece. Finger or air holes are on the sides. The necks are pierced for suspension.
Cf. Lothrop 1926, fig. 269b.

160. TOP-SHAPED OCARINA

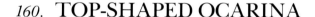

Earthenware, reddish clay body under a cream slip, with black and red paint
Diquis Zone
Period VI (AD 1000-1550)
Chiriquí Phase, Buenos Aires Polychrome Group (AD 1000-1550)
Height 3" (7.6cm) Diameter 2¾" (6.9cm)
Condition before conservation: cracks on body; paint chipped in spots
Accession no. N-1033

One end of the spindle of this top-shaped whistle is open to serve as the mouthpiece. An air-return opening is at the other end next to the spindle. Finger holes around the sides regulate the notes. Alligator motifs of dot-filled triangles and squares decorate the surface.

161. LARGE TRIPOD JAR

Earthenware, reddish clay body fired to a creamy-tan or buff color
Diquis Zone
Period VI (AD 1000-1550)
Chiriquí Phase, Tarragó Bisquit (or San Miguel Bisquit) Group
*(AD 1200-1550)**
Height 9¹⁄₈" (23.2cm) Width 9⁵⁄₈" (24.6cm)
Condition before conservation: large patch of "fire-clouding;"
surface fragile with substantial spalling; section of rim reglued
Accession no. N-1144

This large, elegant jar is modeled in a voluptuous tripod shape with the tripods and body merged to form a cohesive unit. The body curves in to a short neck which rises straight up to the broad rolled, everted mouthrim. On the shoulders on opposite sides of the neck are two small lug handles formed of clay strips with punctate designs. They probably represent stylized frogs.

Diquis Zone Tarragó Bisquit or San Miguel Bisquit ceramics are among the most elegant pottery vessels in Costa Rica and true expressions of the art of pottery making. In them, form was supreme with almost no distracting surface decoration except for small appliquéd adornos or handles. The potters' pleasure in form is evident in the way they made full, bulging shapes with clean, sensuous lines. They were also capable of making the walls of some of the large globular bowls, as well as those of small vessels, as thin as two millimeters, and without the use of a potter's wheel. This ware, produced in a large variety of shapes, was apparently used domestically rather than for interment, and was also extremely well fired, often completely oxidized. According to Wolfgang Haberland, the production of this ware was the work of specialists, probably working in one village or in a small group of adjoining villages. "That it may come from only one source is also indicated by the fact that thin sections of Bisquit pottery are all identical, regardless of where the

material was found. The most probable area of origin seems to be the lower slopes of the Pacific side of Chiriquí Province; here, as far as can be judged, the greatest variety of shapes and also the largest percentage of Bisquit pottery has been found. Some of the shapes, but not all, were exported to the more remote subareas. For instance, four out of five Bisquit vessels at Buenos Aires were large tripod bowls, which are otherwise quite rare."[1] Most of the Bisquit pottery has been found in habitational sites and the polychromes have been found in cemeteries; these findings reinforce the view that polychromes probably represent funerary ware and imply an association of special funerary offerings, while Bisquit pottery was for domestic use. Such a view further necessitates rethinking patterns of ceramic production and distribution of diversified wares over local and regional networks.[2]

Recent excavations have demonstrated that Bisquit pottery characterizes a later temporal unit or subphase in the Diquis Zone.[3] As far as present evidence indicates, Bisquit ceramics were added to the material inventory of the Diquis Zone without other important changes and were produced commercially. Areas obviously specialized in certain ceramic types and traded them to other subareas, and Bisquit pottery was not the only type produced commercially in Greater Chiriquí during the late period.[4]

Numbers 162 through 171 are examples of the varied shapes and sizes of this ware.

1. Haberland 1984, pp. 248-249.
2. Drolet 1984, p. 261.
3. Linares 1968, p. 66, at the Estero de Horconcitos, where Bisquit pottery appears late in the sequence, about AD 1200. The same phenomenon occurs at Buenos Aires, in the Valle del General; also Haberland 1984, p. 248.
4. Haberland 1960c, p. 83-84, Haberland 1961c, pl. VIj, and Haberland 1984, p. 249.
**OXTL analysis (ref. no.381p95, 5/10/85) estimates that the sample tested was too insensitive to allow age calculation.*

255

162. LARGE JAR with tapir lugs

Earthenware, reddish body fired to a creamy-tan or buff color
Period VI (AD 1000-1550)
*Chiriquí Phase, Tarragó Bisquit Group (AD 1200-1550)**
Height 9³/₄" (24.8cm) Width 10³/₈" (26.4cm)
Condition before conservation: chips on rim;
spots on surface worn
Accession no. N-1064

This large ovoid jar curves in to a slightly splayed neck with a thickened everted mouthrim. Hollow, modeled adornos which appear to be the head and front legs(?) of a tapir(?) are applied on the shoulders on opposite sides of the neck.

Cf. Ferrero 1977, Ilus. III-122, for a similarly shaped vessel and its adornos in the MNCR, acc. no. 770; Haberland 1984, fig. 9.5, for a similar vessel in the Hamburgisches Museum für Volkerkunde, from Grave V Mound I, Buenos Aires, Costa Rica.

**OXTL analysis (ref. no. 381L35, 4/3/84) estimates that the sample tested was last fired between 630 and 1010 years ago (AD 975-1355).*

163. SMALL JAR with tapir lugs

Earthenware, reddish clay body fired to a creamy-tan or buff color
Diquis Zone
Period VI (AD 1000-1550)
Chiriquí Phase, Tarragó Bisquit Group (AD 1200-1550)
Height 4³⁄₄" (12.1cm) Width 6¹⁄₈" (15.6cm) Depth 5⁵⁄₈" (14.3cm)
Condition before conservation: intact
Accession no. N-1167

Another ovoid jar, this is a smaller version of Number 162. Its body swells up to the shoulder and then curves in to a short flaring neck. On opposite sides of the neck, high on the shoulders, are appliquéd anthropomorphic adornos which appear to be modeled as seated tapirs, with the long snout hanging down between the upraised knees. Each is slotted through, probably to serve as lugs for suspension. The use of lugs in this way occurs in other areas of Mesoamerica.
Cf. Number 162.

164. LARGE STEPPED JAR with animal adornos

Earthenware, reddish body fired to a creamy-tan or buff color
Diquis Zone
Period VI (AD 1000-1550) or later
*Post-Conquest, Tarragó Bisquit Group**
Height 7³⁄₈″ (18.7cm) Diameter 7¹⁄₂″ (19.1cm)
Condition before conservation: intact
Accession no. N-1140

The lower body is globular and curves in at the shoulder. The upper body steps back to form a flat, round, disc shape from which it steps back again to a chimney-like neck. At the joining of neck and body are two modeled animal adornos which were probably used as suspension loops.

**OXTL analysis (ref. no. 381L85, 6/24/84) estimates that the sample tested was last fired between 220 and 360 years ago (AD 1624-1764).*

165. JAR with alligator adornos

Earthenware, reddish clay body fired to a creamy-tan or buff color
Diquis Zone
Period VI (AD 1000-1550)
*Chiriquí Phase, Tarragó Bisquit Group (AD 1200-1550)**
Height 6½" (16.5cm) Width 6" (15.2cm)
Condition before conservation: intact
Accession no. N-513

The globular lower body is surmounted at the bulging shoulder by the upper section constructed of a separate attachment of clay which forms the sloping sides of a collar *cum* neck. It also tapers to join the flaring cup-shaped mouth with everted and rolled rim. Appliquéd on opposite sides of the neck are spread-legged alligator adornos whose backs and tails are hatchured, and toes indicated.

**OXTL analysis (ref. no. 381m11, 7/1/84) estimates that the sample tested was last fired between 240 and 450 years ago (AD 1534-1744).*

166. JAR with anthropomorphic adornos

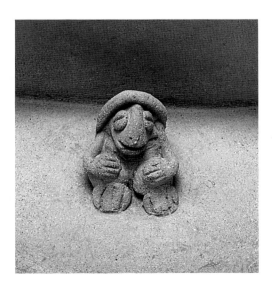

Earthenware, reddish clay body fired to a buff color
Diquis Zone
Period VI (AD 1000-1550)
*Chiriquí Phase, Tarragó Bisquit Group (AD 1000-1550)**
Height 5½" (14cm) Diameter 5½" (14cm)
Condition before conservation: intact
Accession no. N-1166

The body, rising from a rounded base, expands to the rounded shoulders curving in to join the flaring neck *cum* collar which splays to the rolled mouthrim. Appliquéd adornos as small whimsical anthropomorphic figures are perched high on the shoulders on opposite sides of the neck. They appear to have an alligator head and sit with their knees drawn up and hands on the knees. Feet and hands are large in proportion to the size of the figures themselves. A cowl-like head covering falls down their backs.

**OXTL analysis (ref. no. 381p96, 5/10/85) estimates that the sample tested was too insensitive to allow age calculation.*

167. TRIPOD BOWL

Earthenware, reddish clay body fired to a creamy-tan or buff color
Diquis Zone
Period VI (AD 1000-1550) or later*
Post-Conquest Phase, Tarragó Bisquit Group (AD 1000-1550)*
Height 5¼" (13.3cm) Diameter 8¼" (21cm)
Condition before conservation: piece of rim broken and repaired;
surface rough throughout
Accession no. N-1063

The graceful, conically shaped bowl curves in to a slightly thickened but sharp-edged mouthrim and rests on three conical legs with slightly flattened and everted feet. The legs have wide splits on their exterior sides to contain clay pellets for rattles. According to Haberland, large Tarragó Bisquit tripod bowls were quite rare but were items of export.[1]

1. Haberland 1959, pls. VIII1-1, IXa-b.

*OXTL analysis (ref. no. 381M11, 7/1/84) estimates that the sample tested was last fired between 250 and 400 years ago (AD 1584-1734).

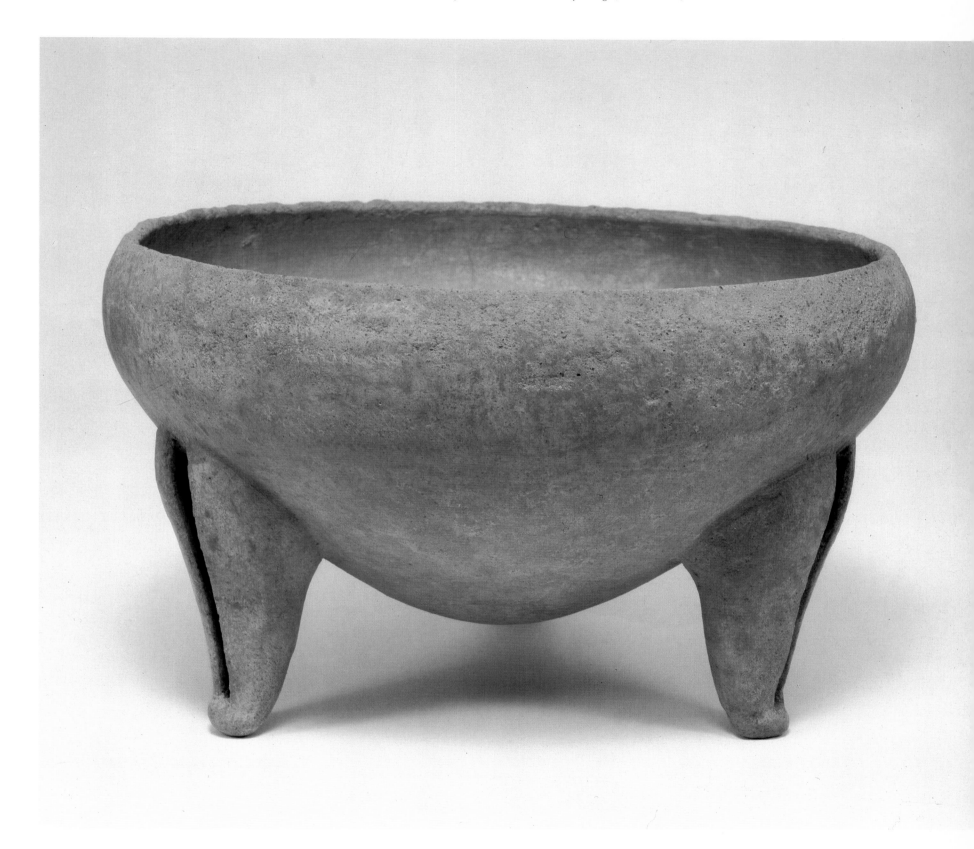

168. SMALL TRIPOD BOWL

Earthenware, light reddish clay body fired to a creamy-tan or buff color
Diquis Zone
Period VI (AD 1000-1550)
Chiriquí Phase or Post-Conquest, Tarragó Bisquit Group
Height 3⅛" (7.9cm) Diameter 4¼" (10.8cm)
Condition before conservation: surface slightly worn
Accession no. N-1168

This miniature deep bowl has a very thin, well-potted body.
Its sides curve up from the rounded base, then taper slightly
before flaring gently to the barely everted mouthrim. It rests
on three conical legs which curve out to a rounded and
thickened foot. The butt or shoulder of the cabriole-shaped
leg is slotted in a star pattern. Inside the legs are clay pellets
for rattles.

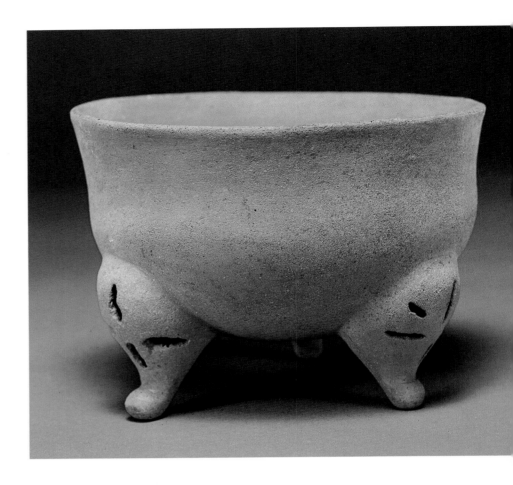

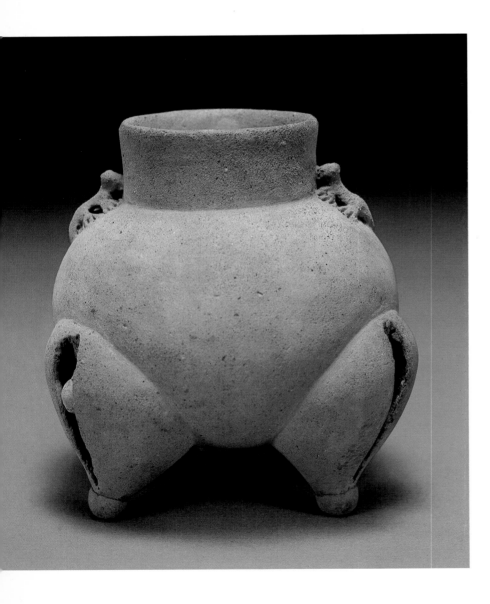

169. MINIATURE TRIPOD JAR
with zoomorphic adornos

Earthenware, reddish clay body fired to a buff color
Diquis Zone
Period VI (AD 1000-1550)
Chiriquí Phase or Post-Conquest, Tarragó Bisquit Group
Height 4⅛" (10.5cm) Diameter 3⅝" (9.2cm)
Condition before conservation: intact
Accession no. N-1169

The body of this globular jar curves in at the shoulder to
join a straight, tall neck which rises to a slightly rounded
mouthrim. It rests on three hollow mammiform or conical
rattle legs with round button feet and long vertical slits on
the exterior sides. Small modeled animal (alligator?) ador-
nos are appliquéd on the shoulders on opposite sides of the
neck and serve as suspension lugs.

Cf. Ferrero 1977, Ilus. I-191 for a very similar but slightly more rounded and
taller (height 14 cm, width 15 cm) tripod vessel in the MNCR, acc. no. 21.420.

170. MINIATURE TRIPOD
with anthropomorphic adornos

Earthenware, reddish clay body fired to a creamy-tan or buff color
Diquis Zone
Period VI (AD 1000-1550)
Chiriquí Phase or Post-Conquest, Tarragó Bisquit Group
Height 2⁷⁄₈" (7.3cm) Diameter 2¹⁄₂" (6.4cm)
Condition before conservation: intact
Accession no. N-1170

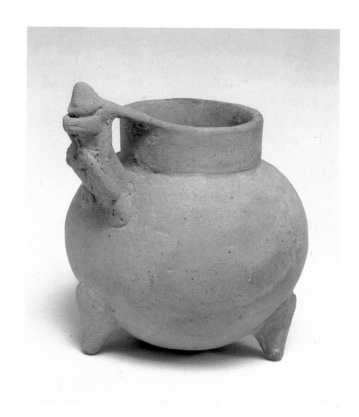

Somewhat similar in shape to Number 169, this globular jar is more rotund and rests on three conical legs which are much smaller and less elegant than those in the previous Number. The body constricts above the round shoulder to form a straight, fairly high neck which thickens slightly at the mouthrim. Appliquéd on one shoulder, and attached to the neck by a ribbon of clay extending from the back of the headdress it is sporting, is a seated anthropomorphic figure with alligator (?) characteristics. Its knees are drawn up with its elbows resting on them. The figure, wearing a cap on its head or a high headdress, appears to be holding something to its mouth, possibly a musical instrument.

171. ZOOMORPHIC OCARINA

Earthenware, reddish clay body fired to a creamy-tan or buff color
Diquis Zone (?)
Period VI (?) (AD 1000-1550)
Unnamed Type related to Tarragó Bisquit Group (?)
Height 4¹⁄₈" (10.5 cm) Width 3¹⁄₄" (8.3 cm) Depth 5³⁄₄" (14.6 cm)
Condition before conservation: right arm broken and tail broken and repaired; surface abrasions; fire-clouding on leg
Accession no. N-1048

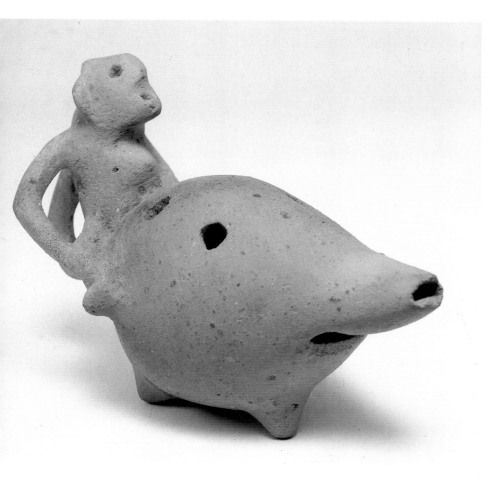

The body of this ocarina, made from a quite thin bisquit-like ceramic, apparently molded into shape, then smoothed on the surface, appears to be a boar's head with the mouthpiece forming the snout, the air return the mouth, and the finger holes the eyes. Small tab ears are attached on either side of the animal's head. Attached to the back of the boar is the body of a monkey. The long, bowed arms rest on the hips and the tail curls up the back to rest on the top of the head. Eyes and mouth are punctate.

Similar instruments are seen primarily in the Atlantic Watershed/Central Highlands Zone in El Bosque or La Selva phase contexts whose modeled adornos typically portrayed costumed human beings. The figure here, however, shown from the torso up as are most of those from the Atlantic Watershed/Central Highlands Zone, does not wear the typical headdresses seen on figures on ocarinas from that area.[1]

1. Snarskis 1981, nos. 126-129, and pls. 27 and 28.

172. NASAL SNUFFER as human head

Earthenware, light brown clay fired to a reddish-buff color
Diquis Zone(?)
Period VI (?) (AD 1000-1550)
Unnamed Type related to Tarragó Bisquit Group(?)
Height 3" (7.6cm) Width 3⅞" (9.8cm) Depth 6⅜" (16.2cm)
Condition before conservation: nose broken and repaired;
left ear restored
Accession no. N-1049

This pipe-like object, a nasal snuffer, probably was used for inhaling snuff made from *cojoba (Piptadenia* sp.) and/or tobacco. The bowl is minimally modeled as a human head, Pinocchio style, with the mouth pursed as though inhaling. Coffee-bean-shaped eyes are appliquéd onto the face. The hollow nose served as the inhaling tube.

Drug usage was common in Pre-Columbian Costa Rica. Paraphernalia included "needle case" coca containers, small clay "mixing" spoons and nasal snuffers sometimes with double tubes. Coca, used in neighboring Panama and cultivated by the Nicarao in historic times, undoubtedly was used in Costa Rica as well. *Piper* sp. is chewed today by the Boruca Indians in the Diquis region and may have been used in Pre-Columbian times[1].

The clay body of this snuffer and its general construction does not seem to fit the image of Tarragó Bisquit ceramics of the Diquis Zone although a related type, of a coarser clay and less finely potted, was produced and may be the group to which this snuffer belongs.[2]

1. Stone 1977, p. 158.
2. Snarskis 1982, p. 132.

173. LIDDED JAR OR TWO-PART INCENSE BURNER

Earthenware, reddish clay body fired to a buff color, unburnished, with purple-red slip or paint
Diquis Zone (?)
Period VI (AD 1000-1550) (?)
*Unnamed Type (AD 1415-1635)**
Height 8½" (21.6 cm) Diameter 9" (22.9 cm) Width 11⅛" (28.3 cm)
Condition before conservation: section of rim of lid and two horns broken and repaired; one horn chipped; chips on base; cracks on base
Accession no. N-1086 A and B

Acquired with the other ceramics in the collection as a vessel from Costa Rica, this unslipped buff-colored lidded vessel—jar or incense burner(?)—seems to belong in the Diquis Zone, but in shape and style it is an aberrant piece (personal communication to the author from Doris Stone). The center section of the body is decorated with raised clay ribbons or bands and alligator prongs(?). The latter, although solid, remind one of the prongs on Chinese root jars. The fitted lid slopes in to a ridged, flat top with a perforated knob of floral shape with a smoke(?) opening running through it. When inverted, the lid can stand on the flat knob and be put to other use. The splayed foot, round body, high flaring neck and lid shape are reminiscent of similarly shaped large lidded jars found near the mouth of the Amazon.

**OXTL analysis (ref. no. 381P82, 5/10/85) estimates that the sample tested was last fired between 350 and 570 years ago (AD 1415-1635).*

The vessels and effigies in Numbers 174 to 182 illustrate the few objects in the Sackler Collection which derive from neighboring cultures in Central America and northern South America with whom the Pre-Columbian Costa Ricans may have traded or by whom they may have been influenced.[1] They are included here for contrast and comparison and to anchor the Costa Rican ceramics in their regional context.

174. OBLATORY FIGURE with bowl

Earthenware, brownish-tan body, with traces of slip and burnish
Nicaragua or El Salvador (?)
Period IV (1000 BC-AD 500)
*Type uncertain (1826-376 BC)**
Height 8⁷/₈" (22.5cm) Width 5¹/₂" (14cm) Length 16³/₄" (42.5cm)
Condition before conservation: broken into many pieces and repaired
Accession no. N-1153

The large hollow female figure is molded in an oblatory pose, resting on knees and elbows, with head raised and with arms stretched out with an offering bowl in both hands. The eyes are lidded slits; the nostrils of the small, turned-up nose are prominent; and the shape of the mouth echoes the slitted eyes. Cap-like hair extends down around the ears whose pierced lobes once held ear ornaments. The lower part of the legs from knees to feet are raised above the ground in an awkward position, perhaps imitating an oblatory pose assumed during an offering ritual.

Purportedly found in Costa Rica, this was possibly a trade piece from further north, Nicaragua or El Salvador. A ceramic figure in similar style, although in a different pose and covered with cream and orange slip, is illustrated by Baudez.[1] From Chichigalpa, northern Nicaragua, it is attributed to circa 200 BC to AD 550, which corresponds to the dating derived from thermoluminescence analysis of the Sackler figure. Perhaps the Sackler figure originally was similarly slipped, although now there is no evidence of it. The style and proportions of the head are similar to that on a standing buffware figurine in the National Museum of Nicaragua which has the same ridged hairline and broad forehead. The facial features, however, particularly the eyes, are different. The Nicaraguan figurine, attributed to circa AD 750 to 1000, does not correspond to the span established for the Sackler piece.[2]

Pottery figurines, almost invariably nude figures of women whose function is difficult to determine, were widely distributed. Of solid or hollow construction and of varying sizes, sometimes painted, their features were usually simply rendered, incised or in relief. The best known are those from Playa de los Muertos, in the Ulúa Valley, northern Honduras, dating from circa 250 to 750 BC, which are rendered in graceful proportions and with charm of attitude and expression.[3]

1. Baudez 1970, pl. 11, from the collection of Enrique Neret, Managua, Nicaragua.
2. Dockstader 1964, no. 147.
3. *Ibid.* no.141, for examples of four of these figures in the collection of the Museum of the American Indian, New York, acc. nos. 4/3874, 18/3091, 4/3871,7595.

**OXTL analysis (ref. no. 381M83, 9/4/84) estimates that the sample tested was last fired between 2360 and 3180 years ago (1826-376 BC).*

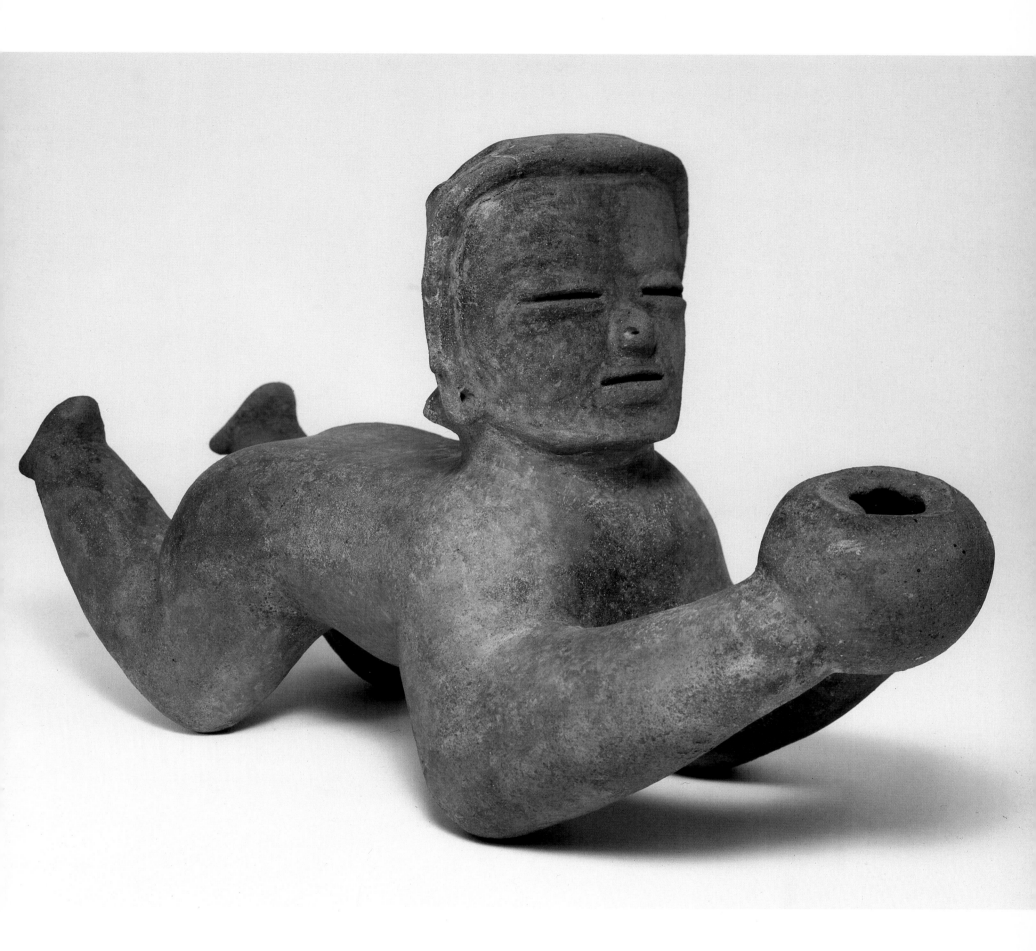

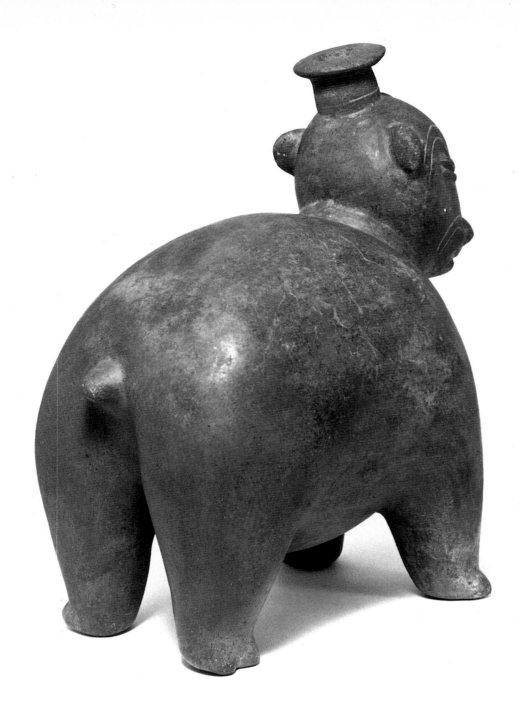

175. BEAR EFFIGY BOTTLE

Earthenware, brownish-tan body, burnished
Nicaragua or El Salvador (?)
Period IV (1000 BC-AD 500)
*Type uncertain (1046 BC-AD 124)**
Height 11" (27.9 cm) Width 6¼" (15.9 cm) Depth 10⅛" (25.7 cm)
*Condition before conservation: fractures on side; right front leg
broken and repaired; part of lip of spout reconstructed*
Accession no. N-1108

The large, modeled hollow bear-like figure has a lipped
spout projecting from the top of its head. The sensuously
round body curves down from the back, moving smoothly
into the animal's four legs. Its head, projecting from the
round shoulder, has a slightly more oval form. Facial fea-
tures include heavily lidded slit eyes, a broad triangular-
shaped nose, a wide slit mouth and two engraved whisker
lines curling around and down on either side of the nostrils.
A notched appliquéd strip of clay in the middle of the snout
runs down from the spout at the top of the head to the top
of the nose. Short stubby ears stand out on either side of the
head. The animal is wearing a collar and may represent a
village pet.

The nature of the clay bodies and generalized forms of this
animal effigy and the figure in Number 174 are sufficiently
similar to accept the notion that the two derive from the
same place. Although the age spans indicated by thermolu-
minescence analyses are different there is enough overlap-
ping time within them to find some common ground for
dating.

**OXTL analysis (ref. no. 381M9, 7/16/84) estimates that the sample tested was last
fired between 1860 and 1330 years ago (1046 BC-AD 124).*

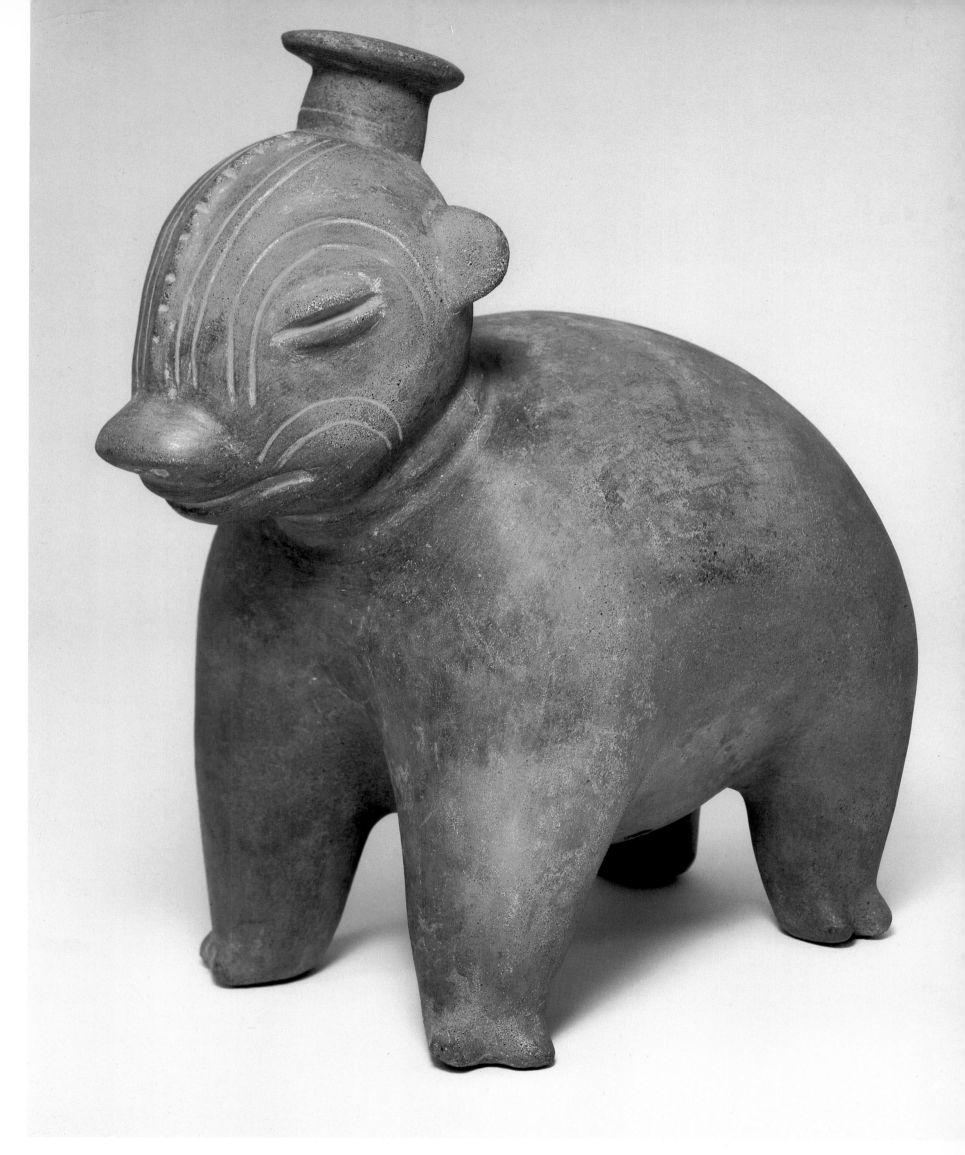

269

176. MOLDED VASE

Earthenware, tan clay body under a cream slip, burnished
Honduras, Ulúa Valley (?)
Period VI (AD 1000-1550)
*Type uncertain (AD 734-1274)**
Height 7¼" (18.4 cm) Diameter at widest point 6⅝" (16.8 cm)
Condition before conservation: chip in lip and base broken and repaired
Accession no. N-1142

This mold made vase rises from a flat base narrower than the width of the expanded lower body which then tapers in to the vessel's waist before splaying as it rises to the slightly wider mouthrim. It is decorated with relieved alligator bodies on opposite sides of the vessel. Incised lines encircle the vessel above and below the relief decoration. Geometric designs fill the background.

The decoration is very similar to that on the famous marble vases from the Ulúa Valley in Honduras. The marble vessels originated in Santana Farm in the Sula Plain, a small region of the Ulúa Valley, but were widely distributed, presumably through trade. Little is known of their iconography: Mexican Toltec influence is apparent in some; El Tajin-like designs (from Vera Cruz, Mexico) are found in others. The marble vases are characterized by stylized serpent scales, scrolls, projecting animal heads and their split counterparts on the vessel body.[1] They combine basic Central American and Nahuat or northern motifs carried to foreign ritual centers during the Late Classic Period, circa AD 600 to 900. Obviously, it was such marble vessels that must have inspired the production of clay imitations.

1. For examples of the marble vases see: Stone and Lange 1984, Fig. 6.10, for a small vase from the Sula Plain in the Peabody Museum, Harvard University; Stone 1977, p. 141, for two others, one from Peor es Nada at the southern end of the Sula Plain, Honduras, now in the Middle American Research Institute, Tulane University, and one from Ortega, near El Viejo, Guanacaste Province, Costa Rica, now in the Maria Eugenia de Roy Collection, San José; and Dockstader 1964, no. 136, for another one in the Middle American Research Institute, acc. no. 38-58.

**OXTL analysis (ref. no. 381L86, 7/10/84) estimates that the sample tested was last fired between 710 and 1250 years ago (AD 734-1274).*

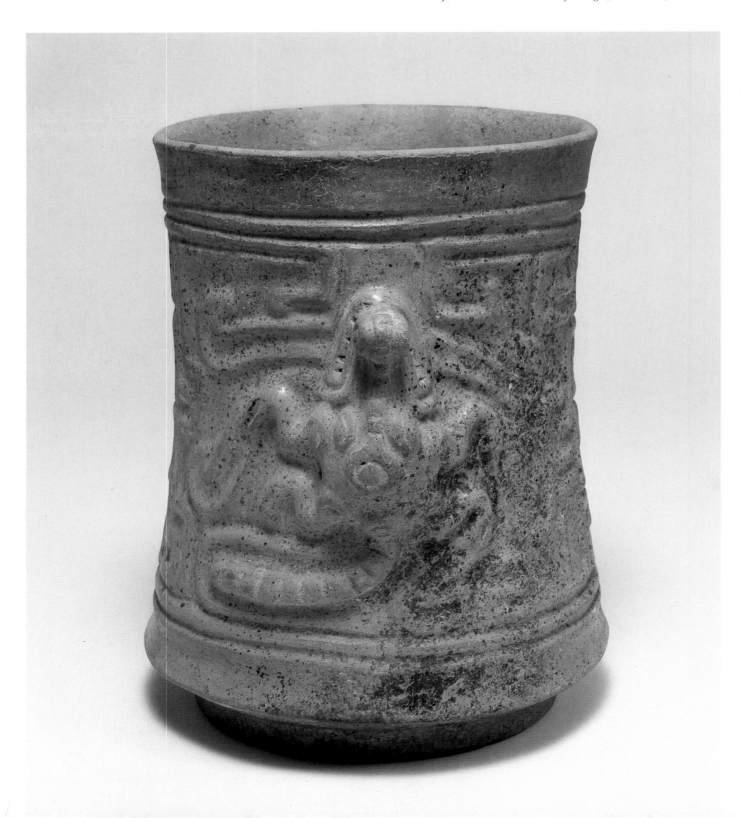

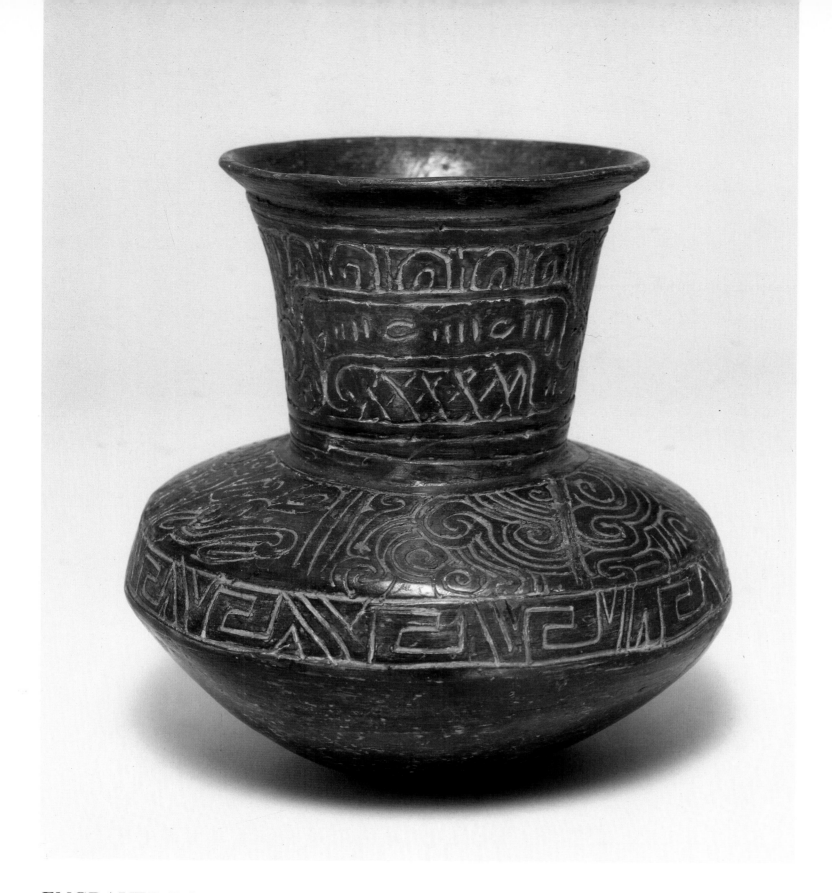

177. ENGRAVED BOTTLE

Earthenware, light reddish clay body under a brown slip, burnished
Guatemala/Honduras
Post Classic Period (AD 900-1500)
*Tohil Plumbate Ware (AD 1250-1550)**
Height 6³⁄₈" (16.2 cm) Diameter 6¹⁄₄" (15.9 cm)
Condition before conservation: broken into fragments and repaired
Accession no. N-1001

The bottle has a globular lower body and tall chimney-like neck with everted mouthrim. The walls of the lower body rise from a flat base and splay out to a broad shoulder. The tall neck flares slightly as it rises to the everted mouthrim. From the shoulder to the rim the vessel is decorated with panels of incised or engraved curvilinear designs. Around the edge of the shoulder is a rectilinear fret pattern alternating with oblique lines.

The shape of the vessel is common to the central plateau of Mexico.[1] Plumbate Ware probably first originated in western Mexico during the Post Classic Period. It is known for its burnished slip which approaches the consistency of a glaze. Often the color darkens to a leaden buff, but here it is a burnished brown. Examples of Tohil Plumbate Ware from the Mayan area have been found in Costa Rican sites.[2]

1. See Dockstader 1964, no. 31, for examples of central Mexican pottery from Ozumba and Teotihuacán.
2. Lothrop 1966, p. 183 and figs. 280 and 281.

**OXTL analysis (ref. no. 381P71, 4/18/85) estimates that the sample tested was last fired between 470 and 750 years ago (AD 1235-1515).*

178. HUMAN EFFIGY BOTTLE

Earthenware, buff clay body under a red slip, burnished,
with purple, black and white paint
Panama, Coclé Province
Period VI or VII (AD 700-1100 or 1100-1550)
*Macaracas or Parita Pottery**
Height 13½" (34.3 cm) Diameter 11¼" (28.6 cm)
Condition before conservation: surface paint fragile;
repair to upper neck
Accession no. N-1146

The large globular bottle has its neck modeled as a human head. Arms, hands and nipples are painted. The face is covered with a red mask probably representing body paint or tatooing. Black designs are painted on either side of the chin. The figure wears a cap with purple bands.

This vessel was probably used in burial. The soil remaining inside had dried grain imbedded in it, which may indicate the remains of a ritual offering at burial. Purple paint, seen on this vessel, came into use in the central region of Panama in Period V when four-color polychrome appeared. By Period VII, purple paint had gradually disappeared in this region. Designs had become stylized and rectilinear, and greater emphasis was placed on modeled overpainted decoration. Huge vessels were sometimes used in burial.[1]

1. Cooke 1984, pp. 263-302, for updated chronological sequence for central and eastern regions of Panama.
Cf. Lothrop 1942, fig. 123, for a similar vessel.
**OXTL analysis (ref. no. 381M82, 9/4/84) estimates that the sample tested was last fired between 540 and 870 years ago (AD 1114-1444).*

272

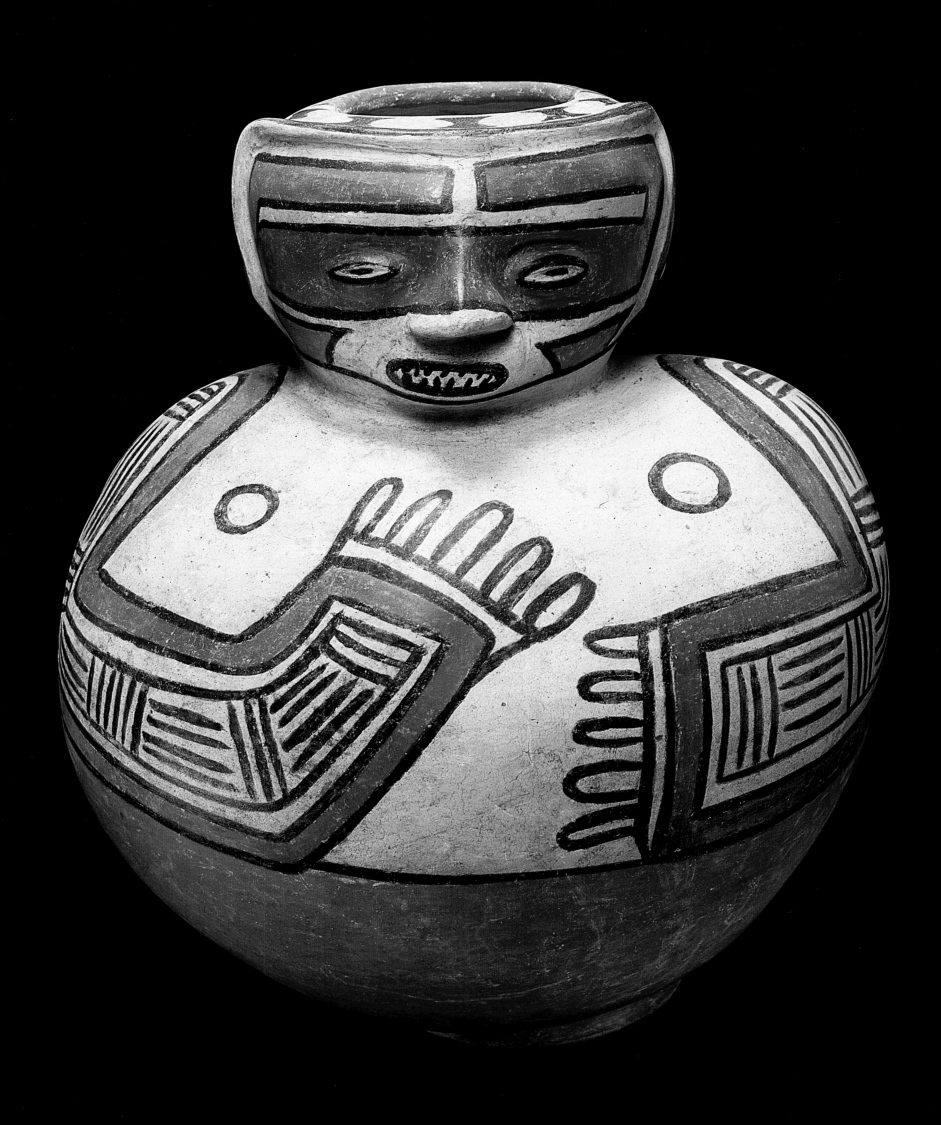

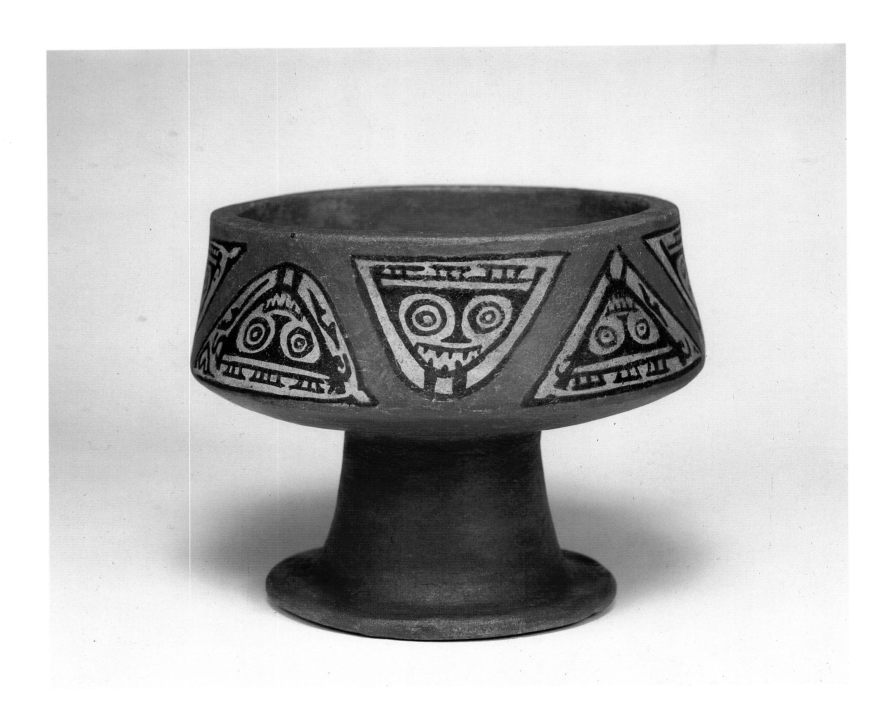

179. PEDESTAL BOWL

Earthenware, brownish clay body under a red slip, burnished,
with black and white paint
Panama, probably Coclé Province
Period V (AD 500-700)
Conte Pottery (AD 500-700)
Height 4⅜" (11.1 cm) Width 5¼" (13.3 cm)
Condition before conservation: chip at base, surface chips on interior
Accession no. N-1059

The deep bowl with walls which slant inward, rests on a flared base pedestal foot. Shield-shaped masks, alternating right side up and upside down constitute the design on the exterior of the bowl. They are probably meant to represent trophy heads (?) or the mask of the ubiquitous crocodile god found on the goldwork at Sitio Conte, Coclé Province, a site near Parita Bay in the central region of Panama. Besides the mask or face designs on one side of the bowl, there are similar triangular fields on the other side but they are pat-

terned differently. The vessel here, which seems to have been finished with a glossy resin varnish, is comparable to one excavated from Sitio Conte.[1] It may have been a trade item in Costa Rica.

Sitio Conte was a ceremonial center. Crude columns, some six feet high, many of which were sculpted, were found there in association with "altars" made of flat-topped boulders. It differs from ceremonial centers of upper Central America since stone masonry was not used, only perishable materials such as wood, cane and perhaps adobe. Sitio Conte was only one of the sites of this period when large, nucleated, maize-cultivating villages existed in Panama. It was a period during which there was increasing social differentiation in cemeteries, with mass burials around central persons. Mutilation of enemies (?) was also practiced.

1. Lothrop 1942, Fig. 305.

180. BIRD PEDESTAL BOWL

*Earthenware, reddish clay body under a buff slip, burnished
with red and black paint*
Panama, Parita Bay
Period VII (AD 1100-1550)
*Parita Pottery (AD 1000-1550)**
Height 8⁵⁄₈″ (21.9 cm) Diameter 8⁷⁄₈″ (22.5 cm)
Condition before conservation: intact and excellent
Accession no. N-1107

This elegant pedestal bowl is beautifully painted and is typical of the long polychrome pedestal vessels which began to appear in the central region of Panama in Period VI (AD 700-1100). The body of the bird, with short wings and a square tail, becomes the bowl or container. The head extends from the front. The bird represented may be a vulture. Details of body and face are picked out in paint against the buff or tan ground. The bottom of the pedestal is decorated with red and black geometrics with wing-like designs.

The period during which this vessel was produced continued the pattern of living and culture traits described under Number 178, but urn burials and interments in artificial mounds became more common. There is some evidence for a decline in the number, though not the size, of sites, and for the artificial modification of hilltops. In the central region of Panama ceramics from Period VI on show an increasing stylization of animal motifs and the development of long, polychrome pedestals.

Cf. Dockstader 1964, fig. 170, for a similar Parita pottery bird pedestal bowl from Veraguas, Panama in the Museum of the American Indian, acc. no. 22/8374, and Dockstader 1973, fig. 151, for another bird pedestal bowl from Santiago, Veraguas, Panama, also in the Museum of the American Indian acc. no. 22/8351.

**OXTL analysis (ref. no. 381M86, 9/3/84) estimates that the sample tested was last fired between 650 and 1150 years ago (AD 834-1334).*

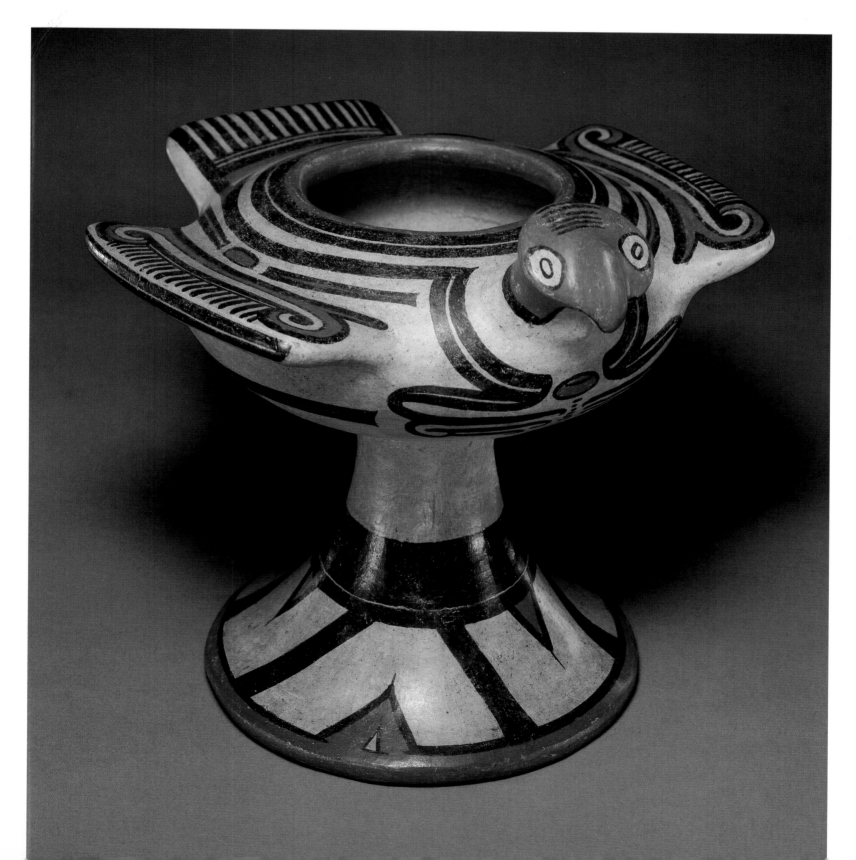

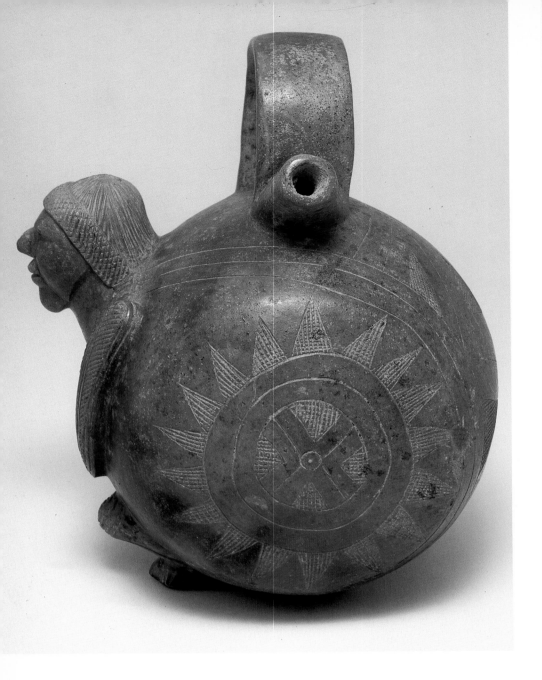
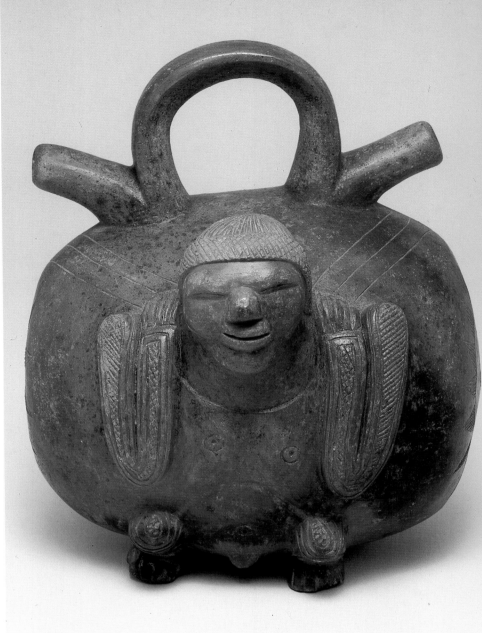

181. EFFIGY BOTTLE
with double spouts and ring handle

Earthenware, red clay body under a brownish slip, burnished
Colombia, Middle Cauca Valley
*Quimbaya Culture (AD 500-1000)**
Height 8½" (21.6cm) Width 6⅝" (16.7cm) Depth 6¾" (17.2cm)
Condition before conservation: intact; small chip in left side;
some "fire-clouding"
Accession no. N-1178

A horizontal cylinder or drum shape comprises the major portion of the vessel. The double spouts and strap handle emerge from the top of the drum. A squatting male figure with arms pendant partially modeled on the front of the cylinder appears to be carrying the drum on his back with the aid of a tumpline which circles his forehead on one end and supports the burden on the other. On the circular ends of the vessel small incised circles and triangles form a sunburst-like pattern surrounding a *kan* cross.

This vessel type is from the Quimbaya area, the Middle Cauca Valley. The vessel form, the earliest examples of which were found in the San Agustín area and attributed to the Isnos Period (AD 40-300?), continues into the Quimbaya style (AD 500-1000), named for an historic tribal group, and through the protohistoric period (AD 500-1500). The lower Cauca and Magdalena river valleys, which were settled during the first millennium BC, provided natural migration routes inland from the Caribbean for those who came either by land from the Isthmus of Panama or by sea. Apparent in Colombia are influences both from Meso- and Central America and the high cultures of the Central Andes in Peru. Clearly related to Ecuadorian and Peruvian cultures, Quimbaya ceramics were well-made and competent, many of them double chambered, double spouted with strap handles, polychromed and burnished. Quimbaya goldwork however, magnificent in its mastery of form and technique, ultimately influenced all pre-conquest goldwork in Meso- and Central America.

The earliest art of Colombia, ceramics of Puerto Hormiga on the Caribbean coast, dates from circa 3000 BC.[1] The other geographical-cultural areas began to stir aesthetically and culturally around 500 BC. Distinctive artistic achievement was attained in the Cauca Valley, the Eastern Cordillera, Sierra Nevada and the Darien. Two main cultures, the Tairona on the northeast coast and the Muisca (Chibcha) in the eastern central highlands, existed at the time of the conquest.

1. Reichel-Dolmatoff 1965, p. 45.

Cf. Perez de Barradas 1943, p. 93, fig. 130 top, and Reichel-Dolmatoff 1972, pls. 80, 82, and 85, for early examples of the form; Dockstader 1967, pl. 18, top right and left, for examples of Quimbaya black burnished vessels in this form, as well as Cordy-Collins 1979, no. 185; and Broadbent 1974, pls. 262a and b, for examples through the Late Period (AD 100-1500).

OXTL analysis (ref. no. 381R5, 7/8/85) estimates that the sample tested was last fired between 1800 and 2800 years ago (815 BC-AD 185).

182. ANTHROPOMORPHIC SEATED SLAB FIGURINE with metal nose ring

Earthenware, buff clay body under a red slip, burnished, with traces of negative resist decoration
Colombia, Middle Cauca Valley
*Quimbaya Culture (AD 500-1000)**
Height 7¼" (18.4cm) Width 6⅞" (17.2cm) Depth 2¾" (7cm)
Condition before conservation: head broken at neck; burnishing worn; hairline surface cracks
Accession no. N-150

The male figure emerges from a stiff rectangular slab body and head. The rigidity contrasts with the minimally modeled curving arms, legs and nose. The simple slit eyes and mouth are typical of the Quimbaya style in ceramic figurines and in metallurgy as well. The Sackler Collection has several similar examples of Quimbaya slab figurines but the one here has the gold or gold alloy nose ring still in place. Perforations in the head and body suggest that some material was probably attached; perhaps feathers, fiber, cloth or metal. In many of these figures, the right arm is raised in an undeciphered gesture, while the left hand rests on the left knee. The significance of these Quimbaya figurines is not known but they are often seen in pairs with female counterparts.

**OXTL analysis (ref. no. 381R3, 7/8/85) estimates that the sample tested was last fired between 600 and 1000 years ago (AD 985-1385).*

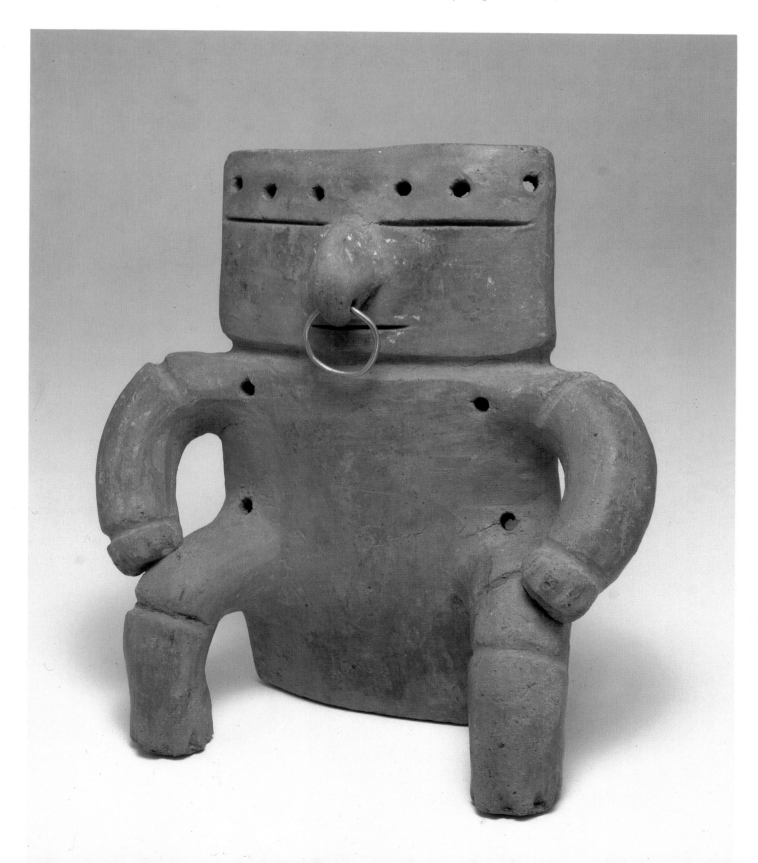

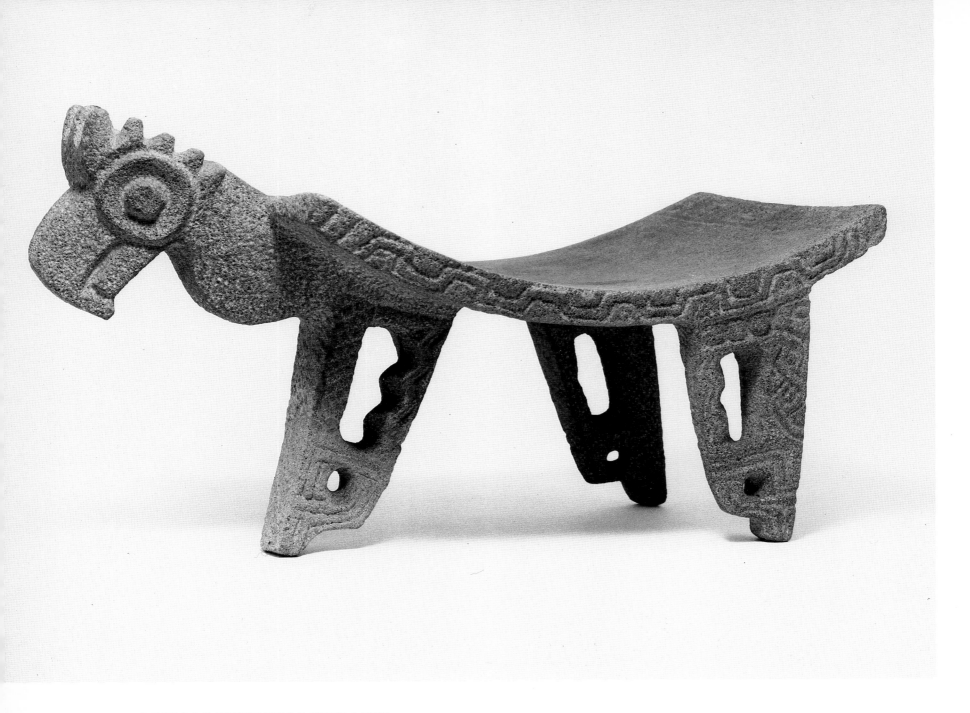

183. AVIAN-EFFIGY METATE

Volcanic stone
Guanacaste-Nicoya Zone
Late Period IV to Early Period V (AD 300-700)
Height 11" (28 cm) Width 9¼" (23.5 cm) Length 20" (50.8 cm)
Condition: worn slightly on upper surface
Accession no. X-1

Three kinds of stone objects are found together in obviously elite funerary contexts in the Guanacaste-Nicoya and the Atlantic Watershed/Central Highlands Zones: carved ceremonial metates, ceremonial mace heads, and jade pendants or axes. All seem to have been of significant symbolic importance, perhaps associated with high rank.

This avian effigy metate is carved with a projecting bird head adorned with feathered crest, which appears to belong to the raptor family. The sweeping curve of the plain metate plate is set off by low relief volutes on the sides and by the three slab legs carved in an open fretwork. The zoomorphic effigies may have been clan symbols, representations of deities, or of other significance. None, however, portray humans, only animals and birds.

The metate form, as illustrated here, is a refinement on the low, grain-grinding table (see No. 187). The plain tripod metate, a selective, local adaptation of a highland Mesoamerican ritual-mortuary trait, first appears in Nicoya about 300 BC to AD 300. The complex and elaborate three-legged version was possibly for the ceremonial grinding of grain, to process special foodstuffs and/or drugs in ritual contexts, and as burial furniture. Zoomorphic effigy metates, carved as this one is from a single piece of volcanic rock, were manufactured in Guanacaste-Nicoya from about AD 300 to 700. Most Nicoyan metates show little wear due to their primarily symbolic function. They were carved with stone, wooden or other perishable tools, and with abrasives.

It has been suggested that the metate was a symbol of transformation in the human life cycle.[1] As an implement of food transformation, the metate as a primary mortuary symbol may have extended the concept of transformation and signified a place of transformation in the realm of human life and death. On the other hand, some archaeologists believe that the metates may have been used as seats for elite persons since they frequently occur in high-ranking tombs. Some ceramic figurines are seen sitting on stools or seats, but the latter are always four-legged probably imitating wooden stools not three-legged metates.[2]

1. Graham 1981, pp. 123-124.
2. Snarskis 1984, no. 76.

184. CEREMONIAL METATE

Volcanic stone
Guanacaste-Nicoya Zone
Late Period IV to Early Period V (AD 300-700)
Height 11" (28 cm) Length 22½" (57.1 cm) Width 10¾" (27.4 cm)
Condition: shows some wear on curved plate
Accession no. X-2

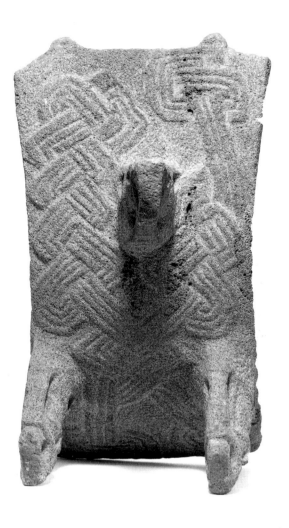

The thin, curved grinding plate on this metate rests on three legs sculpted as seated human figures with crested headdresses descending down their backs. When seen in profile, each leg appears to be a zoomorphic avian head. These figures can only be seen when the metate is turned with the curved plate upside down. The upper surface of the plate is carved in low relief at the front end (supported by one leg) with geometric interlaced motifs. Two nodes or tiny heads extend from the front edge. The underside is decorated with low-relief carving in a mat pattern or interlocking plaited design. The geometric interlace may represent the woven mat which was a common sign of authority in Mesoamerica, especially among the Maya.[1] The position of the design under the concave plate suggests that the metate was stored with the underside exposed.

1. Robicsek 1975, figs. 83-89; Graham 1981, pp. 127-130.

Cf. Snarskis 1981, no. 72, pl. 50 for another metate (with its *mano*), without effigy head but decorated with low-relief carving and openwork legs and two tiny feline heads, in the MNCR, acc. nos. 24182/24205. Snarskis also refers to two other similarly decorated metates excavated in 1980 by the MNCR from tombs at the Nacascolo site, Bay of Culebra, Nicoya.

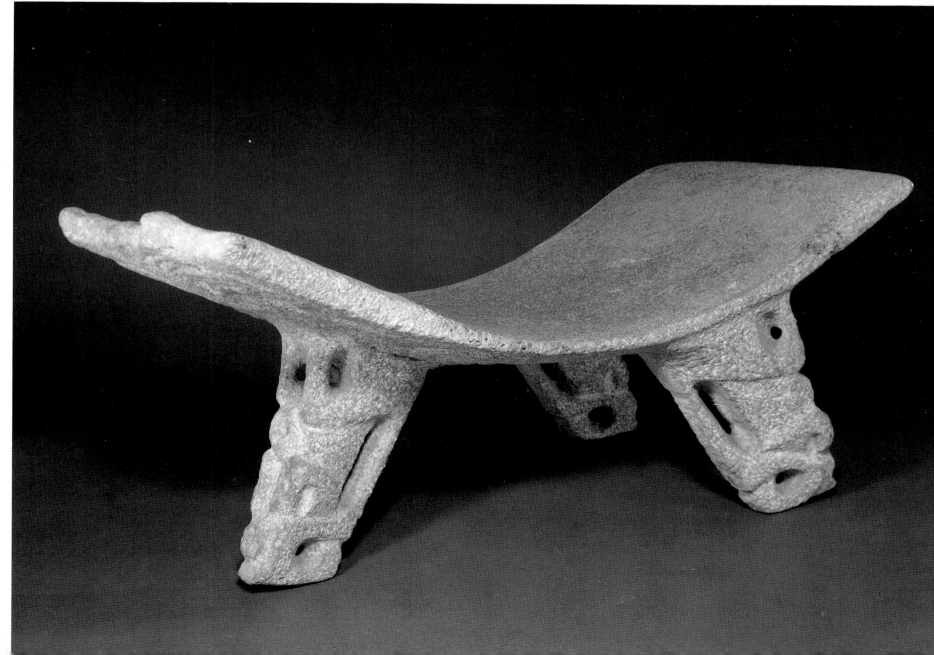

185. "FLYING PANEL" CEREMONIAL METATE

Volcanic stone
Atlantic Watershed/Central Highlands Zone
Late Period IV (AD 1-500)
Height 10¾" (27.4 cm) Width 23⅛" (58.7 cm) Length 26¾" (67.8 cm)
Condition before restoration: broken into large fragments
Accession no. X-3

So called "flying panel" metates, made in Late Period IV, are among the best examples of intricate stone carving in the Atlantic Watershed/Central Highlands Zone. Here, a slightly raised-rim plate, in concave, rectangular shape with rounded corners, is perched on a supporting "flying panel" incorporating the beak-bird deity standing on an interrupted crossbar. On the legs, the beak-bird is also seen pecking at human heads (see No. 132). Human trophy heads, stylized into simple notches, line the exterior rim of the plate. It has been suggested that the simple underside motifs

on Nicoyan and Atlantic Watershed metates initiated the development of this unique and most spectacular "flying panel" type of Costa Rican stone sculpture and that the technical achievements of metate carving may have contributed to the emergence of the first free-standing stone sculptures.[1]

1. Graham, 1981

Cf. Snarskis 1981, no. 144 (for an Atlantic Watershed flying panel metate with a representation of the beak-bird, in the MNCR, acc. no. 25679), no. 145 (another flying panel metate, reportedly from Azul de Turrialba, in the MNCR, acc. no. 20788, with an anthropomorphized beak-bird or a person wearing a bird mask and attendant monkeys on the legs), no. 146, pl. 51 (for a flying panel metate reportedly from La Unión de Guápiles with the central image of a human wearing an alligator mask perched on an animal back and with vulture-like birds holding human heads hanging from the outside of the tripod legs, in Caja Costa Ricense del Seguro Social Collection, now on loan to MNCR, acc. no. 73.981), and no. 147 (for a central human figure wearing an alligator mask with serpentine tongue and feline effigy headdress, and monkeys holding their tails swept up between their legs with felines below them holding trophy heads in their front paws hanging from the exterior sides of the tripod legs, also in the MNCR, acc. no. 15150, reportedly from San Rafael de Coronado, Central Highlands).

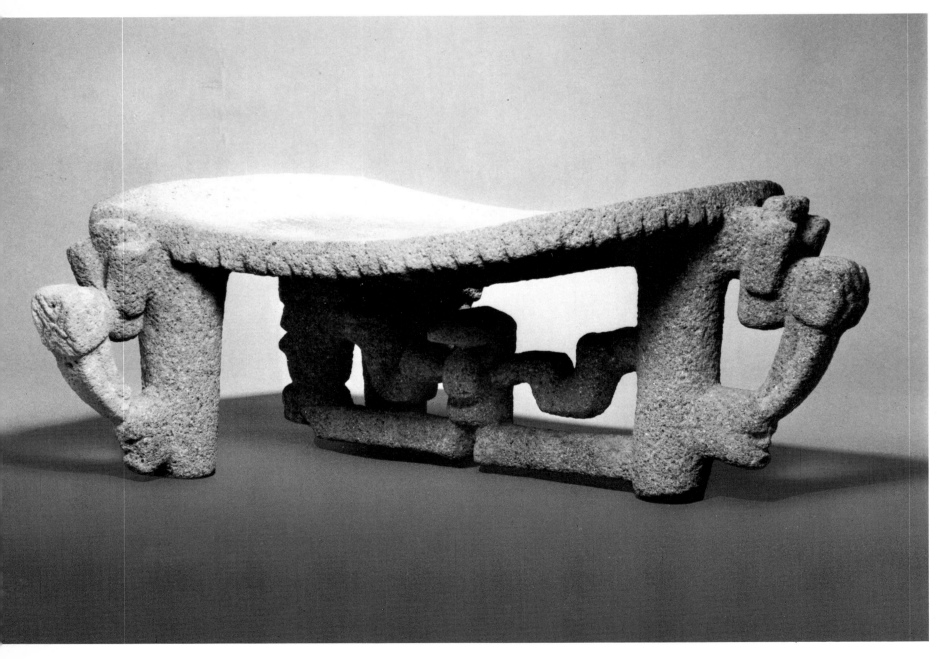

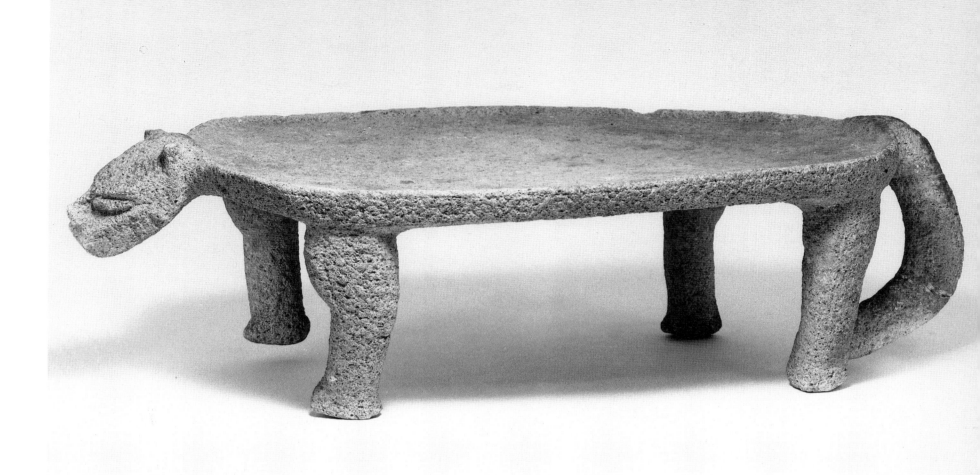

186. FELINE EFFIGY METATE

Volcanic stone
Atlantic Watershed/Central Highlands Zone
Period VI (AD1000-1550)
Height 8½" (21.6 cm) Width 15" (38.1 cm) Length 30" (76.2 cm)
Condition: intact
Accession no. X-4

The oval plate is supported on four legs. A jaguar head projects from one end of the plate and its tail from the other. The tail curves around and is attached to one of the hind legs of the animal. Such tetrapod forms are basically feline effigies. They appear to have been inspired by jaguar thrones of the Late Classic or early Postclassic periods in Mesoamerica. This metate style is the most likely to have doubled as a seat. The main area of its production was eastern and southern Costa Rica. In Nicoya, tetrapod metates or stools seem to be quite unknown.

Cf. Mason 1945, pls. 15-22, for other similar examples from Las Mercedes and of unknown provenience.

187. CEREMONIAL(?) METATE

Volcanic stone
Atlantic Watershed/Central Highlands Zone
Period VI (?) (AD 1000-1550)
Height 2¾" (7.0 cm) Width 7¾" (19.7 cm) Length 10¼" (26.1 cm)
Condition: intact and showing no wear
Accession no. X-5

This small-sized metate has an oval plate with notched designs around the edges representing stylized trophy heads. It stands on three undecorated, stumpy feet. Small, tripod metates, one with limited use polish and the other with no grinding wear, accompanied two low-relief carved metates without prominent effigy heads excavated from the Nacascolo site, Bay of Culebra, Nicoya.[1] Others of similar type reportedly from Las Mercedes in the Atlantic Watershed are illustrated by Mason.[2]

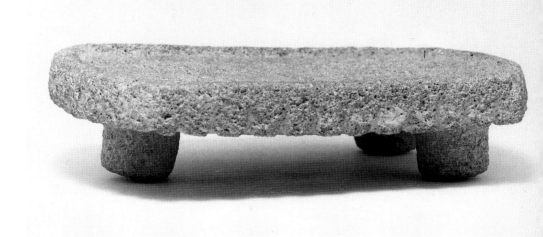

1. Snarskis 1981, no. 72.
2. Mason 1945, pl. 13.

188. REPTILIAN MACE HEAD

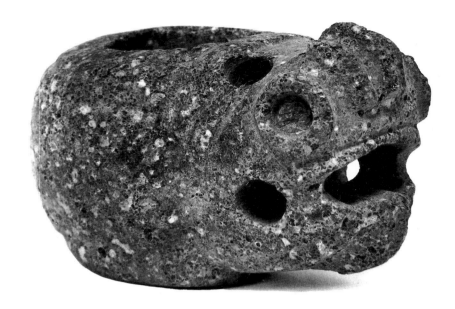

Stone, mottled brown
Guanacaste-Nicoya Zone
Late Period IV (AD 1-500)
Height 2¾" (7 cm) Width 3" (7.7 cm) Length 4⅝" (11.7 cm)
Condition: intact with wear around edges, polish remains in spots
Accession no. X-6

Extending from one side of this ceremonial mace head is the sculpted head of a reptile with a triple crest. Many solid and weighty ceremonial mace heads may have functioned as war clubs, but others, delicately carved and fragile, could not have been used as weapons. As seen here, a large central perforation or socket, usually biconical and made with a tubular drill, received the wooden shaft or handle to which the stone was hafted, although the nature of the handle and hafting are not known.

Mace heads have been interpreted as badges of office or emblems of clan or moiety affiliation. They were probably ceremonial versions of plain stone weapons. The display and ritual use of ceremonial versions of close-combat weapons may have signified a warrior's prowess and status. As with ceremonial metates or figure-decorated stone axes, they must also have been made by specialists and their distribution controlled by the ruling group. As do the metates, mace head imagery represents saurians, avians, felines and canines as well as bats, owls, human heads, and skulls.[1]

1. Graham 1981.
Cf. Ferrero 1977, pl. V, and Ilus, I-39, for other mace heads; and Stone 1977, Fig. 32, for examples from Guanacaste.

189. FELINE MACE HEAD

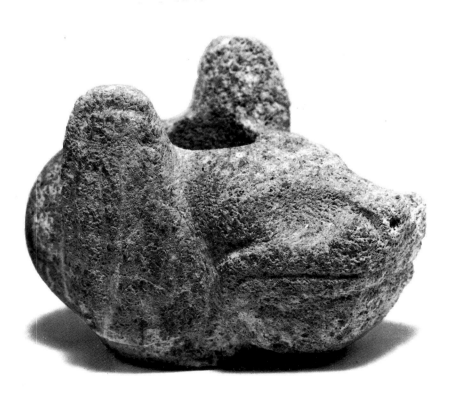

Light porous volcanic stone
Guanacaste-Nicoya Zone
Late Period IV (AD 1-500)
Height 2¾" (7 cm) Width 2¾" (7 cm) Depth 3¾" (9.5 cm)
Condition: intact, rough surface
Accession no. X-7

The mace head here was almost certainly not a weapon. It has been sculpted as a feline animal head, probably a jaguar. The socket is drilled, using a tubular drill, through the top of the head between the high-pointed ears. The squared muzzle shows the teeth and flared nostrils. Eyes are core drilled, i.e., drilling was done using hollow reeds, a bow with the string around the reed to give a circular motion, and sand and water.

Guanacaste-Nicoya mace heads are virtually identical to examples from the Atlantic Watershed/Central Highlands Zone from Late Period IV. Their similarity suggests limited centers of manufacture and a well established trade network.

Cf. Snarskis 1981, no. 48, for a ceremonial mace head, in the INS, acc. no. 3082, in the form of a *Urocyan,* a member of the Canidae family, a small four-legged animal known in Costa Rica as "little tiger."

190. PESTLE

Volcanic stone
Atlantic Watershed/Central Highlands Zone
Period IV (1000 BC-AD 500)
El Bosque Phase (100 BC-AD 500)
Height 7³/₄" (19.2cm) Width 3³/₄" (9.5cm)
Condition: rough surface
Accession no. X-8

Sculpted from fine-grained volcanic stone, this pestle, as do others of its type, has a thick flared head with convex base, elongated cone-shaped shaft, and the top or butt end surmounted by a carved stylized bird. Held on the butt end, it was probably used to crush grains, nuts and pigments with hammer-like blows. Although a functional tool, the carving on it, together with its relative proportions from part to part, has helped to convert it into a free-standing sculpture.

The conical pestle is a type often found in the Atlantic Watershed/Central Highlands Zone. Ornate conical pestles were found at Las Mercedes, an outstanding ceremonial site in the Santa Clara Valley;,they are similar to the pestle here. Many similar pestles have been found recently in Period IV El Bosque phase sites.

Cf. Mason 1945, Figs. 16f and g, for similar pestles with bird carving on the butt from Las Mercedes; Snarskis 1981, nos. 135 and 136, for two similar pestles of volcanic stone from the Atlantic Watershed Zone, Late Period IV, the former in the INS, acc. no. 3152, and the latter, with bird carving on the butt end very similar to the Sackler pestle and those from Las Mercedes, in the MNCR, acc. no. 11745.

191. STIRRUP-SHAPED *MANO*

Gray Volcanic Stone
Atlantic Watershed/Central Highlands Zone
Late Period IV (AD 1-500)
El Bosque Phase
Height 7¹/₂" (19cm) Width 6⁵/₁₆" (16cm) Depth 3³/₁₆" (8.2cm)
Condition: intact with hardly any evidence of wear
Accession no. X-9

Carved in close-grained stone, this stirrup-shaped tool, meant to be grasped with two hands and used to crush nuts, grains, pigments or other substances, exhibits a strong sculptural quality. It has a rocker or convex base, two side arms, and a connecting crossbar on top carved with an anthropomorphic bust on either side and a saddle-shaped covering which hangs down in front and back.

Stirrup-shaped *manos* also occur in the Guanacaste-Nicoya Zone and in the north coast highland region.

Cf. Snarskis 1981, no. 137, for a stirrup-shaped *mano* with a supine human form incorporated into the upper part, in the INS, acc. no. 3879.

192. POT STAND

Dense gray volcanic stone
Atlantic Watershed/Central Highlands Zone
Late Period V (AD 700-1000) or Period VI (AD 1000-1500)
Height 5⅝" (4.3 cm) Diameter 6¾" (17.2 cm)
Condition: intact
Accession no. X-11

This napkin-ring-shaped pot stand has been hollowed at the top. Carved around the top exterior rim is a continuous band of nodes probably representing trophy heads. Similar objects are also found in pottery.

Cf. Mason 1945, pl. 29, for comparisons of shape and trophy head rim.

193. WARRIOR with trophy head

Dense gray volcanic stone
Atlantic Watershed/Central Highlands Zone
Late Period VI (AD 1000-1550)
Height 14¾" (37.5cm) Width 9¼" (23.5cm) Depth 3⅞" (9.8cm)
Condition: tip of knife broken off; one ear broken off
Accession no. X-12

The standing warrior holds a human trophy head in his left hand and a stone celt (knife) in the other. The pose is a standardized one, as are the poses of most freestanding stone sculptures of Pre-Columbian Costa Rica. The crown of the warrior's head is set apart by grooving, indicating a cap or coiffure. His eyes are slits between double horizontal relief bands, and his mouth, thick lipped, echoes their shape. His nose is flat and broad. Horizontal raised projections in the middle of his legs indicate knees. An inverted "Y", incised on his upper body, marks his rib cage. The face of the trophy head is a mirror image of the warrior's.

Independent figural sculpture gained prominence for the first time in the Atlantic Watershed during Period VI, probably as the result of changed ritual activity. A variety of sculpture emphasized fertility and sexuality. Sacrifice was essential to secure fertility. The cycle of human sacrifice began with prisoner figures. Warrior figures like this one represent the completed act of sacrifice, ending the cycle.[1]

Because of the emphasis in their religion on human sacrifice, war was necessary; it was continuous in the Atlantic Watershed and the Diquis region. Some tribes waged war to obtain victims to be sacrificed and buried with the corpse on the death of the head of a family, and to capture males whose heads became trophies. Among other reasons, at the time of the Spanish conquest at least, it was waged to obtain women and youths for slaves. Among some tribes "slaves were well treated for a year after their master's death and given all they could eat and drink to become fit and strong. They were then tied to a tree and their ribs and loins beaten with poles until they died, and they were buried with their former master to serve him in the afterworld."[2]

1. Graham 1981.
2. Stone 1977, p. 135.
Cf. Mason 1945, pl. 40c, for a comparable figure; Snarskis 1981, no. 205, pl. 46, for a warrior figure holding a trophy head, in the MNCR, acc. no. 11697; Ferrero 1977, Ilus. III-85, for a warrior figure with tattoos on his chest, arms and around his abdomen, in the Alfonso Jimenez-Alvarado Collection, Costa Rica; and Stone 1977, Fig. 239b, for another figure in an unidentified collection.

284

194. STANDING MAN with trophy head

Pourous gray volcanic stone
Atlantic Watershed/Central Highlands Zone
Early Period VI (AD 1000-1550)
Condition: intact
Accession no. X-13

This is a stereotyped warrior with trophy head rather than a portrait of a specific individual. The heavy rope draped across his chest and over his shoulders has a trophy head dangling from it on his back. His arms, bent at the elbows, curve out from the shoulders and his long hands rest on the rope across his chest. His coffee-bean-shaped eyes are heavy lidded slits, his flat nose is a triangle, broad at the base, and his mouth is pursed as if he were whistling.

Many carved stone male figures assume similar poses. They project a rigid stylization and give evidence that certain role images were strictly perceived. Their standardized forms undoubtedly aided in their production. The trophy head cult was a manifestation of the fertility cult. Female figures, in this same pose, holding their breasts, were part of it.

Cf. Mason 1945, pl. 41c, for a comparable male figure with hands on breast but not wearing a rope with trophy head, and pl. 41a, for one with a rope for a trophy head over his right shoulder, both from Las Mercedes; also Snarskis 1981, no. 206, for another warrior with trophy head over his right shoulder, an axe against his left, and a diamond pattern coiffure on his head, in the MNCR, acc. no. 14832.

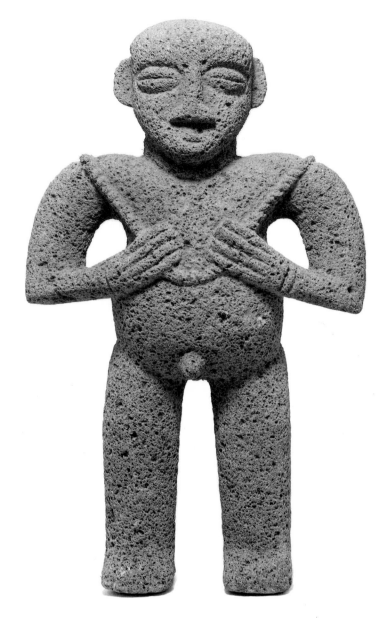

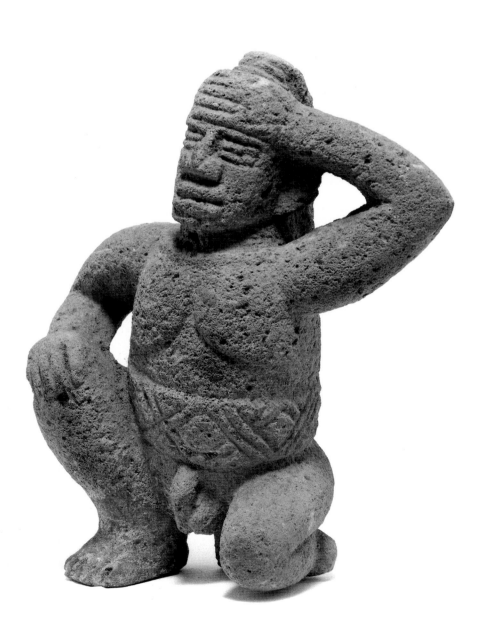

195. KNEELING BALLPLAYER

Cream-colored stone
Atlantic Watershed/Central Highlands Zone
Period VI (AD 1000-1550)
Height 7⁷⁄₈" (20cm) Width 6¹⁄₈" (15.6cm) Depth 3¹⁄₄" (8.3cm)
Condition: intact
Accession no. X-14

The figure may represent a ballplayer, momentarily dazed, in the midst of the sacred ball game, a Pre-Columbian Mesoamerican ritual event in which the defeated ballplayer was sacrificed.

Sculpted from a lighter colored stone than the previous figures, the kneeling ballplayer seems to have been hit a heavy blow to the head which has caused him to fall to one knee and to hold his head with one hand. His other hand rests on his right knee. What may be bark or cloth armor encircling his waist, is incised in a guilloche band or textile pattern. His long hair, delineated with vertical grooves, descends from a knot on the top of his head in thick locks down his back.

Cf. Mason 1945, pl. 44b, for a kneeling figure from Las Mercedes.

285

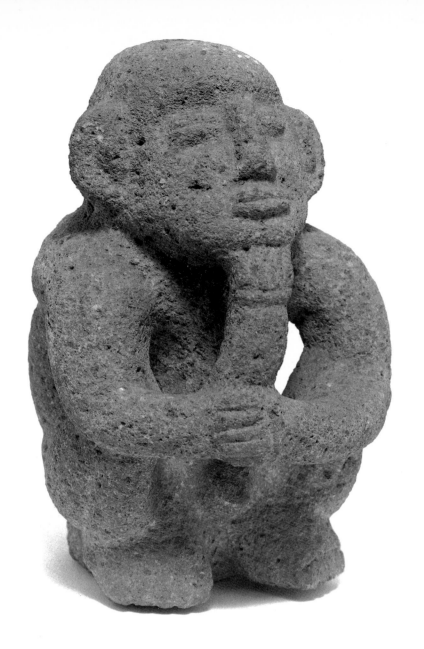

196. SMALL SEATED *SUKIA* FIGURE

Tan stone
Atlantic Watershed/Central Highlands Zone
Period VI (AD 1000-1550)
Height 7½" (19cm) Width 4⅞" (12.3cm) Depth 5⅝" (14.3 cm)
Condition: intact
Accession no. X-15

This sculpture is characteristic of the hunkered forms known in Costa Rica as *sukia* figures. *Sukia* is a Mosquito Indian word meaning medicine man. Many such figures were found at the Las Mercedes site. They are, like the figure here, nude males seated with folded arms resting on their knees or playing what appears to be a flute. The pose is contemplative. The figure sits upright with knees flexed. The elbows of his folded arms rest on his knees. His face is tilted up and exhibits heavy-lidded, oval eyes in relief from the hollows of the eye sockets. He has a straight triangular nose and wide pouting lips. His ears are large in proportion to the head and features of the face. Toes and fingers are indicated by grooving. One hand appears to clasp an object, with a frieze of decoration at its top end, which reaches to his chin. It is actually the figure's hand and fingers, but the carver made an error in the length and construction of the right forearm.

Sukias have been described as shamans playing a flute, smoking or blowing and sucking a tube, perhaps as part of a curing ritual. They are also seen in attitudes of contemplation. As figural sculpture they are the most frequently encountered Period VI type in eastern and central Costa Rica. Thousands have been found in varying sizes in which the pose is almost identical, giving the impression that the figures were mass-produced.

Cf. Mason 1945, pls. 43 and 44, for other examples from Las Mercedes.

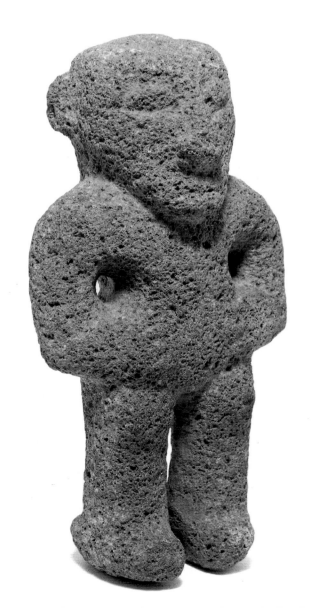

197. STANDING FIGURE

Gray volcanic stone
Atlantic Watershed/Central Highlands Zone
Period VI (AD 1000-1550)
Height 7½" (19 cm) Width 4" (10 cm) Depth 2½" (6.3 cm)
Condition: unfinished
Accession no. X-17

Two holes drilled through the stone on either side of the upper body delineate the shoulders and arms. A large vertical groove, splitting the lower part of the stone, separates and defines the legs with their stumpy feet. An almost heart-shaped oval forms the overly large neckless head with the chin resting on the chest. There is no indication of the sex of this standing figure whose arms are flexed with hands on hips. From the lack of facial or body details, it appears unfinished.

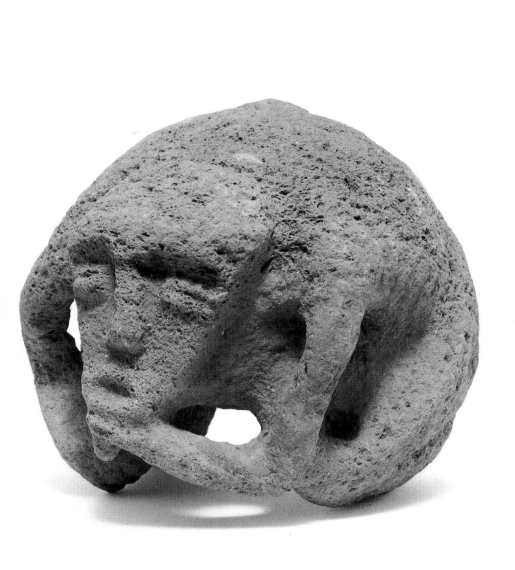

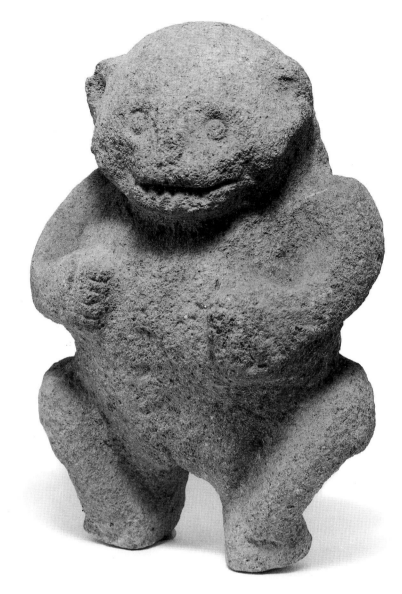

198. SEATED MONKEY

Gray porous volcanic stone
Atlantic Watershed/Central Highlands Zone
Period VI (AD 1000-1550)
Height 7½" (19cm) Width 7¾" (18.3cm) Depth 6⅞" (17.5cm)
Condition: intact
Accession no. X-19

The monkey is seated on his haunches with his knees flexed.
His left elbow rests on his left knee with the hand raised to
his chin. His right hand rests on his right knee. The long
triangular face, supported under the chin by the left hand,
looks like that of an aged person. The eyes are small and
protruding and the mouth is pursed as if making monkey
sounds. The pose of the animal is similar to the *sukia* figures
discussed in Number 196.

199. STANDING BEAR

Sandstone (?)
Atlantic Watershed/Central Highlands or Diquis Zone
Period VI (AD 1000-1550)
Height 9" (22.8cm) Width 6" (15.3cm) Depth 4¼" (10.7cm)
Condition: intact but surface worn
Accession no. X-20

The bear appears to be walking. It has a massive head with
small circular eyes, a large muzzle with open mouth and
prominent teeth, and small flattened ears. Its front paws rest
on its breast.

This figure is unusual among published examples of stone
sculpture although Mason illustrates some small seated ani-
mal figures from Las Pacayas, situated on the slopes of the
Irazu Volcano in central Costa Rica. They are somewhat
similar in style, differing markedly from the art of the Las
Mercedes stone figures. A resemblance to the style of carv-
ing at Palmar, a small settlement near the mouth of the Rio
Diquis in southern Costa Rica, is apparent. Mason illustrates
some animal figures from Palmar carved in fine-grained
sandstone which have the same generalization of form as
the Sackler bear.[1]

1. Mason 1945, pl. 60a, also pl. 52c for an animal and figure similarly carved.

200. STANDING FIGURE

Sandstone
Diquis Zone
Period VI (AD 1000-1550)
Height 17" (43.2cm) Width 10" (25.4 cm) Depth 4¹/⁴" (10.8cm)
Condition: intact
Accession no. X-21

Deity or warrior, this male figure stands on a peg or tenon base extending beyond the feet, presumably to be inserted in the ground. This is typical for figures from the Diquis Zone. Very stylized, they are characterized by lines of large dots or discs, seen here on the front of the arms and body, probably representing jaguar spots. Double incised lines on the legs indicate knees. The figure appears to be wearing a flat cap or hairdo with a knot at the back of the head (perhaps a slingshot), a breechclout and a rope over his shoulder meant to hold a trophy head. Perforations separating arms and body, usual in such figures, do not appear here, yet the figure is more realistic than most of this type.

Sacred enclosures with lines of tenon figures were found at Coclé, Panama. One assumption is that such figures represented deities and stood in sacred places, possibly with temples constructed of perishable materials.

Cf. Mason 1945, pl. 59, for comparable figures.

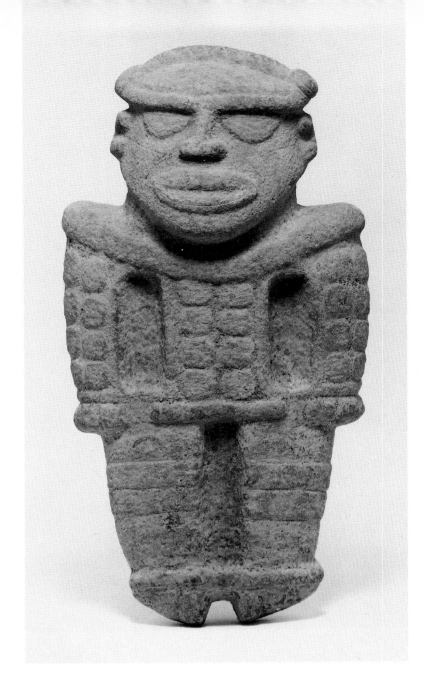

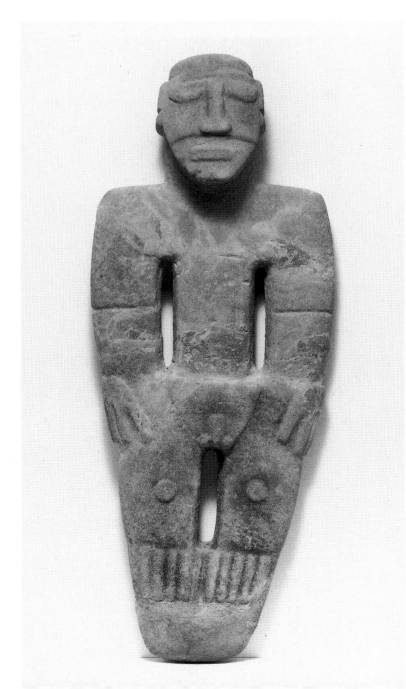

201. STANDING MALE FIGURE

Sandstone
Diquis Zone
Period VI (AD 1000-1550)
Height 21¹/₂" (54.6cm) Width 8¹/⁴" (21cm) Depth 4¹/⁴" (10.8cm)
Condition: cracks on both shoulders repaired
Accession no. X-23

This figure also stands on a peg or tenon base. The head is rather large and flat with a groove below the broad, flat nose. Fingers, toes and elbows also are defined by grooves. Knobs on the legs represent knees, and the male sex organs are indicated. Hands resting on the hips are extremely large. The stylization of the form creates an almost abstract figure which differs markedly in concept from the more realistically portrayed human figures from the Atlantic Watershed.

Cf. Mason 1945, pl. 58, for comparable figures.

288

Objects not in the exhibition

1. BOWL with wide mouth

*Earthenware, reddish clay body under a red slip, burnished,
with white paint
Guanacaste-Nicoya Zone
Late Period IV (100BC-AD500)
Matazana Red on Buff Type (100BC-AD500)
Height 6" (15.2 cm) Width 8¾" (22.2 cm)
Condition before conservation: two surface holes,
one repaired; some fire-clouding
Accession no. N-1055*

2. JAR with alligator motifs

*Earthenware, reddish clay body under a red slip, burnished,
with red, black and orange-yellow paint
Guanacaste-Nicoya Zone
Period V/VI (AD 500-1500)
Carrillo/Galo Polychrome (AD 500-800)
Height 7½" (19.1 cm) Diameter 6" (15.2 cm)
Condition before conservation: crack in rim
Accession no. N-1054*

3. BOOT-SHAPED VESSEL with loop handle

*Earthenware, reddish clay body under a red slip, burnished
Guanacaste-Nicoya Zone
Period VI (AD 1000-1500)
Type uncertain (AD 1185-1485)*
Height 5¾" (14.6 cm) Width 5½" (14 cm) Depth 8⅞" (22.5 cm)
Condition before conservation: surface chips and scratches
Accession no. N-1085*

**OXTL analysis (ref. no. 381 p81, 4/3/85) estimates that the sample tested was last
fired between 500 and 900 years ago (AD 1085-1485).*

4. FOOTED JAR with animal appliquéd on neck

*Earthenware, red clay body under a creamy slip, burnished,
with orange-red and black paint
Guanacaste-Nicoya Zone
Late Period VI (AD 1200-1550)
Pataky Polychrome, Pataky Variety (AD 1200-1350)
Height 13⅜" (34 cm) Diameter of mouth 7¾" (19.7 cm)
Condition before conservation: root marks, surface scratches and
chips near base and rim
Accession no. N-1022*

5. FOOTED JAR

*Earthenware, reddish clay body under a white slip, burnished,
with black and red paint
Guanacaste-Nicoya Zone
Late Period VI (AD 1200-1550)
Pataky Polychrome, Pataky Variety (AD 1200-1350)
Height 12" (34 cm) Diameter of mouth 7¾" (19.6 cm)
Condition before conservation: root marks throughout;
paint chips throughout; small rim chips
Accession no. N-939*

289

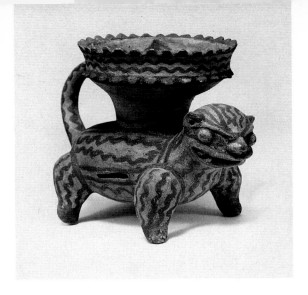

6. FELINE EFFIGY with bowl on its back

Earthenware, reddish clay body under a tan slip,
with black paint
Guanacaste-Nicoya Zone
Period VI (AD 1000-1550)
Guabal Type (AD 1000-1550)
Height 6¼" (15.9 cm) Width 5" (12.7 cm) Length 8⅜" (21.3 cm)
Condition before conservation: broken and repaired
Accession no. N-1045

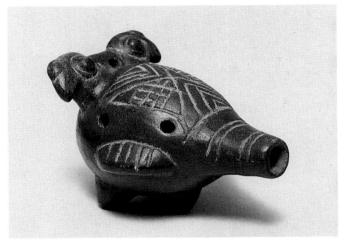

7. BOWL with animal or bird head and tail

Earthenware, brownish body under a brown slip, burnished
Guanacaste-Nicoya Zone
Period VI (AD 1000-1550)
Castillo Incised/Engraved (AD 1200-1550)
Height 2⅛" (5.4 cm) Width 3½" (8.9 cm) Depth 3⅝" (9.2 cm)
Condition before conservation: intact
Accession no. N-925

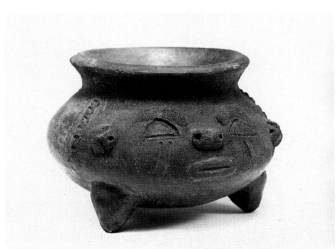

8. FOUR-NOTE OCARINA with double bird heads

Earthenware, tan clay body under a chocolate slip, burnished
Atlantic Watershed/Central Highlands Zone
Period V (AD 500-1000)
Chitaria Incised/Engraved Group (AD 700-1000)
Height 2¼" (5.7 cm) Width 2½" (6.4 cm)
Condition before conservation: slight surface chips throughout
Accession no. N-977

9. TRIPOD BOWL with appliquéd face on chamber

Earthenware, reddish brown sandy clay body
under a red-brown slip
Atlantic Watershed/Central Highlands Zone
Late Period IV/Early Period V (AD 1-700)
El Bosque or La Selva Phase (AD 400-700)
Height 3¼" (8.3 cm) Width 4½" (11.4 cm) Depth 4½" (11.4 cm)
Condition before conservation: exterior worn;
surface chips on rim
Accession no. N-518

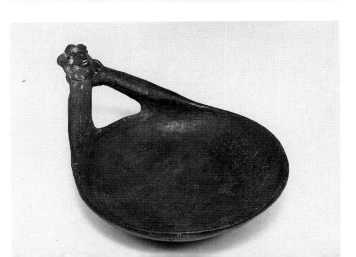

10. FRYING PAN CENSER with head on handle

Earthenware, brownish clay body with orange-brown
slip, burnished
Atlantic Watershed/Central Highlands Zone
Period VI (AD 1000-1550)
Unnamed Type
Height 2¾" (7 cm) Width 6" (15.2 cm) Length 8¼" (21 cm)
Condition before conservation: broken and repaired;
chip on rim; root marks
Accession no. N-397

11. BOTTLE with complex silhouette

Earthenware, reddish body under a dark brown slip
Atlantic Watershed/Central Highlands Zone
Early Period VI (AD 1000-1350)
Tayutic Incised/Engraved (AD 1000-1350)
Height 5⅝" (14.4 cm) Depth 7¾" (19.7 cm)
Condition before conservation: root marks;
chips to rim of spout; crack on rim
Accession no. N-1000

12. TRIPOD BOWL with slanting slides

Earthenware, reddish clay body under a brown slip, burnished
Atlantic Watershed/Central Highlands Zone
Period V (AD 500-1000)
*Type uncertain (AD 685-1035)**
Height 3⅝" (9.2 cm) Width 8¾" (22.2 cm)
Condition before conservation: broken into three
large fragments and repaired
Accession no. N-1097

**OXTL analysis (ref. no. 381p63. 4/3/85) estimates that the sample tested was last*
fired between 300 and 550 years ago (AD 1485-1685).

13. BOWL with strap handles, appliquéd animals and reed circle designs

Earthenware, brownish clay body under a black slip
Atlantic Watershed/Central Highlands Zone
Period VI (AD 1000-1550) or later
*La Cabaña-Pavones Group (AD 1435-1685)**
Height 5⅛" (13.0 cm) Width at handles 6½" (16.5 cm)
Condition before conservation: rim chip; surface scratches
Accession no. N-526

**OXTL analysis (ref. no 381p87, 5/10/85) estimates that the sample tested was last*
fired between 950 and 1300 years ago (AD 685-1035).

14. TRIPOD VESSEL with modeled effigy neck and strap handle

Earthenware, brown clay body under a brown slip, burnished
Guanacaste-Nicoya or Atlantic Watershed/Highlands Zone
Period, type and date uncertain
Height 6¾" (17.1 cm) Width 4¼" (10.8 cm) Depth 4¼" (10.8 cm)
Condition before conservation: spout broken and repaired; surface
chips; legs broken and repaired
Accession no. N-523

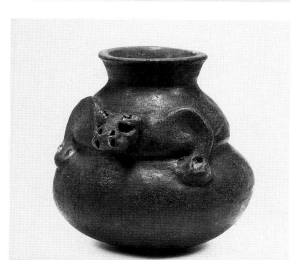

15. JAR with animal appliquéd on neck and strap handle

Earthenware, brownish body under a brown slip, burnished
Guanacaste-Nicoya or Atlantic Watershed/Central Highlands Zone
Period, type and date uncertain
Height 4" (10.2 cm) Depth 4½" (11.4 cm)
Condition before conservation: crack around bowl;
cracks on base and feet; rim chipped
Accession no. N-1050

Fig. 1 Objects soaking in deionized water for removal of absorbed salts and contaminants, after 24 hours.

Fig. 2 Same objects as Fig. 1, soaking in deionized water, 5th day.

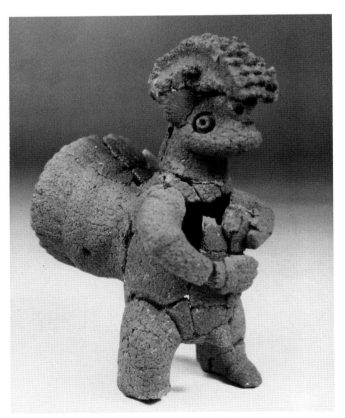

Fig. 3. Assembled figurine in extremely friable condition.

Fig. 4. Careful removal of deposit with dental tool.

The Examination and Conservation of Costa Rican Ceramics

ROBERT and TOBY STOETZER

Each of the Costa Rican ceramics in the Sackler Collection has undergone thorough examination to determine both the condition and authenticity of the object. Considerable information about the ware was first obtained by visual examination which thus laid the groundwork for other types of study.

The first requirement for an examination is skillful observation aided by strong light. Good light will usually expose discolored or poorly matched restorations. By moving light across the object in a raking manner one is able to see differences in texture.[1] A variation in surface texture without the logic of change in design makes an area suspect. If discoloration exists or if color is dull in tone, suspicion is further aroused.[2]

Magnification extends the observer's ability to identify material substance. At magnified levels of vision, differences between original material and additions are usually apparent. Ultraviolet light is also a valuable aid in examining ceramic objects to identify some restorations. Some pigments and their binders fluoresce differently than the pigments of originally fired paint. When viewed in total darkness the differences can be easily observed.[3]

X-rays are another nondestructive method for gaining information. When X-rays are directed through an object, the density and thickness of materials are projected as an image on the film. When the radiation meets no resistance (as in holes) the film is completely exposed and appears black. Where radiation is absorbed by the material the film is unexposed and appears white.[4]

Fractures concealed by prior restoration and additional material, if different from the orginal, are apparent. In interpreting X-rays, one must be familiar with the material being X-rayed.

To determine the extent of any prior restoration on the Sackler Costa Rican ceramics, we examined the material with solvents. The fired paint of ceramic bodies is not affected by acetone. Most paint used for restorations is readily soluble. We used cotton swabs to apply the solvent to small areas on the ceramic surface. We used such a scrutinizing technique on objects which seemed suspicious.

We observed the hardness, deposits, dirt, abrasions, and fractures of the ceramic as well as studying the degree and quality of existing restoration. Thus we were finally able to write a condition report and proposal for conservation, cleaning and/or restoration.

If during examination we began to feel suspicious about the authenticity of an object, we drilled into the underside of the ceramic or an inconspicuous place to remove a sample of the clay body which we then sent to The Research Labora-

tory for Archaeology and the History of Art, Oxford University, for thermoluminescence (TL) analysis, a reliable method for determining the last firing of an object.[5] Many ceramics, other than those of questionable authenticity, were tested by TL analysis to gain information and data for research and further study. The entire process of visual, physical, and scientific examination of the collection was conducted jointly by the curator and the conservator.

The soil conditions in burials can vary from region to region, and minerals and salts which might be harmful to the ceramic material may be present. Therefore, each object had to be cleaned with water to remove accumulated dirt and soil from its surface. Each was also soaked in distilled water, with the exception of extremely friable material, to remove any soluble minerals, salts, or organic materials which might have been absorbed into the porous ceramic body (Figs. 1, 2). By measuring the electrical conductivity of the water and changing the water daily, it was possible to determine when the contaminants had been effectively leached from the ceramic.

During this soaking process many objects developed a surface growth of a clear, gelatinous substance, which, when tested, was determined to be rapidly growing bacteria cultures, slime mold and fungus, warranting additional studies. Presumably these bacteria resulted from contaminants absorbed into the ceramic from the burial and were reactivated in the bath.

Many low-fired ceramics are porous and susceptible to deterioration in humid burial conditions.[6] The resulting friable conditions require consolidation by impregnation of an acrylic resin before any other treatment can be performed (Fig. 3).

Accretions of mineral deposits or plant roots which adhered to surfaces were removed by scaling with dental implements. This was done taking extreme care not to harm the original material (Fig. 4). Burial stains, especially apparent on ceramics with light-colored slips, were cleaned chemically and thus minimized.

Poor prior restorations were disassembled using various solvents ranging from acetone to xylol. The determining factor in choosing not to reverse restoration was the friability of material. Reversal was not attempted if it could possibly result in additional damage. Nor were vulnerable objects soaked in distilled water. Instead, improvements were made to the quality of prior restoration.

Contemporary paints used in prior restorations were removed. The objects were disassembled and the resulting fragments were cleaned to remove any traces of adhesive that would inhibit proper realignment in the regluing

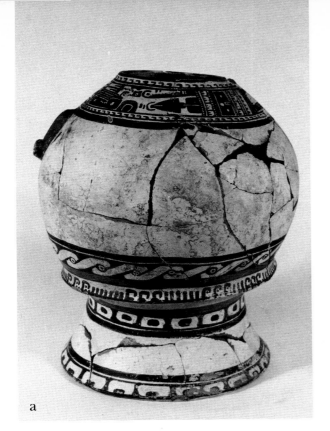

a

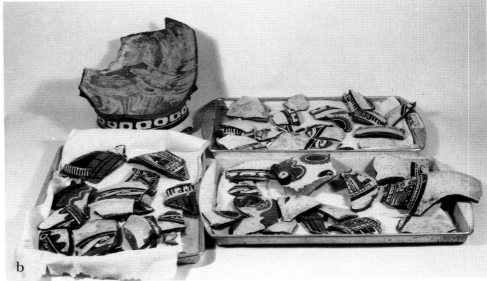

b

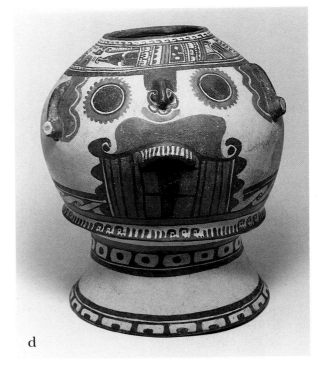

c

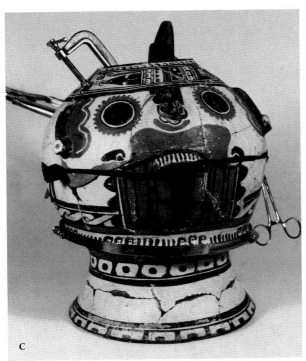

d

Fig. 5. (a) No. 84 in condition of prior restoration.
(b) Object disassembled for proper restoration.
(c) Regluing under tension to achieve proper alignment.
(d) Completed restoration.

process (Fig. 5a-d). The reversing of prior restoration often revealed multiple episodes of restoration. We were able to observe that many ceramics in the collection formerly had been repaired by the same hand, i.e., distinctive characteristics of technique, craftsmanship and materials were apparent.

Unfortunately, in prior restoration episodes, one method employed to compensate for misalignment was to groove the edges to be glued together and to file down raised parts of the original material. Such practices are a violation of ethical techniques of restoration.

Generally a plan for the sequence of reassembly is based on the shape of the object and the shapes of the fragments. The adhesive used is an aqueous emulsion of polyvinyl acetate.[7] This type of solution permits the softening of glue joints for realignment at any time necessary during the assembly process.

By wetting the surface of the fragments prior to application of the glue, any excess glue that is squeezed out when the fragments are pressed together can be wiped off with a damp sponge without affecting exposed surfaces. The joined fragments are placed in a sandbox and adjusted to a position of balance where gravity keeps them aligned until the adhesive has dried. Allowing ample time for bonding to take place is essential. If the pieces are disturbed before the adhesive has hardened, the juncture will be weakened.[8]

One difficulty frequently encountered is the distortion that occurs in the shape of a vessel after breakage. Breaks, especially in low-fired ceramics, release tensions that were set up in the object as the clay dried or as it was fired and cooled down. The result is that fragments do not align exactly. It is therefore necessary, through the use of clamps, to recreate the force of the original internal tension until the adhesive is thoroughly set (Fig. 5c).

Any missing fragments to the whole were reconstructed of laboratory plaster. The requirement here was to match the contour and texture of the fired clay. The open cracks of glued joints were also filled on the exterior and if possible (i.e., open forms) on the interior. Pits, abrasions, and missing flakes of slip were filled with a vinyl compound to return the surface to a complete state of repair.

When all measures were completed, the areas which had been reformed were carefully painted to match color and design of adjacent areas. The paint which is applied is an acrylic emulsion, easily removable with acetone. Paint is mixed to duplicate not only nuances of color but also the luster of finish from flat to gloss. The quality and weight of brush strokes are observed on each individual piece and restoration paint is applied in a manner meant to duplicate those characteristics. Care is taken to apply paint only to newly fabricated parts or filled cracks.

On any objects in which fragments had been missing within areas of design, such designs were completed by careful observation and duplication of the original motif. In no instance has any part of any object been restored without thorough study to assure the propriety of the repair.

A few ceramics suffered from a condition known as fire-clouding. This is seen as a dark stain on the surface and occurs in the original firing. When carbonaceous material is burned, the carbon that it contains combines with oxygen present in the air to form carbon dioxide gas. If the amount of carbonaceous material being burned is greater than the amount of air available, inadequate combustion from a reduction instead of an oxidizing environment occurs. The outcome is the formation of carbon.[9] A smoking fire may cause such fire-clouding.

As a result of primitive firing techniques, design elements on a few ceramics in the collection were badly obscured by this unintentional occurrence. By refiring the ceramic in an oxidizing atmosphere with careful control of the process we removed the fire-clouding (Fig. 6). Refiring destroys the accumulated TL properties of the ceramic. Therefore, the ceramics selected for refiring were first sampled for TL analysis. This insured proper documentation on the age of the object.

The temperature at which the carbon was deposited in the original firing is the temperature to which a ceramic must be refired in order to remove that carbon. For instance, by measuring the temperature of the kiln and observing the temperature at which the carbon was effectively removed from the Vallejo Polychrome, Number 100, we were able to determine that it developed the fire-clouding at 1000°C. Most references on Pre-Columbian ceramics place the range of firing at 500-800°C. The deduction made by refiring Number 100 would appear to extend this temperature to 1000°C.

Refiring solves other problems by removing organic stains, stubborn deposits and insoluble adhesives. While firing may appear to be a drastic measure, it is actually one of the least harmful methods of reversing restoration.

The accumulated documentation of each object may consist of: condition reports based on examinations, photos of original condition, conservation treatment reports, photos of special problems encountered in restoration, X-rays, thermoluminescence analysis reports, and videotapes showing

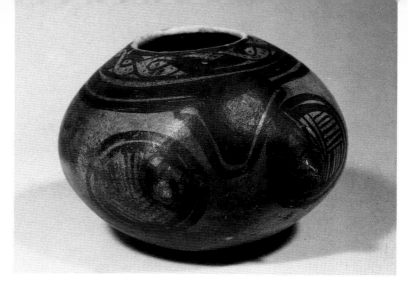

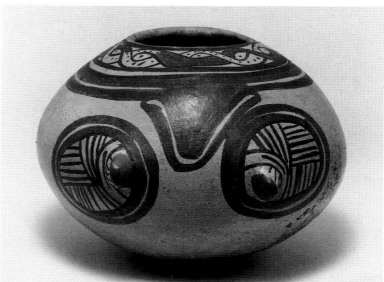

Fig. 6. No. 94 with discolored surface due to fire-clouding and object refired, showing clarified surface.

treatment procedures and completed restoration of the object. This body of information is invaluable for use in further studies of the ceramics and as a reference for future conservation treatment.

These ceramics, as historic and artistic works, will survive far beyond our lifetime. The repairs, however well done, may suffer damage after 75 to 100 years. Rejoined fractures may loosen, abrasions may occur, or the paint of restoration may become discolored and have to be replaced. Every measure of restoration performed on an object must permit easy removal yet this reversal of materials must not expose the object to any hazards. Careful consideration and choice of the type of materials used for restoration will assure that subsequent conservators experience a minimum of difficulties; it can also guarantee that the object will sustain no further damage to its original substance.

Conservation requires a knowledge and understanding of the material and structure of objects. Along with the principle of reversibility, however, the most necessary requirements for competent conservation and restoration are skill and respect for objects being treated.[10] Respect for work produced by the hands of ancient man creates an acute awareness for conservators whose role must be the preservation of the integrity of the work of art and its moment in history. Well-intentioned work ineptly done is wasteful—if not harmful. Skillful work can extend the life of the object and enhance its beauty for many years.

1. Hours 1976, p. 21.
2. Robertson 1967, p. 1.
3. Ibid, p. 6.
4. Ibid, p. 4.
5. Proulx, 1983 p. 90.
6. Taylor 1982, p. 100.
7. Skeist, 1977, p. 100.
8. Macbeth 1965, p. 2.
9. Fraser, 1974, p. 7, 8.
10. Keck, n.d.

Technical Analysis

DOREEN STONEHAM

Thermoluminescence analysis (TL) was undertaken on Costa Rican ceramics in the Arthur M. Sackler Collection to verify, where possible, the age parameters of a vessel and to correlate our findings with the chronology attributed to a ceramic type by Costa Rican archaeologists who base it on excavated material subjected to carbon-14 tests of animate material inside the vessel itself or from a grave or habitation site. One hundred twenty-seven Costa Rican ceramic objects were tested. In case of a significant difference between the result of the TL analysis and the accepted chronology, additional samples were tested and the analytic interpretation was reviewed. In most instances the TL analysis confirmed the established chronology although the age spans are necessarily broad because accuracy is limited for unprovenienced ceramics whose environmental radiation can not be measured. In nineteen cases, clay samples proved too insensitive to allow age calculation. Such insensitivity results from the nature of the clay sample itself (that is, it may not incorporate the necessary minerals to record thermoluminescence), or the inclusion of too much sandy temper in the body fabric, or insufficient material to produce a satisfactory luminescence curve.

Thermoluminescence derives from the interaction of radioactivity with minerals in the pottery fabric, both inside the piece and from the environment. In determining an age for an object it is essential to know how much radioactivity per year is reaching the minerals responsible for thermoluminescence. No problem exists in analyzing the pottery fabric to determine its radioactivity, but, since all the objects tested are of unknown provenience and have been thoroughly cleaned, it is not possible to measure the environmental contribution. A further complication exists: the internal radioactivity of the Costa Rican ceramics is, in most cases, exceptionally low, so that the major contribution to the thermoluminescence comes from the environment. This problem was solved when several objects were found to have soil still adhering to the surface within some part. This soil was analyzed for radioactive content and a plot of soil radioactivity versus the corresponding pottery radioactivity was drawn.* It was immediately apparent that a strong correlation existed between the two parameters and therefore it was possible to construct a simple equation to give the environmental contribution corresponding to any given pottery radioactivity within certain limits of accuracy. The equation is not necessarily valid for all the pieces, but in the absence of further data all the ages have been recalculated based on this equation. The accuracy of the results is further limited by the necessarily small sample size. We have quoted a data span for each object which is ± 20% of the derived age. Each catalogue entry reports the TL analysis with its reference number and date, and the time span during which the clay was last fired.

In five cases, after sampling for thermoluminescence analysis and in an effort to clean the ceramics, objects were refired in a modern kiln at a temperature which would remove fire-clouding or grave stains not removed by other cleaning methods. When refired, the radioactive clock for each object is put back to zero so that subsequent TL analysis will record a modern date.[†]

*Soil samples to determine environmental radiation were taken from the following objects from parts of the vessel noted:

Cat. No.	Accession No.	Taken from
6	N-1109	inside the legs
28	N-1143	inside the nose
81	N-890	inside the feet
106	N-1112	around the teeth
108	N-1012	inside the legs
109	N-886	inside the legs
149	N-1007	inside spots of appliqué
150	N-1102	inside the decoration on the legs
163	N-1167	inside the lug figures

†Ceramics refired, after TL analysis, to remove burial stains or fire-clouding:

68. (N-988) Refired at a temperature of 1000-1100° F (523-579° C).
76. (N-1004) Same as above.
94. (N-1013) Same as above.
96. (N-1056) Same as above.
100. (N-1205) Refired at a temperature of 1800-1850° F (968-996° C). In her discussion of the blue paint on Vallejo Polychrome, Dr. Day noted that there was an indication of two firings for such vessels: the first at the time of applying the slip and the second firing, at a much lower temperature, after the blue and orange paint were applied, to insure that the blue, which is considered to have been very fugitive, would not burn away at the higher temperature. The high temperature used to burn away the fire-clouding in the refiring of the vessel, however, did not affect the blue.

Bibliography

ALCA* *The Archaeology of Lower Central America*, edited by
 Frederick W. Lange and Doris Z. Stone. School of
 American Research Advanced Seminar Series.
 University of New Mexico Press, Albuquerque.

BC/BS* *Between Continents/Between Seas: Precolumbian Art of
 Costa Rica*, edited by Elizabeth Benson. H. N. Abrams,
 New York.

*Vinculos** Museo Nacionál de Costa Rica, San José.

 **Abbreviations and Periodicals in the Bibliography*

Abel-Vidor 1980 Abel-Vidor, Suzanne. "The Historical Sources for the
 Greater Nicoya Archaeological Subarea." *Vinculos* 6(1-
 2):pp. 155-86.

Abel-Vidor 1981 _____. "Ethnohistorical Approaches to the Archae-
 ology of Greater Nicoya." *BC/BS*: pp. 85-92.

Abel-Vidor and _____. and Jane Day. "Ethnohistory and Archaeology
Day 1983 of Guanacaste, Costa Rica." Paper presented at the
 Annual Meeting for the Society for Ethnohistory,
 Colorado Springs.

Accola 1978a Accola, Richard M. "A decorative sequence of prehis-
 toric ceramics from the Vidar site, Guanacaste, Costa
 Rica." M.A. thesis, University of Texas.

Accola 1978b _____. "Revisión de los tipos de ceramica del Periodo
 Policromo Medio en Guanacaste." *Vinculos* 4: pp. 80-105.

Aguilar 1953 Aguilar, P. Carlos Humberto. *Retes, un deposito arqueo-
 lógico en las faldas de Irazú.* San José.

Aguilar 1972 _____. *Guayabo de Turrialba.* Editorial Costa Rica, San
 José.

Aguilar 1973 _____. "Contribución al estudio de las sequencias cul-
 turales en el area central de Costa Rica." Paper pre-
 sented at the 9th International Congress of Anthro-
 pological and Ethnographic Sciences, Chicago.

Aguilar 1974 _____. "Asentamientos indigenas en el area central de
 Costa Rica." *America Indigena* 34: pp. 311-317.

Aguilar 1975 _____. "El Molino: Un sitio de la fase Pavas en Car-
 tago." *Vinculos* 1:pp. 18-56.

Aguilar 1976 _____. "Relaciónes de las culturas pre-colombinas en
 el intermontano central de Costa Rica." *Vinculos* 2: pp.
 75-86.

Alfaro 1846 _____. *Antiquedadas de Costa Rica.* Tipographia
 Nacionál, San José.

Alfaro 1893 Alfaro, Anastacio. "Arqueológia Costarricense." *El
 Centenario* 4: pp. 241-246. San José.

Balser 1953 Balser, Carlos. *El Jade Precolombino de Costa Rica.*
 Museo Nacionál, San José.

Balser 1955 _____. "A Fertility Vase from the Old Line, Costa
 Rica." *American Antiquity* 20(4): pp. 384-387.

Balser 1966 _____. "Los objetos de oro de los estilos extranjeros
 de Costa Rica." *Acta*, 34th International Congress of
 Americanists (Seville 1964) 1: pp. 391-398.

Balser 1968 _____. "Metal and Jade in Lower Central America."
 *Actas y Memorias del XXXVIII Congreso Internacionál de
 Americanistas.* Republica Argentina (1966) IV: pp. 57-
 66. Buenos Aires.

Balser 1974 _____. *El Jade de Costa Rica.* Liberia Lehmann, San
 José.

Balser 1980 _____. *Jade Precolombino de Costa Rica.* Tipographia
 Nacionál, San José.

Baudez 1966 Baudez, Claude F. "Incised Slate Discs from the
 Atlantic Watershed of Costa Rica: a Commentary."
 American Antiquity 31: pp. 441-443.

Baudez 1967 _____. "Récherches archéologiques dans la vallée du
 Tempisque, Guanacaste, Costa Rica." *Travaux et Mémoi-
 res de l'Institut des Hautes Études de l'Amérique Latine* 18.
 Centre National de la Recherche Scientifique, Paris.

Baudez 1970 _____. *Central America* (Trans. by James Hogarth).
 Barrie and Jenkins, London; Nagel Publishers,
 Geneva.

Baudez and Coe _____, and Michael D. Coe. "Archaeological
1962 Sequences in Northwestern Costa Rica." *Proceedings of
 the Thirty-fourth International Congress of Americanists* 1:
 pp. 366-373. Vienna.

Beadle 1972 Beadle, George W. "The Mystery of Maize." Bulletin,
 Field Museum of Natural History, 43(10): pp. 1-14.
 Chicago.

Bell 1974 Bell, Betty. *Archaeology of West Mexico.* Sociedad de
 Estudios Avanzados del Occidente de Mexico. Ajijic,
 Jalisco, Mexico.

Bishop 1984 Bishop, Ronald. "Ceramica de La Gran Nicoya: Un
 acercamiento basada en la composición quimica de la
 pasta." Paper presented at the 3rd Conference on
 Ceramics of Greater Nicoya, San José.

Blackiston 1910 Blackiston, A. Hooton. "Recent Discoveries in Hon-
 duras." *American Anthropologist* 12: pp. 536-541.

Bozzoli de Willi Bozzoli de Willi, Mariá Eugenia. "Contribucion al
1962 conocimiento arqueológico de Pueblo Nuevo de
 Pérez Zeledón, *Informe Semestral* July-December:pp.
 73-101. Instituto Geográfico de Costa Rica, San José.

Bozzoli de Willi _____. "Observaciónes arqueológicas en los valles del
1966 Parrita y del General." *Boletin de la Associación de Ami-
 gos del Museo* 19.

Bransford 1881 Bransford, J.F. "Archaeological Researches in Nicara-
 gua." *Smithsonian Contributions to Knowledge* XXV.
 Washington, D.C.

Bransford 1884 _____. "Report on Explorations in Centrál America
 in 1881." Annual Report of Board of Regents, Smith-
 sonian Institute (1882): pp. 803-825.

Bray 1972 Bray, Warwick. "Ancient American Metalsmiths." *Proceedings of the Royal Anthropological Institute for 1971*: pp. 25-43.

Bray 1977 _____. "Maya Metalwork and Its External Connections." *Social Process in Maya Prehistory*, edited by Norman Hammond. Academic Press, New York.

Bray 1981 _____. "Goldwork." *BC/BS*: pp. 153-166.

Bray 1984 _____. "Across the Darien Gap: A Columbian View of Isthmian Archaeology." *ALCA*: pp. 305-338.

Broadbent 1974 _____. Broadbent, Sylvia M. "Tradiciones ceramicas de las Altiplanicies de Cundinamarca y Boyaca." In *Revista Colombina de Antropologia* 16: pp. 223-248.

Clifford 1983 Clifford, Paul, et al. *Art of the Andes: Pre-Columbian Sculptured and Painted Ceramics from the Arthur M. Sackler Collections*, edited by Lois D. Katz. Washington, D.C.

Codex 1975 *Codex Nuttall*, Zelia Nuttall ed.

Coe 1962 Coe, Michael D. "Costa Rican Archaeology and Mesoamerica." *Southwestern Journal of Anthropology* 18: pp. 170-183.

Coe 1962 _____. "Preliminary Report on Archaeological Investigations in Central Guanacaste, Costa Rica." *Proceedings of the 34th International Congress of Americanists*: pp. 358-365. Vienna.

Coe and Baudez 1961 _____, and Claude F. Baudez. "The Zoned Bichrome Period in Northwest Costa Rica." *American Antiquity* 26: pp. 505-515.

Colón 1947 Colón, Hernando. *Vida del almirante Don Cristobal Colón*. Fondo de Cultura Economica, Mexico.

Cooke 1976 Cooke, Richard. "Panama: Región Central." *Vinculos* 2: pp.122-140.

Cooke 1984 _____, and Anthony J. Ranere. In press: "The Proyecto Santa Maria: A Multidisciplinary Analysis of Prehistoric Human Adaptions to a Tropical Watershed in Panama." *Proceedings of the Forty-fourth International Congress of Americanists* (Manchester).

Cordy-Collins and Nicholson 1979 Cordy-Collins, Alana, and H. B. Nicholson. *Pre-Columbian Art from the Land Collection*, edited by L.K. Land. California Academy of Sciences.

Covarrubias 1946 Covarrubias, Miguel. *Mexico South: The Isthmus of Tehuantepec*. Alfred A. Knopf, New York.

Covarrubias 1966 _____. *Indian Art of Mexico and Central America*. Alfred A. Knopf, New York.

Covarrubias 1971 _____. *Indian Art of Mexico and Central America*. Alfred A. Knopf, New York.

Creamer 1979 Creamer, Winifred. "Preliminary Survey Near Upala (Alajuela), Costa Rica." Paper presented at the 44th Annual Meeting of the Society for American Archaeology, Vancouver.

Creamer 1980 _____. "Evidence for pre-Hispanic exchange systems in the Gulf of Nicoya, Costa Rica." Paper presented at the 45th Annual Meeting of the Society for American Archaeology, Philadelphia.

Creamer 1983 _____. "Production and Exchange on Two Islands in the Gulf of Nicoya, Costa Rica, AD 1200-1550." Ph.D. dissertation, Tulane University.

Day 1982 Day, Jane Stevenson. "The Late Polychrome Period Ceramics." Paper presented at the 1st Denver Conference on Greater Nicoya Ceramics.

Day 1984a _____. "New Approaches in Stylistic Analysis: The Late Polychrome Period Ceramics from Hacienda Tempisque, Guanacaste Province, Costa Rica." Ph.D. dissertation, Tulane University.

Day 1984b _____. "Greater Nicoya Polychrome Ceramics: Regional and Inter-Regional Ties." In *Inter-Regional Ties in Costa Rican Prehistory* edited by Esther Skirboll and Winifred Creamer. B.A.R. International Series 226.

de Minelli see Laurencich de Minelli.

de Vries et al. 1958 de Vries, H. and others. "Groningen radiocarbon dates II." *Science* 127: pp. 129-137.

de Willi see Bozzoli de Willi.

Dockstader 1964 Dockstader, Frederick J. *Indian Art in Middle America: Pre-Columbian and Contemporary Arts and Crafts of Mexico, Central America and the Caribbean*. New York Graphic Society, Greenwich, Ct.

Dockstader 1967 _____. *Indian Art in South America: Pre-Columbian and Contemporary Arts and Crafts*. New York Graphic Society, Greenwich, Ct.

Dockstader 1973a _____. *Indian Art of the Americas*. Museum of the American Indian, Heye Foundation, New York.

Dockstader 1973b _____. *Masterworks from the Museum of the American Indian*. Heye Foundation, New York.

Drolet 1984 Drolet, Robert P. "A Note on Southwestern Costa Rica." (Proyecto Boruca 1980-81). Summary in Haberland 1984: pp. 254-262.

Drucker 1955 Drucker, Philip. *The Cerro de las Mesas Offering of Jade and Other Materials*. Bureau of American Ethnology, Smithsonian Institution, 157:44. Washington, D.C.

Easby 1981 Easby, Elizabeth K. "Jade." *BC/BS*: pp. 135-152.

Edwards 1965 Edwards, Clinton. "Aboriginal Watercraft on the Pacific Coast of South America." *Ibero-Americana* 47. University of California Press, Berkeley.

Ekholm 1942 Ekholm, Gordon. "Excavations at Guasave, Sinaloa, Mexico." Anthropological Papers of the American Museum of Natural History, vol. 30.

Fernández 1881-1907 Fernández, León. *Colección de documentos para la historia de Costa Rica*. 10 vols. San José.

Fernándo de Oviedo 1851-55 Fernando de Oviedo y Valdes, Gonzalo. *Historia General y Natural de las Indias, Islas y Tierra-Firme del Mar Océano*, edited by J. Amador de los Rios. 4 vols. Madrid.

Ferrero 1975 Ferrero Acosta, Luis. *Costa Rica Precolombina*. Editorial Costa Rica, San José.

Ferrero 1977 _____. "Costa Rica Precolombina." 2nd ed. *Serie Biblioteca Patria 6*. Editorial Costa Rica, San José.

Flint 1882 Flint, Earl. Letters to George Putnam, beginning in 1882 and continuing for the years 1884-85 and 1889, in the Peabody Museum Archives, Harvard University.

Fonseca 1979 Fonseca Zamora, Oscar. "Informe de la primera temporada de reexcavación de Guayabo de Turrialba." *Vinculos* 5: pp. 35-52.

Fonseca and Richardson 1978 _____ and James B. Richardson III. "South American and Mayan Cultural contacts at the Las Huacas Site, Costa Rica." *Annals of the Carnegie Museum* 47: art.131. Pittsburgh.

Fowler 1981 Fowler, William. "The Pipil-Nicarao of Central America." Ph.D. dissertation, Department of Archaeology, University of Calgary.

Fraser 1974 Fraser, Harry. *Glazes for the Craft Potter*. Watson-Guptill Pub., New York.

Glass 1966 Glass, John B. "Archaeological Survey of Western Honduras." *Handbook of Middle American Indians* 4, edited by Gordon F. Ekholm and Gordon R. Willey. University of Texas Press, Austin.

Graham 1979 Graham, Mark. "A New Look at Mesoamerican Influence on Costa Rican Art." Paper presented at the 44th Annual Meeting of the Society for American Archaeology, Vancouver.

Graham 1981 _____. "Traditions of Stone Sculpture in Costa Rica." *BC/BS*, edited by E. Benson. H.N. Abrams, New York.

Haberland 1957 Haberland, Wolfgang. "Excavations in Costa Rica and Panama." *Archaeology* 10: pp. 258-63.

Haberland 1959 _____. *Archäologische Untersuchungen in Sudost Costa Rica*. Series Geographica et Ethnographica 1. Franz Steiner Verlag, Wiesbaden.

Haberland 1960 _____. "Peninsula de Osa. Anotaciónes Geográficas y Arqueológicas." *Instituto Geográfico de Costa Rica, Informe Semestras* (Enero-Junio): pp. 75-86.

Haberland 1961a _____. "Arqueológia de valle del Rio Ceiba, Buenos Aires." *Instituto Geográfico de Costa Rica, Informe Semestral* (Enero-Junio): pp. 31-62.

Haberland 1961b _____. "New Names for Chiriquían Pottery Types." *Panama Archaeologist* 4: pp. 56-60.

Haberland 1984 _____. "The Archaeology of Greater Chiriquí." *ALCA*: pp. 233-254.

Hartman 1901 Hartman, Carl Vilhem. *Archaeological Researches in Costa Rica*. Royal Ethnographical Museum, Stockholm.

Hartman 1907 _____. *Archaeological Researches on the Pacific Coast of Costa Rica*. Memoirs of the Carnegie Museum, no. 3. Pittsburgh.

Healy 1974 Healy, P.F. *Archaeological Survey of the Rivas Region, Nicaragua*. Ph.D. diss., Harvard University.

Healy 1980 _____. *Archaeology of the Rivas Region of Nicaragua*. Wilfred Laurier University Press, Ontario.

Holmes 1888 Holmes, W.H. "Ancient Art of the Province of Chiriquí." Bureau of American Ethnology, Smithsonian Institution, Fifth Annual Report. U.S. Government Printing Office, Washington, D.C.

Hoopes 1980 Hoopes, John. "Copador Polychrome: A Ceramic Style of Classic Copán and its Influence on Polychrome Types of Lower Mesoamerica." MS, Yale University.

Hours 1976 Hours, Madeline. *Conservation and Scientific Analysis of Painting*. Van Nostrand Reinhold, New York.

Instituto Costa Ricense de Turismo *Arqueológia de Costa Rica* 3.

Joyce 1916 Joyce, Thomas A. *Central American and West Indian Archaeology, Being an Introduction to the Archaeology of the States of Nicaragua, Costa Rica, Panama and the West Indies*. Putnam, New York.

Keck n.d. Keck, Caroline. "On Conservation." *Museum News Technical Supplement* (reprint from American Association of Museums).

Kennedy 1968 Kennedy, William J. "Archaeological Investigations in the Reventazon River Drainage Area, Costa Rica." Ph.D. diss., Tulane University.

Kennedy 1969 _____. "Current Research, Costa Rica." *American Antiquity* 34:p.358.

Kennedy 1975 _____. "The Appearance of the Chiefdom and its Environmental Setting in the Reventazon River Area, Costa Rica." Proceedings of the Forty-first International Congress of Americanists 1:pp.560-67. Mexico City.

Kennedy 1976 _____. "Prehistory of the Reventazon River Drainage Area, Costa Rica." *Vinculos* 2:pp.87-100.

Kubler 1975 Kubler, George. *The Art and Archaeology of Ancient America*. Penguin Books, London.

Lange 1971a Lange, Frederick W. *Cultural History of the Sapoa River Valley, Costa Rica*. Logan Museum of Anthropology, Occasional Paper 4. Beloit College.

Lange 1971b _____. "Northwestern Costa Rica: pre-Columbian Circum-Carribean Affiliations." *Folk* 13:pp.43-64.

Lange 1984 _____. "The Greater Nicoya Archaeological Subarea." *ALCA*:pp.233-254.

Lange and Accola 1979 _____and Richard M. Accola. "Metallurgy in Costa Rica." *Archaeology* 32(3): pp.26-33.

Lange and Scheidenhelm 1972 _____and K. Scheidenhelm. "The Salvage Archaeology of a Zoned Bichrome Cemetery, Costa Rica." *American Antiquity* 37: pp.240-245.

Lange and Stone 1984 _____and Doris Z. Stone, eds. *The Archaeology of Lower Central America*. University of New Mexico Press, Albuquerque.

Lathrap 1975 Lathrap, Donald W., with Donald Collier and Helen Chandra. *Ancient Ecuador: Culture, Clay and Creativity, 3000-300 BC*. Field Museum of Natural History, Chicago.

Laurencich de Minelli 1983 Laurencich de Minelli, Laura. *Il Sito Barra Honda, Un apporto alla storia e alla cultura precolumbiana della Nicoya (Costa Rica)*. Bologna.

Laurencich de Minelli and Minelli 1966 _____, and Luigi Minelli. "Informe preliminar sobre excavaciones alrededor de San Vito de Java." *Acta*, 36th International Congress of Americanists (Seville 1964) 1: pp. 415-427.

Laurencich de Minelli and Minelli 1973 _____. "La fase Aguas Buenas en la región de San Vito de Java (Costa Rica)." *Acta*, 40th International Congress of Americanists (Rome-Genoa 1972) 1: pp. 219-224.

Lehmann 1910 Lehmann, Walter. "Ergebnisse einer Forschungsreise in Mittelamerika und Mexiko, 1907-1909." *Zeit fur Ethnologie* 42(5). Berlin.

Lehmann 1920 _____. *Zentral Amerika. Die Sprachen Zentral-Amerikas*. 2 vol. Berlin.

Leon-Portilla 1972 Leon-Portilla, Miguel. "Religión de los Nicaraos: Análisis y Comparación de Tradiciónes Culturales Nahuas." *Serie de Cultura Nahuatl* Mono 12. Universidad Nacionál Autonoma de Mexico, Instituto de Investigaciónes Historicas, Mexico.

Leopold 1972 Leopold, A. Starker. *Wildlife of Mexico*. University of California Press, Berkeley.

Linares 1968 Linares, Olga. "Cultural Chronology in the Gulf of Chiriquí, Panama." *Smithsonian Contributions to Anthropology* 8, Smithsonian Institution, Washington, D.C.

Linares 1977 _____. "Ecology and the Arts in Central Panama: On the Development of Social Rank and Symbolism in the Central Provinces." *Studies in Pre-Columbian Art and Archaeology* 17, Dumbarton Oaks, Washington, D.C.

Lines 1935 Lines, Jorge. *Los Altares de Toyopan: estudio hecho con motivo de la Exposición de Arqueológia de octobre 1934*. San José.

Lines 1936a _____. *Una Huaca en Zapandi: notas preliminares tomadas a propósito de las excavaciónes arqueológicas hechas a raiz de la immudación del Rio Tempisque en 1933, Filadelfia, Provincia de Guanacaste, Peninsula de Nicoya, Costa Rica*. San José.

Lines 1936b _____. *Notes on the Archaeology of Costa Rica*. National Tourist Board of Costa Rica, San José.

Lothrop 1926 Lothrop, Samuel K. *The Pottery of Costa Rica and Nicaragua*. 2 vols. Contributions from the Museum of the American Indian, Heye Foundation, no. 8. New York.

Lothrop 1942 _____. "The Sigua: Southernmost Aztec Outpost." *Proceedings of the Eighth American Scientific Congress* 2: pp.109-116.

Lothrop 1950 _____. *Archaeology of Southern Veraguas, Panama*. Memoirs of the Peabody Museum of Archaeology and Ethnology, 9 (3), Harvard University.

Lothrop 1963 _____. *Archaeology of the Diquis Delta, Costa Rica*. Papers of the Peabody Museum of Archaeology and Ethnology, 51, Harvard University.

Lothrop 1966 _____. "Archaeology of Lower Central America." In *Handbook of Middle American Indians*, vol. 4, edited by R. Wauchope. University of Texas Press, Austin.

Macbeth 1965 Macbeth, James A. and Alfred C. Strohlein. "The Use of Adhesives in Museums." *Museum News Technical Supplement* 7: p.2.

MacCurdy 1911 MacCurdy, George G. "A Study of Chiriquían Antiquities." *Memoirs of the Connecticut Academy of Arts and Sciences* 3.

Martír de Angléria 1944 Martír de Angléria, Pedro. *Décadas del neuvo mundo*. Bueno Aires. Oviedo y Valdés, Gonzalo Fernandes de.

Mason 1945 Mason, J. Alden. "Costa Rican Stonework: The Minor C. Keith Collection." *Anthropological Papers of the American Museum of Natural History* 39. New York.

Meggers 1966 Meggers, B.J. *Ecuador*. Ancient Peoples and Places Series: pp.49-68. Frederick A. Praeger, New York.

Meggers and Evans 1959 _____and Clifford Evans. "Archaeological Investigations at the Mouth of the Amazon." *B.A.E. Bulletin* 167. Smithsonian Institution, Washington, D.C.

Melendez 1959 Melendez, Carlos. "Un Jaron Representative de la Guerra Sagrada." Paper presented at the 33rd International Congress of Americanists. San José.

Nicholson 1982 Nicholson, Henry. "The Mixteca-Puebla Concept Revisited." In *The Art and Iconography of Late Postclassical Central Mexico* edited by E. Boone: pp. 227-254. Dumbarton Oaks, Washington, D.C.

Norr 1980 Norr, Lynette. "Prehistoric Diet and Bone Chemistry: Initial Results from Costa Rica." Paper presented at the 45th Annual Meeting of the Society for American Archaeology, Philadelphia.

Norr 1981 ———. "Prehistoric Human Diet in Lower Central America: The Maize vs. Marine Fauna Problem." Paper presented at the 3rd Annual Meeting of the Society for Archaeological Sciences, San Diego."

Norweb 1964 Norweb, Albert H. "Ceramic Stratigraphy in Southwestern Nicaragua." *Actas y Memorias del XXXV Congreso Internaciónal de Americanistas* 1: pp. 551-561. Mexico City.

Oviedo y Valdés 1945 Oviedo y Valdés, Gonzalo Fernando de. *Historia General y Natural de las Indias, Islas y Tierra-Firme del Mar Océano.* Madrid.

Oviedo y Valdés 1976 ———. "Nicaragua en los Cronistas de Indias: Oviedo." Serie Cronistas 3, Fondo de Promoción Cultural, Banco de America, Managua.

Parsons 1980 Parsons, Lee A. *Pre-Columbian Art: The Morton D. May and the St. Louis Art Museum Collections.* New York.

Pasztory 1983 Pasztory, Esther. *Aztec Art.* Henry Abrams, New York.

Paulsen 1977 Paulsen, Allison. "Pattern of Maritime Trade Between South Coastal Ecuador and Western Mesoamerica 1500 BC-AD 600." In *The Sea in the Pre-Columbian World* edited by E. Benson: pp. 141-160. Dumbarton Oaks, Washington, D.C.

Perez de Barradas 1943 Perez de Barradas, José. *Arqueológia Agustina.* Bogotá.

Perez de Barradas 1954 ———. *Orfebreria Prehispanica de Colombia. Estilo Calima.* Texto. Banco de la Republica, Museo del Oro, Bogotá.

Perez Zeledon 1907-1908 Perez Zeledon, Pedro. *Las Ilanuras de Pirris valle del Rio General o Grande de Terraba.* Informes presentados a la Secretaria de Fomento. San José.

Proulx 1983 Proulx, Donald et al. "The Nasca Style." In *Art of the Andes: Pre-Columbian Sculptured and Painted Ceramics from the Arthur M. Sackler Collections,* edited by Lois D. Katz: pp. 87-105. Washington, D.C.

Ramsey 1975 Ramsey, James. "An Analysis of Mixtec Minor Art, with a Catalogue." Ph.D. diss., Tulane University.

Reichel-Dolmatoff 1965 Reichel-Dolmatoff, Gerardo. *Colombia.* Ancient Peoples and Places Series, no. 44, edited by G. Daniel. Frederick Praeger, New York.

Robertson 1967 Robertson, Clements R. "The Visual and Optical Examination of Works of Art." *Museum News Technical Supplement* 20: pp. 1-6.

Robicsek 1972 Robicsek, Francis. *Copán: Home of the Mayan Gods.* Museum of the American Indian, Heye Foundation. New York.

Robicsek 1975 ———. *A Study in Maya Art and History: The Mat Symbol.* Museum of the American Indian, Heye Foundation. New York.

Robinson 1978 Robinson, Eugenie. "Mayan Design Features of Mayoid Vessels of the Ulúa-Yojoa Polychrome." M.A. thesis, Tulane University.

Root 1961 Root William C. "Pre-Columbian Metalwork of Colombia and its Neighbors." *Essays in Pre-Columbian Art and Archaeology,* edited by Samuel K. Lothrop and others: pp. 242-257. Harvard University Press, Cambridge.

Ryder 1980 Ryder, Peter. "Informe de las Investigaciónes Arqueológias Preliminares de la Región de Guayabo de Bagaces, Guanacaste." In *Memoria del Congreso Sobre el Mundo Centroamericano de su Tiempo: IV Centenario de Gonzalo Fernandez de Oviedo:* pp. 157-165. Editorial Texto, San José.

Santley 1983 Santley, Robert. Personal communication with Jane Day.

Service 1975 Service, E. R. *Origins of the State and Civilization.* W.W. Norton and Co., New York.

Sharer 1984 Sharer, Robert J. "Lower Central America as Seen from Mesoamerica." In *ALCA:* pp. 63-84.

Sheets 1984 Sheets, Payson D. "The Prehistory of El Salvador: An Interpretive Summary." *ALCA:* pp. 85-112.

Skeist 1972 Skeist, Irving. *Handbook of Adhesives.* Van Nostrand Reinhold, New York.

Snarskis 1981 Snarskis, Michael J. *BC/BS:* pp. 15-84 and 176-227.

Snarskis 1982 ———. *La Ceramica precolombina en Costa Rica/Precolumbian Ceramics in Costa Rica.* Bilingual edition. Instituto Naciónal de Seguros. San José, Costa Rica.

Snarskis 1984 ———. "Central America: The Lower Caribbean." In *ALCA:* pp. 195-232.

Spinden 1925 Spinden, Herbert Joseph. "The Chorotegan Culture Area." *Compte-Rendu du XXI Congrès Internaciónal des Americanistes* 2: pp. 259-245. Gothenberg.

Stark 1978 Stark, Barbara and Barbara Voorhies. *Prehistoric Coastal Adaptions: The Economy and Ecology of Maritime Middle America.* Academic Press, New York.

Stirling 1969 Stirling, Matthew. "Archaeological Investigations in Costa Rica." *National Geographic Society Research Reports 1964 Projects:* pp. 239-47.

Stone 1943 Stone, Doris. "A Preliminary Investigation of the Flood Plain of the Rio Grande de Terraba, Costa Rica." *American Antiquity* 9: 74-88.

Stone 1958 ———. *Introduction to the Archaeology of Costa Rica.* National Museum of Costa Rica, San José.

Stone 1962 ———. *The Talamancan Tribes of Costa Rica.* Papers of the Peabody Museum of Archaeology and Ethnology, vol. 43 (2), Harvard University.

Stone 1966 ———. "Synthesis of Lower Central Ethnohistory." *Handbook of Middle American Indians* vol. 4, edited by Gordon F. Ekholm and Gordon R. Willey, University of Texas Press, Austin.

Stone 1967 ———. "The Significance of Certain Styles of Ulúa Polychrome Ware from Honduras." *Folk* 8-9: pp. 335-342.

Stone 1970 ———. "An Interpretation of Ulúa Polychrome Ware." *Acta,* 38th International Congress of Americanists (Stuttgart-Munich 1968) 2: pp. 67-76.

Stone 1972 ———. *Pre-Columbian Man Finds Central America.* Peabody Museum Press, Cambridge.

Stone 1973 ———. "El dios-hacha de jadeita en la America Central: su localización geográfica y su lugar en tiempo." *Atti* XL International Congress of Americanists (Rome-Genoa 1972): pp. 213-219.

Stone 1977 ———. *Pre-Columbian Man in Costa Rica.* Peabody Museum Press, Cambridge.

Stone 1979 ———. "The peripheral importance of lower Central America in pre-Columbian trade." Paper presented at the 43rd International Congress of Americanists, Vancouver.

Stone 1982 ———. "Cultural Radiations from the Central and Southern Highlands of Mexico into Costa Rica." *Aspects of the Mixteca-Puebla Style and Mixtec and Central American Culture in Southern Mesoamerica* edited by Doris Stone. Middle American Research Institute, Occasional Paper 4: pp. 60-70. Tulane University, New Orleans.

Stone 1983 ———. "A Synthesis of Pre-Columbian Ceramics from Costa Rica." *Gedenkschrift Walter Lehmann. Vol. 3. Indiana.* 8: pp. 201-221. Berlin.

Stone 1984 ———. "Pre-Columbian Migration of *Theobroma cacao* Linnaeus and *Manihot esculenta* Crantz from Northern South America into Mesoamerica: A Partially Hypothetical View." *Pre-Columbian Plant Migration.* Papers of the Peabody Museum of Archaeology and Ethnology: pp. 67-83. Harvard University.

Stone and Balser 1958 ———and Carlos Balser. *The Aboriginal Metalwork in the Isthmian Region of America.* National Museum of Costa Rica, San José.

Stone and Balser 1965 ———. "Incised Slate Disks from the Atlantic Watershed of Costa Rica." *American Antiquity* 30 (3) January: pp. 310-329.

Stone and Lange 1984 ———, and Frederick W. Lange. *The Archaeology of Lower Central America*. University of New Mexico Press, Albuquerque.

Strong 1948 Strong, William Duncan. "The Archaeology of Costa Rica and Nicaragua." *Handbook of South American Indians, Vol. 4: The Circum Caribbean Tribes* edited by Julian Steward: pp. 121-142. Washington.

Swauger and Mayer-Oakes 1952 Swauger, James L. and William J. Mayer-Oakes. "A Fluted Point from Costa Rica." *American Antiquity* 17: pp. 264-265.

Sweeney 1975 Sweeney, Jeanne W. "Guanacaste, Costa Rica: An Analysis of pre-Columbian ceramics from the northwest coast." Ph.D. diss., University of Pennsylvania.

Sweeney 1976 ———. "Ceramic Analysis from Three Sites in Northwest Coastal Guanacaste." *Vinculos* 2: pp. 37-44.

Taylor 1982 Taylor, Dicey. "Problems in the Study of Narrative Scenes on Classic Maya Vases." In *Falsifications and Misreconstructions of Pre-Columbian Art*, by Elizabeth P. Benson and Elizabeth H. Boone. Washington, D.C.

Viel 1978 Viel, Rene. "Etude de la Ceramica Ulúa-Yajoa Polychrome (Nord-Ouest de Honduras): Essai d'analyse stylistique de Babilonia." Ph.D. diss., René Descartes University, Paris.

von Heine-Geldern 1967 von Heine-Geldern, Robert. "American Metallurgy and the Old World." In: *Early Chinese Art and its Possible Influence in the Pacific Basin. Vol. 3, Oceania and the Americas*. A symposium arranged by the Department of Art History and Archaeology, Columbia University, New York City, August 21-25, 1967.

von Winning 1974 von Winning, Hasso. "The Shaft Tomb Figures of West Mexico." *Southwest Museum Papers* 24. Southwest Museum, Los Angeles.

Wallace 1980 Wallace, Henry and Richard M. Accola. "Investigaciónes arqueológicas preliminares de Nacascolo, Bahia Culebra, Costa Rica. *Vinculos* 6.

Weaver 1980 Weaver, David S. "Un análisis osteologico para el reconocimiento de las condiciónes de vida en sitio Vidor." Investigaciónes arqueológicas en la zona de Bahia Culebra, Costa Rica 1973-1979. *Vinculos* 6.

Willey 1966 Willey, Gordon R. *An Introduction to American Archaeology: Vol. 1, North and Middle America*. Prentice-Hall, Englewood Cliffs, New Jersey.

Willey 1971 ———. *An Introduction to American Archaeology: Vol. 2, South America*. Prentice Hall, Englewood Cliffs, New Jersey.

Willey 1984 ———. "A Summary of the Archaeology of Lower Central America." *ALCA*: pp. 341-378.

Zeledon 1907-1908 Zeledon, Pedro Perez. *Las Ilanuras de Pirris valle del Rio General o Grande de Terraba*. Informes presentados a la Secretaria de Fomento. San José.

Zucchi 1972 Zucchi, Alberta. "New Data on the Antiquity of Polychrome Painting from Venezuela." *American Antiquity* 37: pp. 439-446.

DRAWING AND PHOTO CREDITS

Drawing Credits

POLYCHROME CERAMICS AND ICONOGRAPHY
Figs. 6a after Códice Féjérvary-Mayer and 6b after Lothrop 1926; Fig. 9 from Ramsey 1975

DRAWINGS IN CATALOGUE ENTRIES
Nos. 24a, 84, 85, and 87 by Judith Ford Russell; Nos. 26, 74, 75 and 81 by Toby Stoetzer; Nos. 29, 69, 91 and 92 by David Stoetzer; Nos. 70, 71, 73, 88 and 96 by Doris J. McNair; No. 67 by Luis Gomez

Photo Credits

CLAY AND CIVILIZATION
Figs. 1 and 2 by Otto E. Nelson; Fig. 3 by Murray Shear

ARCHAEOLOGICAL WORK IN COSTA RICA
Pg. 14 by Fred Lange

PRE-COLUMBIAN TRADE IN COSTA RICA
Figs. 1, 2, 3, 4, 5, 6, 7, 8, 9, 10, 11, 12, 15, 16, 19, 20, 21, 23, 24, 25, 26, 27, 28, 29, 30, 31, 32, 33, 34, 35, 36, 37, 38, 39, 40, 41, 42, 43, 44 courtesy Doris Stone; Figs. 13, 14, 17, 18, 22, 25 by Murray Shear

POLYCHROME CERAMICS AND ICONOGRAPHY
Figs. 1, 2, 3, 4, 5b, 6, 7, 8, 9 by H.E. Day; Figs. 5a and 5c by Murray Shear

FIGURES IN CATALOGUE ENTRIES
Fig. 1.1 courtesy the Museum of the American Indian; Fig. 7.1 courtesy Museo Nacional de Costa Rica; Figs. 7.2, 7.3, 7.4 courtesy Instituto Nacional de Seguros

THE EXAMINATION AND CONSERVATION OF COSTA RICAN CERAMICS
Figs. 1, 2, 3, 4, 5, 6 courtesy Stoetzer, Inc.

MAPS pp. 10, 16, 27, 32 and 38 courtesy Doris Stone

PRODUCTION NOTE:
This catalogue was designed and its production
was supervised by Victor Trasoff.
Production coordinator was Edward Tuntigian.
It was printed and bound in limited edition
in Italy by Amilcare Pizzi S.p.A., Milan.
Photo composition in *Baskerville* by Empire
Typographers, New York.

Index

303

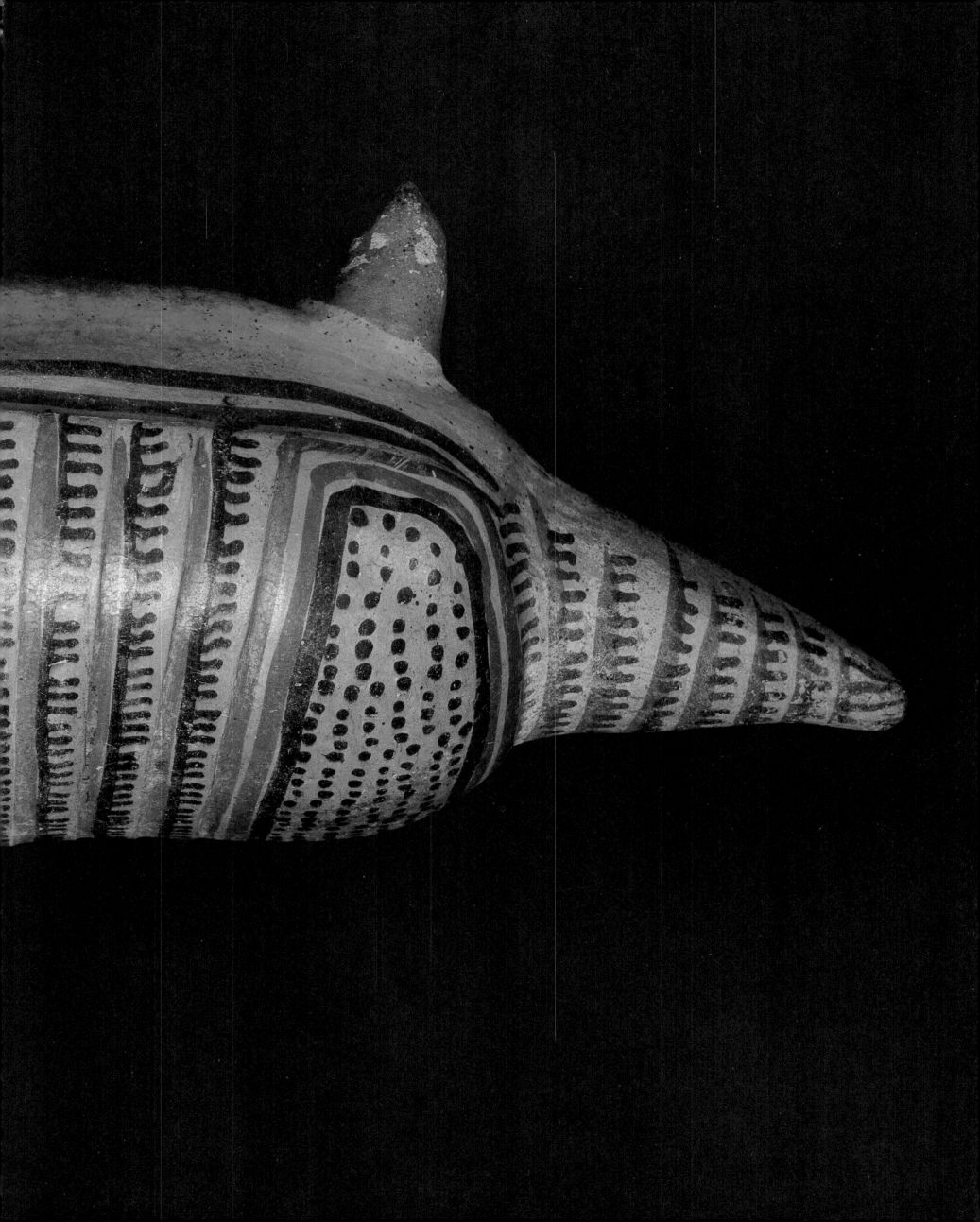